TOULOUSE-LAUTREC
and the *Fin de Siècle*

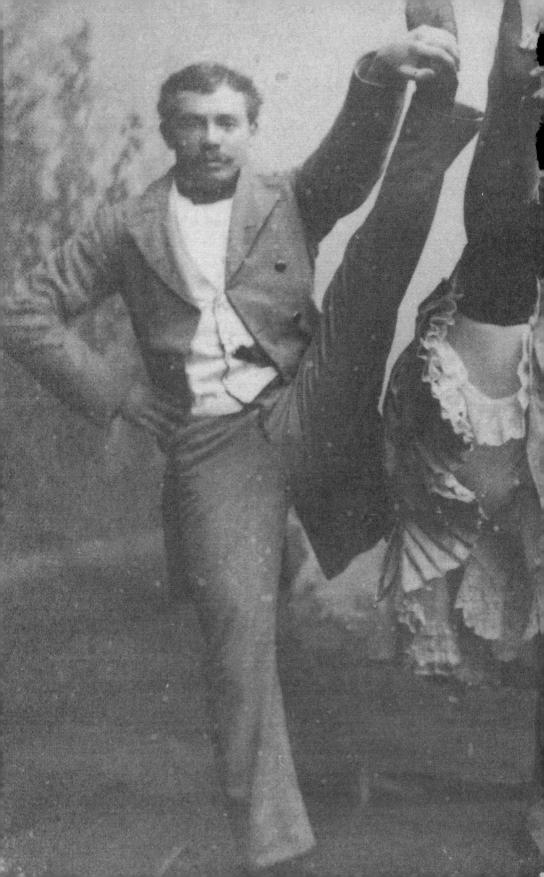

TOULOUSE-LAUTREC
and the *Fin de Siècle*

DAVID SWEETMAN

Hodder & Stoughton

Copyright © 1999 by David Sweetman

First published in 1999 by Hodder & Stoughton
A division of Hodder Headline PLC

10 9 8 7 6 5 4 3 2 1

A CIP catalogue record for this title is available from the British Library.

ISBN 0 340 60748 3

Designed and typeset by Behram Kapadia

Printed and bound in Great Britain by
Mackays of Chatham PLC, Chatham, Kent

Hodder and Stoughton
A division of Hodder Headline PLC
338 Euston Road
London NW1 3BH

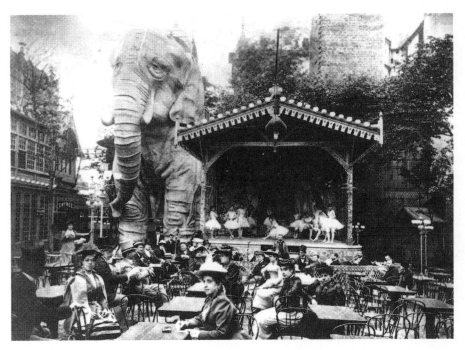

The model elephant in the gardens of the Moulin Rouge.

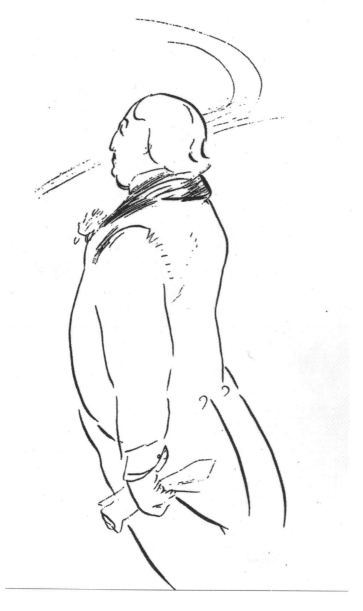

Portrait of Wilde in his heyday;
Lautrec's illustration for Paul Adams'
defence of the imprisoned author in
La Revue Blanche, April 1895.

CONTENTS

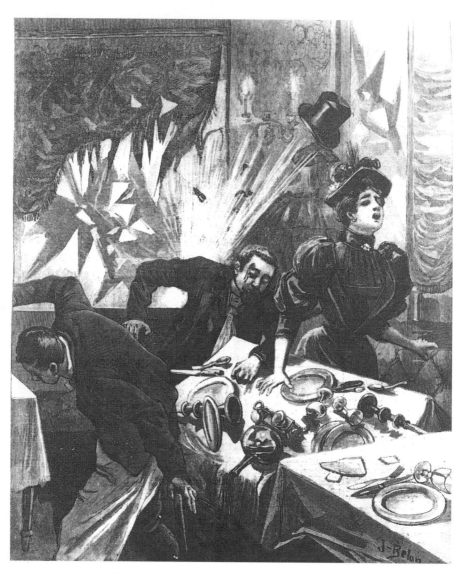
Anarchist explosion at the Restaurant Foyot, 1894.

PART ONE

ALL THE WAY UP TO THE TOP OF THE HILL . . .

There had always been innovation; no generation had passed without novelties. Now change became the nature of life, novelty a part of the normal diet, served by institutions like the press and news agencies – dedicated to it, or to its invention when in short supply. The fin de siècle *is the age of material novelties, of news, of* faits divers, nouvelles à sensation – *of scoops and beats and bulletins, newsbriefs and sensational tidings; the time when fashions – in dress, politics, or the arts – became clearly defined as being made to pass away: change for the sake of change.*

EUGÈNE WEBER

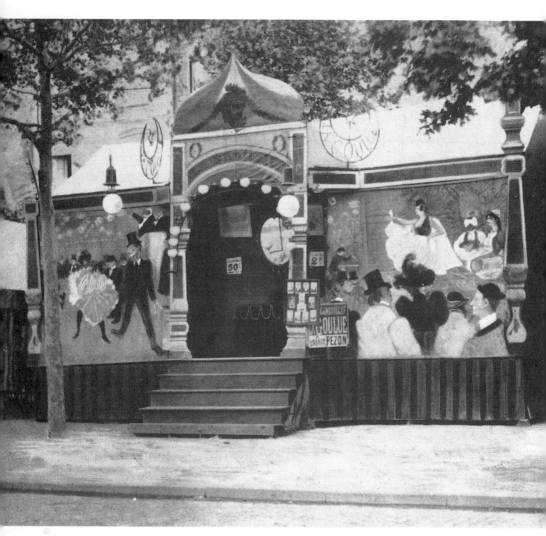

La Goulue's funfair booth with Lautrec's panels; photograph taken for *Le Figaro* at the Neuilly Fair and published in 1902.

1

A COMMISSION

In November 1926 the Parisian magazine *L'Amour de l'Art* carried an indignant article by the critic Georges Duthuit which brought to light the disturbing news that a dealer called Hodebert had been cutting up and selling segments of two huge paintings by Henri de Toulouse-Lautrec. According to Duthuit, Hodebert, a partner in Barbazangues et Hodebert, had organised an exhibition at his Paris gallery that featured eight unknown portraits by Lautrec. As the artist had died twenty-five years earlier in 1901 and was already famous, the appearance of a number of previously unseen works inevitably caused a stir. If Hodebert hoped that potential customers would accept that he had somehow stumbled upon eight missing canvases, he was quickly disabused. While most of the subjects were innocuous enough, the usual characters from Lautrec's night-time existence in the bars and cabarets of Montmartre, two of the heads were so unusual that suspicions were immediately aroused.

Indeed Duthuit not only identified the two portraits, he also knew where he had last seen them and could now report that they had been cut from two of the oddest works that Toulouse-Lautrec ever produced, two panels which had been hung on either side of the entrance to a funfair booth that was set up at the Foire du Trône in east Paris in April 1895. As Duthuit also recalled, Lautrec had painted these large canvases for the one-time star of the Moulin Rouge, Louise Weber, whose nickname – La Goulue (The Glutton) – signified the cause of her decline.

Louise had loved food and drink, she had emptied anyone's glass and a spreading waistline monitored her consumption. By 1895 it had spread to the point where she could no longer go on dancing the can-can and her new idea was to perform an Egyptian belly-dance in a 'Moorish' funfair booth

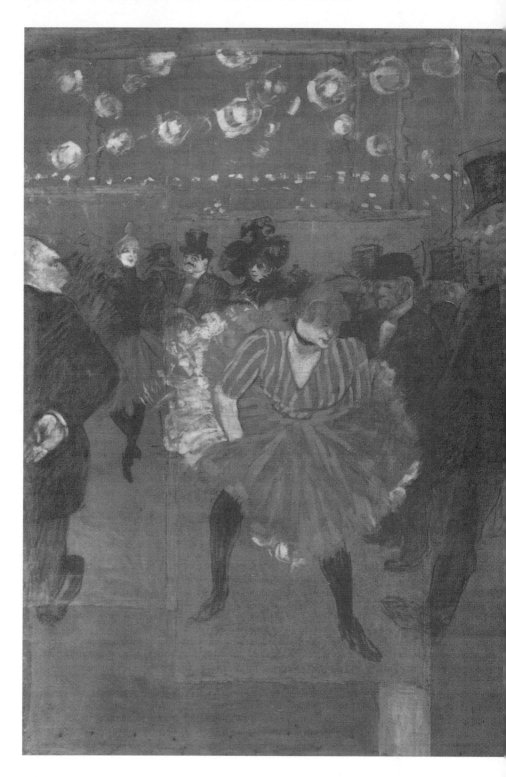

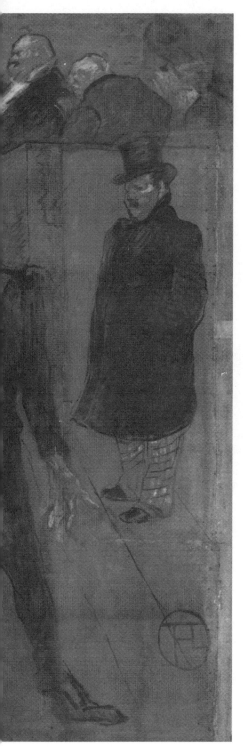

The left-hand panel for La Goulue's booth.

that she was having built. For this, she needed some eye-catching artwork – she would provide the canvas, Lautrec the art. No doubt amused by her audacity, he agreed, working non-stop to produce the two huge scenes in time for the opening a week later. In the left-hand panel he showed the dancer in her glory, the leading performer of the Montmartre dance halls aided by her supple partner Valentin le Desossé ('the Boneless') with his trademark jutting chin and high top hat. In the second panel he painted much the same thing, with a solitary La Goulue still going through her old high-kicking act rather than the new belly-dance promised within, though that is less surprising than the people gathered round watching her. Most were friends of the artist, like the dancer Jane Avril, and there was even a glimpse of Lautrec himself, though only back view, but it was the two large figures in the foreground, who really stood out. In the bottom right-hand corner was the easily recognisable profile of the literary critic Félix Fénéon, a notorious anarchist whom some suspected of having caused an explosion in a Paris restaurant that seriously injured one of the diners. While Fénéon was never found guilty, few doubted that he was more than just a lover of avant-garde art and poetry. But this was relatively minor compared to the reputation of the second figure, the most notorious character of the *fin de*

siècle, someone whose behaviour was considered so vile that his name could not be mentioned in polite society – Oscar Fingal O'Flahertie Wills Wilde.

Armed with this information Duthuit was able to launch a campaign to stop Hodebert from dispersing the portraits and thus wrecking for ever what he and a few others knew to be two key works that revealed a side to Lautrec that was often overlooked. To the men trying to save the panels, the presence of Fénéon with memories of his terrorist activities and Wilde with the revelations of his double life among the society queens and low-life rent-boys of the British capital, was just too significant to be passed off as an attention-grabbing joke. Both were anarchist theorists, leading revolutionaries in their day, yet Lautrec placed himself beside them, as if he and they were a team. In all, Lautrec made nine portraits of Wilde, one painted when he visited London during the trials that ended with Wilde's imprisonment in Reading Gaol, and when Fénéon became editor of the radical journal *La Revue blanche*, Lautrec joined him as a contributor and an intimate member of the close-knit group of anarchist writers and artists that gathered in the publication's offices.

And there are other works, drawings especially, a surprising number, that reveal interests and depths quite

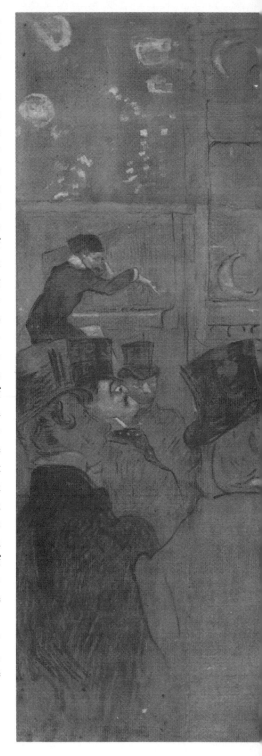

The right-hand panel for La Goulue's booth.

different from the amusing images of Montmartre night-life that have been reproduced over and over again in countless coffee-table books. Many of Lautrec's best drawings were a result of his friendship with the singer Aristide Bruant, whose earthy ballads about the poor of the Paris slums were anarchist anthems intended to shock his bourgeois listeners, or the *diseuse* Yvette Guilbert whose plaintive songs about the lonely and the down-trodden stand in stark contrast to the superficial gaiety that Henri de Toulouse-Lautrec is thought to represent.

And how familiar these characters seem to us as we stumble through our own *fin de siècle*. The 1890s may have been a time of relative calm after the unprecedented upheaval of a century of change, but socially, personally, morally, there was an inner discontent that was experienced by many, yet little understood. In France, governments were more moderate than formerly and some of the most glaring social injustices were recognised and were beginning to be eradicated, but creative people, artists and writers, felt excluded from a political system that was at best callous and at worst sickeningly corrupt. Women were making the first moves towards a degree of emancipation, inducing fear in many men. There was a sexual disease that afflicted countless people, had no cure and might strike at any time, and often ended in a lingering, hideous death. Hundreds of thousands doped themselves to madness with alcohol, and often died of it. Anonymous terrorists exploded bombs in city centres for no very clear political reasons. Yet despite it all, most people continued to believe in the vague notion of progress, holding to a blind faith that things would somehow get better.

Paris is the key to the story, for the city seemed to attract and exaggerate all that was good and bad at the time. The writers caught and dissected it well enough. Lautrec, if we let him, can show us what it looked like. With Van Gogh dead, and Gauguin in self-imposed exile in the South Seas, Lautrec continued to look hard and long at the city and its denizens as his century drew to its close – almost 1,000 paintings, over 5,000 drawings and more than 350 prints and posters survive, and he was only thirty-six when he died. Yet he was not as alone as that sounds – indeed it is the repeated emphasis on the solitary nature of Lautrec's art, the isolated figure drinking and sketching in a corner of a dance hall, or the only male permitted to inhabit a brothel, which has created the impression that Lautrec's art is somehow insulated from the real world and is only an amusing counterpart to the sparkling showbusiness world that he often painted. In truth, as La Goulue's panels revealed, Henri de Toulouse-Lautrec was constantly surrounded by the most fascinating figures of an age of tumultuous social

and cultural change. Wilde and Féneon were only the most shocking of a host of fascinating characters that Lautrec knew and worked with, from the revolutionary playwright Alfred Jarry to Emile Péan, the greatest surgeon of the age. Nor were they mere bar-room acquaintances – although seldom acknowledged today, Lautrec was involved in some of the most radical theatrical productions of his time – he was even one of the set designers for Jarry's *Ubu Roi*, the obscene masterpiece which outraged the critics yet altered for ever the course of European theatre. Controversy engulfed him. Whatever the outrage, Lautrec and his friends were at the heart of it. When the mass protest over the Dreyfus trial was at its peak, the future Prime Minister Georges Clemenceau asked Lautrec to provide illustrations for a book about the Jews that some condemned as anti-Semitic while others lauded their sensitivity and compassion.

All of which suggests that a conventional biography would reveal little more than a fraction of the man and his art. Only a portrait of the age could hope to embrace something of the diversity that Duthuit had glimpsed in those panels for La Goulue's booth, those things that had made him so determined to save them.

There is a real sense in which those canvases typify the two quite different ways we can approach the *fin de siècle*. On the left panel we have the conventional view – fun and champagne, wild dancing and high-kicking women. But that was painted just as the good times were ending and the real *fin de siècle* began. It is Lautrec's growing awareness of that change that imbues the

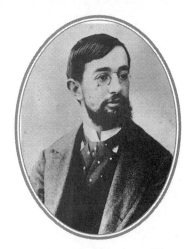

Henri de Toulouse-Lautrec c. 1892, aged twenty eight

Oscar Wilde in 1875.

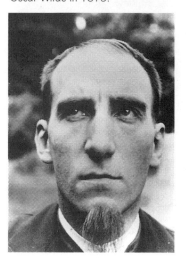

Félix Fénéon photographed by Alfred Natanson in 1894.

right-hand panel with its nervous air of impending collapse, drawing in Wilde and Fénéon to represent the rich intellectual and political life that Lautrec knew, so different from those simplistic images of drinking and whoring with which he is usually associated.

The right-hand panel, with its air of a world falling apart, proved terrifyingly prophetic. Most of those in the painting, including the dancer and the artist who painted her, came to a bad end. The first to fall was the man whose presence in the picture still holds the power to shock, for within weeks of the canvas being completed Oscar Wilde was condemned to hard labour and carted off to prison and the wreck of his life and his art.

The positive side to this story is that Duthuit's campaign was successful, Hodebert was thwarted and the portraits saved. The restored panels now hang in the Musée d'Orsay in a corridor on either side of the entrance to the first of the two large galleries on the upper floors of the museum that house Lautrec's work. The two pictures are so big, it is hard to get far enough back in order to see them properly. In any case they hardly seem to merit the effort, having been painted in rapid, crude brush-strokes on what looks like pieces of old sacking that have been roughly stitched together. Patched and faded and brown, these curiosities lack the immediate allure of much of the artist's work. At first glance they seem to be no more than weaker versions of the scenes of can-can dancing that can be glimpsed in the better-preserved canvases further on. Why linger? In fact, few do, a judgement shared by the occasional critic or art historian who has bothered to consider the two scenes, which are generally written off as little more than an amusing aberration.

Yet how wrong that assumption is. Those faded scenes are far more than the passing whim of a great artist. Approached with an open mind, they offer a glimpse of a lost world of ideas and feelings, of the beliefs and confusions, the ambitions and doubts that impelled Lautrec and Wilde, Fénéon and Jane Avril and all the others through the last decades of the nineteenth century. And like those visitors to the Foire du Trône in 1895 we too may climb, in imagination, the five steps up to the arched entrance of La Goulue's booth, push aside the curtain and enter the tiny space, lit by flickering lights, pungent with the odours of greasepaint and sweat, noisy with the wailing pipe and crashing tambour. Then, as La Goulue wriggles her *embonpoint* and twitches her gossamer veils, we may let our minds ease away from the tacky illusion to take in the surrounding details: Félix Fénéon watching it all with searching eyes and knowing smile, Wilde bemused by this further evidence of the human folly that is so often the hapless child of lust, and Lautrec, of course, there to record it all, sketchpad at the ready

2

Sporting Prints

There was nothing in his background to indicate that Henri de Toulouse-Lautrec would one day paint the portraits of a louche dancer, a notorious homosexual and a violent revolutionary. On the contrary, at birth he was destined for a life so different, it is amusing to compare the two – amusing and sad. The event that precipitated this reversal of roles, took place on the morning of 13 May 1878, when the thirteen-year-old Henri was sitting with his parents, the Count Alphonse and the Countess Adèle de Toulouse-Lautrec-Montfa, in the salon of his grandmother's town house, the Hôtel du Bosc, in the southern French town of Albi. With them was an especial favourite of Henri's: his father's brother, Uncle Charles de Toulouse-Lautrec, who was eager to hear their news. The boy had just come from Paris where he had been taken to the vast Universal Exhibition with its echoing metal and glass pavilions crammed with the new machinery and futuristic products, intended as a showcase for French commerce, a proof that the nation had weathered the humiliating defeat of the Franco-Prussian War with the loss of the provinces of Alsace and Lorraine. As they talked together, the local doctor was announced and Alph, as Henri's father was always known, ordered the boy in his usual brusque manner to come and greet their visitor. Eager to please, Henri jumped down and hurried over, momentarily forgetting the weakness that had dogged his young life. In an instant, the walking-stick he used skidded on the waxed floor, causing him to lose his balance and tumble to the ground.

For anyone else, so slight a fall would have been nothing, a mere bump, which made the revelation that he had badly fractured his left femur all the more ominous. For the limb to be so weak was clearly very serious indeed, though at least the doctor was present and able to improvise a splint out of a cardboard box, the first of several such inventions that were to double the young man's miseries.

Early oil painting by Henri of his mother, *La Comtesse Adèle de Toulouse-Lautrec* (1881).

All the family rallied round but the long convalescence, punctuated by periods of intense pain, began to dent the good-humoured façade that Henri tried to maintain. Now that he was bedridden it was hard to take his mind off the grim implications of his accident nor to disguise the loneliness he felt once all his cousins, except the young Jeanne d'Armagnac, had returned to school, a sadness all too apparent in the little note he wrote to an unknown correspondent a month after his fall:

[Albi, June 1878]

I am completely alone all day long, I read a little, but ulti-
mately I get a headache. I draw and paint as much as I can,
so much so that my hand gets tired of it, and when it starts
to get dark I wait to find out whether Jeanne d'Armagnac will
come near my bed. Sometimes she comes, and I listen to her
speak, not daring to look at her, she is so tall and beautiful
and I am neither tall nor beautiful.

Mr One-Foot

Although the accident made matters more acute, in essence his situation
remained much as it had been since his birth – young Henri's life was clear-
ly divided between the gentle, nurturing female world in which his mother,
grandmother and a bevy of aunts and cousins pandered to his every whim,
and the hard, masculine world of doctors and medical treatments allied to
the indifference of his father and his uncles for whom a man was only a man
if he could ride hard and hunt wildly. It was a divide that had troubled the
boy's childhood and would condition his life. Alone in bed, nursing his
broken limb, the dichotomy was all too apparent.

It was from this time that Adèle began to embroider her account of the
accident, first hinting that her son had fallen while climbing, then letting the
idea spread that he had had a tumble while out riding and that the doctor
had somehow botched his treatment; anything but the obvious truth that her
son was congenitally sick. Such explanations ran in tandem with the attempt
to convince herself that the worst was over and that something approaching
normality would now return.

Her attempts at self-deception were understandable – the truth, which
she well knew, was almost unbearable. The simple fact was that Henri de
Toulouse-Lautrec was suffering from a malady that, while never precisely
defined, was undoubtedly the result of his parents' consanguinity. Alph and
Adèle were first cousins who were themselves the children of first cousins
and there was much else about them that was not exactly as they wished to
appear to the outside world.

On the surface, Adèle's husband, Henri's father, was the Count of
Toulouse-Lautrec and the Viscount of Montfa, heir to an illustrious line
descended from the medieval Counts of Toulouse who had reigned like kings
over a domain that, at its height, included Toulouse, Aquitaine, Languedoc,
Rouergue and Provence. Yet one has only to visit the Hôtel du Bosc, the town
house in Albi where Henri de Toulouse-Lautrec was born in November

1864, for doubt to creep in. This mansion, so the visitor is informed, has barely changed since that inclement day. The elegant if plain, stone and tiled eighteenth-century building, is approached along one of the narrow cobbled streets of the old town from which one passes through a simple doorway into a courtyard only to discover that the house is surprisingly situated on the fourteenth-century ramparts, with views down the terraced gardens to rows of scented lime trees planted along the line of what had been Albi's defensive moat. But despite this pleasing position, the house is just that: a house, not a palace; most of the rooms are papered in that flowery chintz manner of an English country cottage and are remarkable only for the number of paintings and drawings of dead animals that adorn the walls. At first glance the large dining room, decorated in a more sumptuous Louis XIII style and dominated by a large portrait of a Comte du Bosc, seems to support the notion that the inhabitants were indeed rather grand; yet this turns out to be only the first of several illusions – the room was a creation of the 1870s and was decorated by Henri's Uncle Charles, when he decided to 'improve' the property, a process that included his making a copy of one of the portraits in the family's country château to hang above the fireplace in the town house. Uncle Charles was a talented amateur artist, capable of working in a variety of styles, but there is a family tale that he was no good at hands and that the young Henri helped with those in the portrait, making it one of the earliest Toulouse-Lautrecs. What is not said is why Uncle Charles should have felt the need to make his family appear more ancient and grand than they were. Artificially ageing dining rooms and creating ancestors is usually a preoccupation of the *nouveaux riches*, rather than the ancient aristocracy. Clearly, Henri de Toulouse-Lautrec-Montfa, to give him the full name his family used, was not born into a residence in any way resembling the fabulous châteaux of the Loire or the Ile de France usually associated with the grandest French nobles – all too often the impression given when one reads about his early life. The result has been a universal acceptance that Henri de Toulouse-Lautrec the artist was a direct descendant of one of Europe's most ancient houses, accompanied by the assumption that this 'fact' can be used to explain much about his character, his attitudes and his art. That Lautrec began among the highest in the land and ended among the lowest is an important element in his legend. After all, no other artist of his importance was also an aristocrat, though as the nearly 2,000 pages of the annual *Bottin mondaine* make clear, there are an awful lot of aristocrats in France, multiplying down the generations, many of whom turn out to be somewhat less than they wish the world to believe and a close look at the artist's family tree

reveals the somewhat unexpected fact that far from being the real Counts of Toulouse-Lautrec as they claimed, theirs was a cadet branch with no right to the title they used.

Following the French Revolution the family had been reduced to the status of fairly-well-off but essentially minor provincial aristocrats. A law passed during the Revolution, that all children of a marriage had a right to equal inheritance, resulted in the family's limited wealth being further dispersed though it also meant that in the absence of any royal authority, there was nothing to stop all the sons from adopting the title 'count' and from passing it on to all their sons. Alph's grandfather had begun the process, even though he was only a third son of the then count, and his son continued what they claimed was now a tradition. Of course, marriage was the only way these otherwise impoverished counts could go on living as they believed they should. Unfortunately for them, at the beginning of the nineteenth century, only two local families with properties in and around Albi had sufficient marriageable girls of the appropriate ages, the Imbert du Boscs and the Tapié de Céleyrans, who for similar reasons had also married among themselves. Thus Casimir, Henri's grandfather, married Gabrielle d'Imbert du Bosc, while their eldest son Alphonse, Henri's father, married Adèle-Zoë Tapié de Céleyran, whose mother was the daughter of Louise d'Imbert du Bosc, sister of Gabrielle. This worrisome genetic mix, later proscribed by the Church, was made infinitely more dangerous by the centuries of inter-marriage that had always gone on within that narrow aristocratic world. The infant Henri's genealogical chart was not so much a tree as a tortuous jungle creeper. His parents were first cousins born of cousins in a world where almost everyone was a cousin of sorts.

Superficially it looks, and has most often been interpreted, as if these 'Counts' of Toulouse-Lautrec had married somewhat lower down the social scale. The Imbert du Boscs were mere barons while the Tapié de Céleyrans had only joined the nobility half a century earlier and then only by adoption, and were really lawyers and administrators – people who *worked*, in other words, an unthinkable condition for the Toulouse-Lautrecs. Except that Casimir and Alph were not really counts at all and as far as the main branch of the family, that which was descended from first sons, was concerned they ought really to have dropped Toulouse from their name and become simply Lautrec. Indeed, according to the present head of the main house of Toulouse-Lautrec, Alph's father Casimir never wanted to use the title. It was his wife, Gabrielle d'Imbert du Bosc, who rather fancied the idea of being Comtesse de Toulouse-Lautrec and over time her wish prevailed. By the time

Henri was born, his father was referring to himself as the Comte Alphonse de Toulouse-Lautrec-Montfa and was equally determined that his son should be known as the Vicomte de Toulouse-Lautrec-Montfa, a formula that had never been used before. In post-Revolutionary France, many similar adjustments took place, though such presumption still rankles the present Comte de Toulouse-Lautrec, rightful holder of the name and title. When Henri grew up, he side-stepped the whole business. As a child he had practised signing his name in his exercise books along with the title 'Monsieur le Vicomte', but as an adult he chose the more neutral 'Monsieur de Toulouse-Lautrec', or the even simpler 'Monsieur de Toulouse.'

All this is not quite the glorious patrimony that the artist's hagiographers have always invoked, and it is equally clear that despite their supposed lesser status, it was really the Imbert du Bosc and the Tapié de Céleyran women who were the dominant partners in the union. It was they who brought with them the farms and vineyards that paid for the upkeep of the town houses and châteaux that also came with the marriages. The Hôtel du Bosc was not part of any long-standing Toulouse-Lautrec-Montfa heritage. There wasn't one. It, and all the other homes where Henri would stay, were occupied by his maternal forebears, his grandmother's Château du Bosc, other châteaux at Le Pech Ricardelle and Saint-Lucie, town houses in Narbonne and Béziers, even the 5,000 acres of farms and vineyards at Céleyran and the superb Mediterranean Villa de César, which they used for holidays, were all properties that descended from Henri's maternal great-grandfather. His paternal forebears owned almost nothing except the ruin at Montfa. Even the hunting estate at Loury near Orléans, which his father and grandfather used, was only rented on a short lease. It was thus inevitable that the succession of strong-willed women would really govern the family, while their drone-like menfolk tired themselves out at the hunt or idled away their days in Paris. Perhaps conscious of the weakness of their claims, these new Comtes de Toulouse-Lautrec-Montfa displayed an exaggerated aristocratic disdain for those outside their caste. By the time of Henri's birth, no one remembered that the Toulouse-Lautrec-Montfas were not quite what they claimed to be. As far as they and their neighbours were concerned, they were the descendants of the Princes of Toulouse, a little faded to be sure, but very grand for all that. Henri's grandfather, Casimir, a large, imposing man with a prominent dark beard that earned him the nickname the Black Prince, passed his days hunting at Le Bosc or on the rented estate at Loury, a practice quickly taken up by his sons. Indeed, they appear to have hunted their way through the reign of Louis Philippe and the Revolution of 1848 and on

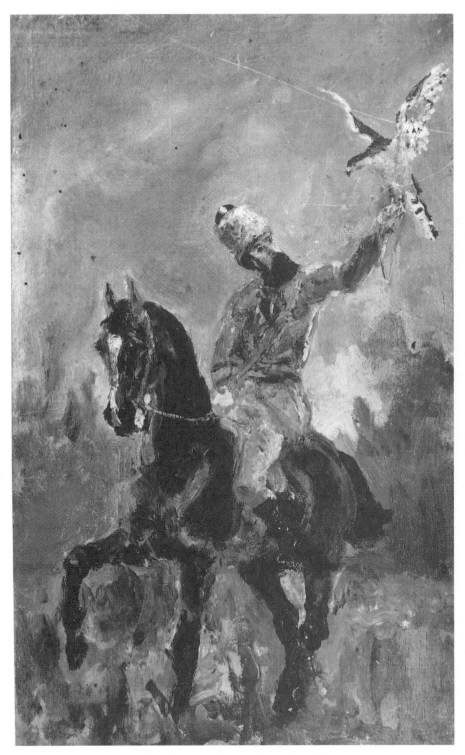

An early painting by Henri of his father 'Alph' dressed as a Cossack, hunting with a falcon.

through the Second Empire under Napoleon III, the first Napoleon's nephew, another self-invented aristocrat.

The decision to marry Casimir and Gabrielle's son Alphonse to Adèle Tapié de Céleyran, their niece and his cousin, was clearly a matter of keeping land and wealth within the family. Yet the family can hardly have been entirely ignorant of the terrible risk that weak or malformed children might result from such a union. To their relief, they were aided in this pairing by the good fortune that the young and impressionable Adèle fell conveniently in love with Alph who just happened to be serving briefly as a cavalry officer and who thus benefited from an attractive, and clearly irresistible, tight-fitting uniform. Yet given the closeness of their families it seems hardly credible that it was only after her marriage in May 1863, that this young woman discovered that her noble husband was anything but the chivalrous, dashing soldier she had taken him for.

Alph's behaviour is usually termed eccentric, though this euphemism tends to mask what must have been distinctly tiring for those obliged to live near him. Alph, his two brothers Charles and Odon and their many cousins shared a family love of charades but to judge by the surviving photographic record, this passion for dressing up was, in Alph's case, an activity, bordering on obsession. According to some sources, on occasions he would camp in a tent in the courtyard of the town house in Albi, on others he moved to the top of the tower in order to be 'near the birds'. As this rather sentimental desire reveals, the count was not even a straightforward slaughterer of animals, he occasionally stopped the hunt before the kill, presumably to the annoyance of his less-sensitive confrères, actions which meant that there was almost no section of society of which he was fully a part.

In his defence, one must state that many of these tales have probably been embellished in the retelling, with some of the eccentricities of other members of his family being laid at his door. But there is one eyewitness, still alive, who can confirm just how strange Alph was. As a little boy of seven the present Comte de Toulouse-Lautrec was walking across the Place Vigan in Albi with his father, when they saw 'Uncle Alphonse' sitting on the edge of the pavement washing his underwear in the water that was released to flush out the roadside drains. When they approached, Alph happily explained that this street water was the purest it was possible to find and that he had acquired one of the special keys that allowed him to turn on the flow whenever he needed to do his laundry. He even had a similar arrangement in Paris for his visits there, when he was in the habit of doing his wash-

ing in the rue Boissy-d'Anglas near to the apartment he rented for the season. In some ways the strangest thing about the whole episode was the fact that this inclination to wash his own clothes was the only practical task that Alph ever undertook.

Such personal memories of Alph's odd behaviour are augmented by the photographic evidence which is far more telling than the exaggerations of biographers. What these sharp black-and-white images make clear is that Henri's father was living out a dream of the noble warrior – the highland laird in kilt and sporran, his gloved hand raised to receive a returning falcon; a Cossack chief on horseback, the falcon on his wrist about to fly from him. Why the obsession with falconry? Because that was the most ancient and warrior-like sport and one that, unlike stag-hunting, had remained utterly untainted by the participation of the lower orders. It all looks a trifle foolish – there is a series of photographs of Alph as a Circassian warrior with bow and arrows, his face partially obscured by the nose-guard and chain-mail drooping from his pepper-pot helmet. In the final print, facing the camera he looks silly enough but an unexpected shot, taken just before he got into position, has survived and this shows him struggling with the bow which seems to have got entangled round his right leg. It is hard to believe that any son would feel particularly thrilled to have a father who might suddenly burst in among his friends dressed as a medieval character and likely to start falling about. Mary Tapié de Céleyran, the Comtesse Attams, a grand-daughter of Henri's aunt Alix-Blanche, published the picture in her family memoirs in 1990, suggesting it was only a joke and that Alph was really laughing at himself, but even if that were so, it still seems a little pathetic for one who had had every opportunity to make something of his life yet had chosen to do nothing.

That Alph was unreliable was apparent to his wife from the start of their marriage – he once boarded a moving train leaving her standing on the platform with no money. While it was fortunate that his supposed aristocratic status – in reality the money of his wife's family – exempted him from having to do anything so lowly as earn his living, he was woefully unable even to manage the tenanted farms and vineyards he had acquired and could not be counted on to keep the simplest appointment. The only career open to a man whose sole skill was the ability to sit on a horse longer than anyone else, was the cavalry, but before he abandoned a half-hearted attempt at a military career, this supposed descendant of crusader knights had been so frequently disciplined for his unconventional behaviour that he was lucky to avoid a dishonourable discharge. In a curiously boastful letter, written to his

mother while he was undergoing officer-training at Saint-Cyr, Alph proudly reveals that he has recently spent a total of sixteen days in the guard-house for petty acts of disobedience such as wearing his uniform incorrectly buttoned, or on one occasion for having turned up on parade with a swagger-cane under his arm, as if he were some sort of old-style lancer.

But worse for Adèle than all this childishness, was her husband's equally uncontrollable passion for liaisons with serving girls and farm women. Alph's lax morals have led to some speculation that at a time when syphilis had achieved epidemic proportions and was said to affect 25 per cent of the population of France, this too might account for some of their son's malady. Weak bones, easily fractured, and stunted growth were known signs of congenital syphilis and given Alph's behaviour, he might well have infected his wife, though as no one ever discussed such things, let alone committed them to writing, speculation is all that remains and the fact that others in the family made close marriages and suffered the same hereditary problems tends to indicate that Alph and Adèle's consanguinity was still the primary cause of the problem.

Although her husband's behaviour broke her heart, Adèle was an obediently stoic upper-class woman and would have tolerated such infidelities had she and Alph managed to sustain a façade of marital happiness. Tragically, Henri's birth, four years after their wedding, put an end to any pretence.

Despite their later attempts to pretend otherwise, Alph and Adèle knew that something was wrong almost from the moment that Henri was born during a dramatic storm on the morning of 24 November 1864. From then on, his health was a matter of grave concern to all around him and if it was just possible to hope for the best when he was a babe in arms, swaddled and protected, the birth of his brother Richard on 27 August 1867, followed by his death just under a year later on 4 July 1868, told Alph and Adèle what they had feared from the start. After a brief period of mourning they were effectively to live apart even when under the same roof, the vigorous athletic count barely bothering to conceal his disappointment at his weak surviving son, while his wife would smother her precious boy with attention driven by a deep sense of Catholic guilt. Given Alph's unpredictable behaviour, his long absences were probably an unrecognised blessing for the child. That one so fortunate should have done nothing with his life would have been just about tolerable as long as he had at least enjoyed it, but Alph's days were so clearly a waste, even to himself, that the outside observer is soon irritated by his constant posturing. All too quickly, his endless dressing up, his raucous pranks, his days on end chasing wild animals, come to seem less the activi-

ties of a fun-loving man and more the tedious acts of a club bore. Alph was fortunate that his inability to take care of his family was counterbalanced firstly by his wife's dowry, a handsome 25,000 francs, and secondly by the spread of the new railways during the Second Empire which meant that the rather basic wines produced around Narbonne and Béziers could be rapidly conveyed north while still drinkable as *vin ordinaire*, a new commerce that greatly increased Adèle's share of the revenues from the Céleyran vineyards.

While Alph spent much of his time at the hunting lodge at Loury, Henri and Adèle stayed at grandmother Gabrielle's Château du Bosc near Naucelle, some forty-six kilometres from Albi on the road north to Rodez. This was to be the little boy's principal childhood home and the one to which he was most attached. Today the house has again passed to the female line of the family and is the home of Madame Nicole-Berengère Tapié de Céleyran, great-niece of the artist and last of her line. From the outside, the rough square stone keep, its two towers topped with pepper-pot domes like the Circassian helmets Alph liked to wear, has the air of a fantasy castle that Disneyland tries but fails to evoke. But this medieval look belies the rich interior with its Aubusson tapestries and handsome seventeenth-century portraits and furnishings, which finally lay to rest any notion that the Imbert du Boscs were anything other than fitting partners for the newly elevated Toulouse-Lautrec-Montfas. Yet more than this sense of grandeur – the displays of fine china, the private chapel – it is Adèle's and Henri's bedroom that best reveals the taste and atmosphere that coloured the future artist's earliest years. As with the house in Albi, there is the chintz wallpaper, which gives the distinctly English look that the French call 'le Cosy', while the cot with its lace layette and a magnificently painted Punch and Judy theatre speak of a pampered childhood. The little boy's first books, most of them from England, include works such as *The Three Jovial Huntsmen* by Randolph Caldecott, the most advanced illustrator of his day, whose use of broad areas of pure bright colour were thought to have the same effect as Japanese prints and which influenced artists as diverse as Gauguin and eventually Lautrec himself, whose interest in illustration was possibly aroused from a very young age by these surviving volumes.

But the most interesting revelation of the Château du Bosc is the family's attachment to art, not merely as passive spectators but as passionate participants. Both the Imbert du Boscs and the Toulouse-Lautrec-Montfas liked to say that they were 'all born with a pencil in our hands'. It is one of the most surprising things about Alph and his brothers that despite the long hours spent chasing animals, they still found time to draw and that far from

considering art something alien and effete, Alph in particular considered the ability to wield pencil and brush one of the essential attributes of a noble-man. As grandmother Gabrielle put it: 'If my sons kill a woodcock it gives them three distinct pleasures: the stroke of a rifle, the stroke of a fork and the stroke of the pencil.' If Alph were staying with them, Adèle and Henri were treated to the sight of this wild and gruff figure, along with his broth-ers Odon and Charles if they were there, sitting in the salon, drawing or painting in water-colours and modelling in wax. Nor were these entirely ephemeral activities. The sheer amount of family art that survives in the Château du Bosc and the house in Albi testifies to just how seriously they regarded their work – one of the sitting rooms in Albi still displays a mag-nificent bronze racehorse cast from one of Uncle Charles's wax models, while in Le Bosc there are drawings of game birds, each as meticulously detailed as a Dutch still life.

As soon as he, too, was able to wield a pencil, little Henri joined his father and uncles and while his earliest surviving works, paintings of horses, are from as late as 1878, when he was already thirteen, we know that he had been applying himself to such subjects from an early age. As can be seen in the Château du Bosc, Henri's great-grandfather, another Alphonse, founder of their cadet branch, was a serious portrait painter in the grand manner. His painting of his wife, Adèle de la Roque-Bouillac, is an entirely professional eighteenth-century piece that now hangs above the fireplace in the main salon and, as can be seen in the Albi house, Henri's Uncle Charles could turn out a decent copy of an oil portrait even if he couldn't manage the hands. The presence of so many highly finished works places Alph and his brothers beyond the ranks of mere Sunday painters. As the portraits at Le Bosc sug-gest, the family's artistic connections were far more varied and surprising than is usually assumed, connections which owed much to one of Henri's more extraordinary relatives who lived on an estate at nearby Rabastens – his great-uncle Pons de Toulouse-Lautrec.

Uncle Pons was the only member of the recent family to have done any-thing notable in the world beyond the family home. After the first Napoleon's defeat in 1814 the young man left for Paris and service in the honour guard of the Comte d'Artois, brother of the newly restored Bourbon monarch Louis XVIII. He was to stay in royal service until 1824 when the death of his wife and two sons in an epidemic of what was probably the croup, put an end to his desire for adventure. Settled at Rabastens, Pons decided to help his younger brother by selling him a run-down estate at nearby Montfa, which he had inherited when their father's property was

Pons de Toulouse-Lautrec; self-portrait in the uniform of a Colonel des Gardes du Corps de Monsieur, *frère du roi*, 1822 (at the age of 34).

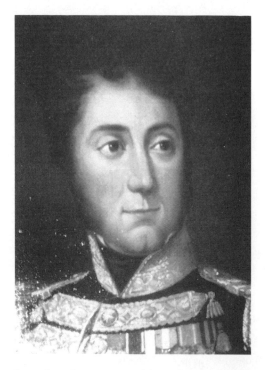

divided at his death. It was from this, that Casimir, and later Alph, called themselves Viscounts of Montfa as well as Counts of Toulouse-Lautrec. But the connection with Uncle Pons went much deeper, for he brought to his near relations connections with the world of the court and of culture that were to have a lasting effect on his great-great nephew. When Alph's sister Alix was born in 1846, Pons became her godfather. Visits to the family were frequent and the present occupant of the Château du Bosc remembers reading letters from Pons that showed how close they all were.

To the young Henri, Pons must have seemed like a creature from another world with his tales of military service, the sumptuous gold-braided uniforms of the Garde de Monsieur, the story of the flight to Ghent with the King after the return of Napoleon and of the second restoration when the Battle of Waterloo had finally removed the persistent would-be Emperor. Over his years of service Pons became remarkably close to the royal family, out hunting nearly every day with Artois and even considered a candidate for marriage to one of his patron's daughters by his mistress – a proposal that Pons decided was both 'too much and too little'. Despite this, it was Pons who was chosen to present to the waiting crowds the *enfant du mirâcle*, the posthumous child of Artois' son the Duc de Berry who was assassinated just before his wife gave birth, thus saving the legitimate

31

Bourbon line from extinction. Indeed Pons might have settled into the comfortable life of a senior courtier had the tragedy of his own family not prompted his return to Rabastens. In some ways it was to prove a fortunate move. The overthrow of the childless Louis XVIII and his brother's ascent to the throne as Charles X, followed a mere six years later by the *coup d'état* engineered by their cousin the Duc d'Orléans who chose to reign as Louis Philippe, the 'citizen-king', was a maelstrom that Pons did well to avoid. But it was not just his tales of high politics, of war and court ceremonial that were passed on to his attentive relatives – Pons had also enjoyed some quite remarkable artistic connections during his years in royal service.

When Pons joined the Garde de Monsieur in 1814 he found that both his patron the Duc d'Artois and his brother the King, had surrounded themselves with writers and artists, much as their ancestors had done. Before the Revolution and during the years of exile, Artois had been the centre of English influence at court. This had nothing to do with politics, England remained the eternal enemy, but was more a question of style – of English clothes, dogs, guns, of anything to do with hunting and riding. And this in turn was to have a key influence on artistic taste, for the English had developed a form of art closely linked to these outdoor pleasures, which crossed the Channel in the form of the sporting prints that were to become highly fashionable in French aristocratic circles. The century-old tradition of painting hunting scenes in France had tended to concentrate on the royal hunt as a part of courtly ceremonial whereas in England a more popular tradition had flourished, from humble scenes of coursing to the more elevated images of horse-racing by major artists such as Stubbs. This was an art that appealed directly to those like Artois who lived for the hunt and it was not the great names of the official art world, men such as Ingres and the Baron Gros, who were part of his entourage but the altogether more humble figure of Carle Vernet, a painter of horses and hunting much influenced by the English style.

Son of Joseph, the famous marine artist, father of Horace the history painter, Carle was best known for prints of his 'lively swan-necked' horses taken directly from studies of the living animal rather than from the antique originals that were the usual objects of study. Before the Revolution, Carle was a primary exponent in France of the English tradition of sporting and animal art, much admired by Artois with whom he hunted, sketching him in action and painting the scene later in a manner that still seems extraordinarily fresh and lively when compared to the static Classicism then coming into fashion. For Vernet it was the dramatic, living moment that mattered –

his painting of a horse startled by lightning still shocks when set beside the primly trotting chariot horses then in vogue.

This newly established Classicism was rigidly opposed to any art that was not studio based. Nature was, by definition, not art and while it was just possible to begin with sketches from the motif, antique originals were preferable, and in either case the final result had to be worked up, indoors, according to clearly defined principles. Subjects, too, were to be drawn from antiquity or mythology, while anything contemporary, whether a landscape or a recent event, was shunned. It was not unknown for a leading Classicist to leave a gap in his canvas where a glimpse of landscape would be filled in by a hack specialist hired to carry out so menial a task, and not surprisingly, paintings of anything connected with real life – portraits, seascapes, battles, animals – were considered mere genre, on a level far below the high Classicism of the great masters. A landscape was just about acceptable if some hint of antiquity was included – a temple on a hilltop, a satyr in the glade. But the greatest suspicion was reserved for artists such as Carle Vernet who persisted in painting horses in motion, fiery forces of untrammelled nature, so worryingly popular with the ignorant public. And they were right to be suspicious, for it would be the painters of animal and sporting scenes who would lead the way out of the studio in what, as the nineteenth century progressed, became a mass exodus to the countryside and the move to paint directly from nature, unregulated, in the raw.

Vernet was followed by another friend Pons made during his service at court, the artist Théodore Géricault, who had joined the King's Guard, whose members also hunted with Artois' troops. When Pons first met Géricault, he was just finishing *The Wounded Cuirassier Leaving the Field of Battle*, in which a defeated rider leads his nervous mount out of the fray, a dark image of the collapse of Empire, that disturbed, even irritated, many of the visitors to the first Salon of the Restauration. Géricault had been a pupil of Vernet and was always keen to emphasise that he shared his teacher's love of the fleeting moment. He recounted how he was once out riding to Saint-Cloud when he saw a dappled grey carthorse suddenly panic and bolt into the sunshine – and just like Vernet and his horse startled by lightning, so too this escaping beast was hastily sketched and used for Géricault's first major work, *The Charging Chasseur*. By lifting Vernet's embryonic realism out of the obscure world of the sporting print and thrusting it into the mainstream of high art, Géricault had taken a huge stride down that road that would one day lead to an art of modern life, drawn directly from nature. And one of his earliest followers, if only on a modest

scale, was Pons de Toulouse-Lautrec. There is a highly finished self-portrait dated 1822, which now hangs in the home of the present Comte de Toulouse-Lautrec, that suggests that Pons received lessons from his friend. Posed in the elegant uniform of the Garde de Monsieur, Pons could well be a figure from one of Géricault's military scenes. The present count also owns four drawings that by family tradition are by Géricault, one of which is a nude portrait of Pons, presumably done while they sketched together.

The two young men were parted when the King and his ineffective troops fled before the newly returned Napoleon in 1814. While Pons remained loyal to Artois and his brother, then exiled in Belgium, Géricault quit royal service, disgusted at the spectacle of the court floundering through the muddy fields of northern France. It proved the turning point in the artist's life – after Waterloo and the second Restauration, Géricault's subjects became harsher, more often concerned with political and social issues, from the small-scale *Executioner Strangling a Prisoner* and *Liberation of the Victims of the Inquisition*, his epic protest against the French military campaign to restore the reactionary Spanish Bourbons to their throne, down to the vast unfinished painting that he hoped would help bring an end to slavery. Throughout all this he remained true to his first teacher, Vernet, painting the horses racing to the finish on Derby Day while on a visit to England, and it was this continuing attachment to observed reality that ensured the success of the one great painting that made Géricault the most famous and controversial artist of his time, when he exhibited his massive canvas, *The Raft of the Medusa*, at the Salon of 1819. This was a work that explicitly criticised the Bourbon regime for its propensity to give advancement to its aristocratic supporters with little concern for their ability, in this instance the captain of the *Medusa*, Hugues Duroys de Chaumereys, whose incompetence led to the wreck of his vessel. It is the despairing survivors who are the subject of Géricault's moving scene, helplessly watching the rescue ship, the *Argus*, turn away, abandoning them to their fate. But it was not just the subject that made Géricault's masterpiece so effective, it was the way all who saw the work were convinced that this was how it must have looked. Although on the scale of a major history painting, Géricault wanted to portray the urgency of pictorial journalism and had hired the actual carpenter who had sailed with the *Medusa* to make a copy of the raft in his studio. He then used any friends who happened to be ill as his models for the dead and dying, prompting one witness to describe the room as a 'sort of morgue'. Yet it was this that still gives the extraordinary work its power to disturb. Géricault's concern for visual truth was in effect a nascent form of 'Realism' which, allied to his

political commitment, gave birth to a new line in French art that would develop through the century – the corpse, face-down in the foreground, was modelled by the twenty-two-year-old Eugène Delacroix whose later master-piece *Liberty Leading the People*, his tribute to the failed revolution of 1830, owed much to Géricault's work, and continued the radical spirit it had awoken.

While it is difficult to imagine that any of this would have appealed to the ultra-royalist Pons, it is too easy to assume that he rejected Géricault's new work out of hand. The annual Salon was a fixed part of the social season and Pons was surely there when the *Raft* was first exhibited and the King was confronted by Géricault and his shocking work. Witnesses noted how His Majesty greeted his one-time guardsman coldly, aware that the white shirt waved in despair by the topmost figure on the raft was a reference to the white flag of the Bourbons. Pons, too, was no doubt shocked by so radical a message, yet against all odds, there are signs that Pons and his family never quite rejected Géricault's art. Mementoes of 'Uncle' Pons, kept by the present Comte de Toulouse-Lautrec at his château in Normandy, suggest that the friendship survived – a drawing of Pons by Géricault stands on the Count's writing desk beside a Classical *jardinière* by Berenger presented to

An early sketch for Géricault's *The Raft of the Medusa*.

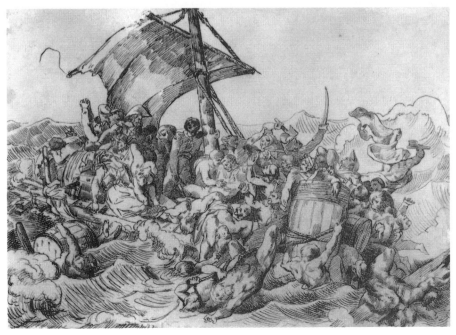

Sketch of Louis XVIII reviewing his household troops by Géricault – the sort of ceremonial display in which he and Pons took part.

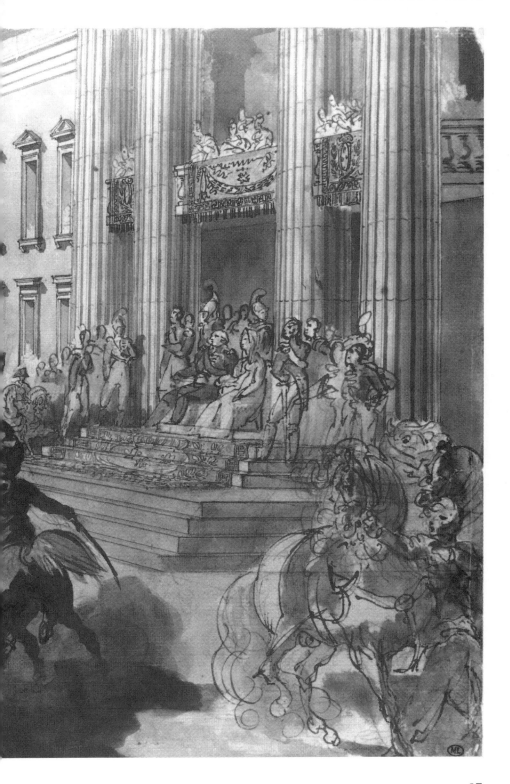

Pons by the Duchesse du Berry for his service at the birth of her son. And far from dismissing *The Raft of the Medusa*, the family appear to have rather admired it. When Pons' nephew, grandfather of the present count, read a paper at the Congress of the Société Française de l'Archéologie in 1863, he used the opportunity to praise what he called the *Nauffrage de la Meduse*, which he described as being more moving than any play, adding a number of anecdotes about the artist that he could only have heard from Pons himself.

These apparently contradictory elements in Pons' make-up – royalist politics co-existing with radical ideas about art – were passed on to his great-great-nephew in various ways. The royalism was most obvious – Henri was named after the Comte de Chambord, the legitimist pretender to the throne of France, whom Pons had first displayed to the waiting crowds from the balcony of the Tuileries Palace, and now known to his more fanatical supporters as Henri V. While Alph would later go hunting with the Prince de Bourbon, the Orléanist pretender to the throne, he never wavered in his loyalty to the legitimist cause. In a fine confusion of legitimism and *Anglomanie*, Adèle always spelled her son's name 'Henry' in the English manner and when the Comte de Chambord was allowed to return from exile, her greatest pleasure was to attend those functions such as the races at Longchamps, where he and his wife might be present, in order to offer them her deepest curtsy. Such things mattered. They proclaimed what you believed in and thus who you were, it was the very epitome of 'our world'.

Yet even after Pons' death in 1878, when Henri was thirteen, his influence continued as the boy joined his father and his uncles, drawing the bag from that day's hunt, an attachment to the immediate and the natural that connects Henri, through Pons, to Géricault and Vernet and the tradition of the English sporting print, and an approach to nature totally at odds with the conventional art establishment of Académie, Ecole des Beaux-Arts and annual Salon, with its emphasis on timeless subjects and settled formulae. This connection was certainly recognised during Lautrec's lifetime. His first newspaper profile, a scurrilous article in the series *Les Hommes d'aujourd' hui*, which appeared just as his art was beginning to attract critical attention, drew on this relationship with Pons as the means of satirising the great-great nephew.

> . . . four preceding generations of Toulouse-Lautrecs have produced a number of amateur pastellists equal in virtuosity to professionals. One amongst them, Pons de Toulouse-Lautrec, great-uncle of the artist of Montmartre, is better

known in the Languedoc region for his eccentricities than his pastels. Extremely rich, but with appetites that could outclass Pantagruel, he gorges himself on all the most exquisite sweet-meat, being ceaselessly in search of new delights, having eaten in the course of a two-day succession of roasts and variously garnished entrées, a monkey prepared to his instructions.

This Pons de Toulouse-Lautrec was, I repeat, the great-uncle of the artist and not his father. One prays that the malicious artists of Montmartre will not spread the rumour that this ancestor has transformed his monkey into the figure of their colleague

Pons had been dead some ten years when the article appeared but journalists were never very particular about facts when it came to attacking Henri, whose physical shortcomings were often used to explain his supposed artistic vices.

One thing at least is clear about all this – the Toulouse-Lautrec-Montfas were not quite what they are generally made out to be. They were neither the grand aristocrats they wanted to appear nor the absolute cultural philistines stuck away in a provincial backwater that legend has created.

Henri was first taken to Paris in the autumn of 1866 when he was only two, Alph having decided to accompany his wife to the opera, and all three were frequent visitors to the capital from then on, it being the custom of the French aristocracy to pass the season, from mid-autumn to late spring, in the capital before returning to their country châteaux to hunt and, in the case of Alph and his brothers, to draw. In Paris, the very grand had elegant private residences, the less fortunate rented houses or apartments or stayed *en pension* in discreet blocks in the better *arrondissements*. If possible, the husband would stable a horse in town to ride in the Bois at the appointed hour or keep a carriage and coachman so that his family might be taken there to see and be seen by the *beau monde*. The season was punctuated by concerts and performances at the opera and the Comédie Française and with visits to the races at Longchamps and Chantilly or, on occasions, further afield in Deauville. If one ignores Alph's occasionally grotesque behaviour, Henri's family were little different from other reasonably well-off provincial families, living comfortably, if not grandly, from their rents, able to afford several indoor servants and the expense of the hunt, maintaining a modest apartment in Paris along with a carriage and groom. Despite the worries about Henri's health, it was still possible to believe that he would turn out

like the other men in his world with nothing to concern him beyond the enjoyment of the chase and the fathering of children to continue his line. He was, after all, an affectionate child, given to applying himself to any new interest with a single-minded passion that amused his elders, reminding them of his father.

Much of the boy's early life was spent on a nomadic circuit around the homes of his female relatives, with periods at the hunting lodge in Loury where he and his mother had separate quarters, only seeing Alph in the evenings on his return from the day's chase. Adèle had a tendency to sacrifice herself to her son's every need, an over-protectiveness that sprang from feelings of guilt induced by her unspoken awareness that Henri's frequent illnesses were due to her improvident marriage. For Henri as a child, her attentiveness meant a carefree existence filled with travel and new places and animals, all of which kept him amused and alert so that he quickly acquired a reputation within the family for his good humour and cheerful talk. Initially quite pretty, with an appealingly dark, southern look, with rich raven hair and heavy black eyebrows over large attractive eyes, he was popular with his little cousins and was often the leader in their games. His early education was given by a private tutor who had no complaints about his young pupil's ability or willingness to study and if things had gone on as they were, he might well have remained securely within that comfortable milieu, physically troubled, but otherwise a typical representative of his class, perhaps less snobbish and outrageous than his father, yet still holding much the same views and leading the same sort of indolent country life, with occasional trips to Paris to assuage the monotony.

In the autumn of 1869, just before his fifth birthday, his mother took him again to Paris, this time to stay at the Hôtel Pérey, a pension found by his Uncle Odon and used by families of their own sort, in the Cité du Retiro, a smart block on the fashionable rue du Faubourg Saint-Honoré, in the manifestly correct eighth *arrondissement*. This visit was to allow Henri to acclimatise himself to life in the capital before entry into school the following year when his parents intended to enrol him in the Lycée Bonaparte, a school favoured by 'good' families, where he could be educated among others of similar background. With her child about to embark on his education, it must have seemed to Adèle that her worst fears about his health had not been realised, while to Alph there seemed some chance that his son, though he would never be the sort of daredevil huntsman the family expected, might go on growing without mishap. Although the two parents continued to forswear physical intimacy, afraid to repeat the tragedy of their second child,

One of the first newspaper articles on Toulouse-Lautrec, a not very sympathetic biographical sketch.

some element of family life seemed possible. They might not approve of Napoleon III and his vulgar empire but they had to admit that his capitalist revolution had improved their finances and created an extremely pleasant world in which to be an aristocratic landlord. Although they were obliged to share these good things with the new rich businessfolk who prospered under Napoleon, people who were not of their world, there were compensations.

In November Alph took Adèle and Henri to Loury, intending to stay until the autumn of the following year when school proper would begin. Adèle hated the gloomy lodge, but put up with it in her self-sacrificing way, looking forward to their return to Paris and the start of Henri's school year. It was not to be. In July 1870 the world they knew was plunged into chaos, collapsing so rapidly and so completely, it was impossible to keep abreast of the unfolding disaster.

Alph and Adèle may have looked down on the Emperor Napoleon III as a parvenu who occupied a throne that rightfully belonged to 'Henri V', but they, like many others, had been happy to benefit from his liberal economic reforms that had built railways, encouraged industry and established France as a major capitalist power. With his downfall, few chose to remember these successes. There were two Schneiders in the Second Empire, one male, one female – Eugène, the King of Iron, exemplar of France's burgeoning industries, and Hortense, star of the Offenbach operettas, potent symbol of the carnival world that collapsed when the little Emperor, sick and ill-advised, objected to Prussian attempts to put a member of their ruling family on the throne of Spain. Goaded by the Prussian Chancellor, Bismarck, who believed that a common enemy would help him unify Germany, the gullible Napoleon declared war in July 1870. Inevitably, it is the female Schneider whom history has chosen to see as typical of the age – Hortense in the role of the Grande Duchesse de Gerolstein, swigging flutes of champagne until, crash, she is suddenly transformed into the grotesque death-mask of Nana, Zola's fictional prostitute, dying of syphilis in one of the luxury hotels built when the Baron Haussmann pulled down the old Paris to create the new wide boulevards, the florid apartment blocks and vast department stores that illustrate the swaggering imperial comedy. For Zola, Nana's suppurating corpse prefigured the carnage that would result from the lost battles in eastern France, while the mob in the streets below her window, screaming 'To Berlin! To Berlin!', were the embodiment of Napoleon's foolish generals who believed that their troops far outclassed the advancing enemy.

Adèle and Henri were back at Le Bosc when France declared war. Alph, however, was cut off in Loury. As an otherwise unemployed aristocrat he

ought to have rejoined his regiment and ridden to the defence of his country. Such an act would have been in the great tradition of service to the nation that the nobility of France claimed as theirs. Indeed, Alph's brother Odon insisted on being given a commission and though used only as a courier, had at least done the decent thing in the eyes of his caste. But Alph's earlier behaviour, with his frequent periods in the guardhouse, ruled out such a move, leaving him stranded near Orléans, an impotent figure throughout the six weeks of the disastrous campaign that led to the Emperor's surrender at Sedan and the total collapse of his world. As the Parisian mob set about declaring yet another Republic, the Empress Eugènie was persuaded to follow the example of Charles X and Louis Philippe, and flee the Tuileries as discreetly as possible. After some difficulty finding a master key, she was hustled from the palace into the Louvre, through the ghostly galleries towards a side door that it was hoped would lead into empty streets, and thus found herself staring, 'thunderstruck', at the one painting that had proved too large and too heavy to take down, Géricault's *Raft of the Medusa*, that awesome representation of betrayal and despair.

With the Empress gone, the country was left to its fate. If the Emperor had quickly been replaced by a united government, then a deal might have been struck with the invading Prussians, but there was nothing to fill the void save chaos and when it came, it was sudden and terrible. By 17 September 1870, the Prussians had laid siege to the capital and their troops began to penetrate the countryside around the Loire. Probably because he could no longer hunt, Alph decided it was time to rejoin his family in the south; he only narrowly avoided a ducking in the river when a group of peasants mistook him for a spy. Some indication of his lack of status in the area is shown by the fact that it was his neighbours and not the enemy who ransacked the lodge, scattering his belongings and taking some of Henri's clothes, which they handed out to the local children.

Together in the south, the reunited family could only wait, like the rest of an increasingly perplexed nation, for events to take their course. Adèle and the other women knitted comforts for the troops but the hard winter kept their menfolk from the hunt and with too few of his cousins to play with, the six-year-old Henri was getting as fractious as his father who was deprived of beasts to chase. One imagines that Alph would have initially shrugged off the collapse of the upstart Emperor, though the subsequent proclamation of a republic was hardly to his taste and worse was to come when the new government's attempts to settle with the enemy provoked an uprising in Paris and the declaration that the city was now an independent Commune.

Not since the original Revolution had such an upheaval taken place. A commune is normally a municipal district governed by an elected council and presided over by a mayor, but the founders of the Paris Commune, or *The* Commune as it has ever since been known, saw themselves as the embodiment of a new France. What passed as the national government had effectively surrendered to the Prussians but the Commune would hold out. Besieged and eventually starving, the citizens of this free state refused to accept defeat, defying both the enemy and their own provisional government in Versailles. And for some it went beyond mere resistance – many radicals saw the Commune as a means to establish a new order, a second chance to carry out the revolutionary dream begun almost a century earlier. The Commune would save France from enemies without and reactionaries within.

With the new year 1871, France was at war with itself, the self-appointed Republican government having repaired to Versailles where it began to negotiate a settlement with the invaders that put it at odds with the increasingly radical Commune still holding out in the capital. It would be May before the citizens of Paris were brought to heel after five highly-charged months that transformed their doomed resistance into a double-sided myth. For those on the right, like Alph, they were the worst sort of bloodthirsty mob, thieves of legitimately held property and murderers of priests, who had seized power and who at the end showed their true colours by rampaging around the heart of the city tearing down monuments and burning some of its most hallowed buildings. Yet for others, the Commune was to be a symbol of the noble attempt by the common people to set up a truly egalitarian state in which all citizens would give freely according to their abilities and only take according to their needs. Neither story was quite true, of course, but few have ever been willing to see the Commune as a rough-and-ready attempt by a mix of opportunists that included some men and women of goodwill and some outright villains to respond to an impossible situation. That it got out of hand and ended in unpardonable violence and destruction can hardly be disputed, but while the enraged Communards burned down the Tuileries Palace soldiers of the victorious Marshal MacMahon were hunting down the defeated rebels on the side-streets of Montmartre as if they were animals.

Despite the Republican sympathies of Thiers and Gambetta, the architects of France's post-Commune revival, the National Assembly was primarily Monarchist and by 1873 had succeeded in getting one of their number, the Duc de MacMahon, the same military leader who had finally subdued Paris, into the Presidency. But what the Monarchists had in num-

bers they lacked in vision and what has been called 'the masochistic tendency of the French right' succeeded in prolonging the fragile Republic. The Deputies might want a king, but which one? While legitimists like Alph supported the claims of the Comte de Chambord, others were Orléanist or Bonapartist and there were even those who championed the cause of the Merovingian descendants of Pippin the Short. If the Comte de Chambord had not stubbornly insisted on retaining the white-and-gold flag of his Bourbon ancestors he might have reigned, but insist he did. Much to Alph's distress the Republic weathered these early crises. A year later an amended constitution established a system that was to see out the century, survive the First World War and last until another German invasion in 1940 finally brought the system crashing down once more. Not such a bad run, though in those early years 'the Republic of the Dukes', as its opponents dubbed it, looked something of a sham.

Safe in the south, well-provided by their farms and vineyards, Alph and his family were materially little affected by the turmoil in the capital. But the failure of Chambord to claim his throne and the establishment of a regime that in theory claimed to represent that despised entity 'the people' was ill-received among the inhabitants of the Château du Bosc. For one as young and impressionable as Henri, overhearing Alph and his brothers furiously decrying events in the north, the conclusion was obvious – elected politicians, the rulers of the country, were only to be despised.

As soon as the Commune fell and the government in Versailles regained control of the capital, Alph returned to Loury to supervise the repair of the lodge little suspecting that Adèle had no intention of ever again settling in such a gloomy place. She might have accepted to live in nearby Orléans but when Alph refused to consider this compromise, she decided it would be Paris with Henri during the school terms, then back to Le Bosc for the holidays. Her main concern was the boy's health – some problem with his sinuses kept him perpetually troubled with colds. Worse, he was clearly not growing as quickly as his healthier cousins and was occasionally unsteady on his feet. Touching evidence of her concern can still be seen on the wall of one of the rooms in Le Bosc where lines were drawn to mark the children's growth, with Henri always a little below his contemporaries.

As soon as things began to get back to normal Adèle organised a holiday on the coast near the family's estates at Céleyran where Henri was able to take the fashionable and beneficial baths at the local spa, though through-out all this his mother's letters to her relations in Albi and Le Bosc continue to maintain the fiction that her son is as playful and lively as ever and that

they are living without a care. The following year he would start school in Paris but as 1871, that terrible year, drew to its close, and life seemed to be resuming its former stability, the new peace was shattered by the death just before Christmas of grandfather Casimir.

The men in the family were often involved in hunting accidents but the Black Prince had contrived to have a bad fall in an obscure valley as night approached and he could not be found till the following day, by which time he had died of exposure. As was now the custom, Casimir's property had to be divided among his sons with Alph getting the château and land at Le Bosc, while Charles took the town house in Albi. Alph now assumed the title his mother Gabrielle had chosen, calling himself Comte de Toulouse-Lautrec-Montfa, which ought to have meant that his son was now Henri, Comte de Toulouse-Lautrec-Montfa, the addition of the Christian name indicating his junior status; instead his father decided that his son should have the title of Viscount. In any case, little had changed, the widowed Gabrielle continued to live in the château with Adèle and Henri, while Alph, as before, drifted between Le Bosc, Loury and Paris.

Despite his grandfather's accident, Henri was given his first horse though a succession of minor ailments and the increasing amount of time he was obliged to spend in bed recovering, made the gift more a gesture than a genuine belief that he was fit to hunt. As usual Adèle reassured herself that he would soon be in Paris and at school like other boys, but before the move, she took the precaution of organising a pilgrimage to Lourdes to see if a miracle could achieve what the local doctors in Albi had not.

They arrived in Paris in the summer of 1872 and settled again into the Hôtel Pérey in the Cité du Retiro. Contrary to what she had expected, Adèle was surprised to find all signs of the upheaval being swept away. With Alsace and part of Lorraine ceded to the enemy and the payment of a huge indemnity agreed, the new regime had got down to the task of pretending that nothing had happened. A determined optimist, if he ignored the odd burned-out ruin, such as the Tuileries Palace and the empty plinth in the Place Vendôme, could just about imagine that the city was her old self again – and who save a few skulking revolutionaries in Montmartre wanted it otherwise? With commendable effort the municipal authorities were able to hold that year's Paris Industrial Exhibition, which even included an exhibition of painting and sculpture, in the Palais de l'Industrie. Adèle took Henri to visit it, though it was obvious that he found the walk up the Champs-Elysées difficult. Nevertheless, this was to be his first visit to a major exhibition and he was doubtless impressed, if not by the art then by the great crush of

people determined to enjoy themselves now that the nightmare had passed.

The art on show represented a conscious attempt by the authorities to re-establish solid artistic values. Only those works that were safely historical and preferably patriotic had been allowed in: obscure medieval monarchs in mildly dramatic anecdotes from the past, scenes of mindless gaiety at the court of Versailles, long-ago battles that the nation had contrived to win. It was all of a piece with that spirit of self-deception in which a Republican government, dominated by Monarchists, dreamt of a king who himself lived in a fantasy world two centuries out of date, a world where a self-regarding nobleman like the new Comte de Toulouse-Lautrec-Montfa preferred to wear fancy dress and spend days on end chasing wild animals rather than lead anything that could be thought of as a useful life. It was a time in which those who had, chose not to see those who had not, and in which the poor and the destitute in their turn preferred to forget their condition with the aid of absinthe and loud music. France, and in particular Paris, in the wake of military defeat and the trauma of the Commune, was a world in which everyone seemed to be avoiding reality, where poverty, crime and political dissent were hidden away, where sadness and desperation were masked by the drunken smile and the mindless dance, and where art helped sustain this charade by offering up meaningless chunks of the past painted with the deceptive precision of photographs.

Only later would this be apparent to Henri. Aged seven, he was probably more impressed by the surface grandeur, by the huge canvases in their massive, gilded frames being gawped at by the great crush of admiring visitors. It was a spectacle that would have conveyed to him the useful lesson that in his nation's capital art was no mere rainy-day hobby but a thing of considerable importance and wide public concern.

While there was no denying that Henri's health was worsening, the fact that he was about to go to school like other boys gave Adèle new reason to hope. He began his first term at the Lycée Condorcet, as the Lyceé Bonaparte was now named, in October 1872, a month short of his eighth birthday. Less than three years later, when the pain in his legs had become intolerable, this attempt at formal education would be abandoned.

It was sad from every point of view. His brief period at school had raised hopes that he might achieve an impressive academic record; he was bright, good at exams, and the Condorcet was a congenial place for someone unused to rigid discipline. The school was famous, or notorious, as the only lycée in the capital for day-pupils. The boys were free to come and go as they pleased

between lessons, a licence that had earned them a reputation for being what would today be called 'streetwise'. One old boy wrote of his fellow pupils that: 'They find themselves marked excellent in the Greek essay, excellent in Latin oration, after having made no effort to excel at anything but billiards.'

As the rue du Havre was near the Gare Saint-Lazare and all the bustle of the *grands boulevards*, the Condorcet was ideally placed for adventure. Of course the youngest pupils would hardly have been left to roam wild and we know that Adèle continued to accompany Henri to and from school long after he could have made the journey on his own. But even in the well-ordered world of central Paris, he would have seen something of the human misery visible on the streets of any major European city at the time, sights far more shocking than those of the rough but tolerable rural poverty that he knew from Albi and Le Bosc. Montmartre was only a brisk walk from the school and though he would not have gone there himself, he would have heard something of that forbidden enclave from the accounts of older pupils, boasting of what they had seen when they returned from their escapades, between lessons.

Happily, there was more than poverty to be discovered in Paris and another ex-pupil expressed this in a poem, in which he described how the boys at the lycée were familiar with the latest ballet and had seen the newest paintings at Goupil's Gallery. Despite his mother's cosseting, it is likely that by the time he was eight, Henri de Toulouse-Lautrec had become something of a city boy. He even stayed in Paris that Christmas and, like the pupils in the poem, had his first taste of the capital's distractions early in January, when he was taken to a puppet-show version of *Cinderella*, a modest beginning to a lifelong obsession with the theatre.

At the end of his first year he was awarded the class prize in history, and after a short break on the Normandy coast he returned in September for the new term, a pattern that continued over the next two years, making the break with formal education in the new year of 1875 all the more difficult to accept.

By his tenth birthday Henri was increasingly unsteady on his feet and the pain in his legs was hard to bear. He seemed to be suffering from something akin to permanent growing pains without actually growing much, while the deformation of his sinuses had worsened to the point where he suffered from frequent toothache and near perpetual colds. What touched everyone was the fortitude and good humour he stoically maintained despite the increasing evidence that there was something seriously amiss. Adèle, however, went on trying to believe that each illness in turn was merely a passing malady

that could be dealt with by finding the right cure and to this end, she removed Henri from the Condorcet and launched him on the series of treatments that came to dominate his life.

The lycée, or rather his absence from it, has become one of the more telling 'might-have-beens' in the future artist's life. During his short stay he had managed to befriend Maurice Joyant, who would one day be his dealer and eventual biographer but there were others with whom he had no contact and who might have had considerable influence on his development. The leading Symbolist author Stéphane Mallarmé had just joined the staff as an English teacher and might well have taught Henri languages, had he stayed on. Indeed, the year he left witnessed the arrival of a new group of pupils who were all to make their mark in the arts: Paul Sérusier and Maurice Denis would be leading figures in the Nabis' school of painting and while some, like the critic Thadée Natanson, the actor-director Aurélien Lugné-Poë and the poet Stuart Merrill, would cross his path in later life, Henri was to miss the close association that only a shared childhood can bring.

Indeed, solitude was now the salient feature of his life as short periods of private tuition alternated with seemingly endless treatments: the hours of traction and manipulation followed by boring periods of enforced rest. There was by then another reason to find more 'cures'. Back in 1866 Alph's sister, and Uncle Pons' goddaughter, Alix, had married Adèle's brother Amédée-Marc Tapié de Céleyran. Theirs was another marriage of first cousins, made for the same dynastic reasons, but this time there was to be no question of restraint – Alix and Amédée produced fourteen children in quick succession, four of whom were to suffer genetic deformities far worse than those of little Henri. One daughter Madeleine would die young, two others: Kiki, Henri's godchild and her sister, Geneviève, were dwarves, while a third, Fides, spent her short life confined to a tiny baby-carriage.

All this was enough to penetrate even Adèle's carapace of denial, but even while she was beginning to acknowledge the possibility of a serious genetic disorder within the family, she still had no way of knowing what precisely was wrong with Henri nor what might be done to cure him. Even today, the causes of Henri de Toulouse-Lautrec's disabilities are still a matter of considerable speculation. Since his death, his condition has fascinated a long line of doctors and amateur diagnosticians. *Osteogenesis imperfecta, achondroplasia, hypo-achondroplasia, polypiphysial dysphasia, familial osteochondrodystrophy* and *lipochondrodystrophy* have all been proposed and disputed. The most recent and now widely accepted diagnosis is *pycno-dysostosis,* a form of dwarfism, though even this is challenged by those who

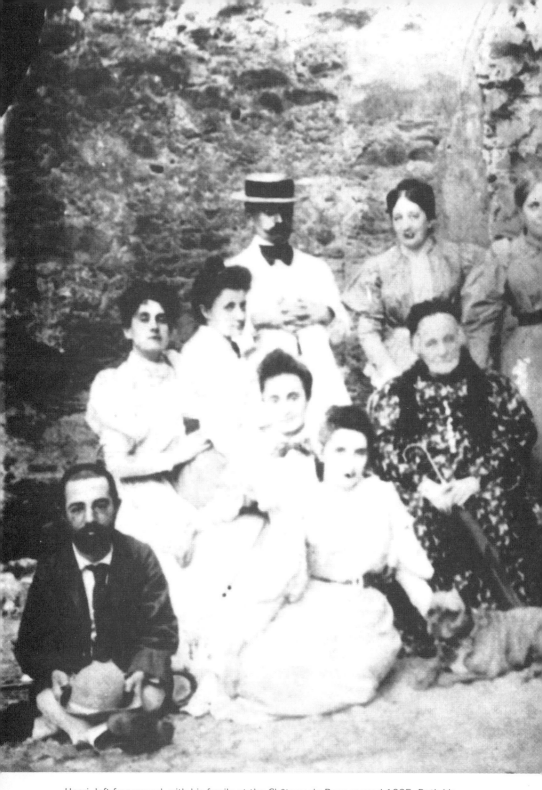

Henri, left foreground, with his family at the Château du Bosc around 1895. Both his grandmothers are seated at the centre but the three handicapped cousins in the picture, especially Fides in her baby-carriage, illustrate the family tragedy.

51

prefer the more general 'genetic mishap', so that as with Van Gogh's madness and the effects of Gauguin's syphilis, the issue has become one of those strange 'hobbies', a source of study and, occasionally, fanaticism, for those ghoulishly drawn to medical mysteries.

Whatever the name for the cause of his afflictions, the boy was to enter his teenage years as little more than an object of experiment, moving between Paris and the country and back as Adèle searched out new doctors and new cures: when he first left school he was sent to Neuilly, then a fashionable town outside Paris, where he stayed at the house of a Monsieur Verrier who ran a clinic for people with problems with their joints. As this vagueness suggests, Verrier was probably not a doctor, just one of many offering alternative treatments into whose hands Adèle would fall. For her son it was as if the caring maternal world had surrendered him to its cold medical/masculine counterpart. Although Adèle travelled from the Pérey to the clinic every day – frugally by public omnibus – their separation was clear enough to the lonely little boy.

It took nearly a year for Adèle to accept that Verrier might be a quack, but even then the search for the elusive cure was unending – there were electric brush treatments, that probably involved mild electric shocks, and applications of sulphur, which did him neither harm nor good. These experiments sometimes irritated him, sometimes hurt, but he tried to be brave for his mother's sake, developing in his brief letters to his family, a wry, self-deprecating wit which seems to have been his way of trying to maintain the sort of courage his father would have wanted him to show on the hunting field, had such a thing been possible. He had been a pleasant-looking child, wide-eyed with a sweet expression and, before the pains began in earnest, he had loved games and been something of a team leader among his cousins. Now, as photographs reveal, he was becoming awkward, his features, especially his lips, were beginning to thicken and he was increasingly obliged to use a cane to steady himself as he walked. In mute testimony, the lines on the wall at Le Bosc grow closer as his growth slowed and he ceased to keep pace with his cousins. In his brief, affectionate letters to his family, by far the most moving details are those which reveal a confused mix of resignation with blind hope, derived from Adèle, that the cures would, in some miraculous way, work and that he would eventually be the same as other boys whom he always described as being 'tall' or 'big' or simply 'strong'.

To take her son's mind off his sufferings, Adèle would do what she could to satisfy his simultaneous love of animals and any art associated with them. In

a Christmas letter from Paris to his grandmother Gabrielle, written at the end of 1875, Henri describes a book of illustrations by the animal painter Victor Geruzéz, who signed himself 'Crafty', which he had bought himself as a present. As this was written at the end of his first year of treatment at the Verrier Clinic in Neuilly, he was certainly in need of cheering up, and as he also reported he and his mother had been to see: 'M. Princeteau's big picture showing Washington on horseback', the first recorded mention of a painter friend of Alph's who had been a close member of his circle since they moved to Paris in 1872. Alph and Adèle had separate sets of rooms at the Hôtel Pérey and Alph used one of his as a studio, where he could draw and paint and where René Princeteau could come and advise him in an informal way.

The portrait Henri mentioned was made for the French pavilion at the international exhibition in Philadelphia to mark the centennial of American independence. It was certainly unique as far as Princeteau was concerned, for as soon as the portrait was varnished, he returned to his more usual sporting scenes. But there was one feature of the work that was true to form – Washington's mount was a horse straight out of Vernet via Géricault, a living, fiery, swan-necked creature that could have been bred from one of the charging beasts in the dashing military canvases of Géricault's youth.

As with Vernet and Géricault, Princeteau's riding and sporting interests were as important to him as his artistic ones, indeed there was little distinction between the two. Despite a provincial background in trade, when he came to Paris in 1865 his ability in the saddle led to invitations to ride at the private studs of the Prince de Joinville at Chantilly and Baron Schickler at Ermonville. Both became loyal patrons when the young artist began his career as a painter of riding and hunting scenes, specialising in the winners of the major races at Longchamps and Deauville and occasionally further afield at Baden-Baden.

It is easy to see what brought Princeteau and Alph together, and the similarities with Géricault and Pons are intriguing. As the well-off son of a wine merchant, the artist had no need to earn a living from his art and was thus free of any hint of vulgar commercialism in Alph's eyes. But it was riding that formed the strongest bond – Princeteau was said to handle a horse-whip as ably as a brush and with his membership of the prestigious Jockey Club he was certainly no bohemian. 'I never paint a horse worth less than 20,000 francs,' he liked to claim, ensuring that his wealthy clients were suitably grateful for his attentions. Typical of this sort of work was his *L'arrivé du Prix du Jockey Club 1892* (The Finish of the Prix du Jockey Club, 1892), a long canvas with the eleven contenders for the most prestigious race of the

season strung out as they approach the finishing post, with each animal clearly portrayed, a carefully constructed presentation of expensive horse-flesh in its most elevated social setting, a work meant to flatter the purchaser's artistic taste while pointing out his ability to move in the right circles. By then, works by *animaliers*, painters of animals, and *peintres sportif*, painters of sporting life, were accepted by the annual Salon, though they were still looked down on as minor genres, not to be compared with the High art of history painting. Yet despite their connection with living nature, many *animalier* works were self-consciously static – a race winner posed in a paddock, a favourite dog asleep by its kennel, as if the artist was trying to play down the crude reality of the scene. Not so Princeteau whose *Finish of the Prix du Jockey Club* is a remarkable representation of speed and movement captured through loose expressive brush-strokes, that owes much to Géricault's *Derby at Epsom* from which it clearly descends. What Princeteau took from Géricault, and thus from Vernet, was their sense of dramatic movement. His best works are snapshots of sudden activity – *Lad en difficulté avec son cheval* (Stable boy in difficulty with his horse) is less a finished work in the academic sense, than a painted sketch, made up of short sharp strokes of colour that in themselves represent the rapid movements of the horse and the boy's attempts to control it.

Princeteau was about thirty-nine when he came into Henri's life. To the boy, he was everything an artist should be – tall, elegantly turned out and well-liked by Alph and his fellow hunters and riders – though the true source of their friendship was more private. Princeteau had been born deaf and while he had taught himself to lip-read and could speak after a fashion, his words were distorted and often sounded odd. With all the snobbery he could muster, Princeteau affected a disdain towards those of his fellow sufferers who had failed to master any speech whatsoever, but the fact remains that art was something of a refuge for him. As Henri's medical problems increased and the dull years of 'cures' dragged on it was only natural that Princeteau's visits, whether in Paris or the country, should have brought the welcome reassurance that life was possible even for someone who fell far short of the physical perfection his father seemed to admire. Here, after all, was someone who had suffered and won through and as the boy increasingly used drawing and painting as an escape from pain and isolation, it was understandable that he should turn to a kindred spirit, for reassurance and advice.

For the seven years after 1871, their relationship was somewhat like that of a friendly uncle and admiring nephew but as Henri's interest in art deep-

ened, Princeteau began to take on the role of teacher and counsellor. Initially, Henri sketched and painted to amuse himself and the surviving drawings, carefully preserved by his mother, show no more than one would expect from a child of that age. They vary from hasty scribbles to the rather overdrawn and stilted work children produce when they are concentrating hard on what they are doing. More interesting than the surface result is the link between doing and drawing, for even at an early age Henri was clearly a visual diarist, recording his visits to the circus, imitating his father and his uncles sketching the day's kill. It might well have gone no further than this, but for that day in 1878, his thirteenth year, when everything changed.

On 1 May, President MacMahon opened the Universal Exhibition in Paris, a sprawling temporary city that stretched from the enormous Trocadero Palace on the Chaillot Hill, down across the Seine along the Champ-de-Mars to the Ecole Militaire. Henri was one of the first to visit this triumph of technology but there was art too, and on a grand scale – a vast display of the acceptable giants of French culture, men such as Baudry and Bonnat, Cabanel and Carolus-Duran. This time, however, other forms of art

One of Henri's paintings of his father racing his coach.

were allowed their little corner – even the once-despised painters of animals and sporting scenes were permitted to take part and Henri was able to see work by Princeteau hung beside the great masters of the Academy and the Salon.

It was exciting to feel part of this success and the exhibition marked a high point in an unusually good time that would make the subsequent crisis all the harder to bear. Straight after the visit, Henri left Paris with his parents for a holiday with Uncle Charles and grandmother Gabrielle at the Hôtel du Bosc in Albi where on that otherwise innocent Monday, the crippling accident took place, the tragedy that ensured that nothing would ever be the same again.

He was bedridden for a week, at the end of which the temporary splint was replaced, in a painful operation that lasted three hours, by an *'appareil'* attached to his thigh to prevent his leg from moving. After a further four weeks this was in turn removed and he was allowed to walk, first on crutches, later with the aid of a cane.

Throughout this grim period, Henri did everything he could to bolster his mother's illusion that all was well. Propped up in bed, he worked at his art with a new conviction, encouraged by Princeteau's success at the Universal Exhibition. To cheer him up, he was given his first oil paints, though as one would expect from someone learning to master unfamiliar pigments, the initial results were somewhat solid, brown and heavy. The earliest survivor, a painting of a horse called Bruno being held by a groom, is a typically static, *animalier* horse-portrait, but before long the convalescent painter was attempting to create the sort of movement and action he could see in the work of his friend.

Princeteau appears to have been particularly solicitous at this difficult time. When the patient was allowed out, the older man took him for short journeys, a brief respite from the cloying attention lavished on him at the house. One day the two of them were riding along in a carriage when an incident took place that curiously recalls Géricault's experience on the road to Saint-Cloud. They had stopped at a level crossing and as the train clattered by they watched enthralled as two horses, grazing in a nearby field, were suddenly startled by the noise and speed of the passing engine. It was just the sort of vivid incident that Princeteau loved and both were to use it, Princeteau in a painting, Henri as a rapid, water-colour sketch *Deux chevaux effrayé par une locomotive* (Two horses startled by a train) that conveys all the shock and confusion of the original event.

Princeteau now assumed the role of informal tutor to his young friend.

Whenever Princeteau appeared Henri would bring out his drawings for a little gentle criticism and on occasions a full-scale lesson would take place. Princeteau's usual teaching method was to get Henri to place tracing paper over one of the paintings in the house, to make a black-and-white copy of part of it – say a pair of figures – then to take this monochrome image and colour it in, with quick rapid brush-strokes, the result being often more lively than the original. There is a surviving painting of Alph on horseback with his falcon that was inspired partially by a sculpture of the same subject that Pierre-Jules Mène had exhibited at the Universal Exhibition, but also by a photograph by Delton of Alph in action, which is preserved today in the family home in Albi. This use of various sources was also encouraged by Uncle Charles, who wanted his nephew to look beyond the limited world of the sporting print and who may well have introduced him to Géricault's *Derby at Epsom*, which is clearly the inspiration for a pair of galloping racehorses that Henri painted around this time.

Adele, meanwhile, had stepped up her search for a cure for Henri's damaged leg and in the summer of 1879 she took him on a second visit to Barèges, a spa in the Hautes-Pyrénées, whose waters were expected to fortify his brittle bones. The weather was unseasonably cold and wet and on 21 July, while they were out walking, Henri suddenly slipped and fell into a dry gully, no more than a few feet deep, but enough to break the femur in his other leg. Once again he was obliged to wear a splint and to undergo the succession of treatments thought to be good for his condition, though this had the inevitable consequence of throwing him together with other sufferers, a situation that brought Adèle uncomfortably close to reality. As he waited, bedridden, Henri made friends with a boy of his own age, Etienne Devismes, a hunchback who happened to be a grandson of the painter Fragonard. Looking at the two together, it was impossible for Adèle to go on pretending that her son's condition was anything but permanent and incurable. From this point, Henri's lines on the wall at the Château du Bosc stop – he was just under five feet tall and would grow no more. From the waist up he would be fairly well proportioned, from the waist down he would have stubby, bandy legs that would cause him to waddle around, duck-like, leaning heavily on his cane.

As before, there was the grim combination of intense agony interspersed with interminable periods of total ennui. In September he wrote to Devismes, who had left Barèges, to tell him that the 'surgical crime' had been committed, when the doctor removed the splint and painfully bent his leg into place, a performance that caused him to 'suffer atrociously'. As soon as he could he

returned to his art, and the way his paintings become even more vivid and action-packed seems to reflect a growing realisation, as if he were willing his hands to do what his legs would never manage again. From then on, movement becomes the whole point of these rapidly brushed oil sketches. Horse-drawn carriages belt along at a reckless gallop – there are several in a series, which culminates in a startling image of his father driving his coach, a work of such astonishing vigour which is usually singled out as the young artist's first major work. It is also significant that he signed and dated it *Nice 1880* where he was again recuperating under the watchful eye of his mother, for it was while they were staying by the sea that he reached the conclusion that he wanted to make art his life; that like his friend Princeteau, he wanted to be a 'gentleman-painter'. It was not an irrational idea and even Adèle, when he first broached the subject, could hardly faint with horror – he would never be able to live a life on horseback like his father and uncles and that in turn ruled out the only career acceptable to one of his class, the military. Provided it was conducted as it was by Princeteau, then art could be seen as an acceptable part of the social life of the capital. The Salon was a major feature of the annual season, the grandees of the art world were famous national figures who commanded huge fees for their labours, and Henri had no sooner hinted at his intentions than his mother was mapping out his future along suitable lines. To Adèle, it was obvious that her precious boy could have a glorious career as an artist while remaining safely within the confines of his caste. What she, and indeed everyone else in their circle, seems to have overlooked was the change in Henri's attitude that had taken place after the second accident. On the surface he was still the same charming and uncomplaining figure he had always been, but there were signs that he now saw the world in a less rosy light than before. When he was undergoing the 'surgical crime', his cousin Madeleine, the eldest daughter of Aunt Alix and Uncle Amédée, was in Bordeaux undergoing treatments on her legs similar to those he had already suffered and in order to distract her he decided to make a visual diary, a series of cartoons of wild happenings and cheeky snippets of observation that he hoped would amuse her. It was begun on the way to Nice, took almost a year to complete and he called it his *Cahiers des Zig-Zags* (The Zig-Zag Notebook), presumably a nod towards *Caprices et Zig-Zags*, Théophile Gautier's account of his travels, but equally a reference to the pointed lines of the illustrations and the sharp edge to much of the text. At one point he mocks his own illness in a drawing that shows him sitting up in bed vomiting, while in another section he writes wickedly of an Englishwoman, a Miss Armitage, who came to a dance he was obliged to sit

through, describing her as a 'female chimpanzee, a clergyman's sister, fifty winters old'. This is harsh but was clearly an attempt to resist the tide of sympathy that must have threatened to engulf him. At sixteen he was already demonstrating the unforgiving eye he would cast over strangers and friends in the years to come, and if such acerbic comments seem slightly repellent in a boy of his age one must remember who made them and who they were intended to amuse – two people whose lives had been blighted through no fault of their own. Better to be hard than self-pitying.

By the time his gift was ready, Henri and the family were back in Paris debating his choice of career. Uncle Charles was encouraging and Princeteau and some of his colleagues came to look at Henri's work – though not the *Zig-Zag* sketches, one supposes – and dutifully enthused. In any case, what could Adèle and Alph say to contradict him? Despite Alph's attempts to ignore the reality and Adèle's pretence that all would be well, deep down both knew they shared responsibility for his condition. Adèle, of course, was determined that it would all remain firmly under her supervision – her mind was already running over the best path her son could follow. There was the Ecole des Beaux-Arts, which she understood one or two young men of good background attended, though that would have to wait another year until Henri was eighteen and had passed his *baccalauréat*. Then again, there were the smarter studios maintained by the leading members of the Académie – her mind dwelt on Cabanel, one of the more fashionable painters, but once again this would have to wait until Henri had achieved a standard acceptable to so elevated a master. In the meantime, the two of them could go on living at the Hôtel Pérey while Henri went to Princeteau's studio to continue his training.

In many ways it was an ideal arrangement, and Adèle was reasonably content, though even she could not completely suppress the obvious conclusion that with friends like Devismes, and with his life as an artist about to begin, Henri was moving out of 'our world' into one of his own.

3

TOWARDS MONTMARTRE

With so many indolent men in her family, it was something of a novelty for Adèle to see how strictly Henri interpreted these rather loose arrangements, whereby he would do a little work at Princeteau's studio and receive much the same occasional tutoring as he had at home. To her surprise, Henri took all this very seriously indeed. Every day, after an early breakfast, he left for the short journey to the block of artists' studios at 233 rue du Faubourg Saint-Honoré where Princeteau had his rooms, and where the pupil dutifully carried out the master's instructions.

As Adèle well knew, this was a smart address that Princeteau shared with a group of colleagues of which she thoroughly approved – the Comte de Ruille and the Vicomte du Passage were fellow aristocrats who worked in the same area of elegant sporting art that the Toulouse-Lautrecs admired, and there was also the painter of horses and military scenes, John Lewis Brown who, although French, had a name that indicated acceptably British origins. With horses and grooms in the courtyard, this *cité des artistes* was not unlike a country house and all the talk of hunting and riding made it seem as if nothing had changed. Even the work Henri was required to do was little different from the tracing and colouring-in that he had already been practising under Princeteau's guidance, and to Adèle it must have looked as if things would go according to the outline for his future that she had established as soon as her son's wish to become an artist had been made known to her.

At this point Henri seems to have been happy to share his mother's hopes that he would become a respected figure within the official state-sponsored artistic system whose bastions were the Institute, the Académie, the Ecole des Beaux-Arts and the Salon, yet in a mere three years' time it would seem an impossibly naïve plan. If Adèle imagined that she could continue to manipulate her son's future she had reckoned without the one element that

unsettled all who moved there – Paris itself, the city of ferment and change, where districts like Montmartre exerted such a powerful influence on anyone connected with the creative life. Adèle might hope that Henri would stay for ever within the safe confines of the city's better districts, untouched by the more worrisome ideas that were said to circulate among those outside her world, but like so many mothers before and since, she reckoned without the irresistible allure of the forbidden.

We do not know exactly how or when Henri de Toulouse-Lautrec became aware of the strange notions that held sway beyond the enclosed life he had always known. Throughout his life he remained fastidiously reticent about his deepest thoughts and beliefs. His letters reveal little beyond family chit-chat and one looks in vain for a hint of any political or artistic theorising. When he came to Paris in 1881, he was an impressionable seventeen-year-old still willing to do as he was told, yet within a year he was making his own decisions, with a clear idea of where he wanted to go, evidence that he was by then aware of the city and the ideas circulating within it. However this happened, it is clear that Henri's transformation had much to do with his discovery of Montmartre, the part of the city that would eventually become the central feature of his life and art.

Montmartre changed so much and so rapidly in the nineteenth century that one must try to understand the way it was when Henri first knew it, if one hopes to comprehend its effect upon him. At the end of the 1870s the area was still very much a creation, albeit an unwitting one, of Napoleon III's empire and the labours of his city planner, Baron Haussmann. While we can accept that the Emperor was genuine in his desire to create the most beautiful city in Europe and that part of this involved sweeping away the insanitary hovels that disfigured large sections of central Paris, it was equally the case that those who benefited most were Napoleon's supporters in the financial community, who were granted cleared land on which to build the sumptuous apartment blocks and elegant hotels that now line the rue de Rivoli and the areas around the newly-laid-out Parc Monceau, areas still accessible only to the richest sections of society. The original inhabitants were driven away, out to the very edges of the town, beyond the last broad streets, the areas whose names were to become redolent of squalor and abandon: Clichy, Batignolles, Montmartre, La Villette, Belleville, though of all these Montmartre held pride of place partly because of its elevated position on the hill dominating the elegant city below but also due to the ambiguities that had marked so much of its history. Even the name divides opinion. Is it pagan, the Mons Martis, the Mount of Mars – or sacred, the hill of martyrs?

Certainly the pious held it longest, from Saint-Denis, the martyred first Bishop of Paris, carrying off his severed head to where his shrine now stands, to the last abbess who lost hers during the Revolution. But even as the Christians were tunnelling under the hill to lay their bones in catacombs, others were mining the gypsum for the plaster-of-Paris needed by the city's sculptors – always the sacred coexisting with the profane.

Montmartre's nuns made indifferent wine, but as their lands were then outside the city and free from its taxes, open-air drinking places, *ginguettes*, sprang up where it was cheap to get drunk and where singing and dancing soon followed. Thus, the good sisters had inadvertently launched the hill as a place of free-wheeling entertainment, where aristocrats built love-nests, such as the elegant Château Rouge, for their mistresses, but where the seamier side of life was never far away. Just over the summit of the Butte, the wretched hovels of the migrant workers, brought in to labour in the quarries, ran down the northern slopes until they merged into the market gardens and open land between the city walls and the first line of defensive forts. Thus Montmartre became a bucolic site of pleasure houses, airy windmills, gardens and allotments, a home to struggling artists and writers from the early years of the century, yet only a little further north lay the *maquis*, a filthy pit of insanitary alleys and rough wooden shacks, a refuge for criminals and drunks. In 1860, the area was finally absorbed into the city, becoming the 18th *arrondissement*, but when the rest of France collapsed Montmartre's citizens snatched back their independence when the Commune began on that northern hill. The notorious nightclubs and dance halls were transformed into workplaces and even the Elysée-Montmartre, where young working-class men and women had met to drink and dance, was used to manufacture the enormous balloons that carried men and mail beyond the enemy lines. At the same time, other cabarets became political centres, such as the Club de la Vengeance in the Place Blanche or the women's club at the Boule Noire, where the passionate Louise Michel harangued her listeners, where anyone could get up to address the crowd, and where votes were taken on the wildest schemes in a grotesque exaggeration of democratic government. In its last days, the Communards tried to pass legislation that would help create the ideal society, but such an odd association of the followers of Marx and Engels, with several varieties of anarchists, along with freethinkers and anti-clericalists, could only have existed outside everyday reality. If, by a miracle, the enemy had retreated and the Commune survived, their utopian exercise would surely have imploded through its very impracticality.

Bodies of massacred Communards before a mass burial, 1871.

Yet despite the otherworldliness of these dreams, the populace remained surprisingly loyal to the revolutionaries on the hill, helping to throw up barricades to hold back Marshal MacMahon's troops, though to no avail. Dreamers are not usually good soldiers and the end when it came was marked by atrocities on both sides, the maddened women dashing down from the Butte to burn the Tuileries Palace and the Hôtel de Ville, the government soldiers hunting the Communards through the alleyways of the cemeteries of Père-Lachaise and Montmartre, a manhunt among the graves, so that the blood of the martyred Communards made Montmartre, in the words of Philippe Julian, 'quite as sacred to the revolutionaries as the blood of the Christian martyrs had done to the citizens of Paris in the Middle Ages'.

Those captured Communards who hadn't been shot in hot pursuit were tried and sentenced to the firing squad or to grim exile on the various prison islands or remote pacific colonies that France possessed. But not all were captured. Many hid in the crammed slums of the *maquis* on the other side of the Butte and others drifted back there after serving their sentences or when a final moratorium was declared in 1885. Together such survivors made Montmartre the home of French dissent and while many of the clubs like the Elysée-Montmartre returned to their former function as dance halls, others maintained the tradition of the Commune by providing entertainment with a distinctly political edge. It was all so flagrant it was obvious the authorities had given up caring, at least for the moment. Montmartre could be tolerated because the population at large was fed up with revolution. A wave of reactionary conservatism was now the dominant national sentiment. Even when the Monarchists were replaced by a Republican majority in 1876, the system of pork-barrel politics, of favours and hand-outs, of place-men and outright corruption was by then so entrenched that for those who longed for something more decent, more honourable even, there was only the appeal of radical philosophies to nourish their dreams.

In many ways, the stumbling republic was no bad thing. As the *fin de siècle* merged into the *belle époque* in the early years of the new century, many of its sorrier aspects had been eased. There are many worse periods in history than France from 1871 to 1914, and few offered quite as much fun, an ingredient often overlooked in historical judgements as indeed it was at the time. In 1879, the *République des Ducs* with its programme of Moral Order, was swept away when the right lost its majority in the Senate, which proceeded to elect a republican, Jules Grévy, to the presidency, ending any lingering hopes that the childless Chambord might still become King. His death four years later brought to a close the legitimist line in France, leaving only

the unpopular Orléanist branch hopelessly claiming the French throne, as they do to the present day. In the meantime, the Republic began to establish itself in the popular consciousness, in 1879 the 'Marseillaise' became the country's anthem, the following year Bastille Day was proclaimed the national holiday, and the image of Marianne, based on the statue in the Place de la République in Paris, became the symbol of the nation, reproduced in countless busts and prints displayed in town halls and government offices, and on coins and stamps and medals ever since.

To the likes of Alph she was the *La Gueuse*, the whore, and along with other aristocratic families the Toulouse-Lautrecs refused to celebrate Bastille Day, preferring the pretence that nothing had changed and that their world remained as it always had been. In effect, the French aristocracy had been cast into that limbo which is tellingly portrayed in all those scenes of hunting and horse-racing, which seem to exist in a timeless no-man's-land, occasionally elevated to a realm of pure fantasy when we see Alph in his Cossack outfit launching a falcon into the air.

Reality, however, was not far away. The 1870s had been a disaster for France's agrarian economy, with imported grain from America forcing down prices and driving peasant-farmers off the land and into the slums of the industrialised cities. This was further exacerbated in the region where the Toulouse-Lautrecs had their various estates due to the pernicious effects of the phyloxera beetle that was remorselessly destroying the vines on which the family's income depended. As a result, 'our world' was no longer quite the secure place it had seemed to be. Life was changing with alarming speed and nowhere was this more apparent than in the capital where an almost frenzied search for the new was already challenging even those seemingly impregnable bastions of state culture in which Adèle placed such faith.

To be a young art student in Paris around the end of the 1870s and the beginning of the 1880s, was to share in a creative outpouring not seen since the early days of Renaissance Florence. Ideas and movements bubbled up, flourished and died in an atmosphere of shock, outrage and elation, while the masters of the old order, angry and confused by turns, tried hopelessly to damp down the flames. Even the carefully circumscribed world of Princeteau and his friends was not entirely impervious to this upheaval, though it would be some time before Henri learned the full extent of what was happening beyond the studio walls. He was only out of his mother's sight for a small part of the day, returning to the Perey to bath and change and dine with her, leaving little chance for him to see people outside her limited circle of friends. We have no knowledge of the galleries he visited and

the art he saw nor the ideas he discussed with young people of his own age on the rare occasions when his mother was not there to listen in. Frustratingly, we cannot be sure when or how he came into contact with the many ideas that were transforming art at that time – even the most important of them is not mentioned in his correspondence. Yet it is impossible that he could have been in the capital, living among artists, without realising that, unlike Princeteau and his friends who were upper-class gentlemen with right-wing royalist views, many creative people considered themselves radicals, allied in spirit to the poorest sections of the community, men who saw themselves as heirs to the spirit of the Commune. Anarchism was a key element in intellectual life at the end of the nineteenth century. After the collapse of the Commune, many creative people in France claimed to be anarchists, though few had much idea what it was they were paying lip-service to.

There were two varieties of anarchists, those who thought and those who did, and with only one known exception, the two were not to be joined in the same person. It is easy enough to see why the thinkers – although they were often the children of well-to-do bourgeois families – came to adopt such radical views. As students, or while struggling through their early years as writers, artists, and intellectuals, these young people lived close to those who suffered from the whirlwind effects of *laissez-faire* capitalism, which the liberal regimes of Northern Europe had done much to encourage without making, so it seemed, much corresponding effort to counterbalance its excesses. It is difficult now for us to imagine the wretchedness of life in the Montmartre *maquis* or in London's Whitechapel or among the miners of the Borinage in southern Belgium or any of the dozens of pitiful slums and shanty towns that marred the urban areas of the industrialised nations. Only a glimpse of the fringes of a Third World city today offers some idea of how bad they were, and in the dire winters of the north, life was probably worse, with entire families crammed into one room in a stinking, leaking block that they shared with quarrelling drunks and shrieking whores. Periods of back-breaking labour over long hours without holidays or any allowance for illness alternated with desperate times of unemployment that brought hunger and despair. Worst among the sufferings of those at the lowest reaches of society was the lack of hope, the chilling certainty that their children and their children's children would know nothing better than a dank room, in which unwashed bodies would be crammed through the unlit hours, until dawn brought another long day of toil for a pittance or the humiliating search for employment or charity.

The climate of revolution would be created by the Propaganda of the

Word but it would be from those foetid slums, from the ranks of the dispos-
sessed, that those who would carry out the actions proposed by the theorists
would come. But their hour had not yet arrived. The excesses of the
Commune had satiated the appetite for violence. Writing just after the events
of 1871, the diarist Edmond de Goncourt thought that this would stave off
the next French revolutionary cycle by twenty years. He was to be proved
wrong, though not by much. A mere fifteen years hence and all the thinking
and writing about anarchy that had preoccupied France's intellectuals would
finally provoke a physical response. Until then, anarchism remained a vague
rallying cry answered by those who felt sorry for anyone who suffered, those
who believed that there ought to be a better method of tackling society's
problems. To most of those who called themselves anarchists, the word was
synonymous with goodness and caring, which makes one think of the dinner-
party left-wingers of the 1920s and 1930s of whom it was said that
they believed in bicycling, free-love and the Soviet Union. Few of the late-
nineteenth-century anarchists had ever bothered to read the main theorists
of the movement any more than the parlour socialists of a later age would
trouble themselves with the turgid theorising of *Das Kapital*. Had they done
so, they might well have been forced to reconsider their allegiance – it was
one thing to long for everything and everybody to be nicer in some dewy-
eyed way, quite another to consider the possibility that it would take bomb-
ings and deaths to bring it about.

Anarchist theorising only really got under way in France in the wake of
the failed revolution of 1848 and the events that eventually led to the *coup
d'état* that brought Napoleon III to power. Provoked by that failure, it was
the philosopher Pierre-Joseph Proudhon who became the true initiator of
European anarchism, establishing it as an essentially moral force based on
Rousseau's belief in humanity's basic goodness. For Proudhon, the 'abstract
idea of right' would sort everything out. Once men saw that there was no
need to be bossed or bullied, their natural inclination to co-operate would
come to the fore, and in this, art, according to Proudhon, had an essential
role to play in stimulating such positive reactions. In 1865, three years after
his death, a collection of his essays on art was published as *Du Principe de
l'art et sa destination sociale*. In it, artists were encouraged to be committed
to social change through forms of painting that would speak directly to the
downtrodden, guiding them towards enlightenment, in effect a Propaganda
of the Brush, which like that of the Word would one day be proclaimed by
deed. Nor was this mere theorising: a large part of the latter half of *Du
Principe* dealt with the one living artist, his friend Gustave Courbet, whose

work best exemplified Proudhon's concept of an art of revolutionary mean-ing. Courbet, like Proudhon, came from what has been described as the rural bourgeoisie in the Franche-Comté near the Swiss border, but his identification with those at the very bottom of the social order, lower even than peasants with land to farm, the truly dispossessed, was no mere intellectual conceit. Even after moving to Paris, Courbet dressed in simple country clothes, no matter where and in no matter what company. But while he may have played the part of the näive yokel, he played it up not down. His *Bonjour Monsieur Courbet* shows his loyal dealer, the collector Alfred Bruyas, respectfully greeting him as they meet on the road, a sign of the artist's elevated status whatever his origins. By representing himself like this, Courbet was follow-ing Proudhon's exhortation to raise what was too often despised to the level of those who thought themselves superior.

Not least of the innumerable human and cultural tragedies that resulted from the firebombing of Dresden during the Second World War was the loss of Courbet's *The Stone-breakers*. That acts, however misguided, intended to end a fascist tyranny should have removed one of the profoundest expres-sions of compassion towards the poor and the disadvantaged, is humbling. More than any other picture of the time, *The Stone-breakers* exemplified Proudhon's assertion that it was the 'thematic content' of a painting that was its only important quality. There was nothing of that sentimental 'nobility' of labour that other painters of peasants used to make their scenes of rural poverty acceptable to the art-buying public. Courbet's young boy helping with the back-breaking toil has only the image of the work-weary older man before him, the grim prospect of what he will surely become.

It was the rise of Napoleon III that had finally radicalised the young Courbet. When he painted his vast canvas showing the interior of his studio in 1855, he subtitled it 'a real allegory of seven years of my life' and peopled it with some of the key figures from the troubled period. Representing the weight of authority we find the Emperor himself, an unlikely visitor, and the two men who represent the somewhat contradictory elements in Courbet's art: Proudhon, who wanted a radical subject-matter but one painted in an acceptable neo-classical idiom, and the poet Baudelaire, who had called for a new realism, the 'painting of modern life', as he famously put it, but one that would be expressed through a modern style. By showing himself at the centre of this crowd, cheekily at work on a landscape, Courbet was signalling that while he continued to support Proudhon's anarchist views, it was to Baudelaire, and this new non-Academic art, that he was now increasingly allied.

By the middle of the century it was just about acceptable to paint the real world, provided the artist confined himself to sanctioned subjects – noble peasants, docile horses – and painted them on small canvases to acknowledge their inferior status. To paint a scene from contemporary life on the grand scale of a history painting was treacherous and when Courbet offered *The Burial at Ornans*, his unsentimental depiction of the funeral of a simple peasant, without any mitigating emotional gloss, and on a canvas of a size normally reserved for some great event from antiquity, it was clear that this 'artist-peasant' had gone too far.

But if the subjects of Courbet's early paintings outraged the establishment, at least they were finished indoors in the acceptable academic manner. What really offended his enemies were the later nature paintings done outside, straight from 'the motif', a working practice that implied that the painter had attempted to capture the fleeting moment, to see nature as it was at a specific time and not as the carrying through of a theory that had already set out what everything should finally look like. When Courbet was at work on the Normandy coast in 1867, capturing the effects of light and shade on sea and rocks, he was joined by the twenty-seven-year-old Claude Monet who was already won over by the idea of painting everyday subjects – Baudelaire's 'modern life' – and would soon make a complete break with the rigid, studio-based dogma that Courbet had first challenged. Courbet's approach was instinctive rather than theoretical, little more than the use of a slightly lighter palette or the addition of a few white highlights to raise the brightness of the scene, but it was enough for Monet and far too much for the grandees of French art. When *The Studio* was rejected, for the art section of the great Universal Exhibition, organised in Paris in 1855, Courbet simply hired himself a space nearby and set up a one-man show, his Realist Exhibition, which, if poorly attended – Delacroix found himself quite alone when he went – at least set a precedent that others would later take up and use to finally destroy the all-embracing power of the state's apparatus of artistic management.

Courbet's proclamation that 'art must be dragged through the gutter' highlights his role as the principal opponent of official culture in the mid-century. His art brings together the various strands of nineteenth-century painting that had been working towards what would now be called Realism – the animal and sporting art that had evolved from both Vernet and Géricault, as well as from the landscape painters who had challenged convention by working direct from nature and the painters of peasants and rural scenes who had chosen a subject-matter far removed from the pomposities

Courbet's portrait of Proudhon and his children, 1853.

of history or the antique. They were now joined by artists who were beginning to heed Baudelaire's call for an art that celebrated the contemporary and the everyday, what Courbet called 'an essentially democratic art'.

Courbet's greatest achievement was to circumvent Proudhon's limited vision by recognising that these new subjects could only be incarnated through new methods, that the highly finished neo-classical style advocated by his friend, would look comic if used to depict scenes that were ordinary and unheroic. With the benefit of hindsight, it is possible to see Courbet and the Realism he fostered as the pivotal movement in nineteenth-century art, the counterpart to the political and social movement that transformed an Empire to a Republic, a world of kings and princes into one of assemblies and elections, moving from an enclosed elite to an open society. Such a view of so complex a time is of course simplistic – on one side the bad old history painters on the other the good new painters of modern life, but while one can find dozens of examples that do not fit this reductive interpretation, the basic scenario remains surprisingly valid.

Despite several official attempts to win him over, Courbet never compromised, rejecting Napoleon III's offer of the Légion d'honneur and promptly accepting the role of President of the General Assembly of Artists when the Commune was established, the only artist of any significance to offer his wholehearted support to the besieged Parisians. By then fifty-two, Courbet threw himself into organising meetings and committees intended to revolutionise art education while at the same time preserving the culture of the past. Like all the Commune's idealistic schemes this was to prove just talk, though it might have remained an inspiration to the future had not the artists' committees and Courbet in particular been damned for the destruction that marred the Commune's last days, in particular the toppling of the column in the Place Vendôme celebrating the victories of Napoleon I.

Whether or not Courbet was present when that monument came crashing down hardly mattered in those vengeful days. Following MacMahon's victory, he was arrested and sentenced to six months' imprisonment but when a subsequent tribunal required him to pay the astronomical costs of restoring the column, he was forced to flee to Switzerland. He died on the last day of 1877, having spent his years in exile running a studio where minor artists were hired to turn out Swiss landscapes for him to sign, an act of defiance towards his enemies in Paris, which until quite recently was thought to have damaged his artistic reputation, but is now considered no more than mildly comic.

With the death of its leaders and the exile of those like Courbet who had sought to combine art and belief in one forward reformist sweep, the anarchist dream ought to have faded away. But Proudhon was not the only theorist and some who came after him were less gentle – men like Michael Bakunin who had been tempered in the more oppressive school of Tsarist Russia and who believed that only violence would achieve their radical aims. Bakunin was closer to other left-wing exiles, those bearded figures hunched over café tables plotting the downfall of states, aware that only a bloody uprising could hope to sweep away the entrenched forces of capitalist tyranny in their native lands. But whereas Marx and his followers believed that the workers would have to be trained and organised for any revolt to succeed, Bakunin still agreed with Rousseau and Proudhon that it was enough for the poor to be aroused for them to know instinctively how to liberate themselves. Thus was born the idea of the Propaganda of the Deed, the notion that all that was needed would be one spectacularly violent act against the edifice of power, say a bomb thrown at a leading politician, to provoke the mass uprising that Bakunin desired. This was the great dividing line of nineteenth-century revolutionary activity: with Marx and Bakunin wrestling for control of the International, a struggle which Marx was to win, leaving the anarchists outside the mainstream working-class movement. Of course in retrospect it was a foregone conclusion. By definition the anarchists were incapable of organising themselves into a coherent force when the whole idea of electing a committee, let alone any sort of leader, was anathema to them. The great test of Bakunin's theory was the Commune when, for a moment, it looked as if he would be proved right. A catastrophic event had caused the people to rise up and seize power just as he had predicted. When the state proved too powerful for an unprepared revolt, just as Marx had foreseen, it broke Bakunin's heart. He died, five years later, 'A Columbus without America', as Alexander Herzen rather tartly put it.

But a theory does not have to succeed to live on. All too often the reverse is the rule and with anarchism this was certainly so. The movement was to survive in the dreams of romantics across Europe but nowhere more openly than in Montmartre, where waves of new arrivals quickly found themselves rubbing shoulders with real revolutionaries, survivors of the Commune, who lingered around the bars and dance halls of the Butte, ready to tell again for the price of a drink the tales of those precious months of liberty when every man and woman had played a part without coercion. It was in this way that an entire generation of artists became convinced that they too were anarchists. Coming to the area in search of cheap studios and models, the

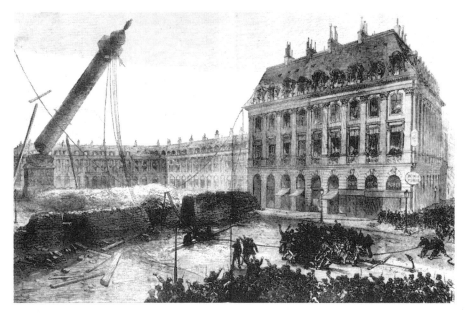

Toppling the column in the Place Vendôme, 1871

newcomers quickly fell in with men like Père Tanguy, a paint and canvas supplier who had fought with the insurgents and avoided the firing squad at the end. The younger crowd went to Tanguy's little shop, then at 14 rue Clauzel, not least because the kindly old Breton was willing to exchange colours and brushes for paintings no matter how wild and unsellable they might prove. His generosity was especially needed in the early years following the upheaval, when the official art world, taking its tone from a highly conservative government, closed its doors more firmly than before against any form of experiment or deviation from the established ethos set down by the Académie and the Salon, once again pre-eminent as the guardians of approved culture. The problem for these defenders of the *status quo* was the age-old allure of the new and the irrepressible desire of the young to contradict their elders.

All over Paris, in schools and studios, art students bored with the daily grind of learning the academic disciplines, gossiped and joked and passed on news of the outrageous things that were being done by artists who were openly in defiance of the rules. The best known of these outrageous iconoclasts were called Impressionists, a name which seemed to say it all, suggesting something intriguingly unclear and ambiguous where the great history painters were solid, bold and straightforward. No wonder the word

itself was enough to evoke ideas of mystery and romance in those who had never seen any of their works. Even Henri, safely immured, so Adèle hoped, in Princeteau's studio, heard the whispers and longed to know more about these painters who were said to daub pigment like children and who made their canvases so bright they hurt the eyes.

Things had moved on from the days when Monet had been content to work alongside Courbet, admiring the older man's instinctive attempts to lighten his palette. Since then the technique had become far more self-conscious with Monet and a group of like-minded friends studying the work of optical scientists like Chevreul, Helmholtz and Rood in an attempt to understand the fundamental laws that govern colour and light. What Monet and his friends discovered were often practices they had been edging towards while painting outside, direct from nature, but which were now reinforced and carried out to a more confident degree. The scientists showed how colours tend to tinge the space around them, which to Monet and his friends meant that shadows should cease to be nothing more than dark patches and should reflect colour from the surrounding areas. The resulting brightness was further enhanced by the use of complementary colours – red and green, blue and orange – side by side, which made the canvas shimmer, and this brilliance was further enhanced by the technique of 'optical mixing' where-by short dabs of pure colour were set down beside each other so that at a distance they appeared to combine, yet without the lifelessness that often resulted when the pigment was mixed on the palette before being spread on the canvas. Taken a stage further, allowing some of the white underpainting to appear between the dabs of pure colour and the result was, in the vocab-ulary of the time, 'luminous', especially when set against the heavy, deliber-ately sombre canvases approved by the Salon. Indeed that was the problem – the Salon was having none of it, rejecting automatically any of these impertinent sunny canvases that were not only glaringly bright but which dared to depict scenes of ordinary life such as people having picnics or boat-ing on the Seine.

Yet despite this implacable opposition, by the time Henri began his stud-ies there was hardly an art student in the city who was not aware that the new school existed. Even Princeteau must have learned about them as far back as 1874 when Monet and his colleagues decided to organise their own exhibition in what had been the studios of the photographer Nadar on the Boulevard des Capucines. It ran for a month, from 15 April to 15 May 1874. Thirty artists took part, lesser names clustered round the central group of the movement that the exhibition gave birth to: Claude Monet, Pierre Auguste

Renoir, Edgar Degas and Camille Pissarro. Auguste Renoir and his brother Edmond seem to have done most of the hard work. Auguste chose a background of reddish-brown wallpaper and organised the hanging while Edmond dealt with the catalogue, doing his best to persuade the participants to buck up the affair by choosing more exciting titles. Monet was the least helpful in this regard, tediously dubbing his canvases exactly what they were, a railway station or a street name. Under Edmond's influence he renamed a hazy river view, painted near Le Havre in 1872, *Impression: Sunrise* and when an irate critic seized on this passing invention and launched an attack on these mere 'Impressionists', what had been a loose gathering of young painters coalesced into a group.

Five further exhibitions were held by the new Impressionists up to 1881, the year after Henri's studies began, and while there is no record that he attended the last show, it is hard to believe that he could have avoided all knowledge of it. Though some of the more diehard critics continued to rant about this impertinent new art, a surprising number had already been won over and while the great names of the Académie fought a tough rearguard action to ban such stuff from their studios, it was not long before hints of the Impressionist technique, the short little dabs of pure bright colour, were spreading across the canvases of the capital's art students at a speed that was clearly unstoppable.

Today, we tend to assume that something so radical and so rapid must have shocked everyone but what the Impressionists were doing only seems so revolutionary if their small, light, bright scenes of people dancing and boating are placed beside the great dark ponderous episodes from ancient Greece, Imperial Rome and the Courts of the Middle Ages that dominated the Salon. If one moves away from that David and Goliath contest, comparing the new art to other sorts of work that was also painted from direct contact with nature, the shock is far less brutal. Monet and his band were only one of several groups that had branched out from the line that links Vernet, Géricault, Delacroix and Courbet, and however and whenever Henri de Toulouse-Lautrec first came across the new school it would be safe to assume that it would hardly have horrified him. Accustomed as he was to Princeteau and those like him, whose studies of animals were done from the motif with quick sharp brush-strokes and a notable lack of Academic 'finish', neither the Impressionists' open-air practice nor their tiny strokes of colour would have seemed especially unusual. Discovering this new school was less likely to have radicalised Henri's technique than to have simply confirmed what was already standard practice. To the question: was Toulouse-Lautrec an

Impressionist, the answer has to be no, though his style was certainly impressionistic, which is not quite the same thing.

Even the subjects normally chosen by the Impressionists would not have seemed strange to Henri. Following Manet, the Impressionists had taken up Baudelaire's challenge to be painters of modern life, but their depictions of the pleasures of the rising urban bourgeoisie, the dances and picnics and the bustling boulevards and busy railway termini that were central to their lives, was hardly very radical. Monet may have worked alongside Courbet in Normandy but his subsequent art reflects little of the older man's political concerns. None of the Impressionists joined Courbet when the Commune was declared and far from being as offensively revolutionary as their first critics claimed, scenes like their Sunday-afternoon boating parties, hazy under the sun-dappled surface of their canvases, only create the illusion that life under the new Republic was very pleasant indeed. Even Pissarro, who held genuinely radical political views, only later expressed them in his art, and while Monet and Renoir might express radical opinions, as most artists did at the time, such things were not allowed to seep into their paintings. Theirs is a dreamy, unblemished view of *fin-de-siècle* life that found its sweetest expression in the work Renoir was doing in the 1870s when he lived in Montmartre, work that shows not a hint of the political sentiments that are usually associated with the home of the Commune and the heartland of revolutionary theory.

Far from sympathising with Courbet's activities during the siege, Renoir did everything possible to avoid joining in. Finding himself trapped in Paris when the Commune was declared and threatened with compulsory enlistment in its defence forces, Renoir persuaded an old friend, who had been elevated to police commissioner under the new regime, to issue him with a pass that would get him through the lines and out to his mother's house in Louveçiennes where he spent the rest of the conflict painting the surrounding countryside as if nothing were happening. 'They were madmen,' he said somewhat ruefully, 'but they had about them the little flame that never dies.'

With peace restored, Renoir and his wife Camille moved into the outskirts of Montmartre where they stayed for over forty years – at one point with a studio in the Bâteau Lavoir, the disused laundry where Picasso would later work. Every weekend Renoir would climb to the summit of the Butte where one of the surviving windmills, the Moulin de la Galette, still stood. Far from milling flour for the little flat cakes after which it was named, the windmill and the area around it had long been transformed into a *ginguette*, an open-air bar, which in turn had evolved into a large dance area, outside under the

trees. Eventually a ballroom was built which, to judge by illustrations made over a number of years, was frequently enlarged and redecorated. Only in the really bad weather did the public choose to be inside – it was so good to sit out under the trees in the clean air above the crowded city. It would, however, be wrong to think of the Moulin de la Galette as a sort of bucolic picnic area. Its situation, right on the summit of the hill, made it the last bar before the precipitous descent into the alleys of the *maquis*. Visitors from the more sedate areas south of Montmartre would climb the steeply winding rue Lepic to the top but would hesitate to walk any further, lest they plunge into what was well known to be dangerous territory. Given its situation, the dance hall was not the sort of place the children of the bourgeoisie would choose to visit when out for a jolly time. A few adventurous souls might go in search of that hint of danger that came from being so close to the city's most infamous slums, but in the main the Moulin de la Galette was a genuine working-class haunt, the sort of place where those who had spent their week in grinding labour and who had only insalubrious lodgings to go back to, could forget for a moment the weariness of it all. The bar specialised in cheap mulled wine, the music was loud and fast, the men might be soldiers or street sweepers, the women drawn from the ranks of the city's underpaid milliners, laundresses, serving maids. Some came in the hope of a little affection, others perhaps to supplement their meagre earnings with a small present given in return for love. There were real prostitutes with their pimps but most were amateurs, driven by impossible wages to combine the need for pleasure with the need for food, possibly for the child with which she had been abandoned and which was now being looked after by a mother who was by then too worn out to think of climbing to the dance hall any more.

A photograph taken in 1890 shows a fairly imposing arched entrance set with fretwork and topped with wooden balls and spikes, like a Victorian gingerbread railway station – a pleasing image somewhat offset by the rather sleazy-looking bar to one side and the old windmill itself plastered with advertisements for liqueurs. Representations of the interior vary wildly – in some paintings we see a vast high-ceilinged assembly room, the sort of space you would expect in a grand hotel, in others, no more than a narrow claustrophobic cabin, more like a wooden hut. There is likewise little agreement as to the clientèle. In some engravings they are jolly folk, young bloods with their smiling fresh-faced girls out for a night of fun, in others their ages advance and the spirit is somewhat less carefree. For once the photographic record is little help in revealing just how sleazy or otherwise this notorious night-spot really was and this needs to be borne in mind when looking at

Renoir's *Dancing at the Moulin de la Galette, Montmartre,* which he paint-
ed in 1876, two years after the first Impressionist exhibition. What he shows,
are the wide open-air gardens filled with dancing couples, surrounded by
trees hung with lanterns. In the foreground a group of young friends have
gathered round a table to drink and talk, an enchanting evocation of a sunny
Sunday afternoon passed in good company, a carefree idyll on a par with the
artist's scenes of boating parties on the Seine, of hot, lazy summer days by
the river, those expressions of youthful charm that have nurtured a vision of
fin-de-siècle Paris, as a world of innocence, lost for ever with the outbreak
of the First World War and the brutal arrival of the modern age.

Renoir's Impressionist technique reinforces such a mood; its soft, fluid
colours add to the dreamlike quality, an effect imitated by countless photo-
graphers and film cameramen smearing Vaseline on their lenses to replicate
that sun-drenched, wine-hazy feel for fashion shoots and television com-
mercials. Not for Renoir the sad-eyed tarts and their hard-faced pimps, the
sallow butcher's boy with his ill-fitting jacket and his bad teeth, the old hag
who has drunk too much and who probably has not washed in a month.
Indeed, not for Renoir any of the real characters who regularly attended the
weekend dances – most of the people concentrated at the front of his paint-
ing were friends who had been persuaded to go with him, so that they could
take up the same positions over the several weekends that it took to finish so
large a work. They were used to it – Renoir often asked them to pose in the
large abandoned garden behind his house near the *moulin,* a house he had
chosen when the idea of the painting first came to him, a time recalled by
his friend, Georges Rivière, who remembered days

> . . . spent happily between the old lodging in the rue Cortot
> and the Moulin, where Renoir worked in the afternoons at his
> great canvas of the Ball. We carried this canvas from the rue
> Cortot to the Moulin every day because the picture was paint-
> ed entirely on the spot. This was not always very easy-going
> when there was a wind blowing and the big stretcher threat-
> ened to fly away like a kite above the Butte.

We can identify some of the friends in the painting, Rivière sitting with the
painter Henri Gervex at the table and a dancer called Estelle on a bench, but
this use of models makes the scene as artificially conceived and executed as
any academic work, with none of that spontaneity that was thought to be so
important to the Impressionists. Such a painting has less to do with realism
than with the old idealism, the notion that art should be a begetter of well-

being and joy, rather than the vehicle for portraying the truth about contemporary life that Baudelaire had proposed.

From this perspective Princeteau was more of a Realist than Renoir – his hunting scenes might exist within a sealed-off aristocratic enclave, but they represented what was there, not some parallel fantasy of what ought to be there. Of course Renoir and the other Impressionists had gone much further in their use of colour and light than Princeteau whose brighter palette and sketchy brush-strokes were due to the rapid way he worked rather than to any deep interest in luminosity. But to someone like Henri, the difference would not have seemed as great as it did to those students working in the ateliers of the grand masters of history painting, where dark tones and heavy shadows were the rule, and where Impressionism appeared a dangerous revolutionary force. To Henri, there was little incentive to rebel against someone who was quite so easy-going. Unlike the strict disciplinarians of the Ecole de Beaux-Arts or the little dictators who ruled over their private ateliers, insisting that their pupils mould themselves into the 'house' style by imitating the master's works, Princeteau saw nothing wrong in Henri trying out the styles of the other occupants of the Cité, some of whom were producing work quite different from his *animalier* interests and who, at a personal level, did not share the social milieu that Adèle assumed to be that of the entire block. Indeed, Henri had discovered that there was another friend of Alph's working in the Cité des Artistes, though not one that Adèle would ever have chosen as a tutor for her son.

Jean-Louis Forain was hardly the sort of man anyone would have associated with Alph. A character straight out of some scurrilous story of the Bohemian underworld, Forain was a working-class boy from Reims who had taught himself to paint by copying pictures in the Louvre after his family moved to Paris. True he had been spotted by Carpeaux, the most fashionable sculptor of the Second Empire, and offered free lessons, but Carpeaux was a drunk and for some unspecified reason threw the young man out, as did his parents, whereupon he became a vagrant, forced to live and sleep on the streets of the capital. All told, Forain had led a bizarre existence up to 1884 when he took a studio near Princeteau, an odd decision given his origins and the fact that he was never an *animalier* or a *peintre sportif*. He occasionally painted racecourses but it was the fashionable crowd that interested him rather than the splendid horseflesh, and even then he was as likely to offer a somewhat sarcastic view of the follies of the rich rather than a portrait of the *beau monde* in all its glory, an approach that reflects the two streams in his art.

Forain was both a cartoonist and a painter. In 1876 he began to publish the satirical drawings that by the 1890s had made him one of the most famous political commentators in France, a role that continued until his death in 1931. Today there are few equivalents of the once powerful political cartoonists who were accorded considerable space in nearly all the major European newspapers and magazines until the 1950s, making it difficult to recognise just how important a figure Forain was. In his day, he was often compared to Daumier whose mantle he was said to have inherited and while few now would elevate him to such a level, the comparison does pinpoint the tradition to which he belonged. Again, this can be traced back to Carle Vernet, who not only helped introduce the English sporting print into French art but was also responsible for transplanting English satirical drawing which, under the pen of a Rowlandson, a Gilray or a Hogarth, had been a biting, often vicious weapon against the powerful and the corrupt across the Channel. Vernet turned to caricature partially to earn money when the Revolution drove many of his patrons into exile, but also out of a deep loathing of the Terror during which one of his daughters was guillotined. Vernet's sharp, black-and-white caricatures of the outlandish clothes and dandyish manners of the young bucks of the *Directoire* and their overdressed ladies – the *Incroyables* – may have lacked the surgical qualities of the English originals, but they nevertheless brought to French illustration a new topicality, recognised by Baudelaire, when he praised Vernet in *The Painter of Modern Life* for having helped create an art of his own time, an art that demonstrated that 'particular beauty of circumstance and the sketch of manners' that the author so admired. However bland his elegantly witty drawings may seem now, Carle Vernet can at least take credit for launching a form of art that his one-time pupil Géricault would continue in the scathing political lithographs that were the principal preoccupation of the last years of his short life. Baudelaire had no doubts, and singled Vernet out at the opening of his essay on the French caricaturists as the founder of a genre that came to fruition with Honoré Daumier who elevated the cartoon to what Baudelaire acknowledged as a form of Realist art.

Daumier's political commitment was provoked by the *coup d'état* engineered by Louis Philippe and his cronies in 1830, a betrayal of democracy that drove many into outright opposition to what they saw as a corrupt, money-grubbing oligarchy. This was to be the golden age of French satirical drawing, made possible by the new medium of lithography that Géricault had already used and which now led to the publication of illustrated journals such as *La Caricature*, and the even more popular *Le Charivari*, which

heaped abuse on the pear-shaped King and the bourgeois society that grew equally fat under his shifty ethos. In an age especially rich in cartoonists Daumier surpassed them all – a lithograph like *The Legislative Paunch*, which shows the rising tiers of overfed ministers and deputies in the hemisphere of the National Assembly, is a brilliant visual conceit, with the rows of seats swelling out in a bloated parody of their self-satisfied occupants and thus of the subject itself. As Baudelaire pointed out, the thing that separated Daumier from the others was that you had only to remove his captions to leave a work of art standing by itself. And there was more than humour – when an uprising in eastern Paris, led by the Société des Droits de l'Homme, was brutally suppressed by the police, Daumier drew some of the inhabitants of a rooming house in the rue Transnonain, slaughtered during the bloody reprisals, in which the principal figure of a working man, spread-eagled on the floor of his room beside his dead child, was taken directly from one of the foreground corpses on *The Raft of the Medusa*.

Such openly fierce political criticism was not tolerated under the Second Empire but the tradition continued, more in the manner of Carle Vernet, by mocking the foibles of a society indifferent to the poverty that underpinned its flamboyant wealth. It was to this line of earthy social criticism that Forain belonged with his scenes of *La vie Parisienne*, the cafés, theatres and circuses, where those who lived well under the new Republic liked to gather, but also the world of brothels and seedy night-spots that were the hidden side of bourgeois life.

In Forain's case many of these underworld scenes were largely autobiographical. At one point in his youthful wanderings he had been taken in by the artist André Gill who introduced him to the poet Verlaine then in the throes of his wild, violent homosexual affair with the young, beautiful, and dangerous Arthur Rimbaud. Surprisingly, Forain, who would later be happily married and a father, moved in with the two, and seems for a short time to have transformed their relationship into a *ménage à trois* – Verlaine referred to Forain scatologically as his *petite chatte brune*, with Rimbaud as his *petite chatte blonde*. While one doubts that such details were vouchsafed to the young Lautrec, the air of louche glamour that clung to the irrepressible Forain would have made his art all the more appealing and it is easy to see how Forain's scenes of metropolitan life with their suggestions of sexual possibility – an old roué eyeing a young ballet dancer backstage at the opera, a couple making eye-contact at a ball – were bound to fascinate someone of Henri's age.

Less easy to understand is Forain's appeal to Henri's father, who, despite

Honoré Daumier: Rue Transnonain.

having so little in common with this one-time street-boy, seems genuinely to have admired his paintings, at one point paying his debts and accepting a portrait in return, a work to which Alph was passionately attached. That aside, it is hard to imagine that there was anything in Forain's other oil paintings that would have appealed to so unexpected a patron. When he first launched himself as an independent painter in 1872, after serving with the military during the siege of Paris, Forain quickly fell under the influence of Edgar Degas who introduced him to Manet and the others at the Nouvelles-Athènes, then the preferred café of the avant-garde artists living in or around Montmartre. Forain and Degas were to remain close until the older man's death in 1917 and it was due to his intervention that Forain was able to exhibit in four of the Impressionist group shows, even though his use of the new colour theories, and the surface effects of light and sunshine that we most associate with the Impressionists, was at best tenuous. What Forain did show was a total subservience to Degas' ideas which the older man must have found irresistibly flattering. They were not destined to be friends – Degas had considerable pretensions about his background and place in society as the offspring of a wealthy *haute-bourgeois* banking family, a view of himself that ought to have precluded any relationship with the louche-living Forain. But it could be argued that Degas, too, was hardly an Impressionist

and that his links to Manet and to an art based on the more abrasive side of city life were stronger than those with Renoir and his chocolate-box, party and picnic world. Where everyone smiles in a Renoir café, Degas gives us two silent characters, plodding towards oblivion in *The Absinthe Drinkers* of 1876. This, however, was quite mild when compared to other, secret works that Degas was making, works shown only to selected friends like Forain. When Henri first encountered Forain, Degas was just starting work on a series of fifty or so monotypes – each a single print pulled from an inked plate – that show scenes inside a brothel; claustrophobic, fairly crude images of not especially attractive women, flimsily covered or totally naked, lounging around on banquettes waiting to be picked out, often exposing or even playing with themselves and sometimes being ogled by a prospective client, a watching voyeuristic figure who could be Degas himself or ourselves, a spectator peeping in on this subfusc world.

Of course, Degas was not the first to tackle the subject of paid sex. His mentor, Manet, had made two outstanding images of apparently available women: first in *Olympia* where his favourite model, Victorine Meurent, reclines naked on her bed, staring insouciantly out at us as her black maid delivers a bouquet of flowers, presumably from another well-wisher; and a second image of Victorine posed in her underwear, powder-puff at the ready, playing the part of Nana, eponymous heroine of Zola's novel of the rise and fall of a courtesan during the Second Empire. But courtesans were precisely what those two painted ladies were meant to be, women who had amassed some money of their own and who could therefore choose their protectors, a role immortalised in *La Dame aux Camélias* whose heroine Marguerite is allowed to fall in love and to have a heart of gold, unlike the wretched shawl-wrapped streetwalkers, huddled in doorways in Montmartre, hoping for a sou from a quick trick in the dark. Degas at least avoids the more clichéd aspects of bought love, which was often glossed as a merry romp in the glittering crystal-lit salons of the capital, though he too stops short of exposing the *maisons de tolérance*, the licensed brothels, as the places of exploitation they clearly were. In some of the prints he appears to be taking much the same line as de Maupassant in his short stories, where the local brothel is a sort of jolly cat house, with saucy women who are inclined to jump into bed with each other or to cuddle up to the *madame* on her name-day, which was the substance and title of one of the monotypes. Like De Maupassant, Degas shows the humble, side-street *maison close*, the cheap, plain establishment with its *estaminet* on the ground floor, a first-floor salon where the choice of partner was made and the upper bedrooms for what was

often referred to as 'hygienic practices', a cheap solution for the increasing numbers of unattached males that were another by-product of the shift in population from village and town to city that so fractured nineteenth-century existence.

It is this double life of the brothel: the public world of the bar and the salon, the private world of the upper rooms, that Degas gives us in his prints – the contrast between the De Maupassant life of the salon, with its playful good-time girls, and the harsher scenes in private where a woman lies back, professionally exposing herself, a sex-worker going about her business. Both are valid assessments of aspects of brothel life, but it would be going too far to suggest that the series was meant as some sort of social criticism intended to improve the lot of those obliged to sell themselves in this way. Degas was no reformer. Snobbish and conservative, nationalistic in his political views, he would later assume an extreme patriotic standpoint over the crisis that would divide France in the 1890s. Above all there remains the secretive nature of the enterprise: he never exhibited the prints and thus consigned them to a minor, private role in his *oeuvre*. And yet, the story is more complex than that. The prints are not the only instance of Degas' interest in the subculture of bought sex; similar concerns can be detected in some of his public paintings of young women at work in the city: laundresses and milliners and the studies of young ballet dancers that are among his best-known pictures. To those who have derived much innocent pleasure from these apparently innocuous works, the idea that there is a link with the brothel prints will no doubt seem preposterous, until one accepts that they contain coded messages about a role forced on many women at that time. Rapid urbanisation and the consequent weakening of family and marriage ties, from the middle of the century on, had radically altered women's lives, throwing many into low-paid employment as shop assistants, waitresses, seamstresses, laundresses, hairdressers, domestic servants and milliners. Insecure and unprotected, with only limited education, many saw no alternative to accepting the advances of any man willing to offer them a 'present' for their services. At two to four francs a day, a Parisian milliner simply could not have survived without some form of additional income and a contemporary study of registered prostitutes reveals that 75 per cent of the *filles inscrites* had migrated from the provinces to Paris where they initially worked in drink shops, laundries and sewing studios until financial reality forced them to become full-time sex-workers. All of this would have been well enough known to anyone looking at a Degas painting of a millinery shop at the time. Likewise, the *ratons*, the young girls training to be ballet

dancers, whom Degas shows practising at the *barre* or slumped in repose, unsmiling figures, slaving to fulfil a dream of fame and liberation from the marginal world of their mothers, those seamstresses and laundresses, sometimes glimpsed in the background or waiting beside their daughters, dressed in a prim black bonnet and clutching a formidable handbag in an attempt to generate that air of bourgeois respectability which Degas and his contemporaries knew to be assumed rather than real. In effect, the ballet was a brothel by other means, and the men who hung around the opera house on ballet nights were as often found backstage in the rehearsal studios or corridors, rather than front-of-house engrossed by the performance. For the *ratons* and their ambitious mothers, a good marriage was the ultimate dream, though the reality was often little more than dinner, bed and a gift – albeit a much needed one. It was a duplicitous world that was brought out in *La Famille Cardinal*, the satire by Degas' boyhood friend the librettist Ludovic Halévy whose work on the Offenbach operettas such as *The Grande Duchesse de Gerolstein* had given him a unique insight into that amoral backstage world. Halévy asked Degas to illustrate the book, but backed away when he found himself included among the characters lurking in the wings with Madame Cardinal, looking uncomfortably like the waiting customer in the brothel prints which, as a friend of the artist, he would certainly have known.

Because Halévy rejected them, the *Cardinal* illustrations, like the brothel prints, might have remained part of Degas' obscure private world had not Forain been on hand to spread the word. In simple terms, the younger man took the scenes in the prints and transformed them into full-scale paintings – some are almost exact copies down to the inclusion of the watching customer waiting at the side. And because Forain had none of Degas' bourgeois pretensions, and was not averse to displaying them, he was able to offer the world Degas by proxy, a role he played most effectively in the case of the young man who now frequented his studio. That Degas was the greatest single influence on the mature work of Henri de Toulouse-Lautrec was obvious from the first and never denied by him, yet the two rarely met and over the years Degas showed little interest in this supposed disciple. The link was Forain, first through his own paintings based on Degas', but probably also because he may have had examples of the private works, borrowed from the master, on view in his studio.

In 1882, aged eighteen, Henri's awareness and understanding of such things would still have been fairly limited, but there are signs that the discovery of an artist like Forain, who happily combined painting and

Degas: *The Client*.

caricature and was thus both a fine artist and a commercial illustrator, reinforced his own tentative efforts to operate in both spheres. For despite his apparent acquiescence in his mother's vision of his future as a solid painter in the Academic mould, Henri had continued to make cartoons and caricatures, mainly for his own amusement, though occasionally with a broader, more public dimension.

Some of this can be seen in a collection of drawings made in September 1881 while Henri was staying on the Céleyran estate near Narbonne, where he witnessed his Uncle Amédée's attempts to save the family's vineyards which were severely infested with the phyloxera beetle. The only known method of defeating the pernicious pest was by drowning, and as Uncle Amédée's lands bordered the River Aude it was possible to undertake the hugely expensive task of dividing up the fields with dams and dykes then flooding the rows of vines for the period it took to kill the insects, in some cases as much as six weeks. Henri made a thorough record of the process in seventy-seven drawings over forty-eight sheets in an album which he entitled *Submersion*, part strip-cartoon, part visual history. Mostly centred around the tall, epicene figure of Amédée Tapié de Céleyran directing the operation, Henri himself occasionally appears as the recording artist, pen and pad at the ready. It is all there, from Amédée surveying the fields, to the arrival of the heavy machinery and the flooding itself, down to the final celebratory banquet offered to the tired but happy workers. While we have little in the way of social commentary – nothing about the effects of the collapsing vineyards on the lives of the poor, who are here little more than jolly bumpkins – we are nevertheless a long way from Princeteau's isolated, costumed world of hunting and racing.

It may be that Henri was trying to distance himself from the art he had been dutifully copying in Paris. It may also have added to a growing dissatisfaction with his limited ability to handle the human figure, which always took second place to horses in Princeteau's scale of values. Influenced by Forain as much as anyone, Henri was beginning to question the training he was receiving and to express his own views on how things might change. Things came to a head when he failed to pass the *baccalauréat* in time to gain entry to the Ecole des Beaux-Arts. It looked as if his mother's ideal plan for his future career was beginning to founder, at which point Henri took matters into his own hands. He went to see Henri Rachou, an old friend from Albi, who was studying under the fashionable portrait painter Léon Bonnat, a leading figure in the art establishment, who offered a traditional academic training, with its emphasis on drawing the human figure. Surprisingly,

Henri was not deterred by Rachou's descriptions of the rigid discipline enforced at Bonnat's atelier, though Adèle, when she first heard of this possible move, must have been unnerved. Whatever happened, Henri would no longer be within the familiar, enclosed world of the *animalier* painters and she was no doubt relieved when Princeteau supported the idea. At least Bonnat was known to take students of the right sort – Rachou was the son of a wealthy banker, thus assuring a connection with 'our world' and offering some hope that the worst effects of Paris and its strange new ideas might yet be resisted.

4

THE ODOUR OF REDHEADED WOMEN

Léon Bonnat did not accept just anyone, either as client or pupil. It took considerable influence for even the most fashionable woman to have her portrait painted by the great man and it was probably only his inherent snobbery and the name Toulouse-Lautrec that persuaded him to overcome his reservations about Henri's limited gifts. At their first encounter Bonnat cast a disdainful eye over a portrait of Henri's cousin Germaine and asked, 'Have you done any drawing?' This set the tone for what was to come – during the short period, a mere five and a half months, that Henri attended his studio, attempting to carry out Bonnat's instructions to the letter, he received little except the most acid criticism. Yet he clearly found the older man's sharpness a spur to greater effort, one he would miss when he moved to a studio where the criticism was far more easy-going.

Much of the opprobrium that is now attached to Bonnat's supposed ill-treatment of his young pupil, as well as the assumption that Henri must have gained nothing from it, and may even have resented it, comes from an ignorance of Bonnat's life and the exact nature of his art. It is usual to dismiss him as the academic artist *par excellence*, the ultra-fashionable portrait painter best remembered for grandiose images of Jules Ferry and Victor Hugo, a painter who terrorised the wives of the *nouveaux riches*, who were considered nobodies until he condescended to depict them as rigid as wax-works in their expensive gowns. But while there is no denying that Bonnat was a pillar of the artistic élite and a powerful player in the arena of state patronage, his own career had not followed the conventional progress, from studio to Ecole des Beaux-Arts through the Prix de Rome to the Salon, which he was supposed to be defending as a teacher. Indeed Bonnat had led a surprisingly unconventional life, leaving his native Bayonne at fifteen to join his father, a bookseller, in Madrid, where he taught himself art by copying the Spanish masters – Murillo, Velázquez, Ribera, Goya – in the city's galleries.

When he eventually went to Paris to study, he was still a devotee of the moody chiaroscuro effects of his earliest influences and at odds with the prevailing bright classical style favoured by the art establishment. For one who would later be the epitome of the official artist, Bonnat was considered an awkward misfit. He was passed over for the Prix de Rome, an essential step on the ladder to official recognition, but decided to travel to Italy on his own before visiting the Near East and Egypt with the orientalist painter Gérôme. He went back to France during the Franco-Prussian War to take part in the defence of Paris but fled during the Commune, an experience that seems to have awakened a previously dormant right-wing conservatism that stifled his earlier unorthodox attitudes. When he returned after the collapse he assumed the role of conventional 'master', violently opposed to artists such as the Impressionists who seemed to challenge his authority.

But here one needs to divorce what Bonnat said from what Bonnat did. During the five and a half months Henri was with him, the older man was working on his best-known canvas, a striking picture of the Old Testament character Job, naked, seated on the ground, arms outstretched and eyes raised to Heaven in supplication over his trials. That at least is what it claims to be yet to those less easily swayed by titles, the work is not so much a portrait of Job as a study in geriatrics. The authors Robert Rosenblum and H. W. Janson note how the artist so concentrated on 'every wrinkle, blood vessel, strand of white beard or inch of sagging, emaciated flesh' that what we actually see is 'the sheer physical fact of a specific and extraordinarily aged model striking a pose of lonely desperation (that) makes the biblical reference almost an afterthought, a theatrical charade . . .' Far from being the unwavering upholder of the French Academic tradition that is usually depicted, Bonnat was a hyper-realist, what today we would call a photo-realist, which was a pretty odd thing to be just as photography itself was getting into its stride. What is strangely disturbing about the art of Bonnat is how little art he chose to put in it. As that quotation makes clear, his portrait of a very old man is just that and nothing more, and to many students of Lautrec it has seemed obvious that someone used to the free-style work of Princeteau, and to the thrill of recreating lively outdoor scenes, would have found such a manner of working rather dull. Yet Henri seems to have been more than happy to follow where Bonnat led, willingly submitting to the supposedly dire regime of copying parts of bodies from engravings before progressing to plaster casts of Antique and Renaissance originals and only later to live, usually male, models in similar poses. Like every student in every atelier in Paris, Henri was expected to produce finished *académies*, formal studies of

the posed figure first in black-and-white, emphasising a strong command of proportion, perspective, light and shade, and later doing exactly the same thing in colour, and the fact that Henri plunged into this repetitious task with considerable enthusiasm, indicates that he had a clear vision of what he wanted from his studies and that this was to acquire the ability to render accurately the visible world. What he would eventually choose to do with such a skill was another matter, but at the time Bonnat's hyper-realism was something to be aimed for, not despised.

As most of these trial pieces were inevitably undated it is difficult to set them in order, but some show signs of development, even in the short time he was with Bonnat. An early drawing of Michelangelo's *David*, probably done from an engraving rather than a cast, is crude enough to merit the sort of scathing comments Bonnat is said to have directed at his new pupil's work. At one point he even declared that while Henri's painting was not bad – 'chic' was the word he rather crushingly chose – his drawing was 'downright atrocious'. Which was going too far, when some of the works that can accurately be attributed to his studio indicate considerable progress – the *David* was followed by a charcoal drawing of a cast of the *Belvedere Torso* which, though still somewhat awkward, is such an obvious advance on the first sketch that one might have expected the master to have melted a little. But no, the criticism remained as harsh as ever, even when Henri managed a competent *académie* based on Bonnat's *Job*. Père Cobb, the eldest of the sitters used by Bonnat and the one who had posed for the biblical character, was booked for a week every year and on that year's annual visit was drawn by Henri with perfectly respectable results. Well yes, he left the feet somewhat vague but the confident composition and the illusion of solidity is such an advance on the flat, ill-proportioned David that one can hardly avoid being impressed.

Other than Bonnat's disappointment with Henri's lack of aristocratic reserve – when not working he could be boisterous and liked joining in the rough-and-tumble of the studio – it is hard to see what it was that so irritated the older man, though size may have been part of it. Bonnat was short and wore raised shoes, and this may have prompted an enduring antipathy to the unfortunate newcomer.

At the time it hardly mattered. Henri liked being forced to work hard and in any case it ended abruptly that September when Bonnat announced that he had accepted a post at the Ecole des Beaux-Arts and would be closing the studio, taking only a few chosen students with him. Henri was not one of them.

Henri's decision to enter the studio of Fernand Cormon, a younger, more open figure, has been interpreted as a break for freedom after the constrictions imposed by Bonnat. The truth, however, is that Henri only went because his friends were going and later bemoaned the fact that the new teacher was less rigorous than the old.

With a lank strand of hair across a broad forehead, Cormon was described by Henri as the 'thinnest and ugliest man in Paris', but as with Bonnat, precisely rendering this complex man is not easy. His father had written scripts for the music halls and the son's decision to change his name from Fernand-Anne Piestre to the more anonymous Fernand Cormon, might have indicated a desire to shed his rather common origins in an attempt to rise within the artistic establishment, had he not been so indifferent to conventional behaviour. While it is true that in later life he attained a place on the Salon jury and a Beaux-Arts professorship, he did so while avoiding the usual route to fame through the production of conventional neo-classical history paintings and pompous society portraits. While Cormon was no revolutionary, his decision to make himself master of a curious self-invented genre, the fastidious representation of scenes from the dawn of history based on recent archaeological research, made him anything but a straightforward candidate for establishment honours. Despite the antiquity of his subjects, Cormon owed much to contemporary Montmartre – it was the sheer weight of bones found in the mines, which honeycombed the Butte, that had led Cuvier to reconstruct the first extinct mammals half a century earlier. But if one looks at Cormon's huge paintings today, it is clear that palaeontology and the new study of prehistory were less important to him than his own personal fantasies. For one thing his characters look more like the blond long-haired Gauls of late-nineteenth-century romance, the forebears of today's Asterix, than the crude primitive figures one might have expected. In some ways Cormon seems never to have quite escaped his roots in the theatre, which may account for the overwhelming popularity of *The Flight of Cain* when it was exhibited at the Salon in 1880, a success that led him to open his atelier to take in the pupils that Bonnat was discarding.

Although his new teacher was friendlier and more relaxed, Henri showed no inclination to return to the easy-going style he had used under Princeteau. The *académies* continued, progressing over the next two years from charcoal studies to full-blown paintings, and Henri's only complaints were about Cormon's gentle criticism when compared to the tongue-lashings he'd endured from Bonnat. Closer examination, however, reveals an increasing split in Henri's thinking. While at Cormon's he would do whatever he

was told, keen to acquire the ability to reproduce faithfully what was in front of him, which had been the basis of artistic training since the Renaissance, no matter how repetitive the task might seem. He was even willing to try out his new master's personal working method, a curious mix of art and amateur dramatics, in which Cormon would assemble a group of models and arrange them in a scene that represented the incident he wished to paint. Thus his *Return from a Bear Hunt in the Iron Age*, which was exhibited at the Salon of 1884, was recreated day after day in the studio over the long weeks needed to fill out so vast a canvas. The semi-clad models would be decked out with a few props from the piles of bric-à-brac stacked on the studio shelves – spears and swords, pelts and wigs – so that the room resembled some mad game of charades. One imagines that it could have looked pretty silly, but Henri was happy to try his hand at this sort of painted theatre and there are a few surviving sketches with very un-Lautrec-like titles – *Peuplade primitif* (Primitive tribe) and *Allégorie: Le printemps de la vie* (Allegory: The spring of life). What remains are only blotchy outlines, which is a shame, as one rather longs to see what someone so unsuited to such a task would have made had a third painting, *Scène Merovingienne* (Merovingian scene), been completed.

Art historians have tended to assume that this sort of overblown dramatic prehistory painting was all there was to Fernand Cormon. For despite his moment of glory as a Beaux-Arts professor, he was almost forgotten by 1924 when he was run over by a taxi outside his studio, and is barely remembered today save as the teacher of more illustrious pupils. But there was more to that not unkindly figure than his mammoth Neolithic fantasies suggest. Despite their artificiality, Cormon still insisted that studies made directly from nature were an essential preliminary to the final working up in the studio, and he urged Henri and the others to get out and about with their sketchbooks when the morning sessions indoors were over. Such encouragement was needed as there was a tendency among the students to simply go on practising the academic exercises that would help them get through the admissions procedure for the Ecole des Beaux-Arts – the goal towards which most of them were aimed. Normally, Henri and his friends would have lunch then go to one or other of their rented rooms where they would use each other as models, or hire a professional to pose if they had any money. This was, of course, no different from what they had been doing at the studio, hence Cormon's laudable attempts to get them to work on something different, though Henri seems to have been one of the few to heed the master's

Henri, seated foreground left, watches as Cormon demonstrates at the easel. Around 1883.

advice, probably because he always sketched out of doors and it was little hardship to continue doing so.

As before, most of this other work was done during holidays at home where he could get the servants and farmworkers, and any members of the family who happened to be around, to pose for him. With people he knew, his portraits were altogether different from the anonymous studio figures. There are several studies of an old friend Routy, a peasant boy on the Céleyran estate, who is sometimes shown idly whittling a stick or just staring back, placidly watching Henri at work. These gentle drawings and paintings have all the lazy feel of a hot summer's afternoon when the farm work was over and the two young men could get together in some quiet corner, and are closest in spirit and technique to the sort of Impressionist works that Henri was by then fully familiar with. Yet there are other works from this period which show he had not forgotten the other, harsher world that Forain had revealed. One painting, dated 1882, entitled *Céleyran, a Wagonful*, has an overburdened donkey waiting to be led away, while in the background two figures appear to be quarrelling. Similarly, there are a number of related drawings of the cart being pulled by the weary beast, which seem to use the same storytelling skills employed in series such as *Submersion*, and there are signs in some of the family portraits that the sharpness previously reserved for his caricatures was beginning to cross over into his paintings. There is a portrait of his mother, made in 1883, which seems to reflect this change of approach. Most of Henri's depictions of her are either in left profile or, if full-face, then looking down. It has been suggested that this may have arisen from his desire to disguise the fact, that can be glimpsed in some photographs, that Adèle had a cast in her right eye. However, in the 1883 picture he now seems to use this quirk to introduce a touch of satire that captures her character perfectly. Adèle is shown seated at a garden table at Le Bosc with a cup and saucer before her. As usual her eyes look down, giving her a meek, pensive expression that perfectly reveals the self-punishing, sacrificial role she had assumed over her son's life, the excessive concern she poured into her letters – so much so, that it is hard to doubt that Henri was using his art to point this out to her. Why else would he have chosen to mock that air of weary saintliness by putting a halo-like glow behind her head while making the table and the cup look not unlike an altar and chalice?

In her defence, it must be said that Adèle had by then some cause for concern. The simple act of taking a carriage alone from the Hôtel Pérey to Bonnat's studio in Montmartre on 17 April 1882, had been enough to trans-

form her son from an overprotected late teenager, into an independent young man, able to face up to a world in which she was not the dominant feature. Not that the difference between the elegant avenues around the Faubourg Saint-Honoré and the jumble of little alleyways surrounding the Impasse Hélène was as alarming as it sounds. Bonnat's studio was in the more gen-teel outer edge of the *quartier*, as one might expect from a man who would soon re-establish himself near the Champs-Elysées. The real Montmartre, the sleazy run-down labyrinth of decaying houses, lay further up and beyond the Butte, but for someone like Lautrec the difference between his mother's world and that first jumble of working-class apartment blocks and gaudy cafés must have seemed magical.

At Bonnat's, many of his fellow students were from south-west France and, no doubt forewarned by Rachou, Henri's first appearance among them passed without any awkwardness. He was spared the usually wild initiation ceremony inflicted on new boys – which sometimes involved being tied to a ladder and paraded round the neighbourhood before being dumped some-where for a moment of public humiliation. In Henri's case, this was reduced to some bawdy singing and a round of drinks. From then on, it was up to Henri to get himself accepted by his fellow students, which he did by a mix of high spirits and self-deprecating humour that quickly removed any embarrassment about his appearance. Within a short time he had made three of his best friends, each of whom would help him in his own way: Henri Rachou, who had been with Bonnat for a year and who would become his protector, a role he shared with Louis Anquetin, and Albert Grenier. Anquetin had entered the studio that same spring despite being three years older, and was quickly adopted by Henri as a sort of cleverer elder brother. Born in Normandy in 1861 Anquetin had been recognised even as a school-boy in Rouen to have a precocious talent for drawing and almost as soon as he arrived at the studio this was confirmed by Bonnat who, from the start, seems to have seen the young man as a potential successor. For Henri, Anquetin had everything. He was tall, good-looking and talented and seemed able to switch from style to style, trying out everything with a facil-ity that made his own hesitant efforts seem even more maladroit. Fortunately, not all these new friends were so awesomely gifted and the third, Albert Grenier also from Toulouse, was really something of a dilettante and thus rather relaxing company, a companion with whom Henri did not have to compete. Albert was fairly rich and only attended the atelier because he found it entertaining to be a student. He and his girlfriend Lily – always known as Lily Grenier as if they were married – turned their house into a

club for their fellow students, a place where they could all drink and relax together, a home in effect but one of choice rather than obligation.

All four – Lautrec, Rachou, Anquetin and Grenier – moved together to Cormon's atelier, first to a building near the Place Blanche and later to a new studio on the Boulevard de Clichy. Both buildings were on the front line between the scruffy romantic streets above and the respectable if dull streets further south. It was the new cafés and cabarets along the boulevard that attracted those hoping to experience a hint of the dangers known to lurk further up in the twisting lanes, to enjoy the idea of vice without risking the reality; and it was there, carefully protected by his new friends, that the young Lautrec began to enter that thrilling world he had heard so much about.

To one who had only ever eaten with his family, lunch with his fellow students after the morning life class was an especial pleasure, to which was soon added the thrill of having a drink when they had finished the afternoon's sketching. Of course he longed to have his own studio, but for the moment such a move was beyond him. He still relied totally on his mother for his finances and it was inconceivable that she would countenance such a complete break. And she was probably right – for behind a surface air of sophistication, enhanced by the sort of English dandyism he displayed in his well-made clothes and the brave way he tried to become part of the raucous sexual bragging in the studio, Henri was still rather naïve. It cannot have been easy when he realised that his new friends had casual relationships with the models that they hired in the neighbourhood and that, at eighteen, he was probably alone in still being a virgin. One of his fellow students, Charles-Edward Lucas, later claimed to have taken pity on him, introducing him to a young model called Marie Charlet who was said to be a nymphomaniac and thus less likely than most to be bothered by his unappealing exterior.

What little we know of Lautrec's more intimate relations comes from a book somewhat suspiciously entitled *Psychanalyse d'un peintre moderne, Henri de Toulouse-Lautrec* published in Paris in 1933, written by a professor, Emile Schaub-Koch. Doubts about the book are raised, perhaps unfairly, by its racy style – the book is really a series of tabloid revelations about Lautrec's love life interlarded with 'analysis' of his motives and reactions, which is odd as its author appears to have been an otherwise respectable art historian with a wide range of publications on subjects ranging from the philosophy of art criticism to Graeco-Latin Classicism. The date of publication, the early 1930s, means that he could have interviewed many of those who

A drawing by Caran d'Ache of an evening at the Chat Noir, 1886.

had known Lautrec, including some of the women involved, a fact which has meant that few writers on the artist have been entirely able to disregard this 'study', though there is an understandable tendency to pick out only those morsels that seem 'reasonable' to the researcher. On the subject of Marie Charlet, Schaub-Koch is quite alarmingly detailed; she had, he claims, lost her virginity to her drunken father with whom she had maintained an incestuous relationship until she was sixteen, whereupon she left home to live in a fifteen-sous-a-day room in the rue de l'École-de-Médecine where, inevitably, she became an artist's model. She was, so Schaub-Koch maintains, utterly debauched and was so content with the young Henri's physical performance that she nicknamed him the 'coat-hanger', an appellation that spread around the neighbourhood with the result that from then on he had little trouble finding women for sex – many, it seems, coming to him out of curiosity. That Schaub-Koch interviewed Charles-Edward Lucas, the man who claimed to have introduced the young Henri to Marie Charlet, indicates that there could be some truth in all this, including Lucas's claim that the poor girl had syphilis, which, given her lifestyle, was more than likely. But even if Lucas had lied about the introduction, something very similar must have happened – such presentations were commonplace at a time when many fathers took their sons to brothels to introduce them to sex. In Henri's case such visits were to become increasingly frequent – while at Cormon's he used a *maison de tolérance* at 2 rue de Steinkerque, later moving to a more classy establishment, the Perroquet Gris in the rue Colbert. It was in the brothels that he acquired his second and most enduring nickname, the 'coffee-pot', further proof that while his legs had stopped growing this was not a problem shared by other parts of his anatomy.

Evidence of his loss of virginity and his debut as a frequent visitor to the *maisons closes* can be found in a portrait painted in 1883 of a young woman seated sideways on a bed, dressed only in knee-length black stockings and high-heeled shoes, a conventional way of representing a *fille de joie*, implying that she has just undressed or is in the process of undressing for the person who is watching her. Of course one is bound to wonder whether this particular girl was Marie Charlet, though the shy expression Henri gave her, a finger rather childishly stuck in her mouth, is hardly the look one associates with the rapacious lover described by the pandering Lucas.

One thing is certain, however, whether or not she was a lover, the model for the painting came from a background quite different from that in which Henri de Toulouse-Lautrec had been raised. Until he joined Cormon's studio, Henri's world had been neatly divided between family and others of

similar ancestry and means on one side, and servants and farm labourers on the other. This split was leavened with a sprinkling of professional people, the local doctor, the priest and the schoolteacher, plus the occasional stray figure like Princeteau who did not quite fit any group. But with his move to Montmartre Henri began to encounter an urban population quite different from anything he had formerly known. At one end of the spectrum were those who had become rich through trade and speculation; below them were the reasonably well-off – professional people, doctors and schoolteachers and businessmen, small shopkeepers and restaurant owners, the solid bourgeoisie. Inevitably, they were less fascinating than those at the lower end of the financial scale: the city's manual workers struggling to keep their heads above water, and on downwards to those on the edge of destitution, and lower still the impoverished beggars and even the criminal element that was nowhere and everywhere, if rumours were to be believed. Henri had been observing such things since those early childhood visits to the city, but he had never before had direct contact with them. Now, his visits to brothels and bars made him part of their world and all the evidence is that he found this the most intriguing, most exciting thing that had ever happened to him. It was a fascination that would condition much that followed, as Henri increasingly organised his life to ensure that his participation in this new discovery was not compromised. In particular it began to influence the way he thought about art, ruling out any possibility that he might be interested in Bonnat's world of society portraits and character paintings or Cormon's prehistorical fantasies. As soon as he encountered it, Henri knew that the 'real' world of ordinary humanity was for him more intriguing than anything imagination could dream up. Many reasons have been given for this, though the most usual is the assertion that he relaxed among people who accepted his disabilities easily, that he had found people with too many problems of their own to be much fussed about anyone else's and who were in any case more likely to be compassionate if the matter did arise. While there is no doubt some truth in this, one shouldn't rule out two other, somewhat contradictory elements. On the one hand there seems to have been a degree of anthropology about Henri's interest in the urban poor – they were a mysterious tribe, whose customs and culture seemed wildly exotic when compared to his own. On the other hand, Henri was quite simply sympathetic to the people he encountered – when they drank and danced and were happy, he was happy too, when they suffered and were miserable, he felt for them.

Henri was soon joined on his brothel escapades by fellow student Maurice Guibert, the son of a wealthy family with a private estate within the city's limits, who, like Grenier, was only studying art for fun and company. Just as he had been with his cousins, Henri was soon the leader of their little group, deciding where they should go and often what they should drink, a thing that was already becoming a central part of his life.

It was probably only after they had moved to Cormon's that the group began to explore Montmartre's more interesting cafés, though which these were needs a little care as many of the bars and cabarets that we most associate with Montmartre, and by extension with Lautrec himself, were not open when he first became a student. In 1993 the Société des Amis du Vieux Montmartre published a list of over a hundred cabarets that flourished in their area in the last quarter of the nineteenth century, but many of these were short-lived, opened after Lautrec's time or simply replaced earlier ones that had been on the same site. Back in 1882, when Lautrec first started to visit such places, their numbers were surprisingly limited. There were still those long-established drinking places that the Impressionists had frequented in the days before they came to public attention: Le Guerbois, first discovered by Manet in 1866 but abandoned in the mid-1870s when the group chose the Nouvelle-Athènes as their preferred meeting place. The cabarets, those cafés where some sort of performance took place, were yet to establish themselves as one of the major attractions of the area and most surprising is the paucity of dance halls – surely the most typically Montmartrois of all entertainments. Some way along the Boulevard Rochechouart, near what was about to become the grand staircase leading up to the new basilica, the old Elysée-Montmartre had survived its transformation as a revolutionary club and balloon factory under the Commune, and was just beginning to attract customers from the better districts in search of that atmosphere of danger the area was supposed to possess. Despite Montmartre's reputation for wild dancing, at that time, there were only two dance halls patronised primarily by local people – the Moulin de la Galette, painted by Renoir, and still offering a cheap night out to young working-class men and women, and La Reine Blanche near Cormon's studio. This had once been the haunt of artists and their mistresses but was by then somewhat run down and would shortly be replaced by the most famous night-spot in Paris as Montmartre began transforming itself from a place of cheap lodgings and artists' studios into the main centre for music and entertainment in the capital, if not the world.

It is not difficult to trace the history of this transformation as the new bars and cabarets tended to spread, one from another, becoming larger and

more adventurous as the decade progressed. It was said to have begun with a landlord called Laplace, since credited as 'the father of picturesque Montmartre' – a dubious distinction at best – who opened La Grande Pinte on the corner of the rue Lallier and the avenue Trudaine in 1878. At the time the place was unique in sporting mock-medieval decoration with stained-glass windows on the outside and an interior plush salon with wooden tables and long benches covered in Utrecht velvet. It was a style that quickly spread and when Laplace's bar became the preferred meeting place for many of the area's artists and writers, it set the tone for much that was to follow. La Grande Pinte failed because Laplace was an inveterate gambler and a poor businessman and by 1890 a new owner, Gabriel Salis, had reopened the place as L'Ane Rouge, the Red Ass, a reference to his own red hair. The place survived its owner's suicide, but by that time his brother, Rudolph Salis, had opened a rival, which was soon to become the most important of all the cabarets and the one that for nearly a decade eclipsed all others.

Rudolph Salis had begun as a painter and at the beginning of the decade he rented the old post office at 84 Boulevard Rochechouart close to the Elysée-Montmartre, intending to use it as a studio. Sensing that his chances as an artist were slim, and seeing the initial success of La Grande Pinte, he offered his main room to a group of poets and singers, who called themselves the Hydropathes because they claimed to have an aversion to drinking water, as a place where they could stage performances of their work. In 1881 the post office was transformed into a bar/cabaret in the style Laplace had initiated. There was an outer room, open to the general public, done up in that same mock Louis XIII style with tapestries and an open country fireplace with columns and a sloping chimney. The place was cluttered with bric-à-brac and Salis himself liked to dress up as a musketeer, bowing low as he greeted his clients with fairly light insults, just enough to amuse without giving offence. Three or four steps led up to a rear room, dubbed the *Institut* after that venerable seat of knowledge, which was open to selected guests and those who worked on the journal that Salis now spearheaded to feature the work of those who performed in his cabaret. He named his new establishment Le Chat Noir, some said because of the black cat in the Edgar Allan Poe tale, others because he had simply found such a creature on the premises one night. But whatever the origins of the name, his club was to become famous both for the art it sponsored and the illustrious clientèle it attracted. But it is important to remember that there were two versions of the club – as its popularity grew Salis acquired his neighbour's premises but even that enlarged space could not contain all those eager to see what had rapidly

become an entertainment phenomenon, so in 1885 he decided to move to larger premises, further south, just below the Place Pigalle. It is this second Chat Noir that is most usually referred to in accounts of the period, for it was by then much more organised, with highly professional performances that were patronised by a surprising number of the great and famous, including on one notorious occasion the Prince of Wales, greeted by Salis with a cry of: 'And how's that mother of yours?'

However, it is the earlier period on the Boulevard Rochechouart that is of most interest here, for this had been a more open, amateur and mostly spontaneous affair, with local poets and musicians performing their work. At the same time the *Chat Noir* magazine was in the hands of a brilliant group of illustrators that included Willette, Caran d'Ache, Steinlen and Henri Rivière, artists who were the inheritors of the Vernet–Daumier tradition which they adapted to the new technologies that were revolutionising printing and print-making, all of which were to be of crucial importance to the later work of Toulouse-Lautrec.

We can imagine the reactions of the somewhat awestruck Henri, at eighteen, being taken to Le Chat Noir for the first time, presumably by the more worldly Anquetin and Rachou. First came the flamboyant greeting of Salis himself, a striking figure whether or not he was dressed as a cavalier in knee-breeches and plumed hat. Being mere students, the young men would have been waved to a table in the outer room, cluttered with bric-à-brac and dense with smoke, where they would have hugged their drinks and waited for the show to begin. From there they could watch the grander figures being ushered into the *Institut* by waiters dressed as members of the Academy and hired by Salis because each bore an uncanny resemblance to some leading politician or other celebrity. The clientele was nothing if not mixed, from the grandest of the grand like Victor Hugo in the *Institut* to scurrilous characters like Verlaine, who probably shared the outer room with Lautrec and his friends. Salis was everywhere, greeting newcomers, putting down hecklers with a joke. Unlike the rivals who would later try to imitate his success, he never stooped to outright rudeness and, in those early days, Madame Salis looked after the bar and was known to be quietly generous with food and drink to those of little means. At about half past nine, Salis would call for order and begin presenting those who had given notice that they wished to perform. 'Mesdames and Messieurs,' he would call out, 'our excellent friend, this good poet, will now give us a few verses.' If encouragement were needed, there might be a second cry of: 'My lords, pay attention, it is the mouth of genius that speaks.' Salis's own genius was not to let any particular liter-

ary or musical movement dominate his club, though it was certainly the progressive elements that created the unique atmosphere, with poets like Maria Krysinska, who was said to have invented free verse, and composers like Claude Debussy and later Eric Satie ('Esoteric Satie' as one fellow member would dub him) who were transforming French music in the aftermath of the Wagnerian revolution.

The poets may have begun it but music quickly came to dominate the performances, with a number of regular accompanists on hand to play the piano for visiting singers, among them the diminutive Albert Tinchant, who appears on the right-hand panel for La Goulue's booth, hands poised over the keys, his tiny frame in a sort of seizure as he pounds out a tune. A curious figure, a philosopher and poet as well as a pianist, Tinchant acted as editorial secretary to the *Chat Noir* journal, though why he of all the musicians who played at the club should have been singled out by Lautrec is not clear. It may have been his epic drinking – he would be dead by 1889 – which would certainly have been noticed by Henri who was just beginning to savour the release that strong spirits such as absinthe could offer. Perhaps it was just Tinchant's eccentric reputation that appealed – it was said that he never left the confines of Montmartre and yet he could still tell you the winner of every horse-race anyone had ever heard of, anywhere – the sort of bizarre accomplishment that would surely have fixed him in the young man's memory.

But however widely Salis cast his net, allowing almost anyone a chance to perform, it soon became apparent that his cabaret was taking on a distinctly political edge, both in verse and song. In the early days the preferred songs were sentimental ballads like 'Le Fiacre', first launched at Le Chat Noir before passing out into the world at large and still popular in France today, but it was the gradual evolution of the *chanson réaliste*, the lyrical equivalent of Zola's novels or the new naturalist painting, that gave Salis's club its position at the centre of radical politics. These earthy songs dredged up their subjects from the dark side of the Butte: the cheap streetwalker, wrapped in a shawl, selling herself for a sou, the aged worker left without shelter who was the hero of one Chat Noir song that pointed out how the architects had managed to dig niches in stones to shelter 'a heap of saints' (a reference to the despised Sacré Coeur) while the poor old workman had no home to go to. With such songs, hard satire began to predominate and before long the word *chatnoiresque*, meaning jokey and irreverent while at the same time topical and cutting, entered the language. Even that song sung by the homeless workman ended with a touch of bitter *chatnoiresque*

humour with the line, 'at least I haven't any rent to pay'. But such humour was serious in intent and clearly anarchist in spirit and in that regard Le Chat Noir and its singers were pointedly in tune with the times.

The opening of Le Chat Noir, and indeed Lautrec's passage into manhood as a student at the opening of the 1880s, coincided with the first stirrings of revolutionary activity in France since the collapse of the Commune and the political vacuum left in its wake. Throughout the 1870s, various anarchist groups had slowly been won round to the idea that only through extreme acts of violence, the Propaganda of the Deed, could the oppressed be stimulated into overcoming what was seen as the crushing tyranny of a repressive right-wing regime. To these men, the advent of the first truly Republican government had changed nothing, now it was time to act. Initially it was outside Paris, especially in and around Lyon, that the movement was strongest, while the first rumblings of discontent in the capital were neatly subverted by the prefect of police, Louis Andrieux, who infiltrated anarchist cells to the point where he was able to finance the movement's first journal, *La Révolution sociale*, the more easily to identify its contributors. But in the end, such subversion only succeeded in provoking the revolutionaries far more than their own theorists had done, and it was not long before Paris experienced the first atrocities.

It began in 1881 when an unemployed weaver, Emile Florian, walked from Reims to Paris with the intention of shooting the radical politician Léon Gambetta but having failed to get anywhere near, simply shot the first bourgeois he encountered, a doctor as it turned out. It was just the sort of random act guaranteed to horrify the wealthier classes, who were already unnerved by rumours of the dynamite that would be used to cause explosions here, there and everywhere. And such fears seemed to be borne out a year later when the workers in the mining town of Monceau-les-Mines organised themselves into a secret group known as the Black Band, which proceeded to threaten company managers and government officials before destroying a small amount of church property. The police were certainly not inactive but the subsequent trial of sixty-five prominent anarchists, including Peter Kropotkin, and the stiff prison sentences that followed, only served to convince a now thoroughly rattled public that there was far more going on than the authorities had been able to unmask. Indeed, 1882 was a dire year for the wealthy. It opened with the disastrous collapse of the country's leading investment bank, the Union Générale, and closed with the ignominious death of Gambetta, not from an assassin's bullet but from a self-inflicted wound caused when he was cleaning his own revolver, an accident compli-

cated by appendicitis which proved inoperable due to the majestic size of his well-fed belly. Little wonder that many believed history was repeating itself when in March 1883 a demonstration by a group of unemployed workers, led by none other than the old *Communarde* Louise Michel, turned into a riot that ended with the pillaging of a baker's shop. In fact it was pretty small stuff, but such was the political atmosphere that when she was tried and sentenced to an astonishing six years' solitary confinement, public opinion was so split on the issue that the government was forced to back down and pardon her.

The most extraordinary thing about all these events was that while they terrified the *bon bourgeois*, they failed to harm the anarchist movement in the eyes of liberal intellectuals. On the contrary, as the decade progressed and as the anarchists' Propaganda of the Deed intensified, more and more writers, artists and others came to identify with a theory that a decade earlier had almost slipped into oblivion. It was this spirit of revolt, born of an inchoate sympathy for the poor and the unfortunate, that lay behind the often savage humour of the Chat Noir cabaret and its journal, and which drew to it the young, politically committed intellectuals who were at the first stages of their careers in the arts or in journalism and who would dominate the cultural life of France well into the next century. All of them were eager to be published no matter how, no matter where, and would willingly review books and exhibitions for nothing in the hope that their own work – novels, stories, poems – might also find a place. It was hard to make this breakthrough, especially when a journal like *Le Chat Noir* was taken up with pieces by the original Hydropathes or the art of the illustrators who had come to the club from its first days. For the younger men there was no alternative but to launch their own publication, a common enough practice in a decade that saw literary magazines appearing in staggering numbers, most barely surviving beyond a few issues. They nearly all followed a set formula, publishing one or two articles by a reasonably well-known name, followed by reviews written by the organisers along with some of their own fiction. The finances of these ventures were inevitably precarious, with no one beyond the star-names expecting to be paid, though that was hardly the point and was certainly no discouragement to the group of younger men who had come together at Le Chat Noir and who decided in 1883 to launch their own effort under the title the *Libre revue*. A group they may have been, but there was one dominant personality who in effect ran the operation, a young man called Félix Fénéon, who had come to Paris only two years earlier but who was already a regular and highly noticeable character at the club.

It was impossible to ignore Fénéon. His cool, elegant 'look' was an essential part of a self-created image of himself as someone slightly apart from the garrulous, untidy literary types that were the mainstay of Salis's audience. In an age when only male waiters and actors were clean-shaven, the wispy goatee, dropping from under the otherwise bare chin, like a youthful Uncle Sam, was an openly provocative gesture on the part of one who had to earn his living as a civil servant in the War Ministry, an institution not known for harbouring eccentrics. Fénéon, like Lautrec, was a dandy who chose his clothes with considerable care, a pose intended to identify him as one of Baudelaire's *flâneurs*, those well-dressed men-about-town, set to savour the pleasures of modern life that the poet had extolled. Occasionally, the reality was a little more prosaic, such as when Fénéon had to suffer a court order restraining his salary because his account with his boot-maker had not been settled for some time. Only later would Lautrec capture that memorably etiolated face and wispy goatee in no more than a couple of rapid, sinuous brush-strokes of ink on paper but given the remarkable appearance that each offered to the world, they must at least have noticed one another in those early days at Le Chat Noir.

In addition to his flamboyant appearance, Fénéon was also the most committed anarchist among the young group at the club. He was determined to be a novelist of note and a figure of substance on the literary scene, which no doubt explains his desire to attract attention to himself. But no one should doubt the sincerity of his beliefs which were constantly recharged by the sight of the poor and destitute on his frequent, long, night-time walks around the city. What alienated Fénéon, and others like him, from the growing groups of Marxists in the various socialist and communist organisations that were manoeuvring for support among the workers, was his refusal to countenance any form of control over his thinking, a total libertarian viewpoint that he identified with the bohemianism of the modern artist which refused to be restrained by dogma of any sort and which was thus naturally anarchistic.

It was not until the 1890s, when the first openly anarchist journals were published, that such views appeared in print, but from the first, Fénéon's opinions were apparent in the philosophy that underpinned his literary and artistic criticism. Once he abandoned his attempts to be a novelist, Fénéon remade himself as the most prescient commentator on the art and writing of his day, as well as the only figure in the curious saga of French anarchism who combined in his own person the Propaganda of the Word and that of the Deed.

Paul Signac: *Against the Enamel of a Background Rhythmic with Measures and Angles, Tones and Hues, the Portrait of M. Félix Fénéon in 1890, Opus 217.*

Even those who knew him well were never able to say what it was in his background that had created his unusual personality. His father had been a modestly successful travelling salesman, peddling his wares in northern Italy where he fell in love with a young Swiss woman, marrying her in Turin just four months before the boy was born in June 1861. Back in France, his education began at the prestigious Ecole Normale Spéciale at Cluny, in Burgundy, paid for by an uncle until funds ran out, whereupon he was transferred to the local lycée in Mâcon. Fortunately, this did not affect his scholastic progress – he won several prizes and was one of the few to pass the *baccalauréat*, and while there was no money for further studies this at least allowed him to sit the civil service examinations and find a junior post in the War Ministry in Paris.

None of this accounts for his passion for literature and his later fixation on the visual arts, nor indeed does it explain anything of his belief in anarchist politics. While schools at that time were fiercely disciplined and illiberal, that seems hardly sufficient to have stimulated his radical sentiments.

The fact that the disasters of the Franco-Prussian War began when he was nine may well have done something to incline his thoughts towards the rejection of official politics and nationalist sentiments. But, overall, we know little of his early life beyond that vague outline and despite his subsequent status as the pivotal figure in several literary and artistic movements over a long life, Fénéon himself has not been the subject of much critical study. His only biography was written by an American, Joan Ungersma Halperin in 1988, a work of exemplary thoroughness that is inevitably the source of much of the material found here. Halperin speculates that it may have been Fénéon's resourceful Swiss mother who imbued him with some of her own independent spirit but that it was his experience of the Commune, news of whose violent downfall filtered through to his provincial outpost, that filled the ten-year-old boy with horror and pity for the workers slaughtered during Mac-Mahon's bloody repression. Fénéon witnessed the Republic of the Dukes through the eyes of an increasingly sceptical and rebellious teenager. He loathed the religion that was crammed down his throat at school and determined to fight back once he had gained his freedom. A brief period as a journalist in Mâcon was followed by military service, which he escaped by successfully sitting the civil service examinations and entering the War Ministry as a junior clerk, where he carried out his duties with surprising fastidiousness – a front which allowed him to seal off his working life from the new world of gallery-going and literary *soirées* that occupied his free time.

It was at this point that he transformed his personal appearance into the living art work that would be his trademark for the rest of his life, keeping his short military haircut and growing that highly noticeable goatee. He can only have confused his superiors in the ministry – on the one hand a weird-looking oddball, on the other a perfect employee who was soon indispensable to the military recruitment division where he would pass thirteen years of his life, a remarkable post for an out-and-out anarchist. He was not, however, entirely alone. The ministry also harboured two aspiring young poets who introduced him to the literary groups they had managed to penetrate. The art galleries he found for himself, going without lunch in order to visit the exhibitions in the rue Lafitte, quickly discovering the Impressionists, urged on by Zola's art criticism, just the sort of writing he longed to undertake himself, as soon as he had found some unknown artists of his own. Upon his arrival in Paris, he began his search for new talent to promote, along with attempts to write the great novel, and the long late-night strolls around the darkened city that he loved to make, all of which

ensured that in his early twenties Fénéon barely slept.

Like most of his contemporaries, the aspiring author was willing to write for anything that would publish him, sending articles to short-lived anarchist journals and obscure literary reviews. Halperin calculates that in the twelve years from 1883, Fénéon contributed to more than twenty-one different publications, though often under a pseudonym, perhaps to protect his War Ministry post though it may also have been from some sort of latent, if contradictory, aversion to that frantic search for self-publicity that aspiring writers like himself were obliged to undertake. But despite these successes Fénéon was well aware that only a journal of his own would allow him the freedom to publish what he wanted and when the *Libre revue* came into being in the latter half of 1883, Fénéon did all he could to ensure that he had a dominant role in editing the publication. His first task was to persuade some of Le Chat Noir's better-known customers such as Verlaine to contribute, while Fénéon himself wrote reviews and oversaw the sub-editing, printing and distribution of the finished product. The magazine duly appeared that October, but Fénéon's overall plan of using it as a launchpad for his own fictional creations was not to be. Despite working hard and long on two stories and a novel, he was gradually forced to admit that he had little talent for creative writing and that his true vocation lay in criticism and editing, though even there he needed time to mature. It is something of a relief to learn that a man who would eventually be considered an unsurpassed judge of literary and artistic merit, began with such faltering steps. His first attempt at art criticism in the *Libre revue* hardly displayed the witty and incisive prose style that was to make him one of the most imitated literary journalists of his time. Having chosen to write about the *Exhibition nationale des Beaux-Arts*, one of the duller points on the cultural calendar, he proceeded to use the same pompous phrases that were then the prescribed critical manner, at one point describing a painting of Andromeda by Jean-Jacques Henner as 'an enthusiastic hymn to the splendour of form'.

Fortunately that sort of cliché-ridden, imprecise waffle did not last. The following year, he abandoned the *Libre revue* for *La Revue indépendante*, which he founded and edited over the next twelve months with the financial backing of an old schoolfriend. Completely in charge at last, Fénéon was able to develop the precise, spare, ironic style that allowed him to communicate the ideas and sensations of a new world of writing and painting that was just beginning to appear and for which those earlier orotund mannerisms were totally inadequate. And all this from someone aged only twenty-three.

As the new year, 1884, opened, Henri, although nineteen, was still not free of his mother's protective embrace. Three years after their move to Paris their relationship was increasingly tense. He still dined with her every evening, slipping away later to rendezvous with friends at places like Le Chat Noir, one attraction of which was the fact that Adèle would have been mortified had she known where he was going. Indeed, he had no sooner begun studying under Bonnat than Uncle Odon had written to grandmother Gabrielle to complain that Henri was spending his life 'in a neighbourhood not often frequented by people of our world'. Back in 1882, this was excessively critical. At the time, Henri still lived at the Pérey and ate with Adèle and when he did rent his first studio it was near his old school and still close to her, and even then only used in the afternoons. For a time he sublet another artist's studio but again this was not in the areas that he knew would upset his family. Although he tried to disguise his visits to the bars and cabarets of the Butte, they seem to have guessed that something was going on and it was only a matter of time before his activities were exposed. Travelling between the Pérey and Cormon's atelier and his own studio and then back to the Pérey for dinner, and back again to Montmartre for the evening, was time-wasting and exhausting for one who was far from strong. In January 1884 he eased the situation by renting a studio of his own in the rue Lepic, finally entering that forbidden territory. True he still slept at the Pérey and dined with Adèle, but she must have suspected that this was the first move in her son's bid for independence – and she was right, though the final move would only come after a series of bitter disappointments had opened a rift between Henri and his family.

That February he learned that his cousin Madeleine, for whom he had created the *Cahiers des Zig-Zags*, had died despite the years of special treatments that had caused her so much pain. One can imagine his feelings, though as Adèle noted, he tried to keep them to himself. The death of one whose sufferings so clearly mirrored his own was bound to induce some reflection on his own situation at a time when he was due to decide how best to continue his studies. After three years of patient application to the rigid rules of formal art education, it was time to consider the way ahead though, as before, his path was unclear. Was he to simply emulate someone like Princeteau by setting himself up as a fashionable painter of horses and hunts, a role to which destiny seemed to have called him, or was he to act out his mother's dreams of higher things – a place at the Ecole des Beaux-Arts, followed by the Prix de Rome and success at the Salon, until he could rise like Bonnat to membership of the *Institut* and all the other glories of the

official system? Or was there something else, a way not laid down by either tradition?

For the moment, the official route seemed overwhelmingly attractive – that year's Salon opened on 1 May and everyone he knew seemed to have triumphed. Princeteau won a prize and Cormon's monster canvas that Henri had watched him create, the *Return from a Bear Hunt in the Stone Age*, was that year's popular success, and was immediately purchased for the nation. Some of Cormon's students, including Henri's friend Rachou, also won prizes, confirming the impression that this was the route to success. At the same time, Henri's attachment to the solid, dependable official art world was confirmed when Cormon chose him to be one of the students who would work with him on a substantial commission to provide illustrations for a luxurious edition of Victor Hugo's *La Légende des siècles*, the four-book cycle of poems that had already provided the inspiration for Cormon's famous painting of the Flight of Cain. Several well-known artists had been invited to contribute to the project and everyone, including Adèle, considered it a great honour that someone like Henri, at so early a stage in his career, should be asked to take part.

She was less pleased when she realised where this success was leading, for while she was out of Paris that summer, Henri quietly left the Pérey and moved in with his friends the Greniers in Montmartre. It was meant as a temporary arrangement that would save him the bother of travelling back to the hotel while his mother was away, but the outcome was never really in doubt – Henri de Toulouse-Lautrec had moved to Montmartre and there he would stay.

The Greniers' block, at 19 bis rue Fontaine, was another *cité des artistes* though it was far more varied than the one Princeteau shared with his *animalier* friends. Degas had an apartment on the fourth floor and a studio at street level, though this new proximity seems not to have brought him and Henri any closer together. Part of Degas' antipathy was probably due to his insecurity about his own place in society – his family had been grain speculators during the food shortages after the Revolution and this was followed by a period as money-changers before they moved into banking, profiting from the get-rich-quick ethos promoted by Louis Philippe and Napoleon III. At some point they tried to burnish this rather dubious image with a touch of aristocratic grandeur by splitting their name to de Gas, but they were unable to keep up the pretence. By 1876 the bank had failed and the family was beginning to disintegrate and Edgar decided to drop the particule and revert to the original Degas, leaving him distinctly touchy on the subject of

his background. Confronted by someone like Henri, whom he assumed to be the genuine article, this edginess was bound to cause problems.

But though they rarely met, to be near someone whose work he admired so much, reinforced those elements in Henri's life that were drawing him away from the world of Cormon and Princeteau. Despite the success of the atelier at that year's Salon, there were other voices, Anquetin's in particular, that spoke of experiment and change. Much to Henri's delight, Anquetin had been dabbling with Impressionism and whenever Cormon was absent, he and the other students spent much of their time discussing these new developments. The studio was particularly aroused that spring of 1884, when the painter Pierre Puvis de Chavannes won the medal of honour at the Salon for a classical allegory entitled *Le Bois sacré cher aux arts et aux muses* (The sacred grove, beloved of the arts and the muses), a huge painting, a mural in effect, that proved hugely popular with the general public, a complete reversal for the sixty-year-old artist whose earlier work, *The Prodigal Son*, had been greeted with scorn. What needled Henri and his friends was the difficulty they had in situating this stubborn, solitary figure. On the one hand, he was the last of the Classical masters working in a flat, non-Realist manner, using faint pastel colours that seemed to refer back to the Italian Primitives but which also had hints of the blocks of pure colour found in the newly fashionable Japanese prints, which in a confusing way seemed to make Puvis even more avant garde than the Impressionists. But it was less this puzzling technique than his subjects that most aroused his young critics. To the students at Cormon's, it was the message inherent in the allegory of the sacred grove that irritated them. What Puvis shows is an open space with an Ionic portico at its centre around which are ranged figures personifying the arts and the muses who converse or sit in silent contemplation. To Henri and his friends, Puvis's figures seemed to represent the timelessness of art, its divorce from the crude business of everyday living, and if so, a direct challenge to the sort of new ideas they admired, ideas which extolled the virtue of being as contemporary as possible. With this in mind, it was decided that they should make their own version of the sacred grove, but one that reflected these more radical sentiments.

The *parodie*, as such adapted copies were called, was a common enough genre by then, usually made as a homage to the original, in the way that Manet had shown his admiration for Velázquez's reclining *Venus* in his modern *Olympia*. But in the case of the Puvis *parodie*, the intention seems to have been part satire and part sneaking admiration for one who continued to follow his own line no matter how solitary or abstruse it might be. The

work was done over two days with several students painting different sections under Henri's leadership. The overall setting, the glade and the portico, remain pretty faithful to the original but the tranquil atmosphere is shattered by the arrival of a band of revellers that includes Anquetin in check overalls and other friends pointedly in modern dress, along with a policeman in uniform and the diminutive bow-legged figure of Henri, who rather rudely turns his back on the figure representing Painting, in order to have a piss. Far from being a tranquil affair, art is here presented as a difficult, precarious business, intimately bound up with the noisy, messy reality of everyday living – a message reinforced by the addition of a clock-face to the portico, its hands at five past nine probably to indicate that the work was completed on the ninth of May but certainly to show that the task was part of the here and the now.

Henri alone signed the *parodie*, an act of bravado that marked a further break with the official academic ethos that Cormon, for all his quirkiness, still represented. This might have been no more than a touch of student rebelliousness, the sort of thing that usually dies away when the real business of life intervenes, had it not been for a serious setback some time in the autumn, when Henri learned that his contribution for Hugo's *La légende des siècles*, had been rejected by the publishers. This ought not to have surprised him: his spidery line drawings create an ethereal, moody atmosphere that suggests he was more concerned with conveying his own emotional reactions to Hugo's verses than in providing illustrations to illuminate the text. In any case his style was so idiosyncratic that his drawings could never have fitted in with the lush, romantic imagery provided by the other artists. But despite all this, he was depressed by his rejection which put an end to any hopes that he could become a book illustrator after only a short period of training.

His mother was sympathetic, though her letters reveal that much of her regret was reserved for herself, over the way her life had been disrupted when he was working on the illustrations, now to no avail. By contrast, Alph was growing increasingly unsympathetic to the direction his son's work was taking. Above all, he was determined that such unpredictable art should in no way be associated with the family name and to this end he insisted that Henri exercise discretion when signing his drawings and paintings. To pacify him, Henri began using the pseudonym 'H. T. L. Montfa', though he disliked doing so and made his distress clear in a cartoon of himself seated on a chamber-pot under which he wrote the English word 'LOST', a play on Toulouse pronounced as the English 'To lose'. This exercise in word-play was to prove eerily prophetic when later that year he learned that his father had

115

The parody of Puvis de Chavanne's *Bois Sacré,* 1884.

sold the Château du Bosc to his sister, Henri's aunt, Alix. The deal had been done nearly two years before but had been kept secret from him, though he ought to have suspected something when his grandmother lent Adèle the money to buy a home of her own, the Château de Malromé near Bordeaux. But he hadn't and was consequently very distressed when he realised that his father had effectively disinherited him by selling off the family home, thus making it abundantly clear that, in his eyes at least, his crippled son would never really be the Comte de Toulouse-Lautrec-Montfa. All this was further exacerbated that autumn when his maternal grandmother Louise, who had not been in good health, decided to sell off the estate at Céleyran, his other childhood refuge. His sense that his past was being taken away from him

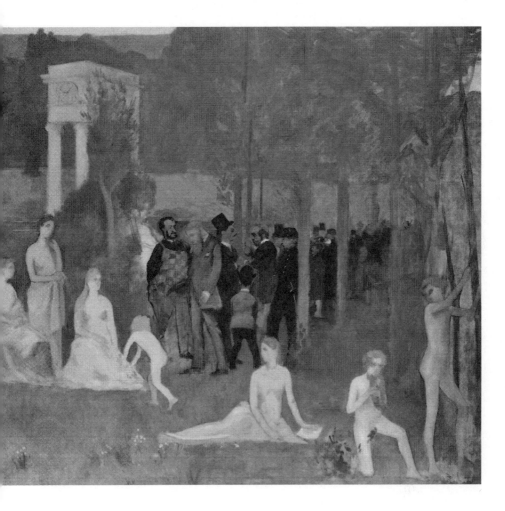

was now complete and though he spent that summer with Adèle at Malromé, she remained behind when he returned to Paris and the Greniers for his third year with Cormon. He was twenty years old and free at last, though how that liberty would reveal itself in his art was still unclear.

There can be little doubt that Henri was in love with Lily Grenier and that she was happy to encourage him. A big woman, bordering on the plump, she had a handsome presence that made her much sought-after when she worked as an artist's model, posing for such worthies as Napoleon III's cousin the Princess Mathilde Bonaparte. Despite being alienated from her family when she formed her irregular liaison with Albert, Lily had money of her own, with two country houses in Villiers-sur-Morin, where she liked to gather her admirers around her. Yet all this was less important to Henri than her

red hair for, as he freely admitted, he was addicted to what he claimed was the unique sensual odour of red-headed women.

Most biographers have assumed that their relationship was platonic, that her marriage to Albert made her a safe companion who could be adored without any risk of rejection, that Henri had a beautiful companion with whom he could occasionally appear in public. For her part, Lily, who loved to be surrounded by worshipping males, had a devoted puppydog who was never less than amusing. This was somewhat undermined when it was discovered that the Greniers had kept a secret cache of thirty pornographic drawings made by Lautrec, one of which shows him being fellated by Lily. This hardly constitutes irrefutable evidence of a three-way relationship and the drawing may be no more than a masturbatory fantasy on the part of the artist, but whatever went on in private, in public they played out their roles of goddess and acolyte to an extent that convinced some that there was more going on. Henri loved the way she was seductive and motherly by turns, taking his arm to guide him across the street. She would pose for him when asked, though she always showed her proudest, most dominating side. He dubbed her *Lili la Rosse*, a play on her red hair and a slang word for an old horse that had come to mean someone tough and bitchy.

It wasn't so much life with the Greniers, as night-life with them. Evenings at Le Chat Noir, then up the Butte to the Moulin de la Galette or along the Boulevard de Rochechouart, to the only other dance hall, the Elysée-Montmartre. After Henri moved in with them, there was a sudden fashion for masked balls, which they loved – an extension of their passion for dressing up that for Henri was a continuation of the life he had known with his father, though Henri and Albert were so often in women's clothes it is hardly going too far to consider that there was at least a hint of transvestism in all this. They loved being photographed in costume, and there are numerous posed tableaux showing Henri as a gypsy dancer, as Carmen, an Arab muezzin, a choirboy and in full fig as a Mikado, a sign of the interest in Japanese art that had spread among the city's artists and students. Three years on he would paint Lily in a full Japanese robe, her hair astray, that haughty imperious look firmly in place, a look that had already appeared in one of the first new paintings that he made since his break for freedom, a nude which he entitled *La Grosse Maria*, Big Maria. While this is supposedly the portrait of a prostitute that he hired at the Pigalle models' market, it looks not unlike a naked version of Lily in her Japanese outfit and might well be a mix of the hired model with remembered elements of his friend.

More telling than any speculation about the subject is the manner in

which *La Grosse Maria* was painted. Instead of his usual light, Princeteauesque strokes, Henri used a dark range of colours and a striking full-frontal pose, a take-it-or-leave-it earthiness which suggests that he was seeking to emulate the current fashion for 'dark realism', which was trying to bring to painting some of the crudeness found in recent novels and cabaret music. A Japanese mask hanging on the wall behind the figure further suggests the current obsession with Japanese pottery and prints, and there is some hint of Impressionist influence in the use of pure colours rather than dark shades for the shadows.

Normally, students did this sort of experimental work away from the schools and studios, where the old rules still applied, but Cormon was relatively easy-going and could persuade himself that even *La Grosse Maria* was just a somewhat *outré* version of the usual academic nude. It was this openness that kept Lautrec at Cormon's at a time when he had little more to learn from him – that and the use of the model and the ability to associate with

Dressing up: Henri in Jane Avril's hat, coat and feather boa.

other young artists, all keen to try new ideas. Anquetin was still their leader in artistic matters and was by then openly Impressionist, pushing Cormon to a point where he could no longer disguise his irritation with the scribbles of light-coloured paint that seemed to be spreading everywhere. And Anquetin was no longer alone. The previous year a young man had joined the studio who was proving even more audacious. A mere sixteen, Emile Bernard was the son of a textile merchant in the northern city of Lille, who had been brought to Paris for his health, though when it came to art he showed no sign of any physical weakness, combining energy with a passion for the new. At first this had fascinated Cormon but he quickly came to regret taking on one so young and reckless. Bernard would try anything, starting with Impressionism then joining Anquetin in a search for something completely new. Like many others in the studios across Paris, they were less concerned with what they painted than with the effect it would have. They noted how the Impressionists achieved fame by provoking the critics and the gallery-going public and in 1886 this lesson was reinforced when a twenty-eight-year-old painter, whom few had ever heard of, became the most talked-about artist in the city.

A Sunday Afternoon on the Island of the Grande Jatte, exhibited at the eighth Impressionist exhibition, confirmed the young Georges Seurat as the first artist to break away from Impressionism. Seurat's technique was even more audacious than the bright flecks of colour used by Monet and Renoir. In fact, Seurat had already come to the attention of the few interested in avant-garde art two years earlier when he had shown his *Bathers at Asnières*, a formal arrangement of stiffly-posed working-class figures enjoying their day off on the banks of the Seine. This attracted furious criticism and bemused admiration in equal measure, due mainly to Seurat's use of the technique of optical colour mixing whereby tiny strokes of pure colour – say yellow and blue – seen at a distance, became 'mixed' in the spectator's eye – in this case as green. This had been the basis of the Impressionist revolution but they had used it instinctively. With Seurat it became a rigid application of a scientific formula, taken to extremes in the *Grande Jatte*, which showed a group of better-off characters parading in their Sunday best on the opposite bank of the river, the canvas covered in countless, even tinier dots of pure colour applied with fanatical exactitude. It was a style that satisfied neither side of the artistic divide, antagonising both the Academics and the Impressionists, who had wanted to achieve a naturalness that they believed would come from painting spontaneously out of doors – Seurat's art might be as brightly coloured as an Impressionist scene but it was also as frozen

and hieratical as an Egyptian tomb-painting. Yet despite these contradic-
tions, or rather because of them, that one painting attracted more attention
than the rest of the exhibition put together. And it didn't end there. Fénéon,
who longed to be the new Zola, a literary figure leading a revolution in
painting, had been waiting for someone like Seurat to appear and having
found him, set about promoting his new style as the legitimate successor to
the Impressionist revolution.

The promotion of avant-garde art by the anarchist press had been started
by the man who, if it were not tautological, could be called the leader of the
French anarchists, Jean Grave, a one-time shoemaker – a trade curiously given
to nurturing anarchists – turned indefatigable propagandist. Grave had been
in exile in Geneva where he edited *Le Révolté* but in 1883 he transferred to
Paris, renaming his journal *La Révolte* a slightly more urgent designation.
From then on, the centre of anarchist activity moved from Lyons to Paris
where other publications were launched, many of them allied to one or other
of the newer artistic and literary movements. The close link between radical
styles in painting and writing and anarchist politics was now established. On
one hand the other-worldly idealism of the artists, on the other the politi-
cians with their raucous calls for bloodshed and chaos as reflected in the
names of the anarchist cells that were now set up: the Paris Panther, the
Bordeaux Hatred, and by the charming little ditty written by Marie
Constant, another anarchist shoemaker, who urged her fellow believers to
listen out for the stronger music of dynamite.

In 1887 Grave added a literary supplement to his journal and began a
regular series of articles on art. Naturally these were highly critical of move-
ments such as Art for Art's Sake and full of praise for the teachings of the
English Arts and Crafts Movement and its leader William Morris. At one
point Grave especially singled out a then little known author from across the
Channel, Oscar Wilde, lauding his remark that 'art is the supreme manifes-
tation of individualism', though his greatest praise was reserved for the
Belgian poet Emile Verhaeren whose poems dwelt on the ruin of rural life
and the rise of a murderous urbanism, verses which a critic in *La Révolte*
described as nothing less than 'art and great art'.

Clearly this newly formed union of avant-garde art and radical politics
was highly congenial to someone like Felix Fénéon. Since 1884, his *Revue
indépendante* had combined anarchist politics with avant-garde literary
interests, though it was sometimes difficult to make a direct connection
between the two. While many writers and artists were content to describe
themselves as anarchists, few included any direct political elements in their

work, other than rather generalised depictions of the poor. To Fénéon, however, art and politics were a single cause and from the start of his career as editor and critic he was on the look-out for a cultural movement that would embody this ideal.

His chance came in 1886 when a young poet, Jean Moréas, published what he called the 'Symbolist Manifesto' in *Le Figaro*, giving a popular impetus to a movement that had until then been loose and unco-ordinated. Fénéon had been aware of the growing movement before Moréas' article and indeed would have learned little more from the poet's defence other than to discern that the new writers wanted suggestion rather than description, preferred the irrational to the literal and considered the outer appearance of things of less importance than their inner meanings. In any case, Fénéon was already aware that the true leader of the new movement was an obscure middle-aged poet named Stéphane Mallarmé who had translated *The Raven* by the American author Edgar Allan Poe, whose macabre tales were much admired by adherents of the new school. Surprisingly, Mallarmé was neither a leading literary editor nor an influential academic, only a simple teacher of English who had moved from a provincial school to the Lycée Condorcet just before Henri left

Mallarmé's role was played out at his *Mardis*, the Tuesday-evening soirées when the disciples gathered at his small apartment in the rue de Rome to hear the master expound on a literary topic that had caught his fancy. Fénéon was soon a regular attender, happy to make whatever magazine he was working on the house journal for the movement. It began at the *Revue indépendante* where he published work by Mallarmé, Moréas and Verhaeren, and even Verlaine who had been deftly appropriated by the new school. Fénéon's labours were prodigious – commissioning articles, chasing them up, editing and processing the finished magazine, all the while holding down his full-time civil service job while struggling to take care of his elderly parents in a tiny apartment on a meagre salary. By the time he agreed to write for *La Vogue* in 1886, his art criticism had progressed beyond the days when he reviewed the anecdotal painters of the Salon in such glowing, overwritten terms. Since then he had educated his eyes and pared down his writing to the sharp, incisive language that could echo the 'feel' of the work under review, and when he began to promote Seurat, he placed himself at the forefront of progressive criticism as an interpreter of the latest and the most outrageous for the small but influential audience that read his magazine.

Why Fénéon chose his artists is not always obvious given that some were not known to be advocates of his particular political creed. Seurat was

noticeably neutral when it came to the specifics of political theory and while some have seen signs of a deeper social message in some of his work, nothing Seurat said supports such a view. It is just about possible to see his two large scenes besides the Seine as a diptych with the workers on one bank in the first picture and the bourgeoisie on the other in the second. But what this might mean is hard to say and in any case it hardly mattered to Fénéon, who admired the artist's radical style, seeing it as a direct challenge to the artistic establishment – rather than in terms of any supposed message his subjects might have. Seurat may have parted company with Impressionism but his Sunday sunbathers, whichever bank they are on, are little different from Renoir's happy revellers in the gardens of the Moulin de la Galette. But even if this fell far short of Courbet's ideal of a committed art conveyed through a radical style, Seurat, as interpreted by Fénéon, was at the outer edge of the avant-garde and until his untimely death in 1891, this symbiosis between artist and critic made *La Vogue* the leading anarcho-literary-artistic 'little-magazine' with an influence that reached way beyond Paris. It even crossed the Channel and found its way into the hands of a few avant-garde folk in London, a cosmopolitan set who sensed that it was in Paris that the arts were now being transformed and who needed just such a guide as Fénéon to help them make sense of all the confusing notions that seemed to flower and die before anyone could recognise their existence. And Fénéon was much more than just an editor, tidying up the contributions and handling the printers. Writers and artists were beginning to rely on his judgement, knowing he could always be found late at night working on the journal after his day at the Ministry was over, always willing to listen to a new idea or comment on a work in progress. It was what he was made for and now that he had abandoned his earlier idea of becoming a creative writer himself, he revelled in it. He might never be a novelist or a poet, but he was determined to be the greatest editor and critic of an age of creative ferment.

Thanks in part to Fénéon's advocacy, Seurat had achieved a *succès de scandale*, bitterly attacked by critics and academic artists but a hero to students around the capital. To them, the message was clear – first get yourself a new, preferably outrageous style, then promote it with as much noise and opposition as you can provoke – and if possible, get someone like Fénéon on your side. In ateliers and garrets across the city, the search was on for some manner of painting that would stir up the same sort of fuss. Gauguin wondered if religious imagery or primitive idols might do it; at Cormon's the group gathered round Anquetin and Bernard toyed with Japan. What could possi-

bly be as shocking as those myriad dots of paint? Well, maybe the exact opposite – flat areas of colour with no brush-strokes at all, the sort of thing seen on a Japanese print. One can almost hear the sigh of relief as these young men realised there was still something outrageous enough to get them noticed.

The previous generation of artists, painters like Manet and Whistler, had been influenced by the High art of the Edo period, through the pottery, lacquerware and furniture that had been exhibited at the various universal exhibitions. But this influence had been more a question of image than technique – a model posed in a kimono, holding a fan or surrounded by screens and vases, symbols of discrimination and taste. Only recently had appreciation begun to grow for the brightly coloured posters that had initially arrived as wrapping paper for the pottery shipped mainly to Holland. At first these had provided cheap decorations for student flats and artists' studios but by the 1880s some had begun to look more carefully at the scenes of everyday life that could be seen in the prints: the porters carrying their loads along the Endo Road, the glimpse inside a sparsely furnished room where a woman combs her hair, peasants knee-deep in flooded fields on which rain falls in rigid lines, all offered with an apparently cartoon-like simplicity that was clearly the result of a complex set of graphic techniques quite different from anything practised in Western art. As artists began to study how printmakers like Hokusai and Hiroshige achieved these effects, some began to filter into Western art. For Anquetin and his friends it was the use of flat areas of pure colour that appealed, the absence of all detail that still permitted an astonishing degree of realism. What the prints revealed was that shading and brushwork were not essential and once this idea took hold it was obvious that there were other, Western, art forms that seemed to relate to this bold aesthetic: stained-glass windows with their hard contours and bright panes, medieval woodcuts with sharp unfussy outlines, enamel jewellery with strict metal borders filled with solid, bold colours. Eventually they would develop this into a fully-fledged style in which areas of pure colour were separated by solid black edges but in those early days it was all quite tentative. Anquetin and Bernard attempted a hotchpotch of ideas – a bit of Impressionism, a bit of Seurat intertwined with the first sightings of flat 'Japanese' colour.

Henri was fascinated but not entirely convinced by Anquetin's approach, largely because his interest in Japanese art was more profound than most of his contemporaries. While Anquetin and Bernard were mainly interested in the flat look of the prints, Henri was intrigued by the unusual angles that

The Reading by Theo van Rysselberghe, 1903. Emile Verhaeren, seated, reciting his poetry, Félix Fénéon standing centre beside André Gide, seated with his hand on his forehead.

Japanese artists used – scenes looked down on from above, streets shooting away to the side of the picture, the space dissected by the branch of a tree or crossed by a bridge. More extraordinary was the shocking technique of 'cropping' a figure, which might be cut in half by the edge of the picture as if disappearing into the void, a conceit virtually unknown in the Renaissance tradition where every painting was arranged like a view from a window or through the proscenium arch of a theatre, straight on with one fixed viewpoint. In the West, perspective had become everything, with a single focal point towards which all lines converged. One consequence of this was that the primary action of a painting or drawing nearly always took place in the foreground with everything else smaller and less significant as the picture receded to a distant nothing. What was amazing to the few like Henri who really studied the Japanese prints, was the way these extraordinary artists simply ignored this presumably unbreakable rule, preferring a form of layering in which the picture space was split into bands with nearer objects larger in the bottom layer, furthest objects smaller in the top but with the

main action taking place somewhere around the centre. This allowed the work to be viewed from almost any angle, with the eye roaming over the surface much as it does in real life, constantly flickering from thing to thing, never static. And the result, far from the solid fixed scene of most Western painting, was an impression of movement and activity, the very things that Henri via Princeteau had always wanted to achieve.

What stopped Henri from committing himself to a particular school or theory was a natural wariness about joining any group that might try to tell him what to do. Like many an ambitious revolutionary, Anquetin was happy to bolster his own role as leader by surrounding himself with a tight circle of admirers, but Henri was just too anarchistic to play such a game. Perhaps as a defence, he deliberately chose his friends from those in the studio who were less concerned with artistic success and more with having a good time in the bars and cabarets of Montmartre, those like Albert Grenier who didn't take things too seriously. This jovial circle included another student from the Languedoc, François Gauzi, who had been introduced to Cormon by Rachou and who would later write an invaluable account of Henri's life and work; and the three Albert brothers – Adolphe, a future printmaker, Joseph, a somewhat conservative artist who liked to dress in formal city clothes rather than the more 'conventional' velvet jacket most art students wore, and a third brother outside the studio, another Henri, who was a literary journalist and translator. But it would be the unwitting actions of their teacher, Cormon, more than these happy-go-lucky companions that ensured that Henri de Toulouse-Lautrec would go his own way, rather than follow any theory laid down by others.

Only someone as tolerant as Cormon would have put up with the experiments going on whenever Anquetin and the others thought he wasn't looking, but in 1886 he finally snapped and expelled Bernard for painting bright colours on the usually sombre backdrop that was hung behind the model. Undaunted, the young man left for a long walking tour in Brittany where he met Gauguin who was also casting about from some piece of artistic territory to colonise and happy to hear the news from Paris. Back at Cormon's the atmosphere was tense and when the master closed the studio for the summer he could only hope that a long break would help clear the air and that things would settle down after the holidays. Unfortunately for him, when he reopened he only added to the manic atmosphere by agreeing to admit the thirty-three-year-old Vincent van Gogh who had moved to Paris to be with his brother, the art dealer Théo. Vincent had turned to painting after a failed attempt to become a Christian missionary in the Belgian coalfields, an expe-

rience that had precipitated his slow descent into the mental illness that would lead to his suicide five years later. When he arrived at the studio in the autumn of 1886 he was already teetering on the brink of emotional collapse, enervated by the excitement of Paris, obsessed with wild enthusiasms, swinging between delirious happiness and sudden, uncontrollable rage.

Poor Cormon, he was clearly losing control. Despite his strictures, the experiments continued and even the exiled Bernard dropped by from time to time to see how things were progressing. But for Henri, the arrival of Van Gogh was to prove an unexpected blessing, reinforcing his opposition to the general line the other 'progressives' were adopting. However revolutionary Anquetin's technique might be his subjects remained entirely conventional, the same street scenes and river views common to the Impressionists and all the others who now considered themselves 'painters of modern life'. The problem for Henri was that this was an art without meaning or commitment, an art of surface and abstraction more concerned with surprising effects than with what they conveyed. To him, the subject of a painting was as important as how it was rendered and in this he found an unlikely ally in the newly arrived Van Gogh. As Henri soon learned, this strange wild-eyed, redheaded figure had come to art out of a burning need to depict the sufferings of the wretched Belgian miners. When his religious convictions were shattered by the terrible reality of the grim conditions that they and their sick and hungry families were forced to endure, he had turned to drawing as a means of acknowledging their pain. Van Gogh's earliest sketches show the men shuffling to the pit-head for the interminable sessions in the cramped and dangerous galleries way below the earth; others show them hauling sacks of slag from the grim pit-heads that dotted the polluted countryside. Later, back in his native Holland, the still searching artist had painted the peasant farmers labouring in the fields or, in his first masterpiece, gathered in a hovel for the meagre evening meal of potatoes eaten under a flickering oil-lamp.

A later friend of Henri's, Thadée Natanson, another early biographer, was much taken with the unexpected sympathy that grew up between the unlikely friends, much of it based on Henri's growing interest in a world that was only now becoming apparent to him, one which Van Gogh had experienced first hand:

> He was most intriguing on the subject of Holland and particularly the life he led among the miners, a life it took him a long time to give up. Vincent van Gogh would explain the soul of a miner and the souls of the poor and the aposto-

late which almost caused him to give up painting. This religious conviction, which was to outlive his faith, and the special way he spoke of Jesus – he pronounced it Yessouss – seem to have awakened in Lautrec distant echoes of a yearning he might have felt back in Albigeois.

Lautrec was equally attentive to everything van Gogh showed him. It was in the eighties. He would take a deep breath, then look and listen. Every time his horizon broadened, he would clap his hands.

Liberated, or rather overexcited by the freedom of Paris, Van Gogh lightened his palette before heading south to that apotheosis of swirling, intense colour most associated with his name, but back in 1886 in Cormon's studio there were still traces of the committed political artist he had originally intended to be. For Henri, the past two and a half years at Cormon's had been an intense period of absorption of the new ideas that were circulating in the city. Most were purely technical, from Seurat's dots to Anquetin's flat colours, and it had taken time and determination for him to survive with his own idea of what art should be. In this, Van Gogh appeared at the right time to bolster Henri's conviction that art must be more than just a question of aesthetics, that what really mattered was commitment to an ideal. If he was not going to create Stone Age tableaux or be a fashionable painter of horses then he would have to find some other place to set up his easel, a place where all the different ideas that had crowded in on him over the past three years could find expression. Fortunately there had already been some signs that such a thing was possible and its source was Le Chat Noir where Henri had discovered a stocky, handsome, foul-mouthed character, a master of the *chanson-realiste* by the name of Aristide Bruant. Henri sat happily through Bruant's act night after night after night, listening to gritty ballads that ignored the idealised world of brightly-lit dance halls and sun-dappled boating parties so beloved of Henri's colleagues. Bruant's lyrics dragged his listeners down the seedy back-streets and into the scruffy hovels of the Butte, places Henri had glimpsed in passing but never dared explore.

'Between ourselves,' Bruant sang, 'I think the upper classes/might take the trouble to see what passes/on the streets.' Which, as he looked round for some role of his own, was increasingly Henri's view of things.

5

WHAT PASSES ON THE STREETS

The old Montmartre began to change in June 1885 when, with customary flamboyance, Rudolph Salis organised a noisy procession to move his cabaret from the Boulevard de Rochechouart to larger premises in the rue Laval (later the rue Victor-Massé). Since opening Le Chat Noir, he had been bothered by young roughnecks turning up drunk and causing trouble. The previous December a violent quarrel had broken out when he tried to turn away a particularly offensive character. Salis had picked up a chair to defend himself, accidentally striking one of his young waiters, killing him. The scandal and the subsequent court case, though he was acquitted, convinced the usually jovial proprietor that it was time to find more decorous premises.

Modelled on the recent massive State funeral for one of Salis's old customers, Victor Hugo, an event attended by a good part of the population of Paris, the procession set off at midnight on 10 June. Everyone was encouraged to carry a piece of the old club, a chair or a picture, and to follow behind the band of drums, fifes and violins, all led by Salis himself dressed in the uniform of a provincial prefect, accompanied by two waiters in the full regalia of the Papal Swiss Guard.

The rue Laval, though only just south of the Place Pigalle, was outside the hinterland between crime and respectability that co-existed uneasily at the foot of the Butte. Salis had moved into a more settled world of regular apartment blocks and neat small shops, though his new neighbours can only have seen this in reverse as they watched the louche life of Montmartre suddenly invade their previously calm backwater, marching to the tune of Olivier Netra's 'La Polka des Volontaires'. One doubts they were pleased, less so when the move proved a huge success and the *tout Paris* flocked to see this new, wild attraction. Salis had, in effect, succeeded in transforming an

amusement for writers and artists into a scene of mass entertainment, a change that was to have a profound effect on nearby Montmartre and its inhabitants.

Meanwhile, the old premises at 84 Boulevard de Rochechouart were taken over by one of Salis's performers, Aristide Bruant, who was to become even more popular than his former boss. Where Salis attempted to amuse and flatter his audience, Bruant insulted them, crudely and loudly, which, of course, was why they turned up, suffering his bad, overpriced beer, for the curious pleasure of watching this stocky, handsome character belting out filthy tales of the dispossessed and the criminal underworld, interspersed with choruses of 'The customers are pigs'.

When Salis first took him on, in 1883, aged thirty-two, Bruant's crudeness and vulgarity had brought him instant notoriety, but it was his radical, political attitudes that firmly established him as the leading Realist singer of the day, not least because his listeners could sense that the sentiments he expressed were the result of first-hand experience of the underworld of deprivation and misery that he so violently evoked. What had begun as a quiet country childhood in Courtenay near Orléans had been transformed by his father's drinking into a descending spiral of poverty and instability. At first the young Aristide had been given a good education by the local priest, who had taught him Latin and trained him to sing plainsong, a musical form that can be traced in his later ballads, as can the influence of the local folksongs which the young boy performed from an early age. But the father's decision to move to Paris, when his son was only ten, shattered that peaceful idyll. Pursued by his creditors, the elder Bruant was constantly on the move, transporting his family around the worst areas of the city, slipping from cheap lodgings to hovel to slum, ever downwards. The boy's limited education proved useful when he was apprenticed to a notary, but even that was taken away when another hasty move sent them to a worse part of the city and Aristide into a low-paid job with a jeweller. The Franco-Prussian War saved him. Setting off on his own as a sniper, the young man was eventually enrolled in the regular army where he served until the defeat, an experience which left him with a tenacious patriotic streak that seems strangely at odds with his revolutionary sentiments. In fact many of the supporters of the Commune believed that they were the true patriots, fighting on against the enemy without and within. For Bruant, there were the poor and there was France and he saw no contradiction: the enemy were the rich who had sold out the nation. As one of his songs put it:

A nous la gloire et fortune
Massacrons les bidards
Et faisons la Commune
Des lettres et des arts!

Ours is the fortune and the glory
Slaughter the bloated rich
Set up the Commune
Of letters and arts!

Out in the country, where he had been forced to return when the army was disbanded, Bruant could only watch the Commune's rise and fall from a distance, but after the collapse he returned to Paris to work on the railways, a job that again sent him moving around run-down working-class districts where the poverty and despair were, if anything, worse than before the conflict.

Still a passionate amateur singer, Bruant began to spend his evenings in bars where there was music, the café-concerts, where anyone could get up and sing until they were shouted down, and where many professional performers began their careers. For Bruant it was a two-way process – he sang his country folk-songs but at the same time he began noting down the rich street language, the *argot* of the city's underclass, the slangy, funny speech used by tarts and thieves and policemen. They provided material he could use when he started to create his own songs, the realistic ballads that he was soon performing at dance halls and concerts. His break came after a successful audition for the *Concert de l'Epoque* near the Bastille, an ideal spot given the revolutionary nature of his lyrics. His success brought him to the attention of Salis who recognised his talent and agreed to let him sing at Le Chat Noir, unpaid, but with the right to sell sheet-music of his songs to the audience, an arrangement that was to prove advantageous for both men.

Bruant was no fool. Despite the interruptions he had had a good basic education and would one day prove a competent author, writing his own memoirs and even a dictionary of *argot* that is still published today. Performing for a more sophisticated audience, he adapted his ballads, which gradually became more consciously poetic, bringing him praise as a latter-day François Villon. In fact Bruant played up the idea that he was a poet of the people – he was stocky and tough-looking and wore a working-man's black corduroy jacket, with trousers tucked into black leather boots, offset by the sort of floppy velvet fedora usually associated with the romantic

poets, the effect heightened by a bright red scarf dramatically thrown over his left shoulder. Bruant was clearly as much an actor as a balladeer, which suited the first-person narrative lyrics that the Realist singers had evolved. The effect was often sentimental, but the simple four-bar motif with words that were often repeated was easy to learn and join in with. When performed in Bruant's resonant baritone such songs instantly commanded the attention of his listeners and quickly achieved the kind of wide following that many grander figures of the Paris stage could only dream of. From his first appearance in Salis's cabaret it was Bruant who began to draw the crowds and it was certainly Bruant above all others that Lautrec went to see.

On the night of the procession, Bruant simply moved into Salis's old premises and started up. He renamed his club Le Mirliton but left the decor as it was, letting it evolve as he hung the place with paintings by his regular customers. Apart from the plain refectory tables and stools where those who arrived early could find somewhere to perch before the crowds began massing around the sides of the room, the only other decoration was a Louis XIII chair which Salis had accidentally left behind. With typical insolence, Bruant hung the chair on one of the walls, and used it as the subject of the song that became Le Mirliton's trademark anthem:

> *Ah! Mesdames, qu'on est à l'aise*
> *Lorsqu'on est assis sur la chaise Louis XIII.*
> *Elle est à Rodolphe, et cependent,*
> *Pour s'asseoir dessus, faut aller chez Bruant.*

That, it must be said, was the only 'innocent' song the excited customers, hoping for a touch of the gutter, were likely to get. Most of Bruant's numbers were melancholy evocations of the miseries these listeners knew could be found further up the hill in the narrow lanes few would actually dare go and see – the world of cutthroats and beggars and ageing prostitutes wasting away in the darkened doorways with their frazzled hair and flaccid breasts:

> *Les Ch'veux frisés*
> *Les seins blasés*
> *Les seins blasés*
> *Les pieds usés.*

Such harsh stuff had clearly moved on from the softer world of the earlier Realists. It had already happened in literature and to a lesser extent in painting where the gentler scenes of modern life had given way to an obsession

One of Henri's striking posters for Bruant, 1892.

with the nastier elements of urban existence, a style most associated with Zola's novels and Degas' prints where an interest in those below the respectable bourgeois level of society was often expressed in a manner as hard as the lives described. This new, earthy, often bitter, art was dubbed Naturalism, a poor choice as the word seems to imply something fresh and rural, when what it actually represented was the choking stench of the run-down inner-city slums and the unwashed near-criminals they sheltered. This was the world Bruant evoked in searing harangues that clearly embodied his political manifesto:

> *J'suis républicain socialisse,*
> *Compagnon radical ultra,*
> *Révolutionnaire, anarchisse . . .*

> I am a republican socialist,
> An ultra radical comrade,
> A revolutionary and an anarchist . . .

None of this would have mattered very much if news of Bruant's act had been confined to the few who could make it to Le Mirliton, but the singer had the good fortune to find himself part of a revolution in the spread of information which was taking up what had been almost private activities and hurling them into the public domain. Thousands who would never hear Bruant sing, now read about him in the popular press. Newspapers and magazines were sprouting up across France, due to a combination of legal and technical changes which had unleashed a social and cultural revolution that today still has the power to transform society in unpredictable ways. Between 1860 and 1890 the number of periodicals published in Paris leapt from 500 to 2,000 in a frenzied attempt to satisfy a new readership, the result of the spread of elementary education. This mass public wanted a mix of easily accessible news and entertainment and the arrival of the steam press and cheap newsprint, and the inevitable collapse of the government's attempts at censorship, allowed businessmen to embark on a race for fabulous profits.

At first it was politics that provided the thrills the public required. One of the first popular papers, the *Petit Journal,* pushed its circulation to a million daily sales when President Grévy was forced out of office in 1887, after his son-in-law was caught selling honours. This was followed by the farce of General Boulanger's failed *coup d'état,* after which politics cooled down. By then the press had realised that a mix of sex and showbusiness could achieve much the same results so that newspapers such as *Le Matin* and *Le Petit*

Parisien, the most successful of them all, were soon so full of murder, prostitution, deviancy and fraud masked by a façade of moral outrage, that they came to resemble a Zola novel or a version of a Bruant song. In fact the two worlds overlapped and fed off each other as journalists realised that their new readers loved to learn about the doings of people in public life other than politicians. Despite the establishment of the Republic there was an insatiable desire to know what the old upper classes were doing – the balls and races they attended, the clothes they wore, the marriages their children made, while at the same time this need also encompassed those from the opposite end of the social scale, the ambitious working-class performers who had become a species of new aristocracy through the acquisition of popular success. Thus performers like Bruant began to appear in the daily newspapers and weekly magazines, promoted and quoted and suddenly famous simply for being famous in a way unthinkable only a generation earlier.

The downside to all this flattering attention was a loss of credibility. Fénéon never quite trusted Bruant's anarchist credentials and doubted his sincerity, especially when his club became profitable and Bruant began to spout rather right-wing patriotic opinions. But many of these apparent contradictions arose because the singer was far more complex than the simple image of a revolutionary balladeer suggests. His military experience had imbued him with a belief in the honest French soldier, which easily trespassed on jingoistic patriotism. But the fact that he was no blinkered radical, just a difficult, confused figure, does not discount the sincerity of his angry costive ditties. Some proof of his sincerity can be found in the tone of his lyrics, for beneath the rough *argot* of the streets, behind many of the comic lines, there was a bitterness that seemed to come from his experiences during the Commune, a bitterness that made him despise the well-off folk who came to listen to him – treating them 'like shit' and yelling at them to shut their ugly gobs. 'They laugh because they think I'm joking,' he would say. 'But I'm not.' And Henri de Toulouse-Lautrec certainly believed him, listening to his act night after night, absorbing sentiments a world away from the genteel salons of the Château du Bosc or the political ethos of the Jockey Club.

> *Je parlerais des petits fieux*
> *Des filles-mère, des pauvres vieux*
> *Qui l'hiver, gèlent par la ville,*
> *Ils auraient chaud, comme en été*
> *Si j'étais nommé deputé*
> *A Belleville.*

A drawing by Vaughan Trowbridge of Aristide Bruant performing.

I'd speak of the small sons
Of unwed mothers, of the poor old people
Who in winter, freeze throughout the city,
They would be as warm as in summer
If I were made deputy
In Belleville.

There is a photo of Lautrec and a friend, usually identified as Anquetin, though it's hard to be sure, seated at one of the long tables in the Mirliton when the club was closed, an indication that they were more than ordinary customers. Indeed, it had not taken long for Bruant and Henri to become close friends, a relationship that was to be one of the most important in the painter's life. When one thinks of the two of them, it is usually the posters Lautrec made for the singer's performances at the Ambassadeurs and Eldorado nightclubs that spring to mind, his dramatic portraits of Bruant the tough-guy with his trademark red scarf flung round his neck, an image that has come to represent the whole world of the *fin-de-siècle* café-concert. But these were made when Bruant had already become more concerned with

promoting his showbusiness career and less with singing about the poor and the dispossessed. Back in the mid-1880s, Bruant meant what he sang and Lautrec, who was looking for something to believe in, something that would give his art a direction and a purpose, was clearly transfixed by what he heard.

In later life Bruant made a number of recordings of his best-known songs but he was by then rather mellow and they come across as little more than charmingly dated music-hall ballads. By contrast, accounts of his performances in the 1880s speak of his bellowing coarseness and the sheer aggression of his brash delivery. Some idea of the effect he had can be gathered from the description of the cabaret singer Legras in Zola's novel *Paris* of 1897, a character demonstrably based on Bruant at Le Mirliton:

> The pianist began the prelude; Legras sang the song 'La Chemise', the horrible thing that made all Paris come running. With whiplashes, the last underwear of the poor girl, of the prostituted flesh, had been lacerated, stripped off. Every lust of the street was displayed there in its obscenity and in its acrimoniousness. And the bourgeois shame cried out, behind this body of the woman dragged in the slime, thrown in the communal grave, without a shroud, murdered, raped. But more than the words the scorching insult was in the manner in which Legras threw it in the face of the rich, the happy, the beautiful ladies who packed in to hear him. On the low platform, in the midst of the smoke of the pipes, in the blinding gas furnace, he hurled out the lyrics with a thrust of his mug, like spit, all a blast of furious scorn. And when he had finished, there was delirium, the pretty bourgeois ladies did not even suffer from so many affronts. They applauded frenetically, the room of people stamped, grew hoarse, wallowed, frantic in its disgrace.

It was typical of Zola to be so dismissive of someone who shared his own approach to the dark side of society and we know that Bruant was hurt when he read this somewhat two-faced attack, claiming that the author had never visited Le Mirliton and had simply made it all up. But an exact portrait or not, the description of Legras' performance does bring out the sheer animal force that Bruant must have exuded, while at the same time targeting the inarguable fact that these songs about the poor and the dispossessed were

enjoyed by a comfortable bourgeois public that came to be entertained by his shocking subject-matter.

Not all the lyrics at Le Mirliton were so harsh; a lot of the material was the usual repertoire of popular songs performed elsewhere but there was a hard core of radical material that was later published in two volumes, under the title *Dans la Rue*. One volume can still be seen among the books kept at the Château du Bosc and is believed to have belonged to Lautrec even though Le Bosc had been sold to his aunt by the time the book appeared, and Henri would more likely have been visiting his mother's house at Malromé. However, there is little doubt that Henri had his own copy, given that the songs were the central passion of his life at the time. Leaving aside some of the blander *chansons populaire* that were slipped into the collection, the bulk of the lyrics add up to a discernible agenda on Bruant's part. Out of sixteen songs, nine are set in the run-down slum areas created by Haussmann's rebuilding of the inner city. There are songs about Saint-Ouen, La Châpelle and La Villette in the north and Montrouge in the south, and an inner ring beginning at Batignoles and Montmartre (Montmerte in Bruant's *argot*), moving clockwise round to Belleville, La Bastille, on to Montparnasse stopping at Grenelle where the circle is broken by the wedge of upper-class neighbourhoods in the sixteenth *arrondissement*, from Trocadero to the Arc de Triomphe. He also created songs for certain significant landmarks associated with the poor – the great parks: the Bois de Vincennes in the east, the Bois de Boulogne in the west, and the prisons: La Roquette, La Mazas and Saint-Lazare. In total, there is a song set in each of the city's working-class districts, though it is the characters who inhabit each district who are the true subjects of the stories he narrates. Set in a precise place, Bruant's songs are about specific people seen by the narrator/singer who may be either male or female. Thus the tale of little Flora, who does not know who her father is and who goes to school at *à Batignoles*, until she grows up and begins frequenting the local bars and has an affair with the male narrator of the song, because, as he explains, she didn't charge much. It ends when he discovers her with another, not that it matters as she soon dies of smallpox which, the singer concludes, just goes to show that girls without fathers shouldn't go to school *à Batignoles*.

The same sort of savage humour is there in 'A la Villette' where the female narrator, a prostitute, describes her lover Toto, who knocks her about a bit while living off her earnings, sometimes mugging her clients until he gets caught and ends up in La Roquette, the city's main prison, where she sees him for the last time with his head on the block. Prisons loom large in

WHAT PASSES ON THE STREETS

these acrid little ditties, proof that the poor were constantly on the edge of criminality, with the law as their enemy. The song 'A la Roquette' has a male prisoner on death row writing to tell his girl that clemency has been denied and it will soon be dawn and his last day, which doesn't bother him as much as the cold touch of the scissors on his neck as they cut off his shirt-collar to prepare him for the guillotine. This was a typical Bruant detail, emotional rather than precisely political, for none of these songs are rallying anthems that suggest solutions, nor are they exactly a call to arms. Bruant was not offering the Propaganda of the Word intended to provoke the Deed, rather he was conjuring up his own childhood, his memories of being hurried round the seedier areas of the city by a father, sinking ever lower with each succeeding move. Yet despite the lack of political focus there is no denying the philosophy that underpins his songs. The acutely snobbish diarist Edmond de Goncourt described Bruant's 'ignoble lyricism' and 'foul adjectives, dirty words, purulent slang, the vocabulary of sordid brothels and clinics for venereal diseases', and concluded by alerting his readers to '. . . Bruant's songs in society drawing rooms and dynamite in carriage entrances! These are the two warning signs of the approaching end of the bourgeois age.'

Goncourt was right. Bruant's lyrics were anarchistic, at least in spirit, elevating downtrodden, forgotten individuals, rescuing his previously unsung victims from the anonymous mass lost in the wretched urban underworld. But because he presented these sad creatures to the well-off and complacent, Bruant was easily dismissed as a mere entertainer, out to shock a bunch of late-night thrill-seekers. The easiest charge to lay against him was that of sentimentalism – that he mawkishly used these low-life figures to milk easy sympathy from an audience. There is something of that in 'A Saint-Lazare' where this time it is a woman, confined in the notorious hospital prison for prostitutes, who is writing to her lover-pimp, a letter full of tender care for him – suggesting he find another tart to look after him until she gets out and begging him not to get into any fights in case he gets hurt and won't be able to visit her. But whatever sentimentality there is, is quickly offset by the cold, clipped tone, a detached, ironic approach bordering on the cruel. In 'A Saint-Ouen' a few stark phrases describe a boy's wretched life – born on a filthy bottle-strewn wasteland on the banks of the Seine, brought up on the streets where clean clothes were a luxury, frequently hungry and forced to take work that was hard, dirty and demeaning but where there was always the compensation that the cemetery wasn't far away. His audience may have laughed at this 'sick' joke but one imagines the phrase would have given some of them pause during the carriage ride home.

Bruant's songs offer little general description of these neighbourhoods, yet are strong on precisely observed details such as when he evokes the hungry making love at night in the Bois de Vincennes, lying among the remains of holiday picnics that had been enjoyed by the well-off visitors. But in the main, the visual elements were left to the imagination of his listeners and it was no doubt this absence that most intrigued Henri de Toulouse-Lautrec as he sat night after night entranced by a world he had barely imagined before he discovered Bruant. What, after all, could this sheltered offspring of the provincial aristocracy know of the prisoner in 'La Mazas' asking his girl to explain to his parents what has happened to him; how could someone like Henri have ever imagined that the night thieves in the Bois de Boulogne always came out in groups of three, or that the poor in Montmartre often married 'in the hay', simply finding a bit of wasteland on which to make love, a contract 'without mayor, witnesses or honeymoon'? These were people so far from his milieu one can easily imagine the incredulity with which he must have reflected on stories like that of the Jewish girl, 'A la Bastille', who struggles to take care of her father and mother – for five francs she'll take off her hat, for ten it's her coat, for twenty the lot.

As Bruant recounted such things with his customary brutal simplicity, Henri imagined them, saw them and decided to use them. Over the three years from 1886 to 1889 he made six paintings directly from, and using the same titles as, Bruant's songs, while another six draw obliquely on the singer's material. Even in those where the subjects appear to be Henri's alone, the result is still imbued with the same harsh, slightly offbeat attitude, typical of the singer.

What made Henri's work unique was the way his supposedly fictional characters were often real people with lives not too far removed from the story he was telling. It was a combining of fact and fiction that it began with his discovery of a model called Carmen Gaudin. She was a *blanchiseuse*, a laundrymaid whom Henri and Rachou saw as they were leaving a restaurant some time in 1885. According to Henri's friend François Gauzi, Henri was supposed to have looked her up and down and exclaimed 'What an air of spoiled meat she has', presumably prompted by the fact that, like so many desperate, underpaid women, she was a small-time prostitute. But Gauzi wasn't there and may have been exaggerating – his recollections of Carmen imply that Henri somehow discovered her, launching her career as a model, suggesting that his friend saved the poor creature from life on the streets. Cormon certainly used her later as one of his Stone-Age tribeswomen, but there is an earlier portrait of her as a grieving widow by the Irish artist Alfred

Supervised labour in the women's prison, Saint-Lazare, in the 1890s.

Steven, as early as 1883, which makes it more likely that she was already doing whatever she needed to survive, mainly laundry work but with a little prostitution when necessary and some modelling if the opportunity arose. Her main attraction for Lautrec was obvious: the reddish-blonde hair that fell in two peaks over her forehead. In the autumn of 1885, Henri wrote to tell his mother that he was, 'painting a woman whose hair is absolute gold', and most of his studies of Carmen seem to concentrate on that one salient feature. He used her as his 'afternoon' model for the sort of open-air work Cormon encouraged, posing her outside in a friend's garden in order to benefit from direct sunlight. In some of these her head falls forward so that we see almost nothing but her hair, a fact reflected in the titles of the surviving works: *Carmen the redhead, Redheaded woman in a white blouse.* But these charming portraits were still student pieces – he even referred to them as his 'punishment works' – whereas the truly interesting pictures of Carmen are those that touch on the artist's other life at Le Mirliton.

When he first painted her as a laundrywoman, it was in the same 'dark Realist' manner he had used for *La Grosse Maria*. There were precedents in Degas' studies of laundresses and in Zola's novel *L'Assommoir* of 1876, much of which centred on a failed laundry whose owners descend into poverty and drunkenness. There is a Bruant song 'A la Goute d'Or' named after the street of the laundrywomen behind the Boulevard de Rochechouart, not far from Le Mirliton, though this was one of Bruant's more jolly ditties and had little in common with the weary figure in Henri's painting, leaning on her ironing table, exhausted from her labours.

At the time, everyone was aware of what being a laundrymaid implied, and knew that the figure in Henri's painting was someone hovering on the edge of urban existence, used and abused almost at random. Here, at least, the portrait was a true representation of its subject, for while another of Henri's initial observations about Carmen had been that she looked as if she would be 'something of a bitch', he soon discovered that she was polite, punctual, discreet and pathetically eager to please. In fact this passivity was one of her saddest traits – he eventually discovered that she had a lover, or more likely a pimp, who beat her up, though she never deserted him and it was this that made her the ideal candidate for Henri's first openly Bruant-inspired painting, *A Montrouge*, a song that has echoes of *L'Assommoir* with its unforgettable vignette of the slum girls strolling along the outer boulevards looking for men, an incident based on an episode in Zola's novel. Everything about Bruant's lyric is red – set in Montrouge, it tells of 'Rosa the Red' who lures her client into a dark corner where her pimp kills and robs him:

C'est Rosa . . . j'sais pas d'où qu'a'vient
Alle a l'poil roux, eun'têt' de chien . . .
Quand a' passe on dit v'là la Rouge,
 A Montrouge.

Quand a'tient l'michet dan' un coin
Moi j'suis à côté . . . pas ben loin . . .
Et l'lend'main l'sergot trouv'du rouge
 A Montrouge.

It's Rosa . . . I don't know where she comes from
She has red hair, a dog's head . . .
When she passes they say, here comes 'Red'
 At Montrouge.

When she gets a 'John' in a corner,
Me, I'm right there . . . not far at all . . .
And the next day the cop finds 'red' all right,
 At Montrouge.

None of this drama is seen in Lautrec's painting but much is implied. Lautrec had Gauzi photograph Carmen standing in a doorway and it is this docile, monochrome figure, waiting for a customer that he offers – the only colour, her red hair as ever falling forward, totally passive, ready to accept whoever turns up. It may be that Lautrec thought that the Bruant song was so well known that the shared title would make the message underlying this understated image perfectly clear. Alternatively, he may simply have been using the song as the starting point for something different, in this case his own insights into the life of someone like Carmen, with its harshness and exhaustion. Just as Bruant avoided straightforward political propaganda and dealt with precise individual cases, so Lautrec concentrated on the character of his model, seeing her as a victim, mauled by circumstances over which she clearly had no control. Together *La Blanchiseuse* and *A Montrouge* offer a tragic image of the grey world that lay behind the façade of starched shirts and layered dresses, the world of bourgeois fashion and comfort, whose slaves were the available playthings of the same men who paid so little for their daily luxuries. Where Degas' laundrymaids were usually shown busily at work, washing and ironing, Lautrec offered a woman at the point of collapse – in another painting of Carmen, she is shown leaning against one of the ironing tables as if trying to massage away the pain in the small of her back. All his portraits of her are studies in melancholy, embodied in the

extreme weariness of the pose, the slumped body, the fallen head. We are seldom shown her eyes, which remain hidden behind the red/blonde fringe, as if there was still some part of her that had to remain private and undefiled by our gaze. She certainly intrigued Henri, for he went on hiring her throughout 1886 and on into 1887, until an incident occurred which spoiled her allure. He hadn't seen her for some time and when he next asked her to come round she was a different woman, her hair no longer red – it had always been dyed and she had let it grow out. Now a conventional brown, she had, as Henri put it, 'lost all her appeal'.

The odd thing is, he must have known from the start that the colour he loved so much was, in her case, acquired. She could hardly have had that 'odour' of the true redhead that he found so irresistible and yet he seems not to have minded as long as she continued to look the part, as if this artificiality was, in itself, intriguing.

Some time in 1886 (clearly to fill the gap left by Carmen) Henri took up with a genuinely redheaded prostitute whom he named 'Rosa la Rouge' after the Bruant song – the only name we know her by. Friends warned him that she had syphilis but he is said to have dismissed this with a laugh as she had already infected him. As with the possibility of congenital syphilis, nothing of this was ever directly communicated by him and there are only passing comments from friends to substantiate the claim – though his later illnesses do show many of the signs of syphilitic degeneration. It would only be in the early years of the new century that the malady would be correctly defined and it was not until the discovery of penicillin in the 1940s that an effective cure became possible. In the late nineteenth century it was a terrifying scourge believed to be responsible for as many as 15 per cent of all recorded deaths in France, with the arts and letters providing many prominent victims – Manet, Jules de Goncourt and the most famous chronicler of prostitution and the one who most often made passing references to the condition, Guy de Maupassant. The result was that the disease was as feared as AIDS is today and for much the same reasons – the unwholesome combination of a seemingly mysterious ailment that inflicted horrific suffering on its victims who were consumed with shame and lacerating remorse over what could only be seen as a self-inflicted misery. As if all this were not bad enough, commonly held myths about syphilis only added to its terrors – it was widely believed to have so weakened the French soldiery as to be the primary cause of the nation's defeat by the Prussians and an opposing belief that the malady could on occasions produce genius offered little consolation.

To many, it seemed as if no advance had been made since the horrendous

epidemic that had swept across Europe in the closing years of the fifteenth century. Whether the disease had erupted spontaneously then, as was commonly believed, or whether some freak combination of circumstances had caused some long dormant nightmare to break loose, no one knew. That the event had been written in the stars was, by contrast, firmly established and that after its initial furious explosion the symptoms appeared to mutate into something slightly less ferocious, was the only mercy to be descried in its entire history. Again, the similarities with AIDS today are astonishing, from the universally held belief that the disease had spread from Africa to the Americas and thence to Europe, thanks initially to the voyages of Christopher Columbus and his successors, and that it had originally been generated as a result of humans having sex with monkeys. A slightly more poetic birth was ascribed by some writers to the coupling of the Devil with Salomé, stepdaughter of Herod and the nemesis of Saint John the Baptist. As with AIDS, everyone blamed everyone else for the arrival of the disease, thus to the French it was the Neapolitan sickness while to their neighbours it was all too obviously the French Malady. From the sixteenth century onwards its effects were both tragic and bizarre – syphilis can be credited with the successful spread of publishing, which until its arrival had been solely preoccupied with issuing Bibles but which now produced countless tracts on the new sickness. One of the first novels in Spanish had syphilis as its subject, a theme that maintained its prominence down to Henri's day, culminating in the disgusting spectacle of Nana's death in Zola's novel. Of some relevance to Henri's career was the parallel way illustrated publications joined this outpouring, as attempts were made to reveal the disgusting effects the malady had upon the human frame, effects matched by the stomach-turning vocabulary that became common currency, with talk of buboes and chancres, of suppurating ulcers, oozing lesions, pustulae, verrucas, purulent tumours, nodules, fetid sanies, mucous syphilides and osseous gummas. The classic illustration shows a rotting syphilitic, his face almost a fleshless skull, his jaw held on to his body by a bandage, his limbs wrapped in filthy webbing, looking back at his own offspring enjoying their sexual frolics aware that they too will follow where he has led.

If Henri had caught syphilis from the girl who has come down to us as 'Rosa', then he would certainly have known about it from the open ulcer, the chancre as it was traditionally called, that would have appeared on his penis and while this would probably have healed after about ten days, the infection and with it his potential to infect others, would have remained with him for the rest of his life, while the spirochaete in his system would have

attacked his bones, joints, eyes and central nervous system even though no outward signs would have been visible. This period, the secondary stage, could, in one in four cases, lead to tertiary syphilis, in which almost any part of the body might be infected but which in Henry's case would most likely lead to a worsening of his already weak limbs, causing acute weariness and thence to mental degeneration bordering on madness. It was this above all else – the image of the filthy, mad creature, face half eaten away by the ravages of the disease – that so terrified late-nineteenth-century men and women and led those who believed they were infected to seek out any treatment, no matter how unpleasant, despite it being well enough known that a cure was impossible. The most anyone could hope for would be to avoid the tertiary stage, passing instead into what the doctors called benign late syphilis, though even then some of the side effects, such as ulcerated lesions on organs such as the liver and the testicles, were hardly inconsequential. Indeed, the surest confirmation that Henri de Toulouse-Lautrec had contracted the disease is the appearance about this time of a new friend, Henri Bourges, who although still a medical student appears to have agreed to treat Henri with the usual 'remedy'. This was a mix of mercury and potassium iodide, a ferocious concoction that risked turning the patient's teeth black but which could have some effect on the visible symptoms, the unpleasant ulcerated lesions that caused so much distress, though it could do nothing to halt the ultimate ravages of the disease in later life.

Bourges, a short man, somewhat conservative in dress and opinions, was evidently drawn to Henri through the attraction of opposites. Where drinking pals like Maurice Guibert encouraged Henri's excesses, Bourges attempted to calm him down, warning him about the risks he was taking, especially now that he had a second source of trouble for his already weakened frame. All to no avail, of course, though Henri seems not to have resented the attempt.

After *A Montrouge* there were to be six more paintings based directly on Bruant's songs. *A Saint-Lazare* offered a more direct illustration of the lyrics, showing the girl sitting at a prison table writing to her lover, whereas *A la Grenelle* returned to his more oblique approach, showing a figure, half back view, seated at a bistro table, a generalised study in melancholy rather than an illustration of Bruant's story of an old prostitute still hanging around the army barracks where she had earned her living before her looks went. Pictures of lonely drinkers at bistro tables were already a well-worn subject among the painters of modern life, most notably Degas' *Absinthe Drinkers*, but Henri took it a step further. The title clearly links his version to Bruant's

song, and makes it clear that we are looking at one whose life has been blighted both by the profession she was forced to practise and by the fact that she is too old to go on with it. To the complacent Parisian male, presenting a prostitute as capable of suffering was an unwanted intrusion that undermined the gloss, usually applied to such matters, that the women were always good-time girls or whores with hearts of gold, a fiction employed to mask a reality of loneliness, disease and a later life in which the worn-out prostitute was forced to eke out a shadowy existence, an outcast even among the city's poor. In the Bruant song, the old prostitute survives only because the soldiers have taken pity on their old 'love' and granted her a pension of a daily meal out of the mess-pot.

Henri returned to the subject of the solitary drinker so many times that he eventually moved a one-legged metal bistro table into his studio so that he could work in comfort. Sometimes he merged fiction and reality by painting a figure at the table as if in a café while showing his stacked canvases in the background, as if to say: 'this may only be theatre but it is still a tragedy'. He went even further in a series of six works based on 'A la Grenelle', which show the old prostitute sitting patiently at a table while one of the soldiers weighs her up, perhaps wondering if there is any mileage left in her. Henri entitled these works: *Artilleur et femme* (Soldier and woman) and did not shrink from the nastier side of such an encounter – the male figure seems to be either adjusting his trousers as if he has just finished with someone else in a back room and is on his way out, or is groping himself – a lewd gesture towards the woman who, rather pathetically, is still dressed in her old décolleté dress, as if there might still be some chance of a customer. Of all his Bruant-inspired works, this brief moment out of the many sordid encounters in the city's underbelly is probably his most effective. For the figure of the soldier he used a fellow student, Frédéric Wenz, who had a suitable square-headed Prussian look – it didn't hurt to make out that the callous military exploiter was somehow associated with the hated enemy! Overall, the various versions of *Artilleur et femme* show a coalescing of Henri's previously isolated interests – fine art and satirical drawing. A painted version was never completed but a coloured sketch shows him using stronger tones than before as if to bring out the garish nature of the image, an alliance of subject and technique that would be a feature of his work from then on.

Henri extended the theme of the solitary female drinker via two further Bruant songs. For *A la Bastille*, he used Frédéric's mistress, Jeanne, her dark looks matching those of the fallen woman, whom the song suggests is Jewish

and who prostitutes herself to help her mother and father survive. The tension that we sense in the lyrics – the good girl lowering herself for the best of reasons – is taken up in the painting by the way Jeanne is dressed in a high-necked black dress with a housemaid's white pinafore and yet is sitting alone at a café table with a drink in front of her, an unthinkable act for a decent woman. At the time, it was this frisson of seeing the respectable behaving badly that gave such images their shock value. It appalled many people that a woman could go out unaccompanied and, worse, that she could enter a bar and drink as a man did. Such a suggestion exploded the comfortable division of male and female roles that were assumed to be unbridgeably separated between the inside and outside worlds. According to this view, woman was the respectable keeper of the hearth while man drank and caroused with her looser sisters. They in turn could be categorised as jolly tarts or abandoned whores.

While Bruant and Henri illustrate this assumption, neither offers an especially original insight into the hypocrisy that underlay it, an apparent neutrality that has provoked some critics to question just what they hoped to achieve from the use of such provocative imagery. Bruant, in particular, was dismissed by men like Zola and de Goncourt as a mere entertainer who profited from a particular fad, the public's desire to sniff around the dirty underside of things, which grew after the siege and the Commune, a desire that he satisfied by hurling insults at the middle classes who packed out Le Mirliton in order to shriek with laughter at his foul-mouthed performance. This is the Bruant depicted by Zola in *Paris* and memorialised by historians of the period since.

By association, Henri's efforts have been written down as the strivings of an art student struggling to climb on to his bandwagon. Earthy, dirty naturalism was the intellectual fashion of the mid-1880s and, in Bruant, Henri had surely found easy access to material he would otherwise have been unable to witness. Using such stuff, so the argument goes, enabled the unknown artist to produce the shocking images that would induce the scandal needed to bring him the critical attention he craved. It is undeniable that Henri was ambitious – keen to prove to himself as much as anyone that he could make a life of his own – and Bruant certainly had the means to help him. Le Mirliton's walls had been unadorned since Salis's departure, and clearly offered a highly visible exhibition space that Henri yearned to fill and there was also the magazine, called after the club, that Bruant had founded and which was already a phenomenal success. It was this above all that Henri wanted to be part of, for he had already sensed, perhaps far quicker

Soldier and woman – Henri's bleak vision of an ageing prostitute.

than any of his 'fine art' contemporaries, that the new illustrated journalism was about to transform society as much as radio, cinema and television would do in the coming century. The popular illustrated press would be a crucial element in the social and cultural changes that make the *fin de siècle* so fascinating – an upheaval that would touch everything from politics to art and would, as he correctly saw, be the forerunner of a much larger revolution that was already percolating in and around Montmartre.

What Salis and Bruant and their many imitators were unwittingly unleashing was a phenomenon that would dominate almost every aspect of life in the newly industrialised world: mass popular culture. Not the old, slowly evolving folk culture of earlier ages, not the 'High Culture' of a ruling élite, but something entirely new, growing so rapidly and with such broad influence that nothing would remain immune to its pervasive appeal.

The first manifestation of this revolution was the sudden appearance of a widely circulated illustrated press whose growth matched the earlier explosion of newspaper and magazine publishing and whose influence was to prove equally far-reaching and unpredictable. Again, this was largely a result of technical innovations. Various photographic processes, most notably photogravure, replaced the old laborious wood-block engravings. The use of zinc plates, instead of stones, for lithography provided flexible sheets that could be bent into cylinders, which meant that illustrations could be run off on the same high-speed circular printing presses as the rest of the publication. The most spectacular result of these innovations was undoubtedly the *Petit Journal*'s Sunday colour supplement, and its subsequent imitators, but there were also illustrated equivalents of the small literary magazines, produced for artistic or political reasons, whose influence was far greater than their limited circulation. The earliest artists who interested themselves in these new developments were inevitably those already working in the field of commercial illustration – Forain, Caran d'Ache, Henri-Gabriel Ibels and Steinlen were already producing black-and-white drawings with a distinct social or political message in the Daumier tradition and easily made the transition to colour. Allied to the new print journalism, the new illustrated press also involved itself with politics and scandal, using the naturalist style to depict the underworld of crime and vice, a preoccupation with the sordid and the decadent that would make Forain, for a time at least, the most popular artist in France, a household name, when those he himself admired, like Degas, languished in obscurity.

All this was clear to Henri as he looked for that elusive space in the artistic landscape that he could make his own, and clearly part of his interest in

Bruant was the possibility he offered of an entrée into this new world through his widely circulated magazine. The first edition had been a mere four pages printed on a single folded sheet that sold for ten centimes. The cover was a full-page illustration that, over the ten years the magazine survived, was generally a satirical drawing exposing some odd element of city life. The articles were mainly funny gossipy stories about Montmartre, alongside the lyrics of Bruant's songs, which were probably the main reason why the magazine was such a huge success, and which was probably part of the reason why Henri chose to make paintings that illustrated, no matter how obliquely, the same lyrics, no doubt hoping that he would be invited to transform them into line drawings for the magazine.

Bruant, however, proved irritatingly unattracted to this bait, preferring to employ Steinlen to illustrate his music covers. Despite his efforts, Henri's first published graphic work was not for the *Mirliton* but for its slightly older rival *Le Courrier Français*, a promotional magazine that ran articles on the various entertainments in and around Montmartre backed with advertisements and with no clear division between publicity and reportage, much like local city guides today. Unlike the *Mirliton*, there was no evidence of anarchist sympathies in the commercial *Courrier*, though it was happy to use the devices of naturalism to attract readers, with drawings of sexy working-class girls or with articles that attacked those public figures who railed against the pleasures of the night while sneaking up the hill to enjoy them. Of course this was the usual device of yellow journalism: offering titillation while pretending to take a moral line about it. It was in the pages of the *Courrier* that Forain had begun to make a name as a brilliant chronicler of that point where the worlds of vice and respectability met and blurred. As before, he followed where Degas led, with glimpses backstage at the ballet or depictions of life in the new cafés and cabarets, scenes that clearly fascinated a wide public eager to see something of what was going on in Pigalle and beyond without the risk of going there. And it was the *Courrier* that offered Henri his first entrée into the illustrated press when it published his drawing *Gin Cocktail*, a simple sketch of two drinkers seated at a bar behind which two waitresses are preparing drinks. It was a conventional piece, clearly produced to satisfy editorial requirements, but it was a breakthrough and was probably instrumental in persuading Bruant to relent.

Three months later, in December 1886, Henri was given a two-page spread across the middle of the *Mirliton*, which reproduced a black-and-white line drawing entitled *Le Quadrille de la chaise Louis XIII à l'Elysée-Montmartre*, a hectic scene in the crowded dance hall, a few paces further

along the Boulevard Rochechouart from the Mirliton. Henri shows a group of dancers performing a new high-kicking routine, a sort of free-wheeling polka that they called the *quadrille*, and which they danced to the tune of Bruant's theme song, 'La Chaise Louis XIII'. Henri's illustration is fascinating for two reasons: it was his first paid graphic work of any significance, and it was also his first depiction of a dance hall, a subject that would be the basis for several future works including the left-hand panel for La Goulue's booth. A note printed under the drawing points out that it was based on an already existing painting, one that was by then on display in Bruant's club, proof that Henri's plan of tempting the singer with paintings that could be turned into illustrations had finally worked, this time at least. In fact Henri had rammed home the point by painting the scene in *grisaille*, in shades of black and white, so that it was effectively an illustration from the start. Equally interesting is the fact that Bruant had bought and hung the canvas in his club, for while he may have favoured Steinlen to illustrate his music covers, he was unstinting in his praise for Henri's original paintings, which he eagerly collected and displayed on his walls, so that by the end of 1886 the club had effectively become a Toulouse-Lautrec gallery with *Le Quadrille de la Chaise Louis XIII à l'Elysée-Montmartre* as its centrepiece along with the works related to the songs: *A Montrouge*, *A Grenelle* and the others being added as they were completed. At one point there were as many as ten canvases on view, an astonishing and very public success at a time when so many artists were struggling for a single space in the galleries and salons of the capital. As a result, from his earliest professional years, Henri de Toulouse-Lautrec was able to display his work to a wide public though not quite in the way conventional history suggests, for it was not his graphic art that first brought him to public attention but the more conventional easel paintings and these, as a glance at the titles acquired by Bruant shows, were the most radical and the most anarchist of all.

Henri was given four *Mirliton* covers in the following year, 1887, all dealing with themes of Parisian working-class life: one, *A Saint-Lazare*, was a direct illustration of a Bruant song and the other three were well within the same naturalist satirical vein. One drawing, *Sur le pavé* (On the sidewalk), shows a young girl being kerb-crawled by an old roué above the caption:

> 'How old are you, little one?'
> 'Fifteen, sir.'
> 'Ah, a little past it already.'

This desire to latch on to the burgeoning world of popular graphics has made it too easy to dismiss Lautrec's work in the second half of the 1880s as nothing more than the attention-seeking ploy of an ambitious newcomer. Over and over again we are told that he never made a single comment espousing any political cause, that when he drew a girl, such as the under-age streetwalker in *Sur le pavé*, he was at best ambiguous about this kind of amateur prostitution, showing her half-turning towards her questioner as if willing to earn a sou should the occasion arise. To some, the girl's apparent complicity diminishes the moral force of the work, and places Henri on the same level as the journalists of the yellow press who hypocritically moralised about the otherwise unacceptable subjects they exposed. By extension, Henri has been accused of using standard 'low-life' characters, 'Types' as they are generally dubbed, stock figures, easily recognisable as representing a particular role, sometimes based on their occupations – the chambermaid, the squaddie, the coachman – and sometimes on their personal or moral characteristics – the fat sleazy bourgeois, the brassy tart. Yet despite the easy option such figures offered, Lautrec, in his Bruant paintings and drawings, generally dealt in complexities of behaviour that go way beyond the conventional satire of Forain or the jokey witticism of Steinlen. In a way, Bruant's Paris songs are about the ultimate Types, his women are symbolic figures representing the area that is the title of the lyrics, such as 'Montrouge' and 'Grenelle', not unlike the sculptures of antique female figures on the façades of railway stations who represent The North or The Republic or Alsace. But in his visual interpretations of the songs, Lautrec carefully avoids any suggestion that his women embody anything more universal than their own misery. We know from the lyrics of 'A Grenelle' that the sad-faced creature in Henri's *Artilleur et femme* is an old whore who used to make a living having sex with squaddies, yet Lautrec invites us to feel a measure of disgust at the way the arrogant soldier eyes her up and down, assessing her worth while hitching up his pants and gesturing towards his crotch. Indeed, the reason Bruant preferred Steinlen was that he avoided such disturbing images, confining himself to the comedy of the streets rather than trying to see beyond into the misery and degradation that was the lot of many of those who were so glibly transformed into stock caricatures. It would have been impossible for Lautrec to completely avoid the whole notion of the Type, given that his subjects were taken from that world, but by continuing to work with 'real' people, whose own lives were close to the subtext of the work, he avoided the emotional neutrality masked as wit or irony that was preferred by many of his contemporaries.

153

The written evidence of Henri's concern may be slight, but if one looks closely at the works themselves, their underlying purpose and their position in the unfolding story of French radical art in the nineteenth century is clear enough. With the general exhaustion following the Commune, that tradition seemed to have been ruptured. A few artists tried to maintain that radical line, most noticeably Maximilian Luce, in harsh drawings like *Civil War Scene* which showed the victims of the army massacres following the Commune, spread-eagled across a Paris street. But for the most part, the artists of the 1870s and 1880s preferred an approach so oblique as to be virtually indistinguishable from that produced by artists of no particular political persuasion whatsoever. The Impressionist Camille Pissarro and his son Lucien were outspoken anarchists and Fénéon always claimed that Seurat's silence about politics did not mean that he was anything but a true believer, yet in the two decades after the Commune neither they nor their friends let any sign of these beliefs seep into their paintings and drawings. Pissarro insisted that his choice of subjects from the world of the new urban poor and the way he depicted poor agricultural labourers without dressing them up as noble peasants was a sufficient attack on bourgeois values. Paul Signac, a friend of Pissarro and a follower of Seurat, elevated this oblique approach to the level of a positive theory, arguing that the radical style of the Neo-Impressionists was itself an attack on the dominant political class and the fact that their art often exposed the decadent pleasures of the bourgeoisie was a 'solid blow of the pick at the social edifice'. But given the fact that this same bourgeoisie was the only available patron for such work and that the few who bought the work of any of these artists appeared to find no such disturbing message in them, does tend to diminish Signac and Pissarro's arguments.

By contrast it was Henri de Toulouse-Lautrec who maintained the tradition that had passed from Vernet to Géricault to Courbet to Daumier through a disturbing mix of high art and low caricature that concentrated not on vague principles but on individual suffering and who refused to dilute this by deflecting attention into the arid stylistic battlefield that preoccupied many avant-garde artists such as Anquetin and Bernard. A work like *Artilleur et femme* was a direct assault on one of the pillars of the State, the army, where an officer is clearly revealed as lecherous, exploitative and callous. In its small, modest way, it can stand beside the gigantic *Raft of the Medusa* as a revelation of the indifference of the powerful towards those they can dominate. Similarly, Henri's exhausted laundrywoman, easing her tired back against the ironing table, shares her pain with Courbet's *Stone-breakers* whose toil can never be dignified, only endured.

While it might seem that there was little in Henri's background that could have provoked the sort of radical stance that Bruant had acquired from a childhood of ever deepening poverty, they were not quite as different as one might assume. Henri had been brought up to despise the Republic and savour its shortcomings, yet the sort of automatic right-wing monarchist belief that ought to have governed his actions was swept away when his father's insensitive behaviour cut him adrift from that isolated aristocratic world. As soon as he entered Montmartre, Henri had discovered a natural affinity with those he was painting. He might be unable to ride to hounds or marry a wealthy countess but in this world of the poor and the corrupted he was accepted, initially as a slightly comic figure, a 'character', but eventually, to the ones who mattered most, as a sympathetic friend who seemed to understand their lives, their longings and their failings. This is why the paintings of Carmen Gaudin ring so true and why they take up the sentiments of Bruant's songs and transcend them. And that is why the extraordinary paintings of those early years, so often dismissed as novice pieces, as opportunistic bandwagon works, trial pieces that merely precede the achievements of the Moulin Rouge years, are in fact neither Types nor caricatures, neither slogans nor propaganda, just acutely sensitive portraits of the individuals they depict made in a manner that precisely reflects the sentiments that Grave had attributed to Oscar Wilde when he quoted his remark that 'art is the supreme manifestation of individualism'.

6

LOVE

However one interprets the intentions of Bruant and Lautrec there can be no denying that they, rather than the literary magazines, were most responsible for bringing anarchist sentiments to a wide public. The crowds who crammed the Mirliton every night to hear Bruant's songs and see Lautrec's paintings, may have come for little more than the thrill of the vulgar but they were nevertheless obliged to hear and see something of those who lived beneath their own level of bourgeois comfort. And this mix of radical politics and popular entertainment quickly attracted other entrepreneurs; a few because they genuinely believed in the politics and wished to spread the radical message ever wider, most because it looked like a good way to make money. In 1885, with the passing of an amnesty for the exiled Communard prisoners, Maxime Lisbonne returned to Paris and opened the Taverne de Bagne, named after a slang word for a colonial prison. Appropriately enough, the Bagne was at first no more than a wooden hut on a piece of wasteground where each waiter wore prison garb and carried a ball and chain, but it was quickly transformed into a large purpose-built café-theatre, proof that you could get rich from political entertainment, provided it was just that – entertainment. People were now demanding the right to be amused, to forget about work, to lose themselves in an evening of noise, drink and plenty of surprises. The trick was to keep one step ahead of a public that was quickly bored by anything conventional, though many failed to learn this elementary lesson. The Brasserie des Frites Revolutionnaires opened in 1888 and Aux Brioches Politiques the following year, though to no great success, the momentary desire to be shocked by the grubby side of life having abated almost as quickly as it arose. But the basic need to be amused endured and the most successful of the new entrepreneurs were those who realised that political cabaret had

been a passing fad and that the smart thing was to offer something else, that newness itself was the key to wealth.

Rodolphe Salis at the Chat Noir was one of the first to see the way things were going. The entertainment he offered was now more professional than it had been at the old place, where an essentially haphazard amateur concert got up by a few poets and musicians had sufficed. At the new Chat Noir, the artist Henri Rivière installed an ever-expanding shadow theatre, a marvellously ingenious display of cut-out silhouettes that suggested depth by the use of cleverly arranged receding shapes which eventually rose to the use of colour. An impressive array of writers and musicians worked under Rivière's strict control and the Chat Noir theatre nights were soon drawing large appreciative crowds for what was in effect the true precursor of the cinema. Rivière's cut-outs were also a crucial influence on younger artists like Anquetin and Bernard who were still trying to create an art of clear flat shapes not unlike the shadows on the Chat Noir's screen – whose shape uncannily resembled a modern television set. Lautrec and Gauzi were passionate about Rivière's increasingly spectacular shows and would go round early to get a good seat and a meal before the performances. They were there on Bastille Day 1886 when Salis invited them to join him and Tinchant for a meal, after which they watched the shadow play then organised an impromptu orchestra and got everyone dancing until five in the morning. It was this new passion for dancing, not formerly a feature of places like the Chat Noir, that showed where entertainment was now headed. What had started as a concert given by a solitary performer was turning into a show where all could take part. At this point, there were still only three dance halls of any note in Montmartre: the Moulin de la Galette, though that was far up the Butte, a working-class club near the *maquis* and thus somewhat forbidding to outsiders from below; the old Reine Blanche in the Place Blanche, though by then this was a somewhat seedy, run-down affair on the point of closure, which left only the Elysée-Montmartre near the Mirliton on the Boulevard de Rochechouart as the one place the general public could safely visit.

Lily Grenier had been ahead of public taste, making her friends tramp up the hill to the Moulin de la Galette, or along the boulevard to the Elysée after they had spent the early evening listening to Bruant. In her company, Henri was well placed to see that a change was sweeping across the world of Montmartrois entertainment, a change that seems to have started up at the Moulin before sweeping down to the boulevard and which, by 1886, was beginning to attract an astonishingly large public.

Left to themselves, working people, like those who frequented the Moulin de la Galette, had always had a passion for noisy group dances in which individuals could step forward and show off their special skills. It was an old folk tradition transferred to the city, a tradition that lives on today with sudden fashions for line dancing and other performances with fixed identical movements. This is still a form of public entertainment that allows a few dedicated individuals, who practise at home, to show off their dazzling steps in public and thus gain a little fame among their peers, something to look forward to at the end of the day's work, a moment's glory to cheer up a hard life. Some time in the early 1880s a new craze began to catch on at the Moulin. It had grown out of the polka, a mildly scandalous dance for two that had come from Eastern Europe and which itself had developed from an earlier passion for the waltz. The polka was of course far more energetic, with little leaps and kicks, but at the Moulin this merged with an earlier passion for the Spanish fandango, the music was speeded up and the athleticism of the dancers given free rein with high kicks over the head or full turns with the leg held high as the whole body revolved in a circle. Sometimes this was done by one woman alone, sometimes with a male partner, but if there were enough girls to make up a line then there would be a spectacular 'show' as they all moved in unison, legs up together in a great rustle and swoop of material. One should not, however, imagine that this was anything like the strictly choreographed can-can performed in today's Moulin Rouge by a chorus-line of identically dressed dancers usually to music from Offenbach's *Orpheus in the Underworld* which predates the dance by nearly thirty years. In the 1880s the can-can was a wild display of individual skills. Of course what the audience liked was the shock of seeing the dancers' frilly undergarments or, if the wearer was careless of the number of layers she wore, a glimpse of leg or even more . . . There were several names for this new dance; the most common at the time was the *chahut*, slang for something like a 'riot', not unlike the old English vernacular 'shindy', though this later gave way to a common expression for noise or idle chatter, can-can, which is the name that has survived. At the time, there was some attempt to make the performance more respectable by linking it to the current fashion for the earthy and crude in the arts and letters, thus in 1886, when Maurice Vaucaire published an article celebrating the cut-price, coarse, loud freedom of the Moulin's dance routine he dubbed it the Quadrille Realist or Naturaliste. But whatever the name, Vaucaire was clear on one point: its greatest exponent was the twenty-year-old Louise Weber, universally known as *La Goulue*, 'The Glutton'.

A sketch of the Taverne de Bagne with the 'prisoner' waiters.

The names of these women did not lack an odour of vulgar poetry: La Goulue, The Glutton, Grille d'Egout, The Sewer Grating! The one thin and nervous, laughing delicately and mysteriously; the other pudgy, with an immobile face, proud of her mission of stuffing herself.

The men who served as partners, facing these girls, dressed in provincial calicoes, pirouetted with them, lifted them up, as if to say to the public: 'Here are our women, they are of the people, we are their true mates, they will always return to us.'

The article was published in the *Paris illustré* of August 1886 accompanied by an illustration entitled *La Quadrille naturaliste aux Ambassadeurs* (The naturalist quadrille at the Ambassadors) by the painter Jean-François Raffaeli that shows La Goulue and Grille d'Egout, legs held up in the whirling high kick, which was one of the central features of the performance, partnered by two male dancers one of whom is recognisable as the ultra-

159

skinny, amazingly supple figure of Valentin le Desossé or Valentin the Boneless. Raffaeli was not the first to depict the new dance in action. Dance-hall scenes had been a stock part of popular illustration since the 1830s when an early form of the high-speed polka had started up among left-bank students at the Bar Bullier, or the Bull-Park as they called it in the already fashionable mock English. The Bullier was a dance hall built in the old pleasure gardens the Closerie des Lilas at the end of the Jardin du Luxembourg near the Boulevard Montparnasse and thus close to many of the university departments. But while that student 'can-can' had been pretty rough and wild, by the time it reached Montmartre and La Goulue it had become a little more refined and erotic. Raffaeli's drawing, like Vaucaire's article, was the first to capture the atmosphere of seduction and voyeurism that enveloped the dancers and spectators and the first to single out individual performers for particular note. With the article and the picture, a star was born and as with such figures today, it was a birth that passed rapidly out of the realm of truth into one of pure fantasy. Where Vaucaire's piece was an honest attempt to convey the underlying reality of the quadrille and those who danced it, an age of yellow journalism was bound to find a sexy creature like La Goulue too tempting a subject to be left to mere theorists. A year earlier, in 1885, she had already featured in *Mon petit homme*, a novel by Emile Bonnetain, which described how 'dressed like a dairy maid' she 'bounded about like a little goat with the noise of her milk can clinking at each movement', and by the end of the decade she was a regular subject for newspaper profiles, which dutifully recorded her by then fanciful version of the life of a poor little working-class girl brought up in run-down Clichy by her laundress mother, taught to read by nuns before poverty drove her into that marginal world of the laundrymaid, flower-seller and small-time prostitute that ended with her miraculous success as a dancer. It was a scenario – rags to riches, obscurity to fame – familiar to readers of popular newspapers today, and then as now it emphasised the magical and the accidental at the expense of the tough ambition that was probably the real cause of her success. At this distance it is hard to unpick fact from newspaper fiction but the little we know reveals a life that, while not radically different in factual detail, can certainly be set down with a different emphasis.

In reality Louise was born not in Paris but in Lorraine in 1866, only arriving in the capital in 1870 when her family fled to avoid the invading Prussians. Her stories about being dance crazy from an early age, going to her first communion in a pair of dancing shoes left for cleaning at her mother's laundry by a trapeze artiste from a local circus, or borrowing the

customers' clothes to go to the nearby dance halls could well be true. It was a practice she claimed to have continued once she began work as a laundress herself, in the same rue de la Goute' d'Or featured in Zola's *L'Assommoir*, Bruant's song and Lautrec's drawing. By her own account she lost her virginity to a soldier when she was only thirteen and had a subsequent affair with Renoir when she briefly modelled for him. She claimed to have started dancing in her milkmaid's outfit at the Grand Vefour, where old men stuck gold coins in her hair, though this was probably an invention as she varied where her career began depending on her mood. Sometimes it was the Elysée-Montmartre or the Boule Noire, sometimes the Moulin de la Galette or the Jardin de Paris – she even turns up at the old Bar Bullier in one undated piece. The most likely story is that she started up at the top of the Butte at the Moulin de la Galette, still then an exclusively working-class place and open to anyone wanting to get up and show off, before moving down the hill to places like the Elysée-Montmartre where the performers were already recognised as embryonic stars.

This would fit what was clearly the underlying thrust of her career which was far from the accidental fairy story she and her journalist hagiographers chose to perpetuate. In reality Louise Weber was driven by open and unalloyed ambition and it is clear that from a very early age she had not the least intention of remaining a laundress. Even her remark about the soldier who took her virginity at thirteen, 'they bring you luck you know', does make you wonder who seduced whom!

Dance halls like the Elysée-Montmartre offered ambitious working-class performers a chance to show their talents. It was a novel situation – earlier performers who rose from the ranks of the proletariat did so by submitting themselves to the rigorous training needed to master an established art form, spending years learning to dance the formal routines of classical ballet, or sing the rigid musical forms of grand opera. Dancing the quadrille was something new, self-invented and highly individualistic with any lack of finesse covered by a veneer of robust sexiness. The quadrille was athletic, fast, crude and noisy, a people's show, totally removed from the refined perfection of the high arts that had once been the only route out of the slums for the few with an exceptional natural talent and the luck to find someone to support them while they learned to apply it. This was a democratic culture open to those with energy and ambition. Louise Weber had plenty of both.

It is not hard to see why Lautrec should have been drawn to this dynamic little figure as soon as he saw her perform. Her red hair would have been part of it, as well as her undisguised sexiness, for La Goulue knew just how

to wiggle her prominent behind and her arrogant, even tetchy, manner only added to this image of a petulant, spoiled child who might be capable of any kind of excess. But for Henri, it clearly went beyond the image that her admirers fantasised about. His interest in her was as much to do with her background and her own reaction to it. When he first saw her Henri was just beginning the process of illustrating Bruant's songs, many of which featured the helpless female victims of a disordered urban world, yet here was just such a figure who seemed to show that you needn't be a victim, that with enough will and energy you could rise above the general ruck and make something of yourself. At the Elysée-Montmartre, La Goulue was still an amateur, unpaid by the management and forced to accept advances from her gentlemen admirers if she wanted to make any money from her show, but it was *her* show. The management were beginning to realise that the crowds were now coming expressly to watch her. At the height of the quadrille, with her leg in the air, Louise Weber was not a greedy little laundry girl that you could have for small change, she was a queen, and that is the image Lautrec chose to make of her in his first dance-hall painting: *La Quadrille de la chaise Louis XIII à l'Elysée-Montmartre*. Although the composition owed much to Raffaeli, with La Goulue and Grille d'Egout high-kicking at the centre and Valentin going into one of his rubbery contortions at the side, Lautrec's version is significantly different in not concentrating solely on the dancers. Raffaeli had placed his group in the centre foreground but Lautrec chose a broader view of the dance hall with the show taking place in the middle distance, surrounded by a watching crowd, as if Lautrec wants to show that this was not just a performance, it was also a shared social event. Some of the spectators can be identified – Anquetin and Gauzi in the right background along with Bruant in his famous wide-brimmed hat, an arrangement that would clearly be the basis for the left-hand panel for La Goulue's funfair booth. In both works we can see the new conductor of the Elysée Orchestra, Louis Dufour, just appointed that year, wildly waving his arms in time to the music, while in the foreground, back discreetly turned on the dancers, is the unmistakably bewhiskered face of Coutelat du Roché, a mildly comic character hired by the management to forestall any threat of intervention by the police, by acting as an inspector of the performance. Put simply, Du Roché's role was to peer up the dancers' skirts as they made their high kicks to ensure that they were wearing knickers – not always the case! But while earning himself the nickname Père la Pudeur, or Father Modesty, the inspector was pretty easy-going and had a habit, as Lautrec shows, of looking away at the crucial moment.

In 1886 when he painted the *La Quadrille de la chaise Louis XIII* it was just another work done for Bruant and only with hindsight can it be seen as a turning point, his first work linked to the new world of popular entertainment that was opening in Montmartre, rather than the studies of poverty and crime based directly on Bruant's songs. He was still making Bruant works, but from then on there were other obsessions – his '*furias*' or passions as he called them – running in tandem with them.

It is, however, too easy to see them as two quite separate activities – on the one hand the harsh, 'committed' Bruant works, on the other the lighter entertainment pieces. Too easy as well to proclaim that the Bruant works were a passing interest of his late student years, a short-lived dabbling in fashionable naturalism before finding his true subjects in the world of popular culture. In fact, Henri's preoccupation with the new showbusiness was as much driven by his interest in the working-class performers who created it, as in the surface glamour it offered. Through the late 1880s one senses him casting about for a way to depict this world, for a subject that would convey something of the tense atmosphere, the edginess both in terms of the 'act' being done and in social terms, between the performer and the audience. For a brief time he made studies of the ballet, usually of dancers backstage in the manner of Degas, or rather of Degas as processed by Forain. But while he would occasionally return to the subject, one does not get the impression that this world where working-class girls were trained almost like performing animals for the entertainment of their betters, was really his sort of subject and it is hardly surprising that he preferred those entertainments where the self-trained performers could transform themselves into stars. If one adds to that his continuing love of horses, then it is easy to see why he left the refined world of the ballet for that of the brash and colourful circus.

Although his circus works date from 1887 we know that he was thinking about the subject a year earlier because he asked the Venetian-born artist Federigo Zandomeneghi if he could suggest a suitable model, someone who would look the part of an equestrian performer. He had become friendly with Zando in 1886 when he rented a studio in a building at the corner of what was then 27 (today 21) rue Caulaincourt and 5 rue Tourlaque. This was to be his permanent workplace for the next two years. His fellow student François Gauzi soon joined him, renting the studio opposite, so that the two saw each other constantly. Henri had a large room on the third floor where he could work on ever larger canvases and entertain friends and in the end he was welcoming almost anyone who knew about his Friday-night open parties. These were often drunken affairs, with Henri mixing lethal cocktails

while singing Bruant songs and generally enjoying being the ringmaster even if, as Gauzi noted, some of the strangers and hangers-on were laughing at him behind his back. The block was on one of the steep streets running up from the Place de Clichy and was surrounded by other artists' studios so that Henri was soon friendly with some of his neighbours. He was drawn to Zando partially because he was one of those painters who hovered on the fringes of Impressionism and knew most of the major players but also because he was a hunchback who masked his feelings with a show of flamboyance, sporting a musketeer's cape and arguing in a loud voice whenever he joined a conversation. The two got on well and Zando appears to have given Henri some useful advice, especially over the use of Japanese techniques such as overhead viewpoint, abrupt foreshortening and dramatic cropping.

When Zando heard that Henri was looking for a model, and a redheaded one at that, he recommended a young woman he had been using who lived in a small apartment that she shared with her mother and son downstairs from Henri's studio. She called herself Marie-Christine and had been a performer at the Cirque Molier until a riding accident forced her to leave, after which she began modelling for artists like Zando and Forain. Indeed, Henri may well have recognised her, for she had posed for Puvis de Chavannes and was said to have been used for all the figures, male and female, in the *Bois Sacré*. There were also social occasions when they could have met – they were both present when the police raided a wild party given by Anquetin back in 1882 and there were plenty of student dances when they could have seen each other. If so, then he would certainly have remembered her. She had an elfin quality that was more intriguing than classically beautiful. She was the exact opposite of Carmen, a natural redhead but also in no way docile – Marie-Christine was fiercely independent, a trait that was to cause Henri much suffering.

It was entirely appropriate that she was born in 1865, the year Manet's *Olympia* provoked such a scandal with its representation of his model Victorine Meuret posed as a defiant courtesan, proudly staring back at her observers – the same attitude Marie-Christine was to adopt when she took up modelling, flatly refusing to be typecast as the available artist's plaything. That said, we know more about Victorine and her painted persona Olympia than we do about Henri's new model who was either an inveterate liar, or an excessively reclusive person who felt an overwhelming need to protect herself in a male-dominated world. Even her name was variable. Some documents gave it as Suzanne Valadon, with her date of birth as 6 June 1867,

though she was originally named Christine Valadon and was actually born on 23 September 1865 near Limoges. The reason for the confusion was simple: she was illegitimate and would never know her father at a time when this was considered shameful. It was the reason why her mother, a cold, unloving figure, moved to Paris while Marie-Christine, as she was now called, was still a baby; it was the cause of her childhood poverty and her early attempts to escape into fantasy through drawing. Real life eventually intervened with the usual succession of poorly paid, grindingly hard women's jobs in that fragile urban subworld where prostitution was an ever-present reality. She was an apprentice in a dress factory, a florist's assistant, briefly in Molier's Circus until the accident forced her to leave, then an artist's model with all that implied. No need to ask why she looks so edgy in her photographs nor why she found it so hard to accept love on the two or three occasions when it was genuinely offered.

But unlike the countless others in that subworld, Suzanne Valadon, as she finally chose to be known, had no intention of being imprisoned by fate. When she began posing for Puvis de Chavannes, she studied him as much as he her, determined to learn from the artist she would later acknowledge as her most important teacher. Not that he volunteered for the role. Puvis had no time for women artists and offered no encouragement whatsoever. He slept with her, of course, that was partially what she was there for, and she seems to have accepted this side of her life with a stoical indifference that easily, and perhaps understandably, slipped over into the manipulative. If that's what they wanted, then she would use it to her advantage. She slept with her next 'teacher' Renoir until his official lover and future wife Aline Charigo realised what was going on and insisted her own face be painted over that of the now dismissed Marie-Christine's in the ravishingly beautiful *Danse à la Campagne*, though by then she had already danced in several Renoirs: *La Danse à Bougival* (1883), *La Danse à la ville* (1882–3), as well as posing naked for one of his monumental bathers. But despite their affair, Renoir was no more encouraging than Puvis had been; 'You too?' being his sole comment when he found her drawing one day. His only lasting influence on her was his insistence that she always wear the fussy little hats then in vogue, complex millinery flummery perched forward on her head as if a bird had just landed, an appendage that Renoir seems to have found irresistibly titillating and which she obediently continued to wear long after their separation.

In any case, even if Aline had not intervened, Marie-Christine could not have gone on modelling as she was by then pregnant. It was only much later

that a Spanish journalist, Miguel Utrillo i Morlius, was identified as the father and gave his name to their son, the future painter, Maurice Utrillo. It had been an unusually passionate affair which ended when Miguel returned home just before the boy was born, an event that has often been written up as the most important element in the mother's life, though at the time she was forced to let her own mother take care of the child so that she could continue modelling in order to keep them all. Inevitably this has been portrayed as the act of a selfish harridan – bad mother equals bad woman. Even her son's alcoholism and early death would be laid at her door despite the fact that her drawings reveal an almost ethereal tenderness for the little boy, a sentiment that would have been very hard to fake. But at the time no one saw these works – after the callous reactions of Puvis and Renoir, Marie-Christine, as she was still known, felt little need to expose herself to any further male ridicule.

It is easy to see why Henri would fall in love with her once she had begun to pose for him, though surprisingly the affair was not entirely one-sided. Marie-Christine liked going out, the night-life of the Butte had a strong appeal and he was the ideal companion for the evening round of the Chat Noir, the Mirliton and the other new amusements that were springing up around Pigalle. The fact that he was an aristocrat and, so she assumed, rich, went some way towards compensating for his physical drawbacks. In any case she wasn't accustomed to sleeping with men for their looks, so it made little difference. For Henri, however, it went much further than gratitude. For the first time in his life love and sex had come together, a heady, irresistible and ultimately dangerous combination that he would live to regret.

In 1887 Henri left the Greniers and moved into an apartment in the neighbouring building at number 19 rue Fontaine, belonging to his friend Henri Bourges. He would stay with Bourges until the doctor married in 1893, an arrangement that provided Henri with a more permanent and settled existence than his former, somewhat peripatetic life, camping for extended periods with various friends. The move would also have made it easier for Bourges to continue treating Henri's syphilis. The doctor was by then an intern at the Bicêtre Hospital where he eventually became a respected consultant at one of the first centres dedicated to the treatment of incurable diseases. Not that the institution had had an entirely glorious history, since it was chosen in the middle of the seventeenth century to be one of the two hospitals charged with supervising the beggars who were regularly rounded up on the Paris streets – Bicêtre got the men, La Salpêtrière the women in a campaign for social control that eventually extended to attempts

A nude photograph of Suzanne Valadon taken during her modelling days,
possibly one of a series of erotic tableaux (Musée de Montmartre).

to regulate the spread of venereal diseases by effectively incarcerating prostitutes in what became hospital prisons. Underfunded, overcrowded, the Bicêtre became synonymous with filth and indifference bordering on savagery – Mirabeau compared a visit there to observing Negroes on the Middle Passage, though by the time Henri Bourges joined the institution it had been radically overhauled as ever-increasing attempts were made to understand and treat all the venereal diseases, syphilis in particular. Bourges himself worked in the more general field of contagious diseases and throughout the 1890s published a number of books and tracts on a range of illnesses, from diphtheria to scarlet fever. By the time he wrote his major clinical monograph on the plague in 1899, he was head of the Hygiene Laboratory at the Paris Faculty of Medicine and had been appointed *auditeur*, or spokesman, for the National Consultative Committee on Public Hygiene, though there is no doubt that his most influential work was *L'Hygiene du syphilitique*, a study that some have assumed arose from his having treated his friend's malady over a number of years, when in fact the treatment of syphilitics was just a normal part of his clinical practice.

Although no cure for syphilis had yet been found, by the 1880s considerable progress had been made in defining and understanding the disease, most notably the studies of Dr Philippe Rocord, which eventually led to the discovery, in 1838, that syphilis and gonorrhoea were separate illnesses, and opened the way to the successful treatment of the latter. By contrast, whatever syphilis might be, its opponents came to respect its cunning as it carefully hid from legions of researchers, coming to the fore only to disprove anyone foolish enough to claim that they had discovered its secrets.

Just after Henri moved in with Bourges, he gave the clearest proof that he was suffering from the dreaded malady when he wrote to his mother to tell her that he had contracted *la petite vérole* (smallpox) which is, he says, 'the blemish on anything'. In fact there is no evidence that he suffered from smallpox, indeed he had been vaccinated against it on several occasions, leaving his readers to assume that he was really referring not to 'small' pox but to *la vérole*, the pox itself. It may seem aberrant that he should so thinly disguise the truth in a letter to his 'saintly mother', as he often referred to her, but it was not uncommon for victims of the disease to experience an almost irrepressibly light-headed sensation of relief that the inevitable had happened and that they need no longer live in fear that it might. When Guy de Maupassant's hair began to fall out and his doctor finally told him the truth, the author wrote to a friend in ecstatic vein:

. . . at last! the real thing! not the contemptible clap, not the ecclesiastical crystalline, not the bourgeois coxcombs or the leguminous cauliflowers – no, – no, the great pox, the one which Francis I died of. The majestic pox, pure and simple; the elegant syphilis . . . I've got the pox . . . and I am proud of it, by thunder, and to hell with the bourgeoisie! Allelujah, I've got the pox, so I don't have to worry about catching it any more . . .

De Maupassant goes on to make clear that, as some of those who would be infected with AIDS a hundred years on would do, he is in the process of 'avenging' himself on the world by deliberately infecting others: '. . . I screw the street whores and trollops, and afterwards I say to them, "I've got the pox". They are afraid and I just laugh.' At least Henri, with Bourge's help, was doing all he could to prevent that grim scenario, though there was little or nothing he could do to save himself, as he well knew. On one embarrassing occasion, Adèle brought a priest home to give her son a moral lecture in the hope of persuading Henri to moderate his behaviour. In the end, the unrepentant sinner silenced the visitor with a simple, ' . . . don't worry, I'm digging my grave with my cock.'

By moving in with Bourges in 1887, Henri was also signalling that his affections had passed from Lily Grenier to Marie-Christine who now became the hostess at his dinner parties. As 1887 was also the year when Cormon, following a resounding success at the Salon, finally gave up teaching and closed his atelier, this marked the point where Henri was fully on his own – a professional artist without anything or anyone to prop him up.

Marie-Christine Valadon was to be Henri's model and his lover for three years, though in both cases it is often hard to be certain where exactly she appears. She never admitted their physical relationship, which was clearly a fairly loose affair mainly carried on when they were working together, though it is well enough documented by others. She was in any case a difficult woman and their encounters could be stormy and any hope of permanence or fidelity groundless. Gauzi records that she was an unreliable model who often failed to turn up or who would suddenly appear in Henri's studio when she needed some peace because her own apartment with her mother and little Maurice was too claustrophobic. As for the paintings Henri made of her, they too are often ambiguous as he seems to have used her as the basis for some figures without always making an exact portrait, much as Puvis

had done for the *Bois Sacré*. She is probably the original for more figures than we can precisely identify, though there are sufficient recognisable images of her to show how important she was to him in the years from 1886 to 1889 when their relationship was at its height.

Although the circus had been on his mind when he asked Zando to recommend a model, this was set aside as soon as he met Marie-Christine and realised that her looks and her background made her the ideal figure for the Bruant series. At first he used her alongside Carmen but within a year she had replaced the original redhead as his main model. As before, he began by using her for the afternoon, open-air portraiture sessions. One shows her primly dressed, sporting her trademark Renoir fancy hat, the epitome of bourgeois respectability strangely at odds with her noticeably over-powdered face that suggests a night creature that has somehow stumbled into the sun-lit daytime world. The biographer Julia Frey has suggested that Henri's garden models seem to look back at him somewhat suspiciously, as if they do not quite trust him, as if they know he will exaggerate any signs of age or show up the grimmer effects of life's hardships. Even Marie-Christine was not spared this treatment. When he first used her for one of the Bruant song series, *A Grenelle*, and for the *Artilleur et femme* series, he made her a sad-faced old whore, alone at a café table, weighed down by her past, the first example of a trait that would dominate his portraits from then on, a tendency to show his subjects not quite as they were then but as they would be one day. These images of Marie-Christine, alone and remorseful, eerily prefigure the hard, sad-eyed photographs of her in later life, long after Henri was dead. Indeed, his paintings unnervingly prefigure her eventual decline. The strangest, the more so for being the most recognisably accurate portrait of her, is *Poudre de riz* (Rice-powder) painted in 1877 which shows her again seated alone at a café table with a container of rice-powder in front of her. Rice-powder was then the most commonly used face cosmetic, so fine it had to be applied before the final stages of dressing lest the user cover her clothes with fine dust. No one would have used the stuff in public and by proposing the possibility of a woman at a café table, about to powder herself, Henri carefully confuses the public and private worlds, the kind of sexual ambiguity that lay at the heart of Montmartre's success as a place where the normally unbreachable division between the boudoir and the street was effectively shattered. In the picture, Marie-Christine sits at the café table in a short white blouse that could be a bodice, echoing a verse from Bruant's 'A la Bastille':

Pour eun' thune a'r'tir son châpeau,
Pour deux thun' a'r'tir son manteau,
Pour un sique on la déshabillé,
 A la Bastille.

For a five-franc piece she takes off her hat,
For two of them she takes off her coat,
For twenty francs one can undress her,
 At Bastille.

Henri had originally interpreted the song with Jeanne Wenz as his model for the Jewish girl; now it was Marie-Christine's turn. When an artist uses his mistress as his model he clearly conflates the private and public worlds, which was of course the very subject of the painting. And this desire to 'show-off' a woman as his mistress, to tell the world that he, an unattractive dwarf, had achieved the seemingly impossible may well have been an essential element in his feelings towards her. According to Gauzi, their relationship was far from straightforward. Male friends sometimes resent the arrival of a woman in the life of one of their number so we must be cautious of Gauzi's memories of Marie-Christine, who is seldom presented in a good light. But even allowing for his antipathy, it is clear that she did not bring out the best in Henri who until then had repressed the streak of upper-class cruelty that often emerged in his father's relations with women, especially his wife. Gauzi records how Henri was giving her dinner at his apartment one evening, where they were served by Dr Bourges' housekeeper Léontine. While Léontine was out of the room preparing the dessert, Henri told Marie-Christine to undress to see what the woman's reactions would be. Marie-Christine readily agreed, stripping down to her shoes and stockings which were hard to remove and were in any case hidden beneath the table. When the servant returned there was a slight movement of surprise but she went on serving in silence. The next day, however, she complained to Bourges who gave Henri a dressing-down for insulting someone who was in no position to defend herself, pointing out that their housekeeper was an honest woman with a right to be respected. Sadly, Henri chose to defend his feeble joke by insisting that Maria, as he often called Marie-Christine, had been hot and needed to cool down and while Bourges quickly forgave him – people usually did – it was a bad omen and a precursor of even worse behaviour to come.

 Henri's dilemma, in some ways his punishment for this sort of unthinking rudeness, was his awareness that the inverted morals of his profession, which

made Marie-Christine instantly available to him, made her equally available to anyone else who chose to hire her. Which is no doubt why he struggled to find excuses to paint her. He even reworked one of the earliest Bruant pieces, *The Laundress*, modelled originally by Carmen, but now, showing Suzanne walking down a street carrying a basket of finished ironing to a customer – a scene more reminiscent of Degas' laundresses at work than the earlier depictions of the exhausted Carmen resting in a moment between her labours. This new laundress also has echoes of the streetwalker in *A Montrouge*, in the way the young woman crossing the busy road, her pannier slung over her left arm, is just another available female haunting the city's streets, a figure out of *L'Assommoir* by Zola. Yet despite those obvious connections, this portrait of his mistress is in a different vein from his previous efforts – for once she is allowed to be young and beautiful, tender and gentle, though by then he must have known that such qualities were not the predominant elements in her character.

According to Gauzi, Henri went downstairs to her apartment one day and caught her busily sketching, whereupon she finally revealed her ambition to be an artist. Unlike his predecessors, Henri took the trouble to actually look at what she was doing, trying to see it without the sort of prejudice that has bedevilled her reputation down to the present day where praise is still withheld for other than artistic reasons. Behaviour that in a male painter would have been treated as acceptably bohemian has, in her case, been labelled vulgar or callous. Part of this came from her refusal, after joining the Union des Femmes Peintres et Sculpteurs, to play the feminine role. Unlike her contemporary, Marie Laurençin, whose soft pastel pieces were thought to be just the sort of thing a woman ought to be doing, Suzanne Valadon, as she became, chose a style normally reserved for male painters – surrounding her figures with hard black outlines somewhat at odds with the shaded brushwork within, but at least offering a forcefulness traditionally absent from self-consciously feminine art. Occasionally, in her forthright double portraits, especially her studies of mothers and children, this hard, cut-out quality can be very powerful, though when applied to inevitably gentler subjects, a still-life, a vase of flowers, the results can be over-dramatic. But if anything is feminine about Suzanne Valadon's art, it is not some male cliché about pastel softness but her choice of subjects: she almost completely excludes men from her canvases. Her paintings are concerned with women: herself as a child with her mother, or as a mother with her own child, her women friends and relations or women models, hired as *she* was, though at least spared the sexual advances they could have expected from a

Suzanne Valadon as the laundress, 1888.

male artist. All are solid, independent figures, though they are better realised in her drawings where her style is a good match for these sturdy beings. Interestingly, she achieved her most satisfying effects in her studies of children, often her son Maurice, the one male figure to occur frequently in her work, mostly during the 1890s, before he grew up and embarked on a life of spectacular self-destruction.

But while these studies were her most rounded creations, friends and dealers despaired of ever having this recognised because of her utter indifference to promoting herself or her art. Not that she had much chance, struggling to cope with a drunken mother and an alcoholic son. Her attempt at a conventional bourgeois marriage collapsed, a long affair with a much younger man ended miserably and only Maurice's eventual success, artistic and financial, brought any relief from a catalogue of misery. Unsurprisingly, time has not been kind to her reputation, leaving her a minor figure on the fringes of the great artistic turmoil that swept across the *fin de siècle* and on into the new century. It is a judgement that also ignores her other indisputable claim to fame: the fact that she was the only figure of that epoch to have been portrayed by several of its leading artists, while at the same time having studied and portrayed herself. This offered her a unique chance to stand outside the solipsistic view that most of us have of our own physical appearance. Puvis de Chavannes moulded her into a Classical bust, Renoir saw sweet girlish innocence on a first date, Lautrec chose to look into the future at a sad hung-over figure, hunched at a bistro table. But Suzanne Valadon herself saw a tough character with raised jaw and wary eyes when young, gradually transformed into an old woman who has seen too much even if her naked breasts are still firm and appealing. It was an audacious gesture to paint herself naked in her sixties, a slap in the face for all those who had treated her as no more than a living version of the jointed wooden dolls used by artists to block out their figures while saving money on models. Significantly, in one of her most successful paintings, she shows herself as a teenage girl with the breasts of which she was so proud, already well developed, sitting on a bed being dried-off by her mother after a bath. It is the details that tell all: the girl is so preoccupied with her own reflection in a hand-mirror that she ignores the fact that her little doll, her child, its hair tied with an identical pink bow to the one on her own head, has fallen to the floor where it lies splayed in a forgotten heap. June Rose, a rare biographer of the artist, sees this as a 'telling' psychological study that shows a mother explaining the physical changes brought on by puberty to a young girl who stares into a hand-mirror, searching for some reflection of her new self, while

the forgotten doll symbolises her lost childhood. At another level, we can see the girl as the embryonic artist, so gripped by the act of looking that even the maternal instinct, usually directed towards her doll, is not strong enough to distract her.

Given the indifference of Puvis and Renoir, Henri's sympathetic attention to her early attempts must have impressed her greatly, though she was far too taciturn to admit such a thing. Henri is said to have introduced her to Degas some time in 1887 whereupon the older man became her mentor, helping her with her engravings and persuading the dealer Ambroise Vollard to give her a first solo exhibition – something Degas was never to do for Henri, about whose work he continued to be noticeably offhand. For his part, Henri treated Suzanne the artist as a colleague and after completing one of his outdoor portraits of her, wrote on the canvas: 'Madame Suzanne Valadon, Artiste-Peintre' (Mrs Suzanne Valadon, Artist-Painter), according her the double status of respectable married woman and professional artist. He was the first to do so and she cannot have been other than grateful, though as the portraits reveal, Henri's responses to her were not unambiguous – on the one hand she was a girl from the underclass, a victim in a Bruant song, on the other she was a strong individual with a character of her own. It was the latter that he was to bring out when he finally got round to using her for the circus picture he had been planning when they first met.

Henri had been going to the circus from his earliest childhood in Paris and often dropped in on one of the permanent troupes to enjoy the relaxed atmosphere. At that time the French circus was quite different from the rather frantic succession of variety acts introduced to the country by the American showmen Barnum and Bailey, where three rings simultaneously offered clowns, acrobats and animal trainers. The circus in France was traditionally an equestrian display, a dashing, popular version of the presentations of fine horsemanship that were put on at court before the Revolution. Such shows were leisurely, with clowns and acrobats appearing between the main acts, which usually consisted of women performing dashing athletic displays on galloping mounts. At a time when work, whether in factories or offices, was making life for many increasingly regimented, it was probably this timeless, unhurried aspect of the show that most appealed to its adherents – once he had bought a ticket the visitor could come and go as he pleased, strolling about, going behind the scenes to see the animals or chatting with his neighbours during the long intervals, only really concentrating when the tension built up for one of the more spectacular bareback performances.

The old travelling circuses were by then rather scruffy affairs that turned up every year at events like La Goulue's Foire du Trône. By contrast, the better shows had now settled into permanent homes around the city, performing for a fixed annual season. The Cirque d'Eté ran from May to October near the Champs-Elysées, and the Cirque d'Hiver near the Place de la République from November to April. Some specialised, like the spacious Hippodrome in the Avenue de l'Alma that could stage chariot races, while the Cirque Equestre Molier, in the rue Bénouville, where Marie-Christine had worked, offered extremely elegant horsemanship and put on an annual show entirely made up of upper-class amateurs like the Comte Hubert de la Rochefoucauld who fancied himself a trapeze artiste. The two most traditional were the Cirque d'Hiver, which today still shows much the same acts in the same sorts of costumes, and the now defunct Cirque Fernando which had begun as a travelling circus before settling in Montmartre in 1873 on a piece of wasteground at the top of the rue des Martyrs, then two years later, moving into a large wooden structure, where it survived under various names until 1972. Originally named after its founder Ferdinand Beert, the Fernando was the first circus the young Henri de Toulouse-Lautrec visited, taken by Princeteau, who no doubt saw the spectacle as an extension of his *animalier* interests. And that would certainly have been part of the attraction for Henri the artist when he rediscovered this delightful place in the 1880s, though he also liked to visit the Cirque Molier where some of his friends would occasionally perform – the photographer Paul Sescau played the banjo and did a mime-act for a time and we know that Henri was especially taken with the clowns, though *they* were usually professional performers.

Of Henri's surviving circus works from this period there are some preparatory sketches, a pastel and a major painting, *Au Cirque Fernando: Ecuyère*, usually known simply as the *Ecuyère*, the Bareback Rider. It is not an especially large work, about a metre high and two metres long, though its dramatic 'Japanese' composition – the way the tiers of seats sweep round the circus ring from right to left, disappearing out of frame, leaving no sense of horizon, creates an illusion of breadth and space far greater than the actual dimensions. As the title makes clear, the focus of the composition is a bareback rider, modelled by Marie-Christine, an image then frequently portrayed on posters and handbills advertising this sort of show, when a rider, wearing a ballet dancer's tutu, charged into the ring and began to circle, driven on by the crack of the ringmaster's whip, until there was enough speed for her to stand upright on her charging mount and plunge through a paper-covered

Suzanne Valadon: *The Abandoned Doll*.

hoop held up by a clown, returning to her position on the horse's back as the crowd cheered her on. It was a spectacle made doubly impressive by the restraints of the ring, whose limited size was a hangover from the days when all circuses had been travelling entertainments. Such a narrow space made getting the horse up to speed difficult though this added to the tension that built up just before the leap into space. This was why that particular moment was used on posters advertising the show with names, dates and times printed inside the hoop held up by the clown. By repeating such a well-known visual cliché, Henri was clearly placing his painting within the accepted imagery of showbusiness culture, a point further emphasised by details such as the well-off patrons in their top hats who are clearly out to enjoy this low-class romp, probably on one of the Wednesday *soirées du high-life* that the Fernando laid on. Lautrec actually plays up the element of low sexual attraction such visitors expected to enjoy, by concentrating on the ringmaster Monsieur Loyal brandishing his whip as he holds the bareback rider in a fixed Svengali-like gaze, while she simpers, a touch nervously, back at him. Where Henri depicts the male figures in the audience as stiff, formal upper-class types, his decision to slightly caricature Loyal and Marie-Christine makes them coarser and thus a greater contrast to those who are watching them. This in a sense is the true subject of the work and one gets a clearer understanding of his motivation if one contrasts his circus with a painting of the *Cirque du High-Life* by the painter of fashionable city life, James Tissot, in which he shows one of the Molier's upper-class amateur nights with the Comte Hubert de la Rochefoucauld, resplendent in bright red leotard, monocle firmly in place, seated on his acrobat's swing and watched by an elegant crowd of bonneted ladies and top-hatted gentlemen. While Henri, who clearly knew the Tissot canvas, used a similar view of the circus-ring, with similar top-hatted spectators, he carefully avoids the recreation of a refined upper-class milieu. His *Ecuyère* is a wry look at the point where the upper-class search for sensation met the working-class showbusiness world, but it is also Lautrec's touching tribute to his mistress, Marie-Christine. It is her picture, she is the star about to stun her public, that audience of stuffed dummies, when she leaps into the air with such reckless abandon. For all their wealth and social position they are dead while she is thrillingly alive.

If this were just another product of a momentary *furia*, we could leave it at that – a pleasant enough tribute to the woman he loved. But there is evidence that he intended this circus scene to have a much larger place in his growing body of work. A photograph, taken much later, around 1893, (see pages 246–247) shows Henri in his studio, working on one of his dance-hall

The Comte Hubert de la Rochefoucauld, on the trapeze, at one of the amateur nights at the Cirque Molier.

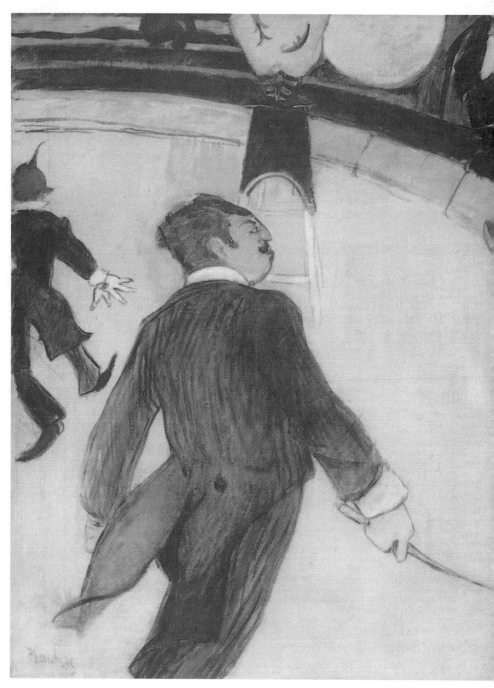

Henri's dramatic painting of Suzanne Valadon as the bareback rider.

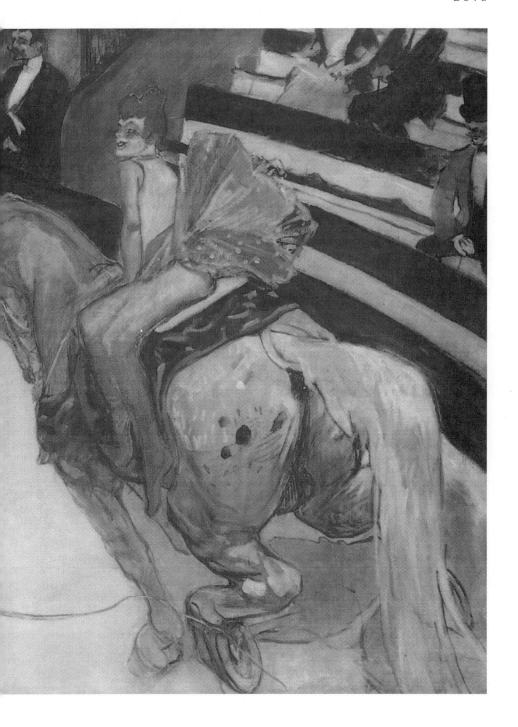

paintings but the interesting thing is a vast canvas, partially visible in the background, which is clearly a circus scene almost identical to the *Ecuyère* but on a much larger scale. Indeed a nearby ladder shows it to have been on the scale of a mural and Gauzi records that this was the only time Henri used the high steps, not the easiest thing for him to manage. This work is now lost but its presence in the photograph seems to suggest that the subject was of far greater importance to the artist than one imagines from its small-scale survivor. The sheer scale of the *Missing Ecuyère,* as it is usually known, is enough to show that he was planning a monumental piece on the heroic scale of much Academic painting, a scale abandoned by the early Impressionists. Zola's novel *L'Oeuvre* deals with a painter, Claude Lantier, and his failure to produce just such a large-scale painting and we know that Anquetin tried something similar with a painting entitled *Chez Bruant,* which is also missing. Away in the South Seas, Gauguin too was increasingly obsessed with mural-size panoramic scenes of his Polynesian fantasy world but only Lautrec seems to have attempted a Realist work on such a scale.

Why he should have wanted to make such a 'loud' statement may be due in part to things that can be read into the making of the work rather than what is actually there on the canvas, for it is obvious to those who know something of Henri's life that the *Ecuyère* bears some relationship to his *animalier* past. The charging horse has obvious correspondences with his childhood pictures of his father driving his mail coach, though in the circus scene the genre has clearly been turned on its head – instead of the count amusing himself at one of his aristocratic country sports, we have his son's mistress in a skimpy costume showing off her skills in a place of freaks and clowns and animal odours, with an air of sexual possibility, where low-class performers dominate the scene and where the upper-class spectators are stuffed dummies. With this in mind, the true subject of the painting is the contrast it proposes between the world Henri had rejected and the one he now chose to inhabit.

His relations with his family support such a reading. Outwardly little appeared to have changed. Adèle still came to Paris, if less frequently, and he still dined with her or his father and uncles every night whenever they were in the city, though by then this was something of a formality, with him leaving for his late-night haunts as soon as the meal was over. While he spent part of his summers with his mother at Malromé, the south of his childhood was no longer such an important part of his life, though he did spend the Christmas of 1888 at Le Bosc with his grandmother and his cousin Gabriel Tapié de Céleyran who was studying medicine at Lille in the north of France.

Part of Henri's problem with his family was his need to keep from them his increasing reliance on alcohol, so that it was hardly surprising that he could only be close to those younger male relations who themselves enjoyed a somewhat louche metropolitan existence and could be relied on to be discreet. Gabriel, a tall gangly youth, whom Henri liked to tease but who remained unflinchingly affable and loyal, was first in this regard but there was also Georges Séré de Rivières, an uncle, though with only fifteen years between them, more like another cousin. 'Uncle' Georges was a judge who lived with his family just outside Paris but was happy to go on drinking binges with his nephew towards whom he became a sort of unofficial guardian, negotiating with Adèle and Alph to get Henri's allowance increased and thus help replenish his frequently overstretched finances. Hard-working and well organised in his studio, other aspects of Henri's life were a mess and he was lucky to have Henri Bourges to manage their accommodation while his loyal housekeeper Léontine took care of his day-to-day needs.

Drinking aside, the other factor that distanced Henri from his family was his art, whose flagrantly low-life subject-matter and obvious anarchist sentiments was hardly likely to please. When at 'home' he confined himself to safe portraits and if his work had remained as unrecognised as that of Van Gogh, he might have been able to sustain this double life, but this was now in danger as he began to enjoy a quite astonishing success, both in having his work exhibited and in getting it sold. Bruant's decision to hang the paintings at Le Mirliton was just the first of a series of very public showings but in 1887 Henri rather riskily chose to have his first exhibition outside the capital, in Toulouse itself, an event which caused his grandmother considerable concern lest he disgrace the family name. In fact, Henri went to great lengths to carefully censor what was displayed and sent south nothing that could reveal his Montmartre excesses and when a local critic attacked the avant-garde style of the somewhat bland works, his grandmother was furious and leapt to Henri's defence like a tigress defending her cubs.

Yet despite these contacts, there can be little doubt that relations were not as they had been, in large measure due to his affair with Marie-Christine who was hardly a candidate for marriage that his family would have chosen. Not that there was much chance of such a thing, given Marie-Christine's unreliability. That their relationship was doomed from the start must have been obvious to everyone except Lautrec himself, though just as we know little of their lives together so it is hard to be certain when it ended. Despite Gauzi's later claim that it came to an abrupt finish, there are ample signs

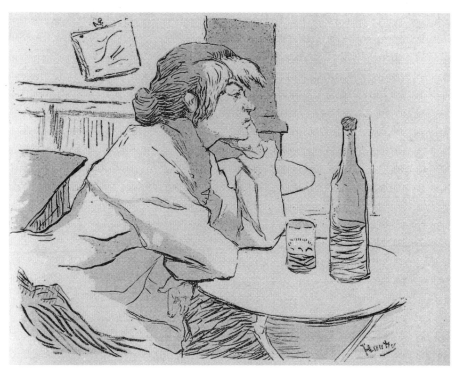

Gueule de Bois (Hangover), Henri's most devastating image of Suzanne Valadon.

that Henri went on seeing her long after the physical side of their relationship was over. Given the narrow world of Montmartre it could hardly have been otherwise but as 1888 was the last year that he seems to have used her as a model, it is reasonable to suppose that it was some time around then that the lingering crisis came to a head. The two works that feature her in that year are so wildly different, they could almost represent symbolic poles in their stormy relationship. As the young laundress hurrying along the road, her heavy basket over her arm, Valadon is the ethereal, sad-eyed, hard-done-by Parisian *mignonette*, the eternal victim, at the mercy of every male *flâneur*. But in a final group of works showing her at a café table, she is both a stony-faced fallen woman and a pitiable wreck, depicted in a way that seems almost accusatory. The title, *Gueule de Bois* (Hangover), says it all. There was a preliminary pastel sketch, then a painting and a final drawing most likely begun early in 1888 and showing her, head on hand, as the solitary drinker – a bottle of red wine and a glass on the now familiar bistro table, as she stares into eternity weighed down by the effects of the previous night's drinking and contemplating the first gulp that will bring her back to

life. While this is not based directly on a Bruant song, it clearly owes much to the lyrics for songs such as 'La Grenelle' and 'A Batignolles', though it was a subject that appeared frequently in the press, in articles that agonised over the problem of women's alcoholism, a by-product of harsh urban conditions and the new, unprotected solitude that enveloped many young women when they arrived in the city. Behind this apparent concern for the well-being of these newcomers lay the unspoken male fear of women behaving like men – that is to say badly. The idea that women might be as interested in sex as they were was deeply worrying to many men and allied to this was the fear that women might also move out into the public world of the bars and cafés, drinking alone, out of male control – all of which is embodied in that image of Marie-Christine's 'morning-after'.

It was to prove a disturbingly prescient image, for while drink was not a great problem for her personally, the early alcoholism of her son Maurice was to have a terrible effect on her life. At the time it was painted, *Gueule de Bois* represented something of the artist's life with his model, for if anyone represented the new uncontrollable woman of male *fin-de-siècle* fears, it was Suzanne Valadon. Gauzi, who admittedly was strongly opposed to her, recalls how Lautrec once called on him in some anguish because she had again disappeared – he'd suggested she pose for Forain but she had never turned up and had simply gone off, presumably with someone else. Gauzi suggests that this was not an uncommon occurrence, though it always distressed Lautrec.

When it came, the end of their relationship may have been the reason why Henri abandoned the large version of the *Ecuyère*. Gauzi, perhaps to protect his friend from further ridicule, records that the reason he gave up was due to a problem with another of the models – he had managed to get a real clown from the Cirque Fernando to pose for the picture but when the circus closed for the summer on 12 June the man simply disappeared. By the time he was available again, the artist had lost interest. According to Gauzi, the canvas hung untouched in the studio for two years until Henri got his old friend Maurice Guibert to fill in some of the background, which he did somewhat like a house painter with large flat swathes of paint. After that there was nothing to be done except roll it up and forget it. Yet such lack of concern for what was intended to be a major work does seem a trifle offhand, even for one as capricious as Henri, and the possibility that he was no longer able to go on because the main subject of the work had left must be considered. Suzanne Valadon, as the world now knows her, had had a remarkable effect on his art – she had stimulated him to continue the Bruant-related

185

works when he might have dropped the theme in favour of other interests, and she had almost inspired his first major large-scale work. Understandable then, that her departure would make it impossible for him to go on with something of which she was the central feature.

Gauzi's account of the final act of their affair leaves us in no doubt that it was a shattering experience for his friend. Things came to a head when Gauzi again found Henri at his door, begging him to come and help as 'Maria' was trying to kill herself. The two of them ran as fast as Henri's 'wretched legs' would allow, down to the Valadons' apartment but as they waited at the door they heard her mother berating her for having failed to get Henri to propose:

'You've really done it now,' the mother was saying. 'He's taken fright and will never come back – then where will you be?'

'He wouldn't play ball,' the daughter replied. 'And I used every trick I knew!'

'You could wait a bit longer . . .'

At this point in the drama, Gauzi has Henri enter the room whereupon the two women fall silent.

'My poor friend,' Gauzi said. 'They have been duping you.' Whereupon, the artist silently picked up his hat and cane and left.

7

BENEATH THE WINDMILL

It had been and would be his only consummated love affair but as with
much else of significance in his life, there is no record of his reactions.
When Bruant bought *Gueule de Bois* for what was by then the perma-
nent Lautrec exhibition at Le Mirliton, Henri found himself confronted by
his portrait of Marie-Christine every time he visited the club, though
without her to model for him his work on Bruant's songs seems to have come
to an end. Nevertheless, he still hoped to get more commissions from his
friend and can only have been bitterly disappointed when Steinlen was
chosen to illustrate *La Rue*, the two-volume collection of Bruant's songs to
be published the following year. The singer was probably concerned about
sales, choosing the lighter, less bitter Steinlen, rather than the acerbic
Lautrec, who might upset the book-buying public, though it was noticeable
that the popular press showed no such caution, with *Le Courrier Français*
publishing two of Henri's harsher Bruant-inspired works, *Gueule de Bois*
and *A la Bastille* in April and May 1889.

Bruant aside, Henri had little difficulty in getting his work shown. After
that first exhibition in Toulouse, which had so upset his grandmother, he
next appeared in Paris in November 1887, when Van Gogh organised an
exhibition of works by himself and his friends in a ballroom attached to a
restaurant in the Avenue de Clichy, Le Grand Bouillon-Restaurant du
Châlet. The Dutchman wanted to include works by all those he dubbed
'Impressionists of the Little Boulevards' by which he meant the younger
artists still struggling to be recognised – unlike the original Impressionists,
Monet, Degas, Renoir, Pissarro – who were now on show in the established
galleries on the *grands boulevards*. However, when the Divisionists, as
Seurat and Signac were sometimes known, declined to take part, Van Gogh's
exhibition was reduced to those artists whose work was most influenced by
Japonisme, using techniques derived from the much-studied Japanese prints,

the sort of things that Anquetin and Bernard had been developing during their last year at Cormon's.

One painting in particular was to exemplify this loose movement, a dramatic canvas by Anquetin entitled *Avenue de Clichy: Five O'clock in the Evening*, a depiction of some late shoppers on a wet lamp-lit pavement that showed the dramatic effects of Japanese composition in the way the street swept away to the left with a female figure cut in half as she disappears out of the frame. More shocking still was Anquetin's use of hard outlines and flat areas of colour, a much more consistent application of the style he and Bernard had been perfecting since they had been jolted into action by Seurat's success. It was this that caught the eye of the critic Edouard Dujardin, an old schoolfriend of Anquetin's, who was by then a leading Symbolist theorist and managing editor of *La Revue indépendante*. Dujardin set about giving his chum a boost by praising this particular work in fairly extravagant terms, noting the similarities between Anquetin's outlines and flat colours and the sort of medieval craft-jewellery where the enamels were separated by metal cloisons, a word he used to describe Anquetin's technique, referring to it as 'cloisonism' and thus giving a name to what Dujardin hailed as a new school. This was something of an exaggeration, but even though Cloisonism as a movement would only have a short, rather artificial life, its influence would be felt by artists who would never have admitted to sharing Anquetin's ideas. When he again left for Brittany, Bernard took the style with him, passing on the idea to Gauguin who had already been edging towards something similar. Henri was interested but less overwhelmed than some of his friends. As paintings like the *Ecuyère* show, he was by then combining his earlier loose, 'impressionistic' manner with the techniques learned from the Japanese prints, first mapping out an underlying framework with sharp angles and unusual viewpoints, cropped figures and divided picture space, to make a dramatic setting on to which people and action could be overlaid with his usual rapid, cross-hatched brushstrokes – a conflict of methods that creates a sense of tension and movement. This would be the main characteristic of his style from then on, along with an increasing tendency to concentrate solely on the main figure or event, leaving other areas of the canvas or paper blank or covered only with a light wash of colour. The result was a merging of opposites, a blend of Realism and abstraction in a tense encounter that both unsettles and attracts and which has proved hugely influential with succeeding generations of painters and graphic artists. The *Ecuyère* does show some use of Cloisonist outlines but Henri offered no hope that he was thinking of joining the movement outright.

Despite his reluctance to sign up for any of these mushrooming schools, he was still invited to exhibit with a whole range of progressive groups, each happy to consider him their own. Late in 1887 he was asked to make a selection of his paintings for display in Brussels the following February as part of the fifth exhibition organised by Les XX (pronounced *Les Vingt*, The Twenty), the progressive Belgian art group which at the time was more in tune with French avant-garde movements than any comparable organisation in Paris. And not only was he asked to contribute, he was also encouraged to propose other participants.

From the first, starting with his exhibition at Le Mirliton, Henri was able to sell his paintings and drawings with reasonable frequency, albeit for quite modest sums, and by late 1887 Théo van Gogh put some of his canvases on display in his gallery. Added to these early successes were reasonably decent reviews. When he travelled to Brussels for the opening of the exhibition, he was pleased to see that he received more attention from the press than any of the other participants. One particularly celebratory review by the anarchist poet Emile Verhaeren was to lead to a close personal friendship. Given his political sentiments, it is not surprising that the poet should have praised the works for the way 'contemporary everyday life is attentively, thoroughly explored'. Of course, others were less sympathetic, with a tendency on the part of some critics to call attention to the 'squalid' nature of his subject-matter and to equate what they saw as deformed images with Henri's own physical shortcomings. One can only imagine what they would have written

Portrait of Edouard Dujardin by Félix Vallotton.

had they known the full range of his subject-matter, for Henri's policy was to send only his mildest canvases to these exhibitions, usually portraits or subjects drawn from the world of entertainment, rather than the Bruant/anarchist pieces. As a consequence, his reputation was being built on 'neutral' works rather than those that contained any political or social comment.

Despite the increasing amount of time Henri was obliged to spend organising his entries for these various showings he was still casting around for a suitable subject for a large painting that would allow him to summarise the ideas he had been tackling over the past four years. Like the circus, the subject would have to bring together the world of Bruant's underclass and that of the public entertainments that so fascinated him and with both elements in mind it must have seemed inevitable that in 1889 his thoughts should turn to the dance hall at the Moulin de la Galette. This was still the main venue for working-class entertainment in the area, the one most popular with ordinary folk and the place that continued to offer the atmosphere of danger that had made the semi-secretive world high on the Butte so intriguing to those from below. The Moulin de la Galette had long been the nursery of fashions that later seeped down to the dance halls at the foot of the hill and in a sense it remained the true heart of Montmartre. There was also the fact that Renoir had painted it twelve years earlier. By now, Henri knew the older artist and was very respectful towards him, though he was not afraid to challenge so awesome a figure on his own territory. Where Renoir had painted the gardens peopled by groups of jolly merry-makers, the sort of place a smart young man could take his fiancée or his sister, Henri was planning something more disturbing.

There was no question of having friends carry a canvas up to the Moulin every day as Renoir had done, though acquaintances did model some of the figures in his studio where the actual painting was made. As usual, Henri made sketches before he began and he certainly absorbed the atmosphere – there is a photograph of him drinking with friends outside under the trees, though this had little to do with the final composition, which is largely set indoors. We look in on the scene from where he would have been as he sketched it, at a table on a raised seating area overlooking the dance floor. A rail separates the sitters from the dancers and this runs in a sharp diagonal, from bottom left to top right, bisecting the picture space, a Japanese device that draws the eye into the action taking place in the busy upper left-hand segment where the dancers are in motion, while at the same time cutting us off from it. On their side there is movement, on ours passive observation, as

if we are voyeurs watching an aspect of life the artist has laid out for us but in which we are not expected to join – a sharp contrast with Renoir whose smiling participants invite the visitor to enter their world. Here there is no such intimacy on offer – the subdued, underwater colours drown any hope of fun. Nor are these characters anything like Renoir's moderately well-off young people out to enjoy themselves – there is not even that sprinkling of middle-class men slumming it among the jolly poor that we find in other dance-hall paintings. This is the real underclass in its own world, people who have climbed the hill to this drab barrack for a cheap moment of relaxation, a place where they can dance and drink and forget the long hours of work and poor wages. Yet even here, things are well controlled. What looks like a member of the *garde républicaine* in his blue-and-red uniform and kepi is holding up his hand, blocking the approach of a man whose top hat and long overcoat mark him out as a coach driver. This agent of the law appears to be dealing with some sort of difficulty. The authorities had such places carefully watched – this was, after all, the city's outer edge: a short walk further on and the path began its descent into the *maquis*. This was the front line where vice was tolerated, a blind-eye turned to petty crime, but only within carefully controlled limits.

Perhaps the most telling detail in the picture is the stack of *soucoupes*, the white saucers, placed on the table where Lautrec would have been sitting and thus at the centre foreground of the painting. A waiter placed a *soucoupe* on the table for each drink served, to be totted up when the customer decided to leave. In the picture there are seven already and while the house speciality was mulled wine, not an especially powerful potion for an absinthe drinker like Lautrec, in such quantity, that was enough to have had some effect.

We should not, however, assume that this was in any way a literal snapshot of an actual evening at the Moulin. Contemporary descriptions of the place suggest that the room was large, brightly lit and lined with scattered tables like the enormous, cavernous hall, illuminated by massive chandeliers, that we can see in the painting Lautrec's friend Charles Maurin would make in 1894, very different from the tightly enclosed, restricted space that Lautrec offers. His composition creates the impression that someone has organised a dance in a courtroom with the spectators sealed off from the actual ball, a jury rather than participants. This is not an attempt at impartial reality but a carefully weighed statement about the meagre, often crude pleasures of the deprived. There is no idealisation but equally there is no pretence that the artist is an uncommitted spectator, the prominent evidence of his drinking removes any suggestion of that – the artist, this seems to say,

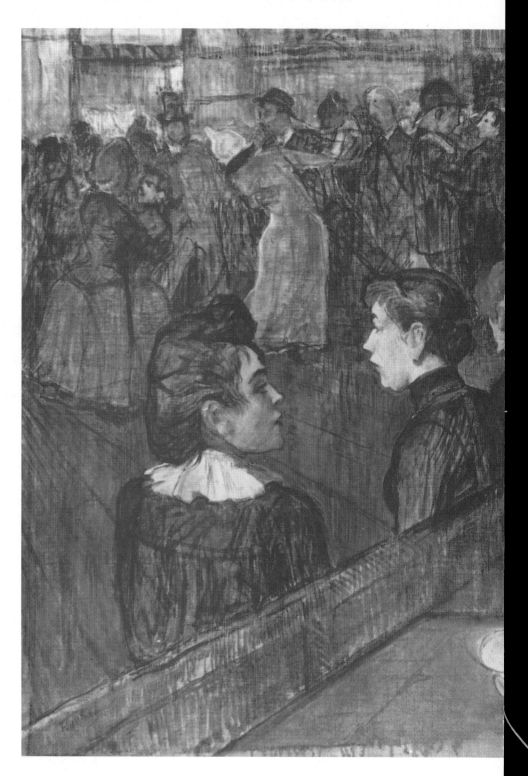

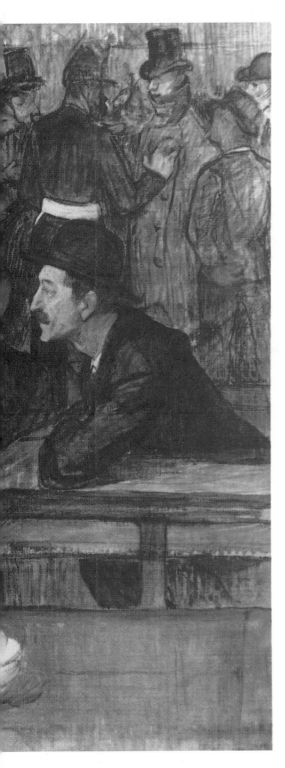

La Moulin de la Galette (1889).

is just another of the folk you see here, as dazed with drink as the girl in front of him, glancing over her shoulder at the man at the next table – a potential customer, or perhaps her *gigolo*. This figure shows how Lautrec carefully composed the scene – far from being some stray ponce that Lautrec happened to find when he arrived, the gigolo in question is his old friend Joseph Albert who was by then a fairly conservative landscape painter, already exhibiting at the official Salon. This may have been why Lautrec amused himself by setting him up as a manager of small-time tarts, though Albert seems not to have minded the joke – indeed he is generally assumed to have been the first owner of the painting.

And so, a bright, outdoor dance hall *à la* Renoir, an echoing indoor pleasure palace as depicted by Maurin and others, or Lautrec's cramped, sleazy club? Being the only one to see it that way, the tendency has been to conclude that Lautrec had glimpsed an aspect of the place which he had exaggerated in order to shock. But if one goes beyond the visual record and turns to other sources, it is clear that Lautrec showed more con-

cern for the truth than his colleagues. Newspaper reports of court proceedings reveal some of the more sordid things that actually took place at the Moulin. In the early 1880s, a Louise Brémant was found guilty of using the dance hall to recruit girls, some as young as eighteen, to work in her brothel on the Boulevard de Rochechouart. The girls were paid a nominal five francs a day with Brémant retaining four francs, fifty centimes to pay for their food. When police raided the brothel they found two muscular 'Hercules' who were there to provide unspecified 'special services'. Despite the overwhelming evidence of what was going on, the girls proved remarkably unwilling to 'shop' their employer, with one, Léontine, insisting that Brémant was a dressmaker for whom she was working as a seamstress. To no avail – unimpressed by such loyalty the court sentenced Brémant to a year in prison and a hundred francs' fine, a squalid tale that gives some insight into why Lautrec saw the place as he did and why he depicts it with such knowing humour.

It was no accident that Lautrec chose the Moulin de la Galette as the subject for his major work of the Bruant-inspired period. It was also something of an adieu to a place that represented an ethos that was drawing to its close. La Goulue had already moved down to the Elysée-Montmartre where she and her first partner Grille d'Egout were now surrounded by equally crudely named rivals: La Môme Fromage (The Cheesy Kid); Miss Rigolette – a play on words between a bit of a laugh and a tiny channel; Nini Patte en l'Air, (Nini paw in the air – a reference both to the dance and the sexual act); and La Torpilte (The Torpedo).

With so much competition La Goulue was obliged to find new ways to keep herself at the forefront of public attention, which is no doubt what prompted her to move beyond Montmartre to other parts of the city where the new craze for low-life entertainment was already catching hold. She even got as far as Montparnasse where she and Valentin danced at the old Bar Bullier where Henri went to see them perform. For these three, who seldom strayed far from the Butte, it must have come as a surprise to see how the cruder aspects of Montmartre's night-life were being manipulated into a form of entertainment more acceptable to the public at large. The Bullier had been totally redecorated in Moorish style with pillars and arches and brass hanging lamps, not unlike a gaudy Turkish bath, in an attempt to reclaim its original status as the first and wildest of the student ballrooms – a first shot in the cultural-topographical battle between Montmartre and Montparnasse that would divide Parisian night-life up to the Second World War.

By 1887, the Bullier already had a dancer to rival La Goulue but one far different in temperament and intellect than the coarse 'Glutton' who had so far dominated the quadrille. When Lautrec first saw this new figure she was already known by her stage name, Jane Avril, an odd mix of English and French, that somehow matched the strange way she slipped into a private, trance-like state once she was alone on the dance floor and in the grip of her routine. Unlike La Goulue, who danced with her arms, legs and above all her backside, Jane Avril's movements seemed almost cerebral, as if prompted by some deep inner emotion. Even those who knew nothing of her past could sense from her performance that they were in the presence of someone who needed to escape into this other world of music and movement. Born thoroughly French as Jeanne Richepin, she was the daughter of a classic 'fallen woman' – her mother was well known as *La Belle Elize*, a famous Second Empire courtesan who failed to amass the fortune customarily associated with those much romanticised figures, dissipating whatever she garnered in a haze of alcohol. Jeanne's father was said to be a visiting Italian nobleman, the Marchese de Font, who put up with his quarrelsome, drunken mistress for two years before returning home, sick and soon to die. Yet despite this inauspicious beginning, the daughter was, initially at least, not too unhappy. Left with her mother's parents, she experienced a few years of reasonable calm in the country, at Etampes, until at the age of nine she was sent back to Paris and her increasingly drunken mother, whose cruelty condemned the child to a living hell. One of *La Belle Elize's* protectors paid for the girl's schooling, but in the evenings and weekends her mother forced her to travel away from their lodgings to parts of Paris where she could not be recognised, where she walked the streets, singing and begging for money. There were beatings and other tortures well into her teenage years until eventually she developed a facial tic, the first sign of an impending mental breakdown. Fortunately, the same protector who had paid for her education was willing to subsidise her treatment at the Salpêtrière Hospital in the east of Paris, which then contained one of the most progressive mental institutions in Europe where she was treated by the famous specialist Dr Jean-Martin Charcot and was looked after by the staff and fellow patients with the sort of loving care she had not known since earliest childhood. By a strange coincidence, given her future career, Jeanne was visited by the actress Sarah Bernhardt who was preparing to play a mad scene and wanted to study the reality at first hand. And in another way, it was a sort of theatrical performance that helped her overcome her malady. Taken to a fancy-dress ball organised by a local doctor, at some point during the evening she took to the

floor and for the first time in her life began to dance. As she improvised some steps the movement and the rhythm seemed to lift her out of herself, inducing a sort of self-hypnosis that left her calm and happy for the first time in years. From then on she would dance whenever the opportunity arose and her improvement was spectacular. Some time around 1885, when she was seventeen, a love affair with a medical student carried her on to the next stage in her self-administered cure. The affair lasted a mere three months, but the young man did take her to the Bullier, where Jeanne stepped on to the floor and went into what was by then her usual solitary routine, letting the music lead her into improvised twists and turns, in a sort of ecstasy as if she alone existed, a dreaming figure communing with her own spirits. This time, however, she was far from alone and when the music ended, wild applause broke out. Everyone else had stopped dancing, entranced by this singular willowy figure so clearly gripped by her own performance. The applause was long and generous and Jeanne Richepin was hooked. Whenever possible she would slip away to the Bullier's popular Thursday-evening dances and waltz herself into a personal dream world, after which she would drink up her reward from a public that was now coming to the dance hall expressly to enjoy her performance.

It was at this point that Jeanne had an affair with a young Englishman about whom she was to remain loyally secretive throughout her life, seemingly to protect his family from a full knowledge of their time together. In later interviews she referred to him only by his Christian name 'Robert' though she was happy to reveal that he was a poet who had introduced her to the intellectual and literary side of Parisian life. Together, they visited places like the Café Vachette, frequented by Verlaine, Mallarmé and Huysmans and where, by her own account, she said little but learned a good deal. According to her later, ghosted biography, Robert's main contribution to her unfolding career as a dancer was to change her name. Apparently he was always singing a popular song of the time, 'Mignonne, voici l'Avril', and so she seized on the month, with its connotations of spring and freshness, and gave herself the stage-name Jeanne Avril. But then, impassioned by all things English, she Anglicised her first name and *Jane* Avril was born.

Unfortunately, her Robert was far from faithful. There were other mistresses and in 1887 he eloped to London with the woman who was to become his wife, leaving Jane with another reason to find strength in her solitary routine. But despite this behaviour, she continued to see him when he returned to Paris and throughout her life remained grateful to him for the entrée he had given her into the literary world, which she continued to fre-

quent. When she became famous and the object of considerable journalistic prying she attempted to protect his identity and only in the 1930s, when a newspaper serialised her life story, was she unable to resist revealing that this mysterious English Robert, to whom she claimed to owe so much, was the grandson of the poet William Wordsworth.

Henri de Toulouse-Lautrec was not alone at the Bar Bullier in seeing how the world of mass entertainment was growing beyond its low-life origins. Another observer was a Spaniard, Joseph Oller, who had been brought to Paris as a child and who has some claim to be the father of modern French showbusiness. A frequent visitor to his native Catalonia, Oller had launched his career by devising a more rational system of controlling the betting at cock-fights, which until his intervention had been a chaotic business with as many fights outside as within the pit. Back in Paris, betting, this time on horse-racing, was his way into the world of mass entertainment when Oller effectively invented the modern Tote, with bets being laid in specially adapted caravans, painted yellow and black, stationed around the capital. This proved a huge success with the poor until the new 'moral' Republic banned off-course betting in 1874, a move that drove the unstoppable Catalan into other forms of entertainment – a swimming pool, an aquarium and then the Nouveau Cirque on the Faubourg Saint-Honoré that featured the first tip-up chairs, an Oller invention which soon spread to virtually every modern theatre on the planet, and a show that included the best clowns in the business.

What Oller was quick to realise was that when the Parisians abandoned their city in the hot summer months, his audience was largely made up of foreign visitors eager to sample the sort of amusements unknown to less fun-loving capital cities. Thus the canny showman began to frequent the dance halls – the Bullier, the Elysée-Montmartre, even the Moulin de la Galette, where he saw how supposedly respectable bourgeois folk were attracted to an atmosphere of risk and sensuality, provided things didn't get too out of hand. What they wanted was the sight of La Goulue kicking her feet so high it might just be possible to imagine one had seen something utterly forbidden – what they didn't want were fights and pickpockets, and having reached this conclusion, Oller decided that 1889 was the year to give them what they wanted.

This was to be a year of flamboyant celebration, the centenary of the French Revolution that would be marked in grand style with another vast Universal Exhibition intended, as much as anything, to show the world that the once fragile Republic had weathered its worst years and that France was

In his painting of Jean Avril's solitary dance, Henri captures the same wistful look visible in a rare photograph taken in the 1890s.

once again on top. Following General Boulanger's novelettish suicide on the grave of his mistress after he had failed to launch an expected *coup d'état*, the passion for undemocratic supermen that had bedevilled French politics since Napoleon I, seemed finally to recede. After so clownish an episode, the Republic was stronger than ever and even the Pope ordered Catholics to support what had formerly been anathematised as an anti-clerical regime. Thus the government decided that there should be another festival of art, science and commerce to hail the acceptance of a constitutional ideal that had so long eluded the people of France.

Whatever their reservations, most citizens now accepted that this was how things must be and with the Franco-Russian Alliance in place, the nation could feel that it had at last emerged from the isolation into which it had been plunged by the rise of Germany. Borne along by this spirit of celebration, the great exhibition looked set to outshine its predecessors. Already the engineer Gustave Eiffel was busily constructing the massive steel tower that would be the central and most enduring symbol of the event. But even as the four massive legs began to rise above the roofline, Joseph Oller was planning something that, while smaller in scale, would in its own way prove just as much a symbol of the age.

Oller had bought the old Reine Blanche dance hall on the Place Blanche, at the edge of Montmartre, and was now converting it in such a way that it would combine all the qualities of the old Moulin de la Galette and the Elysée-Montmartre, though with none of their less-salubrious drawbacks. With Gustave Eiffel's tower already nearly 300 metres above the city, Oller's Windmill, coloured a garish red, began to appear on the roof of his new establishment, a brightly lit emblem of what would be the most famous nightclub ever – the Moulin Rouge. And to ensure that his was the greatest attraction in town, Oller wanted that mix of art and publicity that had made Salis so successful at Le Chat Noir with his judicious combination of creativity and vulgar self-promotion. Oller intended to repeat that success by using the one man whose work already revealed a mixture of glamour and sexuality that was bound to attract the crowds who would be flocking to Paris once the exhibition opened. And so, as he began recruiting dancers and singers, Joseph Oller approached the artist who he believed would embody and immortalise his vision of Paris as the city of endless fun – Henri de Toulouse-Lautrec.

The Universal Exhibition ought to have opened with a bang on 6 May 1889, but the atrocious weather had so delayed work that when President Sadi Carnot set off on his inaugural tour of the main site along the Champ-

de-Mars he had to be steered carefully to the few sections that were suffi-ciently finished to merit inspection. Nothing, however, could detract from Eiffel's spectacular tower, though the not quite complete Machine Gallery, a massive hall of crystal and steel in which visitors were transported the four-hundred-and-twenty-metre length on bridges running on overhead rails, was almost as awesome. Only the Palais des Beaux-Arts failed to impress, as much from its fussy architecture topped with a dome clad in gaudy white, turquoise, yellow and gold tiles, as from the histrionic canvases on show within. Even an attempt to challenge the official show, the independent exhibition organised by Gauguin, was just as much victim of the accidents and delays that dogged the official fair and visitors to the opening would have been able to witness the artist and his friends struggling to drag a hand-cart loaded with their paintings over to the Café Volpini where they were due to be hung. In theory, this was intended to be a broadly based show open to all who were considered part of the avant-garde, which made it all the more painful for Henri when Gauguin decided to reject his work. It was the first time such a thing had happened, but if Henri had stopped to think he would have realised that it was simply a reflection of Gauguin's personal ambition – while he was never averse to promoting mediocrities whose work made his own look good, he was equally determined to avoid any serious competition, which was why Seurat, too, had been carefully excluded.

At the time it hardly mattered. It was only later that the Volpini Exhibition came to be seen as a defining moment in the development of the French avant-garde. Among all the other distractions it was barely noticed by visitors to the café, sipping drinks to the music of an all-women's orches-tra, unaware that the strange images on the walls were anything other than weird decorations run up for the occasion.

Indeed, for many people, the entire fair was a bit of a disappointment and easily outshone by a second spectacle taking place on the nearby Esplanade des Invalides where a presentation of France's newly acquired colonial possessions was in full swing. There, visitors could wander among life-size reproductions of major historical sites or experience complete African villages with 'native' performers brought over to demonstrate crafts and dancing, in an exotic mish-mash that included a huge plaster-cast of a temple from Angkor Wat, with processions of skimpily clad warriors and wild animals, chanting Buddhist monks and masked sorcerers and a complete Egyptian street, the rue du Caire, where strollers could sip mint tea, haggle over the price of a carpet or slip into the Café Egyptien to watch a *Danse à l'Almée*, the uniquely Egyptian form of the belly-dance, by

The Universal Exhibition, 1889: Adrien Marie's portrait of Aiousche performing the belly-dance in the Café Egyptien in the rue du Caire.

Aiousche, a top performer specially imported for the event. This sort of oriental spectacle had first appeared in Paris after 1870 as contact grew between France and its North African colonies and protectorates. Jules Ferry, the Republican politician who did most to encourage the development of France's overseas possessions, once bemoaned the fact that the only feature of their Empire that excited his fellow citizens was this mildly erotic dance. In the main, performers were usually Berber women, often called Fatmas after the name casually given by the colonists to their female servants. Aiousche, however, was something different. As can be seen from an engraving of her by Adrien Marie that appeared in *Le Monde Illustré*, she was a true professional, beautifully costumed, with her own Arabic musicians. Her expert performance was to launch a passion for the dance that would last well into the next century.

Everyone seemed to be drawn to the Café Egyptien – Jane Avril had found a job selling tickets for the show while La Goulue was so impressed by the public's reaction that she determined to put on her own version of Aiousche's act. Lautrec was equally smitten, sketching the Egyptian as she danced – a foretaste of things to come.

If nothing else, both exhibitions confirmed the belief that entertainment could always triumph over more mundane matters. The Universal Exhibition may have been intended as a celebration of France's commercial and industrial achievements and the colonial offering as a tribute to the nation's *Mission Civilatrice*, but to the Parisians and their guests, the whole thing was just another show, with animal acts and sexy dancers laid on for their distraction. It was the desire to be entertained that Joseph Oller had anticipated and now hoped to profit from, though his venture had also been plagued by the same delays as the exhibition and his new club was not ready until the autumn, by which time the World's Fair had already closed.

In the end it hardly mattered, for when the Moulin Rouge finally opened its doors on Sunday 6 October, 1889, so much anticipation had built up that the place was crammed with people of all kinds, from aristocrats like Prince Poniatowski and the ubiquitous Comte de la Rochefoucauld to the soup magnet Alexandre Duval, from the fashionable to the merely curious, with a sufficient sprinkling of the rough and the dangerous from higher up the Butte to convince the rest that the place was nicely naughty. Oller had brought in Charles Zidler, who had been running the Hippodrome as manager-cum-partner, and the two were to make a huge success of the new venture until an abrupt and never explained rupture three years later. Their greatest draw was certainly the place itself – a cavernous dance hall lit

by new-fangled electric lights that added brightness and sparkle to the crowded scene, which was whipped into a frenzy when the line of shrieking dancers dashed on to the floor and began their synchronised high-kicking can-can.

When tired of the garish scene and the thudding noise, customers could repair to the gardens where there were open-air performances, though these were, in their own way, equally bizarre. When the stands from the Universal Exhibition were sold off Oller had bought a model elephant, so huge an orchestra could play inside its cavernous belly, and it was to this weird theatre that Oller would bring La Goulue for her first professional engagements. Inspired by the rue du Caire, she and a partner, La Macarona, had been putting on their own *Danse à l'Almée* at the Elysée-Montmartre and when Oller eventually lured them away, it was this dance that now appeared, appropriately enough, inside the belly of Oller's massive plaster pachyderm. The performance would remain part of La Goulue's act for nearly two years but as a review in *Le Courrier Français* of 1892 makes clear, it was the more lithesome La Macarona who garnered most plaudits for a spectacle that was little suited to La Goulue's ever-increasing girth. Which is no doubt why she abandoned it to concentrate on her original quadrille alongside her first partner, Valentin le Desossé.

From the start, the Moulin Rouge was a *succès de scandale*, for there was, of course, another equally blatant side to the club's activities – it was quite simply the biggest open market for sex in the capital, though no one was quite sure how to react to so flamboyant a phenomenon. Commentators at the time were hard pressed to say whether respectable wives would be furious with their husbands for visiting such a place or more angry with them for not having taken them along to see a spectacle that everyone was talking about.

One thing was certain: whoever you were and for whatever reasons you went, the first thing that confronted you as you entered the Moulin Rouge was Henri de Toulouse-Lautrec's painting of his one-time mistress Suzanne Valadon as the bareback rider at the Cirque Fernando. Oller had bought the canvas from Bruant and hung it in the foyer leading to the main dance hall, certain that this vibrant image of reckless speed was just what was needed to represent the spirit of a place, and which more than anything else was to be the defining symbol of *fin-de-siècle* Paris.

And that apotheosis at the Moulin Rouge was only one advance in what was proving to be Henri's year of wonders. In September 1889 he exhibited *Au Bal du Moulin de la Galette* at the fifth annual Salon des Artistes Indépendants and found himself included in a review by Felix Fénéon in his

La Goulue and La Macarona performing their original belly-dance at the Elysée-Montmartre.

Henri, round about 1889, aged 25.

little magazine *La Vogue*. Despite a rare factual error – he refers to Joseph Albert as 'Alphonse the Lawyer' – the article was prescient in taking seriously the fact that Lautrec had not simply revelled in the thrill of the low-life scene but had actually been interested in the characters he depicted. Fénéon was equally astute in seeing the influence of Degas and Forain while noting that Henri had copied neither. But what gave the review its force was the way its author matched his writing to the painting by employing the same kind of *argot* Bruant used, the very language that had originally inspired the artist.

With his painting displayed so prominently in the entrance to the capital's most notorious dance hall and with the city's most demanding critic praising his talents, Henri de Toulouse-Lautrec had succeeded in uniting the two worlds he had chosen to inhabit, and through him art embraced earthy working-class entertainment. He was only twenty-five years old but in 1889, that crammed centennial year, he had begun to occupy a unique place among the younger artists jockeying for position in the overcrowded hot-house of Parisian culture, accepted by the avant-garde yet also by a

wider public who knew his work as an integral part of the most exciting places of amusement in the city.

And not only in Paris. Thanks to the Brussels exhibition, he was already known to progressive folk in Belgium and now Fénéon's article would carry the first mention of his name across the Channel to London. It was a remarkable achievement for one who only a decade earlier had had to undergo what he called 'the surgical crime' as the doctor reset his fractured leg. The following day he had written to his friend and fellow invalid Etienne Devismes to report the 'atrocious suffering' he had endured but at the same time describing in detail a model boat he was building, as if he could always find relief from his misery in creating something. Most of Henri de Toulouse-Lautrec's letters reveal little, but that short missive says it all: his pain and isolation eased by making and sharing.

> Oh, if you were here just five little minutes a day, I'd feel as
> if I could face my future sufferings with serenity. I eat up my
> time by making the hatchways (the bob-stays and shrouds
> for the bowsprits kept me busy for half a day). But wouldn't
> it be better to make the ramming block in copper instead of
> wood, and shouldn't it be painted or simply polished?

At the top of the page, he drew a tiny sketch of the vessel, as if it were a real ship, able to cross oceans, free as the wind in its sails.

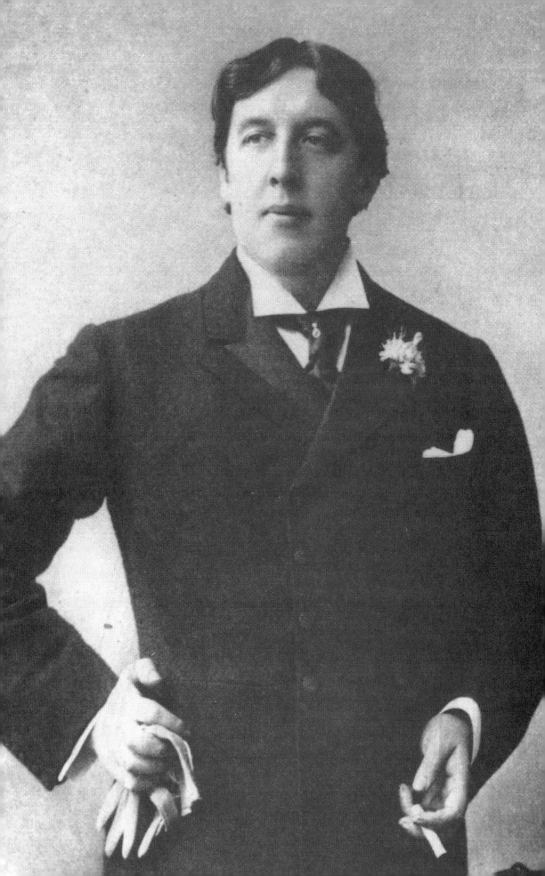

PART TWO

. . . THEN ALL THE WAY DOWN AGAIN

Disobedience, in the eyes of anyone who has read history, is man's original virtue. It is through disobedience that progress has been made, through disobedience and through rebellion . . . I can quite understand a man accepting laws that protect private property, and admit of its accumulation, as long as he himself is able under those conditions to realise some form of beautiful and intellectual life. But it is almost incredible to me how a man whose life is marred and made hideous by such laws can possibly acquiesce in their continuance.

OSCAR WILDE

Oscar Wilde at the height of his fame in the early 1890s.

8

MONSIEUR OSCAR WILDE

For all Fénéon's skills, one might have imagined that the limited circulation of an obscure literary magazine would have done little for Henri's reputation abroad. *La Vogue*, however, was a curious creature that travelled far and had some unexpected friends. Across the Channel, in a house in London's Chelsea, the little magazine was avidly read by a group of young artists and writers keen to follow cultural movements in the French capital. How they first learned about *La Vogue* and how they obtained their copies, remain a mystery but that they should read and discuss its contents whenever it appeared was an established feature of their group gatherings. The owners of the house were two artists, Charles Ricketts and Charles Shannon, who maintained the sort of discreet bachelor ménage that Victorian society could just about accept. The Vale, their charming, ivy-clad cottage in Chelsea, had previously been occupied by Whistler, who had painted it an aesthetic apple-green, and it was now filled with the couple's artistic bric-à-brac. While Shannon concentrated on painting, Ricketts designed books and drew illustrations and was mainly responsible for *The Dial*, their magazine in which they aimed to offer the best in printed illustration along with what was most adventurous in writing. It was *The Dial* that had drawn into their circle a young poet, John Gray, twenty-four, with blond hair and a gentle expression who wrote highly artificial verses much influenced by his limited knowledge of the sort of poetry being produced in Montmartre and Montparnasse. Of all the readers of *La Vogue* at The Vale, Gray was probably the keenest admirer of all things French and when he read Fénéon's articles they reinforced his decision to visit Paris in the hope of meeting him as soon as he could afford the adventure. In this he was encouraged by an older writer he had recently met and who had quickly become a close, indeed an intimate, friend. To have such a relationship with a man already famous for his outrageous journalism was flattering to one so

210

young, but more exciting was the fact that no one seemed to know as much about France and the French as Oscar Wilde, a knowledge he was more than willing to share, especially with someone as eager to learn as Gray clearly was.

There is a drawing of Oscar Wilde, elegant in white tie and tails with a rather too noticeable flower in his buttonhole, made by Toulouse-Lautrec, that shows the Anglo-Irish author when he was the talk of the French capital, largely because of his own outrageous talk. As he confided to *L'Echo de Paris*, 'While in London one hides everything, in Paris one reveals everything', a reflection of the easy relief from the stifling restrictions of Victorian society that many Englishmen found in the French capital during the final decade of the nineteenth century. Initially, however, Wilde's interest in Paris was more intellectual than physical. While there were many writers and painters in England who knew something of what was going on across the Channel, Wilde was one of the few who acted as a bridge between the cultural life of the two capitals – though, in a sense, 'bridge' is inexact as there were really two Wildes: *Mister* Oscar Wilde, the dandyish poet and poseur, the star of the London smart set with his endless flow of intriguing, paradoxical talk, and the other, a *Monsieur* Oscar Wilde, a thoroughly continental figure. Wilde not only straddled two cultures; each nourished a quite separate vision he had of himself. On the one hand there was his desire to be recognised as a great artist, a person admired by the intellectual élite of the day, on the other a yearning for popularity and the applause offered to the showman.

As Wilde said, on several occasions, 'I have put all my genius into my life and I have only put my talent into my work', a judgement that has too often been accepted as a fair summary of a man who was in many ways the precursor of today's self-publicists who create an artistic reputation out of their public persona – a sort of Andy Warhol of the late nineteenth century. This is the Wilde the world knows best: the long shoulder-length hair with centre parting framing a somewhat fleshy face with languid eyes and full lips. Wilde's public performances were extraordinary – a big man, a competent boxer, he chose to appear at public readings in silk knee-breeches and velvet jacket overlaid with a flamboyant cravat, a green carnation in the lapel or a lily held in the hand like a magic wand. It is difficult at this remove to say which is the real Wilde and which is a folk-memory built out of the caricatures in *Punch* or that pastiche of the aesthete in Gilbert and Sullivan's *Patience*, which ridiculed Wilde yet made him famous. Cold on the page, many of his aphorisms can seem mannered, the affected phrases of someone

Oscar Wilde's mother, the indomitable Irish revolutionary, 'Speranza'.

who has been practising before his bathroom mirror. Yet all who heard them agreed on their astonishing spontaneity and some idea of how he 'worked' an audience can be glimpsed in an account of one of his rare failures, a lunch party given in his honour by Otho Lloyd, his brother-in-law, in Paris in 1891, at which Wilde, having arrived late, completely misjudged the sophistication of his French listeners, trying to shock them, *à la Baudelaire*, with lurid tales of morgues in different cities. Realising that he had lost his audience, Wilde fell silent for a time but with the coffee began to speak flatteringly of French theatre as a reflection of French history, displaying a dazzling knowledge of personalities and policies and battles and treaties, speaking with such passion that, according to the memoirist Ernest Renaud, several of his listeners wept 'to think that words should achieve such splendour. And yet it was done so naturally, like ordinary conversation.'

Yet there was more to this than mere dinner-party entertainment. Wilde was a dandy and the dandy was a type that had been defined by Baudelaire who saw such figures as being essentially democratic, inventing their own social class, freeing themselves from the limitations of birth and parental position. Wilde with his light grey suits, broad-brimmed hats, his eighteenth-

century cane and well-chosen buttonhole was outside any definable social order save his own. Dandyism for Wilde was an expression of his philosophy of the individual, a sign that he was very much the son of Lady Jane Francesca Wilde, a flamboyant figure in her flowing veils and shawls, her beads and jewels, who, writing as 'Speranza', had supported the Young Ireland movement, with a call to arms 'Jacta Alea Est' in *The Nation* of 29 July 1848 that had appealed for muskets and barricades against the English: 'One bold, one decisive move, one instant to take breath, and then a rising . . .' – a rallying cry that led to the closing of the paper and the arrest of its editor. Speranza's outburst at the subsequent trial made her a world-renowned figure in the struggle for Irish independence, and at Oxford and thereafter, her son left no one in any doubt of his allegiance to her cause. As he expressed it:

> a map of the world that does not include Utopia is not worth glancing at, for it leaves out the one country at which Humanity is always landing. And when Humanity lands there, it looks out, and, seeing a better country, sets sail. Progress is the realisation of Utopias.

If asked, Wilde most often referred to himself as a Socialist but it is clear from his responses that he was effectively advocating a way of life based on the fullest expression of individual freedom. As he told an interviewer in France in 1894: 'I think I am rather more than a Socialist. I am something of an Anarchist.'

When Gray met him in 1889, Wilde had just started work on his first real literary effort, the novel that would establish his reputation as a serious writer, rather than the minor poet and outrageous journalist he had been until then. The story, whose principal character Dorian still lacked a surname, was to be a curious mix of the English Gothic novel with influences of the new French Symbolism that Wilde had begun to hear about from a friend in Paris, Robert Sherard, who kept him abreast of cultural developments across the Channel.

In Wilde's outline of the novel, an artist Basil Hallward paints the portrait of his young friend Dorian, who sells his soul so that he may keep his beautiful looks and never grow old – the picture will age in his place. He is led to this Faustian pact by Lord Henry Wotton whose own life is given over to the pursuit of pleasure. Dorian's conscience is the artist, Basil, whom he eventually murders, having abandoned himself to the extremes of vice under

the guidance of Wotton, until the day comes when he is confronted with his image, and realises that his portrait is now a vile suppurating bestial thing, the evidence of what he would have become had he not been protected from the effects of his misdeeds by the devilish bargain. Sickened by his excesses, the only way Dorian can find release is through destroying the picture, an act that causes his own death. Thus sin is punished at the end, though this moral is somewhat subverted by the atmosphere of perversity which the book exudes. Significantly, Dorian blames his downfall on the effects of a yellow-jacketed book that Lord Henry had given him and which is clearly Huysmans' novel *A Rebours*, one sign among several that Wilde was edging into Symbolist territory, planning to merge art and life, a fusion symbolically represented by the link between Dorian and his portrait, and by Wilde himself with his creation. Unbeknown to his readers, Wilde was by then 'Feasting with Panthers', his phrase to describe the descent into the low-life of London that would later be laid bare at his trial, a descent suggested in the descriptions of Dorian's search for sensation in the back alleys and opium dens of the capital.

Surprisingly, it had only been three years earlier, in 1886, that Wilde, until then an outwardly happily married man with two young sons had, while on a visit to Oxford, met and been seduced by the precocious Robbie Ross, then a mere seventeen but already well-practised in the techniques that now offered themselves to Oscar like the contents of some long-awaited Pandora's box. The following year young Robbie moved into the Wildes' house in Tite Street as a paying guest, though even then Constance Wilde, and one presumes Robbie's widowed mother, seem not to have suspected what was going on. Oscar liked Robbie, who would stick by him throughout his life, but theirs was not a love affair and the newly liberated writer was soon exploring other avenues of sexual release that he had previously suspected but never dared attempt. For the moment, a veil of discretion still masked these activities as he continued to find his friendships within the subfusc London bohemia that existed just outside society without too blatantly challenging its conventions.

Had Wilde continued in this way, he might have maintained some sort of pretence of family life and outward respectability and have avoided the scandal that eventually destroyed him. After Robbie, his earliest male attachments were within the literary and artistic set centred on Chelsea and caused little comment outside its own closed circle. In 1889, as he was starting work on his novel, Wilde was sent a copy of a new magazine, *The Dial*, a handsomely produced publication that was to appear in five editions up to

1897 and was meant to act as a vehicle for writers and artists devoted to the cult of the beautiful. *The Dial* was to be the house journal of English aestheticism and when he perused that first issue, Wilde was flattered to find that it contained a fairy-tale, written by someone called John Gray, in a style which leaned heavily on his own children's tales. Intrigued, Wilde called at the address given for the magazine, the home in Chelsea of Charles Ricketts and Charles Shannon, which he had known when it was occupied by Whistler. As soon as he entered The Vale, Wilde was immediately caught up in the band of young writers and artists who had made the house their head-quarters and for the next three years he became a constant visitor, sitting at the kitchen table, enthralling his impressionable listeners with the already famous flow of amusing talk. But it went beyond the pleasure of an appre-ciative audience – Wilde genuinely admired Ricketts, whose art seemed to merge the softness of an eighteenth-century *fête champêtre* by Watteau with the decadence of Gustave Moreau, all in the sinuous black-and-white outlines, based on stained glass and woodcuts, that William Morris and his followers had launched. From then on Ricketts was to be his preferred illustrator.

Perhaps more germane was the encounter between Wilde and his young imitator John Gray, who had the sort of looks guaranteed to interest the older man. To someone as inherently sentimental as Wilde, there was also his background. Gray was a carpenter's son who had been obliged to leave school at thirteen in order to work in a factory but who had managed to pull himself free by studying languages, music and painting at evening classes. Sheer hard work had enabled him to pass the Civil Service examinations and to find a junior post as a clerk at the Foreign Office. It was humble enough, but a remarkable achievement for one who had had to work as a labourer, and to add to this the young man now had literary ambitions and was deter-mined to be a poet, even choosing to live in the Temple which at that time had a slightly bohemian reputation. Surprisingly, for one who hailed from Bethnal Green, Gray's verses shunned the muscular narrative of much Victorian poetry and if it is difficult today to take seriously their exquisite ruminations on ethereal love, delicate flowers and whispered passions, it is as well to remember that at the time such things were a direct challenge to all the Victorian orthodoxies. It took considerable courage to reject the accepted values of an age that glorified industrial growth and colonial con-quest, and to proclaim, by the clothes you wore and the gestures and phrases you used, that yours was a different ideal, one that preferred refinement and sensibility to material success. Blond, beautiful and languid, Gray the neo-

phyte author was, for a time at least, Wilde's ideal companion. The novel had been begun before they met, but there can be little doubt that the main character was eventually named in honour of this new friendship and when John Gray had cause to write to Oscar, he now signed his letters 'Dorian'.

Even The Vale figures prominently in the novel, with Rickett's workroom, formerly used by Whistler, being appropriated for Basil Hallward's studio. Wilde had by now quarrelled with Whistler who had accused him of stealing his and other's ideas – a situation that may have added a certain relish to the way in the novel Dorian murders the painter Basil, that nagging voice forever reminding him of his sins.

It is easy to think of the group associated with The Vale and *The Dial* as quintessentially English – the charming evocation of past styles, the eighteenth-century courtly atmosphere of much of the work, the Arts and Crafts ethos. And we might equally see the thirty-five-year-old Wilde, already a famous journalist and man-about-town, satirised in *Punch* and the butt of music-hall jokes, as some sort of elder brother to these younger men in their twenties, sitting in the cosy kitchen, trying to expand their horizons with his amusing recollections of foreign personalities and ideas that they had but vaguely heard of. In fact, Gray and his friends were far less insular than one might assume. Already, that first edition of *The Dial* had shown that the group was not unaware of what was going on across the Channel. The magazine contained a lithograph by Ricketts – *The Great Worm*, which could have been lifted straight from one of Gustave Moreau's paintings – while Gray, along with his Wildean story, had also contributed an article on the Goncourt brothers. How a junior Foreign Office clerk managed to keep in touch with such things would be a complete mystery were it not for *La Vogue*, the seemingly obscure Parisian literary journal that somehow crossed the Channel and made its way to Chelsea, bringing with it the name of Félix Fénéon.

From the magazine's launch in 1886 Fénéon's name appeared with ever-increasing frequency, as he reviewed exhibitions and profiled the younger painters who were beginning to emerge in the Paris art world. By the time Gray and the others discovered *La Vogue*, Fénéon was so dominant a presence that he had effectively become its editor, without ever actually bearing the title, and it was from him that these distant English readers traced the emergence of the new literature that was replacing the earlier Decadence and the new art that was supplanting Impressionism. Fénéon had named the new movement Neo-Impressionism, and while this would eventually yield to the more widely accepted Post-Impressionism, it was Fénéon who first identified

and described the phenomenon. In the September 1889 edition of the magazine, he reviewed the fifth annual Salon des Artistes Indépendants, picking out Anquetin, Van Gogh, Seurat and Signac for especial mention and devoting a paragraph to the works exhibited by the virtually unknown Toulouse-Lautrec. Gray and the others can hardly have avoided noticing just how impressed Fénéon had been by Lautrec's *Bal du Moulin de la Galette*, which he described in some detail, evoking the atmosphere and characters of this working-class dance hall, especially the young *gigolette*, her 'knowing eyes a bit dazed with drink' – an image of low-life abandon way beyond the normal experience of his readers at The Vale for whom art was a thing of noble beauty or, if decadent, then only in a vague and misty way. Such blunt suggestions of sex were alien to these English aesthetes – a *gigolette* is only translatable as the 'girl of a gigolo', possibly a tart, possibly not, but certainly no lady as they would have understood it, and while his London readers may have had some difficulty in fully understanding such terms, they were probably aware that this was a deliberate use of crude *argot* by Fénéon, as his way of evoking the visual street-slang used by Lautrec to depict a low-life haunt.

What must have been tantalising for Gray and his friends were the things they could only guess from Fénéon's brief paragraph. They probably knew enough about the Impressionists to recall that they had often painted the pleasures of ordinary folk – Sunday picnics, the cheap and cheerful dances with bright fresh-faced young people enjoying a moment's leisure. And if they did, then there was enough in Fénéon's short mention, especially in the language he used to evoke the scene, to tell them that this was something grimmer and cruder.

With *La Vogue* offering such heady stuff, it is hardly surprising that John Gray was drawn to Paris and in the summer of 1890 he decided to take leave from his Civil Service post to visit the French capital. Only the pressures of work could have prevented Wilde from accompanying him though it was probably better that Gray travelled alone. Wilde would almost certainly have followed known paths, contacting writers of established reputation. Left to his own devices, the younger man was able to make discoveries that he would share with Wilde on his return, much to the older man's advantage. There were two main contacts to help Gray in his search – Wilde's friend Sherard and a new figure in Wilde's life, the American poet Stuart Merrill who had passed through London in 1889, returning to Paris, where he had been largely raised by his diplomat father. Like Lautrec, a one-time pupil of the Lycée Condorcet, Merrill wrote mainly in French, except when translat-

ing his preferred authors into English. He had begun with Baudelaire but was by then deeply involved with Mallarmé and others in the Symbolist circle so that it was probably he, as much as Sherard, who provided Wilde with the contacts that were in turn passed on to Gray.

Either of them could have directed the young man to Léon Vanier, whose publishing imprint described him as the *Editeur des Décadents*, but whose bookshop on the Quai Saint-Michel had quickly become the main outlet for Symbolist publications, and it was via Vanier that Gray was able to contact Fénéon at the Ministry of War and a meeting was arranged. Their friendship was to be one of those small but crucial elements in the cultural history of the *fin de siècle*. While there were English artists such as Burne-Jones to whom the word Symbolist could be attached, until then, its use had been largely confined to writers and painters working in France and Belgium. Now, thanks in some measure to John Gray, the movement would cross the Channel.

The first thing Gray must have noticed about Fénéon was his remarkable appearance, the self-consciously Mephistophelean face and beard which Fénéon himself had captured in a number of self-portraits, some of which were enhanced with a pair of horns to drive home the point. But if that image created an initial impression of someone austere and aloof, Gray was quickly to learn that his new friend was no sharp-tongued intellectual, but a kind and generous mentor, willing to do anything to help him learn as much as possible of what was happening in the French capital in the short time available. Little wonder the impressionable Gray was overwhelmed. Here was a figure of poise and erudition to match even the extraordinary Oscar – perhaps not as ebullient or as outrageously amusing, but far more intense, and certainly better looking. For Gray, these similarities with Wilde, especially Fénéon's manner of dressing, were to lead to considerable confusion. While avowedly heterosexual, Fénéon's polished appearance and his tendency to a rather finicky perfection in everything he undertook, may have given off the wrong signals to the impressionable visitor.

Of course both men had much in common – not least the need to earn a modest living in the Civil Service of their respective countries while trying to make a mark in the literary world. For Fénéon it was clearly the connection with the exotic Wilde that gave his young visitor some status, though there can be no doubting his kindness in adding to an already packed schedule by showing his new friend the cultural sights. These included a by now obligatory visit to Verlaine, once again in hospital, and an evening at the appropriately named Taverne anglaise where the writers associated with *La*

Vogue liked to congregate. Something of Fénéon's political leanings must have appeared when he introduced Gray to the Pissarros, father Camille and son Lucien, both of whom knew England well, Camille having exiled himself near London during the Franco-Prussian War and Lucien having visited in 1882 to learn the language. The Pissarros were part of the small circle of painters that Fénéon sanctioned. In Camille's case this was partially because he had departed from pure Impressionism to embrace Seurat's 'dots' and could thus be looked on as one of Fénéon's Post-Impressionists, and partially because father and son were both committed anarchists. Gray may have known of Camille's earlier Impressionism from Wilde who had seen his work during a visit to Paris in 1883 but the political connections were probably new to him. Of all the avant-garde painters, Pissarro was the most openly anarchist and it is easy to see why. The son of Jewish traders who had settled in the Danish Antilles, he had witnessed the brutal suppression of the slave riots followed by his own experience of anti-Semitism once he settled in France. Despite their supposed friendship, Degas and Renoir were not above referring to him as 'the Jew Pissarro' and a life of crushing poverty with a discontented wife and a houseful of children, out in the country near Pontoise, had left him with a genuine sympathy for the disinherited underclass. By 1890, the year Gray met him, these sentiments had begun to find their way into his art, though this has not always been given the recognition it merits. It is too easy to think of the elder Pissarro as just another painter of Impressionist landscapes and townscapes in which nature and buildings predominate and human beings are no more than tiny squiggles of paint. Only recently have Pissarro's major figure paintings of peasants working in the fields or at market been given the prominence they deserve. These were intended to show the artist's ideal world, a place of social communion and co-operation, the anarchist Utopia to which he subscribed. But 1890 also saw the creation of his *Turpitudes sociales*, a set of somewhat crude, caricatural drawings, in which he attacked the Parisian middle classes for their selfishness and disregard of the poor. One drawing, entitled *Asphyxiation*, shows three young children sleeping in an airless garret – a bleak image that can be set against *The Stockbrokers* in which top-hatted *coulissiers* bid for shares under the colonnaded entrance to the Bourse – a confrontation that sets the sad inertia of the helpless against the empty frenetic activity of the rich and which makes one think of Lautrec's 'Bruant' works with their confrontation of working-class victim and upper-class voyeur. Pissarro had seen Lautrec's paintings before he embarked on *Turpitudes* and may well have been encouraged to do so by the younger

Lucien Pissarro, *Les Bûcherons*.

man's example. But for some reason, Pissarro's scathing drawings were never published during his lifetime, as if he preferred to persuade his audience by showing them a better life as exemplified in his rural idylls, rather than trying to goad them to revolution with his furious satire.

While John Gray could have met Lautrec, who did not leave Paris until the early autumn having a number of paintings he wanted to complete, it is unlikely as Henri had been deeply affected by the tragedy that had overwhelmed the Van Gogh brothers. When Henri had lunched with Vincent at Théo's apartment early in July, things had seemed to be going quite well. Following his breakdown in Arles and the famous incident of the cut ear, Vincent had spent some time in the asylum in Saint-Rémy before moving north to the village of Auvers-sur-Oise, just outside Paris, where he could be seen by Dr Paul Gachet who, as a medical man and amateur artist and collector of contemporary art, was thought to be especially effective in treating the mental problems of creative people. From the evidence of that lunch Henri would probably have agreed, so that it came as a devastating shock when he learned that Vincent had committed suicide three weeks later. He heard the news too late to attend the funeral and shortly afterwards, was told that Théo too was mentally unwell. By the autumn he would be unable to continue running the Boussod and Valadon Gallery and within six months would also be dead, a terrible blow to the avant-garde artists he had supported even though there was little prospect of much profit from sales of their work. In the end, the change at the gallery turned out well for Henri when his old friend Maurice Joyant was brought in to replace Théo but during the summer of 1890, with Vincent just dead and Théo's illness beginning, things looked rather bleak, inducing an unusual state of depression in the normally resilient Henri.

Even without meeting Lautrec, the procession of new acquaintances that John Gray encountered during his visit must have been daunting. But he clearly acquitted himself honourably as Fénéon seems to have decided that his young friend would make a suitable London representative for his circle. Keen to encourage Gray's interest in Symbolism, Fénéon made up a parcel of books for him to take home and must have been somewhat surprised when his guest asked if there was another present he might have – one of Fénéon's drawings of himself as a wickedly handsome Mephistopheles. Gray also extracted a promise that he would visit London as soon as possible – all of which ought to have suggested to Fénéon that the young Englishman was attracted to him by something stronger than just a shared interest in literature.

Back in London, Gray set about maintaining the connection by sending his new friend prints by Ricketts for publication in Paris and it is revealing to read the praise that the critic lavished on these relatively little-known English works. In return, Fénéon wrote proposing new authors for Gray to translate.

Lucien Pissarro came to London in November 1890 and Gray introduced him to The Vale, opening up years of fruitful co-operation with Ricketts and Shannon. The Vale Press published Lucien's own woodcuts and sets of prints from his father's drawings, a connection maintained after Lucien moved to Epping to set up his own Eragny Press, named after the village in Normandy where his father was then living.

It was a remarkable dialogue and one that owed much to the now forgotten John Gray, soon to experience a complete change of heart, renouncing poetry for Catholicism, becoming a priest and disappearing to a gloomy parish in Scotland ostensibly to purge himself of what he had come to see as the curse of decadence. It was a strange ending for one who, in his brief heyday, had been an essential element in the cultural links between Paris and London and who had counted among his attentive audience the arch-decadent Oscar Wilde. Everything Wilde heard of Paris from Gray convinced him that he must find out more about Fénéon, Mallarmé and the Symbolists. It was essential that when *Dorian Gray* appeared in book form it would be seen as part of the new movement. He already planned to add new chapters for the forthcoming publication but with John Gray's reports dominating his thoughts he decided to open the novel with a preface that would establish its Symbolist credentials and with this in mind he decided to revisit Paris himself for a first-hand encounter with the leaders of the new movement.

This was no sooner decided than Wilde's friend, Robert Sherard, suddenly arrived in London full of gossip about literary life in the French capital. They had first met seven years earlier in 1883 during Wilde's first long stay in Paris when he had dined at the home of Maria Zambaca, a great beauty with a notorious reputation, who had left her husband to become the mistress of the Pre-Raphaelite painter Burne-Jones who had posed her as the model for the female seductress in his masterpiece, *The Beguiling of Merlin*. When the affair ended, Madame Zambaca had returned to Paris where she dabbled in painting and ran something approaching a salon for writers and artists, from among whom she had chosen her current favourite, an artist called Sinanides. It was indirectly due to this shadowy figure that Wilde was to discover the means to penetrate the inner world of Parisian culture.

From Wilde's point of view, the dinner party was a huge success – he held forth and his fellow guests, who that night included the poet Paul Bourget and the painter and society portraitist John Singer Sargent, lapped it up – all except one young man, who silently sulked throughout the evening.

Twenty-two years old, blond and athletic, Robert Harborough Sherard had been in Paris since late the previous year and was making a precarious living as a correspondent for various foreign newspapers, while trying to write poetry and a novel. He had fallen in with Sinanides, hence his invitation to the dinner, and if he had set his cap to win the attention of the principal guest he could not have chosen a more beguiling tactic – an attractive surly boy, paying no attention to him whatsoever, was guaranteed to needle a man who required, indeed demanded, constant admiration.

They crossed swords when Wilde began enthusing about his visit to the Louvre and the physical sensation he felt in the presence of the Venus de Milo, at which point the formerly silent Sherard piped up with a remark that was neither witty nor pertinent: 'I have never been to the Louvre. When that name is mentioned I always think of the Grands Magasins du Louvre, where I can get the cheapest ties in Paris.'

Such crassness ought to have been the end of the young man's social life, but the ever kindly Wilde was willing to do anything to save the situation. 'I like that,' he responded merrily. 'It is very fine.' Whereupon he proceeded to direct all his conversation at the foolish youngster for the rest of the evening, thoroughly mesmerising him and finishing with an invitation for him to dine the following day at the Hôtel Voltaire, on the left bank, directly opposite the self-same Louvre, where Wilde was then staying.

When they met, Wilde continued to flatter Sherard, pretending that the remark about the Louvre must have been part of a pose, scientifically thought out in order to capture his attention, rather than being the boorish nonsense it certainly was. But there was more to Sherard than just his youth or his gaucheness that attracted Wilde: the aspiring author had a most intriguing background. His father, the Reverend Bennet Sherard Calcraft Kennedy, was the illegitimate son of the last Earl of Harborough, and lived in hopes of a considerable inheritance when his lordship should die, while the young Sherard's mother, Jane Stanley Wordsworth, was the granddaughter of the poet. It was thus an alluring set of attributes – looks, aristocracy, literary inheritance – that came together in the form of the man who was now to become Wilde's closest companion, introducing him to Victor Hugo, who holidayed with the Kennedy family on Jersey where he had lived in exile during the Second Empire. Sadly, the reality fell somewhat

short of expectations – the great man fell asleep after his meal, leaving his guests to chatter away in whispers so as not to disturb him. This was hardly an ambience in which the mellifluous Oscar was likely to shine, though he did his best, conscious of the fact that his fellow guest was the eminent Edmond de Goncourt, survivor of the sibling diarists. They were to meet on a second occasion during that visit and the influence of Goncourt's novels, *La Faustin* and *Manette Salomon*, with their manifestations of misogyny and their suggestions of homosexuality, were to help Wilde escape the chrysalis of English aestheticism, which still held to the idea of art as a force for self-improvement. What Wilde could not know was that the diarist had seen elements in his character that Wilde himself chose not to recognise, describing him in the famous diary as *au sexe douteux*. While that was undeniable, it had little to do with Wilde's behaviour on that visit, which was almost entirely devoted to culture. As far as one can tell, Wilde seems to have ignored that other Paris so beloved of unattached foreign visitors and may even have been unaware of Sherard's proclivities in this regard. The younger man led an energetic sex-life in the bars, cabarets and dance halls of the capital. A frequent visitor to the Bar Bullier, he maintained more than one mistress at the same time, using his youth and looks to counterbalance a lack of resources, and ignoring the fact that he had quickly acquired syphilis. But when it came to Wilde, the younger man seems to have set aside these adventures in favour of their literary outings and occasional visits to art galleries.

Not that there was much going on during Wilde's visit, though we know he visited an exhibition of Impressionist paintings at the Durand-Ruel Gallery where he saw the work of Pissarro and was in turn seen and noted by a number of artists and writers who later recalled their shock at first encountering so flamboyant a figure. There is every likelihood that Fénéon saw him at the exhibition for it was from about then that he began to wear the sort of dandyish clothes that owed much to the image offered by the foreign visitor. This connection was confirmed when Fénéon sat for a portrait by his friend Paul Signac who posed him as a somewhat effete man-about-town, fastidiously besuited, holding a flower in his outstretched hand, an unambiguous reference to Wilde who often paraded on the boulevards, just as he did in London, holding a lily before him. Signac always insisted that the flower in his portrait of Fénéon was a cyclamen, but that hardly alters the connection with Wilde which the artist clearly intended.

As Wilde's first long stay in Paris drew to a close, he too remade himself, outwardly at least, casting away the velvet knee-breeches and the shoulder-length hair and insisting that Sherard accompany him to the Louvre with

two hairdressers from the rue Scribe, in order to have their hair curled in the manner of one of the Roman busts. Thus becurled, Wilde returned to London, quickly followed by Sherard who was able to introduce the older man to a number of friends outside his usual ambience. In England, Sherard's contacts were often both literary and political, a duality exemplified by a friend of Sherard's brief Oxford days, John Barlas, who was both an ardent socialist and a poet, considered by many to be the rising star of his generation – both good reasons why Wilde was delighted to admit him to his inner circle. However, young authors were not the main thing on his mind right then – Oscar had decided to marry. This was partly to confuse his critics but also due to his own sexual ambivalence which was momentarily resolved by the boyish looks of the young and clearly rather naïve Constance Lloyd. Having wooed and won her, Oscar took his new wife to Paris, no doubt to the confusion of those who had thought they had pinpointed his sexual preferences as Edmond de Goncourt had done.

Sherard had already returned when the newlyweds arrived in the French capital. He found them very much in love, a condition that left little time for literary junketing. Indeed the only event of 1884 in Paris which had any bearing on Wilde's future was the publication of the ultimate novel of the *Décadence*, Joris-Karl Huysmans' *A Rebours*, which in a way would hold some responsibility for the final collapse of the union that Oscar and Constance were so sentimentally proclaiming as they strolled by the Seine and visited the sights. But that was still several years away – Wilde had learned much about the new ideas that were current in Paris but still had some way to go before he finally caught up with the true avant-garde.

Wilde and Sherard were together again in 1890 when the younger man came to London to write an article for *The Graphic* on the city's underclass, spending his nights in filthy doss-houses and Salvation Army shelters, experiencing at first hand the grim conditions even children were obliged to endure. Despite his frequent bouts of insensitivity, there is no doubt that part of Sherard's appeal to Wilde was his concern for those who had led near-bestial lives in the terrible slums that despoiled the new industrial cities. Britain had enjoyed an economic boom over the twenty years between 1850 and 1870 which had made life very pleasant for the professional and business community and those, such as clerks and upper servants, who benefited from their employers' well-being, but when it was followed by a disastrous depression, fundamental flaws in the system began to appear. In Britain's industrial towns, the squalor of life in the slums was made worse by the absence of a coherent political voice to give expression to the grievances

of the poor. Neither the Tories nor the Liberals spoke for the disenfranchised underclass. At one point it was suggested to Wilde that he stand for Parliament but he was wise enough to dismiss the idea. The political void was filled only by extreme groups with little chance of electoral success – the nascent Communist Party with their divided Socialist allies and various anarchist factions.

Throughout the 1880s there had been a rising tide of political demonstrations organised by shifting combinations of these various bodies – the Social Democratic League, the Revolutionary Social Democrats, the followers of Marx and Engels, and religious reformers such as the Salvation Army and the Methodists. On 8 February 1886, a gathering of some 20,000 people in Trafalgar Square to protest widespread unemployment and the miserable wages of the few who were employed, ended in looting and rioting that went on for days afterwards. The authorities responded with brutality, ordering the police to suppress what looked for a moment to be turning into the British Revolution. It was during one of these ugly stampedes that the poet friend of Sherard and Wilde, John Barlas, was beaten to the ground by a baton-wielding policeman, an attack that left the young man stunned and bleeding at the feet of a horrified Eleanor Marx, daughter of the late philosopher. Barlas never fully recovered and ended up mentally ill, living in filthy lodgings in the Lambeth Road, surrounded by anarchist tracts and vowing revenge on the government that had ruined his life. Wilde did his best to see that he was comfortable, though it became increasingly difficult to deal with someone who was by turns aggressive and depressed.

In the wake of the Trafalgar Square riots the ideas of the various Socialist groups began to coalesce, with most sharing a central belief in the need for massive State intervention to redress the imbalance in wealth and ownership that was destroying so many lives. Some, like the followers of Marx, advocated total State ownership of the means of production, supply and demand; others like William Morris continued to plead for a sort of agrarian, village socialism where communal ownership and mutual help would remove the need for money and possessions. But despite such variations, there was a common belief that a degree of obligation, even coercion, no matter how fancifully dressed up this might be, was necessary to counterbalance the usual human failings of greed and self-aggrandisement which might undermine any new social order. The most polished of these groups was probably the Fabian Society, which Wilde attended in its early days. But while he sympathised with its aims, he was from the outset at odds with its collectivist approach, which he had come to see as just another form of dom-

inance by one group over another. The cause might be good but this was still the old exercise of power that he so despised in the current social order.

He was confirmed in this approach by a meeting which almost certainly took place that same year, with the Russian revolutionary Peter Kropotkin, the leading theorist of the anarchist movement, who began his exile in Britain in 1886. Kropotkin's long flight, after his escape from the Tsarist police to his imprisonment in France, had failed to dent his gentle nature and his unflinching belief that the inherent goodness of humanity would enable a society to be created which depended solely on mutual trust and obligation rather than a regime built on the enforcement of laws. Wilde considered him one of the only two really happy men he had ever known and was later to write of his Christ-like qualities, though it is probable that he had simply overlooked the depth of Kropotkin's revolutionary zeal, for despite his instinctive humanity, the Russian did not share Wilde's rejection of violent revolutionary acts. In France, where he was a hero to the anarchist cause, Kropotkin was revered for advocating the Propaganda of the Deed as the only means of awakening the masses to the need for action.

For his part, Wilde was convinced that the shedding of blood was unnecessary and that reason would prevail. To this end he began to compose his most outspoken political tract *The Soul of Man under Socialism* which appeared almost at the same time as *Intentions*, Wilde's ruminations in dialogue form on the interplay of art and criticism, which for all their wit made it doubly clear that he was not the empty-headed effeminate that Gilbert and Sullivan had satirised in *Patience*, but a considerable radical intellectual thinker, offering a consistent philosophy of individualism to set against the corporate and authoritarian ethos of much Socialist, especially Marxist, thought. Both the essay and *Intentions* advocated a role for art in transforming society: 'Art is individualism, and individualism is a disturbing and disintegrating force.' Of course this could be, and has been, interpreted as an expression of his own wish to be free of the need to conform to society's norms, the need which had led him into marriage and parenthood and which in turn had almost wasted his talents in hack journalism, churned out to earn money to pay for house and servants, the very things he was now rejecting. But in a broader sense, it was an unequivocal assault on the conformist ethos and hierarchical structure of British society in the last century. The supposedly ethereal and silly Wilde may have had little to say on how society was to make the leap from rampant capitalism to his artistic and creative Utopia but that was not his function. Wilde was acting as a solitary propagandist for beliefs that were being swept aside as the forces of left and

right squared up to each other for the great political battles that would dominate the coming century. Wilde was one of the few who saw where the authoritarian left would lead:

> If the socialism is Authoritarian; if there are Governments armed with economic power as they are now with political power; if, in a word, we are to have Industrial Tyrannies, then the last state of man will be worse than the first.

Perhaps appropriately, it was to be in Tsarist Russia that *The Soul of Man under Socialism* would find its most avid, inevitably underground, readership – though sadly the leaders of the eventual revolution were not to heed those words of warning from so unlikely a source.

Wilde finished his only political treatise at the same time that he was completing his only novel and the two works have much in common as critiques of the current social order. Wilde was due to deliver the final manuscript of *Dorian Gray* in February of the new year and having dutifully spent Christmas with his family, he set off in January 1891 for his second long stay in the French capital. It was eight years since those days when the author of a single slim volume of verse had stayed at the Hôtel Voltaire, desperate to meet the literary stars he had been reading all his adult life. He had learned much then but this time would be different; now there was a chance that he could cease being a spectator and become an active member of the only club that really mattered – the Parisian cultural élite.

Sherard's first task was to arrange a meeting with Mallarmé, though the American poet Stuart Merrill later insisted that he had pulled off this coup. Either might have done so, though Sherard had the most colourful version, claiming to have invited the great man to dine with them at the Café Riche only to find that Mallarmé's reply was so illegible they could not be absolutely certain he would turn up until he finally arrived. Once there, Mallarmé usurped Wilde's usual role as chief raconteur by telling a story about the writer Hugues Rebelle who had failed to turn up for the previous night's *Mardi*, the regular Tuesday gathering at Mallarmé's flat on the rue de Rome. It was only when the *soirée* was over and Mallarmé went into the kitchen that he found his pathologically shy disciple hiding there, afraid to draw attention to himself by coming into the salon.

As with Hugo on that earlier visit, Wilde listened in rapt silence and was rewarded after the meal when Mallarmé suggested they go over and join Guy de Maupassant at another table. As they approached, they overheard the

famous author telling an appalled American admirer that most of his stories were just pot-boilers meant to raise enough money to help him forget his years of struggle and poverty. Throughout all this Wilde continued to play the respectful listener, and was duly rewarded with an invitation to his first *Mardi* on 24 February when Mallarmé delivered his customary homily to his attentive followers. Again Wilde listened in silence and while playing the Trappist was no doubt irksome, he was again rewarded, this time with a signed copy of Mallarmé's translation of *The Raven*, illustrated by Manet, a hallowed text as the recipient well knew.

He attended his second *Mardi* the following week, on 3 March, and was warmly welcomed, despite Mallarmé having received a telegram from Whistler warning him against admitting the now despised Oscar with whom the painter had quarrelled. Such tiffs among artists were not unknown in Paris and probably added to Wilde's status. That aside, the insight into Symbolist thinking that Mallarmé offered was just what Wilde needed and apart from the occasional excursion with Sherard, he now shut himself in his room and wrote the preface to *Dorian Gray* in a manner intended to please the master in the rue de Rome.

> To reveal art and conceal the artist is art's aim.
>
> There is no such thing as a moral or an immoral book. Books are well written, or badly written. That is all.
>
> All art is at once surface and symbol. Those who go beneath the surface do so at their peril. Those who read the symbol do so at their peril.

It is generally assumed that Fénéon and Wilde met at one of the *Mardis*, though which of the two cannot be said. That they hit it off is shown by Fénéon's subsequent attachment to Wilde's aphoristic style – occasionally quoting him at the head of his articles – but also by Fénéon's subsequent fidelity to his new friend throughout the dark days that were to come. We already know about their common interest in aesthetics but it is even more intriguing to see how much Wilde's thinking came to permeate the Frenchman's writings.

'The influence of the critic', Wilde wrote in *The Critic as Artist*, 'will be the mere fact of his own existence. He will represent the flawless type. In him the culture of the century will see itself realised. You must not ask him to have any aim other than the perfecting of himself.'

This view of the critic as the equal of, if not ultimately superior to, the artists he writes about, as well as the suggestion that he is part of some priestly cast intent as much on refining himself as he is in explaining the work of others, might stand as a description of Fénéon's own approach to his life. He was to prove both inflexible in the standards he set yet curiously self-negating as regards his own needs and desires and it is hardly surprising to find him, later, writing in a manner that perfectly echoes Wilde's quasi-religious ruminations:

'The critic', Fénéon would write, 'must be a discriminating and inclusive intellect, penetrating the soul of the artist, seizing his aesthetic personality, considering the work of art both from the point of view of the author and from the point of view of the public – a channel for the one and for the other.'

It is interesting that despite a shared reputation for sharp intelligence and fearsome attachment to truth, neither man was particularly scornful towards those they opposed. Neither ever wrote a deliberately hurtful review and it was the practice of both simply to withdraw rather than to provoke confrontation. They were closest in searching for a moral approach to explain their actions. For Wilde, this was most often seen as a question of aesthetics which, so he claimed, explained the critic's 'extreme attention to beauty – and even his fastidiousness in dress', a point applicable to himself and to Fénéon.

Despite the Frenchman's admiration for Wilde he did not become his literary tour guide in the way that he had for John Gray, probably assuming that the visitor was well enough informed not to need such help. In any case Wilde was so focused on Symbolism and his wish to incorporate its principles into his preface, that he had little desire to see what else might be taking place in the city. Although Wilde stayed in Paris until March he seems to have restricted his interest to Mallarmé and others in his circle, ignoring even those elements of the city's night-life that were already becoming notorious across the Channel, most notably the Moulin Rouge. Of course Sherard was a regular visitor to the new club as well as to other night-spots like Le Chat Noir and Le Mirliton, and he must surely have mentioned them to Wilde. Even so, there is no record that the visitor showed any inclination to follow his friend on his nightly outings, even though we know that in London Wilde was already a regular participant in those underground activities he had hinted at in *The Picture of Dorian Gray*.

It was as if some last vestige of artistic ambition still held him back from the final abandon that would ultimately destroy him. As if he were unable to

let go completely until he had proved himself to those he admired by creating some major cultural artefact. One can read this into the way he became obsessed with outshining his Paris mentor by writing something that would raise him to Mallarmé's level. He knew that Mallarmé had long worked on his unfinished poem *Herodias*, based on the biblical tale of the double-lust of Herodias, King Herod's wife, for John the Baptist, with that of Herod for Herodias's daughter Salomé. To be avenged upon the Prophet who has spurned her, Herodias offers Herod the spectacle of her daughter dancing naked, provided he will grant her one wish – which of course will be the death of the saint. Before leaving for France, Wilde had toyed with the idea of a play based on this story, but with his new desire to outshine the author of the unfinished *Herodias* egging him on, he began to give the subject serious thought. These were early days but he was clear about one thing: whatever the play might consist of, it would be written directly in French by Wilde himself.

Wilde was no sooner back in London in the spring of 1891 than he was followed by Fénéon, taking up Gray's invitation for a reciprocal tour of Britain's literary avant-garde.

Gray had already written to Paris in November the previous year to set out the sort of things he wanted them to do together:

> We shall go find everything there is to be seen in London; we
> shall seek out drawings by a fellow named Siméon Solomon,
> a pre-Raphaelite, but also something else – somewhat like
> Verlaine, if what they say is true. People no longer speak of
> him, except in whispers, but he was one of the great artists of
> that School (sometimes) – we shall go to Hampton Court, all
> the art galleries, and see London from one end to the other.
> Ricketts will decorate a room for you in Whistler's old house
> with mystical, sweet arabesques and decadent colours, the
> faint glimmer of gems on a tray of jade.

Even allowing for the fact that Gray was writing in a foreign language and was using the sort of decadent mannerisms he thought closest to his own aesthetic tastes, the letter remains extraordinarily effete for a simple communication between two acquaintances. The significance of the reference to Siméon Solomon was probably lost on Fénéon – the fifty-one-year-old painter was virtually unknown in France and even in England was by then

such a pariah that Gray's assertion that people no longer spoke of him was something of an understatement. From a well-off Jewish family in London's East End, Solomon had worked on the fringes of the Pre-Raphaelite movement, more drawn to Burne-Jones than the others, clearly because of the air of ambiguous sexuality that hangs over many of his figures, the effeminate boys and androgynous angels that animate his paintings. There was also a friendship, that may have been more, with Swinburne who introduced Solomon to the works of Whitman and the Marquis de Sade, and thus provided him with his preferred subject – boys, though clothed in what J. A. Symons described as 'the allegorical mysticism and pensive grace of the middle ages, and the indescribable perfume of orientalism'. Sometimes, however, Solomon's paintings were far less ambiguous. His best-known work *Bridegroom and Sad Love* shows a young man walking along arm in arm with his 'love', a female, while just behind there walks a male angel bearing a diadem with the words *Amore Tristis*. The extraordinary thing is that the bridegroom is quite openly reaching behind him to give the naked angel's genitalia a hearty grope. Whether Solomon could have continued with impugnity this flagrant teasing of Victorian mores must be doubted, but in any case on the night of 11 February 1873, it all came crashing down when he was arrested in a public lavatory and charged with indecent exposure under the old laws predating the Criminal Law Amendment Act that would be used to ensnare Wilde. Given what we can guess of Gray's feelings for his French visitor, this desire to bring him into contact with the work of an artist who, since his release from prison, survived by selling near-pornographic drawings and blackmailing his fellow homosexuals, seems at best ambiguous. If Gray wanted to make his own inclinations clear to Fénéon, why did he propose exposing his guest to the worst that deviant sexuality could do to a man in England at that time? In the coming years, in the parish in Edinburgh where Gray would pass the greater part of his life, he would furiously deny his former existence even to the point of suing a writer who suggested that he had been the inspiration for Dorian Gray. Perhaps this introduction to the works of someone like Solomon was a way of warding off what Gray feared most. What Fénéon made of it all we do not know and probably never will, though he was to get a clearer indication of what had been going on in Gray's mind two years later when he received an edition of his young friend's poems, exquisitely designed by Ricketts in the form of a 'saddle book', a tall, narrow volume with gilded covers picked out in a repeated flame motif that was to make it the very epitome of aesthetic style while its wider-than-ever margins emphasised the isolated preciousness of

the sparse lines. Sadly the verses were less enthusiastically received than the design of the book which was much praised, though what Fénéon found between those sumptuous bindings – translations of Mallarmé and Verlaine and the other Symbolists – was a suitable tribute to his labours as a teacher over the previous years. What he probably had not expected was the poem Gray dedicated to him which finally exposed what it was the poet had felt about him at the time of that visit:

> Men, women, call thee so or so,
>> I do not know.
>> Thou hast no name
> For me, but in my heart a flame
>
> Burns tireless, neath a silver vine,
>> And round entwine
>> Its purple girth
> All things of fragrance and of worth.
>
> Thou shout! thou burst of light! thou throb
>> Of pain! thou sob!
>> Thou like a bar
> Of some sonata, heard from far
>
> Through blue-hue'd veils! When in these wise,
>> To my soul's eyes,
>> Thy shape appears,
> My aching hands are full of tears.

Whatever he may have felt about this declaration, Fénéon continued to treat Gray with extraordinary kindness, keeping him abreast of writing that would otherwise have been completely unknown in London. In one letter, Gray thanks Fénéon for sending him a manuscript 'by a poet who died of hunger', a remark that has sparked off a literary manhunt – the poet in question may have been Isidore Ducasse who died aged twenty-four, probably of starvation, during the siege of Paris in 1871. At the time of his death Ducasse, under the pseudonym the Comte de Lautréamont, had left the manuscript of a bizarre work he entitled the *Chants de Maldorer*, the blasphemous tale of a demonic figure who loathes God and man and who expresses his love for a range of things from toads to octopuses to the ocean itself, in passages of increasingly wild and erotic imagery that would later be hailed by the Surrealists as a forerunner of their own explorations of the sub-

Charles Ricketts' illustration for *Spiritual Poems* by John Gray,
published by the Vale Press.

235

conscious. Limited editions of sections of the Ducasse/Lautréamont text had been issued by small presses but it was Fénéon who arranged for the first complete publication and he may well have passed the original manuscript to Gray in the hope that he would arrange an English translation. If so, it was an over-generous act. Gray was notorious for mislaying things – shortly after his return from his visit to Paris he was obliged to write to Fénéon to ask for another portrait as he had somehow lost the first. But with the *Chants de Maldorer* there may have been another reason for this supposed ineptness. As the 1890s progressed, Gray became increasingly disillusioned with the decadent literary milieu of which he was part. Already on the first steps to conversion to Roman Catholicism, it is possible that Gray came to view so anti-Christian a work with increased loathing to the point where he decided to destroy it.

Whatever the truth of that odd episode, the two men remained in close contact until Gray's conversion, after which he began to distance himself from what he then saw as the unacceptable decadence of literary life. Aside from his brief connection with Oscar Wilde, John Gray is now a forgotten figure given little credit for having briefly united the cultural avant-garde of two cities.

Back in 1891, Gray's obsession with Fénéon must have relieved Wilde of an awkward entanglement now that he too had another, more pressing interest. Despite his size and fleshiness, Wilde's seductive talk and financial generosity were proving quite sufficient to charm a series of young men into passing adventures. At first these consisted mainly of impressionable students drawn from the circle of his original seducer Robbie Ross, but this was quickly extended to include lower-class lads, thrilled to be taken to an expensive London restaurant followed by a night in a smart hotel and the gift of an inscribed silver cigarette case sent round a few days later. That this was incredibly risky, Wilde well knew but that, of course, was a good part of the thrill.

In retrospect, despite the dangers, this sort of cruising might have been the best outlet for Oscar's needs, but in late June that year, possibly while Fénéon was still in London, one of Wilde's friends, Lionel Johnson, brought to Tite Street a cousin, a student at Oxford, who had been reading and rereading *Dorian Gray* and was most keen to meet its author. Wilde was entirely happy to oblige; his visitor was blond and beautiful in a softly boyish way, he was also undeniably aristocratic with a hint of danger to his ancient name, Lord Alfred ('Bosie') Douglas, the youngest son of the notori-

236 Oscar Wilde at the theatre, early 1890s, drawing by Maurice Greiffenhagen.

ous John Sholto Douglas, Marquess of Queensberry. From then on, Wilde's already tenuous relationship with Gray drifted into little but a loose friendship. For Gray, it was the beginning of the road to Rome that would end in a bleak parish in Scotland; for Wilde, it was the start of his rocky path to calvary. Before nemesis struck, Oscar Wilde was to know fame and wealth on a scale that even his ample ego had barely dared dream of.

First there was *Salomé*, the play that would challenge Mallarmé's unfinished *Herodias* and establish Wilde as a leading exponent of the new Symbolism. It was a subject open to almost any interpretation. The biblical sources were slight – the few verses in Saints Matthew and Mark describing the death of John the Baptist refer only to 'the daughter of Herodias' who avenges her mother's rejection by the imprisoned Prophet, using the lust of her stepfather Herod to extract a promise that she will be given whatever she chooses if she will dance for him, a dance that is followed by her demand for the Baptist's head. Two millennia of accretions in painting, sculpture, poems, stories and plays have added layers of myth and meaning to the woman who has become known as Salomé. Wilde, however, began with Gustave Moreau's lurid painting of the dancer ogling the severed head – or more exactly with the description of Moreau's painting in Huysman's *A Rebours* where the image of Salomé represents Des Esseinte's nightmare of the terrifying female body: 'She had become, as it were, the symbolic incarnation of undying Lust, the Goddess of immortal Hysteria, the accursed Beauty exalted above all other beauties by the catalepsy that hardens her flesh and steels her muscles, the monstrous Beast, indifferent, irresponsible, insensibly poisoning, like the Helen of ancient myth, everything that approaches her, everything that sees her, everything that she touches.' While Mallarmé had concentrated on Herodias, it was Huysman's view of Salomé as the embodiment of evil, who herself, rather than her mother, is the one who lusts after the Baptist, that gave Wilde his theme.

Immediately following his return from Paris he did little except brood on the subject. At some point he decided that it would be a verse drama and, more challengingly, that it would be written directly in French. Wilde's French was good, up to a point, but to think of writing a long poem in the language bordered on the hubristic and it was little wonder that he did not rush to begin. By October, he let drop to two friends that he was writing something in French, but passed it off by saying that he was doing it because he wished to become a member of the Académie Française. He may have made some sort of start by then, but if so it only served to convince him of the impossibility of the task he had set himself. He quickly saw that he

would never get through it in London, and that he had best go back to Paris where he would be immersed in the language he was using.

In any case he had something far more pressing to complete. Late in 1890 he had accepted a commission from the theatrical impresario George Alexander to write a play – Alexander had taken over the St James's Theatre and wanted to put on home-grown works rather than continue to import foreign plays which had dominated the London stage in recent years. Unfortunately, no ideas were forthcoming and the deadline of 1 January 1891 passed without any sign of progress. It was only after the return from Paris, while still contemplating Salomé, that a subject finally appeared – Wilde had been on a trip to the Lake District and returned with the name of his principal character, though it would be some time before her name was given to the play that was to make him famous – *Lady Windermere's Fan.*

Pushing Salomé to the back of his mind, Wilde began what was to become his working practice from then on – forcing himself to sit down and write a whole play in an intense, concentrated outpouring. As a comedy of manners, though admittedly one with distinctly French antecedents, *Lady Windermere's Fan* seems as far removed from the intensities of Salomé as he could have arranged, though the fact that he originally intended calling it *A Good Woman* would seem to make it the other half of a diptych, the counterpart to that biblical drama about a palpably 'bad' woman. In fact both plays are imbued with Wilde's subversive morality – Lady Windermere may be a staunch upholder of the marital virtues, seriously affronted when she comes to believe that there is something suspect in her husband's friendship with the scandalous Mrs Erlynne, but as Wilde shows, her puritanism borders on the priggish, which in turn edges towards hypocrisy. Rather than admit the fallen woman to her house she flees to the home of Lord Darlington who she knows is her admirer. When her fan is found in Darlington's rooms, the situation is reversed, the good woman is now threatened with exposure and disgrace and is only saved when Mrs Erlynne steps forward to insist that *she* had dropped the fan, which she claims to have inadvertently picked up during an earlier visit to the Windermeres' home. What the audience knows is that she is really Lady Windermere's mother and has further sacrificed her reputation to save a daughter who despises her. In the end Lady Windermere learns that morality must be tempered with humility and compassion, a simple enough lesson, though one enhanced by the way Wilde flaunted the conventions of comedy usual at the time by not revealing all at the final moment. Lord Windermere never learns that his wife visited Darlington, his wife never realises that Mrs Erlynne is

her mother, while Darlington never finds out how the latter fooled him. What Wilde is saying, is that happiness is best served by the maintenance of deception, not the exposure of blunt truth – a point with considerable bearing on his own behaviour at the moment he was writing the play. Nor was he willing to allow the usual dénouement expected in Victorian theatre by having the fallen woman, Mrs Erlynne, repent of her wicked life. After her solitary sacrificial act, she continues as before, a celebration of amorality unheard of on the London stage and the sort of flagrant teasing of established codes that was bound to attract a good deal of attention when the play was produced, as Wilde no doubt anticipated.

He finished writing the piece in October and arranged with Alexander that he should take it round so that he could read it aloud to him but, on the morning in question, he was unexpectedly summoned to a magistrates' court in Westminster at the request of some friends of John Barlas, the poet he had met through Sherard, and the same young man who had been beaten insensible in the wake of the Trafalgar Square riots five years earlier. On arrival Wilde learned that the poor, demented creature had left his filthy lodgings in the Lambeth Road having suddenly decided that the moment had come for his revenge. Armed with a revolver he had walked to Westminster Bridge from where he had fired several shots at the Houses of Parliament. It was nothing, an empty gesture, meant to show, as he told the police, his contempt 'for the constitution of Parliament'. The police were implacable – despite the fact that Barlas was a harmless madman they were determined on a prosecution and it is to the credit of the outwardly foppish Wilde, that despite the importance of his appointment with Alexander, let alone the personal risk of being associated with a man the police were treating as a violent anarchist, he alone was willing to hurry to the magistrates' court and stand bail for a fellow poet.

Having dealt with the matter, Wilde rushed on to his appointment and somehow managed to perform his monologue – brilliantly as it turned out. Alexander thought so and bought the play on the spot. The text would need a little revision but Wilde had what he wanted and could now afford to give his attention to less commercial matters. It was time to return to Paris and Salomé.

9

ALONG THE BOULEVARD DE CLICHY

O scar Wilde was not alone in looking to Paris for new ideas and, hope-fully, approval once they were put into practice. Throughout the *fin de siècle*, a steady stream of young Englishmen, most of them painters, were drawn to what Walter Benjamin called 'the capital of the nineteenth century', some to learn, some to play. Henri de Toulouse-Lautrec liked these English visitors, one could almost say that he collected them, that they were his hobby. It would be easy to see this as a result of the Anglomania, the passion for all things *outre-manche*, from hunting dogs to Savile Row suits, he had inherited from his parents, but it is just as likely that he was drawn to his English friends because they seemed so absorbingly exotic. Some he met at the Moulin Rouge but one of his especial friends, William Rothenstein, was probably found at the Rat Mort in the Place de Clichy, a sleazy restaurant frequented by lesbians which also attracted local artists.

The son of a wealthy German Jewish family successful in the textile trade in Bradford, it could be argued that 'Will' was hardly representative of the little Englanders who came to Paris in search of foreign culture. Yet for all his European connections 'Will' was as English in his manners and outlook as Henri could have wished; his decision to move to France had come less from his continental roots than from the year he had spent at the Slade where he had studied under the French painter Alphonse Legros. Working in an adapted form of Realism derived from Corot, Legros placed sufficient emphasis on studying nature, especially sketching in the open air, to make the Slade a hotbed of revolution when set beside the studio-based historical work encouraged by the Royal Academy. Under Legros, students like Rothenstein had just about caught up with Millet and the Barbizon School when they were confronted by Impressionism, and while at a distance this may seem pretty tame stuff, in the limited London art world of the 1880s it was dangerously radical.

Of course only someone of private means like Will could have contemplated decamping to the French capital and those who eventually joined him were in a similar fortunate position, a fact which has tended to attract charges of dilettantism. It is true that the work of these young Englishmen often lacks the urgency found in artists who are driven by need. Choosing to study at the Académie Julian was another example of their easy-going approach to art. When he opened his first studio in 1868 Rodolphe Julian had made no pretence that it was anything other than a business. Situated in the Passage des Panoramas, an arcade near the Bourse, this was not the usual atelier run by a famous artist acting as master to his apprentices as Bonnat's and Cormon's had been, rather it was an open house where studio space and models were available and where visiting artists were hired to drop by to give advice to those who wanted it. Provided you could pay Julian's fees, you had a place where you could work pretty much as you wished, with help if you wanted it, but above all it was a superb base from which to see and enjoy Paris and the world of the arts. Not surprisingly the Académie Julian at one time or another played host to artists as diverse as Bonnard, Matisse and Léger. Some students created a routine as strict as they would have followed in a normal studio, hoping to pass the entrance examinations to the Beaux-Arts. Others like Rothenstein used the freedom the Académie Julian offered to sample whatever Paris had on show and within a short time of his arrival, the young man had acquired a remarkable number of contacts from Fantin-Latour and Degas to Toulouse-Lautrec. This was due partially to his obvious talents – at the Slade he had been recognised as a superb draftsman and inspired portraitist, but there was also the attraction of his supposed Englishness. With his rather diffident look, peering out from behind round spectacles, Will seemed to his new French friends to embody all the quiet restraint they liked to associate with their island neighbours and allied to his keenness to learn from them, this clearly made him pleasantly different when compared to the rather brash, egotistical characters often found in the avant-garde art world.

Will had quickly discovered Montmartre though more as a meeting place for artists than as the louche entertainment centre others knew. He took to eating at the Rat Mort, whose two-franc meal was a bit steep for most students but where he could at least see some of the artists he was hearing about. Though he and Henri became friends, there were always doubts on Will's part about a man he would later describe as cynical, even brutal, in his perception of human weakness. Everything Will would say about Henri suggests that while he admired the work he disliked, or rather distrusted,

Preparatory study for Henri's first Moulin Rouge poster with La Goulue and Valentin le Desossé.

some of the motivation behind it. Yet despite this reserve, Rothenstein was soon at the centre of Lautrec's English *coterie*, some of whom were no more 'English' in strict terms than he was, but who seemed to Henri to embody those Anglo-Saxon qualities he had learned to admire at his mother's knee.

Typical of these quasi-Englishmen was the painter Charles Conder who came to Paris in 1890, aged twenty-two, after five years in Australia and who moved to the Académie Julian after a brief period with Cormon. Conder's delicate recreations of the art of Fragonard and Watteau had more in common with Ricketts' illustrations than Rothenstein's tentative Impressionism. But despite their differences, the young men were often compared and when they eventually left Paris for London were seen as two of the more promising figures on the English art scene. Largely forgotten today, it is hard to say what Conder might have achieved if he had not succumbed to drink, dying at the young age of forty-two in 1909, a shadow of the dashing figure so full of promise when the 1890s opened.

But while drink would eventually wreck his career, initially it provided an entrée into certain corners of Parisian life denied to Will. It was Conder who became really close to Henri, joining him on his outings to the Moulin Rouge and accompanying him on the inevitable crawl round the late-night bars, when less hardy companions dropped away. Conder eventually moved in with Rothenstein and they were joined by a full-blown English character, Arthur Haythorne Studd, offspring of a famous cricketing family which would also throw up two lord mayors of London. The public-school Studd was not destined for artistic glory but 'Peter', as his friends called him, would have one rare distinction as the only artist to travel out to Tahiti to join Gauguin for a time.

The reasons Henri acquired such friends were various. With Conder it was undoubtedly the pleasure of finding a drinking companion as serious about booze as himself, though even at the Moulin Rouge their vision of the place was in no way alike. When Conder drew the dancers he created a happy party scene with no trace of Lautrec's wry view of human folly. In the same way, Lautrec's view of Conder had as much to do with the artist's vision of the English as with the individual himself – when he painted Conder's portrait, Lautrec depicted him as a pale, long-haired aristocrat, a figure he went on to use as one of his stock background characters, a suitable representative for the sort of chinless British noblemen, the classic 'Milord' of the song by Edith Piaf, who often frequented the Moulin Rouge.

Judging by Rothenstein's somewhat caustic comments on Lautrec's personality one suspects that, initially at least, these young foreigners looked on him as just another fascinating Montmartre character, talented to be sure but not one of the greats like Degas, whom they admired unreservedly. But this perception was to change in the autumn of 1891 when a work by Lautrec suddenly revealed him as far more than the painter of 'crude

ugliness' that Rothenstein had noted. Even more extraordinary was the fact that his work was not displayed in a gallery or at the annual Salon or even in one of the independent group shows but was stuck up in the street or dragged along on a donkey-cart, offering to anyone with eyes to see, a large printed image at the centre of which was a young woman, lifting her skirts and sticking out her bottom.

A friend of Henri's, Francis Jourdan, was walking along the Champs-Elysées when just such a donkey-cart went past carrying the poster on a raised board. Jourdan was astonished to see that the central figure was the notorious can-can dancer La Goulue performing her high-kicking routine with her strange partner Valentin le Desossé. More amazing still was the fact that this scene of low-life entertainment was clearly signed *H. T. Lautrec*. Jourdan found himself walking along beside the cart, determined to get a better look, stunned that the previously private world of the Montmartre dance hall, a subject that had barely broached the confines of the city's art galleries, should now be openly paraded along its most elegant thoroughfare. In a hypocritical age that chose to keep its vices hidden from view, anyone out on the street that day, respectable middle-class women and little children included, could observe a scene that was unabashedly sexy and socially taboo. Everything in the design was directed towards or radiated out from La Goulue's backside, which was made even more prominent by the use of bold simple outlines and the elimination of unnecessary details. Everything about Lautrec's technique was challenging. The limited range but powerful placing of the colours was so unique that a century later familiarity has not bred contempt. Usually identified as *Moulin Rouge – La Goulue*, the poster remains an uncompromisingly original work of graphic art and one that, more than any other visual statement, has come to symbolise the age when it was made. Henri had taken La Goulue and Valentin le Desossé and made them emblematic of decadent Montmartre and in doing so he made himself instantly and enduringly famous.

So great was the impact of the poster and so profound the consequences of its success on the man who made it, that it has proved near impossible to disentangle Lautrec's career from his association with the Moulin Rouge. It is as if the work he produced in and around the club were the culmination of his career. The fact that Oller and Zidler had chosen to hang his circus painting in the entrance hall and the way Henri appears to have set himself up as a sort of semi-official chronicler of the dance hall from the moment it opened, all confirm this impression. His first painting of the interior of the club, a scene on the dance floor before the club opened, shows Valentin

Henri working on *Training the New Girls, by Valentin 'the Boneless'* in his studio in the rue Caulaincourt, 1890.

putting a new dancer through her paces. *Dressage des Nouvelles, par Valentin le Desossé* (Training the new girls, by Valentin 'the Boneless') is an insider's view of the club when selected members of the public were allowed in to watch the afternoon rehearsals. We can recognise Henri's friends Maurice Guibert and Paul Sescau among the onlookers in the background and anyone with any knowledge of how these things worked would have known that they were on the prowl, looking for girls. In fact, the whole essence of the painting is the contrast between these passive well-dressed onlookers and the frantic rehearsal by the dancing woman whose chignon of red hair has fallen loose as she attempts to satisfy her mentor, who is making sure that that night's quadrille will be as athletic and thus as sexy as possible.

Valentin was quite different from the other performers brought in by Oller and Zidler. He refused to be paid and over the five years that he performed at the club remained almost perversely amateur and in every sense his own man – though just who exactly he was is still a mystery. In appearance at least, he was instantly recognisable: painfully slim, with a hooked nose and upswung chin that in profile gave him the look of an emaciated Mr Punch. The famous suppleness which had given him his nick-name was in no way exaggerated. While waiting for the quadrille to begin, he would dance in a rather slow, pensive manner but once the performance got under way he would begin to ripple and bend as if made of India rubber, movements that were the perfect, sinuous foil to his jerky, high-kicking female partners who considered him such a valuable addition to their act that he was often carried off shoulder high when it ended. Although his presence every evening, dressed in a tight-fitting tail suit with a slightly battered stovepipe hat rakishly perched forward over his forehead, convinced many that this was his job, it was only a curiously obsessive hobby. His original name is sometimes given as Jacques Renaudin and he is thought to have been the son of a *notaire*, a solicitor, and thus from a respectable, well-off middle-class background. Some said that his brother had taken on their father's *charge* and that Valentin spent his afternoons at the *étude* helping with legal documents. Others said that he was a wine merchant, though whatever he did for a living can only have been part-time because the one thing that was known about him was that he rode in the Bois de Boulogne every morning, a sign that he had some money at least. Henri saw him there once with La Goulue, the pair of them parading about for all the world like aristocrats, further deepening the mystery of why he spent every night at the Moulin Rouge. It doesn't seem to have been a matter of sex as it was for so

many. Everyone said that he was always the perfect gentleman, behaving towards La Goulue as if they were a respectably married couple. But the reason why so secretive a figure should have had such an appeal for Henri is not hard to deduce – both were leading double lives and both behaved in a way that had no regard at all for the opinions of others.

Valentin's unpaid career was actually quite brief – he walked out of the Moulin Rouge one night in 1895 and was never seen again. Some said he opened a bistro, others that he worked in a lift factory, and one story has him dying in 1906, none of which can be proven. In a sense his only real existence was as an element in Henri's art, a theatrical apparition, caught in time. And this process was itself captured and held – the *Dressage des Nouvelles* happens to be the painting that Lautrec is working on in the photograph of his studio which has the missing circus scene in the background. This reinforces the assumption that the Moulin Rouge was now the central feature of his life and his art, that he spent every evening alone at his table on the raised gallery around the dance floor, somewhat misty with absinthe, manically dashing off sketch after sketch of the thrilling spectacle, sketches that he would work up into full-scale canvases the following morning in his studio. It is somewhat surprising, therefore, to discover that the *Dressage des Nouvelles* was the only work based on the Moulin Rouge around the time of its opening in 1889 and that of the fifteen or so works that feature the place, most were produced from the end of 1891, two years after the club opened.

This certainly runs counter to the image offered by the novel *Moulin Rouge* by Pierre la Mure and the film of the same name by John Huston, and undermines the assumption that his leading model was now La Goulue. On the contrary, she persistently refused to pose for him, seeing no possible advantage to herself in anything he might produce. She wanted publicity not art and at first Oller and Zidler agreed with her. Like Bruant before them, they were quite happy to shock their clients by hanging a Lautrec canvas in their foyer, but when their club first opened they saw no advantage in hiring him to make one of the new posters which they needed to attract a public that they assumed would not be drawn by anything too 'arty'. For something more commercial, the two men turned, inevitably, to Jules Chéret, the leading figure in the new world of mass advertising, indeed the man who had virtually invented the medium.

Chéret's work was everywhere. The Chaix Studios which he co-owned and managed, employed teams of young designers to churn out posters in his lively, colourful style, advertising everything from soap to plays. It was widely

accepted that Chéret had single-handedly created poster advertising, a fact formally recognised in 1890 when, at the age of fifty-five, he was awarded the Légion d'honneur, a singular distinction for someone who had chosen to work outside the elevated sphere of the Salon arts.

At first sight it is puzzling why this sort of advertising, or indeed why advertising in general, took so long to become the major force it now is. While the occasional historian of the subject usually attempts a connection between early business signs, the painted boards that were hung outside inns and cobblers' shops, and the nineteenth-century printed poster, it would be truer to say that modern display advertising was an entirely original creation of the *fin de siècle*, in some ways a bi-product of the equally rapid rise of modern showbusiness. Before the 1880s there had simply been too much government control of public notices for anything interesting to emerge. Early posters were crude wood-block prints on cheap paper whose colour was strictly regulated by law: yellow for the opera, green for the Comédie Française, white for government notices, with the consequence that most consisted of nothing but typography. As with the growth of newspapers, technical developments liberated the medium, in particular mid-century advances in lithographic printing.

Again, it is surprising that this too took so long. The Bavarian Alois Senefelder's discovery of the lithographic stone had been patented as far back as 1801, but it took some years before it began to be treated seriously. Indeed the whole story is often passed off as a joke. Senefelder, a budding playwright, is said to have accidentally hit upon his method when he just happened to copy out one of his mother's laundry lists with a wax pencil on to a piece of limestone over which he then spilt some water, thus revealing the essential point that the waxed areas remained dry. Whatever the truth, the young man had discovered how areas of ink could be separated, the basic element in any form of printing, and after several years of experiment he perfected the system whereby greased marks, initially with a crayon but later with a more flexible brush, could be made on a specially prepared limestone surface and then chemically fixed before being inked and overlaid with paper which was pressed down to create the reversed image of the original drawing.

Because it was essential to have an expert prepare the stones and handle the complex process of final printing, most Academic artists rejected the new medium as mere craft and it was left to more radical artists to find in lithography an essentially democratic art form whose multiple images were a break with the limited world of the one-off easel painting. In France, Vernet,

bathos, anything to catch the eye and seduce a potential customer.

Outside the United States, little of this work was known to any save the rare transatlantic visitor, with the exception of the thrilling advertisements for Barnum and Bailey's Circus which preceded their arrival in the major European cities – big, brash and colourful, they were produced by the Strobridge Lithographic Company of Cincinnati, to whom must go the honour of altering the course of French, and thus European, graphic design.

After Chéret returned to Paris in 1866, the new technology began to cross the Channel and he was soon able to use the same large presses he had worked with in London. Due in large measure to Chéret's success, over the next thirty years Paris assumed the role of world leader in large-scale litho-graphic printing. A photograph of the printing works of Paul Dupont, taken in 1894, shows the scale of what was involved – the mammoth rotary press under which the massive limestone blocks have been laid, the dozen or so printers and their assistants ready to pull off the thousands of copies need-ed to make the operation commercially viable. A year after his return in 1867, Chéret had made a poster for the Sarah Bernhardt play *La Biche au Bois*, the work which totally transformed design and publicity in France. More, it utterly altered city life, making an art gallery of the street, adding colour and imagery to dull walls, turning the world inside out.

Before long, Chéret had set up his own studio and was producing the almost one thousand posters that would establish him as the father of modern European advertising. Not that he was constantly inventive. Inevitably he and his assistant came to rely on an instantly recognisable style and an equally recognisable figure to sell whatever product they were han-dling. The Chéret style emphasised the visual above the literary, the seen above the read, rejecting the sorts of tricks of perspective and shading derived from high art in favour of bold flat shapes easily decipherable across a crowded boulevard. As for the figure, that quickly settled into what was sometimes called *la Parisiènne* and sometimes the 'Chéret Girl', a wispy seductive creature, floating in swirling space, offering passers-by some tickets for a play or a bar of soap. As Sherard's interview made clear, Chéret quickly ceased using live models and concentrated on reproducing this hugely successful stereotype. The problem was over-familiarity, with the risk that so vapid a creature would quickly bore a fickle public now used to endless and rapid change. One can get a clear idea of just how empty the Chéret Girl can seem if one looks at her in his poster advertising cosmetic rice-powder then compares this with Toulouse-Lautrec's portrait of Suzanne Valadon which he called *Poudre de riz*. While Chéret's poster is all laughter

and sparkle, Lautrec's painting is hard and disturbing. Chéret represents the sort of advertising that tries to create the illusion that happiness can be bought, which must have seemed an unbeatable assumption until Henri de Toulouse-Lautrec came along and changed everyone's preconceptions of what the poster could and should be.

Predictably, Chéret's poster for the Moulin Rouge featured a group of Chéret Girls riding on a procession of donkeys past the famous red windmill. It was certainly a jolly scene and it has come to represent a certain view of Montmartre as a place of fun and frolics and as such remains a key image of the age. It is rather surprising, therefore, to realise that it was not one of the master's commercial successes. The Moulin Rouge was not about innocent fun but about the possibility, no matter how vague, of distinctly uninnocent fun, and Chéret's poster clearly ignored the sense of risk that drew people to the club. This might not have mattered too much if everything else had been going well but after that first heady year, when their establishment was the most fashionable in town, Oller and Zidler rapidly fell victim to their own success with a host of imitators cashing in, offering ever newer distractions. Astute businessmen that they were, the two men set about a ceaseless search for new acts to tempt the jaded palette – it was at this point that they hired La Goulue, reputedly tempting her from the Elysée-Montmartre for the astounding sum of 3,750 francs a week, though well worth it as a way of enhancing the erotic content of their entertainment programme. But Louise Weber's wasn't the only backside to be bought in – a year after they opened, Charles Zidler found himself auditioning one of the strangest acts ever to grace the Paris stage, an extraordinary figure with waxed moustaches and silk knee-breeches named Pujol, who went by the stage-name of Le Petomane (the Farter). Zidler's interview with this bizarre figure is now a classic but always worth an airing. Having called for a bowl of water, the actor proceeded to suck it up through a hole in the back of his silk drawers then, after a pause, he ejected the liquid (there was, Zidler recalled, a slight whiff of sulphur in the room). Le Petomane then announced that following this enema he was able to make sounds.

> *Zidler*: So in fact you sing through your arse?
> *Le Petomane*: Exactly, monsieur.

Zidler wisely signed him up and thus was born one of the club's greatest stars, a 'singer' who gave renditions of patriotic tunes and simple popular ballads through the slit in his breeches, with the audience joining in the

Study for a lithographic print for the cover of *L'Estampe originale*, showing Jane Avril looking at a proof, pulled from the block by Henri's mentor, Père Cotelle.

choruses and with a plant out front who would come up to inspect the 'instrument' to ensure there was no cheating.

The problem for Oller and Zidler was how to convey to the world that there was something new under their bright red windmill. They now knew that Chéret was unlikely to change his well-worn style, so why not turn to the one man who had already produced a well-known image of their new dancer? Why not get Toulouse-Lautrec to make a poster, preferably featuring La Goulue?

There is a curious photograph of Henri being shown the Chéret poster for the Moulin Rouge which has been mounted on an easel in his studio. The figure doing the showing, his arm round Henri's shoulders in an avuncular fashion, is usually assumed to be Zidler and the fact that Henri has taken off his hat is usually seen as an act of deference to the masterpiece set up before him. In fact the whole thing was probably a spoof on the lines of the Puvis *parodie*. The man was not Zidler but an assistant manager called Tremolada

and the wicked smirk on Henri's face suggests that he was being far from respectful to the Old Master. In fact, his demeanour suggests that he knew he was about to challenge the seemingly impregnable position that Chéret had created for himself.

Yet Lautrec had to do far more than simply take up a crayon and transfer one of his drawings to a lithographic stone. It is true that he was in many ways prepared for the task – his use of simplified Japanese elements in the drawings and paintings were techniques clearly suited to the process of creating the sort of dramatic impact needed to attract the attention of busy Parisians rushing to and from work. Chéret was famous for his clear, bold images but even he never dared go as far as Henri would in purging his design of any extraneous lines and reducing his colours to plain flat blocks of pure tone in the manner pioneered in Anquetin and Bernard's Cloisonism. But to carry these things over into a new medium required skills that had to be learned. There were a number of people who encouraged him – there was the example of Degas who had already used lithography, and his friend Dodo Albert was by then a printmaker, but Henri was also astute enough to realise that to create something truly original he would need to emulate Chéret's apprenticeship and master the new technology, and that meant bridging the traditional divide between artist and craftsman that the Salon artists so snobbishly defended. To this end, Henri found himself a teacher, Père Cotelle, one of the highly-skilled printers at the studio of another lithographer Edward Ancourt, where most of Henri's later graphic art would be produced. By learning the basics from Cotelle, Henri was then free to experiment and by the summer of 1891 he was ready to try something new. The poster would be so large it would have to be produced in three strips on three stones. This would be done at the printing works of C. H. Levy at 10 rue Martel and when Henri got to work on the stones he used both litho chalk and a brush with greased ink, which offered a more fluent line, and then sprayed or spattered ink, sometimes through a sieve, to create new colour tones and subtle shades. Close to, one can see how the figure of Valentin le Desossé in the foreground was made up of sprays of black, red and blue that create a unique dark violet that is almost impossible to reproduce and is only discernible on the original prints.

Of course, to most of those who saw the poster when it was finally displayed around the city that autumn, its most startling qualities were the simple graphic effects – the line of spectators silhouetted in black, watching the dancer, was a clear homage to the shadow theatre at Le Chat Noir while the curious yellow bubbles on one side represented the globes of the new-

fangled electric lighting Oller had installed in the club. But most shocking was the way every element in the scene seemed to concentrate on that one central feature: La Goulue's *derrière* – the floorboards radiate towards it, Valentin seems to stare straight at it, making it, without doubt, the true subject of the work. Nor was it just any old backside – whereas Chéret had reduced his Parisiennes to a stereotype, Lautrec offered an identifiable portrait of a real person, a recognition that this working-class vixen, this part-time tart with her crude language and greedy ways was, despite everything, a star.

By the standards of today's giant billboards the poster was not that large, about the size of the entrance door of the Moulin Rouge, though in those early days of street advertising this was stunning enough and meant going way beyond the limits of normal lithography when the three strips were finally pasted together. Indeed, at the time the effect was monumental and it is small wonder that there were many like Francis Jourdan who found themselves bowled over by this sudden apparition, which appeared like a visual bombshell after the pastel-pretty output of Chéret's studio. Small wonder too that people started to remove them from the walls and take them home, some following the bill-posters around town in order to get the strips down before the paste dried. From the start, it was recognised that whatever the commercial aspect of the medium, posters of this sort were also art. The critic Roger Marx wrote of a new kind of 'fresco art': a return to the sort of thing formerly visible only on the walls of palaces and churches. This was a view of the poster that had already caught Chéret by surprise. Asked to lend examples of his work to an exhibition, Chéret revealed to Sherard that he had not bothered to keep examples of several of his designs, having thought of them as mere ephemera. Henri made no such mistake, and from the first he looked on his posters as an extension of his central *oeuvre*. He even sent that first Moulin Rouge poster to Brussels the following year for the annual Les XX exhibition, as if it were just another painting.

It is from the memoirs of Will Rothenstein that we can learn how much the appearance of that one poster altered attitudes towards Henri, even among those closest to him. Once dismissed as little more than a talented freak – an amusing 'character' in the bars of the Butte – Henri de Toulouse-Lautrec was suddenly better known to the public at large than even the great masters of the official art world. Today, he is seen as one of the founding figures of modern graphic design – no exhibition of the history of the poster would be possible without at least that first Moulin Rouge advertisement and probably another three or four as well. Countless coffee-table books have

been dedicated to these vibrant images, leaving the clear impression that after that first success he applied himself to this new medium with a single-minded devotion that pushed all else aside.

How wrong. In browsing through a few of these books it is soon apparent that the same designs recur over and over again – inevitably as there were only thirty in all, a mere handful when compared to the near thousand posters churned out by Chéret and his assistants. Yet the assumption endures that at the opening of the 1890s Toulouse-Lautrec abandoned an art of vaguely radical sentiments inspired by the songs of Aristide Bruant in favour of a second career as a graphic artist. From the appearance of that poster, perceptions of Lautrec and his art change: in most studies of his work, every-thing before is classified as student work, immature and not too serious, while everything after is work of his maturity. There is also a common assumption that the poster marked an end to any attempt at social or polit-ical involvement that might have been discernible in such 'student' works. After 1891 we have Lautrec as the devil-may-care chronicler of the world of showbusiness. Some sense of the sadness of the city's night creatures may still permeate his work but according to this perspective, we shouldn't read too much into such wistfulness which was just a little spice to enliven the dish.

It is not hard to see why this view of the artist as a rather vapid, light-hearted creature was allowed such currency, even during his own lifetime. His desire to mollify his family's opposition to his art and an equally strong desire to please what he assumed to be the public who might visit the vari-ous exhibitions in which he participated, led to a form of self-censorship by which only certain parts of his output were placed on display. This was rein-forced by his friends, including those well-disposed writers and dealers in his circle who tried to protect him from journalists and critics by suppressing aspects of his activities that they thought might damage his reputation. That they were not entirely successful is clear but they did manage to cloud several issues, leaving the more observant student of his work with the uneasy feeling that many of the things he sees do not match the grand theory and that somehow there must be two Lautrecs, the quasi-official artist of the Paris night and some other, secretive character, who is doing things that are nowhere fully explained.

The works he produced during that year of the poster, 1891, offer a classic example of this dichotomy. Far from being heroic examples of the new graphic art, most were seemingly straightforward portraits of his male friends, standing in his studio in their street-clothes looking as if they had just arrived and been told to 'freeze' while he sketched them. Following so

Henri playing doctor – taking the pulse of a friend with his cousin Gabriel in a
surgeon's gown.

closely on the Bruant works it is not immediately obvious why he spent so much time on such neutral images, though he may have been trying to pacify his family who were still nervous that his association with the night-life of Montmartre would become known to their friends and who were mortified when his signature appeared prominently on the Moulin Rouge poster. His decision to exhibit with the fashionable Circle Volnay, an upper-crust painting society, was probably due to a residual desire to please his mother, who would no doubt have been somewhat reassured by the fact that he was making portraits of his friends that could be safely hung in her château. But it is equally likely that these portraits are a statement about the nature of Henri's male friendships. For a start, all are men and noticeably tall. He was in the habit of choosing long-legged companions as if to delib-erately emphasise his own shortness and thus by proclaiming it himself, forestall any risk of pity or disdain. Yet at the same time he clearly relished being able to dominate or manipulate these outsized characters – deciding what they would do, where they should eat and drink, and demanding unquestioning obedience to his orders. Now that his medical student cousin Gabriel Tapié de Céleyran, a lanky young man, was in Paris, Henri made him a constant companion, mercilessly teasing the long-suffering fellow, making him obey quite silly commands without question. There are few things more limiting than being forced to hold a pose and one imagines Gabriel arriving at the studio expecting a jolly evening out, only to be told to stand where he was and not move until the drawing was finished.

The fact that in the portraits, his friends are all dressed to go out is a recognition of their role in Henri's life – they were his drinking partners and his companions in his visits to the *maisons de tolérance* and according to Emile Schaub-Koch in his book on Henri's sex-life, it was cousin Gabriel who introduced the artist to another of his brief loves, a woman he refers to as *La Panthère*, another model whose real name was Myriame Hayem. She was apparently no beauty – she looked like a goat, and must have had other attributes given the long line of well-placed lovers that followed Lautrec, a coterie that enabled her to amass a substantial fortune which she lost through gambling. Schaub-Koch mentions one other 'love' but gives no indi-cation of when this took place – she was, he claims, called Vera and was already the mistress of a well-to-do art collector. If true, and we only have Schaub-Koch's word for it, none of these passing figures seems to have claimed the position once held by Suzanne Valadon and if Henri did feel anything for them, it is equally clear from Schaub-Koch's book that he made no attempt to prolong or deepen any relationship by living with one of them.

On the scant evidence available, these affairs seem to have been little differ-
ent from his relationships with women inside the *maisons closes*, aside from
the fact that they were conducted in the wider world.

If anything, Henri's closest relationships were with his male friends,
hence the series of portraits, though there was one further, if less obvious,
element that links them together: several, like Gabriel, were doctors.
Whether by chance or choice, Henri had surrounded himself with medical
men. Sharing an apartment with Henri Bourges, he inevitably became
friends with some of his colleagues and some of them in turn had contact
with Gabriel when he arrived in Paris in 1891 after finishing his medical
studies in Lille. That year, Gabriel moved to the Hôpital Saint-Louis to
continue his studies as an assistant to the most famous surgeon of the time,
Jules Emile Péan, and if we pay attention to Rothenstein, who knew Henri,
and not the assumptions of the coffee-table books, we discover that it was
here rather than at the Moulin Rouge that his interest was truly engaged. In
his memoirs Rothenstein notes how it was hard to imagine 'anyone else
ready to face what Lautrec did in order to get material for his studies . . . He
wanted to take me to an execution; another time, he was enthusiastic about
operations performed before clinical students, and pressed me to join him at
the hospital.'

This was not quite as extreme as Will makes it sound – Péan was a notor-
ious showman who kept open house for anyone who wanted to watch him
making one of his personal specialities, the removal of an ovarian cyst or a
tracheotomy. Of course it was usually medical students who came to learn
but Péan, who always said that he had really wanted to be a painter, found
no difficulty in accepting an artist, sketchpad at the ready, among his circle
of admirers. Already sixty when Gabriel joined him, Péan had been chief
surgeon at the Hôpital Saint-Louis for sixteen years and had an internation-
al reputation both for his manual skills, plunging into the open body to
remove fibromas up to twenty kilos in weight (on one notorious occasion
fifty!) and for technical developments such as the invention of haemostats to
close off blood vessels during an operation. The Péan Forceps are still in use
today, as are some of his surgical techniques for vaginal hysterectomy and
gastrectomy.

The son of a miller, Péan was, to judge by his portrait photograph by
Nadar, a bear of a man, square built with prominent side whiskers but with,
by all accounts, a jovial manner. In the gap between the development of gen-
eral anaesthetics and a full understanding of asepsis, Péan instinctively
recognised the importance of hygiene, washing his hands and his instru-

Dr Péan and his pupils.

Sketches of Péan by Henri – above, the surgeon briefs his nurse before an operation and, below, a quick clean-up afterwards.

ments and using his haemostats to seal off wounds from infection. However, one suspects that all this was of less importance to Henri than the actual show that Péan laid on. Despite his concern for cleanliness, Péan always operated in black frock-coat with napkin tucked under his chin and a removable collar and shirt-front that could be changed if any spot of blood dared splash him. Other paintings of Péan, such as the formal portrait of him teaching his pupils by the history painter Henri Gervex, tended to emphasise his nobility and authority; by contrast, Lautrec enters into the blood and guts aspect of the spectacle, showing the relish with which Péan set about his task. One oil sketch on brown card shows the doctor cutting away inside a patient's mouth – possibly a tracheotomy – where the air of a theatrical performance is created by the silhouette of a spectator watching the show, possibly Gabriel, standing between Henri and the doctor. This aspect of looking in on something usually left to the experts has prompted charges of unhealthy voyeurism, of a preoccupation with illness and with

things most normal folk find vaguely disgusting. But given Henri's own history of medical treatments as a child it is not hard to see why he should have found the observation of such practices perfectly normal. Indeed, there is a sense in which the works he produced from his visits to Péan's theatre represent one of the central motifs of his art. In a way everything he produced has something of the surgical about it, a stripping away of the outer layer, the quick flash of the scalpel, the lifting out and the presentation of the diseased element. In this light, his sketches of Péan are almost self-portraits. There is certainly little of Gervex's awed reverence – one tiny sketch even shows that Péan, like Bonnat, wore elevated shoes to compensate for his short stature. Evidently, both doctor and artist were what we now call control freaks and a later painting shows Péan in full performance, arms raised, a conductor leading an orchestra rather than a physician healing the sick. The doctor was certainly more than a passing interest to Henri. According to Péan's biographer, Robert Didier, Henri made over a hundred sketches of the surgeon at work though it is noticeable that Péan never bought one or even, so it appears, asked for one as a gift. Two years later in 1892, when he was forced to retire from the Saint-Louis, Péan paid 800,000 francs of his own money to open the Hôpital Internationale in the rue de la Santé, generally known as the Hôpital Péan, so that he could go on treating the poor and teaching pupils like Gabriel who followed him there, along with Henri who continued to study someone whose character and behaviour he clearly found irresistibly appealing.

Henri Bourges, too, attempted to satisfy Henri's craving for all things medical. Now a house-surgeon at the Bicêtre Hospital, Bourges agreed to take his lodger on a visit to the once notorious asylum that had so shocked Mirabeau when he saw the dreadful conditions in which the imprisoned inmates were housed. While the place itself was much improved, the patients were little changed and the visit was a disaster. As Henri, accompanied by Gauzi and Albert Grenier, crossed a courtyard, he was suddenly set upon by a gang of partially disabled, mentally-ill children who clearly thought he was a new playmate and whom, in Gauzi's account, went almost berserk, making 'hoarse, inarticulate cries, a sort of incomprehensible barking'. Sheltered by his friends, Henri was rushed from the scene but from then on any idea that he might choose to portray the mad was abandoned as he concentrated on the safer world of surgery.

It would be possible to see these medical works as just another of what Henri called his *'furias'* – his sudden passion for a particular subject like carriages or bareback riding or a particular model such as Suzanne Valadon,

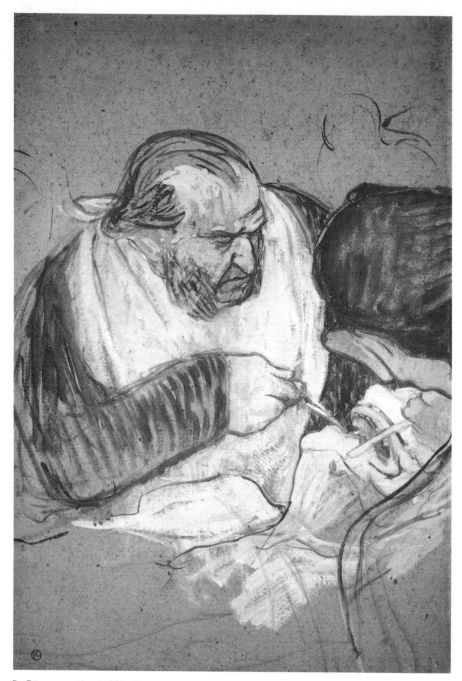

Dr Péan operating (1891–2).

that he would work on obsessively to the exclusion of all else until the mood passed and another *furia* replaced it. But there was something different, something more enduring about this fascination with clinical dissection that makes it altogether more important. It is possible to see the same process at work in paintings that on the surface have nothing to do with the operating theatre but which nevertheless share that same atmosphere of cold, clinical dissection. This is especially true of his depictions of La Goulue. He had prevailed upon Zidler to force her to make posing for him a part of her contract with the Moulin Rouge. Far from being grateful and presenting her as the youthful, radiant star that she no doubt wished to be, Henri lifted away the veil of showbusiness glamour to reveal something rather less pleasant. In 1892 he showed her being led into the dance hall by two companions who could well be holding up a hopeless drunk. Her plunging neckline – down almost to her waist – reveals not the youthful bust of a sexy girl but the slightly sagging bosom of someone who has been around too long, while the arrogant sneer on her face is less the mark of the star whose hairstyle and neck-ribbon were copied by young women all over Europe, than the desperate attempt at superiority by someone who has clearly lost it. It was an approach that still shocked Rothenstein decades later, when he recorded his opinion of Henri's approach to his art:

> There was nothing romantic about Lautrec, he was a frank,
> indeed a brutal, cynic. Human weakness lay naked and
> unprotected before his eyes. While he had a sincere respect
> for genius, for men and women themselves and for their ways
> he had none.

Like so many of Henri's critics, Rothenstein presupposes that the artist's view of someone like La Goulue was simply a reflection of his own spleen when there is enough evidence to show that he was doing no more than witness the truth. La Goulue was an arrogant woman, who used her body to get her way and whose greed and viciousness were legendary. In his poster he gives us La Goulue the star but in his paintings of her he is Péan, cutting away the superficial outer layers to reveal the cyst beneath the skin.

The medical connection was also maintained with the other new subject that appeared during that crowded year: Jane Avril. Her experience working as a cashier at the Egyptian Café during the Universal Exhibition in 1889 seems to have given her a taste for the world of showbusiness. In a rerun of Suzanne Valadon's career, she got a job with the circus, joining the Hippodrome, then managed by Charles Zidler where, again like Valadon,

she eventually became a bareback rider. Henri must surely have seen her perform but it was not until 1890 when she was persuaded to perform at the Moulin Rouge that they first became friends; their interest in each other no doubt reinforced by that shared experience of long years of childhood illness, in his case physical, in hers psychological, yet similar in the effects of isolation and self-reliance such suffering engendered.

Where La Goulue was essentially a simple peasant creature, easy to read in her hard venality, Jane Avril was complex and intriguing with an intelligence far in excess of the limited education she had managed to garner on her uneven passage through life. When she came to the Moulin Rouge she refused Oller's offer of a regular salary in order to maintain her independence. She was paid seven francs if she joined in the regular quadrille but usually preferred to remain aloof, dancing on her own when she chose. Significantly none of her admirers seem able to agree on what she actually looked like during these dreamy isolated dances, and even the nicknames she was given display a considerable division of opinion – to some she was *La Melanite* – an explosive material stronger than dynamite, whereas to others she was 'Silk-thread' or simply 'Mad Jane'. The English Symbolist poet Arthur Symons wrote of her 'morbid, vague, ambitious grace' in complete contrast to one newspaper report that described her legs as moving 'like an orchid in a frenzy'. Perhaps another of her nicknames, *L'Étrange*, the 'Strange One', best captures a woman on to whom everyone seems to have projected their own fantasies. Not least Lautrec, who replaced the ever fatter La Goulue with this new svelte figure in his later studies of the Moulin Rouge, though only by gradual stages. While Lautrec seems to have been aware of Jane from the moment she surfaced at the Moulin Rouge, it was some time before he was sufficiently won over to place her in one of his canvases. In his later paintings she sometimes appears out of costume, in her 'day clothes', usually a long coat and plumed hat. She may even be one of the silhouetted figures watching La Goulue in that first poster and she certainly appears in a painting done later that year. Alternatively entitled *La Promenade* or *La Goulue au Moulin Rouge*, it appears to concentrate on La Goulue as she strolls across the floor with a partner, but in fact the real subject of the painting is a third figure, dancing in the background, whose thin legs and solitary concentration marks her down as Jane Avril. This was her first appearance as a performer in one of Lautrec's works and represents the point where he began to be more interested in her than in La Goulue, who still dominates the foreground, though not, one feels sure, for very much longer. Already, in that tiny background figure, we can sense what it was that attracted the artist

to Jane and why his visualisation of her is far superior to those written accounts of her act which vary so widely. It was Lautrec's friend Paul Leclerc who best captured something of the artist's growing passion for the 'Strange One' when he described the scene at the Moulin Rouge as she performed: 'In the midst of the crowd, there was a stir, and a line of people started to form: Jane Avril was dancing, twirling, gracefully, lightly, a little madly; pale, skinny, thoroughbred, she twirled and reversed, weightless, fed on flowers; Lautrec was shouting out his admiration.'

There was also her English connection to draw them together – Henri with his interest in those strange foreigners at the Moulin Rouge, Jane with her story of Wordsworth's grandson whom she still saw and who she must surely have introduced to Henri. Thanks to this intriguing figure, Jane still went to the literary cafés, especially La Vachette, where she would sit quietly listening to the writers with their endless talk. Of all the new stars of the 1890s she least fits the stereotype of the cunning, if uneducated, working-class girl clawing her way to a brief fame that she will be unable to handle and which will eventually destroy her. Jane was ambitious, but not for money. She danced more as an antidote to her mental problems than as a means to fame, and while she danced, or sat at La Vachette listening to the poets argue, she dreamed of other things. And again, it is Henri, in his role as artist-surgeon cutting away any illusions to capture that ambiguous state – the dreamy look on her face even while her body is contorted in her private quadrille, the pensive faraway sadness of her expression when, dressed in her conventional bourgeois street clothes, she leaves the Moulin Rouge to make her solitary way home, images that link his representations of her to those earlier Bruant studies of working women: the exhausted laundry girl and the weary streetwalker. According to one legend, she agreed to sleep with Henri just once 'as friends' and she was certainly not averse to taking lovers, but there was none of that quasi-professional sex offered by La Goulue and the others, and Henri's portraits of Jane capture something of her intrinsic romanticism, her kindness, even her dignity, in ways that give the lie to Rothenstein's judgement of him that 'for the good he had neither belief nor understanding'.

But then Rothenstein was having a hard time with his judgements that autumn of 1891. Already somewhat shell-shocked from all these new experiences, he was to find his last vestiges of British puritanism finally shattered by the unexpected arrival of an extraordinary visitor. One otherwise ordinary day that November, a fellow lodger came to say that there was someone on the stairs who wished to see him, whereupon the unsuspecting Rothenstein

opened his door to find 'a huge rather fleshly figure, floridly dressed in a frock coat and red waistcoat'. Clearly he was not attracted to this newcomer, who 'had elaborately waved, long hair, parted in the middle, which made his forehead appear lower than it was, a finely shaped nose, but dark-coloured lips and uneven teeth, and his cheeks were full and touching his wide winged collar. His hands were fat and useless looking, and the more conspicuous from a large scarab ring he wore. But before he left I was charmed by his conversation, and his looks were forgotten.'

Oscar Wilde had returned to Paris and young Will Rothenstein was about to find his life turned upside down.

Wilde had arrived in France some time in November and would stay until 23 December, returning home to spend Christmas with his family – a brief interlude but important, not least because it provided a break from his increasingly intense relationship with Bosie Douglas. On this visit Wilde avoided Mallarmé, presumably a trifle guilty at his intention to poach on his territory with *Salomé*. This time Oscar planned to be the master, gathering round him a bevy of young writers and artists who fed his ego but also led him towards wider interests. The young French authors Marcel Schwob and Pierre Louÿs would help with *Salomé*, and even the young André Gide would act as a foil to Wilde's increasingly provocative epigrams, many of which would later surface in the plays that would follow *Lady Windermere's Fan*. Wilde had discovered that his best working method was simply to take his conversation and transfer it to the stage. All his plays are monologues, the author playing all the parts, male and female, talking directly to the audience, as he had done on that morning with George Alexander.

In Paris, writing *Salomé* was now relatively easy – Wilde would dine with his friends, talk about the play, create a scene in conversation then return to his hotel and write it up. Later Schwob or Louÿs could cast an eye over the text to tidy up the French a little. Happily, they were astute enough not to sweep away all Wilde's Anglicisms with their echoes of biblical English, oddities that give the work a sonorous exotic foreignness to French ears, a mood entirely appropriate to the subject. It is to Wilde's credit that despite working in a foreign tongue he nevertheless achieved some remarkable effects, creating a rhythmically musical language that uses luxuriant descriptions in place of a conventional plot, making the piece more truly a verse drama than a straight play in blank verse would have been. Indeed, his reasons for writing directly in French were less flippant than his earlier remark about wanting to be an Academician suggests. As he later admitted, 'My idea of writing the play was simply this: I have one instrument that I

know I can command, and this is the English language. There is another instrument to which I had listened all my life, and I wanted to touch this new instrument to see whether I could make any beautiful thing out of it.'

That this beautiful thing was as much about its author as his subject – or rather, that the subject was the author – was not lost on some of his listeners in the boulevard cafés where he tried out his tales. The young André Gide was at first mesmerised then horrified by the world opened up by such talk and was to spend much of his later life blaming the visitor for having seduced him from his former innocence – a guilt-ridden prissiness that makes the future Great Author sound distinctly silly. But it is probably true to say that Wilde was somewhat obsessed with Salomé and increasingly flamboyant in his search for inspiration, above all, for the dance that Salomé would perform. He wanted Sarah Bernhardt to play the part but should she dance naked, in the unlikely event that such a thing would be allowed, or should she be weighed down with monstrous jewels, or then again should she be hidden away, dancing unseen with everything left to the imagination? Wilde toyed with various ideas, trying it this way and that. One night he went to the Grand Café where there was a gypsy orchestra and having described to the leader of the group the scene he envisaged – the veiled figure, the dance, the bloody head – asked him to play an appropriate tune. According to Wilde, the resulting music was so wild and terrible that everyone in the café stopped talking and looked on with blanched faces. Of course he was already mythologising his own work and even told one group of young writers that he had begun *Salomé* in Paris on a complete whim, having returned to his room where he discovered an open notebook, whereupon he sat down and let the story pour out of him. It was all nonsense, but even his most cynical listeners had to admit that his knowledge of the subject was prodigious, with Wilde able to hold forth on the various directions the story might take – is it Salomé who really loves John and not her mother? Does she kiss the severed head at the end? Does she, too, die by decapitation? One might doubt his embellishments, but no one regretted the telling.

In the end Wilde hit upon an interpretation which presented Salomé as Woman the Destroyer, avenging herself upon the patriarchal figures who have refused her desires. To some, this seems no more than a reflection of the author's own life at a time when Wilde was breaking free from the bonds of a marriage that he now believed imprisoned him. But one can just as easily see, in the veiled figure of Salomé about to slowly reveal herself in the dance of the seven veils, Wilde stripping away the hidden secrets of his new life,

revealing himself through her lust for John's body and her desire to embrace his dead mouth, to bite into his lips: *comme on mord un fruit mûr*.

It was while talking himself through the play that Wilde decided to follow up a friend's suggestion that he visit Will Rothenstein in his rooms in the small hotel in the rue de Beaune just across the Seine from the Louvre and thus quite close to Wilde's old lodgings at the Hôtel Voltaire. Until that encounter on the stairs, Rothenstein had only known of Wilde from his satirical alter egos on the London stage: Du Maurier's Postlethwaite and the foppish Bunthorne in Gilbert and Sullivan's *Patience*. Initially, the young man found the languid, lily-bearing aesthete a somewhat repellent figure, though the famous conversation soon swept away that initial adverse impression and despite the discrepancy in their ages and their sexual mores, the two were to become, if not exactly friends then something more than mere acquaintances. Despite his misgivings, duly recorded in his memoirs, Will Rothenstein proved remarkably loyal to the unfortunate playwright, standing by him at his time of greatest need even though he had little sympathy with the practices that brought Wilde down.

For his part, Oscar was typically generous with his contacts in Paris, introducing young Will to his literary acquaintances and to others outside the art-student world that Rothenstein had occupied until then, though it was also the case that the newly liberated Wilde dragged him along on the sort of excursions he might well have preferred to avoid. One night, a carriage with Wilde, Rothenstein, Stuart Merrill and Sherard set off for the Château Rouge, by then a curious combination of doss-house and rough bar from where visitors could catch sight of the wretched down-and-outs on their way to the squalid upper room where they could pass the night. According to Sherard, upon getting into the crowded carriage Rothenstein complained that someone had kissed him, full on the lips, though no one could be certain it was Wilde. When they arrived at the café it seems to have been Sherard who got out of hand. At one point there was some sort of difficulty with a group of roughs who frequented the place and who were clearly antagonised by Wilde's appearance and mannerisms, whereupon the belligerent Sherard leapt up and threatened to deal with anyone who tried to meddle with his friend. 'Robert,' said a concerned Wilde, 'you are defending me at the risk of my life.'

Despite that rebuke Sherard was still Wilde's main companion on his sorties into the night-life of the city; Rothenstein's role was more cultural, introducing the older man to his artist friends, accompanying him to the Rat Mort and La Vachette, making Rothenstein one of several possible candi-

dates likely to have brought Wilde and Lautrec together. We do not know when the writer and painter first met, though in that autumn/winter of 1891 they could hardly have avoided each other and Rothenstein seems a likely agent. Lautrec had made a drawing of Rothenstein which Wilde suggested should be bought for the British nation by the raising of a penny levy. In response, Will had made a portrait drawing of Lautrec which Wilde would also have seen on that first visit. Of course, Wilde already knew something of Lautrec from Fénéon's article in *La Vogue* and from the poster for the Moulin Rouge which was still prominently displayed around the city, bearing the clear signature: HTLautrec. Moreover, all these mutual acquaintances insisted on taking Wilde to precisely the places where Lautrec was most likely to be found, so that it would have been almost impossible for them to have avoided an encounter. Sherard played his part, taking Wilde to Le Mirliton most nights so that he was soon on friendly terms with Bruant, eating with the singer before the show. When they dined together on 8 December, Bruant presented his guest with a book inscribed *Pour Oscar Wilde le joyeaux fantaisiste anglais* – a pretty accurate description of the man with whom he shared a common anarchist philosophy.

If Lautrec and Wilde had not already met at Bruant's the night was still young and they would certainly have seen each other later at the Moulin Rouge where Oscar would go either with Sherard or with Rothenstein's friend Conder, another possible contact with Lautrec. While the Moulin Rouge's other role as a place for heterosexual encounters would by then have held little attraction for Wilde, he would have been unable to resist the sense of danger that underlay the surface glitter, the very ambivalence he had used in *Dorian Gray*. With his head still filled with images of Salomé, Oscar went to the Moulin Rouge with Stuart Merrill one evening where they watched a performance by a Romanian acrobat who danced on her hands. Gripped by the idea that this might be perfect for Salomé's dance, Wilde sent her a note but received no reply, the performer no doubt imagining that this was just another sexual proposition, a common enough occurrence at the club.

In the end the dancer with whom Wilde had the closest contact was Jane Avril and for quite extraordinary reasons. There can be little doubt that it was Sherard who finally brought the two together either at the Moulin Rouge or at one of the literary cafés like La Vachette that Jane still frequented, for it was Robert Harborough Sherard, great-grandson (not grandson as Jane remembered it) of William Wordsworth who had been her English lover, the man who had created her English stage-name at the time when he was introducing her to his circle of novelists and poets. She would leave clues to the

truth in a sequence of newspaper interviews she gave in the 1930s in which she included Sherard and Wilde among the authors she used to meet at La Vachette and it is this coincidence that makes Sherard, along with Rothenstein, the other candidate for the honour of having brought Lautrec and Wilde together.

At this stage, it is unlikely that any encounters between the two men were other than brief, any conversations cursory. Wilde liked to be amused by pretty, feckless young men or overawed by his intellectual superiors; Henri liked women, or men he could bully. But both would have had sufficient respect for each other's 'image' – Wilde's flamboyant theatricality, Henri's intense creative concentration – to have made a favourable impression. Hence the sketches and hence the fact that of all the people Wilde encountered on his many visits to France, Henri was one of only twenty or so friends to whom Wilde would send copies of his last book. Of course Henri's ancestry, even if he didn't use a title, would have appealed to Wilde but it would only be later, near the end, when both men were battered by life, that anything like true sympathy emerged.

Back in 1891 the most obvious similarity between the two was the fact that neither was inclined to hurry to their respective beds at a reasonable hour and they were thus likely to encounter each other on the quotidian round of Montmartre's night-spots. For Lautrec there were always the late-night bars where he could top up his alcohol level before a visit to one of his preferred brothels. For Wilde there were the new delights he could find in Paris now that he had given up trying to restrain his inclinations. Away from his friends, he could stroll along the Boulevard de Clichy, to ogle the stripped-down boxers and wrestlers in their open-air booths or pay a franc to watch a transvestite perform the *Danse à l'Almée*, another spectacle to add to his store of images for *Salomé*. It may have been on one such outing that he was observed by Lautrec, a sight recalled four years on when the artist showed Wilde gawping at La Goulue's exotic dance on the right-hand panel of her booth.

While Oscar never admitted to these secret adventures, there is a curious document that may offer some insight into the thrills of those late-December nights. In the late 1890s an erotic novel, secretly printed, was passed around English homosexual circles. Who the author or authors of this scurrilous tale were remains uncertain but *Teleny*, named after the book's hero, was long thought to have been written at least in part by Oscar Wilde and to reveal something of his adventures in the French capital. While this has never been settled one way or the other, the book does describe the sort of Parisian

Night-time entertainment: Alexandre Falguiere's sketch of wrestlers.

low-life we assume Wilde experienced, especially the lurid description of a passing encounter in one of the *vespasiennes*, the notorious metal urinals that were a prominent feature of the Paris boulevards until removed in the 1970s:

> I looked at him. He was a brawny man, with massive features; clearly, a fine specimen of a male. As he passed by me he clenched his powerful fist, doubled his muscular arm at the elbow, and then moved it vertically hither and thither a few times, like a piston rod in action, slipping in and out of the cylinder.
>
> Some signs are so evidently clear and full of meaning that no initiation is needed to understand them. This workman's sign was one of them.

Whatever the truth about *Teleny*, Wilde allowed something of this other life to creep into *Salomé* when he added a subplot in which one of Herodias's pageboys is shown to be in love with a Syrian guard who in turn loves Salomé and who kills himself when he sees how much she is attracted to the imprisoned Prophet. That this suggestion of 'unnatural' vices would cause trouble from the Lord Chamberlain, the official censor of plays in England, may have prompted Wilde to attempt a palliative moral tone at the end of the play by having Salomé executed – though this could equally well be an expression of his own unconscious guilt over the life he was leading. By this point Paris was for Wilde clearly less a place of intellectual stimulation and more a repository of strange pleasures.

As Wilde cruised the boulevards or explored the more notorious stretches of the river-bank, Henri was probably slumped at a café table staring at another absinthe or swinging his legs over the edge of a velvet plush banquette in a gilded brothel, trying to decide which of the slightly bored women still available at that late hour he should choose. The two men may have had different tastes yet there was much common ground – the shared penchant for self-destruction, the clinically honest view of humanity in their art, the underlying compassion that many chose not to see but which was the true well-spring of their social criticism. Both had embarked on their careers intending to use their talents to unveil something of the underside of late-nineteenth-century society. Now both appeared to have abandoned such youthful commitment in an attempt to satisfy popular demand – Wilde with his fashionable comedies, Lautrec as the 'Artist of the Moulin Rouge'. That

neither man fits the role assigned to him has not prevented an almost universal acceptance of the myth.

Wilde returned to London for Christmas with his family, ready to forward his career as a dramatist with *Lady Windermere's Fan* and to set about getting *Salomé* produced. From every point of view his visit to France had been hugely satisfying and he was now on the verge of that rapid success that would make him the most famous playwright of his day. Lautrec, too, since the appearance of his poster, was both famous and sought after. For both men, it must have seemed that anything and everything was possible, yet in a mere four years Wilde would be ruined, a pariah; in only ten, both writer and artist would dead. Despite his piercing vision of other people's lives, Wilde seems to have had no such foresight when it came to his own, believing that the glory would last for ever and feeling devastated when it was snatched away. Henri, by contrast, shows through his art that the good times are always about to end, that the dancing will stop, and someone will have to pay the bill.

10

SHOWBUSINESS

On 14 February 1893, the Moulin Rouge played host to the second *Bal des Quat'z Arts*, a masked ball and fancy-dress parade for the students of the Ecole des Beaux-Arts and three of its associated schools: the Ecole des Arts et Métiers, the Ecole du Louvre and the Conservatoire de Musique. The organisers also invited some of the more prominent independent ateliers like Cormon's to take part. The first ball had been the brain-child of the artist Guillaume and the photographer Simmonet and had been held at the Elysée-Montmartre the previous spring. This had proved such a success with the city's artists and art students that they were now clamouring for another chance to compete in the presentation of costumes and sets. Thus Jules Roque, founder of *Le Courrier Français*, and one of the first to commission work from Henri, decided to organise a second evening, persuading Oller to let him hold it at the Moulin Rouge. According to Henri's friend François Gauzi, the anticipation was such that it was soon apparent that the *Bal* would be one of the major events of the year. Everyone seemed to be competing for the limited number of tickets being distributed by the Ecole des Beaux-Arts, which tried to impose some semblance of order on an event that was rapidly getting out of hand.

The weeks before the great night saw the ateliers of Paris given over to the production of lavish floats for the procession along with flamboyant costumes for the students, many in the 'tribal' colours of their particular studio. Henri went dressed as a choirboy though why he chose to carry a chimney-sweep's brush is not clear. The evening opened conventionally enough with dancing, the students having brought along their favourite models, only slightly more dressed than they were when working. According to Gauzi it made little difference whether the orchestra played a waltz or a polka, everyone just danced as they chose with many of the girls exposing their charms as they hopped about. This theme of near nudity was also central to the pageant which was led by Roque, dressed as Petronius assist-

ed by an Achilles in a cardboard helmet with forks for spurs, followed by the floats of the different ateliers and schools, many of whom had chosen to feature one of their favourite models, most skimpily clad. Will Rothenstein was intrigued to see one of his own subjects, a popular model called Sarah Browne, reclining in a litter borne aloft by four students, supposedly representing Cleopatra, though it was hard to be sure as she was wearing nothing more than a gold net. However, as Rothenstein noted, her apparent nakedness definitely made her the 'Queen of the Ball'. Behind her came a line of equally unclad beauties, including another famous model, La Rosière, in a black chemise riding a white ass attended by the Gods of Olympus, Puss-in-Boots, Little Red Riding Hood, and Vercingetorix – presumably a dig at Cormon by his own students. After the procession there was a cold supper with champagne or wine, depending on the diners' resources, then more dancing until the small hours. With so much flesh and drink, the result was perhaps predictable: high spirits turned to rowdiness, some of the, by now, terrified models had their skimpy garments torn away, others were carried off and assaulted. In the end the revellers poured into the Place Blanche and proceeded to create havoc in the neighbourhood. Groups of students ran into bars, forcing the waiters to serve them free drinks until the police arrived and started to make arrests until the last gangs of rioters finally dispersed.

It was in many ways the perfect Lautrec evening, and one can see him, sketching away, rejoicing in the mix of sensuality and debauchery while getting remorselessly drunk himself. This, of course, is the Henri de Toulouse-Lautrec that legend first calls to mind and it is such images of inebriated jollity that are most readily associated with his name. Anyone wishing to conjure up an atmosphere of merry decadence, of amusing depravity, has only to hang reproductions of Lautrec's work, or as so often happens, get someone to paint a Lautrec pastiche on the walls of a bar or discothèque, and the effect is achieved. Lautrec's Montmartre, that mix of sexiness and abandon, is as ready-to-hand for seekers of hedonism as a Madonna and Child is for those in need of the odour of sanctity.

Gauzi and Lautrec's other friends certainly encouraged such a remembrance. Their memoirs make it clear that the early 1890s were the artist's 'Moulin Rouge' years and the impression they give is that he was seldom out of the club, sketchpad at the ready, dashing off drawing after drawing to be worked up later at the daytime painting sessions in his studio. The impression too is that this was the best of times, a happy interlude before alcohol and worse finally claimed him, a conclusion reinforced by the novel and the film *Moulin Rouge* and perpetuated by those Lautrec-style decorations in

countless bars and restaurants around the globe where pleasure and naughtiness are suggested by a mural, usually of can-can dancers, painted in the rough, 'unfinished' manner associated with the artist.

In a sense, this enduring concept of Lautrec's 'Gay Nineties' is perfectly understandable: we want him to have had at least a brief period of happiness so that he can live out the myth of the artist who falls from grace, the self-destroyed martyr figure, essential for his enduring legend. And it is certainly a view of the artist unchallenged by Lautrec scholars who are unanimous in seeing the years between 1891 and 1894 as the period of his maturity. Yet, as with that other phantom career as a graphic artist, the Moulin Rouge works are rather thin on the ground. If the dance hall was so important to him, if he really did make so many paintings and drawings of the place and of the characters who frequented it, why do we always find the same limited range of works reproduced? Flick through any illustrated collection of Lautrec's work and it is immediately obvious that the same images recur again and again. The most frequently offered is his first poster showing La Goulue and Valentin le Desossé in action, followed by the earliest of the paintings in which Valentin is training a new dancer before the club opens. There is one canvas showing La Goulue walking across the dance floor while Jane Avril does her solo dance in the background and another where the customers are moving back to their seats as the quadrille is about to begin. Yet, astonishingly, these are the only paintings that actually show the club itself. Even an occasion as spectacular as the *Bal des Quat'z Arts* is only immortalised in a few stray sketches; no major painting was made to capture what was clearly one of the most memorable nights in the history of the club. In fact, the images that Lautrec usually brought back after sketching at the dance hall were intimate, individual portraits of the people he had been watching, most of them drawn so close-to they could have been done anywhere. As the Artist of the Moulin Rouge, Lautrec is something of a fraud, he seems barely to have noticed the place.

And again, as with the posters there is an assumption that these Moulin Rouge works mark a further separation from the earlier Bruant pieces. From this standpoint, our new Lautrec is an altogether jollier figure who has found his true subject – the new world of popular entertainment – having sloughed off any social or political concerns that might have been bothering him in his Mirliton days. Such an idea is reinforced by the convenient coincidence that the Moulin Rouge was relaunched in 1892 as a place for more professional entertainment, relying less on the old rough-and-ready amateurism, inherited from the Moulin de la Galette. On 10 September 1892 it was announced

that Charles Zidler was leaving 'for health reasons'. No one knows why he and Joseph Oller had fallen out but the latter now decided to brighten up the place, reckoning that its original shock value had been much diminished by rivals copying his ideas. It was at this point that he brought in new talent and began to pay his performers, transforming them into a professional band of stars and encouraging Lautrec to capture them on canvas, the better to publicise an endlessly changing programme of events. Henri seems to have been happy to go along with this; the fame he had achieved came from his association with Oller's world and he was not averse to continuing the arrangement even if it meant offering the public only one aspect of his varied output. He even sent copies of the La Goulue poster and other Moulin Rouge-related works to that autumn's Les XX exhibition in Brussels and he further encouraged the idea that this was his central subject by reproducing other La Goulue and Moulin Rouge images as lithographs. As a result the press began to refer to him as the Artist of La Goulue or as 'The Painter of the Paris Night', when in reality there were barely twenty different images directly related to the Moulin Rouge, though those few were frequently recycled in other media. And far from overwhelming us with riotous scenes of drunken debauchery, the canvases based on the Moulin Rouge usually show solitary figures or at most couples, strolling about either before or after a performance or seated apart watching some activity in which we, the spectators, do not share. In one painting La Goulue saunters across the dance floor, somewhat the worse for wear, supported by her sister and another dancer, La Môme Fromage (the Cheesy Kid), in another, Jane Avril in her subfusc bourgeois day clothes arrives at the club, and in another she leaves it, an unglamorous figure, preoccupied with her own concerns. There are some studies of Henri's English friends, the foppish Conder and another painter, William Warrener, billed as either 'The Englishman at the Moulin Rouge' or simply 'Flirt' because of the two women on either side of him, most likely La Goulue and La Môme Fromage again.

Yet despite the shortage of works to fit the category, this 'Moulin Rouge Sequence' is the very bedrock of the artist's huge international reputation though part of this is surely due to the 'Doppelgänger Lautrecs' available in many major cities around the globe. Take tea in London's Café Valérie, Soho's famous French pastry house, and you will find yourself surrounded by Lautrec murals, though of course painted by some anonymous artist trying to recreate what he assumed to be the true atmosphere of a boulevard café at the *fin de siècle*. There are dozens of similar examples in nightclubs, discothèques and restaurants where a hint of Lautrec is thought to bring

with it a sense of light-hearted decadence, of acceptable wickedness. Of course what you see is not Lautrec at all, but a collage of images of can-can dancers and sexy girls, of drinking and seduction, some taken from actual Lautrec works, though carefully selected to ensure that only jocular characters are used, while most are pure inventions, painted in a vague pastiche of his style. The result has been that a great number of people think that these inventions are the real thing and it must confuse many first-time visitors to the major Lautrec collections in Paris and Albi when they are confronted with the truth, that Toulouse-Lautrec's 'Moulin Rouge' paintings are chiefly concerned with the aftermath of pleasure, with melancholy and weariness. Far from celebrating Oller's new hedonistic showbusiness, Lautrec undermines it. La Goulue sags like a worn-out drunk, Jane Avril leaves exhausted, as if something has been taken from her; no one smiles.

This sense of the end of the party is most apparent in the large canvas that is usually held up as the defining work of the series, *Au Moulin Rouge* (At the Moulin Rouge) now in the Chicago Art Institute. Painted in 1892/3, it is one of the best-known images of the period, yet despite its fame there is considerable confusion about what Lautrec intended when he painted it and whether or not the work we have today is quite as he wanted it to be.

The most obvious and revealing thing about the painting is that it is effectively a mirror-image to his first major dance-hall canvas, the *Bal du Moulin de la Galette*. In that earlier picture, we, the spectators, are seated away from the dance floor cut off by the rail that slices across the picture space, watching the dancers on the other side. In *Au Moulin Rouge*, we are down on the dance floor looking over the balcony rail at a group of customers seated at a table with others moving around behind them. Put simply, the spectators have become the performers. There are nine figures on the balcony and each can be identified. Seated at the table is Anquetin's old schoolfriend, the editor and critic Edouard Dujardin, the man who had first proposed the word Cloisonism and an important figure in the world of Symbolist publishing. Beside him is the dancer La Macarona, she who had once outshone La Goulue at the belly-dance. Moving round we come to two of Henri's drinking companions, the photographer Paul Sescau and the wine merchant Maurice Guibert and finally, back view, her little finger gracefully crooked, is Jane Avril, recognisable from her red hair and rather fussily plumed hat. Walking along behind the table is the artist himself, diminutive beside the towering presence of his cousin Gabriel Tapié de Céleyran, while further back, we can clearly make out La Goulue, doing up her hair, watched by La Môme Fromage.

This compact, rectangular canvas is the work that Henri exhibited on a number of occasions during his lifetime. A photograph of it was reproduced with the article in *Le Figaro* of 1901 along with the photograph of La Goulue's booth. It is not a merry scene by any means. Clearly the show is over, too much has been drunk, there is nothing much to look forward to. The Moulin de la Galette painting showed us the risky world of the underclass, but at least it was alive, sexy, dangerous. Now that elements of that world have moved down the hill to the Moulin Rouge something has been lost. The public world of the old dance hall where strangers met and found companionship in music and movement has given way to the private loneliness of the new, in which people cluster in small groups yet are still isolated, avoiding eye contact, silent. In fact, one could go further to state that the sense of isolation and ennui apparent in the large canvas is prefigured in most of the other Moulin Rouge works where the scenes of gaiety and reckless fun that most assume to be there, rarely materialise. In fact, those few canvases most often depict solitary characters, moodily preoccupied with themselves, the flotsam and jetsam of city life washed up on the edge of the Hill of Martyrs like so much driftwood. It is this which destroys completely the notion that there is a precise division, a before and after, to Lautrec's work. These figures – La Goulue sauntering in with her friend, Jane Avril's solitary arrival and departure, the forced amusement of patrons like Warrener – are all extensions of the Bruant paintings, those isolated figures at café tables, whether victims drawn from the city's underclass or the highly-paid dancers and their rich patrons, who, in Lautrec's city, are all the same under the skin. The subject of Lautrec's art is not a place or a time, it is not Montmartre or the Moulin Rouge or the 1890s or decadence or any other of the usual labels, it is loneliness, solitude, isolation, those maladies of the nineteenth century that spread into the twentieth and which plague so many urban dwellers to this day.

If that were all we could read into *Au Moulin Rouge* it would be enough to show that Lautrec's concerns were far removed from those of the vapid showbusiness chronicler some have tried to present – but there is much more. The painting we see today is significantly different from the one he exhibited in the 1890s, as recorded in the *Le Figaro* photograph of 1901. The canvas that hangs in the Chicago Art Institute is much larger, with the addition of an inverted L-shaped section that runs down the right-hand side and back under the bottom of the rectangle. This section contains the figure of a large, garishly lit woman, sharply cut-off by the right-hand edge of the canvas, drawing the spectator's eyes with her as she leaves the scene. This

large figure is so out of balance
with the rest of the picture that it
is almost impossible to concen-
trate on the main composition
within the rectangle and it is
difficult to see why Lautrec
should have stitched on a further
section which seems to eclipse
his original conception. In 1985,
the painting was cleaned by
David Kolch of the Chicago Art
Institute's Department of Con-
servation, who was surprised to
discover that far from being
added on, the L-shaped section
must have been part of the orig-
inal canvas, but cut off later to
leave the smaller picture that
was reproduced in *Le Figaro*. It
is not known who cut off the
section nor who subsequently
stitched it back on again. Nearly
a century after its creation, it is
impossible to be absolutely sure
just who did what to the picture
we now have, though various
theories have been put forward.
One thing at least is clear: with
Au Moulin Rouge we are con-
fronted with another picture
over which the artist agonised
and which, again, he may never
have fully resolved. We know
that he rarely exhibited the work
and that like the *Missing Ecuyère*
it hung about his studio for

At the Moulin Rouge, the restored
version, with May Milton dominating the
far right-hand edge of the canvas.

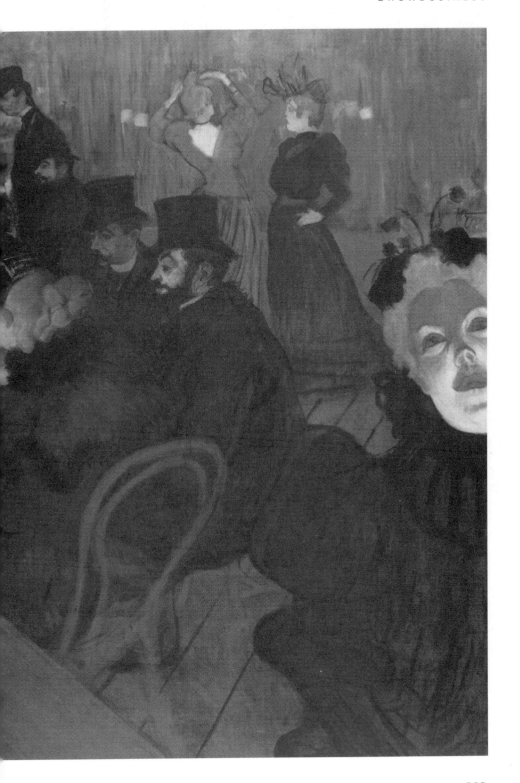

years. He seems to have reworked it on several occasions though never to his complete satisfaction. The most likely scenario is that after several unsuccessful attempts to integrate the right-hand figure, he gave up and cut her out of the composition, leaving the smaller rectangle that he was prepared to exhibit and which thus appeared in the newspaper. Obviously he did not discard the excised section, but who stitched it back on remains a mystery. By 1893, the large canvas was propped up in his studio, the garish right-hand figure still unfinished, the artist unsure what best to do to put it right.

The way the characters in *Au Moulin Rouge* seem to be having a last drink before leaving was a fair representation of what was actually taking place. By 1892 the dance hall was no longer what it had been and some of its original denizens were less attached to a place they had once regarded almost as a private club. Despite his attempts to rejuvenate it, Oller decided shortly afterwards that it was time to move on. His new plan was to open the sort of show that had made Montmartre notorious, but in a safer area of the city, one more reassuring for the general public. In the early 1890s he bought Le Jardin de Paris, an already famous pleasure garden, just off the Champs-Elyseés where the Grand Palais stands today. There he brought his stars from Montmartre, La Goulue, Valentin, Jane Avril, La Môme Fromage, Nini Patte en l'Air, while at the same time providing a horse-drawn omnibus to take those more adventurous customers who dared risk the trip up to the Butte once the new show was over, so that they could sample the Moulin Rouge. The man who had invented the tip-up seat for his theatres had, virtually single-handed, created modern showbusiness and the star system which used publicity to turn self-trained amateurs into highly-paid professionals, followed by an adoring public. It was sufficient for La Goulue to wear a black ribbon round her throat for the fashion to spread from London to New Orleans.

In 1893, Oller opened Olympia, the greatest of the Parisian music halls and still today the most important site for popular entertainment in the French capital. Oller was eventually recognised by the State when he was given charge of the now legal horse-racing Tote and later elevated to a sort of Minister without Portfolio responsible for organising public entertainments, including the State visit for the young King Alfonso XIII of Spain. Incredibly inventive and energetic, this remarkable man died in 1922 regretting that he had not done more, though his single-handed creation of the sort of mass amusements – light-hearted, undemanding and open to all – that

A photograph of Yvette Guilbert, in her trademark black gloves, taken some time in the 1890s.

have survived to this day was surely enough for any man. It was a transition shared by Lautrec who, on the evidence of his surviving works, spent more time painting this new world of entertainment than the older Moulin Rouge. Starting with La Goulue and moving to Jane Avril, Henri latched on to each new star that appeared in Oller's firmament. La Goulue had little conception of how much she and her transient fame owed to the funny little drunk with his ever-present sketchpad, but others like Jane Avril and Aristide Bruant saw clearly that his genius for the sharp, incisive image was needed by even the most talented performer if they were to stand out in what was rapidly becoming an overcrowded profession.

Where Henri had had to ask Oller to order La Goulue to pose for him, Bruant and Avril insisted that their managers hire him to advertise their appearances. Without doubt, it was Bruant who inspired the most startling and memorable posters, his image pared down to that imposing figure in black cape and hat, a red scarf jauntily thrown over his left shoulder, which Lautrec made the singer's trademark. Yet it is said that when the poster first appeared, the owner of Les Ambassadeurs ran into the street screaming for the sheets to be torn down and was only prevented from removing them when the singer insisted they stay and that one be posted on either side of the stage no later than a quarter of an hour before he was due to perform, otherwise he would not go on. When Bruant moved to the Eldorado in 1893, Lautrec wittily reversed Les Ambassadeurs' image by showing the singer in the same costume but from the back, an audacious trick that showed that Bruant was now so famous he could be recognised by his trademark cloak and scarf alone.

It was a technique Henri brought to perfection when he reduced the singer Yvette Guilbert to a simple pair of long black gloves, draped over a staircase – nothing more, yet quite sufficient to instantly call forth his most famous subject. In truth, Guilbert was the only performer he dealt with who really had no need of his efforts. She was, in her day, quite simply the greatest of them all, which may have been why Henri went to such lengths to surpass himself whenever he managed to work for her. Why this gawky, awkward, pinch-faced, lanky creature should have achieved such a status is hard to understand now that we are left with only an inadequate set of later recordings that hardly support the near ecstatic accounts of her performances, written at the time, reports that speak of the spellbound hush as she went into her carefully phrased routine. It is important to remember that she was not so much a singer as a *diseuse* who spoke her words at a varying pitch rather that letting them flow melodically and that it was this ability to con-

trol precisely what she was saying that made her message so affecting. The leading tragic actor Sylvian would bring his pupils from the Comédie Française to watch her act and learn from her technique, which was largely self-taught or rather was a natural talent which she developed quite quickly, though not without a struggle, given her unprepossessing appearance and a background that had hardly destined her for stardom.

Born in 1867, her first attempts to rise above a poverty made worse by her wretched father's hopeless gambling, met with mixed success. After a brief period as a dressmaker and a surprising stint as a mannequin, she tried, despite her odd looks, to make a career in the legitimate theatre. She did get a number of parts but as she revealingly conceded, learning how to act 'taught me how to sing'. Leaving Paris, with its unforgiving audiences, for Lyons she managed to get some engagements as a singer of perfectly straightforward popular songs before moving back to the capital to try again. Her appearance and dress were little short of bizarre – a chalk-white face and cartoonish, rouged, pinched lips above a curiously unmodish full-length ballgown and her already recognisable long black gloves, left her looking like a provincial schoolteacher on a night out. Yet it was possibly this that persuaded Zidler to let her open the show in the music hall under the elephant in the garden of the Moulin Rouge where she sang early every evening. There was still little unique about her save her odd appearance, but her long engagement and Zidler's indulgence offered her the chance to develop her skills, which began to take off when she discovered the *chanson-réaliste* which she was quick to adapt in her own way. Her brilliance lay in taking songs that earlier performers had simply barked at the audience, acting them out in a half-speaking, half-singing style that soon imbued these well-known lyrics with new life, drawing ever larger crowds made up not only of the usual adventurers in search of the louche life of Montmartre but also a wider Parisian public on a scale unequalled until the arrival in this century of Edith Piaf, who was in many ways her direct descendant. It was Zidler who realised that Guilbert would have to move on if she wanted to capitalise on this success, encouraging her to sing in the Divan Japonais, a cramped little cabaret club in the rue des Martyrs where Jane Avril somehow found room to dance and for which Henri produced some of his most thrilling posters. Guilbert's performances at the Divan Japonais gave her a cult following among poets and artists and later with a wider public when she moved down from the Butte to the music halls and theatres of central Paris and then on to well-received appearances in London where she found huge acclaim right up to the Second World War. She died in 1944 and there

Yvette Guilbert taking a curtain-call – one of Henri's many
studies of the *diseuse* in action.

are still those alive today who treasure her memory, an enduring success made all the more remarkable because she performed mainly in an idiomatic street French largely incomprehensible to her English-speaking audience with whom she communicated through her genius as an actress.

While Henri would have seen Guilbert's performances as far back as 1890, when she first appeared at the Moulin Rouge, it probably wasn't until she moved to Les Ambassadeurs near the Champs-Elyseés in 1892 that he began to court her – for it was never a question of *her* encouraging *him* to make the famous caricatures of her on stage, which in the main she rather disliked. Despite her reaction, the sheer number of studies he managed to make of her, established the singer as one of his principal models. Eventually she did come to appreciate what he was trying to do though their first face-to-face encounter, when he was brought to lunch at her apartment, was a near disaster. The hostess was distressed by his misshapen body and felt disgusted at the way 'the food was engulfed into his gaping mouth . . . every time he chewed you could see his wet, drooling lips working'. She was no more impressed when he first tried to work for her. As often as not she thought he had made her look too ugly, which is sad as his 1894 charcoal and paint drawing of her, which he hoped would make a poster for her 1894–5 season, again at Les Ambassadeurs, is surely one of his best and certainly her most memorable image. Only gradually did she come to see that he had not simply been mocking her odd appearance by making her look even more peculiar than she actually was, but rather had attempted, with considerable brilliance, to capture the actual nature of her performance and the message she was acting out, less concerned with Yvette Guilbert the woman, more with her various roles.

In fact there is not the slightest need to search for motives for Lautrec's passion for Guilbert – to him she was a direct continuation of all that he had admired in Bruant. In many ways she was Bruant's closest disciple. It was only after she began performing his songs that her act began to attract a wide audience. She readily admitted that her first 'clean and wholesome' songs had not been up to much and even the diarist Edmond de Goncourt noted in those early days that she needed something by Bruant or Rollinat to buck up her act.

Many of Guilbert's original pieces were sung monologues, where she half-recited, half-acted a comic routine. In *Miss Valérie* she played an English maid – singing with a pronounced English accent – who had to ward off the persistent approaches of her French employer. But while this pleased her audiences, it was little different from stuff on offer elsewhere and it was only

when she began to take an interest in the novels of Zola and Guy de Maupassant that matters improved. As she put it: 'my only aim was realism; I tried to do in song what they had done in fiction.' This brought her inevitably to the one person who had already taken that route – Bruant – who had preceded her at Les Ambassadeurs. Flattered, but also aware that she had some special talent to bring to his lyrics, Bruant decided to take her in hand. He even accompanied her on a night visit to the Château Rouge where Wilde, Sherard and Rothenstein had had their adventure. This whores' bar and doss-house was clearly the central spectacle on the Realist itinerary and it certainly affected Yvette who was mesmerised by the drunken creatures in the downstairs bar – the sleazy alcoholic girlfriend of a guillotined murderer who shrieked that she was going to go to the chamber of horrors at the Grévin waxworks to embrace her lover's head, the young drunk who claimed he could make Queen Victoria smile, which he did by dropping his pants to reveal his 'love tap' then shaking his belly to create a leering, grinning face. They were at least amusing, but there was nothing to redeem the spectacle upstairs where the homeless slept rough on the floorboards, shivering with cold. Yvette emptied her purse into the open hand of an old man, then realised that a nearby mother, huddled with her children, was exactly the sort of figure Bruant had sung about in 'A Saint-Ouen', where the child tells how his mother gave birth to him in the open air, amid the city's refuse.

Suitably trained, Yvette began to sing Bruant's repertoire – 'A Saint-Ouen', of course, and 'A Grenelle' and 'A la Roquette' – but while he bellowed them aggressively at an audience he appeared to despise, she actually enhanced the lyrics, acting out the roles described in the songs, cajoling more out of them than the man who had written them. It must have stunned Bruant when he began to realise that she was beginning to have even more success than he with his own music. Her next move was to commission original songs for herself, though these were to keep so close to Bruant's subjects and style that it is often impossible to tell which are his and which are by other authors. Her most famous song, 'La Soularde' (The drunk old woman), reveals just how much her ballads owed to the master. Written by Jules Jouy, it describes a wreck of humanity staggering about the city streets, pelted with rubbish by children, and ends with the horrifying image of the woman as a stray dog:

> Chien égaré cherchant son trou,
> Parfois, allant sans savoir où,

Loin de la barrière ell'se hasarde,
La Soularde.

A stray dog looking for its hole,
Sometimes, going she knows not where,
Far beyond the walls she wanders,
The drunk old woman.

One enchanted reviewer noted how at the very end of the song her voice cracked over the final word, *Soularde*, splitting it into two notes in a way that took his breath away.

Once she had adopted Bruant, even the grumpy de Goncourt conceded that Guilbert now showed herself to be 'a great, a very great Tragic actress who causes your heart to constrict with anguish'. This was publicly acknowledged in 1893 when she was invited to join a party at a restaurant in the Bois de Boulogne, given by the publisher Charpentier to celebrate Zola's completion of his Rougon-Macquart series, the thirteen novels that cover the transition from the Second Empire to the Third Republic, straddling history and fiction, the books that were, so Guilbert claimed, the inspiration for her career. After the banquet and the flowery speeches, a piano was brought outside and she sang for her hero. As *Le Figaro* reported: '. . . these popular songs, these bursts of laughter, this lovely occasion celebrating the most massive . . . intellectual accomplishment of our time will long remain engraved in my memory.'

Unable to be her publicist in the way he had for Bruant and Jane Avril, Henri eventually recorded his obsession with her in two albums of prints which constitute a precious record of her extraordinary performances, far superior to the hagiography of other artists or the rather feeble recordings that she left behind. Yet so far removed from the conventional showbusiness promotion were Lautrec's sharp images of her act that they succeeded in provoking the wrath of those who preferred a world of flattery and schmaltz. One of the most vicious attacks appeared in *L'Echo de Paris*, whose famously waspish critic Jean Lorrain addressed an open letter to the singer on the subject of Lautrec's first album of prints:

> . . . that you, Yvette, should have accepted these drawings imitated from the walls of the Château-Rouge, this goose-shit-green print, and these cast shadows that bedaub your nose and chin with sh . . for there is no other word for it!

Fortunately for Henri, Yvette was used to Lorrain's bitchiness. A flamboyant homosexual, bejewelled and often stepping out in make-up, he liked to claim he had given the singer her start only to quarrel with her later. Motivated by spite, his vulgarities could be ignored – in any case, Yvette was enraptured by the book and wrote to Lautrec:

> I'm happy! happy! and you have all my gratitude, believe me. Are you in Paris? If so, come to luncheon next week at my new apartment, 79 avenue de Villiers. Kindest regards and thank you again.

The presence of a popular entertainer at the celebration of 'the most massive intellectual accomplishment of our time' was a sign that the gulf between high and low culture, between the entertainments of the people and those enjoyed by the intellectual élite, had been bridged. Of course Zola's realism often meant that he dabbled in much the same scabrous material that Bruant used for his songs, with the result that he achieved a far wider readership than was usual for a 'literary' author. It was a phenomenon soon to be apparent in the visual arts as the Impressionists, with their bright scenes of modern life, achieved the sort of popular following not seen since the adulation offered to religious painters in the late Middle Ages. It was, however, noticeable that one art form remained largely untouched by all this – drama, which ought by definition to have been closest to its public yet had somehow stayed locked in the past. The classics were still declaimed according to fixed traditional rules while the middle classes preferred the polite boulevard theatre with its safe drawing-room comedies whose principal subjects were marriage and money, preferably together. This placid world had been disturbed by the German composer Richard Wagner whose ideal total theatre, uniting poetry, music and spectacle, had aimed to restore to the stage the religious, political and social role it had lost when drama descended into mere farce. In France, the Wagnerites were a dedicated group of reformers, led by Henri's friend Edouard Dujardin who as editor of *La Revue Wagnerienne* kept up a constant assault on the weary world of conventional theatre. But it was in Norway that the process of change began with the first production in 1877 of Henrik Ibsen's *Pillars of Society*, a play that not only attacked the hypocrisy and corruption of middle-class life, the very things the boulevard theatre studiously ignored, but also proposed radical solutions. From then on the aim of the few dedicated individuals trying to transform theatre was to stage Ibsen while at the same time encouraging local authors to emulate his achievements.

Throughout the last twenty years of the nineteenth century, in the main European capitals, young men – and they were very young – put on performances of contemporary works, often with little money or support, in an attempt to challenge the inanities of the commercial stage. Hampered by lack of funds and on occasion by legal opposition, they persevered, setting up theatre clubs to circumvent censorship laws, raising cash through subscriptions, barely sufficient to cover the costs of makeshift productions that if nothing else were creatively ingenious. In France the honour of precipitating this revolution fell, rather improbably, to a young man working for the Paris gasworks, a passionate theatre-lover dissatisfied with the tame stuff put on by his local amateur dramatic society. Only twenty-nine and with little formal education, André Antoine's adventure in experimental theatre began in 1887 in a grubby little playhouse in Montmartre with an evening of short plays that included a dramatisation of a short story by Zola about the return, after ten years on New Caledonia, of an exiled Communard. The radical theme and the straightforward realism of the staging – Antoine had borrowed his mother's living-room furniture – allied to a natural, unmelodramatic style of acting, was praised by the critics, an unexpected success that allowed his group, the Théâtre Libre, to evolve into a professional company, though the struggle for money would never abate and bankruptcy often loomed.

Antoine was followed by the even younger Paul Fort and in turn by probably the most adventurous of all, Aurélien Lugné-Poë with his *Théâtre de l'Oeuvre*. Inevitably, their audiences were often tiny and their plays seldom ran for more than a few nights, if that, while fewer still were as well received as Antoine's first success. A typical evening at Paul Fort's Théâtre d'Art began with a performance of Rachilde's 'cerebral' drama *Madame Death* in which the actors had been directed to 'Suppress all gestures and all vocal or verbal emotional outbursts'. Next came a recitation of Pierre Quillard's 150-line verse drama *The Girl with Two Cut Hands* where the actors were partially hidden behind a translucent curtain as they recited lines about a girl who is fiercely proud of her virginity in 'low, lugubrious and portentous tones', so that it was hardly surprising when the evening ended with large sections of the surviving audience angrily chanting 'Long live Zola!' in honour of the man who had offered simple naturalism rather than this incomprehensible Symbolist obscurantism.

In 1891, when he was not yet twenty-two, Fort staged his most ambitious production, a dramatisation of the biblical *Song of Songs* which would, so he announced to the press, be the perfect fusion of language, colour, music and

smell – his idea being to spray the theatre with different perfumes that would match the changing moods of the solemnly intoned scriptural text. Unfortunately the sprays were not powerful enough and the sprayers too intrusive. Some of the audience laughed, others sniffed noisily, until the auditorium became a battlefield between the 'poetic' supporters and their jeering opponents. One of the 'poets' was Oscar Wilde who, disregarding the technical failure, decided that this use of smell was just what he needed for *Salomé*, for despite such setbacks, the avant-garde theatre exerted considerable influence over a wide range of writers and artists – far greater than its tiny audiences might suggest. They may have quacked through Ibsen's *Wild Duck* but the play survived to become a classic of modern theatre and in spite of the pretension and foolishness of much of what they produced, the efforts of Antoine, Fort and Lugné-Poë transformed far more than French theatre as their ideas seeped into other forms of writing and art in ways that are still felt today. The Wagnerian ideal of uniting all the arts in a single

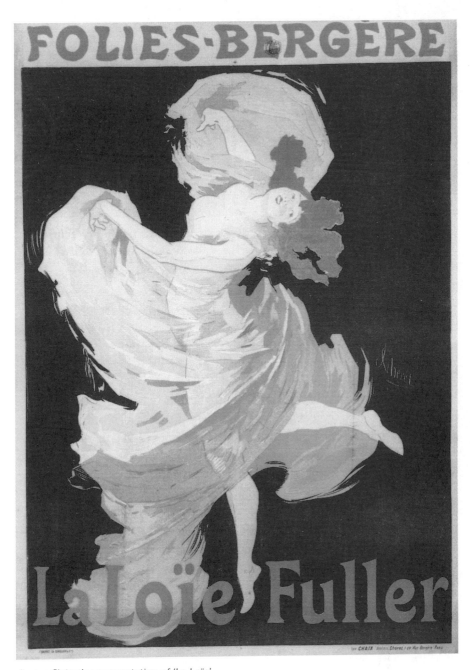

ABOVE Chéret's representation of 'La Loïe'.

OPPOSITE (left) Loïe Fuller captured by a photographer and (right) Henri's interpretation of the same moment.

production meant that they always tried to involve the most exciting young artists in their plays, either as set or costume designers or for the publicity material associated with the first night. These were generally produced so cheaply they had little chance of surviving and much has been irretrievably lost, but we know from contemporary accounts that some of the works produced for those fleeting performances were major elements in the evolution of *fin-de-siècle* art.

What united the apparently irreconcilable worlds of popular showbusiness and the intellectually rarefied avant-garde theatre was the way both used the realism of Zola and Bruant for much of their work. There was, however, an entirely different sort of theatrical entertainment that had nothing whatsoever to do with the poor and the downtrodden – quite the opposite in fact – and which in many ways was the most popular of all. This was the theatre of spectacle and fantasy, of staggering stage effects: sinking ships, burning cities, erupting volcanoes, collapsing temples. It was theatre for a mass, working-class public who demanded glitter, limelight, sumptuous costumes, catchy songs and simple sentimental stories. It was entertainment without any pretence to deeper meanings and the theatre would not hold on to it for very much longer. The Lumière brothers had just opened their first cinema, though they were really little more than theatre managers happy to show anything that would attract a bemused public – one of their first films consisted of no more than a bunch of their own employees leaving their offices to go to lunch. Happily, the true father of cinema, Georges Méliès, was already at work and he, appropriately, had been a theatre magician and would bring to film all the uninhibited thrills and spectacle that he knew the audience demanded, the spectacular dream worlds that would temporarily lift them out of the drudgery and boredom of everyday life.

While the masses wanted spectacle that would bring them into the world of fabulous wealth and exotic pleasure supposedly enjoyed by their social superiors, the intellectual élite wallowed in the gutter, seeking sensation in the harsh lives of the underclass. While the master of the house shuddered over *Germinale*, his maid saved her sous in order to hang from the gallery of the local theatre watching sumptuously costumed heroes and heroines. Yet just occasionally, a performer would appear who managed to take something from that vivacious working-class world and carry it over into the realm usually reserved for the serious and the cultured. One such was the American dancer Loïe Fuller whose act combined dramatic movement with theatrical tricks in a way that completely undermined the staid world of traditional ballet. Was she a dance genius or a cheap showgirl? It hardly mattered to the

huge audiences that flocked to see her bizarre routine – a fact quickly recognised by Henri who used her as the basis for some of his most intriguing works.

'La Loïe', as she was universally known after she took Paris by storm in 1893, was captured in full flow by many artists – both painters and sculptors. These reveal something of her bizarre performance, in which she stood, barely moving her legs, twirling rods hung with veils to create the effect of a butterfly or a trembling orchid. In full flow, La Loïe was the very essence of Art Nouveau, with her apparently sinuous lines imitated in countless plaster busts of streamlined, windswept female figures. Not bad for little Marie-Louise Fuller from Illinois, where she had had a reasonably successful career in opera. She was, however, determined to try something new. Already thirty and running to fat, any hopes of continuing a conventional dance career were rapidly fading but she had hit on a brilliant idea which, though it had little to do with bodily movement in the conventional sense, would revolutionise early modern dance, acting as an inspiration to greater dancers like Isadora Duncan. Before leaving America, La Loïe had seen a not especially interesting play which contained one fascinating scene involving hypnosis, represented by a green light playing on to a white silk dress to create an eerily moody effect. A simple trick yet enough to give Fuller the idea for an entire routine. Her best stage effects were not created by movement alone, but through the way the swirling cloths were lit, the shadows they projected and the repetitions and distortions that were added through the clever use of mirrors. Ever practical, she maintained a team of technicians, led by her brother, who ensured that the whole performance went without a hitch and that no one had an opportunity to see behind the magic. Indeed it became a commonplace for her admirers to be shocked, sometimes appalled, when they saw the supple svelte form of their heroine transformed into the dumpy everyday creature on the Paris omnibus. Rejected after a first audition at the Opéra, Fuller took her act to the Folies-Bergère, making her, like Yvette Guilbert, one of the earliest figures to straddle the worlds of High and Low art. Indeed, she became the inspiration for an entire artistic movement and the major muse for a style of decoration that lasted until her death and whose artefacts are avidly collected today. The sculptors froze time by offering her up as a swirl of drapery; the painters, for the most part, tried to show something of how she did it, revealing her body in outline while veiled by the shimmering silks. Lautrec alone went beyond Realism and in some of his lithographs adopted an abstraction so extreme that without a title, it would be quite hard to say just what or whom the curious, endomorphic splotch of

light was meant to be. This amoebic blob was, however, utterly true to what La Loïe achieved on stage and to what Lautrec had witnessed at a live performance.

When one of the lithographs was published by André Marty in an edition of about sixty copies, Lautrec ensured that no two had quite the same colour, some have effects heightened by sprinkled gold, others show a more intense use of the spatter technique he had developed for the large-scale posters. But overall, the effect of seeing several together creates an impression of what Fuller's performance must truly have been like – its unceasing movement and shimmering hazy colours.

Sadly, she too seems not to have appreciated his efforts and chose Chéret to design her poster for the Folies-Bergère. She had a good run lasting well into the new century and was both a popular performer and an admired artist, a double role seldom achieved. She even managed a rather uneasy affair with Rodin, dying at the age of sixty-six in 1928, a mythic figure from a by then idealised past. But it is not the wonderfully precise photographs that Eugène Druet made around 1900 that have served her memory best – she was really too plump for such unflattering detail. Rather it is Lautrec's risky, witty splotches of colour that alone offer some impression of those billowing eerily-lit moments that in her heyday, she so deftly evoked.

Of course dance, even with La Loïe's stage effects, could never have the same impact as popular music and it was in the realm of the everyday ballad that some rapprochement between High and Low was achieved and there Bruant and Guilbert reigned supreme. Bridging the gap between the concerns of the intellectual few and the desire of the many to be entertained, their ballads became a common language, with several still reinterpreted and performed today, and many others surviving as part of folk memory. Sold in their millions as sheet music, sung in bars across the land, it was this achievement that began the process of closing the cultural divide while the visual counterpart to these popular songsheets were the collections of lithographs of performers like La Loïe and Guilbert that Henri produced, though his role has often been misunderstood. The attack by Jean Lorrain on his Yvette Guilbert album was only the first example of the incomprehension that has dogged the 'showbusiness' works which even today are used to show how his tentative social conscience was quickly superseded by a fascination with surface glitter.

Only a few at the time and since, have argued for his role in bringing together the two sides of the cultural divide. While the link between fine art and popular music, between serious theatre and its more rumbustious

brethren – circuses, music hall, fairground booths – is an accepted element in the culture of our own time, in the 1890s the very idea was fiercely resisted as being, if not immoral, then certainly politically dangerous. It is on this battleground that Lautrec's significance, to his own time and our own, begins to take shape; for when ordinary folk took down the new posters and hung them on their own walls, such stolen images became the Trojan Horse of modern aesthetics, making even the most avant-garde notions of art and design familiar to a wide public. Prior to the 1890s taste was transmitted *de haut en bas*, the styles and fashions adopted by the upper classes being unquestioningly accepted by those below and dutifully applied in watered-down form, depending on the economic circumstances of those trying to ape their 'betters'. Even though the mass-production techniques of the new capitalist industries enabled a wider range of consumers to purchase cheap goods from crockery to ready-made clothing, the designs employed remained rigidly within the nexus of highbrow taste. Even fine art, for the burgeoning middle class with walls to cover, meant officially approved works, in particular the annual Salon prize-winners which were sold us high-quality lithographic prints.

Advertising changed all that. While many long-established promotional materials such as the annual calenders handed out to regular customers by small businesses, continued to use imagery drawn from the High arts, newer forms like the street poster transformed mass sensibility to the point where, by the end of the century, manufacturers were clamouring to provide goods wrapped in designs that would satisfy the public's craving for the 'new' – for it was 'newness' itself that the public had come to expect, an extension of the perpetual search for novelty that popular entertainment had engendered.

Throughout the nineteenth century the primary artistic modes had been revivals of past styles – various forms of the antique resurfacing in the Classical and Romantic schools, the Middle Ages reborn in the Gothic revival. During the Second Empire, this passion for anything other than one's own time reached its apogee in the buildings run up for the great Universal Exhibitions and the products they sheltered, which were often a jumble of disparate artistic and ethnic borrowings – Moorish domes, pre-Columbian figurines, Asian fabrics, Gothic windows, Classical columns – so that a candelabra, or a dinner plate, or a wardrobe became a riot of competing elements, unharmoniously slapped together in a crude attempt to attract attention and proclaim 'quality' by the sheer weight of cultural references.

Now, the public was to be weaned away from this visual diarrhoea by the

appeal of a single artistic sensibility brought to bear on an individual design. The first fashion to emerge from this revolution would be Art Nouveau, the sinuous linear style that spread from posters to furnishings to interior decoration in a mere decade and which drew its inspiration not from earlier artistic conventions but from a fresh study of natural organic forms. This in turn gave way to that gradual simplification and absence of extraneous decoration that we associate with the various forms that are usually grouped together under the title 'the Modern Movement' or simply 'Modernism', the first attempt at a totally original and contemporary style since the Gothic art of the Middle Ages.

No one could argue that this meant an automatic improvement in dress or interior decoration or in taste in art. Rigidity gave way to fashion, stability to reckless change. But at least there was personal choice and the satisfaction of trying to do something oneself rather than the blind acceptance of someone else's vision. Many of the new fashions would be just as eccentric as the old stylistic jumble, but variety and novelty were entertaining if nothing else. Today, with style magazines bombarding their readers with a plethora of fashionable design possibilities, we are as likely to be concerned about the excesses of uncontrollable consumerism, but few doubt that the 'designer' democracies, their shops stuffed with desirable goods, are preferable to the grey tyrannies where all is scarce and no choice is possible. And this debate about choice and freedom has its roots in those first large-scale posters so carefully eased from the walls of Paris and reassembled in dozens of apartments across the city. Even at the time such acts were seen as a direct challenge to the established forces of State-regulated culture. One leading figure in the Parisian education system complained about the corrupting influence of the 'lamentable imagery deployed on walls and shopfronts'. But what could such defenders of the status quo do save rant? Technology had undone them. Artists such as Toulouse-Lautrec, with the aid of the lithographic press, had begun a process of change that was to prove unstoppable.

11

EXPLOSIVE ACTS

That Toulouse-Lautrec was a radical, even a subversive artist was certainly recognised by some critics at the time, though this radicalism was usually seen as a matter of technique – the rapid drawing with colour, the 'unfinished' look of the hasty wash of diluted paint, often on cheap absorbent cardboard, or the vivid blocks of colour in the graphic work, were an obvious challenge to the academic orthodoxies of polished finish and near-photographic illusion. Only the rarest observer saw how radical, too, were his subjects and rarer still were those like Félix Fénéon who were able to link both subject and technique into a single subversive philosophy. As he wrote in the anarchist journal *Le Père Peinard* (The Sly Old Slacker):

> It's not for me – I won't make a fool of myself in exhibitions and get a stiff neck from staring at dirty underwear in gold frames.
>
> Instead of that idiocy, let's imagine you're in the street: you piss against a wall, you stroll with your pal, you're on your way to the job or on the way home, and at the same time, without worrying about it, you glance at posters . . .
>
> It's an open-air exhibition, all year long and all along the street . . . and that's real art, by God! and it cries out, it's part of life itself, it's art that doesn't fool around and real guys can get it.

Fénéon's article went on to praise Lautrec's role in this new 'art-of-the-streets' and this defence of the supposedly flippant artist by the undeniably committed critic ought to have given Henri's more dismissive opponents pause for thought. Writing in the anarchist journal *L'En Dehors*, Fénéon was fulsome in his praise of an exhibition of Lautrec's work that opened in

February 1893. Although this was a joint exhibition shared with the artist and wood-engraver Charles Maurin, Lautrec was very much the prime mover behind the show. Following the death of Vincent van Gogh's brother Théo, Lautrec's friend Maurice Joyant had taken over the Boussod and Valadon Gallery in the Boulevard Montmartre, intending to do what he could to maintain the Dutchman's policy of encouraging contemporary art, even if this brought little profit to the company. He asked Henri to put on a show and suggested he choose someone to exhibit with him and Lautrec selected Maurin, who he seems to have met at the Académie Julian where the older man was teaching printing techniques. While it is doubtful that Lautrec ever enrolled at the Julian, we know he and some of his friends studied some of Maurin's methods which were highly regarded at the time. But while Maurin was another regular at the Moulin Rouge he was only loosely associated with avant-garde ideas; his style was traditional enough for him to be selected for the annual Salon. He was generally admired for his technical skill and major figures like Degas were happy to collect his work, which was probably why Lautrec wanted him to be part of his exhibition. The two would work very closely together over the next few years and an early system of spray painting that Maurin perfected was a clear influence on the spatter technique that Lautrec increasingly employed in his lithographic work. But one only has to look at the way both men tackled the same subject to see that it was Lautrec who used his talent to greater advantage. Maurin's pastel drawing of the Moulin de la Galette, while probably a more accurate representation of the real building, lacks any of the telling emotional force of Lautrec's bleak vision of the poor at their pleasures. Likewise, the older man's pastels of Loïe Fuller dancing, while using line quite effectively to show her in swirling motion, somehow falls short of Lautrec's bizarre, inflated foetal blob, billowing about the stage that so uncannily recreates the sensation of La Loïe in full cry.

Still, the artists clearly complemented each other and it is interesting to note that Lautrec chose their joint exhibition for one of the rare outings for the still unfinished *Au Moulin Rouge*. Not surprisingly it was this work that was seized on by Fénéon in his article, noting how the characters were studied 'with an insistent curiosity', so that they seemed like 'dejected maudlin puppets slipping into senile decay; the men become ludicrous, the women malevolent – like this one, with a face from the grave, shivering in her furs, her red hair, in which the blood and mud of old lechers would congeal, all dishevelled.' Evidently the right-hand figure had not yet been cut off and Fénéon's descriptions of the weird underwater light that infuses the canvas

and the silent, almost uncaring isolation of the people show that he at least was not taken in by the illusion of decadent gaiety that so many have chosen to see. Indeed, it was this air of misery, what one writer called 'a most memorable image of joylessness', that led anarchists like Fénéon to include Lautrec in their stable of sympathetic artists. No one was suggesting that he was an open supporter of their philosophy nor in any sense a political activist, rather that he shared that estrangement from the bourgeois world that by the early 1890s had led an astonishing number of artists, writers and intellectuals to call themselves anarchists. Virtually every Symbolist writer claimed to be one, though very few belonged to any of the underground cells or had any intention of doing something about this 'belief' other than to affirm it when asked. This led to a number of contradictions. Despite the obvious fact that Lautrec's posters had been made to advertise commercial enterprises and were in a sense art put at the service of capitalism, Fénéon could still hail them as an art of the people for the people. This was generous, as the critic had suffered personally as a result of the first Moulin Rouge poster when many of his friends made fun of him, claiming that he must be the emaciated character dancing with La Goulue and not Valentin le Desossé, to whom he bore a remarkable resemblance. Despite that irritation, Fénéon took up the defence of Lautrec's graphic art in the most working class of all the anarchist journals *Le Père Peinard*, a magazine written entirely in street slang.

> Lautrec's a guy with a hell of a nerve and lots of guts; his drawing and his colours don't beat around the bush. Big, simple patches of white, black, and red – that's his scam. Nobody can match him at snagging the snouts of capitalist pigs chowing down with loose chicks who lick them on the snout to make them pay out. *La Goulue, Reine de Joie, Le Divan Japonais* and two of a bar keeper named Bruant, that's all Lautrec has turned out in the way of posters, but they're daring, determined and tough, and those idiots who want everything in spun sugar really get left with jam on their faces.

The 'snouts of capitalist pigs' is a reference to Henri's second major poster *Reine de Joie* which appears to have attracted Fénéon's interest far more than the dance-hall and cabaret advertisements – understandably, as it was the most overtly political of all Lautrec's commercial graphics. The poster

was made to advertise a novel of that name, published in 1892, by an odd character who called himself Victor Joze. Born in Wyszogrod, Poland, in 1861, Joze Dobrski de Jastebiec was the son of a militant journalist forced to emigrate to France after the insurrection of 1863, bringing with him a taste for provocation and combativeness which he seems to have passed on to his son. Under his adapted name, Joze was educated in Paris after which he became a journalist in the radical tradition of his father. An early coup, a much-talked-about interview with France's most prominent hate-figure the German Chancellor Bismarck in *Le Figaro,* made his name and also appears to have given him an insatiable appetite for the wide publicity that can result from stirring up popular prejudice, a taste which persisted into his subsequent career as a popular novelist, deliberately choosing risky topical subjects that were guaranteed to attract maximum attention.

Joze saw himself as the poor man's Emile Zola, offering a down-market, easy-to-read version of the great author's panoramic survey of French life in the last half of the nineteenth century. But where Zola attempted to create a serious historical and social survey of the age, Joze, in his *La ménâgerie sociale* was content to churn out a sequence of suggestive pot-boilers, with saucy titles like *Spanish Fly*, and a clever way of playing fast and loose with the libel laws. *Reine de Joie* was the third in the series and certainly the most effective in attracting publicity for its author. The *Reine de Joie* of the title is Alice Lamy, the central character in a book which at 180 pages is little more than a novella, a picaresque tale of a pretty Parisienne who, when jilted by her lover Charles, embarks on a career as a courtesan. In quick time, Alice passes through a succession of ever older, ever richer lovers – an aristocrat, an American businessman, until she finally hits the jackpot when a notorious panderess, the aptly named Marquise de Saint-Pudeur, introduces her to the super-rich Baron Rozenfeld. The story takes place through 1889, the year of the Great Centennial Exhibition, and it is obvious that Joze expected large sales from the influx of curious provincials and inquisitive foreigners flooding into Paris and keen to learn something of its notorious night-life. Thus we have Alice and her friends visiting the rue du Caire to watch the belly-dance – Joze lingers over the dirt, the sweat and the smells – and spending an evening at Les Ambassadeurs where La Goulue, Valentin, La Môme Fromage and La Macarona are performing. But there is no doubt that Joze expected his readers to be most shocked when Alice enters into a purely mercenary arrangement with the Baron whereby he will pay her a huge monthly retainer and provide her with a fabulous mansion on the most exclusive street in the capital, the Avenue de Bois de Boulogne, now the

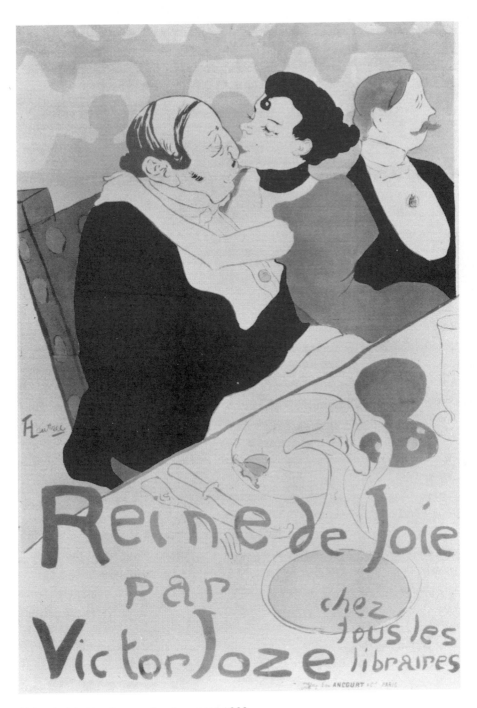

Reine de Joie, Henri's second major poster, 1892.

Avenue Foch, in exchange for her services as his mistress. The dénouement comes at a dinner when Alice unrolls her napkin to discover the title deeds to the property, whereupon she kisses him, sealing their bargain.

The curious thing is the surprising degree of ambiguity that Joze allows to creep into this supposedly simple tale of debauchery. Far from profiting from the offensive, amoral pact as his readers would have anticipated, Rozenfeld turns out to be a charming old buffer who only wants the prestige of having the most beautiful mistress in Paris. Too old for sex and late nights, he only wants to be seen with her from time to time, otherwise she is absolutely free to spend his money any way she chooses. He isn't even jealous and when the tale ends at a masked ball at the Opéra we learn from her gossiping friends that Alice has used the Baron's money to woo back her first love, Charles, who is now installed in her elegant residence.

Thus Joze offers a strangely moral tale with Rozenfeld as its putative hero – though with a twist that leaves a rather sour taste in the mouth of the modern reader. According to the author, Rozenfeld is a typical 'Israelite', a rich Jewish financier, though a very 'grand Seigneur' and a friend of the Prince of Wales. The first time the Baron meets Alice he presents her with a sumptuous diamond brooch and then proceeds to tell her what it cost, establishing what is supposed to be a Jewish fixation with money, and emphasising the fact that he is buying her. In the main, however, his Jewishness is treated as a music-hall joke – at the dinner, when Alice discovers the deeds and turns to kiss him, she finds her way blocked by his large, hooked Semitic nose, so she promptly kisses that.

This is not the sort of image likely to entertain modern readers sensitised by the horrors of the twentieth century, though at the time it was so commonplace as to barely raise an eyebrow and, for the late-nineteenth-century reader, amply counterbalanced by the Baron's evident good nature and his kindness to his nominal mistress. What did stun those same readers was the suggestion that the fictional Rozenfeld was a thin disguise for the all too real financier, the Baron de Rothschild – a conclusion reached by the actual Baron who considered himself an exemplar of all the Victorian virtues and who attempted, unsuccessfully, to have the book banned, inadvertently creating the very scandal Joze had hoped to provoke. Henri's poster was no sooner up than two young stockbrokers, assumed to be either in the pay of or just trying to curry favour with the Rothschilds, were seen going round the city tearing down or defacing the sheets – one of the first skirmishes in the battle between pro- and anti-Jewish forces that would soon metastasise into all-out war.

There are many contradictions in the history of the treatment of the Jews in France. Following the Revolution, the new Republic was the first nation to offer emancipation, permitting, with only a few exceptions, participation in all levels of government service. It is still surprising to learn that outside Israel, France has had more Jewish prime ministers than any other country, even though there have never been that many Jews in France, a mere 70–80,000 in an overall population of some thirty-nine million in the latter half of the nineteenth century. Outside Paris and Bordeaux, Jews were barely visible and most discontented provincials directed their more violent impulses towards beating up Italians, who were the largest immigrant group and the one most often seen as stealers of jobs and women, the usual reasons given for hating foreigners.

Yet despite the apparent assimilation of some of the more successful Jewish families into the upper reaches of French society, many politicians proclaimed themselves anti-Semites, certain that the title would win them votes. Initially at least, disliking Jews seems to have been practised by both sides of the political divide for quite different reasons. Upper-class men such as Alphonse de Toulouse-Lautrec rejected them because they earned their money and occupied his territory, buying large houses and going to the opera, riding to the Bois like gentlemen and generally giving themselves airs. One can add to that Adèle's Catholic aversion to the supposed killers of Christ and the picture is complete. It was not, however, a very active prejudice, as witness someone like Proust who was the son of a Jewish father and a Christian mother and was brought up as a Catholic and thus able to move in the very highest reaches of French society. At worst, the most the Alphonses of this world could achieve was to prevent an upwardly mobile Jew from joining the more 'exclusive' clubs. Perhaps surprisingly, the worst enemies the Jews had were on the left of the political divide. It was the Jews' apparent success in business, their visible role as capitalists, industrialists and financiers, that ignited the wrath of those dedicated to defending the downtrodden workers. This rancour spawned the caricatural Jew, the corrupt usurer: fat, hook-nosed, shifty, foreign; a rootless character without any deep attachment to the sacred soil of France. No matter how much the great Jewish banking families contributed to the transformation of the French economy, no matter how great their charitable donations and their support for the arts, it was always the few corrupt Jewish figures like those implicated in the Panama Canal scandal or in the occasional collapse of an investment scheme, that were picked out and remembered. Lest anyone forget, there was always the writer Edouard Drumont, founder in 1886 of

La France Juive and of *La Libre Parole* in 1892, to reignite their antipathy in articles loaded with any lie or half-truth, no matter how blatantly false, that built up hatred upon hatred for the 'Semites' and any who supported them.

It was into this nasty brew that Victor Joze briefly dipped his pen during the writing of *Reine de Joie*, but he was certainly not unique in dabbling in such matters. Even if one leaves aside such professional haters as Drumont, the depiction of Jews as greedy parasites, as alien nomads, vice-ridden and untrustworthy, was a commonplace, not just of French popular fiction but of writers with the highest literary standards. Maupassant, De Goncourt, Gide all expressed anti-Jewish sentiments and even the supposedly philo-Semitic Zola was not entirely free of the conventional bigotry towards the Jewish business community. His novel *L'Argent* (Money) was set in the frenzied era of financial speculation during the Second Empire that ended with the spectacular collapse of the Credit Mobilier, founded by two Jewish financiers, Jacob and Isaac Pereire, which ruined many who had speculated in its fortunes. In the novel it is the Universal Bank that implodes whereupon its founder, the Jewish banker Gundermann, leaves his ruined investors to their fate even though Zola was well aware that his models, the Pereire brothers, sacrificed their own fortune to ensure that at least some of their supporters were not completely devastated by the crash.

The difference between Zola and Joze was not just a matter of talent, though that was enormous; it was primarily intention – Zola's aim was to criticise the failures of frenzied speculation which were one of the worst aspects of the capitalist scramble under Napoleon III. To Zola the prominent Jewish banking families were an integral part of a social upheaval of which he thoroughly disapproved and were thus legitimate targets for his satire. For Joze, however, the Jews were a target in themselves and his book uses the conventions of anti-Semitism, though without the venom of other prejudiced writers.

Despite these views, Joze was not the all-purpose reactionary one might have expected. Rather confusingly, he displayed an inexplicable fondness for progressive art – one of Seurat's last works, made just before his untimely death in 1891, was a drawing for the frontispiece of a Joze novel. For *Reine de Joie*, the author asked Bonnard to design the book jacket, though the artist chose to play down the novel's somewhat unsavoury connotations, preferring to show a dreamy Alice lying in bed with a few elderly gentlemen, her fantasy 'protectors' hovering in the background, none of whom looks stereotypically Jewish. This may be why Joze wanted Henri to come up with

a more stirring poster and this he certainly did, choosing to show the moment when Alice leans forward to kiss Rozenfeld on the nose. Where Bonnard seems to have been indifferent, Henri brought all the graphic skill he had shown in the Moulin Rouge poster to bear on this moment – the sharp blacks and reds of the costumes against a golden-yellow background, the table slicing dramatically across the picture space, Japanese-style, must have made the result irresistible out on the city streets. It is clear that just as Henri's first poster drew the watching eye straight to La Goulue's *derrière*, so now the entire focus of *Reine de Joie* is the point where Alice's lips touch the financier's prominent hooked nose – for Rozenfeld is quite clearly a caricatural Semite: obese, greasy, hook-nosed, even the ambiguous position of his arm makes him look as if he might be fondling her breasts, a nod in the direction of notions of Jewish lasciviousness towards Aryan women – a point further hammered home by the presence on the other side of Alice of the English nobleman, 'the Lord of Bath', from the novel, who is clearly there to provide contrast to Rozenfeld's 'oriental' foreignness.

Of course Henri was hardly alone in using such caricatural devices. The parallel between evil capitalist and gross Jew was a commonplace for nineteenth-centuary cartoonists. Even Pissarro, a Jew himself, used them in his *Turpitudes sociales*, the series of anarchist-motivated drawings attacking the evils of contemporary life, among which he included a bloated capitalist who bears all the features of Jewish decadence as dreamed up by Drumont. In a letter he wrote to accompany the drawings, Pissarro explained his feelings: 'the statue is a golden calf, the God Capital. In a word it represents the divinity of the day in a portrait of Bischoffheim (sic), of an Oppenheim, of a Rothschild, of a Gould, whatever. It is without distinction, vulgar and ugly.' And this from the kindly and gentle, socially progressive, Pissarro. Of course we are talking of an era before the deportation of a hundred thousand French Jews to their deaths in the Nazi concentration camps and, in retrospect, it may well be impossible to judge such sentiments other than harshly. Yet it is obvious from reactions at the time that the association of capitalist exploiter with caricatural Jewishness was not as offensive as it is today. Faced with both, it was a capitalist that most people saw and not a Jew. This seems certainly to have been the case with Fénéon when he wrote of 'those gaga old capitalists' in his review for *La Père Peinard* and it is clear that the anti-Semitic elements so obvious to our late-twentieth-century eyes were of little consequence to Thadée Natanson, another Jew and the future proprietor of the eminently radical magazine *La Revue blanche* who wrote of 'the delicious *Reine de Joie*, light, captivating and superbly perverse'.

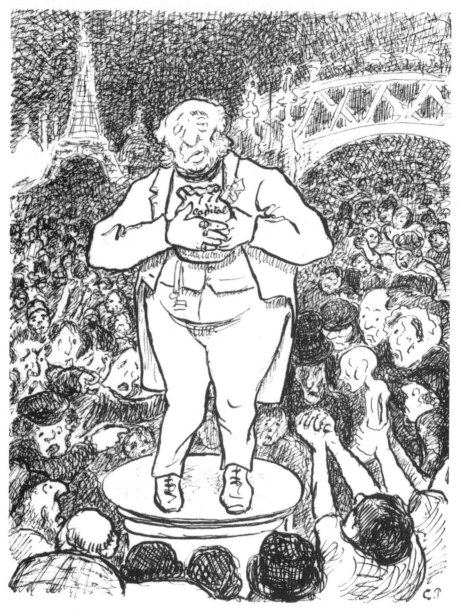

'It is the War of the Haves and the Have-Nots', Camille Pissarro's stereotypical Jew from his series of drawings, *Turpitudes sociales* (1890).

Indeed, it may well be that last word which holds the key to Joze's own brand of anarchism and offers an explanation for Henri's willingness to endorse his book. For it just won't do to try and pass off this association with so dubious a character as Joze as merely the result of Henri doing any work that

came his way. Picturing him as a simple jobbing labourer, happy to be gainfully employed without troubling himself too much over what it was he was illustrating, hardly fits the facts.

For a start, Henri didn't need to work for money and could in any case have had almost any commission he wished after the huge success of the Moulin Rouge poster. In truth, he seems rather to have liked working with Joze and did two further commissions for him. The second, in 1894, was for a poster to advertise *Babylone d'Allemagne* in which Joze merrily stirred up the vast reserves of French loathing for Germany and their desire to be avenged upon their one-time conquerors. Indeed, the poster nearly succeeded in launching another war as Henri had shown a procession of German cavalry passing a sentry-box where the guard on duty bore an uncanny resemblance to the heavily bearded face of the then Kaiser, Wilhelm I. What shocked many who saw it, was the way the Kaiser appeared to be staring at the rather prominent hind-quarters of the nearest horse, an all too literal interpretation of the word Babylon, used at the time to suggest sexual perversion. The German authorities seemed to think so, dispatching their ambassador to the Quai d'Orsay to deliver a formal protest. And there is no doubt Henri knew just what he was doing, carefully paying for the poster to be privately printed to forestall any attempt to ban its distribution, a dedication to the cause that negates any suggestion that he was just a plodding worker, happy to complete any old commission without worrying too much about the details.

So what was he up to? As regards *Reine de Joie*, we know enough about his friendships and allegiances to accept that he did not share his parents' unthinking anti-Semitism, though he clearly saw no reason to reject the conventional stereotypes that associated Jewishness with financial exploitation, stereotypes accepted by almost all his colleagues.

The crucial factor to bear in mind when trying to judge opinions at the time, is the precise date when they were expressed. Zola's *L'Argent* was published in 1891, Joze's crude pastiche *Reine de Joie* a year later, both at a time when a degree of naïveté about anti-Semitism was still possible. A mere two years later such innocence would end with the arrest on charges of spying of an obscure army officer, a Captain Alfred Dreyfus, a Jew, whose trial and imprisonment would throw into sharp focus the previously foggy issue of how one should or should not depict, whether in words or drawings, a previously despised people. Back in 1892, French artists and intellectuals from Zola to Toulouse-Lautrec were about to undergo a process of radical rethinking, but at the time it was still possible to see people like Joze as no

Allégorie

'Allegory', Forain's anti-Dreyfusard view of 'the *Affaire*' – a Prussian officer manipulates a Jew who wears the mask of Zola.

more than rumbustious trouble-makers. Hence Natanson's choice of the word 'perverse', which he seems to have used to encapsulate Joze's form of anarchy, a sort of wild, almost savage wilfulness that refuses to kowtow to any of the polite orthodoxies and which will upset any apple cart, no matter what the consequences. One does not have to defend his more obnoxious offerings to see that it was Joze's very offensiveness that made him so subversive. Unpleasant he may have been, but he was also a sort of cultural terrorist, blasting off in any direction with little thought of the consequences. His was the ultimate anarchy where the Word becomes the Deed and is all the more dangerous for it. And for a time, Henri, with his own black humour and refusal to accept any of the conventional limits society attempted to impose, seems to have been happy to throw a little petrol on the flames. Both his Joze posters offer the same low, embarrassing humour found in Italian Grand Guignol and English Punch and Judy shows, a sort of innocent yet knowing, immature lawlessness, before which all authority is powerless.

It can be seen again in the uproar that followed the *Bal des Quat'z Arts* in 1893. If the authorities had had any sense, the disturbances on the night of the dance would have been quietly forgotten. Given the antics that frequently took place high on the Butte and down in the *maquis*, the violence against lonely prostitutes, the fights that often ended in knifings in dark corners, the population of Montmartre had taken a fairly phlegmatic view of the student riots. But not so one of the nation's senators, René Béranger, who since the start of the decade had been trying to whip up votes from what would today be termed 'the silent majority' through a noisy and opportunistic campaign against the licentiousness that places like the Moulin Rouge clearly represented.

Left to themselves, the police would probably have done nothing more than bring to court the few students they had managed to arrest that night, who would most likely have been given fines and a warning. Béranger, however, was unwilling to let the opportunity slip by so easily, especially since he had been locked in combat for some time with the organiser of the ball, Jules Roques, whose newspaper *Le Courrier Français* had been ridiculing the efforts of the senator's organisation, the *Ligue Morale*, sometimes known by its more fulsome title 'The League Against Licence on the Streets', to combat the debilitating decadence of the Republic. Before that evening at the Moulin Rouge the newspaper had organised a number of masked balls at the Elysée-Montmartre and had already come up against the senator's attempts to harass such activities. This time the *Ligue* was more astute and when the senator filed a formal complaint against the organisers along with

some of the models who had taken part in the procession, the authorities were forced to bring charges of indecent exposure, even though the women had been wearing slightly more cover than they usually did when working for that particular audience. The ludicrous nature of these particular charges – nothing having been said about the sexual abuse of some of the women nor the violence used to extort drinks in the cafés afterwards – nevertheless drew a satisfying deluge of publicity and succeeded in arousing the ire of Henri who, having largely overlooked the actual ball as a potential subject, now concentrated his efforts on depicting the subsequent trial which began on 30 June 1893.

The whole thing rapidly progressed from farce to tragedy. First, many of the students who had attended the ball signed a petition claiming they were all guilty and should all be tried, next the Police Commissioner himself testified to the court that nothing obscene had actually happened, and finally who should step up as main *prosecution* witness but La Goulue who swore that she had been deeply offended by the sights she had been forced to witness on the evening in question. The hilarious spectacle of the most brazen slut in Paris giving witness for the League against Licence on the Streets ought to have resulted in the collapse of Béranger's case but by some bizarre twist of logic the judges decided to find the accused guilty, fining them each a hundred francs, an astonishing sum at the time. Given the febrile nature of political life and the edginess brought on by a recent upsurge in anarchist activity, it was a thoughtless move by reactionary minds dangerously divorced from reality. Out onto the streets the students poured, cursing Béranger's name and refusing to disperse when police arrived with batons. Similar manifestations broke out wherever students gathered. At the Sorbonne a police charge provoked a pitched battle in which an innocent bystander, sitting on the terrace of the Café d'Harcourt, was killed. The protests continued throughout the following days, with young people seizing the Latin Quarter almost as if it were Montmartre during the Commune, provoking a nervous government to call out the troops, who took six days to restore order. When the dust settled, it was clear that all Béranger had succeeded in doing was to create a habit of student uprisings which now became a regular feature of French political life, culminating in the near successful overthrow of the Republic in 1968. After 1893, the flaunting of one's decadence, the refusal of all moral strictures, became more than ever a political act. The sort of riotous behaviour that had seemed natural and of little significance at the *Bal des Quat'z Arts* became, as a result of one man's political attempts to play the moral line, a revolutionary gesture.

Henri revealed his own feelings over the affair by making a lithograph that showed La Goulue giving her evidence in court dressed as an animal trainer, a sign that it was all a performance, but he reserved his most potent venom for the senator when he made a poster for an artists' magazine *La Vache enragée* (The Mad Cow), which had the beast in question, representing all the frustrated artists of the capital, chasing a foolish-looking Béranger off the scene.

Something very odd had happened – just as Paris became a world centre for frothy, empty-headed entertainment, serious political activity took on an urgency not seen since the last days of the Commune. By the early 1890s Félix Fénéon was writing, almost exclusively, for several of the anarchist journals that had mushroomed across the capital over the previous year. In *Le Revue anarchiste* and *Le Revue libertaire*, he published articles on a wide range of subjects both cultural and purely political, from book reviews to reports on strikes, though it was his occasional piece for one of the most radical, *L'En Dehors*, edited by the wild-eyed, red-bearded, archetypal *anarchiste provocateur* Zo d'Axa, that finally brought Fénéon to the attention of the authorities. Worried by the increasingly violent tone of much of the material these magazines were publishing, the police opened a file on Félix Fénéon some time around the end of 1891. In fact he had only contributed some art criticism to Zo d'Axa's periodical, and the police did not yet know that Fénéon's activities had by then progressed beyond mere writing about anarchy and that the secretive, self-effacing critic was now an active member of one of the clandestine groups working to replace the Propaganda of the Word with that of the Deed. How many of these groups there were and how many supporters they had is not known, but in 1891 their moment came.

Throughout the 1880s the anarchists had talked much but done little and the sudden transition into action came more from a series of minor blunders than from any planned course of action. On 1 May 1891 the police used force to disperse a small demonstration held by an anarchist group in the Paris suburb of Levallois. It was nothing, and would have ended there, if some overzealous officers had not decided to pursue the leaders of the protest to a wine shop in Clichy. Both sides were armed and there was a shoot-out before three men were arrested and brought to court, where long prison sentences were doled out.

The case attracted little press attention but it was noticed by a young dyer called Koenigstein who was to become famous under his mother's name Ravachol. Judgements of Ravachol have always been confused: to some he

was a dedicated idealist, to others a vicious criminal. His defenders excused activities such as grave-robbing and the murder of a ninety-two-year-old miser by invoking Proudhon's dictum 'Property is Theft', claiming that Ravachol was simply taking his rightful share of the spoils. But whatever his underlying motives, it is not clear why he was so incensed by the May Day incident to the point where he was able, virtually single-handedly, to plunge the country into a maelstrom of terrorist violence. First he blew up the home of the trial judge in Saint-Germain then, two days later, that of the prosecuting attorney in the rue de Clichy. He was arrested when a waiter in the Restaurant Véry in the Boulevard Magenta overheard him talking about the explosions. Appalled by the reality of violence, many of the literary anarchists initially repudiated Ravachol. For some, however, he was a shining hero and when an unknown activist decided to avenge his betrayal by blowing up the Restaurant Véry – hailed in one anarchist journal as a *vérification* – the entire city was convinced that nemesis had struck and that there were anarchist bombs in every parcel, under every chair, behind every tree. There were stories and songs about dynamite, poems about bombs – even Jane Avril was given the name 'La Melanite', a sort of explosive material, to indicate the vivacity of her act. On 11 July 1892 Ravachol went to the guillotine shouting *'Vive l'anarchie'* and at once became a sacred martyr to the cause, all doubts about his other, less heroic, activities being now subsumed into his glorious legend. Lautrec's joint exhibition at Boussod and Valadon, that Fénéon so lavishly praised, contained an astonishing, near religious portrait of Ravachol by Charles Maurin who, of course, was another self-proclaimed anarchist. Maurin portrayed the bomber as a sort of martyred Christ waiting before the guillotine, as before the cross. According to Fénéon, the image was almost an apotheosis of the dead terrorist: 'Comrade Ravachol,' he wrote, 'his head, proud, energetic and calm, and his naked chest are framed by the vertical posts and the triangular blade of the guillotine. In the distance crops are rippling and the sun, as for a holiday ceremonial, is rising.'

Of course, what Fénéon may equally well have known was the peculiar source this imagery. Unable to sketch the imprisoned terrorist, Maurin probably based his portrait on one of the police 'mug-shots' which were another bi-product of that fraught period. Concerned to deromanticise the bombers, who had often been photographed as flamboyant Byronic poets, the head of the photographic service of the Paris Préfecture, Alphonse Bertillon, created a rigid, high-backed chair which obliged prisoners to sit ramrod stiff while they were photographed head on, a discomfort that reduced them to staring,

confused-looking captives, a method still used to this day by police forces from Los Angeles to Tashkent. What Maurin had done, was to rework the pathetic figure in the mug-shot, returning to Ravachol the insouciance and glamour which Bertillon believed he had finally expunged.

Maurin's anarchist views were no secret, and even one as supposedly indifferent to politics as Henri could not have been unaware of the significance of the Ravachol portrait, yet he was clearly quite happy to be associated with, indeed to have in effect selected a work that most people outside the anarchist circle would have considered morally repugnant.

Up to this point, Fénéon was still a talker rather than a doer though it was only a matter of time before that would change. In 1892 he and his parents moved to a new apartment in the rue Lepic, the steep street that winds up the Butte to where the great white basilica of the Sacré Coeur was still being built. The apartment block was quiet and respectable and the typically nosy concierge began to note Fénéon's habit of going out during the night. At that time he was only visiting the cellar offices of *L'En Dehors* which had become a sort of artistic clubhouse for poets and painters of an anarchist persuasion. At most, Fénéon's activities were limited to the occasional night sortie to stick up anarchist posters – in effect a replacement activity, as he had already published an article teaching his readers how to unglue a Lautrec poster so as to have good art in their own living rooms. Such activities are only significant when one recalls that during the day Fénéon was still employed at the Ministry of Defence where he was by then a chief clerk third class with equivalent ranking to a second lieutenant in the army. He might have remained in that ambiguous state had it not been for the friends he was making at the magazine's cellar club, most notably a young activist called Emile Henry who was to take up where Ravachol had left off.

It is clear that the young Henry, seven years younger than Fénéon, had the charm of a Romantic poet. Having thrown away the chance to study at the prestigious Ecole Polytechnique, he had been leading a sort of Robin Hood existence, stealing from the rich to help the poor, awaiting his chance to make some great gesture on behalf of the anarchist cause. Incensed by Ravachol's execution, Henry decided to do some bombing of his own and though Fénéon initially tried to dissuade him, he eventually gave in, and lent Henry one of his mother's dresses as a disguise. Thus it was that a strange figure, dolled up as Madame Fénéon, entered the offices of the Société des Mines de Carmaux on the Avenue de l'Opéra where a tightly sealed metal kettle loaded with dynamite and wrapped in newspapers was left in the

stairwell near the main office. The package was discovered and the police summoned, but they foolishly made the office boy carry it round to the near-by police station in the rue des Bons-Enfants where it exploded, killing the boy and four officers and mortally wounding another. Emile Henry left for England, though as yet no one had been able to associate him with the deed.

The fact that Fénéon openly approved of the incident – he wrote of the day that 'the delightful kettle of rue des Bons-Enfants exploded' – only added to the weight of material piling up in his police dossier, for by now the authorities were aware that these active anarchists were not confined to a few stray members of the criminal underworld but might also have support-ers in the wider artistic community. While many of the Symbolists quietly reneged on their anarchist views once violence began, others became even more involved, strangely attracted to this sudden blood-letting. On 9 December 1893 a writer and translator known for his work in the avant-garde theatre, Auguste Vaillant, achieved the greatest coup of all when he managed to throw a bomb from the gallery of the Chamber of Deputies. Nobody died but such was the terror he brought to the very heart of the ruling order that he was condemned to death, by then an unheard-of sentence for one who had not killed anyone. The general public were often confused – Ravachol, Henry, Vaillant were clearly terrorists and potential murderers yet they all seemed to love children and were passionately opposed to cruelty to animals. Ravachol's son had reduced the court to an embarrassed silence when he recounted how 'sweet' his father had always been to him and his mother, while Vaillant's lawyer claimed that his client had been driven to his 'symbolic' act in part by his inability to provide for his daughter. In the end these appeals to sentiment failed, Vaillant was condemned, and bowing to public outrage, President Sadi Carnot refused to sign a pardon, making himself a hate-figure of the left and provoking one of Lautrec's rare works directly linked to a political event: the cover for a satir-ical song 'Carnot Malade', ostensibly referring to a recent illness the President had suffered but in reality calling up the many political maladies, mainly associated with the collapse of the Panama Canal Company and the subsequent inquiry that had revealed a web of corruption in his government, which had demolished the reputation for honesty that had brought Carnot to power. In Lautrec's lithograph the sick President's head, wrapped in a silly bandanna, peeps above the bed-sheets as a doctor takes his pulse and a servant offers a bowl of gruel. Spread across the bed are documents, the topmost bearing the word *Bennes*, a northern French word for a form of transport used in the mining and construction industries and presumably a

Carnot Sick! a rare direct political comment from Henri.

reference to the Panama débâcle where millions had been squandered on heavy equipment lost in the mud.

Disgust with Carnot and his government and the Republic they led, was not confined to anarchists and it goes some way to explaining Lautrec's political attitudes when one sees that Royalists, too, were also opposed to the descent into corruption of a State they despised. Many were shocked when the grandest of aristocrats, the Duchesse d'Uzes, matriarch of one of the three premier ducal families, offered to take in Vaillant's daughter and pay for her education.

Vaillant meanwhile had, like his hero Ravachol, gone to the guillotine screaming that he would be avenged – and he was, by the newly returned Emile Henry who made himself another bomb, this time in a cooking pot stuffed with dynamite and 120 bullets, and set off, not to kill some leading politician or functionary of the State, or leading capitalist businessman, but to the Café Terminus near the Gare Saint-Lazare, a place where ordinary working people, bank clerks and shop assistants went for a drink after work while waiting to catch their train home. Twenty of these innocents were wounded and one killed; the general public were understandably aghast. Anarchism, which had been supposedly based on near Christian attitudes of human compassion and faith in human progress, had turned into a violent nightmare. As Emile Henry left the café there was a hue and cry and a shoot-out before he was overpowered. In his bleak rooms in Belleville, the police found enough material to make an arsenal of bombs. And still the blood-letting continued. Shortly after Henry's arrest the city was racked by a series of explosions – a bomb in the rue Saint-Jacques, another in Faubourg Saint-Germain, a third in the Church of the Madeleine where a Belgian anarchist blew himself up. The fourth was in some ways the most dreadful of all for it succeeded in bringing together several strands in this confusing and troubling episode. On 4 April 1894, a mysterious passer-by left a plant pot containing a single hyacinth on the window-ledge of the Foyot Restaurant near the Odéon theatre. The restaurant faced the Palais de Luxembourg which housed the French Senate and was thus a fashionable eating-place for both politicians and people from the world of the arts. The bearer of the plant pot had spent some time walking in the Luxembourg Gardens smoking cigarettes, waiting for the evening crowd to build up inside the main dining room. By rights the place should have been filled with representatives of the ruling order but by a grim coincidence, the table nearest the window was occupied by Laurent Tailhade, a young poet, known like so many for his anarchist sympathies, who was dining with a woman friend. Unfortunately

for Tailhade, the plant pot contained more than a hyacinth: beneath the flower was a lethal mix of dinitrobenzene and ammonium nitrate, closely packed with bullets. The fuse ran up the stem of the plant and had been lit with a cigarette before its manufacturer deposited it on the ledge and hurried off to catch a passing omnibus heading for Clichy, climbing to one of the open-air seats on the top deck from where he clearly heard the shattering explosion. By a miracle no one was killed, though the poet, who had jumped up to protect his companion, was blinded in one eye and disfigured for life.

It was an act that confirmed every doubt now entertained by the intellectual fellow-travellers who had once supported anarchism. Writing of Emile Henry, the critic Octave Mirbeau referred to him as little more than a criminal though Fénéon stayed loyal to his young friend, passionately excusing the bomb in the Café Terminus, defending it openly on the grounds that no one was innocent while men, women and children were exploited by the capitalist system. Even the blinding of a poet and fellow anarchist could be excused by the same logic, for the man riding away from the mayhem of the restaurant, on top of the omnibus, calmly smoking yet another cigarette was Félix Fénéon, editor and critic and now Propagandist of the Deed.

12

A SHUTTERED WORLD

While the people of Paris fearfully awaited further explosions, Henri de Toulouse-Lautrec grumbled. His usual reaction to these sudden acts of violence was an outburst of anger if any disruption interfered with his daily routine and stopped his work. For someone with an unrivalled reputation as an epic roué, Henri was remarkably hard working. His presence before his easel never flagged no matter how much alcohol he had downed the night before and there were long days at the Imprimerie Ancourt, where he worked with the head printer Père Cotelle, a fund of technical information who stood by him as he experimented directly on to the lithographic stones, often working through lunch as he pursued some new idea.

The prints were mostly based on his paintings, carrying further the process of radical simplification which can make the canvases seem little more than studies for these ultimate graphic masterpieces. But this ignores the very different approach Henri brought to each medium. Where the paintings were generally subtle studies of human relationships and were often part of his continuing absorption with themes inspired by Bruant's songs, the prints were more concerned with the formal qualities of line, shape and colour, those abstract elements that culminated in the extraordinary Loïe Fuller series in which every detail was pared away until all that remained was a strange amoebic blob, glowing in the dark, a result closer to mid-twentieth-century abstraction than anything else produced in the nineteenth century. And because he chose increasingly to exhibit his lighter graphic works rather than the more challenging paintings, he further established the view that he was more concerned with purely aesthetic elements than was actually the case. In the first six months of 1893 alone, he took part in eight exhibitions in France and Belgium, and while these offered a mix of paintings and lithographs, all were of subjects that encouraged the idea that he was the artist of Parisian showbusiness, the Master of the Moulin Rouge,

the portraitist of the stars rather than someone concerned with deeper social issues. Given the amount of time he spent personally selecting the work for these shows, this editing of his intentions can only have been deliberate, though the reasoning behind it remains unclear. He may still have felt constrained by the idea of parental disapproval and have wished to downplay the political aspects of his work, though why he should have thought that a display of louche nightclub behaviour was preferable is hard to see.

In personal terms, this constant application to work and self-promotion left him little free time. Virtually the only breaks from his Parisian treadmill were brief trips north to exhibition openings in Belgium or Holland and an annual holiday by the sea, usually somewhere on the Atlantic coast near to Malromé, where he would finish his holiday with what was now a notably brief stay at his mother's home. His almost daily contact with his family in Paris and the long reunions in the country had ended as his life became an unremitting routine of hard daytime labour followed by an equally arduous application to the pleasures of the night. That his already frail body would eventually buckle under such a regime was obvious to his friends, though none would have risked exclusion by trying to persuade him to act otherwise.

The only significant break with this self-inflicted servitude was a trip to London for ten days at the end of May 1892. Maurice Joyant's memoirs contain a section on Henri's cross-Channel trips, implying that the pair of them frequently took what was known as a 'go and back' ticket on the fast train and boat to a place they both found amusingly foreign, with its scents of leather and tobacco, of English ale and Pear's soap. According to Joyant, there was a good deal of drinking – an innocent cup of tea on the Dover train before beers at the Dover Bar and the Queen Victoria, with a glass of port on arrival in London. For Lautrec, the British capital was in Joyant's phrase 'un spectacle clownesque de l'Alhambra ou de l'Empire' – a rowdy music hall, in other words, though Henri managed to be both shocked at the amount of drunkenness on the streets and appalled at the way drunks were treated. Pleasingly, all the restaurants he favoured are still in existence, barely changed in appearance since his time – Sweetings, the fish restaurant in the City, the recently restored Criterion in Piccadilly Circus and the Café Royal nearby. But those 'go and back' trips were some way in the future and the visit in 1892 appears to have been his first, rather surprisingly given his family's deep-seated Anglophilia. This first time he travelled with a friend, the artist Guiseppe Ricci, usually called Joseph, and their days, according to the usual short letters to Adèle, were spent in rather conventional tourist pursuits – visiting the National Gallery where the arrangement of paintings

into schools appealed to Henri, and shopping at Liberty's for fabrics and Maples for furniture, to redecorate his apartment on his return, and of course, dropping in at the British Museum to admire the Elgin Marbles. He came armed with a letter of introduction from Alph to the Sackville family – Sir Lionel Sackville had been ambassador to France – but they were away for the early summer and beyond what he was prepared to reveal to his mother we know little of who he saw.

The fact that he had originally intended to travel with Lucien Pissarro suggests that he was aware of The Vale and the artists associated with it. On later trips Henri would visit Ricketts and Shannon and it is possible that they first met on this trip, in which case he would certainly have seen Wilde again.

Wilde had been in Paris for a few days the previous April and visited an exhibition of Rothenstein's and Conder's work which Henri had persuaded Père Thomas to put on at his gallery in the Boulevard Malesherbes. Rothenstein had included a portrait of Wilde made during his visit the previous December, a fortunate coup when the subject suddenly became the most talked about playwright in Britain with the staggering success of *Lady Windermere's Fan*. This had opened in February, completely transforming Wilde's life, lifting him out of the ranks of those who are famous simply for being famous, placing him among those whose fame rests on solid achievement. In effect Wilde had become what he had long pretended to be, an important literary figure, though his seemingly light-hearted approach to everything was generally taken at face value with the result that his plays would often be seen as no more than pure entertainment, sparkling with wit and daring paradox, but essentially flippant. Few, at the time, bothered to see the message behind the surface humour of *Lady Windermere's Fan*: the assault on upper-class hypocrisy in the political life of the capital. Wilde himself has often been accused of the very things his plays condemn – a love of high society, an evident pleasure at being invited to aristocratic homes, the apparent snobbery. But as Yeats put it, 'England is a strange country to the Irish. To Wilde the aristocrats of England were like the nobles of Baghdad' – implying that while amusing himself at their *soirées*, Oscar had been observing them, the better to expose their shortcomings.

It was a technique he would perfect over the following two years. *A Woman of No Importance*, in 1893, and *An Ideal Husband*, a year later, show Wilde's criticism of the social order hardening, especially in the way he highlights the condition of women in a paternalistic society, one of the principal themes of both plays. *A Woman of No Importance* contrasts the destiny of Mrs Arbuthnot with that of the ruthless Lord Illingworth who abandoned

her after fathering their illegitimate child and who looks set to take every-thing when he decides to make this son, now a well-brought-up young man, his secretary, as if the powerful can have everything at no emotional cost. The twist in Wilde's play comes when Illingworth is thwarted by a woman as devious as he is, who tricks him into exposing himself for what he really is, whereupon the boy turns against him – a rare victory for the socially mar-ginalised over the politically powerful.

An Ideal Husband carries Wilde's social and political critique even fur-ther with the near downfall of Lord Chiltern, who had owed his political career to a fortune made from the sale of State secrets, money that allowed him to climb to cabinet rank. The twist here is that Chiltern is saved from exposure by the machinations of his friend Lord Goring, a thinly disguised Wilde, whose success gives the play its disturbing moral ambiguity. In effect wickedness has been allowed to prosper – a complete reversal of the usual Victorian moral line, but one which the playwright suggests is true to the real nature of society. At one level, *An Ideal Husband* is merry French farce, yet beneath the sparkling surface is a darkly disturbing critique of the veneer of morality that covered the crude reality of political life. Many in the audience must have gone home laughing at the outrageous one-liners only to find themselves suddenly reflecting on the real meaning of what they had heard. It would no doubt have shocked them to learn that some of the epigrams they had so innocently enjoyed were taken almost intact from Wilde's sup-posedly more committed writing so that characters as different as Lord Henry Wotton in *Dorian Gray* and Lord Illingworth in *A Woman of No Importance* make identical remarks about the problem of poverty in the East End of London; both comments directly traceable to *The Soul of Man under Socialism*.

The sharpest political points are made by the one character in each play, like Lord Goring in *An Ideal Husband*, who is really Wilde himself and thus able to lightly 'throw off' the more profound lines in a manner that permits the audience to laugh, at least initially. One supposes Wilde expected his listeners to get the point later, though clearly many did not, a situation still common today where Wilde's 'comedies' are seen as just that and nothing more, a misapprehension identical to that which follows Lautrec. Indeed the similarities between the two men are too obvious to need listing, though one crucial point of contact, the one that may best illuminate their intentions, is most often overlooked. Both men were clearly fascinated by strong, inde-pendent-minded women. Wilde said, for once without a trace of irony, that his most admired women were Queen Victoria, Lillie Langtree and Sarah

Bernhardt – powerful women in an age when, as the social reformer Annie Besant reminded her readers, husbands were empowered to use corporal punishment to discipline their wives. Whatever his sexual preferences, Wilde preferred the company of intelligent free-thinking spirits like Ada Leverson, his 'Sphinx', a relationship which exactly matched that of Henri and a host of women who were forging careers of their own – Suzanne Valadon, Jane Avril, Yvette Guilbert – without husbands to 'guide' or 'protect' them.

Such an attitude was highly unusual. Far from viewing favourably the rise of what was called the *femme nouvelle*, the 'new woman', the self-liberating female, most male writers and artists at the *fin de siècle* looked with alarm on a phenomenon that seemed likely to rise up and engulf them. To such men, it was only reasonable that after centuries of persecution, the liberated woman would seek to take revenge on her persecutor and so the art and writing of the period abounds with cruel women, witches, sphinxes, chimeras and vampires, all ready to prey on the weakened male. To take an opposite view, to positively welcome liberation was an unusual act of faith which Wilde and Lautrec shared. When Henri was in London that May/June of 1892, Wilde was totally preoccupied with his attempts to stage *Salomé*, his most complex female role and the one which best incarnates the philosophy that underpins the later comedies. He had always intended that Sarah Bernhardt would play the part and his seemingly superficial preoccupation with how she would look and dress and the décor and lighting that would surround her, was in fact a serious attempt to ensure that she alone would dominate the play. He wanted her encrusted with diamonds save for that much-discussed dance which, despite her age, she was determined to perform, rather than leaving it to a masked professional dancer as Wilde had expected. The dance, after all, was the key to the character, performed not as a subservient wish to please her lascivious stepfather but as an act of dominance by which Salomé forces him into surrendering to her wishes. For Wilde there was nothing surpassingly exotic in this character, he had known her all his life – Speranza, his mother, in her wispy 'artistic' veils and shawls, her flamboyant beads and jewels, dashing into any political mêlée, crying out for an independent Ireland, insisting on her right to be heard.

To create the right ambience for this fiery creature, Wilde wanted Charles Ricketts to design the sets and there was much discussion about the black floor and violet sky and in particular the burning braziers that would emit effusions of perfumes, their odours changing as the mood of the play dictated – a memory of Paul Fort's *Song of Songs*, though Oscar was no doubt hoping for something more moving than that disastrous 'happening'.

In the end it all came to nothing when the Lord Chamberlain, the official theatrical censor, refused to license the play on the grounds that representations of biblical characters, other than in medieval Mystery Plays, could never be countenanced. Oscar was furious, doubly so when he found the decision praised by the press with little protest from his fellow writers, save for fellow Irishman Bernard Shaw. Stung, Wilde declared that he was thinking of abandoning Britain and planning to take French citizenship – though as one wit pointed out, this would mean he would have to do military service across the Channel, a thought which led *Punch* to publish a caricature of him in uniform and kepi. But humour aside, Wilde was well aware that the reasons for censoring his play went further than a passing desire to protect the Bible from disrespectful playwrights. The Lord Chamberlain's office had recently come under attack for its failure to ban the works of

Wilde doing military service in France – *Punch* mocking the playwright's threat to take out French citizenship when *Salomé* was rejected by the British censor.

Ibsen, whose female characters were so far removed from the delicate wilting flowers of Victorian fantasy – one abandons her husband and children, another debates ending the life of her sick son – as to further arouse neurotic male fears of Woman the Avenger. Phrases like 'unwomanly women' and 'morally repulsive' were bandied about as newspapers demanded that the censor act to stop the likes of Hedda Gabler from infecting the thoughts of their dutiful wives. Having failed to halt Ibsen, the Lord Chamberlain seized the opportunity to pacify his critics by banning Salomé, a woman openly bent on revenge, aware that by arranging the death of the Prophet she will destroy Herod who had earlier killed her father. Worst of all, to those who feared the 'new woman', Salomé openly proclaims her sexuality, something the Victorian male reserved to himself. In a re-enactment of the nightmare that had haunted Gustave Moreau when he painted Salomé and Huysmans when he wrote about the painting, Wilde's heroine punishes John for spurning her love by having him decapitated – read castrated – and seals her infamy by kissing the very thing her executioner had hacked away.

It was not until February the following year, 1893, that the text of the play was finally published in France by the Librairie de l'Art Indépendant and, though still in its original French, by John Lane in London. From the start, the French critics were supportive, the English scathing. Attempts to translate the play into English, first by Lord Alfred Douglas, later by Aubrey Beardsley, proved so inadequate that Wilde was forced to do the job himself, and it was only after a further year that an English version could be issued.

The *Salomé* débâcle marked the end of Wilde's attempts to be a French Symbolist and his acceptance of his new role as the leading popular playwright of the English stage – a development no one could have predicted at the opening of the decade. These were Wilde's glory-years. He had money and could spend his evenings at the Café Royal with Bosie and a devoted group of hangers-on. They were the years of fashion and wit that have made Oscar Wilde the role model for every camp homosexual keen to exercise a sharp tongue, a reputation for bitchiness that has always been unjust, as his tongue was a weapon the soft-spoken, unmalicious Wilde never used. In any case, it was all over in a flash; in a mere two years the storm clouds had begun to gather. For a short time, Wilde managed to keep some distance between his public life and his private passions but under the malign attentions of his lover's father, the Marquess of Queensberry, that thin screen was soon dissolved.

Something of what was going on can be discerned in the illustrations for the English edition of *Salomé*. Wilde had wanted Ricketts to illustrate the

Wilde caricatured as 'The Woman in the Moon', one of Aubrey Beardsley's illustrations for *Salomé*, 1893.

book but Lane insisted on Aubrey Beardsley. In the end Ricketts was commissioned to illustrate Wilde's earlier 'decadent' poem, *The Sphinx*, which was at last to be published. But this compromise did not pacify the author, who thought Beardsley's work for *Salomé* too 'Japanese' for what was essentially, in his view, a 'Byzantine' work. In general, opinion has tended to support Wilde, finding Beardsley's sensuous drawings magnificent in their own right but largely irrelevant to Wilde's story, though this is the result of too little attention being paid to what the artist had actually done. Far from being unconcerned with Wilde's text, Beardsley went straight to the heart of it, ignoring the central action and concentrating instead on the often overlooked subplot, of the Syrian guard and the page, which more than the story of Salomé reveals Wilde's homosexual theme. Many of the drawings thought to be of Salomé are actually depictions of the androgynous pageboy and the naked guard, watched over by a moon that clearly bears the features of Oscar Wilde, who appears to observe their actions like an aged, bloated voyeur – a situation which too accurately reflected Wilde's voyeuristic behaviour with Bosie and his 'renters' that so worried his friends.

In effect, Beardsley's illustrations exposed Wilde's sexual proclivities for the first time and ought to have acted as a warning. It is perhaps surprising to realise that homosexuality in Victorian London was not quite the repressed and persecuted activity that it came to seem in the wake of Wilde's trials. As long as a modicum of discretion was maintained, most behaviour was tolerated. It is said that in the 1890s there were some 20,000 men in London known to the police as homosexuals yet towards whom no action was ever taken, unless their activities became too flagrant to overlook. Indeed, that was part of Wilde's problem – having developed a late taste for frequent and varied male contacts it proved all too easy to satisfy his needs. Gay rent-boys paraded openly in the area around Piccadilly Circus and entertaining young men in popular places like the Café Royal and taking them back to smart hotels like the Savoy provoked no reaction from onlookers. Of course, such practices ought to have been of little concern to Wilde once he met and fell in love with Bosie. Constance Wilde was initially quite fond of the young man and he and Oscar could have conducted a discreet romantic affair without offending anyone. The problem was that while both had a deep emotional attachment to the other, each liked raw sex with a variety of partners, which led them into the dangerous world of night-time cruising and the use of hotel rooms for their temporary trysts. As Beardsley suggested, Wilde apparently enjoyed watching Lord Alfred perform with male prostitutes, and with the flow of money from the plays the two were able to take a

Wilde's friend Maurice Schwabe seated on Lord Alfred Douglas' knee.

permanent room at the Savoy where they entertained a succession of dubious characters – an activity that soon became clear to the staff and thence the management, who for the time being said and did nothing, though clearly the possession of such knowledge by others was a danger that Wilde could have foreseen and avoided.

Subsequent attempts to elevate Wilde's sexual frolics to the level of 'liberating acts' or as expressions of personal freedom, flounder over the tragedy of his wife and family. If Constance was away, Wilde was not above entertaining young men at their home, but increasingly she found herself abandoned as the pace of his indiscretions gathered momentum. Visiting London from Paris, Pierre Louÿs was appalled to find himself in that Savoy bedroom with Oscar and Bosie one morning when Constance arrived to deliver the post from Tite Street. Ignoring the presence of strangers, Constance begged Oscar to come home, only to be told by him that he had been away so long he had forgotten the number of their house. Louÿs noted how she left, attempting to smile through her tears, and he was even more appalled when Oscar blithely informed him that he had made three marriages in his life: 'one with a woman and two with men'. Bosie was surely one, the other could either have been Robbie Ross or John Gray. Nor were his relationships with men entirely kept from his children. The singer Nellie Melba recalled Wilde telling her how he had been warning his sons of the terrible things that happened to children who made their mothers cry, whereupon one of them had asked what happened to naughty papas who did not come home and 'made mother cry far more'.

Heaping all the blame on the head of Bosie, as most Oscar supporters do, is an understandable distortion. In truth, Wilde knew from the start that Bosie was thoughtless and reckless – 'mad', like all the Douglases, as Bernard Shaw succinctly put it. But Bosie did love him in his own way, even if it took the form of playing out the role of malicious rent-boy, a sort of upper-class version of the errand boys and clerks they picked up around town. Bosie was clearly thrilled at getting Oscar to pay handsomely for his company and equally happy to watch him squandering money on other adventurers. Although Wilde visited Paris during those frantic two years it is probable that none of his former associates, including Lautrec, had much to do with him as he travelled either with Bosie, whom few could abide, or even took one of the willing street-boys with him, probably out of a combination of lust, generosity and a dangerously childish desire to show off. Paris had ceased to be a place of intellectual stimulation and had become just another playground in which to satisfy his now insatiable craving.

Wilde had two plays produced early in 1895: his most political piece, *An Ideal Husband*, and his apparently least socially critical work, his final and most popular play *The Importance of Being Earnest*. While the latter contains the usual sharp caricatures of upper-class life, most noticeably the outrageous Lady Bracknell, the humour with which they are depicted seems to come to their defence. But what the play lacks in incisive comment it gains at another level with its underlying theme of the need in any relationship for a measure of deception. Truth, Wilde suggests, is dangerous, masks are a necessary part of love, a philosophy so closely linked to Wilde's own situation at this point that many beyond his intimate circle of friends must have understood the joke. There is no doubt that by then his Paris acquaintances knew a good deal about just what it was that took place behind the closed doors of Oscar's life. Some, like Louÿs were critical, others shrugged. To Henri, Wilde's behaviour would hardly have seemed shocking. During that same period he too had taken up a way of life away from prying eyes, moving into a world like Oscar's where sexual desire replaced reason, where fantasy was the norm, and where it was possible to believe as long as one was there that no other reality existed.

Three weeks after they first met for their disastrous lunch, Toulouse-Lautrec returned to Yvette Guilbert's house to make some drawings of her. As he worked they chatted about this and that and during their desultory conversation she casually asked him where he was living. To her surprise he replied: 'In a house that's clearly marked (*visiblement numérotée*)' and she knew at once that he was referring to a *maison de tolérance*, a brothel. Her initial reaction was to assume that he was hiding from his creditors but his laugh told her that that was far from the reason and closer questioning revealed that he had chosen to live in what was aptly called a *maison close*, a 'sealed' house, so that he could study the lives of what he called the *fonctionnaires de l'amour*, the 'administrators of love'. As he explained to Guilbert, he sympathised with the women among whom he had chosen to live, he was their friend, their counsellor, even their judge, their comforter, perhaps even more their brother in misery.

In 1893 and 1894, Lautrec, by his own account, spent extended periods in a number of brothels, though his claim to have moved in as a permanent resident may need some qualification. Such a move would not only have been irregular, it would have been illegal. The strict rules applied by the Police de Moeurs, the Paris vice squad, to the women who held the *tolérance*, the licence to keep a brothel, strictly forbade any man, even one associated

with financing or running the place, to be there other than temporarily. It is just possible that Lautrec had an arrangement that allowed him to keep some of his belongings, his sketching equipment and a change of clothes in one of the *maisons* where he returned night after night, giving an impression of residence, an illusion of acceptance he may have wanted to encourage because it made it seem less as if he could only have sex as a passing commercial transaction. As a resident, he was part of the 'family' and not just an ordinary client. On one occasion he even tricked the art dealer Paul Durand-Ruel into visiting him at the brothel in the rue d'Amboise, having told him it was the address of his studio. It was hard to tell who was more embarrassed when they arrived at the door – Durand-Ruel or his rather prudish coachman who insisted on backing his carriage down the street so that he could wait outside the less dubious premises of a lawyer.

However he organised it, Henri claimed to have stayed at the Perroquet Gris in the rue Colbert and another unnamed establishment in the rue Joubert but his first long-term arrangement for which there is any evidence was at the brothel in the rue d'Amboise where he was on friendly terms with the *maîtresse*, Blanche d'Egmont, and where he eventually formed a more permanent liaison with one of the *filles*, a young woman called Mireille.

It would be superfluous to spend too much time examining Henri's motives for these arrangements. From that early encounter with Marie Charlet most of his sexual contacts had been with prostitutes. The exceptions might be the brief fling with Lily Grenier, if it did take place, his love for Suzanne Valadon and the three others offered up by the unreliable Schaub-Koch, and even these seem little different from his more usual paid encounters. He seems to have accepted this state of affairs with as good a grace as possible – though the fact that the regular use of brothels by married men in the nineteenth century was an unremarkable commonplace, would have made it less necessary than it might be today for Henri to agonise much over this situation. According to Maurice Guibert, he at least did not delude himself that such paid arrangements were anything other than that – though this does not mean that all his brothel encounters were entirely without some affection. But while he was capable of forming an attachment with a girl like Mireille, he was clear-headed enough never to forget that any reciprocation on her part was conditional on the fact that she was going to be paid. He was, however, touchingly grateful for any sign of tenderness, to the point where the word 'love' was not inappropriate, a conclusion reached by Blanche d'Egmont, who decided to profit from the situation by holding back her 'merchandise', telling Henri that Mireille was indisposed or away for the

day, in an attempt to get him to pay more to reserve her. Seeing through the deception, Henri fought back by persuading the young woman to come to his studio during the daytime when she was free. One day she came of her own volition, bringing him a cheap bunch of violets which moved him very much. This unpredictable mix of commerce and deception with a sudden spontaneous gesture of affection clearly broke through the armour that normally shielded him from being hurt and was why the world of the brothel offered the possibility of emotional experiences denied him in the 'real' world.

Appropriately the brothel in the rue d'Amboise had a slightly dreamlike air – a beautiful seventeenth-century town house with elegant eighteenth-century interiors. We can get a first impression of Mireille from a group of portraits of the *filles* that fill sixteen framed medallions surrounded by garlands of flowers that Henri, with the aid of two friends, made to decorate one of the salons. We can recognise Mireille from other paintings, with her plump features and slightly turned-up nose, her hair piled in the high chignon made fashionable by La Goulue – though unlike the dancer, and all the other women towards whom Lautrec felt attracted, Mireille was not a redhead. Indeed, according to the clearly disapproving Gauzi, it was impossible to tell what she truly was as her peroxide hair had turned 'egg-yellow and her outrageously painted face appeared pink and white', though Gauzi did admit that her complexion looked 'ideally fresh by artificial light', which is precisely what Lautrec would have admired. The point, however, is that with those first medallions and in his subsequent 'brothel' paintings Lautrec ensured that all the women he portrayed were recognisable individuals rather than the anonymous *fonctionnaires de l'amour* they were assumed to be by most clients. In response, the *filles* clearly enjoyed his company, happy to find some distraction in the sight of him working away at his sketchpad while they sat around waiting for the evening's work to begin. Far from being an unending sexy romp or a grim vice-ridden sewer, depending on which salacious nineteenth-century account you prefer, for much of the day life in the brothels was quiet to the point of boredom. In the common areas, behaviour was surprisingly respectable. On one occasion, Lautrec overheard an offended *maîtresse*, dressed no doubt in a conventionally prim black gown, admonishing an overenthusiastic customer: 'Come now, where do you think you are anyway?' Nor were these establishments quite the high-flying enterprises, awash with cash, they are sometimes depicted as. By the end of the century business had begun to decline. The loosening of moral restraints, in the city at least, meant that middle-class men were less dependent on such

houses for sexual relief, a fact recognised by the police who gradually eased the regulations to permit the establishment of *maisons de rendezvous*, where short-stay rooms could be hired, and the licensing of *brasseries*, easy-going bar-restaurants where men and women met on relaxed terms and assignations in upstairs rooms could be arranged. By the century's end there were only half the *maisons de tolérance* there had been at its beginning and these tended to have polarised into the scruffy one-franc bordellos at the very bottom of the market, catering to transient visitors like sailors or the desperately poor, while at the other end were establishments such as that in the rue d'Amboise, the *maisons de grand tolérance*, that existed for the rich, largely by providing special services, in other words, by indulging those more 'exotic' practices not easily arranged at home.

Lautrec was made fully aware of this aspect of the business when Mireille left the rue d'Amboise and he changed allegiance to a more spectacular brothel in the rue des Moulins when it opened in 1894. Mireille had been seduced by an offer of work in Argentina. Lautrec was convinced that this was the white slave trade but was unable to persuade her to stay, though he continued to depict her in his brothel paintings long after her departure and his move to the new, bigger establishment which now became his near-permanent base.

From the street, 24 (today 6) rue des Moulins was an apparently solid bourgeois town house but behind its bland exterior lay a fantasy world that even the most flamboyant theatrical set designers could only envy. Therein, every perversion was served, from grim torture chamber to medieval dungeon, from Chinese den to Second Empire salon. Sadly, the extraordinary furnishings were sold off when the business closed down in 1946 but the occasional photograph gives some idea of the vulgar opulence, the elaborately gilded beds under mirrors set into the ceiling, the plush banquettes in the Moorish salon that looked blasphemously like a mosque. One particularly fine bed was said to have belonged to Marie Antoinette though it was probably part of the furnishings of the opera-singer La Paiva which were auctioned at the sale of her house in the Champs-Elysées in 1893. This may be the enormous *bateau-lit*, its headboard surmounted by a life-size nude woman set in a hall of mirrors, the bed reflected on every surface in the most famous photographic souvenir of that extraordinary temple of desire, but another, rarer shot of the Gothic bedroom shows a more restrained, almost ecclesiastical setting, supposedly designed for those with a taste for necrophilia, though to English eyes it looks not unlike the 'Gothick' fantasies at Windsor Castle or the Barry/Pugin designs for the Speaker's apartment at

The Moorish room in the *maison de tolérance*, rue des Moulins.

the Palace of Westminster. So extraordinary, and so notorious, was the rue des Moulins that it attracted visitors who came merely to stare at the décor and it was not unknown for groups of society ladies to make discreet tours out of the usual working hours, prompting Henri's disdainful remark that 'the biggest tarts are the visitors!'

But it was not just a matter of weird decoration – whatever the client lusted after could be hastily arranged with the aid of the array of costumes and

339

equipment kept by the house. There are hilarious descriptions of visitors walking along corridors only to find themselves overtaken by a nun bearing a whip on her way to an appointment in one of the upper rooms and even, on one occasion, a bride in white gown and veil, hastening to her 'marriage', presumably in the Gothic chamber. For the women who provided these services, it meant leading a curiously schizophrenic existence. They might suddenly be called upon to act out some wild fantasy, yet for most of the day and early evening they did no more than hang around, waiting, bored witless. Exactly pinpointing their position in this surreal world is complicated by the fact that both sides of the debate that raged over the subject during the last century, whether those who defended the brothels as necessary prisons where the filth of the world could be incarcerated or those who wanted to see them abolished as a moral blight, tended to depict the women themselves as pitiable slaves to a vicious system. The abolitionists hoped to reinforce the idea that the women should be liberated, while those who supported the system tried to point out the sort of disgusting trash that would turn up on respectable streets were they not safely held behind brothel walls.

In fact, the few reasonably unbiased studies show that the girls, far from being slaves, tended to move around between *maisons* as the mood took them. The real problem was that they made pitifully little money out of their exertions and were grossly exploited by the *maîtresse* or *madame* as she was coming to be known, though the 'girls' often called her the *taulière*, the gaoler, behind her back. Ex-prostitutes themselves, these stern harridans maintained a system of payments that none of the women dared refuse. They were charged for everything, not merely a percentage of what they were paid by the client but for everything they used: bedlinen, the food and drink they had to consume during the long day. They were even obliged to rent the elaborate gowns and jewellery that they wore to please the clients and were subject to fines for minor offences such as failing to stand up respectfully when the *maîtresse* entered the room. Everyone except the prostitutes themselves seemed to benefit from their labours, with the State taking over 50 per cent of the brothels' income in taxes. The regime was petty and harsh and the inhabitants were literally enclosed as the police insisted that the houses be permanently shuttered, curtains drawn. The only way to make money in a brothel was to rise to the rank of *maîtresse*, otherwise there was only retirement back to the country and marriage to a man who didn't ask too many questions – if you were lucky.

All the honest accounts of brothel life dwell on its tedium, the wasted days gossiping about nothing, playing the piano if they could, cards if not,

the more intelligent reading light romances before the long period of apply-
ing make-up and the elaborate dressing up, which, as one writer put it, was
like watching an army prepare itself for an assault by an approaching
enemy. Even then there was much sitting about waiting for customers to
drift in, at which point the women would perk up and start to act seductively
only to sink back into their customary torpor once a selection had been made
and client and *fille* had disappeared to whichever fantasy chamber was
required.

Little wonder that Henri seemed like a magician, bringing spontaneity
and fun into this dreary atmosphere, made all the more peculiar by such
bizarre surroundings. Jane Avril summed up his behaviour towards the *filles*
in a touching memoir:

> They were his friends as well as his models. He in turn had
> an uplifting effect on them. In his presence they were just
> women, and he treated them as equals. When he ate with
> them, often bringing a party of friends, they held their knives
> and forks daintily, restrained their conversation, had the feel-
> ing of being women of some standing. Lautrec's almost wom-
> anly intuition and sympathy shone like a light for them.

They called him 'Monsieur Henri' and they could hear his stick tapping down
the corridors as he arrived, often bringing presents. He even took the
maîtresse of the rue des Moulins, Marie-Victoire Denis, to the theatre, treat-
ing her as a *grande dame*, no doubt to keep her on his side. When there were
not customers to disturb them Henri would attempt to cheer everyone up, get-
ting them to dance to a pianola, urging them, in Joyant's words, 'to glide
backwards and forwards' in their loosely draped dressing gowns, so that he
could draw them, pleased with the unusual poses 'which he found evocative
of Botticelli's *Primavera*'. The account conjures up a touching yet ultimately
sad picture: the diminutive artist attempting to please these sad, trapped crea-
tures. In her recent biography, Julia Frey suggests that in the brothel he had
'found a home of his own choosing, oddly parallel to the manless houses of
his childhood'. A comparison that would undoubtedly have devastated the
emotionally prim Adèle had she ever been confronted with it. And she would
have been equally appalled if she had known of her son's comment on a fash-
ionable *soirée*, filled with elegant, décolleté and bejewelled women: 'Am I hav-
ing a good time? Marvellous, my friend. You'd think we were in a brothel.'

But while it is fairly easy to understand Henri's personal attachment to
brothel life, there is less agreement over the work he produced out of his

experiences. Given that up to forty 'brothel' works have been identified, they clearly constitute the greatest or at least the most consistent of his various *furias*, more important even than his showbusiness works and certainly far outnumbering the Moulin Rouge canvases. Yet despite their significance in his overall *oeuvre* there has been little agreement as to why they were made or what effect he hoped to achieve. During his lifetime those that were exhibited were savagely attacked in the press and were crudely linked to his physical deformity, being seen as the diseased product of a damaged person. Attempts by his friends to defend the works on the grounds that they reveal the pitiful sufferings of the *filles* who inhabited the *maisons closes* have never achieved total acceptance, given that there were other works by artists like Steinlen that were far harsher in their unveiling of the dismal lives of the prostitutes than Lautrec's were.

Much of this criticism is purely vindictive and is easy to refute. Any suggestion that he was producing some sort of high-grade pornography collapses when one examines the actual work. There is less nudity in a Lautrec brothel than there was in the studios where he studied. His 'loose' women are usually clothed in the baggy shift that was the obligatory uniform of the *maisons closes*. There are a few 'smutty' cartoons but these were little more than idle doodles, inconsequential jokes with no link at all to his real art. Despite this evidence some critics have tried to maintain that there were far worse paintings but that these were destroyed in 1894 when some works that Henri had stored at the family home in Albi were publicly burned by his Uncle Charles. This assumes that the otherwise kindly Charles was driven to act by the vile nature of the work he had discovered, thus proving that all Lautrec's brothel paintings were not as innocent as one might assume from the surviving canvases. In fact, a close examination of the incident reveals a quite different story. Although Uncle Charles had been sympathetic to Henri's ambitions to become an artist a decade earlier, he had no appreciation of what his nephew had gone on to produce during his Paris years. He was also angered by what he saw as the disgrace brought on the family when Henri sent paintings openly, signed, to an exhibition in nearby Toulouse, after which the works had been stored in Albi. More to the point, Charles had become deeply religious and increasingly at odds with his brother Alph whose anti-clerical views and increasingly bizarre behaviour – he had moved into one of the towers at the Hôtel du Bosc and took his baths in the courtyard in full view of the servants – had helped erase any feelings Charles might have had for the equally bohemian son. That Charles was in a mood to destroy anything is borne out by the account left by Franz Toussaint, son

of one of those who witnessed the burning, who noted that there were only eight canvases in all and that these included paintings of dancers and bare-back riders as well as prostitutes. There could hardly have been enough of the latter to radically alter our view of Henri's overall image of brothel life in the forty or so works that survive and which are surely sufficient for us to come to some sort of judgement about his intentions, even with the loss of the two or three that were burned in Albi.

One thing we can be sure of is that despite his boasts of living in broth-els, little beyond quick preliminary studies could have been produced in such circumstances. The largest and most important canvases were painted back at his studio – the most important actually appears in a photograph taken in the studio. We also know that he occasionally hired some of the *filles* to come during the daytime to act as models and this 'delay' in production means that these works were the product of thought and reflection and not acts of unedited, spur-of-the-moment sketching.

But even if we set aside the worst of the criticism, we are still left with the question of why he spent so much time on this problematic subject. One reason for drawing prostitutes, given by artists from Degas to Picasso, is that they can be observed in poses that are more natural and therefore more interesting than can ever be achieved with professional models who tend to adopt positions that they have been using for years. In a brothel it was possible to see women sponging themselves in the low-sided portable tubs used when baths were a rarity, concentrating in a mirror on their make-up, combing their hair or relaxing quite unselfconsciously, sights clearly absorb-ing to anyone eager to get beyond the hackneyed academic poses churned out in their thousands by atelier students. A good many of Lautrec's broth-el works fall into this category – a woman bending to pour water into a tub, another sponging her back, a girl pulling on her stockings or pinning up her hair – simple, domestic tasks that have little to do with prostitution and brothel life other than that it was inconceivable that an ordinary bourgeois housewife would have allowed any man, perhaps not even her husband, to see her performing such tasks. Indeed, the outcry over Lautrec's images of the *maisons closes*, and his Uncle Charles's extreme reaction to the few that he had seen, seems to have been due more to this removal of the veils of discretion that at the time obscured quite innocent behaviour, than to any dabbling in the sort of unbridled sexuality that we are familiar with in some contemporary art. A good many of Lautrec's brothel works are simply portraits, often the back or side view of scantily dressed women who can be identified as prostitutes only because of a background glimpse of what might

be thought of as the tools of the trade – the ewer, washbasin and towel which indicate that she was seen and sketched in her place of work, rather than a studio – sufficient, it seems, to render someone like Uncle Charles apoplectic with fury.

Perhaps as significant is the fact that some of the women are named – the word 'Marcelle' is clearly marked on one portrait while 'Rolande' appears on several works, and far from being in any way romanticised these women are most often captured at their worst moments, staring gloomily into the unforgiving mirror, applying make-up with the dismal air of one who is doing it in order to attract an unappealing client. No one looks happy and even when asleep – another favourite subject – the women appear more abandoned and exhausted than restful. One of the most unsettling, entitled *Femme sur le dos – lassitude* (Woman lying on her back – lassitude), shows an emaciated figure flopped across a bed with her black-stockinged legs draped over the edge, in a manner curiously reminiscent of Yvette Guilbert's trademark black gloves. This idea of both physical and spiritual exhaustion is made all the more unpalatable when one recalls that for much of their lives these women did absolutely nothing but hang around a brothel waiting for a client to appear and that their lassitude was totally ingrained, a product of the utter emptiness of their lives rather than any sort of back-breaking toil. Having avoided the rigours of work or home, which were the lot of their married sisters in the outside world, these women, far from leading lives of pampered luxury, were in fact utterly exhausted by vacuity. And that, unsurprisingly perhaps, is one of the central subjects of the majority of Henri's large brothel scenes, which dwell on the daytime or early-evening hours when the brothels were empty and the women hung about in their shifts, bored and depressed, waiting for something, anything to turn up. He shows them together in the refectory having just had a meal, unconnected figures staring vapidly into space. In another painting two play cards without much interest in the outcome, a seemingly endless pastime; but most just wait, sitting on the large red-plush divans with nothing to say to each other and nothing to look forward to but the appearance of a man interested in nothing about them save their function as what was referred to at the time as *égouts des spermes* (sewers of sperm). Significantly, these men do not figure in Henri's studies. There is only one image that shows a client watching a prostitute fastening or unfastening her clothes and another of a laundryman leering at the woman who is accepting his delivery. Only one work implies sex – a scene in which a woman crawls up a staircase with a man crawling behind her, though this canvas has been cut to remove the male figure,

making it even more of an aberration. Apart from the works destroyed by Uncle Charles, whose subjects were not recorded, the available evidence shows that Lautrec's brothel works have nothing directly to say about the sexual act that was the ultimate reason for the brothel's existence. It is clear that the only subject of these works is the women themselves, a point confirmed by the largest canvas which was meant to be the culminating work of the series (see pages 352–353).

We know the painting was meant to be something out of the ordinary from the careful preparation Henri made before he began, undertaking the sort of preliminary studies usually made before a major Salon history painting, the procedure he'd studied under Bonnat and Cormon. To make that abundantly clear, he had a photograph taken of the finished, framed painting in his studio, surrounded by other smaller works dealing with the subject of prostitution, to indicate the build-up to the large canvas. He also placed one of his naked models to one side, holding a spear, as if she had just posed for a scene from classical antiquity, as if this really was a work by one of his Academic masters. But it is also the case that as with the two preceding major works – *Missing Ecuyère* and *Au Moulin Rouge* – there are things about this canvas which suggest that here again he intended something different from what we see today.

The painting *Au Salon de la rue des Moulins* (The Salon of the rue des Moulins), despite its title, bears only a superficial resemblance to the actual brothel in the rue des Moulins. While the pillars and some of the stucco work could refer to the famous Moorish room, photographs show that the original was far more ornate than the simple arrangement of mirror-lined walls and red-plush divans that Henri offers, which he seems to have intended to represent any brothel, the sort of thing found in *maisons closes* in most towns in France. All we see, in fact, are five women, four seated, one standing, sharing one of those endless periods of waiting for a client to appear. They had, of course, to be in a state of readiness, held in an uneasy twilight world between action and inertia. Three of the women are identifiable – the half-profile, foreground woman turned away from us, holding her leg, is usually taken to be his old love Mireille, from the rue d'Amboise – further evidence that this is a composite work and not a specific scene in a specific place. One of the background figures is Rolande, with her distinctive red hair and snub nose, while next to Mireille is the only woman allowed to wear anything other than a revealing shift, the rather primly dressed Madame Baron, the *maîtresse*, keeping an eye on her charges, making sure that they do not relax too much and are ready to snap out of their torpor the

moment a paying customer appears. Significantly, the *maîtresse* is the only one who looks in our direction, the *filles* stare away into space, a sign both of passivity and disjuncture. It could well be that this sense of a highly structured, hierarchical and subservient world that Lautrec proposes – a world where the most debauched practices could be indulged, provided they were offered in conditions of almost military discipline – was a parody of the social order into which he had been born, the fixed and immutable rule-rigid ethos of 'our world' that sustained his mother and gave even someone as inherently wild as his father a fixed sense of his own, unshakeable position in the rigid order of things. It has been tellingly pointed out that this large painting of a world that would have horrified his mother now hangs in the Lautrec Museum in Albi, which is housed in the former palace of the archbishops of the town, a twist of fate that would certainly have amused the artist greatly.

That the work sums up all his earlier studies of waiting, of ennui, of servitude and availability, which make up the majority of his brothel paintings, is obvious, but *Au Salon* goes further with the standing figure sliced in half by the right-hand edge of the canvas. She, in the way she holds up her shift as if to expose her private parts, is clearly recognisable as a figure that had already appeared in some of his more secretive brothel studies, works which explore a far grimmer aspect of the lives of the women, one which few outsiders were ever allowed to witness.

Of all the many indignities heaped on prostitutes, whether in or out of the brothels, undoubtedly the worst was the fortnightly *visite médicale*, the medical inspection, where they were obliged to submit to an intimate examination to see if they were suffering from a sexually transmittable disease. Indeed it was a book by Réstif de La Bretonne, first published in 1769, which proposed the notion that prostitution should be officially regulated in order to control the spread of venereal disease, that led to the establishment of clinics like the Bicêtre and Saint-Lazare and later to the licensing of brothels where the inmates could be supervised. Syphilis was clearly the primary target. More so after 1838 when it was discovered that gonorrhoea was a separate illness that could be treated as a 'local infection', through acid-based medication of the visible sores. That, however, still left syphilis with only the nearly useless mercury treatments once the malady had been identified. This lack of any viable cure did not deter the authorities from trying to control the uncontrollable, by attempting a regular examination of all suspect females, while overlooking the obvious fact that men were just as responsible for spreading the infection and that it was they, as much as any-

Gabrielle, left, in the line-up for the medical inspection – recreation of the scene in the rue des Moulins' brothel.

one, who needed controlling. This salient fact was totally ignored as continuing attempts were made to regulate, to the point of punishment, the women involved in the chain of transmission, the prostitutes, with no corresponding action taken against their clients. The Paris system was the most extensive but it was to some extent the model for all major French towns. In the capital, the central institution was a section of the main Saint-Lazare Hospital, run by nuns with a justified reputation for severity and intolerance. This prison-wing had a dispensary where the *filles inscrites*, the licensed but non-brothel prostitutes, were obliged to report every fourteen days for examination. Within the brothels there was a fortnightly visit by two doctors and each *maison* was obliged to provide a *lit-fauteuil*, a day-bed, on which the examination could take place, and a box of speculums. These were used to offer access for a visible examination of the vaginal area, the entrance to the uterus, and the anal region, as the doctors looked for signs of surface infections, in particular psoriasis. A similar inspection of the mouth and throat was made to see if any ulceration was visible. If the first doctor found any evidence of lesions, mucus or herpes, his colleague would be called over to confirm the diagnosis, whereupon the woman's card, which she always had to carry with her, would be marked with their comments and she would be forbidden to work until a subsequent examination cleared her. The flaw in all this was obvious even at the time – as there was no cure for any venereal disease, all that could happen was that the visible symptoms would subside, whereupon the process of transmission would be allowed to resume.

Worse, some brothels failed to provide even the minimal examination equipment, making the inspection even more cursory – some had no day-bed, others only one speculum – at one point there was said to be only a single speculum in the whole of Marseilles! – so that the disease was as likely to be transmitted by the doctors themselves as by any other route. Added to that, the older women were often in the final, tertiary stage of syphilis when few of the earlier symptoms were still manifest, while their younger colleagues soon learned the tricks needed to disguise any lesions – treating themselves with silver nitrate just before the visit. None of this prevented a rigid application of rules that were more a matter of society punishing the victims of its own sins than a real attempt at treatment. If a *fille* was found to have severe evidence of the visible symptoms, the doctors had the authority to cast her into a world that was little short of hellish. On their orders, the police arrested the poor creature and took her off in the humiliating *voiture cellulaire*, the prison truck, to the Saint-Lazare and the nuns where she could be incarcerated for between ten and 250 days until her symptoms

subsided. The average stay was twenty days and in 1888, out of the 4,591 registered prostitutes, nearly 3,000 were arrested in this way. Some of the girls were not yet sixteen and should, by any rights, have been taken out of the system and placed in special institutions, rather than the bleak gothic nightmare that the older women were forced to endure. That conditions were near barbaric goes without saying – the daily diet consisted of water and thin gruel with two small pieces of poor meat each week. In the prison wing they were put to forced labour in total silence in damp workrooms and were obliged to sleep in unheated cells even in deepest winter. Any who protested were put on dry-bread-and-water punishments. Any 'free' moments were filled with guilt-inducing religious lectures from nuns who clearly detested their charges and who thought it their duty to add to their miseries.

One can tell how little anyone cared about the well-being of these unfortunates from the attempt in the mid-century by the then leading 'syphologist', Dr Auzias-Turenne, to use prostitutes as guinea-pigs to prove his theory that immunisation was possible through the injection of small doses of the disease so that resistance could be built up. Naturally it was not thought necessary to ask the women if they wished to be 'syphilised' in this way and it was fortunate that a commission, appointed by the Paris Préfet de Police, finally forbade the experiments at Saint-Lazare before a mass outbreak of the disease could be induced by Auzias-Turenne's discredited ideas.

But even without the risk of being subjected to insane medical experiments, it is clear that the city's prostitutes lived in mortal fear of Saint-Lazare. Their terror is clear from the manner in which they approached the fortnightly visit, lining up with their shifts obediently lifted to the waist ready for the humiliating inspection, their faces blankly miserable, unsure as to what would become of them. It is this tense moment that Lautrec depicts in a number of sketches and oils that show two or three women waiting for the dreaded event, though the central character is usually the same middle-aged figure who has been identified as a woman called Gabrielle, a friend of Lautrec's who modelled for him almost to the end of his life. All the characters depicted in the various versions of the *visite médicale* were models but the scene itself is certainly true to the reality he witnessed in the rue d'Amboise and the rue des Moulins. The pose Gabrielle adopts is horrifyingly reminiscent of the hideous medieval woodcuts showing an archetypal syphilitic, rotted by the disease, passively gawping back at the spectator or of the crude female figure, dress provocatively pulled up, with a skeleton in the shadows behind her, used as propaganda by the authorities trying to warn young men of the dangers of consorting with prostitutes.

These are clearly the most coruscating of all Lautrec's brothel images. With the *visite médicale* he brings together his two worlds, the comforting female world that had enveloped his childhood and which he seemed to rediscover in the brothels, and the harsh masculine medical world that had been its obverse. With Gabrielle, they meet and combine and there is little wonder that such a tragic collision inspired his pity. These images refute any suggestion that he was merely amusing himself with the subject of prostitution and that there was no genuine commitment to the criticism implied in his work. The fact that we see Gabrielle, her shift humiliatingly raised in readiness, at the edge of the definitive *Rue des Moulins* canvas shows that the work was intended to be far more than a simple anecdote about the quotidian ennui of brothel life. Her presence transforms the scene into an indictment of a system that perfectly matched exploitation to capricious punishment and the fact that it is devoid of any male presence only increases its accusatory power – where, we are invited to ask, are the truly guilty in this sad affair?

In 1903, the German critic Erich Klossowski wrote of the 'toilets of love into which Lautrec enters' where 'there is nothing tempting, nothing that arouses'. But it was perhaps better put by his friend Yvette Guilbert who noted how, when he spoke of these poor women, 'the emotion in his voice revealed the warm pity of his heart . . . so that I often asked myself if Lautrec hadn't found some sort of spiritual mission in this willingness to offer brotherly, Christian compassion to these women, deprived of all modesty and pride.'

13

SAPPHIC NIGHTS

A t this point, near the middle of the decade, as 1894 passes into 1895, all writers on Lautrec agree that he was at the height of his artistic powers. He had turned thirty in November 1894, still young for one who had already produced a substantial body of work that had attracted the admiration of his generation along with considerable critical praise from the radical press. But two things shadow this apparently glowing aspect: it is already clear that the appreciation and the praise were often based on a limited understanding of his intentions, one that failed to admit the harsher, less superficial elements in his art. There are also indications that he was dissatisfied with his repeated failure to produce large-scale canvases that would convey more powerfully the social commentary found in his smaller easel paintings and lithographs. The now missing *Ecuyère* was still propped against the studio wall, a daily reproach, as was *Au Moulin Rouge* whose large right-hand figure was out of balance with the rest of the composition and seemed to have no particular connection with the other characters in the scene, all of whom were close friends. There was a similar problem with his most recent large-scale work, *Au Salon de la rue des Moulins*, which also had a woman, sharply cut off at the right-hand side – the model Gabrielle waiting in line for the *visite médicale*, which in itself would only have been clear to those already aware of the other studies of this subject that Lautrec had already made. The painting cannot be fully understood in isolation and the photograph he made of the finished work in his studio, surrounded by other, related brothel works, may be an indication that he intended to overcome this problem by creating an entire environment into which the viewer would be drawn, something akin to the popular dioramas, the complete, circular paintings, usually of a landscape or city view, perhaps of a battle or other great historical event, that were put up at funfairs or were part of the entertainments on offer at the new seaside holiday resorts. Zola in his novel *L'Oeuvre* had brought out the concern felt by many artists in the wake of the

Henri and a model studying *Au Salon de la rue des Moulins* and other 'brothel' works.

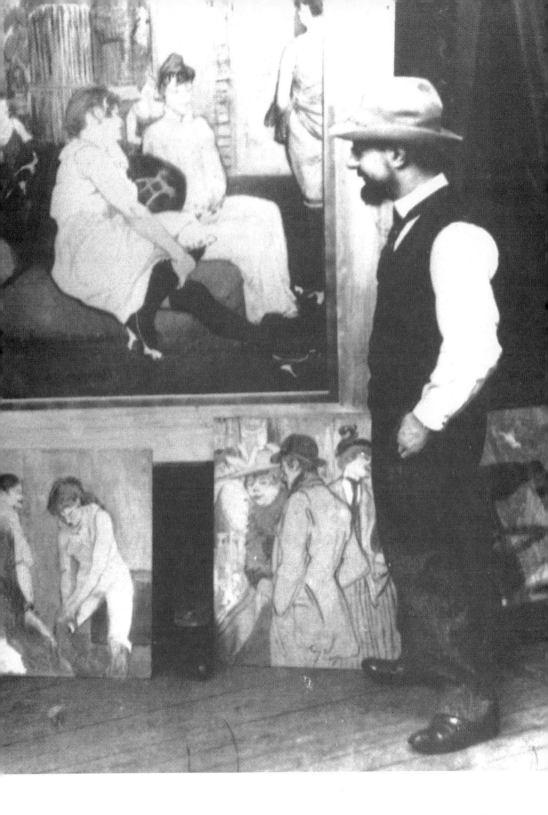

353

Impressionist revolution, that painting had lost some of the force it had in the days when the epitome of High art were the vast canvases of the Academic painters that filled the walls of the annual Salon. Taking up Zola's theme, a number of artists tried to fill this gap.

Three years later, in 1898, the ambitious young art dealer Ambrose Vollard would put on just such an all-embracing exhibition of work sent from Tahiti by Paul Gauguin, nine paintings each relating to the great central canvas *Where Do We Come From? What Are We? Where Are We Going?* – an experience that one critic likened to the discovery of an ancient culture. It may have been something of this sort that Henri had in mind at the beginning of 1896 when he had a selection of the brothel paintings hung in a separate room during his exhibition at the Manzi Joyant Gallery. Significantly, the room was locked and Lautrec kept the key, admitting only those he chose, rejecting any dealers on the grounds that the works were not for sale. Inevitably, some critics chose to interpret this as a sign that Henri was keeping the 'hotter' stuff for his male buddies, the only ones allowed in, to salivate over the sexy scenes. But there is little need to look any further than Joyant's explanation that Henri was simply trying to avoid the sort of bad publicity his many enemies in the press were waiting to unleash. Even his fairly modest studies of women washing, and applying their make-up had proved too much for some of these predators, who had branded him and his work diseased, and when Le Barc de Bouteville put one of the brothel works in his gallery window early in 1893 someone called the police who forced the dealer to remove it. Given that experience, it is hardly surprising that Henri was cautious and unwilling to open the private room to a jeering mob of yellow journalists.

We do not know precisely which works made up this themed showing, but the possibility that they were intended to collectively represent his thinking on the subject of the brothels and their inhabitants is obvious enough. And the fact that in this context the large *Au Salon* canvas had got somewhere near to fulfilling his aims seems to have prompted him to begin reworking *Au Moulin Rouge* in an attempt to give it greater cohesion. To achieve this he repainted the head of the right-hand figure, adding the features of a new friend, a dancer called May Milton, recognisable from the peculiar hat she always wore, a strange creation sporting what appear to be two antennae, giving her the look of a predatory insect. That done, everyone in the painting was in some way related to someone else, though the exact nature of these relationships is far more revealing than is immediately obvious on first viewing the canvas.

Apart from her role in *Au Moulin Rouge,* the few other images Henri made of May Milton would hardly place her at the centre of his art. At first glance she seems to be just another minor showbusiness character who momentarily interested him, but a close examination of Milton's life during her brief time in Paris helps explain just why she was suddenly given so important a role in one of his major compositions. Initially, her story was linked, intimately, with that of another May, her close friend May Belfort, with whom she lived when they first came to France in 1895. Born May Egan and originally from Ireland, Belfort had made a reputation on the London stage before coming to Paris. She had a brief, if starry, time at Oller's Olympia and other variety houses where she would mince into the limelight, caricaturing her supposed Englishness by wearing a babydoll Kate Greenaway outfit – a flouncy dress and Mother Hubbard bonnet – and lisping her way through a song, still sung to English children today by adults who have no idea how vulgar it once was:

> Daddy wouldn't buy me a bow-wow,
> Daddy wouldn't buy me a bow-wow,
> I've got a little cat,
> and I'm very fond of that,
> but I'd rather have a bow-wow-wow . . .

Innocent enough and surely doubly innocuous when sung in English to a French audience, except that Belfort's sly innocent looks and occasional gestures made it very clear that the English cat was the French *chatte,* which in the *argot* of the streets was a *double entendre* akin to the English 'pussy'.

Her friend May Milton had a similar naughty-little-girl routine in her dance act which Henri brought out in a stunning poster to advertise a tour of America she embarked on in 1895, the year they met, which indicates how brief their friendship was. Milton had run away from the English dance troupe that had brought her to the French capital earlier that year and was to prove rather adept at bolting – having started off with Belfort she soon moved to Jane Avril, for 'Miss' Milton, as she liked to be known, was a flamboyant lesbian whose affairs quickly became the talk of Henri's circle. Her affair with Jane was never publicly admitted but their friends knew they shared a tiny apartment on the Butte and that Jane usually responded to invitations with the remark 'Et *Miss* aussi', indicating that her friend should also be invited. She did much to promote the younger woman's career and there are references in Jane's later memoirs to her first visit to London where

Eros Vanné – a 'knackered Eros' with lesbian lovers Yvette
Guilbert and May Milton.

she stayed *en famille* with Milton's parents and which even includes a tale of how Jane and 'Miss' snuggled down out of sight in a carriage one night, details which leave the observant reader with little doubt about what was going on.

Lautrec probably added the antennae to the hat of the right-hand figure in order to transform it into Milton as a joke between him and Jane and he certainly made the connection even clearer by drawing a direct visual link between the somewhat sickly green of Milton's face and the vibrant complementary red of Jane's hair. The fact that Jane has her back turned while her 'lover' storms out of the picture may also be part of the in-joke, probably a reference to Milton's frequent infidelities. She also appears with Yvette Guilbert on the cover of a song sheet Henri designed which seems to indicate that dancer and singer had also enjoyed a moment together. The song, 'Eros vanné' (Worn-out love) by Maurice Donnay, which at the time had a prominent role in Guilbert's repertoire, certainly suggests as much:

> Et je suis un Eros Vanné!
> Elles ne sont pas prolifiques
> Mes unions évidemment,
> J'assiste aux amours saphiques
> Des femmes qui n'ont point d'amants.

> I'm a knackered Eros!
> My unions are not fruitful ones, far from it:
> I preside over the Sapphic love of women without men.

Henri's drawing is surprisingly frank – Guilbert and Milton are posed beside a naked Eros on crutches, battered by his encounter with this other love, his bandaged leg sticking out like a wounded penis. Indeed, Milton's unrestrained behaviour provoked considerable criticism within Henri's circle and it has been suggested that Maurice Joyant cut her out of the painting after the artist's death. This was done, so the argument goes, partly out of loathing for her character but mainly to protect what remained of his friend's severely damaged reputation from being sullied by association with such an unappetising creature. While this is a neat theory, it hardly stands up if one examines the other female characters in *Au Moulin Rouge*. Even without that right-hand figure, the painting remains deeply Sapphic for those able to read the signs: La Macarona, sitting at the central table, was one of the best-known lesbians in Montmartre, given to wearing masculine attire – Lautrec

drew her in a man's riding outfit, jodhpurs, riding cap and all. Then there are the background figures, La Goulue and La Môme Fromage, who were also lovers. Henri creates a visual link between all those women through the colour red – La Goulue and Jane Avril and Milton all have red hair. The connection is so strong that any attempt to excise these Sapphic connotations would have turned the canvas into a lace curtain. Lesbianism is an integral part of the work and once that is accepted, one begins to see that it may also explain many of the other paintings of showbusiness characters which seem so anodyne when placed beside Henri's more radical work. It comes as something of a shock to realise that most of the women in these otherwise bland scenes of singers and dancers were in fact lesbians and that quite a few were lovers. So many, in fact, that it is possible to argue that lesbianism is the hidden subtext of much of the art of Henri's mature years. As a chronicler of his age, this was perhaps inevitable given the increased visibility of the subject in the bars and cabarets of the Butte – some contemporary accounts speak of an explosion of *Saphisme*, as if half the women of Montmartre were falling into bed with each other. But leaving aside the hyperbole, it was clear to others besides Henri that something was going on and that whatever it was went far beyond mere sexual entertainment.

Jean Charcot, the psychoanalyst who treated Jane Avril, linked the rapid increase in lesbianism to the rising claims of equality that were making women more like men. There was certainly a great deal of confusion about just who was or was not lesbian as the century drew to a close, confusion caused by the numbers of highly visible women who chose to dress in male attire without it being absolutely clear whether this indicated a definite commitment to *Saphisme*. The painter Rosa Bonheur had applied for her *permission de travestissement*, the police licence needed for a woman to dress as a man, on the grounds that it prevented her from being harassed when she was out painting – though it didn't stop her being arrested one night on suspicion of being a man in drag! Others simply wanted the convenience of male dress: the writer and journalist Rachilde who described herself as an *Homme de Lettres*, amused Oscar Wilde when he found that far from being flamboyantly transdressed, she was actually got up in a drearily bourgeois outfit. Some, like the archaeologist Jane Dieulatoy who along with her husband discovered the palace of Darius at Sousa, managed to combine male clothes with marriage. The best example of this confusion was Sarah Bernhardt who had female partners while scandalising Paris with her heterosexual affairs and yet preferred to dress as a man, and whose greatest roles were Lorenzaccio and Hamlet. Henri also made studies of the most

famous transvestite performer of the day, the English *diseuse* Mary Hamilton who performed in a costume whose frock-coat with prominent buttonhole and tight velvet knee-breeches were remarkably similar to Oscar Wilde's earlier 'aesthetic' outfit worn on his lecture tours. This calls to mind Wilde's participation in the movement for the reform of female dress – which sounds flippant but which was in truth a serious recognition of the fact that the restrictive corsets and flowing gowns that Victorian women were obliged to wear prevented them from undertaking many of the tasks reserved for men, reinforcing their lowly status as decorative objects. For many women, Mary Hamilton was more than just a sexually ambiguous entertainer, she was a model of what might be if women could cast off the frills and flounces of nineteenth-century couture, the very thing that would later motivate designers like Coco Chanel, herself of variant sexuality, to create practical clothing for the modern woman.

The 1880s and 1890s saw the ineluctable rise of the *femmes nouvelles*. The first International Congress on Women's Rights and Feminine Institutions had been held at the Centennial Exhibition in 1889, with opponents in the press dubbing the participants either *amazones*, huge, fearsome battleaxes, or portraying them as scrawny *hommesses*, ambiguous creatures, mannishly attired, who took on all the tasks formerly associated with men, turning their spouses into emasculated appendages. A *hommesse* courts her man, marries him, then leaves him at home to take care of domestic tasks and children while she goes off to work.

But the opponents of female emancipation could only rant. With higher education opening up to women it was inevitable that they would move into those professions usually reserved for men – though, of course, this was seized on to explain the nation's declining birthrate which would, so it was argued, deprive the army of sufficient conscripts and ensure a second victory for Germany in the inevitable conflict that many foresaw.

These attempts to define a permanent, secondary role for women found expression in the arts. Suzanne Valadon would be only one of many women artists cast into obscurity by their refusal to assume the soft pastel style deemed appropriate for feminine creativity. But the division of roles was if anything even more apparent in male art and in male depictions of women. A portrait of a man by a man was, in the words of the art critic Camille Mauclair, writing in 1899, 'a psychological document subject to analysis and moral evaluation', whereas the portrait of a woman by a man 'was purely physical'. Indeed, most were little more than studies in costume – Bonnat imperiously directed his nervous sitters to the House of Worth for a shim-

The transvestite singer Mary Hamilton. Madame Palmyre and Bouboule at La Souris.

mering ballgown that would give him something to test his skills against, leaving him free to ignore character and relieving him of the necessity to explore any inner life his subjects might have.

It is here that Henri comes into his own, completely turning this convention on its head. From his early depictions of his mother, his portraits offer a searing awareness of motivation, allied to a profound understanding of emotion – Adèle's cloying martyrdom, La Goulou's gutsy vulgarity, Jane Avril's thoughtful melancholia. Dress is used only to highlight character – the rather silly 'Renoir' hats worn by Suzanne Valadon reveal a human touch of insecurity behind her outwardly tough façade; La Goulou's neckline is just a little too low to be sexy, a sign of someone whose excesses will always undermine what she seeks to achieve; the contrast between Jane Avril's anonymous day-clothes and her exotically plumed costumes neatly exemplifies the double life of one who wished to escape the depression of everyday existence in a world of glitter and movement.

This feminisation of portraiture had begun with Manet and his depiction of Victorine Meurent as Olympia; Henri de Toulouse-Lautrec made it the central feature of his art. His opponents said he debased women, much as the New Woman was accused of despoiling the feminine ideal of perfect wife and mother which the anti-feminists claimed to defend. And, of course, they had a point. The women Henri chose to paint had themselves chosen to maintain an independent existence at a time when marriage meant submission to a husband who exercised complete legal and financial control over his spouse. It is little wonder that women such as Yvette Guilbert and Jane Avril preferred someone of their own sex rather than risk such imprisonment. When their careers were established, both women did eventually marry, but during their years of struggle such a move would have been unthinkable. Loïe Fuller, too, was careful to wait until her career was secure before embarking on a tempestuous affair with the elderly Rodin. Of course following such a path was fraught with risk, as every obstacle, legal and financial, was placed in the way of the unmarried woman and many, most notably La Goulue, would one day pay a terrible price for having chosen freedom. But it is not hard to see why the solitary Lautrec, doomed to an unmarried existence, should have identified with those who chose to stand outside the system. If he was aroused by the idea of lesbian sexual activity, this has no part in his earliest paintings of female couples who are depicted as self-confident beings living in a world where men are not the dominant feature. We know from Will Rothenstein that Lautrec liked to eat at the Rat Mort, a notorious lesbian hang-out, and that his evening drinking was often done at La Souris, in the rue de Breda (today, rue Henri-Monnier) near the Place Pigalle, where Madame Palmyre held court on a high stool behind the cash-desk. A flamboyant dragon of a woman, Zola transformed her into Laure Piedefer (Ironfoot) in *Nana*:

> This Laure was a women of fifty, her ample form squeezed into belts and corsets. Women came in, one after another, reached up across the saucers and kissed Laure on the lips with fond familiarity, while that monster, moist-eyed, endeavoured to divide her favours equally and so arouse no jealousy. The waitress, in contrast, was a tall, thin, ravaged-looking creature who served the ladies with lowered eyelids and a darkly flashing glance. The three rooms filled up quickly. There were about a hundred customers there, seated all at random round the tables. Most were nearing forty, huge

361

women, thick and fleshy, with puffy cheeks sagging about slack lips, but amongst the bulging bosoms and stomachs there were a few slim, pretty girls to be seen, still with an air of innocence underneath their brazen manners, novices picked up in some dance hall and brought by a customer to Laure's, where the crowd of obese women, excited by the aroma of youth about them, courted them like fidgety old bachelors and jostled one another to buy them sweets.

The real Palmyre was said to have a heart of gold beneath a rather forbidding exterior – in fact she was said to resemble her little dog, 'Bouboule', who sat in the bar beside his mistress. Bouboule was famous for biting the feet of anyone who tried to befriend him and Henri depicted the pet as a sort of cheeky imp poking his nose into other people's, usually sexual, business much as he did himself.

The Moulin Rouge paintings are almost exclusively feminine. While Oller discouraged overt male homosexuality at his club, lesbianism was thought to be good for business. It was not uncommon for women to dance together, especially any lovers among the performers like La Goulue and La Môme Fromage, which made it inevitable that such couples would figure in Henri's work of the period. But whatever Oller's motives in pandering to the fantasies of his male customers, no erotic element can be found in Henri's record of the scene. The two women in long overcoats who waltz together in one painting, or the stray woman in a rather masculine coat on the edge of one of the *Moulin de la Galette* studies, are not there to titillate the spectator. They are too absorbed with themselves for that.

It is when we see the paintings of lesbians that Henri made in the brothels that the issue becomes more complex. At one level these appear to be a further extension of his preoccupation with the private world of the brothel's inmates, the most private realm of all, those moments when the women tried to experience a little of the intimacy and affection missing from their professional encounters. He made four studies of lesbian couples in 1892/3 with another group mid-decade, but within the two groups, the images vary in what might be called 'intensity'. Most show two women, lying together, either on a bed or on one of the red-plush divans, clearly absorbed in each other, yet with no sign of closer physical contact. The women are not idealised, they are the same ageing and worn-out figures depicted in the other brothel works. Any claim that his lesbian pictures, even the most intimate, are erotic must depend very much on the attraction the observer

can feel towards such weary creatures. And yet the initial problem remains – if they were not meant to excite, why did he paint them in such a blatantly voyeuristic manner? What is Henri de Toulouse-Lautrec trying to tell us when he opens this window on so private an act?

An insight into his intentions can be found by piecing together comments he made to various friends with the accounts of others who saw him at work. He told Arthur Symons that he had been influenced in making these particular paintings by reading Baudelaire's poem *Les Femmes damnée* which had been published as part of *Les Fleurs du mal* in 1857. And this idea that the genesis of the lesbian works was stimulated by some 'outside' literary source rather than being simple acts of reportage is confirmed by other accounts. The fact that we can recognise Rolande and Gabrielle in some of the paintings suggests that as with the other brothel works, the lesbian studies were not painted from life but were reconstructed in his studio, a fact confirmed by Tristan Bernard who went to his place one day and found Henri painting two nude women on a sofa, 'one showing her front, the other her behind'. We know that François Gauzi took a series of photographs of some of the women at the rue des Moulins, both clothed and undressed, images for Henri to use at his leisure, all of which suggests that he was working to a considered scheme rather than merely sketching at random.

But it is the reference to *Les Fleurs du mal* that offers the best clue to his thinking, for it is clear that there is a link with the poems that goes beyond the single title mentioned by Symons. Baudelaire had originally intended to call his entire collection *The Lesbians* and while only three poems on this subject survived into the book we know today, it was these three that provoked the prosecution and seizure of *Les Fleurs du mal* on its first appearance. But while the poet abandoned his idea for an entire sequence of lesbian poems, the three survivors, especially the *Les Femmes damnées* mentioned by Symons, embody most of the themes found elsewhere in the book. All three, and it could well have been all of them that Lautrec was referring to, deal in concentrated form with the same intensely physical preoccupations that figure in the other poems in the collection which deal with love. Baudelaire details the 'hideous realities' of human contact, dwelling on the body's odours and secretions, and the usually unspoken things done to it, even to the point of pain and mutilation. Thus one woman approaches another:

> Like a strong animal that oversees its prey,
> First having taken care to mark it with her teeth.

But the three lesbian poems surpass the others in their challenge to the accepted notion of female sexuality in what Baudelaire's friend, Louis Veuillot, called 'the Age of the Virgin Mary'. The Papal proclamation of the Immaculate Conception in 1854 had marked the culmination of a belief that gained ground throughout the century, in the essential asexuality of women, whose role in marriage was to succumb to male desire but who otherwise found fulfilment only through some sort of ethereal love of their appointed husbands. This neatly matched Parent Duchâtelet's famous study of prostitutes which depicted them as creatures quite different from normal, chaste women. To him, such women were a loathsome if necessary element in society's infrastructure, comparable to a city's sewers as a means of siphoning off its unwanted effluent. Thus to both the religious and scientific mind, sex was a male activity in which women acquiesced without feeling, ideally in exchange for love in marriage, otherwise for money in prostitution. Baudelaire's 'Lesbians' challenge such illusions – within the three poems his women experience, and revel in, every aspect of carnal pleasure, with no need for such desires to be channelled towards men.

The challenge was two-fold. At its broadest Baudelaire's verse gloried in its moral ambivalence – the very reason why he was tried and fined for committing an Outrage Against Public Morality. But it also made a specific point about women as free spirits with their own desires, as creatures that can exist without men. This was the theme that Wilde had taken up, the challenge that made Salomé so repugnant to those who feared the vengeance of the oppressed. And Henri, too, with his paintings of brothels, and in particular of the intimate love-making of the women who lived in them, undermines the hypocritical edifice behind which a pompous politician could pass his mornings in the National Assembly sounding off about public morality and marital duty before spending the afternoon in the rue des Moulins' torture chamber having his bottom spanked. That Henri's images struck their target is made evident by the fact that it was one of the lesbian paintings that provoked the outcry when it was displayed in Le Barc de Bouteville's window – an echo of Baudelaire's confrontation with the law over the publication of his poems. What seems to have been unacceptable to the authorities was the notion that women, too, could enjoy these same 'Flowers of Evil' that so aroused their menfolk, and considered from this perspective, the lesbian works are indeed profoundly shocking. There is one group of four paintings that can be run together like a strip-cartoon and which offer what amounts to a tale of seduction by one woman of another. In the first canvas a tentative approach, in the second they lie closer togeth-

'Les Tribades' – a male fantasy of lesbian prostitutes quarrelling in a brothel.

er, in the third they pull apart as if some doubt has intervened, only to come together at last finally to touch, embrace and kiss.

> Let our closed curtains, then, remove us from the world,
> And let our lassitude allow us to find rest!
> I would obliterate myself upon your throat
> And find the coolness of the tombs within your breasts!

That Henri's motive in making the lesbian works was not primarily erotic is obvious if one compares his interpretation of Baudelaire's poems with the drawings Rodin made in the margins of Paul Gallimard's first edition of *Les Fleurs du mal* around 1887. The sculptor's nude couples are so openly sexual they are occasionally reissued in collections of erotic art. After visiting Rodin's studio in 1897, Will Rothenstein wrote of him 'caressing' his models with his eyes, a description in no way applicable to Henri's tender depictions of the somewhat battered figures who struggle to find a little companionship in an otherwise bleak existence.

To suggest that Henri was committed to any sort of agenda that we would today call feminist or was an open advocate of women's rights, stretches the point too far. But that his conception of women was far more complex and interesting than is commonly acknowledged is clear from these works. At a time when men were first called upon to consider the possibility that women had a right to an independent existence, most chose to avoid the issue so that it is all the more remarkable that in their work, both Lautrec and Wilde chose to present strong characters who reverse the normal social conventions, Wilde's Mrs Erlynne, the 'fallen' women outwitting her puritan opponents in *Lady Windermere's Fan*, Lautrec's Jane Avril side-stepping the whole ethos of male dominance of both her life and her body. Beyond his gang of personal male friends, which recurs as a sort of chorus in his paintings, men are only occasionally central subjects in an art that is principally of and about women, most of whom were lesbians. And this sexual orientation is the unifying theme that explains the presence of otherwise unconnected characters in some of the works – Yvette Guilbert, May Milton, Jane Avril, La Goulue and La Môme Fromage, but also lesser-known but equally intriguing figures such as his friend the model Gabrielle of the *visite médicale* series who appears in a number of works with a woman who was to be the most important model of the mid-decade, the strangely named La Clownesse Cha-U-Kao. She and Gabrielle were, of course, lovers and Henri's studies of La Clownesse and the nature of her sexuality are the central element in what may well be the most important work of his entire career.

For someone about whom we know so little, it is probably appropriate that the only identification we have for La Clownesse is her deliberately confusing stage-name Cha-U-Kao, which was certainly meant to sound oriental but was only a phonetic corruption of the French words *Chahut* (argot for the *quadrille-naturaliste* or can-can) and *Chaos*, to signify the wild abandon the dance often induced. But appearing to be Japanese – hair piled up on the head like a geisha and wearing a clown's costume with a frilly collar that vaguely resembled the fringe on a kimono – was an essential part of an image intended to associate the performer with the currently fashionable, artistic preoccupation with the Land of the Rising Sun. If they knew, no one ever bothered to record who or what she was, nor where she had come from. When she turned up at the Moulin Rouge in 1889 to audition for a role as an acrobat she was a woman without a past. Even her act was ambiguous, she was really a contortionist – one photograph shows her doing the splits, her upper body bent backwards over her left leg, another shows her completely doubled up, hands gripping her ankles, her head between her legs. These photographs were taken when she was young and pretty, though one imagines that Oller was less interested in her rubbery poses than in the fact that, if need be, she was prepared to do them in the nude – another photograph of her bare-breasted shows just how good her youthful figure was.

Inevitably, she changed her act as she aged, becoming part acrobat, part dancer, part clown in baggy pantaloons with an elaborate frilly collar, hence her title La Clownesse. Although he knew her when she was young, Henri showed no interest in painting her when she was firm and beautiful, preferring to wait until she was fat and blowsy before making her one of his principal models, often emphasising her slackness and girth as if fascinated by the way the rolls of fat overlapped her tight costume, her decay exaggerated by the deathly pallor of her clown's white make-up. He made some eight images of her, one of the most famous showing her in full clown's outfit strolling across the dance floor at the Moulin Rouge on the arm of her lover Gabrielle, even plumper and older than she was. In another, the two dance together, looking slightly younger and trimmer in their tightly buttoned day-clothes, in a scene which is again almost entirely lesbian with Jane Avril behind them, and May Milton sitting beside Charles Conder on the balcony. In one painting, we are so close to La Clownesse, fastening up her costume, that her bulk fills the picture space. Henri emphasises the Japanese connection by dividing the shapes into large blocks of flat colour as if this were a poster rather than an easel painting. Cut off, at the top left-hand corner of the canvas is a mirror in which we glimpse a man who has

presumably called on the performer in her dressing room; perhaps Henri wanted to show that even in age, and no longer svelte, Cha-U-Kao still had her admirers, and that sexual allure was not merely the province of the young and physically blessed. It was almost as if he had developed a passion for these signs of ageing and death. On a number of occasions he took friends to the top floor of a run-down building in the rue de Douai to see an old drunken woman, wrinkled and nearly bald, presenting her with chocolates and flowers and listening patiently to her rambling reminiscences of a fascinating past. She was Victorine Meurent who in her youth had been the model for Manet's *Olympia*, the most famous nude painting of the time, and also for the coquettish Nana, Manet's portrait of Zola's heroine, the model for all literary prostitutes, now reduced to begging for coins outside the gallery where her once-ravishing beauty could still be seen. We may assume that in some way Henri used his paintings of Cha-U-Kao to express something of the sentiments he felt in his meetings with the wrecked Victorine, and seen from the perspective of an age in which women have questioned representations of their sex that emphasise only a distorted idealised male view of their bodies, Lautrec's portraits of La Clownesse appear strikingly advanced. He even made this uncompromising figure the central element in a series of eleven lithographs that he published in 1896 under the title *Elles*, the collection that brings together the various themes that he explored in the brothel and lesbian paintings.

The French title, the female form of 'they' or 'them', does not translate into English but in the original it promises a titillating glimpse of some private female world, as if the collection will be a peep-show for the male purchaser of high-class smut. A glance at the cover illustration would seem to bear this out – a woman in a night-robe is doing up her hair while a top hat, placed on the edge of her bed, suggests that she has a male admirer in the room who, like us, is watching her undress. This assumption is reinforced by the penultimate print in which what appears to be a fully clothed man, again in top hat, watches a woman lacing up her corset as if their business is now ended. Although there is no clear narrative line to the prints, there is a progression that begins with a woman waking up, bathing and washing, then putting on her make-up and arranging her hair, until the final witty pay-off, a version of the earlier *Lassitude* painting, in which a black-stockinged woman is sprawled across a bed, presumably exhausted by her labours satisfying her male visitor.

This theme of male voyeurism would seem to be borne out by two plates which show a girl in bed with an older woman in the room, while in the

other, the girl sits up in bed as the elder takes away a breakfast tray. Maurice Joyant was sure that this was a Madame Baron, the mistress of Paul Guibert, with her daughter Pauline, who was in some ill-defined way part of their ménage. Such an arrangement was a common fantasy at the time – Frank Harris, in his scurrilous memoirs, tells just such a story of a prostitute offering him her under-age child, who turns out to be as lascivious as the parent, and the image of the mother serving her daughter breakfast in bed, presumably the morning after, would easily fit that particular erotic vignette.

But Joyant may not be entirely reliable here – after Henri's death, his friends went to considerable lengths, including falsifying evidence, to protect him from accusations of debauchery, particularly in regard to deviant sex. Joyant may have thought it better to have Henri telling a gross tale about a woman assisting in the prostitution of her own daughter, than something that in his eyes was far worse. Until 1979, his version was generally accepted, even though this rendered the collection as a whole largely meaningless, a group of disconnected images more or less to do with voyeurism – hardly a subject of much concern to the artist and not formerly his working method, where individual paintings or series of prints show a noticeable concern for rational narrative sequence. An American art historian, Naomi E. Maurer, in the 1979 catalogue for a major Lautrec exhibition at the Chicago Art Institute, dismissed Joyant's claims and declared that there were only two women in the sequence, one blonde, one dark. The high chignon and flamboyantly frilly collar on the nightdress of the woman on the frontispiece, suggests that this is Cha-U-Kao, an identification borne out in the next print which clearly shows La Clownesse in her younger, slimmer days, in full stage-costume sitting on some steps in the Moulin Rouge, legs spread mannishly apart – an image too startling and too prominent at the opening of the series not to have some special meaning. According to Maurer, Cha-U-Kao is the tall blonde figure who recurs throughout, while the younger darker girl is her lesbian lover.

The only evidence – if that is the word – to support Maurer's assertion is the fact that the prints suddenly make more sense as a sequence once it is accepted that what we are offered is in essence a lesbian love story. *Pace* Maurer, each print progresses chronologically through the early part of a single day from waking, to washing, to dressing, the two women helping each other, especially the elder, Cha-U-Kao, who is especially solicitous of her younger lover's well-being. That we are in a brothel, witnessing the intimate boudoir world of two of the inmates seems fairly obvious, but the fact that we stop short at these preliminary activities and are shown nothing of the

369

The breakfast tray, from *Elles*.

actual function of the *maison* makes the series a simple extension of Henri's brothel paintings where the sexual element in the women's lives is strictly omitted. We return only at the end of the day, when the last customer has gone, with a version of *Lassitude* in which the young woman is stretched out on the bed as if exhausted from her labours.

If the theory is correct then we need not be too concerned about the sup-

posed masculine spectator, who Maurer believes may not have been a man at all. In the age of Mary Hamilton, it is just as likely that the top hat on the cover and on the figure in masculine dress in the penultimate print belongs to some butch character from one of the lesbian bars Henri frequented when he was working on the prints.

Maurer's interpretation is perfectly plausible, and even if not all the prints

are of Cha-U-Kao, she and lesbianism remain the primary subtext that unites the series. And while this does not resolve all its ambiguities, the collection as a whole confirms Henri's role as sympathetic observer of the *condition feminine*. At the time he was working on the album, his favourite bar was the Hanneton, at 75 rue Pigalle, run by Madame Armande Braziers, a one-time prostitute, and an even more ferocious dominatrix than Palmyre over at La Souris. In Henri's portraits of her, Madame Armande's expression varies between a rather haughty indifference and a sickly smile, neither improved by the fact that she had only one eye – which prompted Henri to name her 'La Gambetta' after the similarly afflicted politician. But his interest in this hard character soon waned and he drifted back to the more congenial attentions of Palmyre and Bouboule. But in both La Souris and Le Hanneton, as in the brothels, he was seen as a friend whose physical disabilities made him an unthreatening counsellor, someone who offered a sympathetic ear and who could give impartial advice. And any suggestion that his art exploits this intimacy must be set against the fact that neither the brothel nor the lesbian works were financial or critical successes. An exhibition of the *Elles* prints opened at the La Plume Gallery in April 1896 and ought to have been seen as a stunning union of fine art and the art of illustration. If nothing else, each page was a brilliant example of printmaking, revealing an astonishing range of techniques, with all the subtle tricks of splashing and dribbling inks he had perfected on the posters, combined with his Japanese graphic power that has never been equalled – but no, the critics carped, the very variety of method made the collection seem uneven, and what was it all about? Shouldn't it be erotic? A titillating insight into a world of women doing secretive things? Yet clearly it wasn't quite that. Even today there is little agreement about his intentions or his success with *Elles*; it seems that people like to know where they are, and are easily irritated by what they see as wilful inconsistency or needless complexity.

The La Plume exhibition sold few copies and an exhibition organised by Vollard the following year did no better. Eventually most of the sheets were sold off separately, losing for ever the subtle, almost musical, thread that weaves in and out of the series. Having hoped to convey sensations the visual arts seldom attempt, a world of touch and smell and taste, the intimate sensations aroused by the nearness of another being, the world celebrated by Baudelaire, Henri had only succeeded in alienating a public that preferred to think of him as the jovial ringmaster of a mindless sideshow.

14

TRIALS

Despite his outward calm, nonchalantly smoking a cigarette as he rode away from the mayhem at the Foyot Restaurant, Félix Fénéon must still have wondered what reprisals he could now expect. The noise of the explosion was enough to confirm the enormity of what he had done, leaving no doubt of the carnage he had left in his wake, so it must have been hard to accept, the next day, that all he had achieved was the wounding of a single man, Laurent Tailhade, who considered him a friend. When the police searched Fénéon's apartment that morning, one of the things they found was a visiting card from the now wounded poet, thanking the critic for having favourably reviewed one of his books.

Luckily for him, the police were simply investigating anyone in their files and their first search proved little more than a worrying nuisance. Despite the books and photographs that confirmed his allegiance to radical causes, the officers gave the place no more than a cursory glance and allowed him to leave for work at the War Ministry where, amazingly, he was storing a small box of detonators. He had obviously benefited from the reluctance of the authorities to exert themselves over a case where the only victim was himself an outspoken advocate of the anarchist cause. After Vaillant's bomb-throwing incident in the Chambre des Deputés, Tailhade was rumoured to have exclaimed: 'What matter the victims, if the gesture is beautiful!', which left him in the embarrassing position of having to accept the loss of an eye with as much grace as he could muster. He does seem to have managed this remarkably well, occasionally stunning guests at his home by popping out his glass eye and dropping it into a tumbler of water.

The only immediate effect of the incident on Fénéon was losing his home when the concierge, declaring herself scandalised by the police visit, obliged him to move with his aged mother to a smaller and more expensive apartment. But if he had avoided punishment for his own act he was now to find

himself caught up in the aftermath of another as the trial of Emile Henry approached and the police began to round up anyone even vaguely associated with the anarchist cause.

While records are not always precise at this time, the authorities being in an evident state of panic, as many as eight hundred people may have been arrested. Real bombs were actually rare but false alarms were so frequent, with threats against the Opéra, the Central Courts, and the presidential box at the Longchamps Racecourse, that by 1894 almost the entire population of Paris believed that their city had been overrun by anarchist activists. The police built a specially reinforced bomb centre out in the suburbs where devices could be disarmed but as they were forever plagued with false alarms, being called to pick up abandoned parcels and piles of rubbish, it proved impossible to send everything out there. So jumpy had everyone become that anything could trigger a panic. Out hunting as usual, Henri's father realised that he had left his favourite falcon, Le Grand Duc, locked in his Paris apartment but when he telegraphed the concierge 'Save the Grand Duke' the poor man feared the worst and contacted the *préfecture* who sent the police to search the place. Things had clearly got out of hand with petty criminals claiming what might be called the 'anarchist defence' before the courts, alleging that they had taken someone else's property as a political gesture while at the same time almost every intellectual and artist seemed to be an advocate for the anarchist cause. Little wonder that with so many arrests, those languishing in prison varied from burglars to poets, most of whom had never been near a bomb. The sole exception was Fénéon, who was arrested on 25 April 1894, two days before Emile Henry's trial. At first this was a continuation of the investigation into the Foyot explosion but when a search of his office uncovered the small box containing tiny detonators and a quantity of mercury used in manufacturing explosives, he was held on suspicion of more general anarchist activity. In the event, the trial of Emile Henry went ahead without these suspects being much involved. The accused was found guilty and after President Sadi Carnot again refused clemency, the condemned man, yelling the by then mandatory *'Vive l'Anarchie,'* was sent to the guillotine and duly martyred. The whole thing had taken on something of an atmosphere of a Bruant concert with Emile Henry dead at La Roquette and Fénéon and so many others held at La Mazas, prisons that had figured in the Mirliton ballads and Lautrec's illustrations.

The press outrage following Fénéon's arrest, due mainly to his having hidden the explosive material in the War Ministry, caused a scandal that dragged him out of literary obscurity into national prominence. But despite

that, the absence of any hard evidence that he had actually used explosives, ought to have led to his quiet release now that Emile Henry was dead, save for the fact that no one seemed able to stop the legal juggernaut from lumbering towards a trial. With no date set, the investigation trundled on for weeks. For the prisoners, boredom was the worst of it, with Fénéon reduced to translating, with the aid of an English/French dictionary, one of the rare works of fiction in the prison library: Jane Austen's *Northanger Abbey*. But despite such humorous touches, events were getting out of hand as the population of the city split over reactions to the forthcoming trial, with even the poor beginning to resent the bogus claims to political virtue by many who were clearly only thieves. The man who robbed and set fire to the apartment of Proust's friend the painter, Madeleine Lemaire, and stabbed and killed a policeman while making his escape, claimed that his was the gesture of 'A convict setting fire to his jail' and as for the dead law-officer: 'He arrested me in the name of the law; I struck him in the name of liberty.' Used so cynically, the title anarchist could no longer claim its former automatic esteem, yet, in complete contrast, a virtual cult had grown up around the originally unmarked grave of Auguste Vaillant, with public pilgrimages to the spot which someone had managed, despite the vigilance of the police, to cover with a gravestone, where poets read out their verses and where the wicker basket that was said to have contained his severed head was displayed like a medieval relic, in which the faithful dipped their handkerchiefs hoping to stain them with his saintly blood.

Clearly in such a febrile atmosphere, anything could happen and on 24 June, a month after Emile Henry's execution, something extraordinary did. The city of Lyons was holding an Exposition of its own and on that day the President of the Republic was paying it an official visit. Also there was Santo Caserio, a twenty-year-old baker's apprentice from Milan, the centre of anarchist activity in Italy. Caserio had been living in the southern French town of Cète (today Sète) where he had joined Les Coeurs de Chêne, the Hearts of Oak anarchist group, whose members had been predictably incensed over Sadi Carnot's refusal to pardon first Vaillant then Henry a sense of anger which in Caserio had merged with his traditional belief in vendetta, the blood-feud. Nothing might have happened if Carnot had not rather imprudently ordered the police to let the crowds come close to the presidential cortège and in this easy-going, festive atmosphere it was reasonable to assume that the young man approaching the official party with a rolled-up newspaper was actually carrying a bouquet. By the time he had jumped on the running-board and pulled out the dagger that he had bought

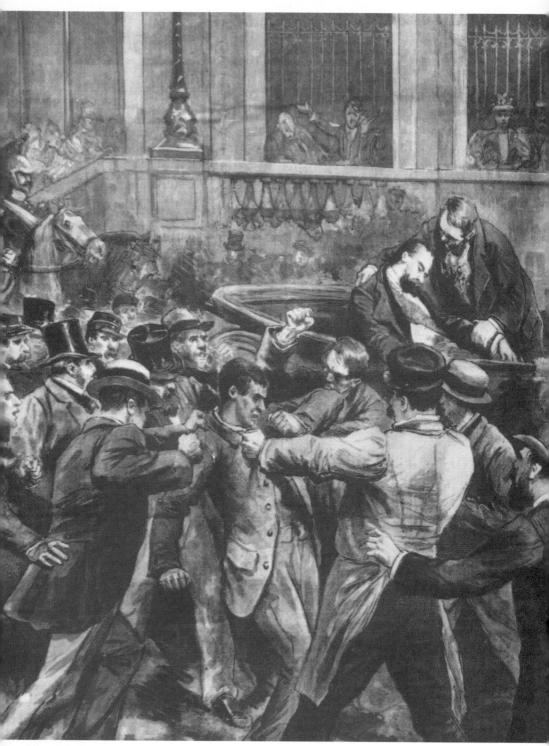

The assassination of President Sadi Carnot, 1894.

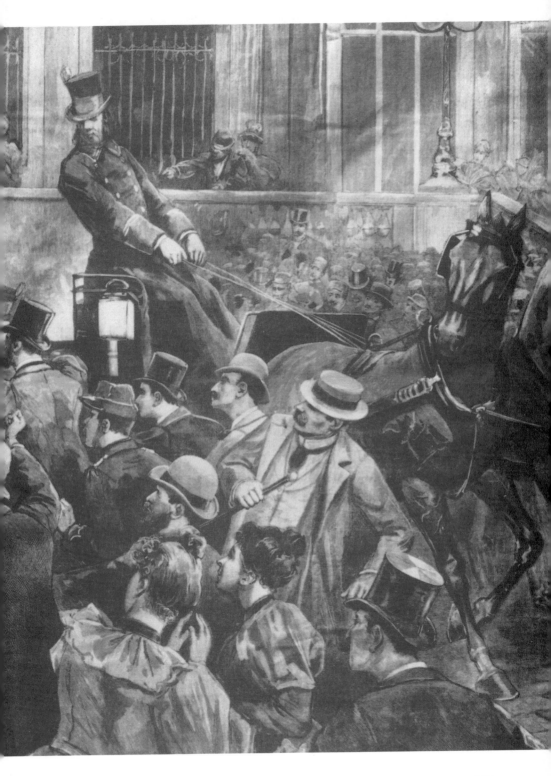

for twenty francs with his 'holiday' money, it was too late to stop him plunging it six inches into Carnot's abdomen, piercing his liver. The President was dead within three hours. The next day Madame Carnot received an envelope containing a photograph of Ravachol, marked 'He is avenged'. It was addressed to 'The Widow Carnot' and had been posted before the attack.

To kill the President of the Republic was surely the most sensational act of all, yet against every prediction by every anarchist thinker of the day this ultimate example of the Propaganda of the Deed had precisely the opposite effect to that which they had always assumed. In short, nothing happened, the people did not rise up. Police activity was doubled and right-wing attitudes hardened but from the left there was little save muted protest. There would be a few more anarchist outrages that decade and into the next century, some quite spectacular, such as the failed attempt in 1905 to blow up the King of Spain and the President of the Republic as they returned from a gala at the Opéra, a bomb which nevertheless wounded twenty innocent bystanders, but effectively the cause was already doomed. Sickened by the bloodshed, radicals and intellectuals moved towards the rising Communist Party while the few diehard anarchist thinkers chose to work within the increasingly active trade-union movement, advocating the general strike as the new, less gory form of the Propaganda of the Deed. In a sense the only remaining anarchists were those independent-minded artists and writers who gave the cause their emotional support without ever really planning to do anything very specific to advance it. In some ways that remains true to this day, where the libertarian attitudes most creative folk claim for themselves echo the thoughts once expressed more clearly by Proudhon, Grave and Fénéon, though who now would call him- or herself, as once so many did, an anarchist?

Whereas the public and the police had panicked over the actions of Ravachol, Vaillant and Emile Henry, it was the government that finally lost all restraint in the wake of Carnot's stabbing. The decision, three days after the assassination, to elect a millionaire mine-owner, Jean Casimir-Périer, to the presidency was a fist shaken in the face of the nation's radicals. It even provoked a unique political comment from Henri in a letter to the Belgian painter Théo van Rysselberghe in which he referred to 'a presidential crisis' which he described as 'booracracy in delirium', concluding that 'everything is ugly and stinks'. Casimir-Périer's election was quickly followed by the third of a series of highly contentious, and grossly illiberal bills, *Les lois scélérates*, laws of 'assumed criminality' intended to entrap anyone vaguely associated with anarchism, and loose enough to include even the vaguely

Drawing of Fénéon in La Mazas Prison by Maximilien Luce, 1894.

anarchist-leaning literary journals and their well-meaning contributors. Now it was the turn of the creative community to panic: a stream of writers and artists found it prudent to take an overseas 'holiday' until things settled down. Among Lautrec's acquaintances, the mild-mannered Camille Pissarro headed for Brussels while the illustrator Steinlen and the writer Paul Adam also went into exile. But the third *loi scélérate*, forbidding acts of anarchist propaganda by any means whatsoever, also ensured that at least some of the near eight hundred that had been arrested would now have to face judgment, though when a mass trial was eventually organised for 6 August only thirty were charged with conspiracy to subvert the State, and of them only twenty-five came to trial, though among them was the one man who was certainly guilty, Félix Fénéon.

Aware of the weakness of its case against most of the writers on trial, the prosecution had included among the accused a bizarre gang of professional burglars, led by a Mexican called Ortiz, who had been giving part of the proceeds of their crimes to the anarchist cause. This could have been enough to cloud the issue and sway the jury against the entire group, had it not been for Fénéon. His time in La Mazas prison had raised his status with many in the intellectual community. Even some who did not know him personally sent him messages and gifts. Among them were Wilde's friend, the poet Stuart Merrill, and Misia Natanson, wife of the wealthy financier and publisher Thadée Natanson. Now, Fénéon's performance at the trial would bring him fame on a wider scale, for though it would shortly be eclipsed by an even more sensational court case, when it opened, the Trial of the Thirty was the most spectacular legal process of the Third Republic, attracting the attention of the entire nation and widely reported abroad. While all the prisoners were collectively accused of a complex web of conspiracies, of aiding and abetting each other in a variety of crimes, Fénéon was given special status in a final charge that included an indictment for possessing explosives. The charges had been drawn up by the prosecuting magistrate Avocat Général Bulot, a hate-figure among the anarchists for having demanded the death penalty for the Clichy demonstrators in 1892 and for his successful prosecution of Emile Henry. But Bulot's tactics, filling the public benches with policemen to keep out any sympathisers and cluttering the court with stolen goods so as to heighten the impression that a bunch of thieves were on trial, seriously backfired when Fénéon was finally called upon to testify and proved brilliant at parrying the prosecutor's plethora of unfounded charges.

It was a mix of his natural suaveness – even under the tough prison

regime Fénéon had done his best to maintain his reputation as a dandy, asking one benefactor to send in some shoe polish, a commodity sadly lacking in La Mazas – allied with an icy demeanour and a clipped repartee that amused the jury and succeeded in laughing Bulot's accusations out of court. When questioned by Judge Dayras, Fénéon responded as if he were a comedian parrying jokes with someone in the audience, primed to feed him his lines:

> *Dayras*: It has been established that you surrounded yourself with Cohen and Ortiz.
> *Fénéon*: (*smiling*) One can hardly be surrounded by two persons; you need at least three. (*explosion of laughter*)
> *Dayras*: You were seen speaking to them behind a lamp-post!
> *Fénéon*: Can you tell me, your Honour, where behind a lamp-post is?

Of course, there was more to his defence than cheeky one-liners. Fénéon cleverly assumed the pose of one who was naïve, bookish and otherworldly and who had innocently frequented anarchist publications out of a simple interest in literature, without having the least idea of what precisely his new friends were advocating. This might have stuck in the jury's throat, had not the prosecution been so frequently wrong-footed – Bulot had been forced to admit that they had known for some time that one of the accused had been falsely arrested, kept in detention and brought to trial despite his absolute innocence. The result was that even non-radical newspapers such as *Le Figaro* seized on Fénéon's performance, reporting his dialogue with the judge in full and thus helping to set public opinion firmly behind a group of men and women who before their trial began had been almost universally denigrated. The last act in the comedy was what came to be called 'The day of the five concierges' when a procession of these harridans was brought in to witness against Fénéon but only succeeded in turning the process into a farce. The nosy creature who had had Fénéon turned out of his apartment in the rue Lepic claimed that one of the accused had visited Fénéon five or six times a day, leaving him to languidly point out that this was strange, given that he had been at the War Ministry at the time. This was then followed by a succession of impressive character witnesses, including Charles Henri, professor of science at the Sorbonne, and a moving tribute from Stéphane Mallarmé, so that by the end, the sole person among the thirty who had actually caused an explosion and wounded a fellow human being, had been elevated to the empyrean.

Even so, the jury's final verdict was astonishing – all thirty were found not guilty of the conspiracy charges, and only Ortiz and three others of his gang were given sentences for theft. While some of the accused were returned to prison on previous convictions, Fénéon was cleared of all charges including that of possessing explosives, of which he was palpably guilty, and was allowed to leave a free man, walking from the court past the waiting reporters to a carriage hired by his new friend Thadée Natanson who took the freed prisoner to his apartment for a celebration.

Until the trial, Fénéon and Thadée Natanson had been little more than passing acquaintances; now, since Thadée's young bride Misia had taken to visiting La Mazas, bringing sweets and other comforts for the prisoners, they had become friends. She and Thadée had only been married a year but already all who worked with him loved Misia Godebska, the ethereally beautiful Polish heiress who had instantly become the social centre of the group gathered round Thadée's magazine *La Revue blanche*. Their home, a large apartment in the rue Saint-Florentin, in the expensive streets between the Madeleine and the Place Vendôme, eloquently revealed a way of life at once luxurious and eccentric. As painted by Edouard Vuillard, the walls of the large salon were lined with dramatically coloured papers and hung about with boldly coloured cloths, with more thrown over chairs and tables. Scale was important: Misia's grand piano, the outsize tropical plants in large jars, the bulky studio pottery and the big black dog. The effect is sometimes mockingly called 'arty' but must be judged in the context of the conventional Second Empire formality with which the well-off in the Third Republic usually enveloped themselves. The Natansons' living room was a mild but significant protest against that world and one which revealed their somewhat ambivalent social position. The three Natanson brothers were Polish Jews, sons of a rich banker who had moved to Paris in 1880. Thadée and Alexandre were both financiers and their wealth allowed them to indulge a passion for the creative life, preferring to be surrounded by the new social class of what were now called 'intellectuals', a group that straddled the old upper- and middle-class divisions. The third brother, Louis-Alfred, 'Fred', although barely out of school, wanted to be a playwright and would eventually work under the name Alfred Athis. Each played a different role on the *Revue:* Alexandre, a lawyer by training, earned the money they needed at the Bourse, the Paris stock exchange, while Thadée occupied himself with the day-to-day running of *La Revue blanche*, whose name, based on the notion that all colours come together to form White Light, indicated an unusually

open spirit, its pages welcoming almost anyone with something to say in whatever manner they chose, provided the result were sufficiently individual. An earlier *Revue blanche* had originally opened in Liège, Belgium, in 1889 but in 1891 Alexandre founded his own version in Paris, which Thadée ran and which gradually became the most enduring and important of all the radical magazines in the French capital.

Given that the Natansons were never going to cover their costs, it was understandable that their new venture began modestly with only four pages appearing whenever they could get an edition together. As with the other avant-garde publications, their aim was always to balance the 'masters' – better-known writers like Mallarmé, Verlaine and Huysmans – with newcomers, though it was here that the *Revue* proved truly prescient, due mainly to Fred whose attempts to break into the theatre brought him into contact with a younger crowd which he introduced to the journal. From these modest beginnings the *Revue* began an inexorable growth to between fifty and a hundred pages, printed on ever more expensive paper.

The first Paris number, on 15 October 1891, was launched with the rallying cry: 'Simply put, it is here that we intend to develop our personalities', heralding a free-wheeling, wide-ranging approach to culture that would prove very different from the narrow literary furrow ploughed by most of the little magazines. From the scientist Charles Henri, who had witnessed for Fénéon, writing on 'disorders of the nervous system' to a then unknown civil servant Léon Blum, one day to be prime minister of France, commenting on bicycle racing, the subjects covered ranged from the profound to the bizarre, though it was the quality of the art work commissioned by Thadée which more than anything else elevated the *Revue* out of the ranks of the cheap, short-lived publications, so that it played a crucial role in the development of *fin-de-siècle* painting and graphic design. Thanks again to young Fred, the *Revue* became the central outlet for work by the Nabis, the group of artists loosely led by Maurice Denis, whose creation of a simple, primitive, religious art had grown out of their contacts with Gauguin and it was another leading Nabi, Pierre Bonnard, who designed the first of the series of stunning posters that would make the *Revue* the most creatively advertised magazine of all time.

Less original, but no doubt inevitable, were the unwavering anarchist sympathies of the *Revue*'s contributors, though only in the usual sense that they paid lip-service to a political creed which seemed to chime with the unfettered individualism of an artistic community now totally alienated from the fabric of the State and aggressively at odds with anything definable as

bourgeois values. But in the wake of the recent anarchist trials, even that was sufficient to put the rich banking Natansons in the curious position of being opponents of the capitalist system. The third of the *lois scélérates*, passed as a result of Carnot's assassination, made it possible to prosecute even those publications that were only vaguely radical. The serious anarchist press had already gone under – on 21 February 1894 *Le Père peinard* shut down followed in March by *La Révolte*, and during the Trial of the Thirty the Natansons considered it wise to play down the more openly anarchist views normally found in their magazine. Though now that the accused were vindicated and Fénéon was on his way to Thadée and Misia's home to join his family and friends for a celebration, such caution was about to be reversed.

The Natansons knew that they had gathered round them a remarkable group of contributors but Thadée was intelligent enough to recognise that editing depends on talent and that few are truly great practitioners of the art. Aware that Fénéon had already shown considerable brilliance at the task and keen to help him now that he had lost his job at the Ministry of War, Thadée hoped to involve him in the running of the *Revue* and when the newly released prisoner found it impossible to get any sort of congenial work, Thadée decided to take a back seat and offer his new friend his own post as Editor. It was the task for which Fénéon had been created and one that would give him the most important role of his career, allowing him to influence nearly a decade of French cultural life. Of course, it also meant that the publication became more openly radical and anarchist in its editorial policy, though this only attracted even greater numbers of young and adventurous authors and artists while doing nothing to deter older contributors. The list of young, unknown talent first encouraged by the magazine during Fénéon's tenure is truly remarkable, with names now so famous one has to remind oneself that when he found them they were not only unpublished but so far in advance of those around them that they were usually unappreciated by anyone else. André Gide and Marcel Proust head the list, but Fénéon's willingness to accept someone as uncompromisingly outrageous as the playwright Alfred Jarry, author of the extraordinary *Ubu Roi*, was surely his single most courageous publishing decision. But perhaps more remarkable was the fact that at the end of his time at the *Revue*, when most editors would have been either worn-out or at least content to rest on their laurels, Fénéon was still discovering unheard-of newcomers like Guillaume Apollinaire and Pablo Picasso. And it was not simply a question of commissioning new work – while that is always the crucial first stage, it was also universally acknowledged that Fénéon was unsurpassed at coaxing the very

best out of his young contributors. He never bullied, but a quiet word, a few hints before writing began, were usually enough to see the author on the right road after which there were prodigies of sub-editing by Fénéon, who was famous for working long into the night, hunched over some recently received manuscript to the point where that image of him, his narrow face and familiar goatee beard aimed at the recalcitrant page, dramatically lit by the desk lamp, became an icon of the decade, painted by several of the *Revue*'s band of artists – Vuillard again, and Félix Vallotton who pictured him at the same desk under the same green-shaded lamp, as if he never moved from his chosen spot.

Fénéon began with the vague title of Editorial Secretary, implying that he played some sort of subservient role to Thadée Natanson, but in 1896 he was given the full title of Chief Editor and thus overall control both of the magazine and of a new publishing house allied to the *Revue* that brought out book-length editions of works by the people he had discovered or by other once famous but now neglected authors. Thus Fénéon was able to publish

Vallotton's painting of Fénéon working at the *Revue blanche*, 1896.

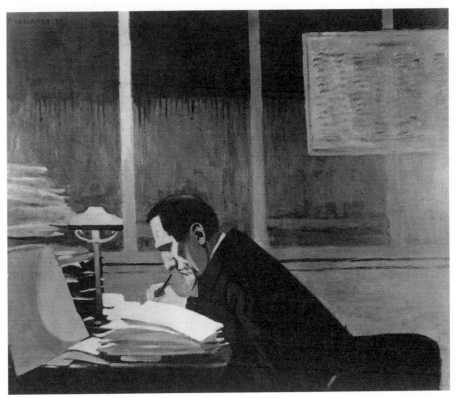

work as varied as Léon Blum's first book and Dostoyevsky's early novel *Un Adolescent*, in a wonderful if wildly unprofitable list that only existed because of the Natansons' unfailing generosity.

Initially, Fénéon contributed some articles under his own name but these withered away as he assumed his true role as the promoter of others' talents. Yet despite his increasing reputation as the finest editor of his day there were many who recalled the care with which he handled the first rejection of a new but unsuccessful author. He was equally good at stimulating the older hands, the 'masters' who had already been persuaded to contribute by Thadée or Fred, and it is interesting to note that on taking up his post, his very first solicitation was to write to Octave Mirbeau, who had recently been to London, to see if he would consider contributing a general series about art in England, a sign that the influence of John Gray was not yet dead. The lingering traces of this cross-Channel connection is one of the more fascinating idiosyncrasies of Fénéon's editorship. Over the eight years he held the post at the *Revue*, he published instalments of the Jane Austen translation he had begun in La Mazas, having enlisted John Gray to help ensure that he had caught the exact ironic tone of Austen's language. Gray, who by the end of their collaboration was preparing for his ordination as a Catholic priest, must by then have been somewhat troubled by this persistent reminder of a past, and of a love, that he was trying to erase.

As editor, Fénéon was at the epicentre of avant-garde cultural activity in Paris and a guide and mentor to many of the writers and artists who would dominate the early years of the coming century, not least Toulouse-Lautrec who for the first time since those heady days when they were newcomers, hanging around Le Chat Noir, found himself frequently in Fénéon's company. During the course of 1893, Henri became a regular member of the informal gatherings held in the magazine's offices where many of the contributors would drop in to find a sympathetic soul to pass a little time with, sitting and talking on the famous green-leather armchairs that reinforced the impression that this was a gentlemen's club. Part of the atmosphere at the *Revue* came from the fact that its offices were on the corner of the rue Lafitte, home to most of the city's private art galleries, and the Boulevard Haussmann, the main artery of the *quartier* that housed the press, the Bourse and most of the commercial theatres. All around the *Revue*'s offices were bars, cafés and restaurants packed with journalists, financiers, artists and actors – on one side the Calisaya, on the other Café Bob's, to which the *Revue*'s contributors, Lautrec included, frequently repaired.

It was this proximity to the bustling café life of the city centre, rather than the artistic ghetto of Montmartre, that gave the magazine its *ésprit boule-vardier*, that brought wit and sophistication to counterbalance artistic theory and radical politics, the latter two commonly thought to be total anathema to Henri. This has presented his biographers with the problem of explaining away his attachment to the place. Now that he rarely visited the Moulin Rouge, the offices in the rue Lafitte had some claim to be his main venue for the early part of the evening, before he began the serious drinking that usually ended in the rue des Moulins. It is often stated that he only went to the rue Lafitte in search of amusing company, and that to ensure he would not be bored, usually took along a companion like his cousin Gabriel who, if all else failed, was always good for a little teasing. If that did not work, then, according to these sources, Henri simply slept till it was time to move on. But this attempt to play down his participation in the more serious aspects of the *Revue*'s gatherings goes too far. He could have done his drinking in any of a dozen congenial bars and sometimes did. He was hardly likely to choose the rue Lafitte if he had no interest whatsoever in what was being said there and the fact that some of his more adventurous activities, especially his work in the avant-garde theatre, coincided with this period when he was surrounded by anarchist intellectuals suggests that he was not as indifferent to their talk as is often proposed

Not that we should ever overlook the intensely personal nature of all Henri's arrangements. His attachment to the *Revue* was in large measure due to his close friendship with the Natansons. Thadée had written a highly sympathetic article about his early posters back in 1891, clearly emphasising their superiority over Chéret's efforts. Flattered, Henri quickly progressed from a curious spectator at the magazine's offices to a guest at Thadée's homes both in Paris and in the country, with weekends at La Grangette at Valvins where the artist rapidly followed many of the other contributors by falling hopelessly in love with the beautiful Misia.

Yes, she had red hair and yes, it was another case of worshipping the impossible, another Lily Grenier, Jane Avril, Yvette Guilbert. And as with Guilbert, Misia began by finding her new acolyte somewhat off-putting, the greasy hair, drooling mouth and damp moustaches, the domineering manner and the bullying of chosen victims like his cousin Gabriel and worst of all the constant drinking. But as so often before, Henri's sheer vivacity, both in his creative life and in the unstoppable flow of jokes and pranks soon erased all thoughts of his physical problems. As Thadée put it, 'We didn't even hear him sniff any more . . .' The Natansons ran an open salon with Misia as its

queen and when, on summer weekends, the court moved to Valvins where they had Stéphane Mallarmé for a neighbour, they brought with them the *Revue*'s more amusing contributors, Henri among them. For much of the time this was one of the few gentle, dreamlike periods in Henri's life. Misia was a talented piano player and it was easy to lie back and adore her as she entertained them. She later recalled an idyllic day as she lay on the grass reading, while Henri gently tickled the soles of her feet with a paintbrush.

If nothing else, Henri's relationship with the Natansons lays to rest any suggestion that he shared the unthinking anti-Semitism that infected so much of the French upper class. For Henri the Natansons' Jewishness was never an issue. Of course, on occasion there were frictions – a drunken Henri crudely trying to seduce the Natansons' maid, or baiting Mallarmé by suggesting that the initials SM painted on his boat stood for *Sa majesté* and on one visit dressing up as a joke king in a bathing costume and paper crown, an impertinence the somewhat sensitive poet never forgave. But these were no more than the ups and downs of any close relationship and for the first time in his life Henri seems to have found a social milieu that was every bit his own, rather than one imposed by his background. As his biographer Julia Frey succinctly put it:

> Here at the centre of the privileged world of well-to-do bohemianism in Belle-Epoque Paris, in this odd mixture of elegance, beauty and snobbishness, of intentional marginality, Jewish intellectualism, internationalism and high living, Henry at last found a meeting of his two worlds, and he felt very much at home.

He painted at least six portraits of Misia, which puts her near the top of the list of frequent subjects, though her importance is somewhat diminished by the unusually gentle way he handled her. This is apparent in the poster for the *Revue* which he made at Thadée's request and which was simply another portrait of the beloved at her most beautiful. He is said to have based the image on an earlier scene of Misia out skating, though as he cut her off at the knees all we see is a dream figure drifting across the picture space. Unfortunately, this romantic interlude is far less interesting than his usually tough view of life which rather negates Misia's role as a muse. So, too, his work for the *Revue* itself was less incisive than normal. At the time he was still producing the last of the brothel and lesbian paintings and all his energy seems to have been directed towards those seminal pieces, whereas

his work for the magazine was generally in response to requests to illustrate articles or to produce versions of work already done in other mediums. He did produce a small number of original pieces both for the occasional illustrated supplement and for the magazine's humorous sister-paper *NIB*, a slang word meaning 'nothing'. There were also a number of little drawings and decorative tail-pieces but the importance of the *Revue* had less to do with his contributions than with his contacts with his fellow contributors, and it is not hard to draw a link between those early evenings in the rue Lafitte and the work he would produce nearby in the rue des Moulins later that same night. There is a sense in which the talk at the offices of the *Revue* played the same role in his art as Bruant's songs had done earlier, and the art of the brothels, of the *visite médicale*, and the private lesbian life of the prostitutes he had befriended, were in many ways the result.

Henri's rapid sketch of Fénéon
who later gave it to the American art
historian John Rewald.

But the most obvious effect of his connection with the *Revue* on Henri's art was his increasing interest in avant-garde theatre. Until then, his association with the subscription clubs that put on radical new plays had been almost entirely passive. In 1893 André Antoine had borrowed one of his paintings to hang as part of the décor for his production of *Les amants eternels*, a play based on Shakespeare's *Romeo and Juliet*. He had then commissioned three posters from Henri, but these seem to show that he was more interested in the audience than the actual productions – in the last poster for Antoine, Conder and a woman who could be Jane Avril are watching *Le Missionnaire* from a box with no hint of what the play was about. Left to himself, Henri's theatre-going was largely confined to slightly upmarket boulevard productions like Hervé's *Chilpéric* which he saw over twenty times, though this had less to do with the actual piece than with his fascination with the anatomy of its leading lady, Marcelle Lender, telling his friend, the author Romain Coolus, that he had come, 'so I can see Lender's back. Look at it carefully. It's rare to see anything so magnificent. Lender's back is a feast.' This hardly indicates much concern for the theatre as such and it is indeed Lender's magnificent back that features most prominently in several of the studies he made of her, though at least he was now looking at the stage rather than the audience. It was only after he joined the group at the *Revue* that he evinced any interest in the plays themselves and even then there was a good deal of innate resistance to be overcome. Henri once joked that avant-garde theatre consisted of actors performing with their backs to the audience, and on occasion he wasn't exaggerating.

It was only out of friendship that he allowed Gauzi to take him, in June 1892, to Edouard Dujardin's Symbolist play *La Fin d'Antonia*, a work intended to portray the author's 'belief in humankind's eternally tragic fate', by suggesting 'that man's earthly lot is to suffer and women's is to betray'. Fortunately for Henri the audience rioted, forcing Dujardin to get up on stage and announce that most of them hadn't paid anyway and that they had better leave. The theatre promptly emptied though the evening had at least allowed Henri briefly to observe the actor who would play a large part in his forthcoming theatrical life, the future director Aurélien Lugné-Poë, who was about to open his own group, the Théâtre de l'Oeuvre.

It was Henri's friendship with Félix Fénéon that prevented him from completely rejecting such difficult stuff. When Lugné-Poë launched the Théâtre de l'Oeuvre, many of the *Revue*'s regular contributors lent a hand, and the close connection between the *Revue* and the company can be seen in a page of Pierre Bonnard's sketchbook in which he shows, in strip-cartoon

manner, a typical day with a rehearsal of a Lugné-Poë production with Bonnard and others painting the sets at the top of the page, while along the centre are the rue Lafitte offices with Fénéon hunched over his editing and the lovely Misia framed in the doorway, and along the bottom, the view of Paris from the artist's studio. But the strongest link was Fénéon who found in the theatre yet another outlet for his political beliefs – given the close links between the company and the *Revue*, it was inevitable that the Théâtre de l'Oeuvre would be yet another anarchist enclave. In 1893 Lugné-Poë moved his group into the Bouffes du Nord, a dingy run-down theatre in the seedy working-class district around the Boulevard de la Chapelle, but his opening season coincided with Vaillant's assault on the Chambre des Deputés and when the police discovered that one of his new plays had been translated by a Dutch anarchist who had been arrested in the mass round-up, and that many of the writers working with the group, among them Fénéon, Tristan Bernard and Henri de Régnier, all had police dossiers stuffed with evidence of their anarchist sympathies, they began to make life difficult for the director. He survived because his subscribers were drawn from the ranks of intellectuals, writers and artists who could be extremely noisy in defence of their rights. The support of this small but vocal group ensured that the opening nights at the Théâtre de l'Oeuvre were the principal meeting place for the city's creative élite where famous figures like Emile Zola, Puvis de Chavannes, Pierre and Marie Curie rubbed shoulders with the scruffiest unpublished poets, for Lugné-Poë usually helped his younger sympathisers by giving away tickets to the gallery which made it a battlefield of conflicting theories and sympathies. Half the spectacle at the Bouffes du Nord was the audience with its noisy partisan support or violent opposition to whatever was on offer. On the notorious evening when actors mimed *La Gardienne*, Henri de Régnier's poem set to music, the poets in the gallery broke into ecstatic applause, while everyone else fell about laughing. In a sense the police had been right: it was anarchy writ large and there was no doubt that the company's founder intended such works not only to transform French theatre but also to change the world outside, that for Lugné-Poë, the whole experience – the play and those who watched it – constituted a radical political act.

Aurélien Lugné, as he was known when he started out, was about the same age as Henri. They just missed each other at the Lycée Condorcet, but were soon following the same path into the world of Bruant and Guilbert, of Le Chat Noir and Le Mirliton, that seems to have provided Lugné with the sort of influences that freed him from the rather drab and empty works then

on offer in the main theatres of the capital. After playing bit-parts in anything that was on offer, he worked with Paul Fort then set up his own company offering works that would make theatre as adventurous as writing and painting had become, bringing back to the stage all the things the bland productions of the boulevard theatres shunned – poetry, spirituality, politics. To Aurélien Lugné the theatre was only marginally a place of entertainment; for him it had a crucial role to play in the way his audiences perceived society and their own role in it. At its best the theatre dealt in heightened emotions and profound debate.

With all this in mind, it was only to be expected that Aurélien Lugné would want to get beyond the naturalist plays that Antoine and Fort had promoted. From its inception the Théâtre de l'Oeuvre was planned as a home for Symbolist theatre – mystery and poetry would be its stock-in-trade, as proof of which Lugné adopted the name of the American author revered by French Symbolists and, as Lugné-Poë, set about recruiting avant-garde artists and poets to bring to the stage the sort of excitement and controversy found in galleries and little magazines. He was helped by his Lyceé Condorcet connections – the painter Maurice Denis had been a fellow pupil and the group of painters, the Nabis, that he had helped form, with their interest in the religious art of the Middle Ages, in Celtic mysticism, in Russian icons and Eastern spiritualism, provided the exotic visual imagery Lugné-Poë needed, as he scoured the dramatic heritage of the world, looking for works that would make the theatre a profound religious experience, something that had been lost when plays became nothing more than amusements. In 1894 he decided to revive a thousand-year-old Hindu drama, *Le Chariot de terre cuite* (The Little Terracotta Cart), commissioning a new version from the writer Victor Barrucand who in turn enlisted Fénéon to help edit the final text, a decision that guaranteed that the play would pass from the realm of religion into that of radical politics. One evening, while they were collaborating on the play, Fénéon went to the Nouveau Théâtre in Pigalle, another shabby old playhouse where Lugné-Poë had recently moved his company, and realised that he was being openly trailed by a couple of plain-clothes policemen, a frequent occurrence in the year following his trial. Seeing his predicament, one of the actresses, Barrucand's mistress, Hedwige Morre, gave him the keys to her dressing room, then Lugné-Poë kept them talking while Fénéon slipped into the theatre to enjoy the performance alone. The following day the police took their revenge by raiding the theatre and disrupting the performance but this petty attempt at persecution only gave Lugné-Poë the idea of cocking a snook at them all by giving Fénéon a promi-

nent part in the new play – a gesture guaranteed to infuriate their political opponents.

At all levels *The Little Terracotta Cart* was one of Lugné-Poë's most outrageously radical productions. Barrucand himself held such *outré* political views that the word anarchist was hardly sufficient to contain them. The hero of his novel, *Avec le Feu*, set during the uproar following the executions of Vaillant and Emile Henry, appears to lead the life of a cultivated, hypersensitive anarchist sympathiser of the time, filled with the sort of loathing of bourgeois society then common among the city's intellectuals, yet in the end he fails to act out the Propaganda of the Deed by setting off a planned explosion and instead chooses to commit suicide, a cynical, despairing view of life, and at odds with the central anarchist tenet that human beings are essentially good and, if permitted, will act in ways that benefit all. Many of Barrucand's political positions have a charmingly antiquated feel. In an 1895 article in the *Le Revue blanche* he made an eloquent appeal for the resurrection of the movement for *le pain libre*, the demand for free bread which had been one of the rallying cries of the original Revolution a hundred years earlier. The following year he published a collection of articles on the subject with contributions from Georges Clemenceau and Kropotkin and distributed a poster, 'Give us this day our daily bread', to every commune in France for the municipal elections in May.

Perhaps through Fénéon's influence their translation of the play was closer to the basic anarchist belief that 'nobility of soul can triumph over social injustice'. The complex ten-act drama had many twists but its central theme was the rejection of material wealth and the conquering of human failings. This was incarnated in small incidents such as the one from which the play takes its title, where the heroine Vasantesana, a rich courtesan in love with the saintly Charandatta, proves her goodness by surreptitiously slipping her jewels into the humble toy cart of a poor child. On a wider scale, the heart of the plot is the attempt by the evil Samsathanaka to murder Vasantesana and blame Charandatta in a bid for power which fails when the heroine survives. The climax of the piece is the moment when Charandatta forgives his enemy and evil is banished.

In essence this was the play as Barrucand found it, though he was unable to resist adding a few details of his own, turning Charandatta, as one critic noted, into a latter-day Emile Henry who nobly spurns all political advancement. This contemporary spin on the ancient text was much reinforced by the presence of Fénéon, who opened the play standing before the curtain in a long blue robe, intoning words of welcome, and closed it in a white toga,

arm raised as he solemnly pronounced an ancient blessing: 'May the bene-
diction of Sambu protect you.' When he had finished he strode away to wild
applause which, as one sour critic huffily noted, was due more to his earlier
role in court than to his talents as an actor. In fact, as Lugné-Poë hoped,
many in the audience had come to see him perform, though to forestall any
problem with the police Fénéon's name had been carefully omitted from the
programme. Lugné-Poë got round this by having Henri design a playbill in
which a figure in a toga, with hands raised, has Fénéon's unmistakably
narrow profile and goatee beard though, unable to resist a joke, Henri set
Fénéon on top of a column held on the back of an elephant that bore more
than a passing resemblance to the gargantuan pachyderm in the gardens of
the Moulin Rouge.

But that small joke aside, it is clear that Henri was seriously involved in
one of the most radical productions of the decade. Lugné-Poë had asked him
to work with his designers Louis Valtat and Albert André on the décor and
while there is no record of the precise division of labour, we know that Henri
was mainly responsible for the backdrop for Act Five, which again contained
the elephant, on the left, with a flowering cactus on the right. Poor lighting
meant that little was seen of either sets or backdrop and there are sadly no
existing sketches or designs, though Lugné-Poë later recalled that a superb
model survived for some years. One critic praised what he called the sombre
and luminous scenery, congratulating the director on achieving such
surprising results on so limited a budget. What he could not have known was
just how limited that budget was. For the opening night there had been
insufficient cash to buy enough material for the scanty loin-cloths and
turbans needed in the final crowd scene, leaving many of the actors either in
nothing but skin-coloured slips, or loosely wrapped in wisps of brightly
patterned cloth. As they were covered in overall ochre body make-up the
impression was that they were naked, an effect which entranced some and
scandalised others. One actor, having stepped on stage, suddenly realised
that the little square of tissue he had been handed failed to cover his essen-
tial parts and promptly sat down with his back to the audience, delivering
his lines over his shoulder, confirming Henri's worst suspicions about pro-
gressive theatre. Commenting on this mêlée of brightly coloured scarves, one
press report accused the director of raiding the flea-market or – interesting-
ly – the rue du Caire at the last Universal Exhibition. Of course reactions
were mixed – the ever venomous Jean Lorrain thought the play boring and
childish, while more supportive commentators thought Barrucand's version
superior to an earlier translation by Gérard de Nerval which was merely

Programme for *Le Chariot de terre cuite*, with Fénéon on top of the elephant from the gardens of the Moulin Rouge.

poetic, whereas this new version succeeded in making the ancient text more relevant to modern life. The aim of Sanskrit theatre and thus of Barrucand's adaptation was to evoke an emotional response rather than a cerebral analysis and, despite its sillier moments, the opening night was undoubtedly one of the great electrifying events in theatrical history whose effects have persevered to the present day, as seen in productions such as Peter Brooks' *Mahabharata*, which was produced at Lugné-Poë's old theatre, the Bouffes du Nord. At the time, this seemingly obscure piece of ancient verse drama established the Théâtre de l'Oeuvre as the leading avant-garde group in Paris, enabling Lugné-Poë to raise the finance needed to plan a long-term programme of productions with Henri de Toulouse-Lautrec on the sidelines eager to take part whenever possible.

One result of the production was to draw Victor Barrucand into the inner circle at *La Revue blanche* when he agreed to collaborate with Fénéon on a column entitled *Passim*, offering snippets of information and witty commentary on current affairs which they signed with their initials, V.B. and F.F. What made their bi-monthly effort so different was that they avoided the sort of artistic and literary chit-chat that Fénéon had provided in his previous magazines. Instead, they concentrated on politics, though even here they plumbed unusual depths by including items on France's burgeoning colonial empire, a subject not much covered at the time and certainly not, as *Passim* endeavoured to do, from the standpoint of the ignored colonial peoples themselves. With his usual perverse humour, Fénéon (his pieces are identifiable by their sharp satirical edge) persisted in returning to the war of conquest then taking place in Madagascar, surely France's most remote imperial battleground and one which left most people completely indifferent. But that was to prove the column's strength: the capacity of both its authors to touch on subjects far removed from the normal concerns of the popular press. One of their earliest columns, in January 1895, referred to the 'lynch-trial' of a Captain Dreyfus, a member of the General Staff who had been court-martialled for passing secrets to the Germans. Found guilty of treason, Dreyfus had been subjected to public degradation and deported to Devil's Island. Given all that was to follow, the huge scale of the *Affaire* as it came to be known, one might think it only reasonable that *Passim* should have leapt to the defence of this victim of a gross miscarriage of justice, but at the time only a handful of astute observers like Fénéon and Barrucand had any notion – and they were only guessing – that the poor man was innocent. Most assumed that he was guilty and had been justly sentenced – the Minister of War thought so, and he had seen the secret file containing the proof of Dreyfus's guilt. True, the defence had been denied the chance to see these papers but who could doubt the country's leading generals when they insisted that all was well and that the judgment was sound? Even the radical Socialist Léon Blum, who would later be one of the leading campaigners to free the prisoner, declared himself startled when he first heard a friend insist that there had been a miscarriage of justice. At the very start of the investigation when it was first discovered that there was a spy at the heart of the General Staff it was perfectly reasonable that Captain Dreyfus should have been among those investigated. The subsequent tragedy arose from the erratic behaviour of one of the investigators, a Major Hubert Henry, who was motivated partially by an antipathy towards the captain, a cold, withdrawn character, unpopular with his fellow officers, but more by the fact that

Le Petit Journal

SUPPLÉMENT ILLUSTRÉ

Le Petit Journal
Le Supplément illustré

Huit pages : CINQ centimes

ABONNEMENTS

DIMANCHE 13 JANVIER 1895

Numéro 217

The degradation of Captain Dreyfus, 1895.

Dreyfus was a Jew and thus, to a man like Major Henry, not really French.

Too much has been made of the notion that Dreyfus was a solitary Jewish officer in an overwhelmingly Aryan army. In fact there were hundreds of Jewish officers and as many as ten Jewish generals in the upper ranks – a

percentage of their community rather higher than for other minorities. There had in any case already been a Jew on the General Staff before Dreyfus arrived and initially at least his Jewishness was not seen as an important factor in the affair – early newspaper reports failed to mention it. But this increasing Jewish presence in the upper échelons of the nation's most powerful élite was not matched by an equal acceptance in society as a whole. Goaded by the new mass-circulation newspapers, themselves led by openly anti-Semitic publications such as the *Libre Parole*, which was now advocating the deportation of Jews 'back to Jerusalem', a good deal of the press was only too willing to play on popular prejudice so that as the *affaire* trundled on, Dreyfus became the most spectacular victim of the new yellow journalism, with senior officers and government ministers afraid to consider the little captain's innocence lest they expose themselves to attack by gutter journalists. When Major Henry could find no evidence to incriminate his victims he simply invented it, crudely forging letters and adding more when these proved insufficient, helped by the most bizarre character in the whole affair, a fellow major, Count Walsin Esterházy, an implausible character like something out of a Victor Joze novel, who it later transpired was actually the guilty man. Recently married and deeply in debt, Esterházy had simply gone to the German legation and handed over documents for cash.

At the outset, Major Henry's superiors saw no reason to question his assertions of Dreyfus's guilt and when they did eventually examine the secret file and realised the truth, they considered it impossible to back down without damaging the army's reputation, its lofty status as the soul of the nation, the very embodiment of France, and so a cover-up began that eventually produced a web of intrigue and deception that enmeshed the entire country. At the time of the trial, none of this was known outside the inner circles of the army command. To those on the right, Dreyfus was the outsider, the Jew, but there were many on the left for whom he was part of the enemy bourgeoisie, and a soldier to boot, and only an insignificant handful of outsiders, men like Fénéon and Barrucand, who trusted no one and doubted everything, were sufficiently bloody-minded to begin the long, slow process of chipping away at the impenetrable wall of lies that had been erected around the sad little man, rotting on a barren island off the coast of South America.

It would be four years before the demand for *Révision*, a review of the case, rose to a clamour that divided the nation and provoked Emile Zola's famous newspaper article accusing the army of falsifying the evidence to mask a gross injustice. Only in 1898 did the *Affaire* explode into the most destructive quarrel France had endured since the original Revolution and

only in 1899, after Major Henry had shot himself and Esterházy fled to England, was Dreyfus brought back for a second trial where again the army was able to ensure another conviction. Only a new President, Emile Loubet, aware of how divisive the issue had become, felt able to pardon the innocent victim of this black charade and a further trial in 1904 finally quashed the original verdict and declared Dreyfus completely innocent. And yet, one cannot repeat too often how rare were the voices raised in his defence when he first stood in the dock, vilified by his fellow officers and reviled by a good part of the nation, with even a majority in the Jewish community convinced of his guilt. Back in 1895 *Passim*, with Fénéon and Barrucand, was almost alone in calling attention to the travesty of justice that had just taken place. And not only Dreyfus – as 1895 unfolded *Passim* began to include comments on another notorious trial that was starting across the Channel, the arraignment on charges of gross indecency of Oscar Wilde, though as with the Dreyfus case, there was little to indicate when the process began that the consequences would be quite so devastating.

Much of Wilde's present difficulties arose from a trip to Paris in early May of that year for a reconciliation with Lord Alfred Douglas. Bosie had threatened suicide if Wilde refused to join him. Had Wilde followed his best instincts and the advice of his friends, he would have continued to avoid the young man whose recklessness threatened to destroy them both. If they had remained apart, Wilde might have evaded the nemesis that awaited him. Following their reunion in Paris there was no going back.

The two were again inseparable after their return to London, where close friends warned Wilde that his relationship with Bosie was now too obvious for safety. We may presume that this was also clear to Lautrec when he saw Wilde on one or both of the trips he made to London that year. Conder, who had recently settled in England, acted as guide and as he was now a part of the group that gathered at The Vale there were frequent opportunities to encounter the playwright and his indiscreet lover. On one of their trips, Lautrec and his companion Joyant went to see Whistler, riding through one of the famous London fogs to his house in Chelsea. They met in his studio, where Whistler was working on a painting of two women in kimonos on a balcony, which to the visitors had echoes of Utamaro's *Princess from the Land of Porcelain*. Whistler invited them to the Café Royal, Wilde's preferred drinking place, where the American ordered an elaborate French meal which was a total failure. In exchange, Lautrec invited Whistler across Piccadilly to the Criterion where he carefully chose an English meal of roast

beef, which was excellent. At some point he made two studies of Whistler and must have done the same with Wilde, whose appearance had completely changed since his early days in Paris. A naturally big man, Wilde was now fleshy and bloated – just as Lautrec would paint him the following year, perhaps using sketches made at this time.

Henri was back in London later that year for an exhibition of posters at the Royal Aquarium Gallery that a fellow pupil from Cormon's, A. S. Hartrick, had helped organise. This opened on 23 October and was the first time in England that a gallery exhibition had been devoted to the humble poster. A land of wonderful illustrators, especially of children's books, this talent had not yet passed into the making of large advertising design as it had in France. Chéret's work was already known in London and he was praised in the catalogue as 'the Coryphaeus of this modern art'. Henri had already completed a few minor commissions from British companies and it was one of these designs, *Confetti*, a small poster made for the paper manufacturers J. and E. Bella, that was used for the title page of the catalogue which also included an article in which Henri was said to be 'pre-eminent among younger men'. Edward Bella was London's leading print-seller and his article in the catalogue and others by Charles Hiatt in *The Studio* did much to encourage collectors of what was now seen as a new art form. While this gave Henri an expanded reputation across the Channel, this was, as in France, initially based on his light-hearted 'commercial' work rather than the more disturbing paintings that would only appear in London four years later.

Whether all the junketing surrounding the opening left Henri any chance to see much of Wilde is hard to say. In any case Oscar and Bosie were now faced with Queensberry's furious attempts to provoke them into some sort of action. That June there was an incident at Wilde's home in Tite Street when he was forced to evict the Marquess, who had stormed in, ranting abuse and threatening violence. It was now clear that it was only a matter of time before a more public encounter would bring their quarrel into the open.

There was one last time when Lautrec could have sketched the doomed author, some time in January the following year, 1895, when a solitary Wilde passed through Paris on his way back from Algiers, where he had left Bosie chasing Arab boys. Wilde had just manoeuvred the formerly virginal André Gide into his first homosexual liaison, an encounter with a young flautist in a café in Blida. Wilde is said to have asked the confused Frenchman, 'Dear, *vous voulez le petit musicien?*' to which Gide could barely cough out the word yes, whereupon Wilde, in the account Gide later wrote, burst into satanic laughter.

Back in London, Wilde's latest play *The Importance of Being Earnest*, appropriately about the need for disguise and deception in human relations, opened on 14 February at the St James's Theatre, after which the laughter died away and his life resumed its ineluctable trajectory towards disgrace and punishment.

The dénouement began on the evening of 28 February 1895. Wilde had been to The Vale to see Ricketts and Shannon and the others, unaware that it would be his last visit. On his way home he called at his club, the Albemarle, where the hall porter handed him a card that had been left for him ten days earlier by the Marquess of Queensberry. The handwriting was bad but it appeared to read: 'Oscar Wilde, ponce and somdomite', the Marquess was no speller, though in fact the phrase, while no more literate, was actually: 'To Oscar Wilde posing Somdomite.' The rest is so familiar it can be recounted in telegraphese: Wilde reluctantly allows Bosie to persuade him to sue their tormentor for libel, having lied to his lawyer that there was no truth in the accusations. The Marquess is arrested, charged and brought to trial on 2 March, whereupon he produces a string of rent-boys to testify to Wilde's activities, obliging him to drop the case and exposing him to arrest and prosecution. The following day, Saturday 6 April, 1895, Wilde was taken to Bow Street police station, where he was charged with offences under the Criminal Law Amendment Act of 1885. Bail was refused and he was returned to Holloway, then a men's prison, where he would stay until his trial.

That same day, in Paris, Henri de Toulouse-Lautrec received a brief letter, which, to his surprise, was signed by his old acquaintance, the dancer La Goulue, hardly the sort of person he would have expected to write to him:

MY DEAR FRIEND,
I will call on you on Monday, April 8 at two o'clock in the afternoon. My booth will be at the Trône Fair, at the left as you enter; I have a very good spot and I would be very happy if you have the time to paint me something. Just tell me where to buy the canvases and I will bring them to you the same day.

Henri was no doubt amused at the aristocratic disdain with which the fading dancer treated him in her short missive. It was nearly four years since he had painted her, in her prime, yet she clearly assumed that he would do the work, and for nothing, though she did agree to provide the materials.

401

The writer Jacques Lassaigne once referred to her haughty manner: 'With her firm chin, her halo of red hair and the very distinctive carriage of her head, she has that innate nobility which belongs to the women of a people of ancient lineage.' Henri would not have disagreed, nor would he have been offended by her demands, given that the only aristocracy he now acknowledged was that self-elected clan of night creatures with whom he had chosen to live and among whom La Goulue, for all her physical decline, was still something of a duchess. She had also made a lot of money from her act and it was rumoured that she had thousands of francs stashed away, ready to invest in her new routine. There is no doubt that performing in a funfair was something of a comedown after her glory-years at the Moulin Rouge but Louise Weber was a hard-nosed, working-class woman not given to crying over the past. For Louise, it was always the next show that mattered. In any event she and Henri met as requested, he agreed to help and thus began one of the strangest commissions of his entire career.

The booth that the dancer referred to in her letter was to be set up at the enormous funfair, the Foire du Trône, that was held every year in the three weeks following Easter Sunday in the large Place de la Nation to the east of the city. This had once been the Place du Trône, hence the abiding name of the fair, though some still referred to it by the even earlier Foire au Pain d'Epice (the Gingerbread Fair). Given what La Goulue was planning, it is amusing to realise that the first fair had been organised by local nuns at Easter 1719, but the event had quickly lost its religious connotation as the Foire du Trône grew into one of the largest open-air *fêtes* in the capital, with switchback rides, freak-shows and booths stretching down the long avenue that led to the Bois de Vincennes. To take in the whole fair was exhausting and she was right when she told Lautrec that she had found a good spot near the entrance where the new arrivals would be eager to join the fun. Whether her idea would draw the crowds was less certain. As Lautrec now learned, she was intending to recreate the *Danse à l'Almée*, the uniquely Egyptian form of the belly-dance, which she had first performed at the Elysée-Montmartre in 1890 and later at the Moulin Rouge where it had remained part of her act for nearly two years.

Now she proposed to restage it, with a troupe of five or six younger dancers to support her, no doubt hoping that so much movement would distract from her increasing bulk. She was, however, enough of a show-woman to know that she must have something eye-catching to attract passers-by, and for that she needed the help of the man who had followed her act night after night in the years of her glory at the Moulin Rouge.

As she described it to Lautrec, the actual construction of the booth was a fairly compact affair. She had had a frame built, nine metres wide by seven deep. On the outside would be a wide, arched entrance topped with a cut-out Moorish dome, under which was the opening, reached by five steps, while on either side would be the panels, each three metres square, made up of the canvas she had brought which Lautrec was to stretch and paint. As Easter Sunday fell on 14 April in 1895, he had only six days in which to complete a very large task. That he chose to do so, when he had a great deal else to get on with, is the first sign that he looked on this commission as more than a mere helping hand for an old friend.

We also know that he finished the work on time and that it achieved just what the dancer wished as the canvases were mentioned in several of the newspaper reports of that year's fair, with one highlighting the 'shrieking colours' and saying, enthusiastically, how good it was 'to see someone flouting the public'.

All La Goulue had wanted was something eye-catching – like her Moulin Rouge poster; what Henri knew was that the great Paris funfairs had a tradition of offering spectacles based on current political events. That year, the Foire du Trône included an enormous diorama showing the assassination of President Carnot in gory detail, while some of the gingerbread figures on sale were decorated to look like General Boulanger. If one hoped to grab attention, then some sort of topical incident or recent scandal was the way to do it. Henri's solution was to create two scenes that look superficially similar, but which are in fact quite different. On the left-hand panel he painted precisely what La Goulue wanted to see, the event made familiar by what are now his most famous paintings: a performance by La Goulue and Valentin le Desossé in a dance hall that is a mix of both the Elysée-Montmartre and the Moulin Rouge. As we look at the left-hand panel, the angle is such that we, the spectators, appear to be on the dance floor just below the raised orchestra podium, as we would have been at the Elysée-Montmartre, looking up at the Elysée's regular conductor Louis Dufour, waving his arms in time to the music. Yet we can tell that this is also meant to be the Moulin Rouge from the bursts of light around the top of the canvas, a memory of the exciting new-fangled electric illumination that Oller and Zidler had installed when they first opened in 1889. At the centre of the picture La Goulue and Valentin go through their routine while to the extreme left, almost cut off on the edge of the canvas, is the comic figure of Coutelat du Roché, old 'Father Modesty', rosy-cheeked with excitement or indignation, still pretending to check out the dancer's underwear. Watching the

performers are some of Lautrec's friends: Jane Avril, Maurice Guibert, Cha-U-Kao and Maxime Dethomas. Their presence suggests that this is one of his 'summary' pictures, like the *Moulin de la Galette*, the *Ecuyère, Au Moulin Rouge* and *Au Salon, de la rue Moulins*, meant to catalogue one of his *furias*, in this case his one-time fixation with La Goulue, the Moulin Rouge and the *quadrille-réaliste*. There is nothing difficult about the scene, no subtext, it is an *hommage* made to help an old acquaintance – they had never really been close friends, but she had played a vibrant role in his past and this was his gift for the pleasure she had brought him.

Which makes the right-hand panel all the more peculiar. At first glance we seem to be getting more of the same – though clearly there has been some attempt to bring the action up to date by showing passers-by what they could expect to find inside the booth. This time La Goulue dances alone, on some sort of raised stage, while behind her sit two figures in oriental costumes: a man in a turban playing a hand-drum, and a woman with a tambourine. This is the new *Danse à l'Almée*, though the musicians and the image of a crescent moon in the backdrop are the only exotic touches – La Goulue is clearly high-kicking her way through the can-can, much as if she were still at the Moulin Rouge. We know this is not how it was, for there is a surviving photograph of La Goulue dressed rather like the illustration in *Le Monde Illustré* of Aiousche in the rue du Caire, from which La Goulue's costume had probably been copied. Of course, in the rush to get the paintings done, Lautrec would not have seen the new routine though he must have remembered what she looked like when she performed the belly-dance three or four years earlier. In any case he had seen the dancers at the Universal Exhibition and versions of the dance were not uncommon after 1889, usually performed by what were sometimes described as 'pseudo-oriental tarts', street-girls who dressed up in vaguely Arabic costumes to entice their customers. Lautrec had two such among his extensive entourage of prostitutes who went under the working names of Kouloudja and Alida, and whose pitch was the Boulevard de Clichy – perhaps one of them was the model for the woman with the tambourine? But the fact that he chose to show La Goulue in her old familiar routine, suggests that while he was happy to oblige her with some large-scale decorations, the scenes depicted on the two panels were personal to him, and their significance had more to do with his private preoccupations than with her new show.

It is obvious that while Henri began with the intention of depicting what the show might look like, he quickly abandoned the plan and went off at a tangent. How else can one explain the pianist to the left of the stage, dement-

edly banging out a tune which would hardly have been needed given the presence of the Arabic orchestra? The pianist turns out to be none other than Louis Tinchant, the composer who played the piano for the early cabarets in the old days at Le Chat Noir. Tinchant, a hopeless alcoholic, had died six years back in 1889 – though in a way that may explain his presence for just below him are Henri's closest drinking friends, again the wine merchant Maurice Guibert with Henri's cousin Gabriel Tapié de Céleyran, a combination representing Henri's worst excesses, the constant drinking that he was no longer able to control.

Just below them, on the bottom foreground of the picture, we have Wilde on the left in lost profile – the puffy, debauched Wilde that Henri must recently have sketched either in London or Paris – and over on the far right in full profile, Félix Fénéon, watching the proceedings with his usual expressionless detachment. Between these two 'jailbirds' are Jane Avril and Henri himself, as if they are a bridge, uniting such strange characters, which is not far from the truth, though why they are all there is not immediately obvious. Two simple explanations are usually given: that their presence was simply a joke on Lautrec's part – they had both been in the news and were bound to attract attention which was just what his patron needed; alternatively they were put there for purely formalistic reasons – the artist needed an emaciated figure like Fénéon on the right to counterbalance the skeletal Valentin on the left, while the plump Wilde in the centre, anchored the whole thing down. Both could be part of the explanation, but from what we know of Lautrec there had to be more to it than that. If the left-hand panel offers a memory of the past, an image of what most people believe to have been his glory-days, then the right-hand panel offers another reality – Guibert's mad, wide-eyed stare, Tinchant's crazy tune, La Goulue's frenzied dance, the suggestion of drinking and excess tell of a world going wrong. Even Fénéon, an unflappable figure whom Henri often referred to as 'the Buddha', becomes a satanic ogre with sickly yellow hair and beard, a message rammed home by the presence of Wilde teetering on the verge of ruin even as his portrait was being painted. The irony of the now openly homosexual Wilde ogling the rippling female flesh of the well-endowed La Goulue was no doubt intended to amuse – though Henri may have expected his audience to connect this with the well-known spectacle of the transvestite belly-dancers on the Boulevard de Clichy or even with Wilde's recent visit to Algeria as his activities there had been the subject of considerable gossip among their circle in Paris. This was certainly the conclusion of the critic who mentioned the panels in his report on the opening of the fair in *La Vie Parisienne*: 'The

colours are crude, the drawing incredible, but it is really amusing and the artist has indulged himself in a touch of irony by putting Oscar Wilde in the foreground.' But despite these sparks of humour, the right-hand panel is an oddly dour scene, frantic yet lowering, the foreboding reinforced by Fénéon's icy stare, surveying the scene as if trying to find the succinct phrase that will sum up this sense of impending collapse laid out before him.

As far as La Goulue was concerned, any 'interpretations' were irrelevant. The panels showed her in her glory, watched by some strange characters who meant nothing to her. The press had taken notice and that was what mattered. She may not have had the figure for the belly-dance but she knew how to put on a show – the interior of the booth was not only lit by gas lamps but had a number of projectors with revolving discs worked by electricity which provided shimmering light effects to distract from her ungainly form.

While there is no precise record of the performance when she first opened, she did go on reviving it for years and a description of *Les Danseuses orientales* by André Warnod in his account of life in Montmartre, *Bals, cafés et cabarets* published in 1913, does sound almost identical to La Goulue's show. Warnod describes going into a booth, with a gilded entrance, covered in Moorish designs, where three dancers in Arabic costumes – two very fat, one younger and thinner – attracted clients with guttural ululations accompanied by a tinny piano. Past the entrance, twenty spectators were crammed into a tiny space scattered with cushions and mock-Persian rugs. The women's costumes were flimsy enough to reveal their pendulous breasts and as an opener one of the fat women undulated a monumental stomach and after finishing this brief routine, informed the watchers that if they would each pay two francs, she and her colleagues would dance naked. As Warnod wryly notes, only an English visitor was willing to pay more, so the second fat woman began to wiggle her stomach until more of the spectators agreed to join him, at which point the women disappeared behind a curtain. Warnod records how he expected nothing to happen, as it was not unusual for the gullible to be tricked out of their money in this way. He was too cynical. This time the younger woman reappeared, lowered her tunic from her shoulders and hoisted her skirts up to her waist revealing everything save her final intimacy, which was protected by a *cache-sexe*. The piano struck up, she weaved about to the music, rotating her hips in an attempt at voluptuousness until the music ended and she flicked up her skirt one last time and stamped her foot. That was it. The customers filed out, each placing a coin on the edge of the stage. It was a far cry from the heady excitement of the Moulin Rouge where the quadrille had offered vigorous athleticism and

the true eroticism that comes from a tantalising glimpse of the forbidden, rather than the crude display of the obvious.

Lautrec went to see La Goulue's show – he made a quick sketch of her dancing in her diaphanous gown which fails to completely disguise her ample figure, but can only have found her performance a sad decline for a woman who had once been the greatest star in the Montmartre firmament. Despite the cachet of Lautrec's panels, her booth was little better than the freak-shows, the fat ladies and dwarves, the two-headed sheep and the flea-circuses that were a prominent feature of the funfair in those days. Nevertheless, she carried on for nine months, moving her booth from fair to fair – the Foire du Trône at Easter was followed by a period on the Esplanade des Invalides by the Seine, then on to Neuilly to the west of Paris in June. This was the equally famous Fête à Neu-Neu, another vast collection of attractions which ran along the boulevard linking the Porte Maillot to the Pont de Neuilly and which was to the well-off what the Foire du Trône was to the poor on the other side of town. The Neu-Neu was the great end-of-season spectacle, patronised by the fashionable before they left for the seaside in August.

Robert Sherard reviewed that year's fair for an American magazine though he omitted any reference to the booth, presumably to avoid any further mention of his disgraced friend, by then in prison. But we know La Goulue was there because the only known photograph of her booth, with the Lautrec panels in place, was taken at Neuilly. After the Fête à Neu-Neu, the fairground folk continued around Paris ending at La Villette in December though before then, La Goulue had had enough – the newspaper reports may have praised Lautrec's panels but some were less than flattering about the performance that went on behind them. *La Vie Parisienne*, while calling the show 'one of the successes of the year' and rather knowingly praising the charms of the younger dancers whose 'purpose was abundantly clear', went on to refer to La Goulue as 'a bundle of fat with an enormous corporation'. This was too much and by the year's end, La Goulue, whose savings were rapidly disappearing, decided to recoup her outlay by selling off the booth. In February 1896, she placed an advert in the fairground trade paper, *L'Industriel Forain*, which ran for three months, though as this mentioned only the framework of the booth along with the lights we can assume that in her canny way, La Goulue had guessed that Lautrec's panels might have some separate cash value and had decided to hang on to them for a time.

While Lautrec and La Goulue were having their meeting to discuss the panels on Monday 8 April, 1895, an increasingly pitiable Wilde languished in gaol awaiting the long sequence of preliminary legal manoeuvres that preceded the opening of the actual trial. This was eventually scheduled for the 26th of that same month. It was an ordeal he was to share with Alfred Taylor, a young man from a respectable middle-class background, who had nevertheless become a homosexual procurer and who had furnished Wilde and Lord Alfred with a number of transient relationships, accounts of which had already featured in the earlier abortive proceedings. These would now return in garish detail to ensure the popular dramatist's crushing humiliation. By linking the case of Wilde with that of Taylor the prosecution had clearly indicated the nature of the arraignment, which was to be more than the mere ruin of an indiscreet man. Homosexuality itself was to be put on trial and, as before, the outline of the drama is now as familiar as an oft-repeated folktale.

The first trial began on 26 April and ended with a hung jury on 1 May, whereupon the judge ordered a retrial and returned Wilde to prison to await the proceedings. Wilde's attempts to parry the charges with the sort of skilled repartee that Fénéon had employed at the Trial of the Thirty had failed badly, nor had he taken an heroic line by proudly proclaiming his homosexuality and offering himself up as a martyr. Instead he had tried to dissemble and it was only the jury's distaste for the prosecution witnesses, rent-boys and blackmailers, some of whom were being paid by Queensberry, that led to the split verdict.

For a week he was held in prison while his friends attempted to arrange bail though when this was granted on 7 May he found himself pursued by Queensberry's thugs, who made it impossible for him to get a room in a hotel. He stayed at his mother's home until 12 May, when his close friend, Ada Leverson, took him into her house at 2 Courtfield Gardens, in Earl's Court, a then fashionable part of South Kensington.

From his first encounter with them, early in 1893, Ada, along with her husband Ernest, had played a similar role in Oscar's life to the Natansons in Henri's. Ernest was a wealthy diamond broker, Ada a free spirit who would later become a moderately successful novelist. They belonged to the well-connected Jewish bohemia that was fascinated by artistic talent and indifferent to the artist's personal morals. With Ada, his beloved Sphinx, Oscar could talk about beauty and boys, occasionally both. She knew everything about Bosie, she never judged or criticised.

To accept someone so vilified into their home took courage and much was done to keep his presence from prying eyes. The servants were warned and

allowed to decide whether to go or stay, though the coachman was sent on leave, lest he gossip with his drinking companions. Number two Courtfield Gardens is a substantial five-storey building in a secluded side street to the west of a square with a railed communal garden and it was decided that Wilde should occupy the nursery floor, effectively a self-contained flat with three rooms and a bathroom, the rooms full of toys belonging to the Leversons' little daughter Violet and it was there, in that quaint yet utterly incongruous setting, surrounded by Violet's rocking horse and her golliwogs, the dado decorated with a blue-and-white frieze with rabbits and other animals, that Wilde received two unexpected visitors: Henri de Toulouse-Lautrec and their mutual friend Charles Conder.

We know about the visit from a memoir published by Maurice Joyant in *L'Art et les Artistes* in 1927. Joyant had come to London with Henri but was not with them on the day in question. Henri and Conder often went out in the evenings, formally dressed, in search of entertainment, which usually meant a good deal to drink. They arrived back at the hotel in the small hours one morning, clearly agitated, their desire to go everywhere and see everything having been, in Joyant's words, rewarded by a *spéctâcle Shakespearien*. On a whim, they had gone to Courtfield Gardens to visit the man of the moment about whom everyone was talking. Although Wilde's whereabouts were not widely known, there were any number of people at The Vale or the Café Royal who could have told Conder where he was, after which it was just a short cab ride to the Leversons' home.

Not having been there himself, Joyant tries to pad out his account with considerable speculation about Wilde's condition. He tries to deflect any possible criticism of his friend with claims that Henri, with his virile gestures, was a completely different sort of person to Wilde with his tragic *hermaphrodisme*. This amateur psychological profile of the participants is so much waffle; the interesting thing is that at some point Henri asked Wilde if he might sketch his portrait and was refused. Joyant believes that Wilde was too agitated to sit still but it is just as likely that he was fully aware of the artist's tendency to unveil the less endearing side of his subjects and had no desire to be revealed in all his misery. But a portrait was made, and while the process is not absolutely clear from Joyant's account, he suggests that after Lautrec arrived back at the hotel he found a piece of cardboard and, working quickly in watercolours, dashed off the hasty image, which despite the speed of its improvised production remains one of his more remarkable works. What Lautrec offers is the image of a tragic figure, sagging under the weight of his impending destruction. Wilde is cut off at the waist which has

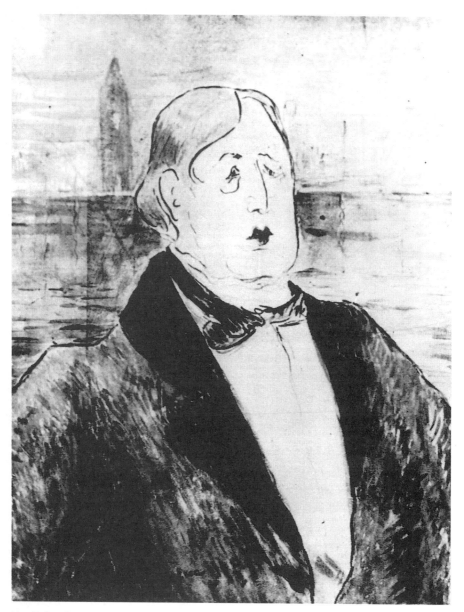

Henri's London portrait of Oscar Wilde.

led some to speculate that the drawing was done in court with Wilde seated at the bar, and while this is unlikely, Lautrec may well have wanted to imply just such a setting. Behind the poet looms Big Ben, the clock tower of the Houses of Parliament, whose illuminated clock-face symbolises the legal authority of the land, the Law which had brought Wilde to his knees, with a

suggestion too of the minutes ticking away as he awaited his crushing sentence. The Houses of Parliament are shrouded in a vague mist which evokes Whistler's river nocturnes, perhaps an ironic reference to the long-standing quarrel between painter and writer. As Wilde may have foreseen when he refused to pose, Lautrec does not flatter him. The bloated features are more the man as he would be after his release from prison, when he returned to France as Sebastian Melmoth, broken in body and spirit. Yet there is still a curious dignity to the effeminate features – the cupid's bow lips, the soft babyish flesh, the over-long hair, as if these marks of his homosexuality were a proud challenge to the harsh forces that had engineered his downfall.

As Joyant didn't bother to record dates we don't know if Lautrec stayed on for the actual trial which began on 22 May but as he makes no mention of what was clearly a sensational event, the likelihood is slight. Lautrec had already made a contribution to Wilde's cause before he left Paris by giving Fénéon a drawing he had made of Wilde as he had seen him when he first amazed Paris, immaculately dressed in tail-coat and buttonhole, and Fénéon used this as an illustration for the first article in support of the doomed playwright, published in the *Revue* on the fifteenth of that month. Written by the novelist Paul Adam, *L'Assaut malicieux* (The Malicious Assault) made the sort of points that Wilde's fellow homosexuals wished he had made at the trial, arguing that homosexuality was less harmful than adultery which the hypocritical Victorians were happy to indulge. Of course such an argument was meant more for the readers of *La Revue blanche* in Paris than for Wilde himself, who was still trying to prove that he was not homosexual and had no need of an article frankly proclaiming that he was, and which was illustrated with a drawing of him at his most elegantly effete. Fortunately that edition of the *Revue* did not arrive in London in time for the trial, though in the end it would probably have made little difference.

When the decision was taken to hear Taylor's case first, Wilde's lawyers knew they stood little chance. Taylor was certainly guilty of criminal acts in procuring young men and coming after him, Wilde was tainted by the evidence, even in those cases where he was not directly involved. The fact that most of the witnesses for the prosecution were compromised – several were blackmailers, others had been receiving money from the Crown to ensure their co-operation – could not hide the fact that under the law as it then stood, Oscar Fingal O'Flahertie Wills Wilde was guilty. Of course the law was unjust, having been slipped through Parliament in a late-night vote only ten years earlier without much debate and seldom employed until this fateful moment. Homosexual practices were common enough among the

411

deeply misogynist upper classes with their segregated schools and clubs and it was noticeable that the prosecution carefully avoided bringing any evidence against Wilde which might have implicated other members of the ruling élite. Thus Lord Alfred's letters were carefully selected as was any reference to Marcel Schwabe, the young man who had introduced Wilde to Taylor, but who happened to have the good fortune to be the nephew of the Attorney-General. Other homosexual figures went in fear of exposure but were duly protected, from Dodo Benson, son of the Archbishop of Canterbury, right up to the august person of the Prime Minister, Lord Rosebery, whose predilections were believed to match those of the disgraced Wilde and who had thought of trying to prevent the trial until he was warned that to interfere would ensure that he lost the next election. As far as the class issue went, the prosecution might seek to condemn him for associating with the lower orders, but they were not averse to calling in servants to support their case, bringing evidence from a housekeeper at the Savoy Hotel that she had seen 'faecal stains' on the bedsheets after a night Wilde had spent there with one of his young friends. Asking servants to spy on their 'betters' was considered worse than the crime itself in Victorian Britain but in Wilde's case nothing was too low if it could help engineer his conviction. Of course, as has been often pointed out, much of his misery he brought on himself in the days of his fame when he virtually abandoned his wife for Lord Alfred, appearing with him in public, flaunting their relationship. As the trial unfolded, his witty remarks at the expense of marriage and society came to seem more like a sarcastic assault on good order and those public virtues Victorian society used to cover its seamier realities. Wilde had been only the most outspoken proponent of a movement that had been attempting to undermine that hypocritical edifice; now he was to be made its scapegoat.

It was only near the very end of the process, when he knew all was lost, that Oscar Wilde finally spoke up for the 'Love that dare not speak its name', though even then, it was only to defend the ambiguous 'Greek' or 'Platonic' love, wherein an elder male affectionately tutors a younger, that had long been the refuge of bachelor vicars and closeted university dons. Attempts to make Wilde a martyr to the cause of sexual liberty founder on his performance at his trial, nor have recent moves to have him granted a posthumous pardon much logic – the law under which he was tried finds little sympathy today and has since been repealed but the fact that one of the boys that he paid for sex was only seventeen, means that his behaviour is still illegal in Britain at the time of writing. Overall, his destruction was a catastrophic

setback for the slowly evolving movement, led by men like Edward Carpenter, who had tried to oppose the alliance of harsh morality and hypocrisy that was such a feature of the Victorian mind-set, with appeals to reason and justice. Wilde's trial only reinforced the worst Victorian prejudices, to the point where it would take a further half-century before its effects could begin to be reversed. But even allowing for all that, the harshness of the sentence, two years' hard labour, the maximum possible, still appalls. Wilde was a broken man. From the prostitutes dancing in the street outside the court, celebrating his downfall, to the idiot on the platform at Clapham Junction who jeered and spat at him as he was forced to wait in his coarse prison uniform, on the move to Reading Gaol, never has a fall been so total and so dreadful. Hard labour meant just that: a regime designed to break a man in body and spirit, from the squalid, freezing cell with its plank bed, which induced insomnia, and the filthy food which caused Wilde's dysentery. Visits were rare and frequently refused for petty reasons. Punishments for so slight a matter as talking during the one-hour shuffle round the exercise yard were mandatory.

Wilde was moved to Reading Gaol, where he would serve the rest of his sentence, on 13 November 1895. Built fifty years earlier, the New County Gaol had been deliberately designed to resemble a medieval fortress with crenellated walls and cruciform arrow slits for windows. The main gate was copied from the entrance to Warwick Castle and until 1862 its flat roof had been used for public executions. By Wilde's time, hangings were effected within the prison walls and the prisoners on death row were kept apart from their fellows. As he was allocated cell 3 on the third landing of C wing, Wilde was from then on known as C3.3, a humiliation as bad as the way his once flowing hair was crudely shorn. Worse was the fact that beneath C wing was a dungeon that Wilde never saw but whose purpose was made plain by the hideous screams that rose to the cells above, for it was there that the brutal floggings of prisoners sentenced to corporal punishment were carried out. That and the sight of children incarcerated for petty crimes and obliged to suffer the same privations as adults, grieved Wilde as much as his own sufferings. He found the isolation insupportable and feared madness. Only towards the end were books and paper permitted; for much of the time there was nothing, a void filled only with misery and self-recrimination. In England there was silence and treachery, in France there was protest, though it was perhaps less significant than has since been claimed. As recently as 1994 a collection *Pour Oscar Wilde* was published in France which brought together the major articles that were written in defence of the prisoner, and

it is noticeable that many seem to have been written for reasons more to do with their author's private concerns than with obtaining Wilde's release. Some, like Octave Mirbeau, did write articles protesting the severity of the sentence but even he found the whole thing useful, using a caricature of Wilde for the character of Sir Harry Kimberly in his novel *Le Journal d'une femme de chambre*. And it was Fénéon who saw through the sham when he wrote that 'France is always ready to rage in indignation over Albion's puritanical depravity, closing her eyes to her own sores' – a clear enough reference to the Dreyfus affair. A print of Henri's London portrait of Wilde was issued with the *Revue* and the theatre director André Antoine bought the original despite his limited financial resources. But such gestures aside, there was little practical that anyone could do. When the American poet Stuart Merrill, who had worked on *Salomé*, attempted to raise a petition to Queen Victoria, asking for clemency, the non-participation by leading figures in the French intellectual community, most noticeably Zola and Edmond de Goncourt, led to the project's collapse. Later, Lord Alfred Douglas on a visit to Paris tried to raise another petition, this time to the new British Prime Minister, Arthur Balfour, but was dismissively accused of trying to drum up publicity for a collection of his own poems that had just been published in France, and once again the attempt was abandoned. In the end it was the non-intellectuals, the night people whom Wilde had admired on his wanderings round Montmartre, who were most eloquent in his defence. In her memoirs, Jane Avril recalled how Aristide Bruant had 'come forward to defend him with his fiery tongue'. While Yvette Guilbert revived a song in Wilde's honour, a camp ditty called 'La Décadente', that had been written for her by the exceptionally camp Jean Lorrain in the days of their friendship. She had never really approved of what she considered the rather obscene lyrics but no doubt felt that their suggestion of decadent vices would help call attention to Wilde's situation. In the end, however, the authorities objected and used their licensing powers to oblige her to drop the song, so there the matter ended.

Sealed off from the world, Wilde knew almost nothing of these acts of loyalty save for one magnificent gesture that penetrated the walls of his prison and lifted his soul. Since his move to Reading Gaol, he had been tormented by a sadistic governor who, according to Wilde, 'could not eat his breakfast until he had punished someone'. Shortly after his arrival a letter arrived from André Antoine requesting permission to stage a production of *Salomé* at the Théâtre Libre, but the governor intercepted the letter and sent it back with a note that his prisoner was not allowed to receive such a

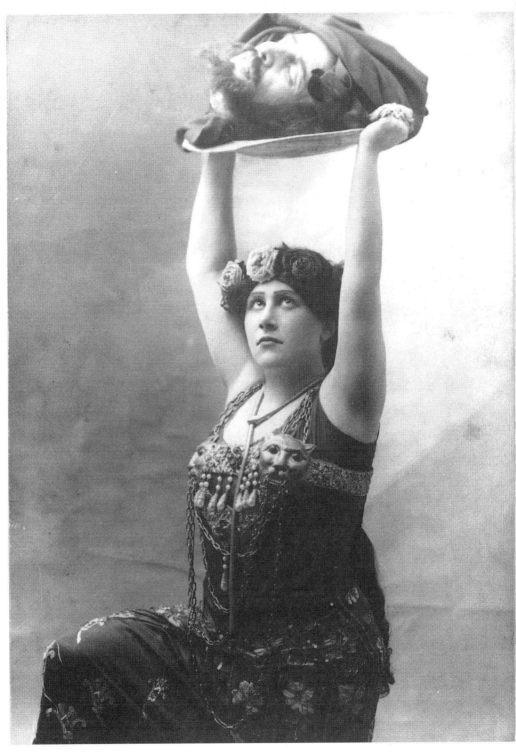

Lina Munte, the first Salomē, holding the ill-fated wax head, 1896.

Programme for the Théâtre de l'Oeuvre with Romain Coolus and Oscar Wilde.

message. Thus Wilde had no idea that the approach had been made or that Lugné-Poë, on hearing of the rejection, decided that he would produce the play at his Théâtre de l'Oeuvre without bothering to clear it with the unreachable author. In order to forestall any action by the English courts, which had jurisdiction over Wilde's literary estate while he was in prison, the rehearsals were conducted in the greatest secrecy. And to avoid any sensationalism that might attract the unwelcome attentions of troublemakers, Lugné-Poë chose to advertise only the second short piece that would share the evening's billing, a new play *Raphael* by another *Revue blanche* contributor, Romain Coolus (the pen-name of René Weil). In the end it proved impossible to completely suppress news of so extraordinary an event and the first night on 11 February 1896 was completely sold out. The packed house had every reason to be satisfied. Despite a pathetically low budget, Lugné-Poë had put all his genius for stage effects into the production. Of course, with so little money, Wilde's dreams of gilded palaces and jewel-encrusted costumes were out of the question, and unwilling to be seen copying his rival Paul Fort, Lugné-Poë would not even consider the perfumed braziers. But even on a modest scale, the astonishingly dramatic lighting effects, especially a startling, blood-red moon, perfectly matched the rich cadences of

Wilde's verse. When the unseen Prophet, his voice sonorous and terrifying, spoke from the depths of the cistern where he was imprisoned, the audience was spellbound. Choosing the Nabi artist Paul Sérusier with his passion for mysticism and vivid iconic imagery to design the single set, was another brilliant stroke, while Lina Munte as Salomé brought a disturbing mix of cold calculation and almost frenzied desire – a description that evokes memories of the right-hand panel for La Goulue's booth. Lugné-Poë himself played Herod, a part ideally suited to his famously deep rich voice, though given the near catastrophe that almost wrecked the opening it was amazing that he was able to perform at all. As usual, the derisory budget meant that the only theatre he had been able to hire, the Comédie-Parisien, was the last of a number of condemned buildings in a block that was about to be demolished. Many of the rooms were in a terrible state, with some of the dressing rooms and passageways full of debris, and just as the show began one of the actresses noticed that some of the costumes had caught fire. She began to beat out the flames, soon joined by Lugné-Poë, already made-up, in full costume and cardboard crown; others joined them and they eventually managed to douse the fire with water. Despite the damage, nobody front-of-house learned what had happened though that was not the end of Lugné-Poë's difficulties – he had begged the Musée Grévin waxworks to lend him a wax head that would do for the severed head of John the Baptist and they had done so only on the understanding that he would be responsible for any damages. Unfortunately, at the previous night's dress rehearsal, the nervous actor playing the executioner had let the precious object fall from its platter to the stage where it broke into pieces. Although it was successfully stuck together for the opening night, the cost of replacing it wiped out any meagre profits the production might have made.

These off-stage dramas aside, the evening was considered a success, though some of Wilde's friends who were present, most noticeably Robbie Ross, who knew the text well, were surprised to find that Lugné-Poë had altered part of the play, in a way that totally ignored Wilde's intentions. Although he had enlisted the aid of Wilde's Paris friends, Stuart Merrill and Pierre Louÿs, both of whom had helped him with the French dialogue, Lugné-Poë followed his own instincts and decided that the homosexual sub-plot was too risqué in the tense atmosphere following the trial. His solution was to have the page, who is in love with the Syrian guard, played by a woman, a radical adjustment that upset Ross, who knew just what his friend had intended.

None of the critics picked up on this change and on the whole, reviews

were favourable, though one reviewer thought the production lacked glamour and another felt obliged to highlight Wilde's borrowings from Flaubert and Mallarmé which, to him, made the piece rather dated now that the theatre of the 1890s was moving away from decadence and artificiality towards simplicity and clarity.

At least everyone was satisfied with Henri's playbill which showed both authors – a drawing of Romain Coolus on the left, a version of the London portrait of Wilde on the right. Henri was a close friend of Coolus, they went to theatres and brothels together and he had illustrated some of his short stories for *Le Figaro Illustré*. For the playbill, Henri reveals the man-about-town, moustached and broad-shouldered, dandyish but manly in greatcoat and top hat. Wilde on the other hand is displayed in all his decadent ambiguity, looming out of the misty Thames, a contrast in appearance that neatly matched the contrast between Coolus's slight domestic 'dining-room' play and Wilde's exotic verse drama.

With such a large British contingent at the opening, among them the original illustrator of the text, Aubrey Beardsley, news of the event quickly crossed the Channel and even managed to penetrate the thick walls of Reading Gaol. Wilde was deeply touched that his work had not been entirely forgotten, though as he made clear in one of the rare letters he was permitted to send, even such heartening news could do little to lessen his sense of grief at what had overtaken him: 'It is precious to me that in this time of disgrace and shame, I can still be considered an artist. I wish I could feel more pleasure, but it seems to me that I am dead to all feelings save those of anguish and despair.'

He was less pleased when Robbie Ross managed to arrange a visit and told him of the editing Lugné-Poë had felt obliged to make, for now that the world knew what he was and was punishing him for it, Oscar no longer saw any reason to dissemble over his sexuality. From now on he wanted it clearly stated and to learn that reference to it had been removed from his play hurt him deeply. But that aside, even he had to admit that news of the production was the only thing that helped ease his sufferings and he would later write to Bosie telling him how the production of *Salomé* 'was the thing that turned the scales in my favour as far as my treatment in prison was concerned'. From then on there would be some lessening of the harshness he had had to endure for over a year and if there was nothing anyone could do to ease his crippling sense of grief and shame at least some of those he had known in Paris, most notably Félix Fénéon and Toulouse-Lautrec, had done what they could to defend him as an artist. More than most, Fénéon knew

from first-hand experience the soul-destroying emptiness, the painful lone-
liness of prison life, but it was Henri who had the deepest understanding of
what it was to be rejected, marginalised by the indifference of a world that
places judgement before feeling and that both despises and fears difference.
His portrait captures something of that and Wilde himself, in his later
account in verse of his terrible experiences, would give eloquent expression
to the void that had opened at his feet.

> I know not whether Laws be right,
> Or whether Laws be wrong;
> All that we know who lie in gaol
> Is that the wall is strong;
> And that each day is like a year,
> A year whose days are long.
>
> But this I know, that every Law
> That men have made for Man,
> Since first Man took his brother's life,
> And the sad world began,
> But straws the wheat and saves the chaff
> With a most evil fan.
>
> This too I know – and wise it were
> If each could know the same –
> That every prison that men build
> Is built with bricks of shame,
> And bound with bars lest Christ should see
> How men their brothers maim.
>
> With bars they blur the gracious moon,
> And blind the goodly sun;
> And they do well to hide their Hell,
> For in it things are done
> That Son of God nor Son of Man
> Ever should look upon!

15

In Poland – That is to Say Nowhere

Thadée Natanson's financier brother Alexandre had an impressive apartment on the ultra-chic Avenue du Bois de Boulogne, now the Avenue Foch, where in February 1895 he gave a party for everyone associated with *La Revue blanche*. There were some three hundred guests in all, a roll-call of the Paris avant-garde at the end of the century, and Henri volunteered to be barman, entering into the spirit of the thing by shaving his head and beard as if he really were a servant, a gesture disapproved of by Dr Bourges who thought he had demeaned himself. The Natansons' grand piano was removed and a bar installed behind which Henri, wearing a waistcoat cut from an American flag, doled out a selection of his more stunning cocktails, mixed from various sorts of alcohol: liqueurs, absinthe, etc. in lurid bands of colours, over two thousand he later claimed, while holding forth on their essential ingredients – sugar for this one, mint for that. It hardly mattered as his 'clients' were soon helplessly drunk. Bonnard chose a charming pink mixture and promptly passed out. Fénéon, having trailed round after Mallarmé trying unsuccessfully to persuade him to drink one of the more violent concoctions, finally found a bed and fell asleep. Though the most remarkable thing was that the barman stayed stone-cold sober, and this from a man who at his dinner parties put goldfish in the water carafes so no one would drink the stuff!

But that evening aside, it was accepted by all who knew him that Henri would be drunk most nights. Some of his friends chose to explain this away as being just part of a gourmet's love of the best in life, an extension of his passion for good food. He was, after all, an accomplished chef, who lived for the days when parcels of delicacies: patés and preserves, wines and cheeses,

arrived from his family's various estates. The publication, in 1993, of *Toulouse-Lautrec's Table* with recipes for his favourite dishes, the rich traditional cooking of the south, *Perdreaux Comme en Périgord, Gras-Double au Saffron à l'Albigeoise, Cuissot de Sanglier en Poivrade,* eloquently revealed the taste of a man in love with sensuous consumption. But there were some who glimpsed a darker side to this indulgence, who saw that as the years passed, the effects of drink were less and less pleasant, especially when the drink in question was the notorious *Fée Vert*, the Green Fairy.

Until banned in France during the First World War, absinthe at up to 136 per cent proof was little short of a liquid hallucinogenic. Produced mainly by the Pernod family, from a mix of herbs whose primary ingredient was wormwood, the plant said to have sprung up in the wake of the serpent as it fled the Garden of Eden, the drink was so bitter it had to be sweetened. As water was poured into the glass through a sugar-strainer and the clear elixir turned a misty jade, its devotees could savour the moment when the green fairy would take them to a place of dreams. For over half a century, absinthe played a significant role in the creative life of Western Europe with addicts among a wide swathe of poets and artists from Verlaine to Gauguin, whose work was sometimes a direct result of the hallucinatory state the Green Fairy induced. Drinking alone in the Café Royal one night, Oscar Wilde suddenly realised the waiters were stacking the chairs and cleaning up around him and as one passed, drenching the floor with a watering can, Wilde asked if he was watering the flowers, convinced that he could feel tulips brushing against his legs. For Wilde, absinthe was 'as poetical as anything in the world. What difference is there between a glass of absinthe and a sunset?' No doubt Henri would have agreed. 'One should drink a little but often', was his contribution to the anecdotal history of absinthe consumption, though one can firmly reject Gustave Moreau's assertion that Henri's paintings 'were entirely painted in absinthe' – until the very end at least, he seems to have kept his two favourite occupations, painting and getting drunk, apart, though he was assiduous in labouring in both vineyards. As if the Green Fairy were not strong enough on its own, he was addicted to creating absinthe cocktails. According to Yvette Guilbert, an especial favourite was the *tremblement de terre*, the earthquake, absinthe with the water replaced by cognac. And there were others: *absinthe minuit* with white wine, and for Bruant, *absinthe de vidangeur*, scavenger absinthe, mixed with red wine, no doubt in homage to the singer's trademark scarlet scarf. At some point a hollow walking-stick that could be filled with a supply of the Green Fairy was acquired, presumably for the moment when the Irish and American Bar

closed and his favourite barman Randolphe, half Chinese, half American Indian, could no longer make up Rainbow Cups, the multi-layered absinthe mixtures that satisfied an ever more demanding habit.

For a time Henri appeared to handle this awesome consumption with remarkable aplomb. He was a happy drunk and it seemed to have little effect on his capacity for hard work. In 1896, in some ways his best year, he was at the summit of his powers and to have suggested that there was anything but good times ahead would have seemed unnecessarily morbid. He was only thirty-one and that year would see the publication of *Elles*, the nearest he would get to a completely resolved thematic work. Yet far from settling on his laurels he was experimenting with new ideas and subjects, pushing himself further. He exhibited frequently and his sales and commissions were gratifying, there was everything to look forward to and yet, a remorseless descent into alcoholic oblivion now sent him stumbling down a side alley away from the broad highway of his own creative genius. The fact that he increasingly fell asleep wherever he happened to be sitting, or suddenly felt too tired to go out, adds to the evidence that he was slipping into the final stages of syphilis which can only have exaggerated his existing physical weaknesses. There would still be the occasional flashes of inspiration, the rare burst of something original and unforeseen, but more often it was repetition or fumbling that marked his work as the Green Fairy and the 'Big S' tightened their grip on mind and body.

Over the three years up to 1899 he showed increasing signs of degenerative alcoholism: his tendency to drool increased, he was less fastidious about personal cleanliness – when he stayed out all night he no longer bothered to bathe and change his clothes before going straight on to work, either in his studio or at his printer's where his clothes might be stained, his breath foul. Formerly, his domineering manner and savage teasing had been accepted with good humour by his friends, now when drunk he became graceless and bullying so that fewer could bear the ill-temper and the insults. Reduced to drinking alone, he slouched off no one knew where, sometimes brought back by the police with cuts and black eyes – on the worst occasion, he fell somewhere and broke his collar bone, though he was just as likely to go the other way and hand over all his money to what he took to be a needy stranger. The Natansons bore the brunt of much of his unpredictable behaviour. The worst moments were his occasional bouts of boorishness – that notorious evening at dinner at their house in the country, when he crudely tried to seduce their maid, reducing the poor young woman to tears. And yet among his friends, were those who experienced the other, sensitive side to his nature that

alcohol never quite extinguished. Fortunately, the Natansons showed him the same degree of understanding and despite his increasingly capricious manner, continued to forgive and protect him. In later life, Thadée wrote an account of his friend's drinking which showed remarkable insight into why it had so taken hold of him and precisely what its effects were:

> He did not drink to forget his ugliness, but it is true that when he drank he did forget it. When he drank, dreams could come true. His head rests on his folded hands, and one can see from the faraway look in his eyes that a woman he desires passionately is perhaps going to let herself be tempted.
>
> In the magical fairyland of alcohol, he could live a life of fantasy. Eventually, he would only have a taste for life when intoxicated. Only then.
>
> His words became more and more incoherent, his speech more and more halting and interspersed with groans.
>
> On his face, a little mustache stood out like two little commas which seemed to drip on the huge lips, which more and more often could be found sipping a drink. Eventually, he could get drunk from merely bringing a glass to his lips. The mustache would no longer have time to dry.
>
> Everything made him laugh. He loved to laugh. Alcohol made him laugh, made him hiccup, with laughter. When drunk, he would laugh until he cried. He would have brief fits of anger, but mainly he would laugh.

As Natanson noted, it wasn't all ill-humour and gross acts, for even through the haze of alcohol, Henri's self-deprecating wit could still shine through – perfectly captured in Thadée's neat rendition of his friend's boozy ramblings:

> 'Gentlemen, I greet you . . . Madame, my deepest respects . . . I haven't been drinking . . . we laughed . . . a hell of a laugh, eh? If I were drunk, first of all nobody would know it . . . But if I were drunk, I would say so . . . and you just wouldn't understand it. Let's go watch them dance, the little darlings . . . they're so cute . . . so Fontanges. Listen, let's go watch them make love. The techniques of affection . . . no, I assure you, Dear Madame, I can drink safely . . . I'm so close to the ground already.'

One reason the kindly Natansons continued to invite him to their country home was that they, along with his other close friends, had noted that his drinking was slightly reduced once he was away from Paris. Perhaps because he had seen the rough way the London police treated drunks in the street, any visits to the English capital were comparatively abstemious. He went twice in 1896. In March there was the second poster exhibition at the Royal Aquarium, for which his friend Hartrick wrote the introduction to the catalogue. But as soon as the opening was over, Henri scuttled back to Paris unwilling to give up work for more than a couple of days. As Thadée Natanson also noted in his article, his friend did not mix business with pleasure – or more bluntly he could just about refrain from drinking while working, though as the amount of time given over to alcohol remorselessly increased, so the period available for work decreased. But the transition was sufficiently gradual to delude many of his friends into believing that there was nothing to worry about – indeed, in 1896 it even looked as if those sessions at *La Revue blanche*'s offices, listening to all that anarchist talk, would at last result in some openly political work.

Perhaps provoked by all the court cases that had impinged on his life – Fénéon's in 1894, Wilde's in 1895 – Lautrec attended two famous trials in 1896 and sketched the proceedings prior to producing a series of lithographs. The first was a suit brought against the army and defended by a clutch of senior officers, over the death from tuberculosis, while doing his military service, of the young Max Lebaudy, heir to a huge fortune, on the grounds that he should have been given an early release which might have saved his life. The second was the trial for corruption of Léopold Arton who was accused of paying up to one and a half million francs to members of the Chambre des Députés during the Panama Canal scandal. Both subjects were highly controversial involving as they did two of the nation's most sacred institutions – the army and Parliament, and some of the Arton drawings, with their clusters of robed lawyers, are consciously within the Daumier tradition of mocking the arrogance of the legal system that pretended to regulate these public functions. In the end Arton was acquitted before he could speak up and bring down others in the charmed circle of government, though Henri did not follow this up with the sort of scathing images that would have been expected from Daumier. It was as if Henri's political engagement could only stretch so far and he appears more at home with the Lebaudy affair, where one of the star witnesses was the unfortunate young man's mistress, Anne-Marie Brochard, an actress who performed at the Comédie Française under her stage-name, Marie-Louise Marsy. By concen-

trating on her appearance in the witness box, Henri again deflects attention from the political substance of the proceedings, the indifference of the high command to the suffering of their men, even one from the upper reaches of society, a situation sufficiently absurd to please any anarchist sympathiser, as it offered the spectacle of the defenders of capitalism being accused of malpractice by their paymasters. But by approaching such subjects only to evade the issues they raised, Henri seems to assume the role of dilettante, the charge often used to cast doubt on his commitment to serious issues. And yet in that same year he suddenly offered his services for the first production of what turned out to be the most revolutionary and certainly the most shocking theatrical production of the age, Alfred Jarry's scatological, outrageous, absurd and just downright crude play, the extraordinary *Ubu Roi*.

From the opening moment when the ludicrous figure of Père Ubu with his fat, roly-poly costume and pointy head, walked on to the stage of the Nouveau Théâtre in Pigalle, and yelled out '*Merdre!*' – theatre changed for ever. Supposedly *merde*, shit, the extra 'r' was the author's attempt to appropriate the word as his own, making it something like the English slang word 'shite'. It was not a substance to be taken lightly – *Merde* was the 'mot de Cambronne', the obscenity with which the gallant French general dismissed Wellington's offer of surrender at the conclusion of the Battle of Waterloo. For the French, it was at once sacred yet unpronounceable in mixed company and its use was bound to cause mayhem. As the opening statement of his play, Jarry had certainly set out to provoke his audience.

Although the author was only twenty-three, his creation was already old – Jarry and a schoolfriend had originally created their monstrous character as a joke at the expense of an overweight, well-intentioned, though ultimately incompetent physics teacher, Professor Herbert, whose name, passing from Père Heb to Père Ubu, has entered the French language and that of world theatre as a synonym for all that is pompous, deranged, yet awesomely unstoppable. Ubu was the vehicle by which the utterly anarchistic Jarry took on the world, though ultimately his creation took on him so that the author eventually spoke, lived, and finally died as the embodiment of his foul-mouthed, irrational alter-ego.

However unstoppable Père Ubu might become, getting started proved understandably difficult. No one, including perhaps its creator, had any idea what the gross monster was meant to be, beyond a childish prank, but once Jarry discovered the Théâtre de l'Oeuvre his determination to see his play produced knew no bounds. In his memoirs, Lugné-Poë indicates that Jarry was first brought to the Oeuvre by friends of Oscar Wilde which raises the

intriguing possibility that the two authors might have met quite early on. They were certainly brought together after Wilde's release from prison and Jarry was present at the opening of *Salomé* during Wilde's absence. Given Jarry's ambiguous sexuality and dark gypsy looks, along with his ferocious dedication to his art, there was everything to appeal to the older man. Indeed after their recorded encounter in 1898 Wilde noted that Jarry was 'most attractive . . . like a nice renter', which says it all. If they did know each other earlier it would have been Wilde's friend Marcel Schwob who brought them together and Schwob too who introduced the young playwright to Lugné-Poë. As early as 1893, when Jarry was barely out of school, living in a black-draped room filled with stuffed animals, Schwob published some of his early essays and after a brief absence for military service from which, on his own admission, Jarry was quickly dismissed for 'precocious imbecility', he set about his campaign, inveigling himself into Lugné-Poë's company, getting himself appointed *secrétaire-regisseur*, a grand title for a combination of personal assistant and messenger boy, a 'gofer' in other words, from which position he was able to promote his strange creation. Despite his utter lack of any social graces – he dyed his hair green, frequently dressed as a bicycle racer in tight sweater with trousers tucked into his socks, lived in a succession of squalid flats and fished his own food out of the Seine for meals eaten backwards; dessert to soup, with a repressed sexual nature that was probably homosexual and usually carrying a pair of revolvers wherever he went, Jarry nevertheless managed to maintain sufficiently influential friendships with some, like the novelist Madame Rachilde, who could ensure that a little of his work was published in the radical magazines. But as with so many others, it was Fénéon who boosted Jarry's confidence by writing to ask him to contribute to *La Revue blanche* – an invitation issued without the knowledge or consent of the editorial board, who over the years proved stubbornly resistant to Fénéon's continuing attempts to help a unique talent that he alone seemed to recognise. Even Lugné-Poë would probably have rejected Jarry's attempts to persuade him to stage *Ubu Roi*, if the devious young man had not entered the play into the theatre's forthcoming programme during the summer of 1896 while the director was away on holiday. Lugné-Poë returned to find the piece scheduled for 11 December that year and let it ride, unaware of the cataclysm that was about to engulf them all.

At least *Ubu* had originally been created for Jarry's home-made puppet theatre and Lugné-Poë had been fascinated by marionettes as a child though he refused to entertain the young man's suggestion that his play should be

Alfred Jarry on his racing bicycle.

performed by human puppets wearing masks, a decision that bitterly disappointed the author who made it clear that he wanted something in the tradition of Grand Guignol. At one level *Ubu Roi* might just be children's theatre, but at the same time its sudden bursts of bloodthirsty violence make it closer to the dark side of Punch and Judy with a story that was by turns hilarious and cruel: Père Ubu and his equally gross wife, Mère Ubu, arrive in Poland where they murder the king and make themselves rulers, disposing of anyone who dares oppose them, embarking on a reign of terror and crude debauchery until they in turn are overthrown by the former king's son, whereupon they move to France, promising more atrocities. The plot might be simple but every conceivable interpretation has been laid upon it: 'A modern version of *Macbeth*', 'A savage satire on the unlimited greed and unscrupulous thirst for power of the French bourgeoisie.' To some, it was topical – a comment on France's recent alliance with Russia, a repressive State that despite its grim internal regime was seen as the guarantor of the

'Portrait' of Ubu Roi by Alfred Jarry (1896).

Republic's security in the face of the continuing German threat. Or perhaps it was the most extraordinarily prescient work of art of the period, looking forward to the Nazi invasion of Eastern Europe and the subsequent occupation by Soviet troops. Or was it just rubbish, the ramblings of a drunk, whose consumption of alcohol made even Henri de Toulouse-Lautrec seem abstemious? Rachilde once listed Jarry's daily intake as beginning with two litres of white wine followed by three absinthes before lunch which was washed down with wine alternating with more absinthe followed by coffee and marc or other liqueurs during the afternoon, apéritifs before dinner then wine and absinthe with the meal, ending with more absinthe during the evening – though she added laconically, 'I never saw him really drunk but once, when I set to shooting off his revolvers which sobered him instantly.' It was usually the other way round, with Jarry scaring the life out of a passer-by who foolishly asked for a light for his cigar only to find himself temporarily blinded by a handgun fired off an inch from his nose.

Henri knew Jarry from *La Revue blanche*, where he practised his confusion of reality and acting, liable to turn up in a pink turban and a woman's

blouse because 'man's linen is too confusing'. Short of stature – some descriptions refer to him as almost a dwarf – yet utterly impervious to the world's opinion, it is easy to see that the two would have had sufficient in common for Henri to set aside his usual preference for tall companions. And it is hardly surprising that following the excitement of *Salomé*, Henri should have wanted to associate himself with what, as the event approached, seemed increasingly likely to eclipse anything the Théâtre de l'Oeuvre had so far attempted. For many years few were aware that Lautrec had been one of the set designers for *Ubu Roi* – the official programme listed only Sérusier and an 'AJ', presumably the author – but in his memoirs, published in the 1930s, Lugné-Poë revealed that the creation had been a collaborative affair, led by Jarry himself, helped by Bonnard, Vuillard, Sérusier and Henri. Initially, Jarry hadn't wanted any sets – hardly the best beginning, though after Lugné-Poë again obliged him to agree, the result was predictably weird and as much a challenge to the audience as the play itself. As a foretaste, a battered table covered in a piece of rough sacking was brought out before the performance began, followed by Jarry who made an introductory speech, much of it in praise of this somewhat unimpressive setting. 'In any case,' he began, 'we have a perfect *décor*, for just as one good way of setting a play in Eternity is to have revolvers shot off in the year 1000, you will see doors open on fields of snow under blue skies, fireplaces furnished with clocks and swinging wide to serve as doors, and palm trees growing at the foot of a bed so that little elephants standing on bookshelves can browse on them.' He went on to tell the audience that they were at liberty to read whatever they liked into the play which would take place in Poland, 'that is to say nowhere'. The table, which had been as pointless as much of the introduction, was then taken away and never seen again, all clearly intended to provoke the already hyper-charged audience that had been drawn to the theatre by weeks of unsubtle campaigning in the press by Jarry who had used every contact he had made since he arrived in Paris to ensure that his play was the most keenly anticipated event of the season. Inevitably, these tactics ensured that those irritated by this approach and now aggravated by the sheer imbecility of his prologue, as near equalled those that he could count on as friends and supporters. When this was followed by the actor Firmin Gémier of the Comédie Française, dressed like a sort of sagging cushion and using a voice that Lugné-Poë had advised him to model on that of Jarry himself, sonorous and pompous, suddenly proclaiming 'Shite', this unstable crowd went berserk. After a quarter of an hour of barracking, whether for or against made little difference, it was only when Gémier did a

little dance and stretched out on the prompt box and said the word again, provoking another outburst of amazed howling, that things were then sufficiently calm for the bizarre drama to stagger forward, interrupted at fairly regular intervals whenever Gémier/Ubu again unleashed the provocative word.

There are several similar violent confrontations in the story of modern European culture but none was as shattering to those who participated in it as Jarry's first night. It is easy to list all that flowed from that evening – much of Surrealism, the Theatre of the Absurd, a whole tradition of fantastical comedy that everyone, principally the English, likes to think belongs to anyone except the French. No one who was there, including the opponents of the piece, was in any doubt that their world had shifted on its axis. Judging by accounts of the brawling, the anti-Ubus were marginally wittier than the pros who contented themselves with shouting, somewhat implausibly: 'It's Shakespeare', whereupon the opposition yelled back: 'It's Lugné – *pot de chambre*', an altogether more memorable response. There were fights and about as much mayhem in the auditorium as Père Ubu was able to unleash on stage, which made it probably the first truly participatory drama since the medieval village miracle plays, a sobering thought.

When it was over, the battle raged on in the newspapers, though for once it proved impossible to predict which side any of the critics would take – the usually snide Jean Lorrain actually defended the piece. That Romain Coolus in *La Revue blanche* would join him was inevitable, though his assertion that literature and politics were now 'impregnated with Ubu; from every side you can smell Ubu; people fight for Ubu and for Ubu people disembowel each other', was ambiguous to say the least. Taste, or the lack of it, predictably preoccupied the opponents, with some seeing the whole thing as an assault on the nation itself, and one critic blustering on about how: 'enfevered with the flood of anarchy, these spoilt children and sullen butchers, their brains either empty or filled with nightmares, exalted by hypocritical and cowardly double meanings, have nothing in their innards except what Oscar Wilde might have left there' – which was about as bad taste as you could get. Fortunately there was Henri Bauer in the *Echo de Paris* to bring both sides down to earth by calmly pointing out that Jarry had simply been having a joke at their expense, that he had been poking fun at them. And it is this simple fact that needs to be borne in mind when considering Henri's role in that extraordinary evening.

As with *The Little Terracotta Cart*, neither the actual sets nor any of the preparatory designs, if there were any, have been preserved and Jarry's

promise in his introduction of what the audience was about to see was intentionally misleading. Nevertheless, what he and his helpers did come up with appears to have been as weirdly unconventional as the rest of the evening. Curiously, given the significance of this stunning event to the unfolding story of French culture, it was members of the cross-Channel contingent, drawn to the theatre by rumours that something amazing was about to happen, who left the best accounts of what they had witnessed – though despite their undoubted literary skills, the sheer audacity of Jarry's creation clearly deprived them of their usual precision. Arthur Symonds, in *Studies in Seven Arts*, recorded how:

> . . . the scenery was painted to represent, by a child's conventions, indoors and out of doors, and even the torrid, temperate, and arctic zones at once. Opposite you, at the back of the stage, you saw apple trees in bloom, under a blue sky, and against the sky a small closed window and a fireplace . . . through the very midst of which . . . trooped in and out the clamorous and sanguinary persons of the drama. On the left was painted a bed, and at the foot of the bed a bare tree and snow falling. On the right there were palm trees . . . a door opened against the sky, and beside the door a skeleton dangled. A venerable gentleman in evening dress . . . trotted across the stage on the points of his toes between every scene and hung the new placard on its nail.

While the young W. B. Yeats ruefully noted how he went:

> . . . to the 1st performance of Jarry's *Ubu Roi*, at the Théâtre de l'Oeuvre, with Rhymer who had been so attractive to the girl in the bicycling costume. The audience shake their fists at one another, and Rhymer whispers to me, 'There are often duels after these performances,' and explains to me what is happening on the stage. The players are supposed to be dolls, toys, marionettes, and now they are all hopping like wooden frogs, and I can see for myself that the chief personage, who is some kind of king, carries for a sceptre a brush of the kind that we use to clean a closet. Feeling bound to support the most spirited party, we have shouted for the play, but that night at the Hotel Corneille I am very sad, for comedy,

> objectivity, has displayed its growing power once more. I say,
> after S. Mallarmé, after Verlaine, after G. Moreau, after Puvis
> de Chavannes, after our own verse, after the faint mixed tints
> of Conder, what more is possible? After us the Savage God.

Although *Ubu Roi* was 'the catastrophe that made it famous', there was only one more performance by the Théâtre de l'Oeuvre, the following night, after which Jarry's outrageous masterpiece disappeared. Firmin Gémier revived it in 1908, though by then the original sets had long been broken up and any precise knowledge of each artist's contribution lost. Lost, too, was the significance of Henri's participation in that amazing evening, much of it to do with Bauer's assertion that the production was all about making fun of the world at large. Fénéon's biographer, Joan Halperin, has been one of the few to see this, noting how Fénéon, Jarry and Henri delighted in creating paradox, how they 'introduced a ferocious kind of humour at *La Revue blanche*', a wildness exemplified by the Natansons' party, with Henri serving drinks while Fénéon and Jarry staggered about trying to convince the other guests that the cocktails wouldn't hurt them, despite the fact that half literary and artistic Paris was falling into an alcoholic stupor. It is this absurd anarchistic humour, this total refusal to see the world as it thinks it is, but to insist on seeing it as one happens to want it to be at the time, that explains Jarry and answers the questions so often raised about Lautrec's apparent inconsistencies. Yes, Henri often fails to rise to the political occasion, to take up the correct radical position, to condemn or to satirise with the force of a Daumier or a Steinlen, but to say all that is to miss the point. Like Jarry, Henri's political commitment can be found in the mockery which most often works at an oblique level to the supposed subject on offer. Look again at the last print in *Elles*, of the girl flopped out on the bed – a tragic figure yes, but also pretty funny – one can almost here the 'oof' as her lover leaves and she is free to drop down and surrender to exhaustion. Or again, there is that early drawing *Sur le pavé* where the young girl is accosted by an old roué who finds her, at fifteen, 'a little past it already'. Making a wry joke out of an unpleasant situation only enhances the condemnation, precisely the point Jarry makes throughout *Ubu Roi* where the fact that we are provoked to laughter only gives our eventual recognition of the cruelty and inhumanity behind the action a sharper edge.

Henri was not just another Géricault, offering the same unrelentingly harsh view of suffering, or another Daumier with his gross exaggerations of the foibles of the rich and powerful; rather he extended this tradition of

French radical art and with his dry cynicism and quiet mockery led it into the modern age. From La Goulue entering the Moulin Rouge, a battered figure on the arm of her lesbian lover, to the self-satisfied image of the one-eyed Madame Brazier of the Bar Hanneton dolled up in her bourgeois finery for a grand night out at the theatre, Henri demolished the pretensions even of those whose lives he defended. Like Jarry's, this was his personal anarchism, an oblique view of the world that saw the joke in the situation where a rich man's mistress is brought before a court to help accuse the army of letting him die, a point far more telling than simply caricaturing the attendant lawyers would have been. So La Goulue wants some eye-catching decorations for her sideshow, so she gets an audience consisting of a terrorist and a homosexual, both jailbirds, and best joke of all, she's happy with it! Laughter was the one thing the defenders of the moral order could never abide. It was Henri's improbable inheritance from a father whose bizarre behaviour confronted a social and political system he despised. Through his art, Henri joined him in that subversive play, a way of turning the world on its head; yes, prostitutes are dangerous, exciting, sexy, but they are as often dumpy, feckless and bored. The best joke of all was the worst, the tragedy of the comedian himself. It was Jarry's most savage role, killing himself with drink, performing a Père Ubu on his own body, extending the role that Wilde had set out for himself of being what he had imagined. Jarry carried this to its ultimate extreme, putting his talent into his art, his genius into his life, and prefiguring those in the coming century, from Picasso to Warhol, whose personalities would be inextricably linked to their creations. A few years after his sensational opening night, Jarry died in hopeless poverty, killed by drink, the only possible last act for the character he had made of himself. Henri would precede him, but first there was still a lot more drinking and, as Thadée Natanson noted, laughing to do now joined by another doomed figure with only a few years left before illness and the Green Fairy would claim them both.

Oscar Wilde was released from prison on 19 May 1897 having served the full two years of his sentence. His requests for clemency on medical grounds – he feared both for his sanity and for his health after damaging an ear in a fall at Wandsworth Prison – were all refused by a Home Office fearful of seeming to pander to one so abhorred by the general public. The only permitted concession was to spare Wilde the attentions of the gutter press by transferring him from Reading to London just ahead of his release, changing from train to carriage at the little used Westbourne Park station in North

Kensington to avoid the waiting reporters. Finally released from Pentonville and safely at the home of a kindly clergyman, he was joined by the ever faithful Leversons, whereupon Ada was congratulated on having chosen just the right hat for the occasion – an attempt at being the old Oscar which somewhat belied the reality. Charles Ricketts had visited Reading Gaol shortly before the transfer and was thus in a position to know just how disturbed his old friend was by the appalling things that were done inside those bleak walls. A day earlier he had had to listen to 'revolting shrieks and howls' coming from the basement cells below his wing, where a prisoner was being punished with twenty-five lashes. This in itself was bad enough but as everyone knew, the man in question, A2.11, was mentally ill, a halfwit, in no way responsible for his actions. Wilde happened to catch a glimpse of the wretched man on his last day and saw that his flogging had pushed him close to complete madness.

As Ricketts noted, by comparison with the quotidian brutality of the system, Wilde was treated relatively mildly towards the end. A change of governor and the intervention of some better-disposed officials in the Home Office had led to an easing of his regime and the rare privilege of having decent books and writing materials. He had used the latter to compose what he called his *Epistola*, the long letter, ostensibly to Lord Alfred Douglas, that would be published after Wilde's death under the title *De Profundis*. At once a justification and in part an attempt to establish who was to blame for his fall, the letter offers a sometimes contradictory account of his affair with Bosie which ultimately accuses the younger man of feckless behaviour leading to his ruin while leaving the reader with the sneaking suspicion that he would do it all again if fate put the chance his way. It deeply hurt Bosie when it finally appeared in print and its main merit was that writing it enabled Wilde to unburden himself of some of his self-destructive misery and allowed him to contemplate the future. Indeed, on his release, far from being the utterly broken and pathetic creature most often portrayed, he was actually quite focused and determined to do something about the appalling injustices he had witnessed over the past two years. As so often with those who have suffered imprisonment, Wilde had been further radicalised by the torment he had undergone.

His first action was to write to one of the more sympathetic warders, Thomas Martin, to see if he could do anything to obtain the release of three children imprisoned for snaring some rabbits. The fact that the young were subjected to the same inhuman treatment as their elders was the single thing that most disturbed Wilde, but on this occasion his concern backfired when

the kindly Martin was caught giving the children some biscuits and was dismissed from the prison service. Appalled, Wilde wrote a carefully reasoned letter of protest to the *Daily Chronicle* entitled 'The Case of Warder Martin: Some Cruelties of Prison Life', using the incident as a way of calling attention to the barbarity of imprisoning young children. He wrote again in March the following year, extending his theme, and despite his own near poverty sent small sums of money to help Martin and others he had known.

Stripped of all stylistic affectation, the simplicity of the two letters reinforces the depth of feeling that had provoked them. They are the anguished expression of a father deprived of ever seeing his own children and of one who on his incarceration had himself been child-like and as such totally unprepared for the punishment the adult world was about to inflict on him.

> The terror of a child in prison is quite limitless. I remember once in Reading, as I was going out to exercise, seeing in the dimly lit cell opposite mine a small boy. The child's face was like a white wedge of sheer terror. There was in his eyes the terror of a hunted animal. The next morning I heard him at breakfast time crying, and calling to be let out. His cry was for his parents. From time to time I could hear the deep voice of the warder on duty, telling him to keep quiet.

His *Daily Chronicle* letters at last allowed a wide public to learn something of the appalling conditions that prisoners endured, sufferings virtually unrecognised by any save a handful of dedicated reformers who had been agitating throughout the century with little to show for their actions. Coming from one who in his prime had been the epitome of elegance and good living, Wilde's unvarnished descriptions of the gruesome routine he had experienced shocked even those who detested the acts that had led to his downfall.

The letters described the petty-minded way prisoners were refused anything intelligent to read and allowed only four heavily censored letters *per year* and only four visits and those from behind a wire grille, monitored by the warders. But it was the fact that little children, even those only awaiting trial, were subjected to the same conditions that most aroused his pity – granting young people only one hour of exercise a day was simply intolerable yet Wilde was almost unique in pointing it out.

Travelling as Sebastian Melmoth, the satanic hero of the novel *Melmoth the Wanderer*, written by his great-uncle, the Reverend Charles Maturin,

Wilde left almost immediately for France, staying first in Dieppe then settling nearby at Berneval-sur-Mer where the issue of prison conditions was still at the forefront of his mind. Determined to shock the British public out of its apathy, he decided to use art in the service of reform by composing the one work in which all agree Wilde surpassed himself and gave dignity to all that he had suffered. Ensconced in that pleasant seaside town on the Atlantic coast of France, his thoughts turned back to the single most horrifying incident of his sentence. On Tuesday 7 July, 1896, a trooper in the Horse Guards, Charles Woolridge, was hanged for the murder of his unfaithful wife. Despite several mitigating factors and a number of pleas for clemency, the Home Office refused to consider mercy and the man was duly subjected to the gruesome ritual of capital punishment, the detailing of which added such force to Wilde's poem – the way the hangman wore gardener's gloves as he bound the condemned man, the traces of quicklime on the warder's boots after they had dumped the corpse in its unmarked grave. But what ultimately unnerves the reader is the way Wilde reveals the effect on the other prisoners of the build-up to the execution, going about their own grim tasks, nerves stretched to breaking point by an event they will not see but can all too powerfully imagine:

> We sewed the sacks, we broke the stones,
> We turned the dusty drill:
> We banged the tins, and bawled the hymns,
> And sweated on the mill:
> But in the heart of every man
> Terror was lying still.

As the moment of death approaches Wilde gives voice to the concerns already expressed in the *Daily Chronicle* but here transformed into a rhythmic chant that hammers home his message:

> The vilest deeds like poison weeds
> Bloom well in prison air:
> It is only what is good in Man
> That wastes and withers there:
> Pale Anguish keeps the heavy gate,
> And the Warder is Despair.
>
> For they starve the little frightened child
> Till it weeps both night and day:

> And they scourge the weak, and flog the fool,
> And gibe the old and gray,
> And some grow mad, and all grow bad,
> And none a word may say.

What ultimately elevates this bleak creation is the presence behind the words of his own suffering, a merging of self and creation at its most terrible, no more so than in the repeated theme, the phrase that recurs throughout the ballad:

> And all men kill the thing they love,
> By all let this be heard,
> Some do it with a bitter look,
> Some with a flattering word,
> The coward does it with a kiss,
> The brave man with a sword!

It would be wrong to suggest that prison had humanised Wilde; he was sensitive to the world's wrongs before he was incarcerated, but the experience certainly enlarged those feelings, making him deeply aware of the kindness of ordinary working people especially, in adversity.

> The poor are wise, more charitable, more kind, more sensitive than we are. In their eyes prison is a tragedy in a man's life, a casualty, something that calls for sympathy in others. They speak of one who is in prison as of one who is 'in trouble' simply. It is the phrase they always use, and the expression has the perfect wisdom of love in it.

He finished the poem at Berneval near the end of August 1897. It was published in London the following February, becoming an instant bestseller, running to several editions in its first year. The handful of prison reformers were delighted and there is no doubt that Wilde's heartfelt pleas, both the letters and the poem, gave great impetus to the movement that culminated, later in 1898, with the reforms incorporated in a new Prison Act which specifically abolished the two years' hard labour for the crime for which he had been convicted. The fact that the author of the protests had himself suffered the horrors described still touches all who read *The Ballad of Reading Gaol* and nothing is more moving than the way a man whose name had once

437

been so famous, signed his most uplifting creation with the mark of his infamy – C3.3.

It is said that for twenty-five years after Wilde's trial, no child in England was christened Oscar – perhaps one of those stories that ought to be true even if it isn't. Wilde certainly knew enough real betrayals – those like Beardsley who turned away from a man they viewed as a pariah likely to contaminate them with his notoriety. Such treachery made the loyalty of Ross, Sherard, Ricketts, the Leversons and Rothenstein all the more laudable. Seeing his dedication to prison reform, his friends dared hope that he would return to writing – perhaps a new play or novel? Perhaps something more serious – another campaign? Lugné-Poë even hurried from Paris to London in the hope of commissioning a piece for the Théâtre de l'Oeuvre and finding Wilde gone, rushed across to Berneval to join him. Their encounter was pleasant enough. Wilde was delighted to lunch with his 'Herod' but the hoped-for play was not to be. Ostensibly, Wilde was disappointed when the eternally impecunious director could not offer him an advance, though it must be said that on this occasion the demand for money, which he knew would not be forthcoming, was probably an excuse to wriggle out of any commitment. Despite the occasional half-hearted attempt, Wilde would not write anything significant again. *The Ballad of Reading Gaol* was his swansong, he had made his protest and nothing further would stir up the cooling ashes of his talent. Lugné-Poë returned to Paris empty-handed, Wilde set about eking out his last few years. Bosie drifted in and out of his life; Constance, who had been living with the boys in Switzerland, using a family name, Holland, died in April 1898. Bored and aimless, Wilde left the coast, travelled a little, sponged off friends when he could, drinking too much, hiring rent-boys when possible, yet still capable of charming anyone who would listen when the mood took him. He quarrelled with Bosie, they were reconciled then quarrelled again. The Marquess of Queensberry died but Bosie preferred to squander his inheritance on the horses rather than give anything to the man who had loved him to destruction.

For want of anything better Wilde stayed in Paris and eventually settled into the Hôtel d'Alsace in Saint-Germain whose proprietor, Monsieur Dupoirier, was another of those saintly souls who for no selfish reason took in the fallen figure, showing him innumerable little kindnesses at a time when fewer and fewer old friends could stomach the drinking and unpredictable bouts of self-pity.

Some relief was offered by the coterie at *La Revue blanche* which welcomed Wilde as an honoured colleague, martyred by Anglo-Saxon hypocrisy.

The *Revue* published a favourable review of *The Ballad of Reading Gaol* by Laurence Jerrold, the Paris correspondent of the *Daily Telegraph*, when the first French edition appeared in April 1899 and this was followed by a letter from Fénéon inviting Wilde to come and join them. Thus we have reports of him drinking in the Calisaya, the group's favourite meeting place, with old acquaintances like the Symbolist poet Jean Moréas and the journalist Eugène Tardieu, who had translated *Dorian Gray* into French, and new faces like the writer Ernest La Jeunesse who left an acute, if somewhat florid, description of the strange phantom who had entered their lives:

> His heavy eyelids drooped beneath the weight of visions that were dear to him – the visions of his former triumphs. He walked with little steps, so as to allow his memory a freer play; he loved the solitude to which the world abandoned him, for he found himself there in the company of the man he had been.

This is the Wilde that can be seen in a drawing by a visiting Spanish artist, Ricardo Opisso Sala, an illustrator and caricaturist who worked mainly in Barcelona, who drew this puffy and bloated figure seated at a café table to one side of Yvette Guilbert with Toulouse-Lautrec on the other. According to Emile Schaub-Koch, Henri and Oscar had met again in one of the bars on the Boulevard Saint-Michel that Wilde frequented, presumably the old Vachette, where they were joined by the poet Pierre Louÿs and the playwright Georges Feydeau, but it is more likely that the drawing was made at what had been the Irish and American Bar, recently absorbed by the neighbouring Café Weber. The Spanish artist showed all three facing an absinthe glass and bearing that slightly dazed look that came from an over-indulgence in the Green Fairy, though at least Henri has a sketchpad in front of him and appears to be drawing while being drawn, a sign that unlike Wilde he had not finally abandoned the creative life.

In fact, Henri had kept in touch with Wilde's circle during the two years of the prison sentence. In his journal, Charles Ricketts mentions a particularly interesting visit, probably in May or June 1896, to the house in Beaufort Street where he and Shannon had moved two years earlier. Henri came with the Belgian poet Verhaeren, another sign of the intricate web of artistic and anarchist connections that linked London with Paris and Brussels. It was during that visit that Henri met the twenty-seven-year-old Laurence Binyon, one of those lucky encounters that was to have a

Ricardo Opisso's drawing of Yvette Guilbert seated between Henri and Oscar Wilde in 1898, presumably in the Café Weber.

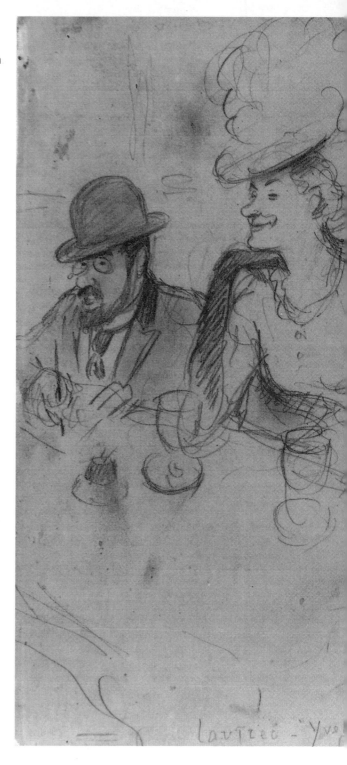

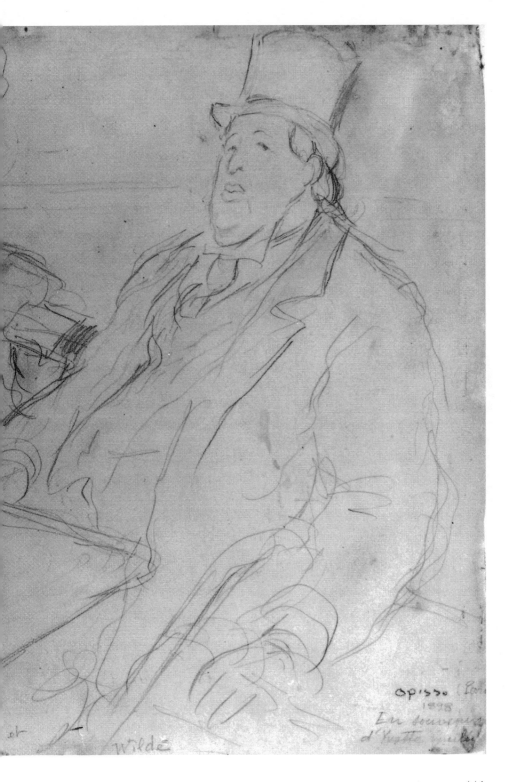

far-reaching effect on Henri's reputation in England. Binyon was an extraordinary polymath – an art historian, dramatist and poet and while his name has almost dropped from sight he has the curious distinction of having written what is probably the most quoted poem in the English language, the First World War elegy *For the Fallen*, with its verse that is recited at countless war memorials wherever the English-speaking peoples gather:

> They shall not grow old, as we that are left grow old:
> Age shall not weary them, nor the years condemn.
> At the going down of the sun and in the morning
> We will remember them.

When Henri met him, Binyon had been working in the prints department of the British Museum for three years and would later be responsible for the Museum's collection of Oriental Prints and Drawings, publishing the series of major studies of Asian art on which his surviving reputation still depends, now that his fame as a poet has receded. Although Binyon's specialism was Chinese and Japanese art, we may assume that he had some influence on his predecessor as Head of Prints and drawings, Campbell Dodgson. During the late 1920s and 1930s Dodgson made the large private collection of over a hundred prints that the Museum inherited in 1948, making London one of the most important centres for Henri's graphic work. Yet another example of the continuing effect of the cultural bridgehead established by John Gray on that visit to Fénéon at the opening of the 1890s.

All Wilde's friends would have been delighted if he had assumed his position as the natural leader of this cross-Channel coterie, a role for which he was eminently qualified. But his experiences in prison had made any effort impossible. In Paris, Oscar could barely summon up the willpower to do anything except waste the small allowance Constance had left him on drink. He would rise in the afternoon with nothing before him except the choice of bar – the Café de la Régence, the Café de Paris or Campbell's Bar. Yet even with time suspended, the aura of tragedy that hung about him ensured that everything he did assumed a terrible significance. In 1900 he was invited to visit Rodin's studio and took along a young soldier called Maurice who had 'the profile of Bonaparte', whom he had met in some bar or other. The aged sculptor, himself in the throes of a late, tempestuous affair with Loïe Fuller, showed this odd pair his most monumental work, thus bequeathing posterity the awesome image of Oscar Fingal O'Flahertie Wills Wilde and a young male lover, staring up at the damned, writhing on *The Gates of Hell*, whose

contorted bodies were so heavily influenced by Géricault's lost sailors in *The Raft of the Medusa*, among them the young Delacroix.

But despite Wilde's attempts at drunken anonymity, his seclusion was occasionally breached by importunate figures from his past. One ghastly night, he was drinking with Bosie in Campbell's Bar when they were joined by an obstreperously drunken Sherard, in Paris to cover the Dreyfus Affair for the *Pall Mall Gazette* and as usual trailing aggression and mishap in his wake. While Oscar could hardly doubt Sherard's fidelity to his cause, his continuing refusal to accept that there was any truth in the charges that had caused the scandal was beginning to irritate. Visiting Wilde in prison, writing in his defence, were actions that seemed to have sprung less from sympathy with the fallen dramatist, and more from Sherard's bizarre misconception of the world. He had the unnerving ability to view almost everything from a slightly skewed angle. On that night when he arrived at Campbell's Bar, he suddenly jumped up and, no doubt with the Dreyfus case at the front of his mind, began yelling 'Down with Jews' at one of their fellow customers. The man promptly treated Sherard to a well-deserved thrashing and it was this sort of incident that gave Sherard a reputation for

Captain Alfred Dreyfus before his arrest and trial – the image of naïve innocence.

A contrasting study in deviousness, Major Walsin Esterházy, the guilty party.

anti-Semitism, despite the fact that he was the only journalist to whom Zola was prepared to grant an exclusive interview at the time of his trial following the publication of his article in *Aurore*, under the banner headline 'J'Accuse', in which he attacked the military authorities for conniving in the cover-up. Sherard even accompanied Zola to the courthouse on the notorious day when the author was attacked by a mob, recruited at two francs a head by one of the nastier anti-Dreyfusard groups. When he put himself between the novelist and one of his assailants, Sherard was knocked to the ground and badly hurt – though again one wonders if this was the fruit of a noble impulse or just his usual love of a punch-up.

As Wilde and Lautrec would both find to their cost, it was impossible to avoid the *Affaire*, nor was life made any easier by the difficulty of knowing just who was or was not an anti-Semite. That Degas, despite the closeness of his friendship with the Halévys, would become a virulent anti-Dreyfusard was predictable, that Renoir joined him was not, that both turned against Pissarro was appalling. Forain, the most radical of political cartoonists, was an anti, while the beautiful Comtesse de Greffulhe, model for Proust's Duchesse de Guermantes, one of the grandest figures in upper-class society, became a secret pro rather sweetly writing to the Kaiser to ask if Dreyfus really had or had not been one of his spies. Ultimately, Dreyfus was saved not by the noble actions of radical campaigners but by a man of the right, a fellow army officer with known anti-Semitic sentiments, Lieutenant-Colonel Georges Piquart, whose belief in justice overrode any antipathy he may have felt for the victim. Piquart's discovery and revelation that the documents in the secret file were clumsy forgeries led to his own imprisonment and the launching of the campaign that would slowly, very slowly, lead to the ineluctable call for the review of the case, *La Révision*, that in its progress split the nation and caused the gravest internal crisis in the history of the Third Republic.

It was Zola's trial and conviction on charges of libelling the army high command and his subsequent flight to England that finally galvanised the Dreyfusards into a frenzy of activity. There were different centres of campaigning with one key group based at the *Revue blanche* offices in the rue Lafitte. Immediately following the trial, both contributors and editorial staff organised a production at the Théâtre de l'Oeuvre of Ibsen's *An Enemy of the People* with some of the text rewritten to ensure that everyone realised that on that night Ibsen's hero was undoubtedly Emile Zola. As many as possible took part, with Fénéon and Coolus in the Act Four crowd, the evening stretching out as the audience broke into long periods of wild applause.

From then on the magazine was obsessed with the *Affaire*, article following article, some of the best by Victor Barrucand whose impassioned reports on Dreyfus's second trial at Rennes and subsequent shameful re-conviction, won many waverers to the cause. Jules Renard claimed that many of his fellow writers barely saw their families as they spent most evenings at the office waiting for news of the various activities being launched across the capital. So much did the *Revue* become essential reading for anyone interested in the political machinations behind the *Affaire* that its circulation soared. In his memoirs of the period, Léon Blum evoked the charged atmosphere of those evening sessions where Fénéon and Natanson were usually joined by the painters Vuillard, Bonnard, Roussel and Vallotton and how, at the same time every night, the entrance door would bang open and they would hear the unmistakably noisy laugh of Octave Mirbeau, bringing the latest edition of *Le Temps* which he read out like a wartime communiqué. Each one added whatever he'd learned during the day, trying to sort rumour from fact, weighing up which politicians were now for or against *Révision*. And their advocacy did not stop at articles. Blum and the others organised meetings and campaigned to get signatures for the great petition calling for a new trial organised by the newly formed League for the Rights of Man, which had been set up following Zola's trial. Generally known as 'The Protest of the Intellectuals' or more simply, 'The Protest', it became the single clearest deciding factor (the Dreyfusards signed, the antis did not). Accept or refuse to sign and your closest friend, your dearest relative, your most admired colleague might never speak to you again.

Where, in all this, was Henri de Toulouse-Lautrec? He still spent at least the earlier part of his evenings at the rue Lafitte, yet he was not among the artists on Léon Blum's list of Dreyfusard activists. Thadée Natanson was convinced that Henri, like so many others, was hopelessly split by the *Affaire*, unable to attack the unthinking anti-Semitism of his class and family, yet longing to be loyal to his Dreyfusard colleagues. Henri's solution, according to Natanson, was to keep quiet, hoping that the whole thing would just go away so that he need not be forced to choose between family and friends. This was not unusual – even Fénéon did his best to separate his commitment to the cause and his personal relations, some of which were with openly anti-Dreyfusard authors. But Henri was less successful in his attempts to remain detached from the *Affaire* – in November 1897 he turned down a request for a drawing from the Dreyfusard paper *L'Aurore* which had published Zola's 'J'Accuse', on the grounds that he didn't touch 'current affairs', yet that same year he provided the cover for Victor Joze's latest and most overtly

anti-Semitic novel and compounded this by refusing to donate anything to the album *Hommage des artistes a Piquart* (The artists honour Piquart) which was being assembled as part of the campaign to free the other victim of the army's calumny. Most puzzling to his colleagues was the fact that Henri did not join them in signing the great Petition for Dreyfus later that year, the sure way of showing where your sympathies lay, the unavoidable gesture that divided the creative and intellectual community.

But worst of all was the cover for Joze's book. Keen to profit from the enormous public interest in the *Affaire*, the irrepressible author had decided to re-use the most controversial character from *Reine de Joie* and to create round him a new series of novels entitled *The Rozenfelds – the History of a Jewish Family*. The first, *Le Tribu d'Isidore*, would outline the history of what Joze called, 'a family of modern Israelites as they set about conquering Europe, thanks to the four qualities of their race: intelligence, energy, trickery and patience.' Isidore Rozen, alias Rozenfeld, is a Polish Jew whose offspring, like the Rothschilds on whom they were obviously based, spread across Europe, forming a powerful business network. When they pass into France via Alsace, as many Jews did after the loss of the province to Prussia, the family adopt names common among French Alsatian Jews: Mayer and Heyer, Wolff and yes, Dreyfus – for there can be no doubting Joze's intention to ride that particular tiger. In an audaciously frank foreword he claims not to be 'an anti-Semite in the precise sense of the word' but just a simple observer of reality. He then goes on to list the usual features of the Jewish race as he sees them – the fact that they won't marry Christians, that they are solely concerned with money-making, that they bring to the world of modern finance the same rapaciousness they had used to exploit the poor peasants on the plains of Eastern Europe. These are the arguments that constitute the main thesis of the novel, which sets out to show that if you scratched a supposedly evolved and sophisticated French Jew, just beneath the surface you would still find the old inhabitant of the ghetto and the *shtetl*.

There would be two more novels in the series, *La Conquête de Paris*, which tried to stir up the usual paranoia about Jewish conspiracies to take over gentile society, and *Jerusalem sur Seine* which toyed with notions of Jewish lasciviousness, though by the time they appeared, the public were so exhausted by the emotional upheaval caused by the *Affaire*, that Joze's efforts made little impact and a further three novels were abandoned as he turned instead to books that exposed the hidden vices of the capital. He lived on till 1933 and would probably be completely forgotten today were it not for this connection with Toulouse-Lautrec, a fact that has led some to double their

criticism of Henri's work on Joze's books on the grounds that by doing so he granted immortality to someone who would otherwise have disappeared without trace. While they have a point – he had no need to involve himself with such stuff other than by choice – the signs are that when he realised that this second 'Jewish' novel was on a different level than the less serious *Reine de Joie*, he simply backed off. If one examines the supposedly shameful cover he drew for Joze there is barely anything to see save a rather sketchy drawing that is certainly nothing like the vivid design for the earlier poster. Unlike the dramatic moment when Alice kisses Rozenfeld on the nose, there was no particular incident in the new book that he could have used. Instead we have a rather hasty scribble showing a man riding in an open trap with a little lapdog by his side, presumably the tellingly named Judas Rozenfeld who has been successfully transplanted into a new society where he is able to ride out each day like any other member of the *haute bourgeoisie*, whose manners he has carefully adopted. The odd thing about Henri's interpretation of the scene is that Judas, far from looking particularly Semitic, resembles the wild-eyed Maurice Guibert on the right-hand panel for La Goulue's funfair booth. In order to make some sense out of this Henri added two disembodied heads floating in the sky above Judas, heads whose long beards and prominent noses are presumably meant to indicate that they are Judas's ancestors, those unevolved Polish patriarchs who, according to Joze, highlight the fact that beneath his veneer of wealth and sophistication Judas is still an Eastern Jew, with all that that implies. Little of this is apparent in Henri's quick sketch. While the two heads appear to use the conventional stereotype to represent Jewishness they are hardly the hook-nosed, slobbering grotesques then found in openly anti-Semitic publications such as *La Libre Parole Illustrée*. Rather like Bonnard whose cover for *Reine de Joie* virtually ignored Joze's text, Henri seems hardly to have bothered with *La Tribu d'Isidore* – or perhaps he had read it, decoded its message, and decided he no longer cared for such stuff and that it was best ignored. Whatever his reasons, consciously or not, he does seem to have distanced himself from one of the least attractive works of the Dreyfus period and as if trying to redeem his standing in the eyes of his *Revue blanche* colleagues he accepted a commission to illustrate a book which consciously tried to undermine the sort of attitudes Joze represented, a collection of scenes of Jewish life by the socialist politician and radical journalist Georges Clemenceau.

Clemenceau's role as France's great wartime leader was still twenty years in the future. At the time of the *Affaire* his political career was in the doldrums. His steady rise from mayor of Montmartre at the inception of the

Commune to a position in the Chambre des Deputés where he was known as 'the Breaker of Ministries', through his power to switch sides in a coalition, had ended when his friendship with some of those involved in the Panama Canal scandal had led to the humiliating electoral defeat of 1893. Obliged to take up journalism in earnest, he attempted to mask his frustration at the public's rejection by posing as a man of letters with greater things to aim for than mere office. The truth was he desperately needed money and early every morning, seated at his vast horseshoe desk, goose-quill pen in hand, he dutifully churned out an article for his newspaper *La Justice*, on anything from the major political issues of the time to the minutiae of his personal life. Among this outpouring were a number of pieces based on his yearly visits to the elegant spa at Carlsbad, today Karlovy Vary, in the west of the Czech Republic, then part of the Austro-Hungarian Empire. Some of these reports included descriptions of the Jewish communities in the region which were, to judge by Clemenceau's clearly fascinated reactions, already something of a tourist attraction. These and other pieces connected with Jewish life – six in all – were brought together under the title *Au Pied du Sinai* (At the Foot of Sinai) and despite having been written piecemeal, they are sufficiently homogenous to indicate that he had a clear intention in reissuing them and that given the time and the circumstances, this was largely to counteract books like Joze's novel and thus provide a more sympathetic background to the *Affaire* for those who wished to go beyond the sensationalism of the gutter press. He had every reason to be concerned, for it is obvious that just as Joze had spent years cribbing ideas from Zola and then twisting them to make something more sensational, so had he used a story by Clemenceau, *Le Baron Moise*, as the basis for *La Tribu d'Isidore*, turning the former on its head by carefully omitting any of the moral arguments that underpinned the original. This was the story that Clemenceau now chose to open his selection, a clear sign of what lay behind his decision to produce the book.

As his critics were quick to point out, Clemenceau had undergone something of a change of heart. He had not been one of the few who originally supported Dreyfus – 'they bore us with their Jew' being one of his earlier remarks on the subject, and when he did become the leading Dreyfusard his enemies suggested that his interest was less to do with justice and more with the fact that it provided him with a cause popular with a sizeable segment of the population at a time when he needed to rebuild his political fortunes. According to this theory, he only came down against anti-Semitism when he concluded that it was the province of his political enemies on the right, and in particular of the Catholic Church for which he had an especial loathing.

With that in mind it is easy to pick out words and phrases in Clemenceau's text that appear similar to those used by writers like Joze. Clemenceau, too, expresses shock at what he saw in the ghettos and *shtetls* of Galicia; he too describes prominent noses, straggly beards and greasy curls, while some of his characters, if taken out of context, seem perilously close to the stereotypical Jewish money-grubbers of anti-Semitic hate fiction:

> In the depth of the black little shops, among dress goods, metals, victuals and what not, eyes shine out of the silvery waves of a prophet's beard. Hooked noses, clawlike hands seem to grip obscure objects and refuse to release them unless the tinkling of money is heard.

Yet in context such things are radically different, for alongside the hooked noses and clawlike hands, Clemenceau sees faces out of Michelangelo and Leonardo da Vinci, the same biblical figures that Rembrandt had sketched on his walks through the Jewish quarter of Amsterdam. And why shouldn't he have been shocked by what he saw? For a Frenchman, used to the sophistication of upper-class Jewish life in Paris, the world of the Rothschilds and the Perrières, with their mansions on the Parc Monceau, their boxes at the Opéra, a first sight of what was usually called the 'Jewish Market' in many of the towns east of the Rhine, was enough to induce shock. Even a Jew like Bernard Lazare, one of Clemenceau's fellow contributors to *La Justice*, expressed amazement at what he saw of Jewish life in the ghettos of Galicia and Poland which, after centuries of repression, not discounting the horrors of the pogrom, was often reduced to a level of squalor and poverty worse than anything one was likely to encounter in the West at the time. It could hardly have been otherwise when even a descendant of Eastern European Jews, the writer Isaac Bashevis Singer, in an article entitled *The Old Country*, also brought out the essential strangeness of *shtetl* life as seen from outside: the 'Hasidim in their traditional raiment', 'a cluster of fantastically dressed youngsters . . . a destitute tailor, a shoemaker who wears no shoes.' What Bashevis Singer makes clear is that all this was a product of extreme poverty: 'the streets with their shabby wooden houses were covered with dust in dry weather and deep in mud when it rained. Men and women wore boots not for fashion, but out of necessity.' 'Wood and mud', as Clemenceau succinctly put it, for much of what his critics have taken to be anti-Semitic mockery was really only the forceful language of the naturalist novel *à la* Zola, where words were meant to match the thing described. According to

449

Bashevis Singer, the *shtetl* was a place shared with animals – chickens, calves and goats, and who could deny the exotic appearance of the inhabitants, the women in wigs to cover heads deliberately shaved at their marriage to make them unattractive to any but their husbands, who for their part wore fur-trimmed hats and long kaftans 'borrowed' from the Polish gentry and the Ukrainians. To men like Clemenceau, used to 'unexotic' Sephardic Jews who had emigrated to France mainly from Portugal and to a lesser extent Spain, a first sight of the Ashkenazim was bound to provoke wonder.

By contrast, Clemenceau was not merely familiar with Sephardic Jews, they were part of his family – his brother Paul, his son Michael and grandson Georges all married Jews and once he had become convinced of Dreyfus's innocence no one was more energetic in his defence. It was Clemenceau who, as editor of *L'Aurore,* decided to publish Zola's 'J'Accuse' and thus, overnight, made the *Affaire* the most important issue on the national agenda. And despite his initial shock at the strangeness of Ashkenazi life, Clemenceau soon rallies and succeeds to a remarkable degree in getting inside the characters he describes. Mercifully free of politically-correct attitudes that refuse any suggestion of ethnic or cultural difference he is able to affirm their essential Jewishness and this at a time when assimilation was the watchword for correct-thinking people in both communities in France. Even at the height of his campaign on behalf of Dreyfus, Zola could still tell Sherard that his 'proposed remedy for the antagonism of the two races was intermarriage', as if only the eradication of any suggestion of difference was sufficient to resolve the problem.

When Wilde was driven to despair by the cruelty of the governor of Reading Gaol, Lieutenant Colonel Henry Isaacson, he referred to him as 'a mulberry coloured Dictator, a great red-faced bloated Jew', as if the word were an adjective and a pejorative one at that – a common enough practice until the death camps made such un-thought-out solipsisms impossible. Clemenceau, by contrast, drew a clear distinction between the things that had shocked him in Busk and elsewhere and what had actually caused them. For him poverty and superstition, not race, were what had made the ghetto and the *shtetl* so abysmal – not the Jews themselves, and throughout his little book runs a plea that tolerance and understanding should replace the persecution that had driven the Jews of Eastern Europe deeper into the misery he had seen and deplored.

But ultimately it is the humour that counts, what Bashevis Singer calls the 'fist of humour' by which the oppressed defended themselves; the thousands of little stories in which the weak but clever Jew outsmarts the strong

Georges Clemenceau and the oculist Mayer, from *Au Pied du Sinaï*.

Goy. Clemenceau offers one such, a story of how he was gulled by a Jewish optician into believing himself short-sighted and thus into paying for a pair of expensive spectacles. But it is the first two stories in the book, tall tales that Clemenceau says were told to him on his travels, that exemplify Singer's description of the essential levelling nature of *shtetl* humour, in which the wealthy man 'is always presented as a glutton or miser whereas the poor is warm and wise; the pious is a bigot and the simple believer is honest and

451

straight; the learned is devious and a hypocrite while the unlearned is pure and virtuous'. Thus Clemenceau's eight stories are paired off to make four diptychs in which each 'panel' is a mirror to its neighbour. The first, *Le baron Moise*, tells the tragic tale of a hugely successful Jewish businessman, the Baron Moise von Goldschlammbach, who appears to have followed perfectly the route of assimilation after leaving the East and travelling to France. He is 'very rich in fact, too rich', in Clemenceau's words, having bought a title and an equally assimilated Jewish wife, nominally converting to Christianity to advance his progress. While clearly portrayed as calculating, even callous, Clemenceau nevertheless allows his anti-hero the more intriguing characteristic of self-doubt to an ultimately destructive degree. Why, the Baron asks himself, do beggars always plead that they are hungry, when this is a condition that he himself cannot even begin to imagine? Intrigued, he begins to starve himself but as the experiment overtakes him he slips into delirium and driven by convulsions of pain dashes into the street and begins to beg, automatically using the conventional gestures and phrases he had once observed with such incomprehension: palm outstretched, his voice pleading that he is hungry. Of course, he receives in return the same indifference that he had once shown and, aware that he is watching himself as he was, the Baron suddenly sees the truth that one must 'give, give generously, give all, before it is too late'. For him it is too late, for he no sooner reaches this spiritual enlightenment than he collapses and dies, too late to redeem himself.

In complete contrast the second tale, *Schlomé Le Batailleur* (Schlomé the Fighter) tells the story of a poor Jewish tailor in the little village of Busk in eastern Galicia who is betrayed by his fellow Jews. Unable to accept military service, which would oblige their sons to eat non-kosher food and break the Sabbath, the Jewish communities are allowed to pay for substitutes to replace them in the Imperial army. But in 1848, with revolutions breaking out all across Europe, the Empire is plunged into war and there are three conscriptions in a single year. The elders of Busk manage to raise funds for two sets of substitutes but at the third call-up they are left a soldier short. One of their fellow Jews will have to be sacrificed but the elders, slightly richer than their impoverished neighbours, carefully exclude their own families from the lottery and thus it is poor Schlomé Fuss who is suddenly seized by the police and taken away, leaving his pregnant wife and five children to their fate.

At least the strong sense of community ensures that his abandoned family are provided with just enough to survive and the matter is forgotten until

suddenly, two years later, a haughty Cossack rides into the village resplendent in gold-braided uniform, medals and sabre. It is Schlomé, now wealthy from looting and pillaging and home to avenge his wrongs. At first he seems content to see his family and bask in his new status as Schlomé the Fighter but at the ceremony of Yom Kippur, he steps forward and bars the Rabbi from approaching the tabernacle and thus from completing the act of atonement by which the worshippers are pardoned. The crowd is furious but can do nothing when faced with an armed warrior and in the end it is agreed that the elders will go to Schlomé's house to beg forgiveness of his wife and pay over a handsome compensation. Satisfied, the fighter returns to his regiment and more riches and after two more years returns for good, rebuilds his business and settles back into his old life as a simple Jewish tailor wearing traditional dress indistinguishable from his neighbours.

Two charming stories celebrating humility and simplicity over wealth and power, appropriately coming from a socialist like Clemenceau. In fact, if one could ignore their Jewish settings they would fall into the broad category of moral tales, those uplifting nineteenth-century polemics meant to improve and inspire the common reader. But it is precisely the Jewish aspect of the tales that has drawn increasing criticism – after all, Moise is not just any old, hard-hearted capitalist getting his comeuppance, he is cousin to the greedy Jew in Joze's novel, arrogant during the days of his success, cringing and servile as he begs for a crust. Schlomé too falls foul of an old anti-Semitic canard, the penchant of the Jews for betraying their own, only able to exact vengeance when he casts off his Jewishness and becomes a tall, upright Aryan warrior. But to read the tales this way involves closing one's eyes to the subtleties in Clemenceau's text.

For Moise, assimilation had cut him off from the compassion of his faith and set him adrift; for Schlomé, a temporary assimilation allowed him to redress the wrongs the supposedly pious leaders of his community had inflicted on him. A key to Clemenceau's thinking lies in the title of the collection, which critics have seen as no more than a pretentious irrelevance but which in fact points up the subtext of both stories – Sinai, the mountain on which Moses received the Law, the very heart of Judaism, while the people below, at the foot of Sinai, surrendered to their baser fears and worshipped the golden calf. Clemenceau's choice of names reinforces the message – Moise, Moses, the leader who can see the promised land but may not enter it, Schlomé, Solomon, the great and wise ruler who is excused his un-Jewish ways, not least his many wives, because he is the builder of the Temple. Both tales are replete with that sense of irony, with that dark, self-

mocking, Jewish humour that we associate with the Yiddish writers of the nineteenth and early twentieth centuries. As a Christian nobleman, Moise is racked with self-destructive guilt, as a beggar he is a failure; Schlomé, as a warrior, redresses his wrongs yet wants only to return to the simple life that had been taken from him.

To suggest that these stories are just haphazard bits of old journalism, cobbled together in a pot-boiler collection, won't do. They were selected because of their topicality, in particular *Schlomé the Fighter*, a Jew transformed by his uniform, the solitary individual ground down by a complex interplay of forces: the army, his uncaring neighbours, the Law, his own background; a plight which echoes that of the condemned captain on Devil's Island. And who can doubt that the message Clemenceau draws from Schlomé's tribulations, that such forces can be overturned by a great act of Will, transforming a helpless victim into an avenging warrior, was meant to bolster the Dreyfusards and confound their opponents?

Clemenceau's decision to ask Henri to illustrate his work thus had a double edge. By getting the man who had worked on Joze's anti-Semitic tract to illustrate his own, would help reinforce the contrast, for it was certainly not the Lautrec of *Reine de Joie* that Clemenceau was after, but Lautrec the radical interpreter of Bruant's streetwise lyrics that Clemenceau had known and admired over the past decade. They had, after all, moved in the same circles for years. Back in 1893 they had both been members of a dining club for writers and artists that met on Friday nights at the Restaurant Drouant in the Place Gaillon, and the following year Clemenceau had written an enthusiastic review of the first Yvette Guilbert album, praising the way Henri acknowledged the significance of the café-concert as a democratic, working-class art form.

But what then was an illustrator to make of such complex, passionate stories? It would hardly have been surprising if Lautrec had done no more than rehash the stereotype he had used for *Reine de Joie* or used the sort of neutral uncommitted sketch he had offered for *La Tribu d'Isidore*. Instead he seems to have engaged with the subject in a way that was both original and committed, though there are some signs of a struggle to overcome his own ignorance of things far outside his personal experience.

At the outset, there does not seem to have been much communication between writer and artist – in May 1897, Henri wrote to Adèle to tell her that he was working with Clemenceau on a book 'against the Jews', which may have been a slip of the pen or an indication that he thought this was going to be just another Joze-style effort. Later that same month, however, he had

met the author and was able to tell his mother that he was 'finishing a book with Clemenceau *on* the Jews', which suggests the author had explained exactly what he intended. The illustrations do indicate that Henri's understanding changed as work progressed and he became more involved with the subject. One suspects that the drawing of Mayer the optician trying to persuade Clemenceau of his short-sightedness is one of his earlier sketches, as Henri shows the optician bareheaded when the story is emphatic that he kept his hat on indoors in the orthodox manner, a detail meant to emphasise his Jewishness. Either Henri had not studied the text closely enough or he may have thought it appropriate to play down any racial touches in a tale about financial chicanery. That his approach evolved as work went on is shown by an unused early print for the cover, which shows an attitude to the book quite different from that revealed in the final version, and among the ten prints eventually used are some that show him using imagery that is again different from the stereotypical, caricatural Jewish type he had used before.

That he was trying a new approach is shown by his decision to abandon the bright, flat, Japanese style of his most famous graphic works in favour of a darker, more consciously 'classical' style, using heavy cross-hatched lines and sombre, moody lighting in a way that intentionally echoes the Old-Master drawing he had been obliged to do when he studied with Bonnard and Cormon. He had tentatively explored this kind of thing the year before, 1896, in a lithograph for the cover of the illustrated magazine *L'Aube* (Dawn) which showed a peasant family struggling to push a dust-cart up a steeply sloping street through the city's early-morning gloom, the heavy, dark style emphasising the plight of the work-weary group, the scene dramatically illuminated by two shafts of light from a nearby streetlamp. With his mind turning towards this sort of theatrical imagery, Clemenceau's book, with its mixture of 'exotic' settings and dramatic incidents, offered an exciting opportunity to go further.

His first attempt at the cover, although ultimately rejected, shows that he had grasped the point that Clemenceau's title had a quite literal meaning. Henri shows Moses at the summit of Sinai, hand outstretched towards the promised land, which turns out to be a massive double-headed eagle, symbol of the Eastern Empires – Austro-Hungary, Russia, Poland – rising over the horizon like the sun in splendour, a sign that these states are now the true home of the Jews. As an illustration of Clemenceau's appeal for toleration of the Jewish communities in the East and their right to exist there, free from the pogroms, the violent assaults perpetrated by officials, either out of

religious hatred or simple greed, the illustration makes a valid point but it was also open to misinterpretation – the ragged Prophet looks a little too much like the old anti-Semitic whipping-boy, the Wandering Jew, the rootless nomad always ready to occupy someone else's land. This may have been why they decided to reject the image, though it could simply have been a practical decision based on the fact that if the print was wrapped round the book, the figure of Moses would be on the front and the double-headed eagle on the rear, thus losing the connection and making the picture meaningless.

The second and final version makes more sense – Moses atop the mountain reaches out towards an empty plain while at the foot of Sinai lie the remains of the golden calf and its broken altar – superstition is shattered and the Jews may at last occupy their homeland – just the sort of message the anti-clerical, rationalist Clemenceau believed in passionately. And this sensitivity over the cover is only one sign of the care they took with material that was clearly open to dangerous misinterpretation. Henri's prints were used only for an early limited edition and publishers of subsequent volumes were less fastidious in their choice of imagery. The frontispiece by an anonymous artist for the eighth edition, brought out in the 1920s when anti-Semitism in France was again a dangerous topic, shows a dark 'Slavonic' Jewish type with an exaggeratedly hooked nose, bulbous fleshy lips, overhung simian brows, clutching a money-bag in his hands as he stares malignantly back at the reader. One imagines that the editors Georges Cress and Co. had hoped to hijack Clemenceau, by then the hero of the First World War, using his names to promote a cause he would never have supported. Such an attempt was ridiculous but it does bring out just what Toulouse-Lautrec, working with the author, managed to avoid. The ten prints they finally selected illustrate either precise incidents from the stories or show scenes thought to be typical of the things Clemenceau had seen on his travels. Baron Moise in his box at the theatre, seated behind a beautiful bare-shouldered woman, is shown in his prime enjoying the elegant rituals of Parisian High Society. By contrast, after his fall, he is shown bent and pleading as he tries to beg money from an indifferent passer-by, a scene reminiscent of Henri's dust-cart illustration for *L'Aube*, the gloom pierced by shafts of light from a streetlamp. In another pairing, the seizing of the miserable Schlomé is parried by the spectacle of him resplendent in his uniform, facing down the worshippers in the synagogue. Next, a light, open-air street scene of Polish Jews in Carlsbad is contrasted by a dimly lit interior with Polish Jews praying. The jovial con man Mayer testing Clemenceau's 'short-sighted' eyes, is set against the crouched figure of the poor tradesman

Anti-Semitic illustration by an unknown artist for the 1920 edition of *Au Pied du Sinai*.

at the back of his ghetto boutique, while an importunate trader chasing an unwilling customer through the cloth-market in Cracow pits low comedy against an image of dignified Jewish elders greeting Clemenceau on a visit to the village of Busk. It was an astute choice, each pair representing the two poles of Clemenceau's observations whose forcefulness was sympathetically analysed by another Jewish author, Barnet Singer, in an article in the periodical, *Jewish Social Studies*:

> Clemenceau does verge into anti-Semitism by emphasizing certain aspects of ghetto and *shtetl*. Correct. He does so as an artist, however, not as a polemicist; and, unhampered by inhibitions his observations seem worthwhile. Would it have been better for Clemenceau to have been a liberal, abstract theorist? *Was* that an abstract world? Did it not smell powerfully? Also does it not help explain a newer world, too: one of bleached hair or orthodontia? He who has no affection for this, will liberalize it all into rubble; he who does, will describe it.

It is this same desire to describe that helps Henri avoid the conventional stereotypes of grasping Jewish banker or 'Slavonic' villain that were readily to hand. Baron Moise is not especially Semitic, if anything, he is another cliché: the bloated capitalist rather than the bloated Jew. But it is in the drawings of Eastern Jews that Henri shows himself most sympathetic. Of course he is showing us recognisably Semitic characters but like Clemenceau he observes rather than damns. It has been said that his problem was an absence of models other than the conventional stereotypes, but that is not altogether true. There were several well-known Jewish artists working at the time whose art he would have known – there was even a recognised genre of scenes of Jewish life accepted at the annual Salon. Henri's contemporary, Leopold Pilichowski, a Jewish immigrant from Poland, had been a pupil of Cormon and was by then a frequent prize-winning exhibitor at the major Paris exhibitions, painting scenes of religious and social life that match those that Clemenceau recorded. A painting like Pilichowski's *The Feast of Tabernacles* offers the same physical attributes: noses, beards, gestures that were exaggerated by hate in anti-Semitic art but which in his work became attributes of jovial, decent folk, following their own traditions, bothering no one. In fact that is the main feature of the genre, the representation of nice, happy Jews who are no threat to Aryan society: the genial matriarch cook-

ing her matzo balls, serious Talmudic scholars bent over their books, sentimental Jewish weddings, as if nothing was wrong, nor ever would be. Ultimately, of course, such 'genre' Jews were no more real than their anti-Semitic counterparts. The impoverished *shtetl* and ghetto dwellers of Eastern Europe did not lead such easy and complacent lives and attempts to pretend otherwise led to what the twentieth-century Jewish painter Chaim Soutine called 'Blood and Bouquets' when he was asked to compare his own work with that of his contemporary, Marc Chagall. Soutine's art, his rotting meat and edgy, nervous portraits prefigure the nightmare that would engulf the Jews. Chagall's happy *Fiddler on the Roof* dream of an ideal *shtetl* is certainly more pleasant but yields to history.

Henri chose reality. Maurice Joyant recalls how, 'Faithful to his documentary method, he went into the Tournelles district where there lived groups of poor foreign Jews – Russian Jews, Polish – existing in sordid houses, veritable ghettos.' This area around the rue Tournelle, now most commonly called *Le Marais*, to the east of what was then the great food market at Les Halles, was known by its Jewish inhabitants as the *Pletzel*, the 'little place', a sort of voluntary ghetto where the recent immigrants from Eastern Europe chose to live so that they could maintain their traditions, dress, food, social customs, etc. Previous waves of mainly Sephardic immigrants had tolerated temporary ghettoisation while they adapted their dress and manners, keen to spread out and lose themselves in the wider French society – now the *Pletzel* of Paris was for the Ashkenazim, their only desired home, with a life that revolved round synagogue, *shul*, ritual bath-house, *cheder* and *yeshiva*, the men in *yarmulkas* and fringed Taleth-Koten, the women in long-sleeved, high-collared gowns, the food shops offering *mlinchkes*, *latkes*, *tayglech* and *tsimmes*, the year divided by the Sabbath and ceremonies like Purim and Yom Kippur which further isolated the *Pletzel* dweller from his Christian neighbour. The fact that Clemenceau was so shocked by his first sight of the Jewish communities east of the Rhine indicates that he had never visited the fourth *arrondissement* where the only difference of any importance was the absence of mud and pogroms. Otherwise, as Henri hoped, the visual impact was much the same. Along the rue Tournelle he could find and sketch an authentic Polish Jew, a hunched shopkeeper and an importunate market trader much as if he were in Cracow or Busk, though again there were precedents – Rembrandt in the Jewish quarter in Amsterdam, searching out models for his biblical characters or, nearer to hand, the Dutch Jewish artist Joseph Israels, leader of the Hague School of painters who specialised in studies of peasant life, which in Israels'

Polish Jews Praying, from *Au Pied du Sinai*.

case often meant the lives of poor Jews, work much admired by Van Gogh and undoubtedly known to Henri from his visits to the Low Countries. Israels' sombre earth-colours, much influenced by Rembrandt's dark, dramatic lighting, influenced in turn the more sombre style Henri was trying to

460

develop and which finds its most complete expression in the best of his illustrations, *Polish Jews Praying*; this depicts an incident in the book where Clemenceau recalls attending the Sabbath worship of a small sect that rejected synagogue services, choosing to follow their own rite in a small room in a restaurant. The Jewish act of prayer, the men rocking gently back and forward, clearly moved Clemenceau and Henri. In the illustration, he captures just such a group of men close to, heads covered in prayer cloaks, one figure bending forward, the two just behind him leaning back, lines of movement rippling down their robes, creating the sensation of what Bashevis Singer described as 'Trees moved by the wind swaying like Jews on the day of Yom Kippur'. There is a nobility that Clemenceau also expressed when he wrote of 'the fine face of an old man suggesting the gentle philosophers of Rembrandt under the arches of a stairway losing itself in nocturnal darkness, impassive with a discreet little smile.'

Clemenceau's text and Henri's drawings evoke both the sacred and the comic that existed cheek by jowl in the enclosed world of the *shtetl*, where even God was not spared the fist of humour. Henri captures this neatly with his image of Schlomé in his magnificent uniform lording it over the congregation on Yom Kippur in Busk. It would be wrong to imagine that Schlomé had truly become Goy; rather he belongs to that long tradition of aping the Goy that can be seen in Abraham Shulman's collection of photographs of *shtetl* life, *The Old Country*, where the 'Jewish Volunteer Fireman' in Minsk in helmet and epaulettes, poses hand on hip like a cavalry officer or, again, a group of stern Jewish soldiers from a Tsarist Russian cavalry regiment sport 'Kaiser Bill' waxed moustaches but look as if they will burst into laughter a second after the photograph is taken.

Such photographs can still evoke the bustle of the market, the rough poverty of the streets, the warmth of home, the joys of Bar Mitzvah, Shevot, and Passover; but those moments of solemn prayer, the pious simplicity of the *shtetl* that so moved Isaac Bashevis Singer, were not amenable to flashlight and long exposure and only Henri's unique dimly-lit print can recall a world now gone. Tragically, it is all that is left – the Jewish communities of Galicia were scattered and as for Schlomé's Busk – on Yom Kippur 1942 the Nazis carried out the first *Aktion* against the village. Between 19–21 May 1943 its population was liquidated.

461

16

IT'S LIFE THAT'S BAD, NOT ME

*P*olish Jews Praying was for Henri neither a new beginning nor an end,
just the beginning of the end. As Joyant put it: 'these lithographs
show what Lautrec might have done in this way if he had not, by his
intemperance, cut short his career'.

For much of the time, he still seemed able to live and work at his usual
intense level but this was deceptive. As Joyant knew, his behaviour could
suddenly become irrational – sometimes amusingly so, more often not. This
became all too clear during a visit to London in the spring of 1898 for the
opening of the first major exhibition of his paintings in Britain, at the new
branch of the Goupil Gallery in Lower Regent Street, which Joyant had
helped set up. Until then his reputation across the Channel had been large-
ly based on his posters and this much-publicised show would have been a
major celebration, had its subject stayed reasonably sober. He arrived a few
days before the opening and stayed at the Charing Cross Hotel – another
place associated with his visits to London that remains remarkably
unchanged, its French Beaux-Art décor just as he knew it – but the pleasure
had gone out of these 'exotic' trips and he found himself hanging around the
station, hoping that his friends would arrive. The exhibition was opened by
the Prince of Wales, no doubt happy to recall some of the places he had
enjoyed on quasi-secret visits to the French capital, but when His Royal
Highness and his sister Princess Beatrice arrived Henri was stretched out on
a sofa fast asleep and the indulgent prince asked that he be left in peace.

Overall, the exhibition was a disaster. While Henri had carefully refrained
from arranging anything like the notorious private room at his last major
show, the suggestion of nightclubs and worse was enough to inflame some of
the critics who were already provoked by the knowledge that the artist still
associated with the infamous Oscar Wilde. The *Art Journal*, while praising
Lautrec's technique, thought his subjects 'unlikely to commend themselves

to old ladies', which was fair enough and less dishonest than the *Daily Chronicle*, whose critic pronounced himself 'shocked', though at least he spelt Henri's name correctly, unlike the *Star* which spoke of a *Lantrec* whose 'distinguished' skills did not compensate for the ugliness and vulgarity of his work. Not surprisingly the *Lady's Pictorial* expressed considerable relief when the show ended and the manager of Goupils, Mr Marchant, was able to put on an exhibition of safe Dutch landscapes, hoping to attract back some of his paying customers.

It would be two years before Henri exhibited again and even then there would be little new work on show – many of his drawings were by that point hardly more than scribbles, so confused they may well have been made while he was drunk. Not that he needed to drink very much – like many advanced alcoholics it now took only a glass in the morning to top up the alcohol level and make him drunk again. On occasions he suffered from violent bouts of delirium tremens, shaking like an epileptic; on others he would simply disappear, who knew where, least of all himself, when he returned, aggressive and foul tempered. Before his London trip, Adèle had moved back to Paris taking an apartment near his new studio on the Avenue Frochot, just down from Montmartre. While still trying to avoid acknowledging the full extent of his illness, she now accepted that he needed help and quickly reinstated their old habit of dining together, even though he might turn up with one of his drinking companions. On one occasion he brought a brothel-keeper who never took his hat off throughout the meal. To set against this, there were sudden bouts of hard work as he laboured furiously to complete albums of lithographs for publishers in Paris and London, but these would give way to periods of inertia in which he doped himself with sedatives provided by Dr Bourges. It was a wretched time for Adèle, whose attempts to shun the truth crumpled in the face of such extreme behaviour. He now told close friends that he had begun to see things: a beast with no head or, in that classic dipsomaniac mix of tragedy and farce, that he was being pursued by the giant elephant from the Moulin Rouge. To him it was far from funny. He slept with his cane to ward off attacks by policemen and saw dogs everywhere – they were the one consistent subject in his ever-rarer works, fox terriers from his childhood hunts and Bouboule, Madame Palmyre's dog, with its nasty prying ways and its tendency to bite anyone who got too close – much like Henri.

Throughout 1898 he had a series of breakdowns, but the crunch came at the beginning of 1899 when Adèle, without warning, decided that she could take it no longer and fled to the country. Henri was devastated; he had spent

much of his adult life trying to escape her cloying affection yet when he truly needed her, she had abandoned him. Her maid Berthe Sarrazin tried to take care of him, but he correctly suspected that she was reporting his behaviour to Adèle and complained of being spied on by servants. Given his condition there is little need to wonder that he did not offer any work for the Piquard Album and failed to sign the Dreyfus petition. He had stepped outside the real world and was no longer fully aware of its concerns.

Wilde's life too appears to have gone off on a drunken tangent. Willing to drink with anyone who would pick up the bill, Oscar had fallen in with Roland Strong, correspondent of the London *Observer* and the *New York Times* who was sniffing around the Dreyfus Affair and managed to have several meetings with the now suspected cause of the entire catastrophe, Esterházy, recently promoted to Commandant. Sometimes Strong took Wilde to their meetings and the three met on several occasions both in Paris and out at the popular riverside picnic haunt of Nogent-sur-Marne where Bosie had found a hotel that was willing to accept delayed payment of accounts. Esterházy seems to have relished the surreal nature of these encounters: 'We are', he told Wilde, 'the two greatest martyrs of humanity – but I have suffered the most.' 'No,' said Wilde coldly, 'I have.' News of these meetings filtered back to London where everything Wilde said was of interest, further blackening his already befouled reputation, especially when word came of his latest epigram which seemed to indicate a lack of sympathy for Dreyfus:

> Esterházy is considerably more interesting than Dreyfus who
> is innocent. It's always a mistake to be innocent. To be a
> criminal takes imagination and courage.

In fact it was hardly likely that Wilde would have approved of a man like Esterházy, though he appears to have been too far removed from reality to moderate his statements on the matter. Clearly, any joke was better than none, given what he had been through – he even told Fénéon that he had contemplated taking his own life but as he stood on the Pont Neuf trying to summon up the courage to jump in, he noticed someone else looking into the Seine and asked if he too was 'a candidate for suicide'. 'No,' said the young man. 'I'm a hairdresser.'

But such pleasantries aside, neither Wilde nor Lautrec were any longer masters of their own destinies. Berthe Sarrazin's frequent letters to Adèle in Albi, between January and April 1899, chart a passage through dementia to violence that is made more terrifying by the simple language, poor spelling

and disregard for punctuation that characterised her reports. Even more moving are the occasions when the news was so bad the poor woman felt she could not relate what had happened directly to her mistress but wrote instead to another of the servants, Adeline Cromont – one of Adèle's chambermaids who had looked after Henri when he was a child – hoping that she would break the news more gently. Solid peasant woman that she was, Berthe was most often upset by the sight of her charge wasting money, inexplicably returning with a set of old pastry moulds he had bought or trying to get her to cook lobster for his friends – she refused on the grounds that the recipe was too complicated – then overpaying the masseur who helped ease the pain in his legs. Three days after Adèle's departure Berthe reported that he had wasted a lot of money on some little plaster figures and had decided to sleep in his mother's bed. She began to get worried when she caught him rubbing his paintings with Vaseline which she thought might damage them but her attempts to intervene sometimes resulted in her 'being put in my place in no uncertain terms. Sometimes he is so ill he only eats raw eggs with rum. Money is an increasing problem with bills being run up here and there.' On 13 January she confessed to Adeline the chambermaid how Monsieur's ranting about his mother was beginning to unnerve her. Behind much of what she wrote can be discerned the manipulative side of the true alcoholic as Henri promises to keep her in his service telling her he will settle an income of 3,000 francs on her, anything, as long as she does what he wants which was usually to provide him with drink. It is only to Adeline that she could reveal that she had caught her charge in bed with two women, one of them the aged Gabrielle, his one-time model, who was by then another hopeless, dirty drunk given to sponging off him. Henri's own physical decline was equally evident: the skin yellow, 'his lips full of yellow crust too'. He even had a boil on his neck and to add to his personal squalor, he had found a little dog which he named Pamela which 'does its business all over the place'.

As the months pass his mood-swings became more violent – he tried to attack the concierge and his accusations of betrayal caused Berthe to despair. He even quarrelled with his cousin Gabriel and for a time refused to see him, and the few who were able to tolerate his temper and his deviousness augmented Berthe's reports with tales of wild behaviour outside the apartment. Found in a hotel bed with two whores and refusing to settle the bill, he began screaming that he was the Comte de Toulouse, the only occasion when he is known to have used the title. After three months, Adèle's apartment was a filthy mess – he had 'washed' the walls with kerosene to kill any germs, and the rare visitor was appalled by the stench from the lavatory. Alerted by

Berthe, Adèle finally returned to Paris and tried to persuade the two doctors, Bourges and Gabriel, to help have Henri committed to an asylum in Neuilly. There is no record of whether they finally agreed to her request, he may have decided to go of his own volition, but there is some likelihood that his mother arranged to have him seized and taken to the asylum under duress. One story has him collapsing with delirium tremens in the brothel in the rue des Moulins, which at least has the symmetry of fiction about it. But however it was achieved, in early March 1899, Henri de Toulouse-Lautrec was admitted to the clinic of Dr Réné Semelaigne at 16 rue de Madrid, Neuilly. Like his friends Fénéon and Wilde before him, he too was now a prisoner. Worse, it was as if he had been transported back in time – the clinic was only a short walk from the Verriers' house where he had been incarcerated after he was forced to abandon school. It was as if the soft, maternal, female world had finally surrendered him to the harsh, male, medical world – he was even given electric shock treatments again, though as this was one of the 'unofficial' ways of treating syphilis it may be that, rather than the initial alcoholism, that his new doctors were trying so uselessly to cure.

The feeling that life had taken on a theatrical, other-worldly quality can only have been reinforced by the strange building in which Henri found himself. Appropriately dubbed the *Folie Saint-James*, this was a charming eighteenth-century pavilion set in an elegant garden dotted with Louis XV sculptures, in which Dr Semelaigne provided a refined retreat where the well-off could dry out in comfort – the Betty Ford Clinic of its day. Despite the various treatments on offer, there was really only one that mattered: the patients could not drink and so in most cases their health improved – for a time. This was certainly the case with Henri, but neither the rapid amelioration of his physical decline, nor the amusing atmosphere in which it was accomplished, prevented him from regarding the place as anything other than a prison. As he was quick to realise, with the high fees they were getting, his doctors had little interest in pronouncing their rich clients cured. He wrote to friends begging them to help get him out and even appealed to his father to do the decent thing, though as ever Alph declined to get involved. It was, however, a sign of just how well-known he now was that Henri's plight was debated in the newspapers, with many of the writers choosing to see in his afflictions a punishment for his moral turpitude both as a man and an artist.

In the end it was art that would provide the key to open his cell. He reckoned that if he could prove to these medical gaolers that he was again able to work rationally, watched by the press they would have no choice but

to declare him fit to be discharged. With this in mind he embarked on what he later called his *Souvenirs de ma captivité*, a total of thirty-seven drawings in chalk, ink and crayon, based on his memories of the circus. He never explained why he chose this particular subject though it is not hard to see why he should have wanted to return to the great pleasure of his childhood and to that brief period with Suzanne Valadon, when anything had seemed possible and the only boundary to his world had been the limits of his own fantasy. The results are certainly competent, if rather unnerving – clowns and horse-riders perform alone, unwatched from the noticeably empty seats save by a solitary dog, presumably the incontinent Pamela. Thankfully, his plan was a success and after only a month and a half in Neuilly, his doctors agreed that he was sufficiently improved to be allowed out, at which point, Adèle arranged for a distant relative from Bordeaux, Paul Viaud de la Teste, who had sometimes joined Henri's holiday parties, to travel to Paris to act as his guardian. What made Viaud so suitable was a stomach ailment that prevented him from drinking which meant, so Adèle calculated, there would be someone sober nearby to ensure that her errant son would come to no harm. She clearly accepted that Henri would quickly return to his old habits. For his part, Henri accepted that Viaud was another Berthe Sarrazin sent to spy on him but this time he was prepared to swallow the indignity, with both sides respecting the other's role in their odd relationship. Almost as soon as Henri was out they embarked on a pattern they would follow for the next two years, spending some time in Paris then travelling in order to get Henri away from his regular haunts and thus reduce his alcohol intake. In June 1899 they stayed at the Joyants' summer home in the tiny fishing village of Le Crotoy at the mouth of the Somme, then travelled down to Le Havre, and then on to Malromé to stay with Adèle, a tour they would repeat the following year. On that first visit, Henri arrived in Le Havre just before Oscar Wilde, who was also 'resting' from the exertions of Paris and its bars. It is generally assumed that this was their final encounter, though there was one further contact the following month when Wilde asked his London publisher to send Henri and a few other French friends, including Fénéon, a copy of the first printed edition of *An Ideal Husband*, whose appearance was a welcome sign that despite his personal disgrace his work would not be completely forgotten.

For Henri, this release from the bars and brothels of Paris gave him the energy to attempt a little work, though as his main subject turned out to be the English barmaid in the Star in Le Havre this was not much of a break with habit. But just when it seemed that he had finally surrendered to drink

and was no longer excited by the mad variety of life passing before him, something would come along that succeeded in stirring his old interest. That summer of 1900 he was fascinated to see that his copy of *La Revue blanche* contained the first extract of *Messaline*, a novel by Jarry that Fénéon had decided to serialise and which he would publish in book form the following year. Any novel by the unpredictable Jarry would have been an unmissable event but an historical novel was simply extraordinary and the fact that he had chosen to write about Messalina, the lascivious consort of the Emperor Claudius, who had famously prostituted herself in a Roman brothel, was bound to interest Henri. Classical sources had provided Romantic authors like Théophile Gautier with some of their more amusing tales, allowing them to offer sex and violence lightly masked as history and glossed with whatever moral lesson they wished to draw. Then as now, it was a formula that proved widely popular – four years earlier, in 1896, the Christian bodice-ripper *Quo Vadis* had not only brought its Polish author Henryk Sienkiewicz an international bestseller but also ensured him one of the early Nobel Prizes in 1905. The looming figure of Nero's vicious wife Poppea had given the tale its dash of *fin-de-siécle* decadence and the search was soon on for other 'bad' women of antiquity, with the result that the turn of the century saw an outpouring of novels and plays loosely based on the infamous Messalina, the strumpet Empress who cuckolds her husband with most of his court and army and who is finally cut down when she attempts to replace him with a lover. Most of these books are pure fiction in the sense that they pay scant regard to the historical record, which made Jarry's effort all the more remarkable – the strange young man had actually gone back to the dozen or so classical sources that refer to Claudius and his wife, of which four – Suetonius's *Lives of the Caesars*, Juvenal's sixth Satire, the *Annals* of Tacitus and Dion Cassius's *History of Rome* – provided him with titillating anecdotes of Messalina's sordid behaviour. But research aside, Jarry was otherwise at one with the Romantic tradition whose authors transformed such historical figures in any way that suited them. Jarry's Imperial Whore is a vehicle to express his wariness of woman the predator – when the book was published in England it was given the title *The Garden of Priapus* but through his erotic saga of coupling and lust one senses the author's fear of what Huysmans called the *Vagina Dentata*, that terrifying organ snapping at enfeebled mankind. Two years earlier, in 1898, Jarry had shown some of his work to Oscar Wilde. The older man had been fascinated, finding 'sometimes the obscenity of Rabelais, sometimes the wit of Molière, and always something curious of his own'. The connections between Salomé and Messalina

MESSALINA.

Aubrey Beardsley, *Messalina Returning from the Bath.*

are obvious and go beyond similarity of subject-matter, with Jarry using the moon as a symbol of unattainable sexual desire in a way that clearly echoes Wilde's play. Indeed Aubrey Beardsley, whose illustrations for the published version of *Salomé* extended the metaphor by incorporating Wilde's face into the watching moon, and who had now met Jarry in Paris, produced a series of drawings for *Messaline* which further link the two works.

This connection may well have provoked Henri's interest in the *La Revue blanche* serialisation, and as the extracts appeared he carefully cut the pages out of the magazine and saved them. As yet he had no particular idea what use he might make of Jarry's tale and for the time being the story was allowed to mature, awaiting its moment.

When they returned to Paris for the autumn, it was clear to Viaud that Henri's condition was worsening. For some time he had managed to fool his guardian, keeping from him the ingenious fact that his walking-stick was hollow and could contain up to a half-litre of spirits and that the knob screwed off to make a tiny drinking cup. But Viaud now accepted that his ward was lost to alcohol and there was little he could do beyond preventing him from hurting himself. Henri's work was now erratic and frequently abandoned. Perhaps realising that one of his best artists was about to disappear Joyant tried to tempt him with commissions for fashionable society portraits. Predictably, this was not a success – aside from Misia Natanson, flattering sitters was hardly Henri's strong-point and one suspects that Joyant's sense of business was beginning to overtake his duty as a friend. He did try to get Henri the Légion d'honneur but all the politicking came to nothing when a sympathetic minister was introduced to Henri, who asked him to imagine how odd the red ribbon would look in a brothel. One is left with the feeling that Joyant was trying to ensure that his investment would be suitably enhanced were the artist to die but that Henri was resisting such moves with all the cunning still left to him. When he was in the asylum he had been invited to join the committee that would select work for an exhibition of posters as part of another Universal Exhibition to mark the new century, a sign that he was now officially recognised as a master of graphic art. This was precisely the sort of public imprimatur Joyant wanted, but in the end Henri refused the honour and did not even bother to submit any work of his own. When the exhibition opened he was weaker than ever and even though he was only thirty-five years old, he had to get Maxime Dethomas to push him round the show in a wheelchair. Unlike the other mammoth exhibitions he had visited, he claimed to have found little to interest him which is odd, given that the exhibition has come to be seen as the apotheosis of the Art Nouveau style to which Henri, especially with his simplified, strongly coloured graphics, in particular the near-abstract Loïe Fuller series, was thought to have made a major contribution. But no, things were not as good as they had been, a judgement that was probably due to increased grumpiness and depression rather than to any shortcomings on the part of the organisers.

When he returned to the coast that summer his drunken antics both amused and appalled his friends – having himself photographed naked on a boat or again with his trousers down, having a shit on the beach – *Ubu Roi* made flesh! But behind the crude jokes there was the ever-present fear that he might again collapse and have to be confined, perhaps permanently. With this in mind he decided not to return to Paris with its irresistible temptations, and in October 1900, he and his loyal guardian settled in Viaud's hometown Bordeaux, near enough to Malromé to please his mother, sufficiently distant to preserve some independence and allow him one last chance to get back to work.

(Above and below) Henri defecating on a beach near the mouth of the Somme, some time around 1900.

They took rooms in the rue de Cauderan in the very centre of that most elegant of southern French cities – indeed, the sophistication of Bordeaux would both inspire and seduce him during his six-month stay. Far from being a provincial backwater, the city had a vibrant cultural life of its own – a rich port at the centre of the wine trade, where the Garonne widens to the sea, a major focus of Jewish life, a hotbed of anarchist activism, Bordeaux had most of the distractions of Paris and was no place to avoid temptation. The food was superb, the bars amus-

ing, and Henri was not one to resist – he even managed to recreate his arrangement with the brothel in the rue des Moulins by establishing himself in one of the local *maisons de tolérance*. This and the exceptionally damp and depressing winter weather ought to have made any thought of work impossible but there was one feature of local life that was able to drive him to his easel, the imposing Grand Theatre whose productions rivalled those of Paris and which that season was staging a work that must have amazed Henri when he saw it advertised – the first French production of a new opera by the English composer Isidore de Lara, his four-act lyric tragedy *Messaline* – yet another creation based on the life of the nymphomaniac Roman Empress.

It must have been difficult for Henri to contain his impatience for the opening night. As engravings of the sets in the Bordeaux Municipal Archives show, the theatre was planning something on a scale that would only be rivalled by early Hollywood – ancient Rome as fantasised by W. D. Griffiths. Although no longer in fashion – de Lara's blockbuster has not been performed in France since 1943 and today is written off as so much derivative bombast – in its day *Messaline* was a huge critical and popular success and the Grand Theatre was thought to have pulled off quite a coup in staging it before Paris or London.

The opera had had its debut earlier that year in Monte Carlo, the following year it would be staged in Italy, making de Lara the first English composer to have an opera performed at La Scala – though in most respects he was already a thoroughly European figure whose work was more French than Anglo-Saxon. Brought up in Boulogne-sur-Mer, trained in Milan, Isidore Cohen (the stage-name came later) was part of the sophisticated cosmopolitan milieu that included people like the Natansons, the Leversons and, in his own way, Will Rothenstein. The newly named de Lara had begun as a singer with the unique, if brief, distinction of having enjoyed the patronage of the most uncultured man in Britain, none other than the Marquess of Queensberry who, inexplicably smitten by the young man's voice, hired him to give private concerts in his London home. To match this, it was to a colleague of Wilde's friend Marcel Schwob, the lyricist Eugène Morant, to whom de Lara turned, asking him to collaborate with Paul Armand Sylvestre on a libretto for his first major opera.

Neither the composer nor his lyricists were much bothered about the history involved and their Messalina was to be less the stomach-churning whore of Juvenal's Satire – 'not yet satiate with men and filthy with her foul'd cheeks and dirty with the smoke of the lamp, she carried the stench

Design for the opening of Act 1 of *Messaline* at the Grand Theatre, Bordeaux, 1900.

of the stew to the pillow of her husband' – and more a lost soul who, denied the possibility of love, can only find some happiness in physical pleasure. In the first act, the Empress seduces the poet Harés only to abandon him for his brother, the handsome gladiator Hélion whom she sees during her brothel outing. When Harés tries to kill the Empress in the Imperial box at the circus, he is struck down by Hélion who, on realising that he has killed his own brother, leaps to his death in the arena, while the cause of the tragedy, Messalina, is for once consumed by bitter grief.

It was strong stuff, and de Lara made the most of it, opening with a much-praised, stirring march for Messalina's first appearance, haughtily descending the massive staircase before the gates of the Imperial palace – a device that clearly echoes *Aïda* and which gives a sure clue to the composer's inspiration. With its Monaco success running ahead of it and with rumours circulating about the cost of the sets and costumes, the forthcoming production was the talk of Bordeaux. De Lara himself was in town for rehearsals, dining at Le Capon Fin then as now one of the best restaurants in a region famous for its gastronomy, and giving interviews to the press – though the greatest publicity was provoked by the scandal of the dress rehearsal, which by convention was open to members of the municipal authority and their friends, but which on this occasion was performed in

473

ordinary clothes as the theatre's director had decided not to reveal his expensive costumes to a house full of free-loaders. Predictably, the curtain came down to a chilling silence though the effect on a now hyper-charged public was electric, with everyone straining at the leash for the following night's official opening, costumes and all.

Henri had been invited by the editor of a local newspaper and, given his absorption with the subject since he had started collecting the extracts from Jarry's novel, it is hardly surprising that he became noticeably overexcited, drank a lot and was in no fit state to enjoy the show. By the time the curtain went up he was completely carried away – yelling 'Splendid' whenever Messalina appeared, ignoring the increasingly aggressive protests of those sitting nearest him, until he suddenly jumped up, pushed his way down the aisle and left. According to the journalist Albert Reche he then spent two days shut away in his studio making sketches of the parts of the opera he had seen, returning to the next performance for the parts he had missed and returning thereafter over and over again. He had plenty of opportunity – the opera's outstanding success ensured that the Grand extended the run for an unprecedented thirty-five performances

This was to be Henri's last *furia*. He now found a workspace in the nearby rue de la Port-Dijeaux, a large storeroom where a local art dealer kept his stock, too poorly-lit to be a real studio, though this hardly mattered given the artificiality of what he was planning. Over the Christmas period and on into the New Year 1901, he produced six large paintings based on the opera, or more precisely on its heroine; when he finally dispatched the canvases to Paris he referred in an accompanying note to his 'new paintings about Messalina'.

That some underlying idea was driving him along is evident in the letter he wrote to Joyant in mid-December asking him to send photographs, 'good or bad, concerning de Lara's *Messaline*. I am fascinated by this opera, but the more documentation I have the better it will be.' He wrote again a fortnight later asking for programmes for *Messaline* and for the stage version of Zola's *L'Assommoir*, another work that dealt with the then shocking notion of sexually active women, especially the scene where a rowdy gang of slum-girls roams the poorer quarters of the city looking for men – which suggests that this was the theme for his new series, an extension of ideas contained in the lesbian and showbusiness works.

If so, then it is hardly discernible – four of the canvases seem barely finished and while it is possible to see that he was trying something new stylistically, rejecting his usual rapid brush-strokes in favour of heavier,

Messalina's entrance, descending the massive staircase in
Act 1 of De Lara's opera.

unshaded colours, contrasting red and green against browns and black in larger swathes of colour in a manner that some have seen as a precursor of Expressionism, the results are little more than rough images of dramatic moments from the opera, seen at an odd angle that suggests that Henri had been given permission to stand in the wings in order to sketch the performance close to. Only one painting, now in the Los Angeles County Museum of Art, offers any clue that he had a deeper meaning in mind. This shows the moment in Act One when Thérèse Ganne, as Messalina, made her first appearance, majestically descending the vast staircase, proud, aloof and sure of her dangerous beauty. But the most revealing element in the picture has nothing to do with De Lara's opera and is drawn directly from Jarry's novel – on the balustrade beside Messalina, Henri has placed the bronze statue of a she-wolf, hindquarters provocatively offered to the viewer, an image drawn from Juvenal who claims that the infamous night the Empress spent in a brothel was passed in a cell whose door was marked 'Wolf Woman', a reference to the city's maternity symbol, the gentle creature that nurtured Rome's founders, Romulus and Remus, and further proof of Messalina's infamy in assuming such a character for her night of debauchery. In Henri's painting, Messalina's appearance is awaited by members of the praetorian guard who, in Jarry's tale, will be her lovers and then her murderers, which, according to art historian Frank Milner, is the key to the painting – for someone like Henri, dying of drink and syphilis, it could only have seemed fitting to celebrate a woman whose death was the result of her uncontrollable lust. Whether, as Milner questions, this was a sign of remorse on the artist's part, or a final act of black humour, is not easy to answer though one suspects the latter.

Such self-mockery was all there was left to him now. By early spring he was again in a bad way. Strapped for cash, poor wine sales exacerbated by disastrous floods having tightened the family purse-strings with no corresponding economies on his part, Viaud had written to Joyant that January reporting how his charge had 'overdone the ladies a bit' which always drained their finances. In March, Henri had a stroke that temporarily paralysed him and again, in a grim replay of his childhood miseries, he was obliged to have electric-shock treatment for his weakened legs. Little need to wonder why the Messalina series is so sketchy and incomplete.

When the canvases had been dispatched to Paris, Henri and Viaud packed up and followed, a last visit though hardly a joyful return. He was, however, still able to paint, though given all that had gone before, it is perhaps appropriate that there has been nothing but confusion and

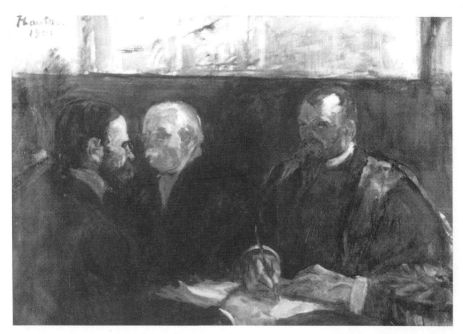

A candidate, possibly Gabriel Tapié de Céleyran, being examined by Dr Wurtz (right) and Dr Fournier at the Faculté de Médecine.

disagreement over these 'last' works. No one can even agree which really is the final canvas though the most likely candidate for the dubious honour is probably the large, rather gloomy painting that shows what appears to be some sort of interrogation – a man seated on the left of the picture facing two older men across a table. The right-hand interviewer is taking notes or marking some sort of examination paper and the painting is always entitled *Un Examen à la faculté de Médecine*, though there is little agreement as to who exactly is being examined. Most scholars have assumed that it is a record of the day when Henri's cousin Gabriel went through the obligatory oral examination, the final stage in the presentation of his thesis on vaginal herniation. Other writers challenge this, pointing out that Gabriel had actually undergone the test two years earlier in 1898, when Henri was trapped in the Neuilly asylum, and while the chief interrogator in the painting, Dr Robert Wurtz, did indeed sign Gabriel's thesis, there are other recognisable participants who did not. In fact the most damning evidence for the 'antis' is the absence of anyone resembling Gabriel himself, with his prominent side-whiskers quite unlike the examinee in the picture who sports a copious dark beard. This absence has led most recent writers to accept that the work has been mistitled and that what we have is simply the examination of an

unknown candidate. They could, however, be wrong as there is one photograph of Henri's cousin that does show him temporarily sporting just such a dark beard, though confirming the traditional title hardly explains why a clearly dying Toulouse-Lautrec should have forced himself to paint so unlikely a subject.

One reason may lie in the details of Gabriel's thesis which he had dedicated to his mentor, and Henri's longtime subject, Péan, who had died in 1898. Gabriel and Péan had remained very close, with the younger man being summoned to the great surgeon's home to help treat his pneumonia caught while out hunting, a favourite pastime. Having failed, Gabriel no doubt thought it only fitting that he should honour one to whom he owed so much and Henri may have wished to join him in some way.

Another 'cause' behind the painting may be the figure of the examiner, Robert Wurtz, who Henri had known, via Gabriel and Bourges, for some time – he had even joined their holiday parties on the coast. Henri had embarked on an individual portrait of Wurtz earlier that year and as the doctor was an expert on alcoholism, and would probably have counselled Henri at some point, it is reasonable to assume that he, rather than the heavily disguised Gabriel, is the central figure in the slight drama of the 'last' painting.

Until, that is, one identifies the chubby moustached figure of the second examiner at Wurtz's side who turns out to be possibly the most distinguished medical practitioner in France since Péan's death and someone hardly likely to have been passing his time examining a doctoral thesis.

This man has only recently been identified as the last of the great French syphologists and possibly the most outstanding medical figure of the *fin de siècle*, Dr Alfred Fournier. Aged sixty-nine when the painting was made, Fournier had been at the Hôpital Saint-Louis for twenty-five years, as head of research into syphilis, a post that had been specially created for him when he was only in his thirties. Fournier was no flamboyant genius, suddenly crying 'eureka' as he made some utterly unexpected discovery, rather he was a quiet, patient researcher who examined thousands of cases, carefully noting everything he saw, breaking down all the facts he gathered into manageable statistics. The result was the demystification of that terrible sickness. Under Fournier, the once feared Hôpital Saint-Louis became 'the Mecca of Dermatology' and the 'capital of syphology', with the first international congress on the subject being held there in 1889. Sadly, Fournier, who died in 1914, did not have the satisfaction of seeing a cure developed – that would not come about until Fleming discovered penicillin in 1929 and the antidote

Alfred Fournier.

was finally achieved in 1943, but to that great French doctor goes the honour of having taught the world how even an incurable disease could be handled, a practice that was to have effects beyond the limited world of syphology. To Fournier, education, prevention and, if necessary, sympathetic treatment were crucial to keeping the disease in check and to that end he encouraged the spread of special clinics where sufferers could expect discreet treatment.

Until Fournier came along, despair had struck those few who still specialised in the subject – it was as if syphilis had defeated all attempts to comprehend its deviousness. By the 1870s things had reached such a pass that the only new 'cure' to emerge involved the surgical removal of the chancres, the hideous suppurating ulcers that appeared in the first stages of the disease and which were believed to contain the actual infectious matter. But given where these chancres were situated, such a remedy was little short of barbaric, in effect self-mutilation, which seemed to chime with the growing view that syphilis was itself a punishment for libertinage and that its medical treatment should somehow reflect and sustain that scourge. It fell to Fournier to put an end to such puritan madness. Not that he was without his moralising side, for it was Fournier's self-imposed task to convince France and the world that in the absence of a cure, a knowledge of the disease should be brought out into the open, so that it could be medically supervised

479

and its impact reduced. This was to be done by the better monitoring of prostitutes, the introduction of medical examinations in the army and navy, easily available hospitalisation for treatment of the infected, the sexual education of the young and a widespread public education campaign.

To this end, Fournier set up the Société Français de Prophylaxie Sanitaire et Morale whose very name reveals the dual nature of the good doctor's thinking. On the one hand he was all for principled treatment of the sick and roundly condemned the practice of carrying out experiments on patients as Auzias-Turenne had done. But there was also that word *morale* in the title, which was to lead to rather prim, and thus not very effective warnings being given to schoolgirls and to the rather blunter posters put up in public urinals that continued almost to the present day and which panicked generations of young men still unsure exactly how the disease was transmitted. Essentially, Fournier's aim was to try to stop the spread of the disease within marriage, the process whereby infected husbands passed on a disease acquired from prostitution, to their wives and thus their children. At a time when the syphilitic was viewed as a social outcast and when many argued that anyone who had suffered from the malady should be forbidden by law to marry, Fournier attempted to persuade society that it should adopt a more reasonable approach, arguing that someone in the throes of the disease should desist from conjugal relations but that after the disease had subsided, normal married life would be possible. Outside marriage there was the new '*capote anglaise*', the rubber condom recently invented in England – though here, the one reasonably sure defence ran foul of the Church and promotion was much hindered by the theological debate about birth control.

Fournier's ideas only really took hold when they were taken up by the playwright Eugène Brieux in a play called *Les Avariés*. Brieux dedicated his drama to Fournier in the hope that: 'syphilis will be considerably less serious when people dare to speak openly of a disease which is neither shameful nor a punishment, and when those afflicted with it, knowing the miseries they can spread, are more aware of the duties they have towards others and towards themselves.' Though in truth the author was being somewhat disingenuous, as his play concentrates single-mindedly on the moralising aspects of Fournier's philosophy – despite the advice of his doctors, a syphilitic marries and brings ruin on his family. Fournier, however, had no grounds to complain as it was not the play itself that spread his ideas but the scandal that surrounded it. Antoine attempted to stage the drama in 1901 and was astounded when the censor refused permission on the grounds that it dealt with matters that should not be aired publicly. This sparked an out-

cry with people protesting that while near-pornography could be staged, a serious attempt to debate what was after all often the unwanted result of such sexual stimulation could not be allowed. In the end, Antoine was able to hold a reading of the play in November of that year, though it would not be performed in France until 1905. Few, however, could have avoided hearing something of the arguments dealt with in the piece, and not just in France. Within a year it had been staged in Belgium, by 1913 it had been launched on Broadway and was taken to Washington for a special performance before President Wilson and Members of Congress.

The outcome of all this was the growth in public campaigns to inform the public of the dangers of the disease and the availability of confidential treatment in special clinics, a dual attack which was especially effective in what the French call the 'Anglo-Saxon' countries with the result that when a disease, if anything more dreadful than syphilis, appeared, America and Britain were able to launch massive campaigns to warn the public of the dangers of AIDS while at the same time finding the huge sums necessary for research and treatment, and this all without either stigmatising sufferers or denying them the right to a sexual existence. It is no exaggeration to say that without Fournier this would probably not have happened in the way it did. It is possible to see a campaign like that for Safe Sex as a direct descendant of the idea of marital restraint that he advocated.

Of course all this was way beyond anything Henri de Toulouse-Lautrec could have envisaged – even that first reading of Brieux's play in November 1901 was too late for him. But with his theatrical connections there is no doubt that Henri had been aware of *Les Avariés* and its arguments during the preceding twelve months that the scandal raged. Indeed, it may be something of this that we can glimpse in the '*examen*'. Brieux's drama largely consists of a series of interviews between the recalcitrant anti-hero and his doctors, in which his various moral choices are aired, and one wonders if this is in fact what Henri is referring to in the painting. The title is no doubt perfectly accurate – what we see is surely the examination of an anonymous candidate at the Faculté de Médecine by Wurtz and Fournier but at the same time it also invokes elements of *Les Avariés* and the whole ethos of Fournier's syphology.

Of course, as with everything Henri did there is always the personal dimension – and it is obvious that the two doctors – Wurtz for alcoholism and Fournier for syphilis – represent the two causes of Henri's downfall, suggesting that in some way he, too, is the figure under interrogation.

Like that one Messalina canvas, the '*examen*' is another dense, personal

481

work and certainly one almost impossible for the general spectator to decode. Both are the products of one who had finally ended his former close contact with the public world of the boulevards, the cafés and theatres that had previously sustained his art. By then friends were dropping away, projects abandoned. He was probably unaware that Oscar Wilde had died the previous November, his final sufferings provoked by a painfully infected ear, the result of his fall in prison, his condition further weakened by syphilis and drink.

By June, Henri had had enough of Paris. According to Joyant, he decided to put his affairs in order by signing all the paintings in his studio and stamping any prints with his red 'oriental' monogram – a wonderfully convenient situation for an art dealer as this greatly enhanced the value of the collection. In fact it seems unlikely that someone so divorced from everyday concerns would have bothered to undertake so arduous a task, especially as it could only benefit someone with whom he appears to have quarrelled. From then on, his few notes to his old friend open with a cold 'Dear Sir' rather than the 'Dear Friend' or 'Dear Old Chump' of earlier days. Perhaps he suspected Joyant of trying to manipulate him, though at this distance it is impossible to say exactly who did what.

Henri and Viaud said goodbye to Paris on 15 June 1901 intending to spend the summer at Taussat-les-Bains, near Bordeaux, but Henri's decline was now accelerating and after a second stroke in mid-August he asked to be taken to Malromé.

There is a photograph of Henri sitting in the garden of the château with Adèle, which was probably taken on an earlier visit, but which gives some idea of what their last two weeks together were like. He is slumped in a chair dozing, she looks glumly on, bottles of what one assumes to be wine on the table, it being pointless to refuse him a drink by then. There is some story that he managed to find the strength to finish a portrait of Viaud dressed as an eighteenth-century admiral, for the chimney-piece in the dining room – a neat ending as this brings him full circle to that long-ago portrait in the dining room in Albi, for which he had completed the hands. Oddly enough, in this 'last' painting, Admiral Viaud stares out to sea towards a sailing ship heading to the horizon, reminding one of the little boat on his letter to Devismes all those years ago, or even the *Argus*, watched by the despairing survivors of *The Raft of the Medusa*.

A nice tale though probably exaggerated: the thought of him climbing a ladder to paint seems far-fetched, though he may have added a few final touches to a work begun earlier. The reality is shown in that photograph, the exhausted artist nursed by his mother who has at last regained the opportu-

nity to purge her feelings of remorse by devoting herself to his comfort. Alph, of course, was away hunting, so there was nothing to disturb the last days that mother and son could eke out together – though his parents would continue to spar, even over their son's corpse. Adèle had already decided that she wanted Henri buried near the convent of Verdelais, a place of pilgrimage, its chapel plastered with *ex-voto* offerings from those whose prayers had been answered. Of course, the anti-clerical Alph would refuse, insisting his son be buried nearby at Saint-André-du-Bois, only to be outmanoeuvred after his own death when Adèle had Henri's body disinterred and put where she had always wanted it to be. Today under a high stone pillar topped with what appears to be a mix of a cross and a flower, with the convent church in the vale below, he who ought to have been buried beneath the counter of the Irish and American Bar or in the Gothic chamber in the rue des Moulins' brothel, rests among nuns.

Oscar Wilde, too, knew little peace in death. Buried outside Paris in the cemetery at Bagneux he was moved, nine years after his death, by the ever faithful Robbie Ross who had paid off Wilde's debts and recovered his copyrights to provide an income for his children. Ross had organised a plot in the Père-Lachaise Cemetery in Paris next to the radical journalist Victor Noir, once the gathering place for young anarchists drawn to pay homage to their assassinated hero. A statue was commissioned from the controversial sculptor Jacob Epstein, a massive ambisextrous Sphinx wearing a tiara yet endowed with a prominent *membrum virile*. This proved too much of a temptation and was later hacked away, though whether by a disapproving prude or a passionate amateur of such things is not known. When Ross died in 1918 his ashes were placed in the tomb, beside those of Wilde whose most loyal friend he had been. Bosie was Bosie, of course, spending the rest of his life either denying the truth of his relationship with Wilde or just as fiercely playing the role of the golden youth adored by genius, an object of fascination, ridicule and disgust. He was not alone in his contradictions – John Gray, who had been ordained a Catholic priest in 1901, sacrificed most of his remaining years to the impoverished parishioners of an Edinburgh slum, always denying that he was the model for Dorian Gray and buying up any copies of his own poems he came across in order, as he put it, to 'immobilise' them. Yet for all his new-found piety, he had semi-opaque glass put into the windows of his rectory so that the rooms were dim and mysterious, the floor covered in heavy velvet, the walls hung with lithographs by Ricketts and Shannon, the sheets on his bed, black linen. Others never quite recovered from having known Wilde – Sherard, twice divorced, alcoholic, often violent,

wrote books on his friend which continually missed the point as he tried hopelessly to defend Wilde's innocence, attacking those like Gide who suggested otherwise. He had almost sunk into total oblivion when he wrote a life of De Maupassant that revived his fortunes and brought him the Légion d'honneur. Then it was all downhill until his death in London in 1943, leaving his then wife the sum of £50.

Henri with his mother in the garden of the Château de Malromé, *c.*1893.

Henri's friends, too, would have mixed fortunes. Aristide Bruant became rich from sales of his music and books, acquiring a château in the village of Courtenay in the Loiret where he had been born, marrying an opera-singer and becoming quite the local squire with opinions to match, though these were more pro-army and patriotic than straightforwardly right wing. When he stood for election to the Chambre des Députés in 1898, he described

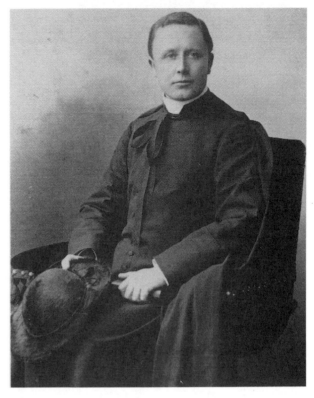

A photograph of John Gray in later life, after his conversion to Catholicism and his entry into the priesthood.

himself as a 'Republican, a Socialist and a Patriot', by which he probably meant something like a left-wing jingoist, a position engendered by his military service during the Commune which had stimulated an undying admiration for the simple French soldier. He preferred to sing rather than make speeches, which pleased his audiences but failed to get him elected. His second collection of songs *Sur la route*, published in 1899, was full of patriotic ditties, far less radical than the earlier *Dans la rue* that Henri had so much admired and when the right-wing author Michael Morphy brought out a gung-ho history of the Fashoda Incident, purchasers were given a free copy of a new Bruant song 'The French Fatherland' which hymned the exploits of the *poilu* in the deserts of Africa, marching to the strains of the 'Marseillaise'. It was to be expected that Bruant would be anti-Dreyfusard and on his later rare but highly profitable concert tours around the country the only radical material allowed was the odd sentimental ballad about an abandoned child or a fallen woman. The death of his son during the First World War darkened his last years but by the time of his death in 1925, he was something of a folk-hero, and despite his luxurious lifestyle and apparent political realignment nothing can alter the fact that his earliest songs did much to

bring the plight of the poor and lonely to the attention of those able to pay to hear him sing. It is noteworthy that when the Nazis occupied Paris they thought two of them still so dangerously radical that a reprinting was officially banned.

The Second World War was a nightmare for Yvette Guilbert. She had never changed her act and her songs were by then more Bruant than Bruant. But while she had to keep silent during the Occupation she could not disguise the fact that her new husband was Jewish, forcing them to live in seclusion in Aix-en-Provence, frightened that he might be denounced, arrested and deported. Sadly she died in 1944 before the Liberation could put an end to her ordeal.

The war years brought some comfort to one of Henri's closest friends, Jane Avril, when an admirer tempted her out of retirement in 1941 to come to Paris for a last celebratory performance. She had left the stage thirty years earlier when she married the painter Maurice Biais who was willing to accept the son she had had by one of her earlier lovers. They lived happily in the country at Jouy-en-Josas but when Maurice died she found herself penniless and moved into an old people's home where she took up knitting, never telling anyone who she was and what she had been. For that final show, she danced as if all the years fell from her, still, as she put it, 'carried away by music'. She died in 1943, alone but not unhappy, hoping that there would be dance halls in the other life where she might be invited to perform the *Danse Macabre*. At least she had made the best of the dull days after her fame had faded away, unlike the woman she had succeeded, the once illustrious La Goulue, whose life had sunk to a level of degradation and misery unimaginable in her heyday at the Moulin Rouge. When Jane Avril died, one observer noted how she still had the erect carriage and slim figure of a girl of eighteen, her beautiful ankles as slender as ever, but when the writer Sylvain Bonmarriage managed to track down La Goulue out in Neuilly-sur-Marne in 1925, she was by then the 'ball of lard' one of her more savage reviewers had predicted, white-haired and toothless, her gross appearance made unbearable by her endless pleading for more drink:

> 'Monsieur de Lautrec? Oh yes, sir, I knew him. That's a long time ago, Monsieur de Lautrec. A small coffee and rum please. I had plenty of fun in those days. It's seven years now since I was last in Montmartre. It must have changed a lot . . . Poor Monsieur de Lautrec. Do you think I could have another little coffee and rum?'

When Bonmarriage found her she was still living in the broken-down gypsy caravan she had acquired during her last fling at fairground life – for no one could deny her indomitable spirit as she staggered from failure to failure, picking herself up and starting again. After the belly-dancing episode she had gone back to her old routine at the Jardin de Paris but after a few tired appearances she had to give up and with tremendous courage offered herself to Baptiste Pezon, the most famous animal trainer of the day, who taught her how to work with hyenas and wolves before graduating to lions. For a time this seemed to work, despite the fact that she was by then so fat that as she cantered round the ring cracking her whip her tights often split. By 1900 she had acquired some animals of her own and was off on the touring circuit along with her newly acquired husband José Droxler and a new booth, though with no Lautrec to help her, this one was rather crudely painted with wild beasts and gladiators – somewhat prophetically, for after she set off her luck again changed for the worse, or rather her beasts turned against her, probably because there was never enough for them to eat. It began in Rouen where a little girl got too close and a lion tore off her arm, then in 1904 La Goulue was just able to save Droxler from the claws of an enraged puma and three years later, as she was dancing the can-can with an old lion called Negus, he suddenly attacked, leaving her scarred for life. Gradually the animals were sold or died off and were not replaced. There is a letter dated 1908, to the town hall at Neuilly, requesting a site where she could put on her animal show which reveals that by then she only had a wolf and a kangaroo, though heaven knows what she did with them. When she finally gave up in 1913 she was down to two pet pigs. What happened to the husband is unclear.

There was now nothing left. In 1900 she had sold the Lautrec panels to a collector of Impressionist art who is unlikely to have realised their true importance. From time to time, the two canvases reappeared briefly – in April 1902, a year after Lautrec's death, *Le Figaro Illustré* used the large photograph of the booth taken at Neuilly to accompany a long article by the artist's friend Arsène Alexandre, which amounted to a first attempt at biography, and which shows that some at least were aware of the importance of the two works that La Goulue had so off-handedly helped create. They were next on view in 1904 when they were loaned to the Salon d'Automne but in 1907 they were sold to the dealer Drouet and appeared less often. It was not until 1914 that they resurfaced when the Manzi-Joyant Gallery organised a large retrospective of Lautrec's work which included a full-scale reproduction of the funfair booth with the original panels in place – another proof of

La Goulue tries a final can-can in the film *La Zone* (1928).

the significance attached to the two works by those like Maurice Joyant who had been close to the artist during his lifetime. Joyant thought about getting La Goulue, who was then begging on the streets of Montmartre, to recreate her belly-dance inside the booth but when he met her he found himself 'faced with a huge, amorphous woman, a real pachyderm who could hardly remember the painter, whom she called Toudouze, mixing him up with the man who made pretty portraits'. Sadly he concluded that 'there are pilgrim-ages which one must not make after twenty years'.

Not that this was an axiom followed by La Goulue herself, who often hung around the Moulin Rouge begging for coins, drunkenly burbling to passers-by that she was a 'good girl – it's life that's bad not me'. The Moulin Rouge was partially destroyed by fire in 1915 and she was sometimes seen staring through the hoardings, looking wistfully at the ruin of the place where she had once reigned supreme. Someone saw her ten years later in a show organised by a heartless huckster who had set up a booth with a sign advertising 'La Goulue of the Moulin Rouge' where for a few sous a passer-by could enter and see her, carefully primed with cheap red wine, making a spectacle of herself. She is said to have worked as a servant in a brothel and

one rather charming myth relates that after Bruant closed Le Mirliton the premises were turned into a refuge for the aged poor with La Goulue among them. That is unlikely, though for a time she did disappear without trace and was only discovered by accident in 1928 by the documentary film-maker Georges Lacombe who was making *La Zone*, his record of the abysmal conditions in the *maquis*, then largely occupied by *chiffonniers*, the wretched rag-pickers who lived like scavengers earning a pittance from the city's waste. While moving around among the ramshackle huts and refuse-strewn mud tracks, Lacombe was told of an interesting character he might like to include in his story. Taking his camera crew he went down some side alleys and found himself standing in front of her old gypsy caravan, the film turned and out stepped La Goulue in a dirty shift and baggy cardigan. The incident had nothing to do with his subject but who could have left it out? Today, the film is preserved by the Centre nationale de la cinématographie in its vaults inside one of the fortresses that were part of the outer defences of Paris that fell before the Prussian advance in 1871. After the customary bureaucracy, one can obtain permission to go out and view it on a tiny machine that throws up flickering images of squalor and poverty until suddenly there is the caravan and out steps that gross figure who grins inanely at the camera, daintily lifts her ragged skirt, raises a fat arthritic leg and waves it about in a clumsy parody of the can-can. It is all one can do not to look away out of shame and pity. She was then living with her last companion, a mongrel called Rigolo (Funny), who she begged to be allowed to take with her when they carted her off to hospital in January 1929 – they didn't agree, but in any case she died the following day. She too had a deathbed priest and was said to have asked him: 'Father, will God forgive me? I am La Goulue.'

She died the year the panels she had once so nonchalantly commissioned were finally restored. They had passed to a Scandinavian collector and only resurfaced in 1926, when the eight 'portraits' were suddenly 'found' by the art dealer Hodebert who promptly came under sustained attack from lovers of Lautrec's work led by the vigilant Duthuit. In his article, the critic evoked the warrior ancestors of the Counts of Toulouse who had so savagely conquered Jerusalem and proposed that their descendants should come to Paris to horsewhip the dealer. At a more practical level, Duthuit suggested that the Department of Fine Arts and the Minister of Culture had a duty to salvage the works, a call taken up by Robert Rey, one of the leading curators at the Louvre, who set about trying to prevent Hodebert from disposing of the mutilated fragments. Over the next three years Rey kept up the pressure. The canvases were acquired by a Hugues Simon and in February 1929 he

offered to sell them to the Louvre. By March of that year, two other missing pieces, plus some offcuts, had been tracked down by Maurice Joyant and by April negotiations for the sale were complete, though it was some time before the final missing strip of canvas with the head of Valentin le Désossé, could be tracked down and stitched back into the work. After prodigies of restoration the two great panels were ready and in 1930 they were hung in the Luxembourg. Later, in 1947, they were transferred to the Jeu de Paume and in 1986 to the new Musée d'Orsay, though few of the tens of thousands of visitors who pass them every year have any idea of their significance.

There is now only one fragile living link with the panels and the world for which they were created – one can still go to the Foire du Trône, every year after Easter, now held slightly further to the east on the edge of the Bois de Vincennes but still crowded with young Parisians in search of spills and thrills and still with the traditional gingerbread on sale. Inevitably the old individual booths with their skilled performers have yielded place to terrifying mechanical 'rides' that hurtle people up and around, strapped in chairs, screaming their heads off. Only at the furthest edge of the vast site can one find a narrow alley of largely unvisited booths where traditional showmen still try to interest the odd straggler in the headless lady or the two-headed sheep, the very last vestiges of La Goulue's fair. When they are gone there is unlikely to be anything to replace them, whereupon that bizarre world of buxom girls and gruesome freaks will disappear for ever.

La Goulue's panels were not the only works by Lautrec to have been subjected to surgery. There was also the somewhat mysterious saga of the large canvas *Au Moulin Rouge*, which at some point lost, and at another regained, the large right-hand figure of May Milton. The discovery, in 1985, at the Chicago Art Institute that the canvas had not been extended and the figure added on, as had always been thought, but had actually been painted in its entirety then cut up and later reassembled, led Professor Reinhold Heller of the University of Chicago to propose a conspiracy theory. According to Heller, Maurice Joyant had excised Milton to protect the reputation of his late friend, then later repented and put her back again. Of course such a thing was possible and it is true that Joyant, like several of Henri's friends, did not like Milton and that at times they did do some odd things to defend him from association with doubtful characters. When the funfair booth panels first entered the Luxembourg, the cataloguer preferred not to identify the disgraced Oscar Wilde, referring instead to a Monsieur de Saint-Aldegonde, a witty if obscure reference to the sixteenth-century writer who campaigned for freedom of belief and was imprisoned for his trouble. But there is as

much likelihood that Henri himself cut up the picture in an attempt to give it greater pictorial unity and that it was Joyant who chose to restore it to its original state, a situation much more in keeping with what we know of Joyant who, from whatever motives, did everything he could to enhance Henri's reputation after his death. Even Alph recognised Joyant's role and following Henri's funeral wrote to him, renouncing his claim to the large body of work stacked in Henri's studio in Paris and offering it to the dealer to do with as he saw fit, though the way Alph expressed this wish was hardly gracious: 'Merely because the artist is dead and was my son,' he wrote, 'I cannot go into ecstasies about what I consider to be no more than rough-hewn works, the result of his temperamental audacity.' He even intervened to prevent Henri's friends from erecting a statue in his memory in Toulouse, writing to the organising committee to insist that his son 'had no talent, and I shall oppose the proposal to the utmost of my power'.

So it was left to Joyant to see that his one-time friend would not be forgotten, even though they appear to have parted company in the last year of Henri's life. As Henri's artistic executor, Joyant was now in a position to ordain which of his works were or were not genuine and realising that the best way to enhance an artist's reputation was to have a substantial body of work included in a major national collection, he prudently donated collections of prints to the Luxembourg Museum and the Bibliothèque Nationale and tried, unsuccessfully, to persuade the Louvre to accept a substantial collection of the paintings. When this was refused Joyant worked closely with Adèle to set up the Toulouse-Lautrec Museum in Albi, to which he donated most of the works he had acquired thanks to Alph's careless dismissal, though at the opening in 1922, it was little realised that Joyant had not handed over all the works and that he still retained a substantial private collection. What he may have intended to do with this is not known. When he died eight years later in 1930, the remaining works passed to his mistress, Geneviève Dortu who continued her lover's efforts on Henri's behalf, producing a *catalogue raisonné* of his art and becoming his most ferocious defender. But she in turn left the collection to her daughter and following her death it passed to her husband Jean Alan Meric, who is currently president of the Société des Amis du Musée Toulouse-Lautrec.

The portrait of Wilde which Henri made in London is also in private hands and thus rarely seen. Having held on to it for twenty years, the death of his son, in the First World War, and growing financial difficulties prompted André Antoine to sell the picture privately to Alexandre Natanson. Years later Alexandre's son recalled a dinner party his parents gave for a few old

collaborators from the *Revue blanche* days who, seeing the portrait hanging in the salon, began reminiscing about Wilde, his wonderful voice and entrancing conversation, his wit and outrageous clothes and manner. Years after his death, Wilde continued to exercise a vivid fascination not only for those who had had the good fortune to hear him but even for those for whom the experience was second hand. Alexandre Natanson kept the portrait until 1929 when a downturn in his affairs obliged him to sell off his art collection, part of which, including the Wilde portrait, was bought by the art dealer César de Haucke and subsequently sold to a private collector. Before the auction, Alexandre had offered the work to Félix Fénéon who was then running the Bernheim Jeune Gallery, but he turned it down on the grounds that over the years it had slightly discoloured, especially round the face, and was in any case, more of documentary than artistic interest. That and the fact that it was unlikely to realise more than six hundred francs made it of little commercial interest to the gallery. This might seem a strange judgement for someone like Fénéon to make, but the fact is that he was no longer the slightly detached observer of the *comédie humaine* he had been before *La Revue blanche* ceased publication in 1902. By then the Natansons' fortunes were already in decline and Fénéon's ever-increasing interest in rather obscure political causes from labour problems in Australia and New Zealand to Communist activity in Manchuria seemed unlikely to win new readers, though the crunch really came when Misia, forever shattering her image as Angel and Muse, ran off with a fabulously wealthy newspaper proprietor. It was too much for Thadée, who convinced Alexandre to close down the magazine, though they helped Fénéon get a job as a news writer, first for *Le Figaro*, and later for the *Matin*, where he came up with his brilliant *Nouvelles en trois lignes* in which even the most complex stories were reduced to a pithy three lines:

The torso of a dismembered man has been discovered in the Bois du Boulogne. For the moment, the man charged with solving the crime, Commissioner Durbec, cannot make head nor tail of it.

They were a *jeu d'ésprit* that owed much to Wilde's paradoxes, an influence Fénéon would have been happy to acknowledge. In the end, four years of keeping up a constant standard of intensive wit proved draining and in 1906, again with the Natansons' help, he was given the job of running the Bernheim Jeune Gallery, the Paris headquarters of what was rapidly becoming the most successful chain of art dealers in Europe, with branches in

London, and New York, even more successful than Joyant's gallery which he and his partner had taken over from Goupil and renamed La Galerie Manzi Joyant. Fénéon quickly signed up the Nabis, Bonnard and Vuillard, who had been with him at the *Revue*, and built up substantial holdings of work by Van Gogh, Lautrec, Picasso, Modigliani and Matisse. On the rare occasion when his directors decided that an intended acquisition was too adventurous or expensive, Fénéon used the excellent salary they paid him to buy the work himself, gradually assembling one of the most extraordinary collections of modern art in the capital: work whose increasing value allowed him to retire in 1924, a withdrawal that was so complete many believed he had died. By occasionally selling paintings like Seurat's *Bathers at Asnières*, which eventually made its way to the Tate Gallery, London, he was able to do only those tasks that pleased him, compiling the complete catalogue of Seurat's work or, generally anonymously, helping dealers like De Haucke with their auction catalogues. But these few essays aside, he effectively disappeared, spending his time resisting efforts to reprint his earlier work or to gather together collections of his journalism, as if this preoccupation with the past was nothing but an irritation. Just before the Second World War, when a budding art historian, the American John Rewald, later the celebrated chronicler of Impressionism and Post-Impressionism, visited Paris in the hope of interviewing any survivors of the period, he was told that Fénéon was dead: it was only when a friend suggested he look him up in the telephone directory that Rewald discovered the 'banal listing' of this legendary figure. Not only did Fénéon invite him to his apartment, the two became friends with the older man rediscovering all his old passion for editing as he reworked the young man's tentative efforts, happily showing him the remaining works in his collection. Rewald discovered Lautrec's rapid ink-brush sketch of Fénéon hanging on the back of a door which you had to squeeze through and close if you wanted to see the picture properly. Typically, Fénéon gave it to him; in fact Rewald discovered that he had been giving everything away, returning letters to the original correspondents as if to totally efface himself from the history of the art of his time in which he had played such a prominent part, as if only the paintings were what really mattered. In his own case, he did succeed in suppressing much of the dross of normal existence that usually occludes and distorts the memory of the famous, leaving only a bright unsullied reputation as the midwife to, and chronicler of, one of the most exciting moments in the history of Western art. Even his role as the only man in the convoluted story of French anarchism to combine in his person the Propaganda of the Word with that of the Deed, has never really

stained this image; his Deed was always suspected but never, even today, irrefutably proven, and seems at this distance more like a creative 'happening' than the dreadful act of meaningless violence which badly wounded an innocent man that it surely was.

Fénéon never reneged on his radical politics, though in later years, with the decline of anarchist influence, he declared himself a Communist and but for the German occupation of Paris would have donated his entire surviving art collection to the Soviet Union just before his death in 1944. Forthright and lucid in expressing his beliefs in art or politics, withdrawn and mysterious in his person, without Fénéon's extraordinary capacity to recognise and bring together the new and the unusual, much of what has been chronicled in this book would never have taken place.

The contrast between Fénéon's enthusiasm for Lautrec and the petty-minded critics who found pleasure in trying to destroy his reputation after his death could not be greater. Their refrain was always the same – despite an aristocratic background, his deformities had led him to search out all that was vile in life. At the time of his death, there was a veritable outpouring of venom with one newspaper writing of his 'curious and immoral talent . . . a deformed man who saw ugliness in everything.' The phrase 'immoral talent' surfaced again in *Le Courrier Française* which also raised the spectre of 'pernicious and unfortunate influences', without detailing what they might have been; and while this particular view was later counterbalanced by more favourable opinions, even as late as 1932 the English critic Hugh Stokes could still mention Henri's 'deformity' as the main stimulus for his art, calling him 'a rapscallion, a member of one of the oldest houses in France, who loved to spend his time with the scum of society. He haunted the Moulin Rouge, and the company of Jane Avril, La Goulue, and the other frequenters and acrobatic dancers of that evening resort. He belonged to an age that passed with the death of Oscar Wilde.' To defend him against such charges, his friends and admirers elevated the other Lautrec, a man of fun and good humour, loving and loved by the good-time girls and mischievous scallywags of a jolly age who really didn't harm anyone and whose art was all about living life to the full. In the end both detractors and defenders leave us with someone so superficial, one wonders why anyone should bother with his art.

Yet those who have bothered to look, really look, will have sensed that there is something more than such simplifications allow. There has always been another Lautrec – it was there from the beginning of his career in the parody of Puvis de Chavanne's *Sacred Grove* made with his friends in Cormon's studio, that proclamation that art should not concern itself with

timelessness, with unchanging Classical values, but with the here and now, with change, the constant dangerous change that was the very essence of the nineteenth century when no concept and value was left untouched by that remorseless thrust into new and uncertain territory which made *fin-de-siècle* life so terrifying yet so exciting. For above all, Henri was the artist of his century's end and the harbinger of the century to come. In his short lifetime everything changed then changed again – the social order shifted out of all recognition as the bourgeois Republic replaced the élitist regimes that had dominated much of the century. Relations between men and women began to move into new territory in ways that infuriated some, frightened many more; the poor demanded pleasure, the right to be entertained, the rich wanted to join them, the powerful began to look human as weaker folk asked awkward questions, idealised love yielded a little to sexual reality, truth occasionally displaced hypocrisy and Toulouse-Lautrec was there to record it. As one of the few prescient newspaper reports at the time of his death put it:

> His wealthy background gave him freedom from all the hardships of life, and he devoted himself to the observation of the world. What he saw is not very flattering to the end of the last century, of which he was the true painter. He sought the reality, disdaining fictions or chimeras which falsify ideas by unbalancing minds. Some will say that he was a snooper, a dilettante of rather melancholic originality, to which disposition, natural for one who suffers, he felt himself drawn. But this was a mistake and all his work shows it. He did not overturn reality to discover truth, nor strive to depict something that was not there. He contented himself with looking. He did not see, as many do, what we seem to be, but what we are.

He was not always successful – his more ambitious, large-scale works, even when completed, often fall short of his intentions and it is to the smaller, lesser-known drawings and prints that we have to turn to get some idea of how profound his thinking could be. Yet taken together the range and depth of his art confirm him as the successor to that often broken yet ultimately persistent line of radical French artists who emerged from the painters of nature and animals to become critics of society and chroniclers of a shifting social order. Vernet, Géricault, Delacroix, Daumier, Courbet, Lautrec – his place in this line confirmed by his successors, those artists who looked to him both as a master and a rival to be surpassed. The young Picasso, fresh from

the café and cabaret society of Barcelona, made Lautrec's night-life works the starting point for his first Paris paintings. He even attempted, not altogether successfully, to outdo his mentor with studies of Yvette Guilbert and cultivated Jane Avril for her stories about her friend. But it is fascinating to realise that it was to the radical Lautrec that the Spaniard turned when he too began to explore the harsher side of city life, using Henri's illustration for Bruant's 'A Saint-Lazare' as the basis for his own studies of the women's prison and finding in Henri's brothel and lesbian paintings the inspiration for a lifelong preoccupation with the world of the *maisons closes*.

For artists themselves, as opposed to those who only write about art, the politically aware Lautrec has always been as much in evidence as the entertaining painter of the Moulin Rouge. He clearly foreshadows the work of the German *Neue Sachlichkeit* artists George Grosz and Otto Dix in the interwar years, who used the decadent nightlife of Berlin, the 'Cabaret' world of Christopher Isherwood's novels, to mock the rise of Nazism with a savagery of which Henri would have readily approved. When one recalls that he came from a family whose eyes were fixed immovably on the past, it is all the more remarkable that he looked only forward, responding to the present with a searing honesty few have equalled. And it is surely this sense of immediacy, of an intense involvement with life being lived that has made him so loved. For while he has never been accorded the status of Degas or Cézanne in the critical ratings that are such a feature of our intellectual life, he nevertheless ranks with Van Gogh and Gauguin as one of the three most enjoyed and accessible artists of the modern age.

Much of this can be put down to the popular conception of his tragic life as portrayed in biographies, novels and films. As with Van Gogh's madness and Gauguin's search for a tropical Eden, the image of the crippled Toulouse-Lautrec searching for love among the outcasts of society has clearly aroused the pity and affection of millions. This romanticising of the artist's martyrdom is best captured at the end of John Huston's film *Moulin Rouge*, first released in 1953, where the dying Henri lies in bed, drifting in and out of consciousness, imagining the room filled with the spirits of his Moulin Rouge years – La Goulue, Valentin le Désossé, Jane Avril, madly whirling about to the familiar music of the can-can. A nice conceit, though the reality was even stranger. By the first week of September 1901, Henri was too feeble even to be taken outside to sit in the garden and by 8 September he could no longer

FOLLOWING PAGES: The classic image of Henri de Toulouse-Lautrec as played by José Ferrer in John Huston's film *Moulin Rouge* (1953).

rise from his bed. A few friends came to await the end, among them Gabriel who was forgiven for having been another of Adèle's spies. When Alph turned up, everyone except Henri was astonished. 'Good, Papa,' he said, 'I knew you wouldn't miss the kill.' Presumably to please his mother, he let the local priest administer the last sacraments but when he had gone there was nothing to distract from Alph's eccentric behaviour – he suggested that they cut off Henri's beard which he had heard was a custom in Arabic countries, but no one paid any attention to him. For Henri it must have seemed that all the impossible weirdness of his childhood had returned for this final act.

The day passed slowly. Midnight came and went but the early hours of the ninth were still intolerably hot, promising a storm to match the dramatic downpour that had marked his birth. Flies filled the room with a relentless buzzing while the family drama that had dogged Henri's childhood was played out at his bedside – his mother sitting with a nun saying their rosary beads, his father bored and unpredictable. Ever the hunter, Alph pulled the elastic bands he used as laces out of his shoes and began flicking them at the noisy insects, trying to shoot them down. 'Old fool,' Henri said. They were his last words, after which time dragged on in silence. It was a quarter past two in the morning when someone realised he was dead.

The final tomb of Henri de Toulouse-Lautrec.

BIBLIOGRAPHY

Three books dominate this field of study. Each is a major biography of its subject, drawing on all preceding research while adding much new material. I have used these works constantly during the writing of this book. All are accessible to the general reader and are highly recommended to anyone wishing to know more about the individuals dealt with here.

Ellmann, Richard, *Oscar Wilde*, London and New York, 1988
Frey, Julia, *Toulouse-Lautrec: a life*, London, 1994
Halperin, Joan Ungersma, *Félix Fénéon: Aesthete and Anarchist in Fin-de-Siècle Paris*, New Haven and London, 1988

OTHER MAJOR STUDIES CONSULTED:
Adler, Laure, *La Vie quotidienne dans les maisons closes 1830–1930*, Paris, 1990
Adriani, Götz, *Toulouse-Lautrec: the complete graphic works*, London, 1988
Anon., *Bottin Mondain*, Paris, annual
Bazin, G., *Théodore Géricault* (six vols), Paris, 1987–94
Byrnes, Robert F., *Antisemitism in Modern France*, New Brunswick, 1950
Champion, Jeanne, *Suzanne Valadon, ou, La recherche de la vérité*, Paris, 1984
Clayson, Hollis, *Painted Love: Prostitution in French Art of the Impressionist Era*, New Haven and London 1991
Clemenceau, Georges, *Au Pied du Sinai*, Paris, 1920
Conrad III, Barnaby, *Absinthe: History in a Bottle*, San Francisco, 1988
Copley, Antony, *Sexual Moralities in France 1780–1980*, London and New York, 1989
Darracott, Joseph, *The World of Charles Ricketts*, New York and Toronto, 1980
Donnay, Maurice, *Autour du Chat Noir*, Paris, 1926

Eitner, Lorenz E., *Géricault's 'Raft of the Medusa'*, London, 1972
Eitner, Lorenz E., *Géricault: His Life and Work*, London, 1983
Émile-Bayard, Jean, *Montmartre Past and Present*, London, 1926
Faunce, Sarah and Nochlin, Linda, *Courbet Reconsidered*, Brooklyn, 1988
Gauzi, François, *Lautrec Mon Ami*, Paris, 1992
Guilbert, Yvette, *La Chanson de ma vie*, Paris, 1927
Hart-Davis, Rupert (ed.), *The Letters of Oscar Wilde*, London, 1962
Heller, Reinhold, *Toulouse-Lautrec: The Soul of Montmartre*, Munich and New York, 1997
Hutton, John G., *Neo-Impressionism and the Search for Solid Ground: Art, Science and Anarchism in Fin-de-Siècle France*, Louisiana, 1994
Jarry, Alfred, *Messaline*, Paris, 1901
Joll, James, *The Anarchists*, London, 1979
Joyant, Maurice, *Henri de Toulouse-Lautrec (two vols)*, Paris, 1926, 1927
Joze, Victor, *La Tribu d'Isidore*, Paris, 1897
Jullian, Philippe, *Montmartre*, Oxford, 1977
Jullian, Philippe, Oscar Wilde, London, 1986
Knapp, Bettina L., *The Reign of the Theatrical Director: French Theatre 1887–1924*, New York, 1988
Lugné-Poë, Aurélien, *La Parade*, Paris, 1931
Magné, Jacques-René and Dizel, Jean-Robert, *Les Comtes de Toulouse et leurs descendants les Toulouse-Lautrec*, Paris, 1992
Milner, Frank, *Toulouse-Lautrec*, London, 1992
Murray, Gale B., *Toulouse-Lautrec: The Formative Years 1878–1891*, Oxford, 1991
Natanson, Thadée, *Un Henri de Toulouse-Lautrec*, Geneva, 1951

Nochlin, Linda and Garb, Tamar, *The Jew in the Text*, London, 1995

O'Brien, K. H. F., *Robert Harborough Sherard in the 1890s: An Encyclopaedia of British Literature, Art and Culture* (ed. Cevasco, G. A.), New York and London, 1993

Page, Norman, *An Oscar Wilde Chronology*, London, 1991

Parent-Duchâtelet, Alexandre, *La Prostitution dans la ville de Paris*, Paris, 1836

Perruchot, Henri, *Toulouse-Lautrec*, London, 1994

Pessis, Jacques and Crépineau, Jacques, *The Moulin Rouge*, New York, 1990

Py, Christiane and Ferenczi, Cécile, *La fête foraine d'autrefois*, Paris, 1987

Quétel, Claude, *La Mal de Naples: histoire de la syphilis*, Paris, 1986

Rose, June, *Mistress of Montmartre: A Life of Suzanne Valadon*, London, 1998

Rosenblum, Robert and Janson, H. W., *Art of the Nineteenth Century*, London, 1984

Rothenstein, John, *The Artists of the 1890s*, London, 1928

Rothenstein, John, *The Life and Death of Conder*, London, 1938

Rothenstein, William, *Men and Memories*, London, 1931 (two vols)

Rubin, James Henry, *Realism and Social Vision in Courbet and Proudhon*, Princeton, 1980

Schaub-Koch Emile, *Psychanalyse d'un peintre moderne: Henri de Toulouse-Lautrec*, Paris, 1935

Schimmel, Herbert D. (ed.), *The Letters of Henri de Toulouse-Lautrec*, Oxford, 1991

Sewell, Brocard (Father), *In the Dorian Mode: A Life of John Gray 1866–1934*, Cornwall, UK, 1983. *Two Friends: John Gray and André Raffalovich*, London, 1963

Sherard, Robert H., *Twenty Years in Paris*, London, 1905

Shercliff, José, *Jane Avril of the Moulin Rouge*, London, 1952

Shikes, Ralph E., *The Indignant Eye. The Artist as Social Critic in: Prints and Drawings from the Fifteenth Century to Picasso*, Boston, 1970

Showalter, Elaine, *Sexual Anarchy: Gender and Culture in the Fin-de-Siècle*, New York, 1990

Singer, Isaac Bashevis, *Forward to: The Old Country, Shulman Abraham*, New York, 1974

Speedie, Julie, *Wonderful Sphinx: the Biography of Ada Leverson*, London, 1993

Sugana, G.M. et al, *Tout l'œuvre peint de Toulouse-Lautrec*, Paris, 1986

Thomson, Richard, *Toulouse-Lautrec*, London, 1977

Tydeman, William and Price, Steven, *Wilde: Salome*, Cambridge, UK, 1996

Warnod, Jeanine, *Suzanne Valadon*, Paris, 1981

Weber, Eugèn, *France, fin-de-siècle*, Cambridge MA, 1986

Wilde, Oscar, *The Complete Illustrated Stories, Plays and Poems*, London, 1991

Woodcock, George, *Anarchism*, London, 1963

Woodcock, George, *Pierre-Joseph Proudhon*, London, 1956

OTHER BOOKS REFERRED TO:

Adriani, Götz, *Toulouse-Lautrec*, London, 1987

Anon., *Figaro Illustré par Toulouse-Lautrec*, Paris, 1992

Anon., *Fille de Joie: The book of courtesans, sporting girls, ladies of the evening, madams, a few occasionals and some royal favourites*, New York, 1967

Anon., *Le Temps Toulouse-Lautrec*, Paris, 1991

Anon., *Teleny*, New York, 1992

Appignanesi, Lisa, *The Cabaret*, London, 1975

Attems, Comtesse, *Notre Oncle Lautrec*, Albi, 1990

Baju, Anatole, *L'Anarchie Littéraire*, Paris, 1892

Bercy, Anne de and Ziwés, Armand, *À Montmartre . . . le soir*, Paris, 1951

Berlière, Jean-Marc, *La Police des mœurs sous la III République*, Paris, 1992

Bernheimer, Charles, *Figures of Ill-repute, representing Prostitution in 19th-century France*, Cambridge, MA, and London, 1989

Bernier, Georges, *La Revue blanche: ses amis, ses artistes*, Paris, 1991

Billy, André, *L'époque 1900 (1885–1905)*, Paris, 1951

Birkett, Jennifer, *The Sins of the Fathers: Decadence in France 1870–1914*, London and New York, 1986

Bloch, Louis and Sagari, *Paris qui danse*, Paris, 1888

Boudard, Alphonse and Romi, *L'âge d'or des maisons closes*, Paris, 1990

Bourgeois-Borgex, L., *La Fin d'un Siècle: des frères Lumière à Aristide Bruant*, Paris, 1937

Brasol, Boris, *Oscar Wilde: the Man – the Artist*, London, 1938

Bresson, Auguste, *Une soirée à Bullier*, Paris, 1874

Brown, Frederick, *Zola, a life*, New York, 1995

Bruant, Aristide, *Dans la rue* (two vols), Paris, 1889. *Les Bas-fonds de Paris*, Paris, 1914. *Le Mirliton*, (ed.) Paris, 1888–92

Buisson, Sylvie and Parisot, Christian, *Paris Montmartre: A Mecca of Modern Art 1860–1920*, Paris, 1996

Cachin, Françoise, *Fénéon: Au-delà de l'impressionisme*, Paris, 1966

Carco, Francis, *La Belle Époque au temps de Bruant*, Paris, 1954

Casselaer, Catherine van, *Lot's Wife, Lesbian Paris 1890–1914*, Liverpool, 1986

Chambers, Iain, *Popular Culture: The Metropolitan Experience*, London, 1986

Chassé, Charles, *The Nabis and their Period*, London, 1969

Christiansen, Rupert, *Tales of the New Babylon: Paris 1869–1875*, London, 1994

Clark, Kenneth, *Animals and Men*, London, 1977

Clark, T. J., *Image of the People: Gustave Courbet and the 1848 Revolution*, London, 1973

Clark, T. J., *The Absolute Bourgeois: Artists and Politics in France 1848–1851*, London, 1973

Clive, H. P., *Pierre Louÿs*, Oxford, 1978

Coquiot, Gustave, *Les Bals publics*, Paris, 1896

Corlieu, A. Dr, *La Prostitution à Paris*, Paris, 1887

Cuno, J. (ed.), *French Caricature and the French Revolution 1789–1799*, Los Angeles, 1988

Dallas, Grégor, *At the Heart of the Tiger: Clemenceau and His World 1841–1929*, London, 1993

Darmerval, Gérard, *Ubu Roi: la bombe comique de 1896*, Paris, 1984

Delsol, Maurice, *Paris-Cythere*, Paris, 1893

Denvir, Bernard, *Toulouse-Lautrec*, London, 1991

Després, Armand, *La Prostitution en France*, Paris, 1883

Devoisins, Jean, *Toulouse-Lautrec: 'Les Maisons closes'*, Toulouse, 1985

Devynck, Danièle, *Toulouse-Lautrec*, Paris, 1992

Dyson. A. E., *The Crazy Fabric: Essays in Irony*, London, 1965

Farmer, Albert J., *Le Mouvement esthétique et 'décadent' en Angleterre, 1873–1906*, Paris, 1931

Fénéon, Félix, *Lettres à Francis Vielé-Griffin*, Paris, 1990. *Oeuvres* (ed. Paulhan, Jean), Paris, 1950. *Oeuvres plus que complètes* (ed. Halperin, J.), two vols, Geneva, 1970

Fletcher, Ian (ed.), *The Poems of John Gray*, North Carolina, 1988

Foucart, B., *La Post-modernité de Toulouse-Lautrec*, Paris, 1986

Frèches, Claire and José, *Toulouse Lautrec, Painter of the Night*, London, 1994

Fried, M., *Courbet's Realism*, Chicago and London, 1990

Fryer, Jonathan, *André and Oscar: Gide, Wilde and the Gay Art of Living*, London, 1997

Gide, André, *Oscar Wilde, in memoriam*, Paris, 1910. *Si le grain ne meurt*, Paris, 1920

Gimferrer, Père, *Toulouse-Lautrec*, Barcelona, 1990

Guicheteau, Marcel, *Paul Sérusier*, Paris, 1976

Guilbert, Yvette and Simpson, Harold, *Struggles and Victories*, London, 1910

Halperin, Joan Ungersma, *Félix Fénéon and the Language of Art Criticism*, Ann Arbor, MI, 1980

Hanson, Lawrence and Elisabeth, *The Tragic Life of Toulouse-Lautrec 1864–1901*, London, 1956

Harsin, Jill, *Policing prostitution in 19th-century Paris*, London, 1985

Henry, Marjorie Louise, *Stuart Merrill*, Paris, 1927

Huisman, P. H. and Dortu, M. G., *Lautrec by Lautrec*, New Jersey, 1964. *Henri de Toulouse-Lautrec*, Milan, 1971

Hüttinger, Eduard, *Degas*, Naefels, Switzerland, 1977

Jackson, A. B., *La Revue blanche 1889–1903*, Paris, 1960

Jeanne, Paul, *Les Théâtres d'Ombres à Montmartre de 1887 à 1923*, Paris, 1937

Jullian, Edouard, *Lautrec*, New York, 1976

Knox, Melissa, *Oscar Wilde: a Long and Lovely suicide*, Yale, 1994

Kohl, Norbert, *Oscar Wilde: The works of a Conformist Rebel*, Cambridge, New York, Melbourne, Sydney, 1989

Langlade, Jacques de, *Oscar Wilde, ou, la vérité des masques*, Paris, 1987

Langlois, Gilles-Antoine, *Jours de Fête*, Paris, 1992

Lecour, C. J., *De l'Etat Actuel de la prostitution parisienne*, Paris, 1874

Lucie-Smith, Edward, *Toulouse-Lautrec*, Oxford, 1977

Mabille de Poncheville, A., *Vie de Verhaeren*, Paris, 1953

Mack, Gerstle, *Gustave Courbet*, London, 1951. *Toulouse-Lautrec*, New York, 1952

MacOrlan, Pierre, *Lautrec: peintre de la lumière froide*, Paris, 1992

Marc, Henri, *Aristide Bruant: le maitre de la rue*, Paris, 1989

Marshall, Peter, *Demanding the Impossible: A History of Anarchism*, London, 1993

McCormack, Jerusha Hull, *The Selected Prose of John Gray*, Greensboro, NC, 1992

Métenier, Oscar, *Le chansonnier populataire Aristide Bruant*, Paris, 1893

Milhou, Mayi, *Du Moulin Rouge à l'Opéra: vie et œuvre de Maxime Dethomas (1867–1929)*, Bordeaux, 1991

Millan, Gordon, *Mallarmé: a throw of the dice*, London, 1994

Mix, Katherine Lyon, *A Study in yellow: the Yellow Book and its Contributors*, London, 1960

Montorgueil, Georges, *Paris au Hasard*, Paris, 1895. *Paris Dansant*, Paris, 1898

Moore, T. Sturge and Lewis, Cecil, *Self-portrait Taken from the Letters and Journals of Charles Ricketts RA*, London, 1939

Mouloudji, Marcel, *Aristide Bruant*, Paris, 1972

Murray, Gale B., *Toulouse-Lautrec: A Retrospective*, New York, 1992

Nattier-Natanson, Evelyn, *Les Amitiés de la Revue blanche et quelques autres*, Paris, 1959

Naudin, Jean-Bernard, Diego Dortignas, Genevieve and Daguin, André, *Toulouse-Lautrec's Table*, New York, 1993

Néret, Gilles, *Henri de Toulouse-Lautrec*, Cologne, 1994

Nochlin, Linda, *Women, Art and Power and Other Essays*, London, 1989. *The Politics of Vision*, London, 1991

Nohain, Jean and Caradec, François, *Le Pétomane 1857–1945*, Paris, 1967

Nunokawa, Jeff, *Oscar Wilde*, New York and Philadelphia, 1995

Oberthur, Mariel, *Cafés and Cabarets of Montmartre*, Salt Lake City, 1984

O'Connor, Patrick, *Toulouse-Lautrec: The Nightlife of Paris*, London, 1991

Oriol, Philippe, *A propos de l'attentat Foyot*, Paris, 1993

Powell, Kerry, *Oscar Wilde and the Theatre of the 1890s*, Cambridge, UK, 1990

Raynaud, Ernest, *La Mêlée Symboliste*, Paris, 1900

Rebell, Hugues et al, *Pour Oscar Wilde*, Rouen, 1994

Rebell, Hugues, *Trois Artistes Etrangers*, Paris, 1901

Rewald, John (ed.), *Camille Pissarro: Letters to His Son Lucien*, New York, 1943

Richard, Emile, *La Prostitution à Paris*, Paris, 1890

Richardson, Joanna, *The Bohemians*, London, 1969

Robichez, Jacques, *Le Symbolisme au Théâtre: Lugné-Poë et les débuts de l'Oeuvre*, Paris, 1957

Rodat, Charles de and Cazelles, Jean, *Toulouse-Lautrec: album de famille*, Fribourg, 1985

Roquebert, Anne, *Le Paris de Toulouse-Lautrec*, Paris, 1992

Rosinsky, Thérèse Diamand, *Suzanne Valadon*, New York, 1994

Rudorff, Raymond, *Belle époque: Paris in the Nineties*, London, 1972

Sagne, Jean, *Toulouse-Lautrec*, Paris, 1988

Salmon, André, *La Terreur Noir*, Paris, 1959

Schmidgall, Gary, *The Stranger Wilde: Interpreting Oscar*, New York, 1994

Sewell, Brocard (Father) *Footnote to the Nineties: A Memoir of John Gray and André Raffalovich*, London, 1968

Shapiro, Theda, *Painters and Politics, The European Avant-Garde and Society, 1900–1925*, New York and Oxford, 1976

Shattuck, Roger, *The Banquet Years*, London, 1955

Sherard, Robert H., *Oscar Wilde: The Story of an Unhappy Friendship*, London, 1905. *The Life of Oscar Wilde*, London, 1906. *The Real Oscar Wilde*, London, 1917. *Bernard Shaw, Frank Harris and Oscar Wilde*, London, 1937

Shikes, R. and Heller, S., *The Art of Satire*, New York, 1984

Silverman, Deborah Leah, *Art Nouveau in Fin-de-Siècle France: Politics, Psychology and Style*, Berkeley, CA, 1989

Southerton, Peter, *Reading Gaol by Reading Town*, Berkshire, UK, 1993

Stevenson, Lesley, *H. de Toulouse-Lautrec*, London, 1991

Stokes, Hugh, *French Art in French Life*, London, 1932

Stokes, John, *Oscar Wilde: Myths, Miracles and Imitations*, Cambridge, 1996

Storm, John, *The Valadon Drama: the life of Suzanne Valadon*, New York, 1959

Taxil, Léo, *La Corruption Fin de Siècle*, Paris, 1891

Tuchman, Barbara, *The Proud Tower*, London, 1966

Vigny, Alfred de, *Servitude et grandeur militaires*, Paris, 1857

Warnod, André, *Bals, Cafés and Cabarets*, Paris, 1913

Warnod, André, *Ceux de la Butte*, Paris, 1947

Welsh-Ovcharov, Bogomila, *Vincent van Gogh and the Birth of Cloisonism*, Toronto, 1981

West, Shearer, *Fin-de-Siècle: Art and Society in an Age of Uncertainty*, London, 1993

Woodcock, George, *The Paradox of Oscar Wilde*, London, 1949

Zévaès, Alexandre, *Aristide Bruant*, Paris, 1943

Zweig, Stefan, *Emile Verhaeren*, Paris, 1985

PERIODICALS, REPORTS OF CONFERENCES, BULLETINS OF LEARNED SOCIETIES AND UNIVERSITY THESES:

Anon., *La Roi Fénéon, Times Literary Supplement*, London, 1950

Avril, Jane, *Mes Memoires, Paris-Midi*, 1933

Berger, K., *Courbet in his century, Gazette des Beaux-Arts*, no. 6, XXIV, 1943

Bowness, Alan, *Courbet's Proudhon, Burlington Magazine*, CXX, 1978

Clive, H. P., *Oscar Wilde's first meeting with Mallarmé, French Studies*, Oxford, 1970

Courteline, Georges, *Chez Bruant, Revue Illustreé*, Paris, 1897

Dominique, Pierre and Galtier-Boissière, Jean, *Histoire de la Prostitution, Crapouillot*, Paris, 1961

Donos, Charles, *De Toulouse-Lautrec, Les Hommes d'aujourd'hui*, Paris, 1896

Duthuit, Georges, *Deux Lautrec mutilés, L'Amour de l'Art*, Paris, 1926

Fénéon, Félix (ed. and trans. Kloeppel, Francis), *The Art Criticism of Félix Fénéon, Arts Magazine*, vol. 315, no. 4, 1957

Georges-Michel, Michel, *Lautrec et ses modèles, Gazette des Beaux-Arts*, series 6, vol. 79, 1972

Guillemot, Maurice, *Le Peintre de la 'Goulue', Comte (sic) Henri de Toulouse-Lautrec (1864–1901), Bulletin de la Commission Municipale, Historique et Artistique*, Neuilly, 1913

Heller, Reinhold, *Rediscovering Henri de Toulouse-Lautrec's 'At the Moulin Rouge', Museum Studies*, 12, no. 2, 1985

Jarry, Alfred, *Correspondence avec Félix Fénéon*, in *Etoile Absinthe*, Soc. des amis d'Alfred Jarry, France, 1980

Johnson, Lincoln F., Jnr., *Toulouse-Lautrec, the Symbolists and Symbolism*, Harvard University, Cambridge, MA, 1956

Mauclair, Camille, *La Femme devant les peintres modernes, La Nouvelle Revue*, 2nd series, 1, 1899

Morice, Michel, *Princeteau, La vérité en mouvement, L'Oeil*, 1990

O'Brien, K. H. F., *Robert Sherard: friend of Oscar Wilde, English Literature in Transition*, vol. 28, no.1, 1985

Potts, A., *Natural Order and the Call of the Wild, Oxford Art Journal*, XIII, 1990

Rewald, John, *Félix Fénéon, Gazette des Beaux-Arts*, series 6, 32, 1947

Roquebert, Anne, *Toulouse-Lautrec au musée*, in *Actes du colloque Toulouse-Lautrec*, Musée d'Albi, Albi, 1992

Sells, C., *New Light on Géricault, Apollo*, 1986

Seltzer, *Gustave Courbet: All the World's a Studio, Art Forum*, 1986

Sherard, Robert H., *Jules Chéret, The Magazine of Art*, 1893. *Louis Anquetin, Painter, Art Journal*, 1899

Symons, Arthur, *The History of the Moulin-Rouge, The English Review*, vol. 34, 1922

Thomson, Richard, *Toulouse-Lautrec, Low Life and High Society, Art News*, vol. 1, 91, no. 5, May 1992. *Toulouse-Lautrec, Arthur Huc et le 'Néo-Réalisme'* in *Actes du colloque Toulouse-Lautrec*, Musée d'Albi, Albi, 1992

EXHIBITION CATALOGUES:

Abélès, Luce, *Toulouse-Lautrec: la baraque de la Goulue*, Musée d'Art et d'Essai, Paris, 1984

Anon., *Les Lautrec de Lautrec*, Queensland Art Gallery, Brisbane, 1991

Anon., *Yvette Guilbert: Diseuse fin-de-siècle*, Musée Toulouse-Lautrec, Albi, 1994

Bella, Edward (ed.), *A Collection of Posters: The London Aquarium*, London, 1894. *A Collection of Posters: The London Aquarium*, London, 1896

Boyer, Patricia Eckert (ed.), *The Nabis and the Parisian Avant-Garde*, The Zimmerli Art Museum, New Jersey, 1988

Boyer, Patricia Eckert, *Artists and the Avant-Garde Theatre in Paris 1887–1900*, National Gallery of Art, Washington, 1998

Breton, Guy et al., *Les Cabarets de Montmartre*, Musée de Montmartre, Paris, 1993

Cachin, Françoise et al., *Seurat*, Galeries nationales du Grand Palais, Paris, 1991

Carey, Frances and Griffiths, Antony, *From Monet to Toulouse-Lautrec – French Lithographs 1860–1900*, British Museum, London, 1978

Castleman, R. and Wittrock, W., *Henri de Toulouse-Lautrec: Images of the 1890s*, Museum of Modern Art, New York, 1985

Cate, Phillip Dennis and Boyer, Patricia Eckert, *The Circle of Toulouse-Lautrec*, The Jane Voorhees Zimmerli Art Museum, Rutgers, NJ, 1986

Cate, Phillip Dennis et al., *Exhib. cat: Toulouse-Lautrec*, San Diego Museum of Art, 1988

Farwell, B. (ed.), *The Charged Image: French Lithographic Caricature 1816–1848*, Museum of Art, Santa Barbara, 1989

Floyd, Phylis, *Jean Louis Forain (1852–1931)*, in, *The Crisis of Impressionism 1878–1882*, The University of Michigan Museum of Art, Ann Arbor, 1979–80

Granadda, Léonard et al., *Suzanne Valadon*, Fondation Pierre Granadda, Martigny, Switzerland, 1996

Henderson, Gavin and Parkin, Michael, *The Artists of the Yellow Book and the Circle of Oscar Wilde*, Clarendon and Parkin Galleries, London, 1983

Julia, I., *French Painting: the Age of Revolution*, Grand Palais, Paris, 1975

Lampert, Catherine, *Rodin: Sculpture and Drawings*, Hayward Gallery, London, 1986/7

Oberthur, Mariel, *Le Chat Noir 1881–1897*, Musée d'Orsay, Paris, 1992. *Montmartre en Liesse 1880–1900*, Musée Carnavalet, Paris, 1994

Shapiro, Barbara Stern, *Pleasures of Paris: Daumier to Picasso*, Museum of Fine Arts, Boston, 1991

Stuckey, Charles F. and Maurer, Naomi E., *Toulouse-Lautrec: Paintings*, The Art Institute, Chicago, 1979

Thomson, Richard, *Camille Pissarro*, the South Bank Centre, London, 1990. *Toulouse-Lautrec*, South Bank Centre, London, 1991

Welsh-Ovcharov, Bogomila et al., *Van Gogh à Paris*, Musée d'Orsay, Paris, 1988

INDEX